American Sculpture in The Metropolitan Museum of Art

Volume 2

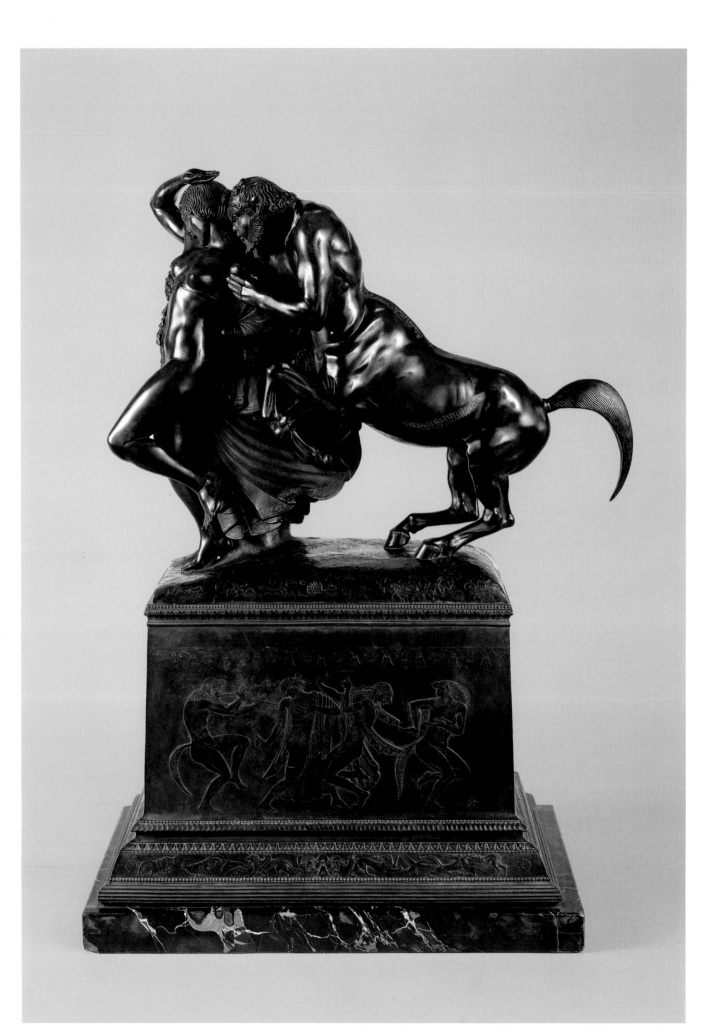

American Sculpture in The Metropolitan Museum of Art

Volume 2. A Catalogue of Works by Artists Born between 1865 and 1885

Edited by Thayer Tolles

Catalogue by Donna J. Hassler, Joan M. Marter, and Thayer Tolles

Photographs by Jerry L. Thompson

THE METROPOLITAN MUSEUM OF ART

YALE UNIVERSITY PRESS

This publication is made possible through the generous support of The Henry Luce Foundation, Inc., the Surdna Foundation, Inc., the National Endowment for the Arts, and the William Cullen Bryant Fellows of The Metropolitan Museum of Art.

Published by The Metropolitan Museum of Art, New York
John P. O'Neill, Editor in Chief
Margaret Aspinwall, Senior Editor
Bruce Campbell, Designer
Merantine Hens, Production
Barbara Sturman, Desktop Publishing

Separations by Professional Graphics Inc., Rockford, Illinois
Printed by CS Graphics PTE Ltd., Singapore

Jacket: Cat. no. 307. Gaston Lachaise, *Standing Woman*
Frontispiece: Cat. no. 375. Paul Manship, *Centaur and Dryad*

CIP data is available from the Library of Congress.
ISBN 0-87099-914-1 (vol. 1: The Metropolitan Museum of Art)
ISBN 0-87099-923-0 (vol. 2: The Metropolitan Museum of Art)
ISBN 0-300-08847-7 (vol. 2: Yale University Press)

Contents

Preface and Acknowledgments

This volume catalogues The Metropolitan Museum of Art's American sculpture by artists born between 1865 and 1885, continuing chronologically from volume 1, *A Catalogue of Works by Artists Born before 1865* (1999). From the works of Horatio Greenough and Hiram Powers, born in 1805, to those of Paul Manship and John Storrs, born in 1885, the two volumes present a history of the figurative tradition in American sculpture. Carving in marble and casting in bronze and plaster, the artists defined and redefined varying stylistic approaches from neoclassical to Beaux Arts to modern. This development is fully represented in the Metropolitan's outstanding collection, formed from the earliest days of the Museum's founding in 1870 to the present. Volume 2 includes sculptures in the departments of American Paintings and Sculpture and Modern Art (renamed in July 1999; previously the Department of Twentieth Century Art), concluding with high achievements of figural modernism by such artists as Gaston Lachaise, Elie Nadelman, and Manship.

The acknowledgments in volume 1 name the many individuals at the Metropolitan Museum and other institutions who have contributed over the years to the completion of this long project. We renew our thanks to those at the Museum who have particularly supported volume 2, especially Philippe de Montebello, director; Doralynn Pines, associate director for administration; Emily Kernan Rafferty, senior vice president for external affairs; John K. Howat, Lawrence A. Fleischman Chairman of the Departments of American Art; William S. Lieberman, Jacques and Natasha Gelman Chairman of the Department of Modern Art; and John P. O'Neill, editor in chief and general manager of publications. Others deserving special mention are: in the American Wing, curator and administrator Peter M. Kenny, administrative assistants Dana Pilson and Catherine Scandalis, research assistants Alexis L. Boylan and Karen Lemmey, and technicians Don E. Templeton, Gary Burnett, Sean Farrell, and Rob Davis; in the Department of Modern Art, assistant curator Lisa M. Messinger, research associate Ida Balboul, assistant for administration Katharine Derosier, administrative assistants Shirley Levy and Jennifer Mock, and technicians John Koski, Anthony Askin, and Cynthia Iavarone; in the Department of Drawings and Prints, assistant for adminis-

tration Molly Carrott; in Archives, archivist Jeanie M. James; in the Thomas J. Watson Library, Kenneth Soehner, Arthur K. Watson Chief Librarian, and associate Museum librarian Linda Seckelson. In the Editorial Department, chief production manager Peter Antony and production manager Merantine Hens expertly guided this book through the typesetting and production stages.

Special thanks are offered to the following scholars for their contributions to this volume: Janis C. Conner and Joel Rosenkranz examined the Museum's Jo Davidson and Malvina Hoffman holdings and gave advice on dating these sculptures. Their extensive knowledge of and enthusiasm for American sculpture have been shared freely during the course of preparing this publication. Gerald Nordland, an expert on Gaston Lachaise, kindly read drafts of catalogue entries and related specific examples to other sculptures by the artist. P. Andrew Spahr, Currier Gallery of Art, Manchester, New Hampshire, conducted research in the Metropolitan Museum Archives for Joan Marter and assisted in her examination of the sculptures in the Department of Modern Art. We appreciate the continued interest of Lauretta Dimmick, whose material appeared in volume 1, and Lowery Stokes Sims, formerly curator in the Metropolitan's Department of Modern Art and currently director of The Studio Museum in Harlem, New York. Gail Stavitsky, Montclair Art Museum, Montclair, New Jersey, conducted extensive research on Scofield Thayer's collection after it was accessioned by the Metropolitan Museum in 1984. Roberta K. Tarbell, Rutgers University, offered generous information on Hugo Robus, John Storrs, and Max Weber, reviewing biographical information and assisting in the dating of the Museum's casts and related editions. Other individuals not cited in volume 1 who were particularly helpful were Sarah Cash, Corcoran Gallery of Art, Washington, D. C.; Stephanie Cassidy, Art Students League of New York; Susan P. Casteras, University of Washington, Seattle; Marie P. Charles, The Lachaise Foundation, Boston; Robert S. Fishko, Forum Gallery, New York; Carol Irish; Elisabeth Lidén, Millesgården, Lidingö, Sweden; Leigh A. Morse, Salander-O'Reilly Galleries, New York; Carole Pesner, Kraushaar Galleries, New York; and Joy S. Weber. Sara Harrington, Leslie Lund, and Jenni L. Schlossman, students in the graduate program in art history at Rutgers

University, assembled research material on many of the artists in this volume. Walter Marter, who assisted with software matters, and Julia Marter deserve special thanks. Institutions not listed in volume 1 whose staff members answered our queries include the Bates College Museum of Art, Lewiston, Maine; Dayton Art Institute, Dayton, Ohio; Iris and B. Gerald Cantor Center for Visual Arts at Stanford University, Stanford, California; Cranbrook Art Museum, Bloomfield Hills, Michigan; Herbert F. Johnson Museum of Art, Cornell University, Ithaca, New York; Joslyn Art Museum, Omaha, Nebraska; Milwaukee Art Museum; Nassau County Museum of Art, Roslyn Harbor, New York; National Arts Club, New York; The Nelson-Atkins Museum of Art, Kansas City, Missouri; The R. W. Norton Art Gallery, Shreveport, Louisiana; Smith College Museum of Art, Northampton, Massachusetts; and Tudor Place Foundation, Inc., Washington, D.C.

For their ongoing commitment to this publication and for their generosity, we extend deep appreciation to The Henry Luce Foundation, Inc., the Surdna Foundation, Inc., and the National Endowment for the Arts. The William Cullen Bryant Fellows of The Metropolitan Museum of Art contributed to the research and production costs of this volume, as they have done for several in the continuing series of collection catalogues of the Museum's extensive American art holdings.

The Authors

Notes to the Reader

The artists in this catalogue are presented chronologically by year of birth, then alphabetically when more than one artist was born in the same year. Each artist's sculptures are arranged chronologically by modeling date.

Biographies and catalogue entries are signed with initials:

DJH Donna J. Hassler, Executive Director, Rensselaer County Historical Society, Troy, New York
JMM Joan M. Marter, Distinguished Professor of Art History, Rutgers, the State University of New Jersey, New Brunswick
TT Thayer Tolles, Associate Curator, Department of American Paintings and Sculpture, The Metropolitan Museum of Art

MMA is frequently used to refer to The Metropolitan Museum of Art.

The department called Twentieth Century Art in volume 1 is referred to in volume 2 by its name as of July 1, 1999, the Department of Modern Art.

At the end of each artist's biography, there is a brief selected bibliography. When these references are cited in the artist's catalogue entries, they are shortened to author or title and date. The bibliography, pages 445–47 in volume 1, lists general publications on American sculpture; it does not include monographs.

In each catalogue entry, wherever possible the title of the sculpture is the one given to it by the artist or under which it was exhibited or published during the artist's lifetime.

The date following the title of a sculpture is the modeling date, and that with the medium is the date of carving or casting of the Museum's example. When only one date is listed, the sculpture was modeled and translated to its medium or created during the given time span.

Dimensions are in inches to the nearest eighth (and in centimeters) in order of height, width, and depth. If the base was created by the sculptor as an integral part of the composition, it is included in the overall dimensions. All sculptures were remeasured for this catalogue.

Markings given are: signature, date, inscription, foundry mark, and cast number; their locations are from the viewer's perspective.

The exhibitions and installations listed at the end of a catalogue entry include only those in which the object was shown after it entered the Metropolitan Museum's collection.

CATALOGUE

Paul Wayland Bartlett (1865–1925)

Born in New Haven, Connecticut, Bartlett was the son of the prominent sculptor, teacher, and critic Truman Howe Bartlett. His family moved to Paris when Paul was four, and by 1877 he was drawing from life and modeling family pets in clay. His plaster bust of his grandmother was displayed at the Paris Salon in 1880. That year, he enrolled as a matriculant at the École des Beaux-Arts, a pupil of Pierre-Jules Cavelier. While still at the École, Bartlett attended classes in drawing and animal sculpture given by the French animalier Emmanuel Frémiet at the Jardin des Plantes. With his friend Georges Gardet, another pupil of Frémiet, Bartlett modeled animals for sculptural projects throughout Paris. He was also a frequent assistant in the studio of Auguste Rodin and studied in the anatomy galleries of the Muséum d'Histoire Naturelle.

Established in a studio of his own, Bartlett executed his first major work, *Bohemian Bear Tamer* (cat. no. 199), which won honorable mention at the Salon of 1887 and was awarded a Grand Prix for sculpture at the 1889 Exposition Universelle. In this piece he announced his command of the Beaux Arts style in both figurative and animal subjects, genres that he would practice with equal facility throughout his career. Bartlett also possessed an extraordinary interest in, and command of, the technical processes of sculpture; he was keenly involved with every small detail of production. About 1892 Bartlett built a foundry adjoining his studio and began to do his own casting by the lost-wax technique and to experiment with patination, creating a number of small bronzes of unusual quality and iridescent color.

Bartlett's best-known public efforts include statues of Columbus (1897) and Michelangelo (1898; both in the Main Reading Room of the Library of Congress, Washington, D.C.) and six allegorical figures for the facade of the New York Public Library (1909–15). His equestrian monument to General Lafayette (1898–1908; Cours la Reine, Paris) was presented to France as a reciprocal gift for Frédéric-Auguste Bartholdi's *Statue of Liberty*, through the donations of American schoolchildren. His sculptural program for the pediment of the House wing of the United States Capitol, *The Apotheosis of Democracy* (1908–16), was his crowning achievement and in 1918 earned the Medal of Honor in Sculpture from the Architectural League of New York.

Bartlett, who worked most of his life in Paris, was honored several times by the French government for his artistic achievements, including being named an officer of the Legion of Honor in 1908 and a corresponding member of the Institute of France in 1911. He was elected an academician of the National Academy of Design in 1917 and served as president of the National Sculpture Society from 1917 to 1919. He died in Paris and is buried at Montparnasse Cemetery. DJH

SELECTED BIBLIOGRAPHY

Bartlett, Paul Wayland, Papers. Manuscript Division, Library of Congress, Washington, D.C.

Bartlett, Paul Wayland, and Related Family Papers. Tudor Place Foundation, Inc. Microfilmed for Archives of American Art, Smithsonian Institution, Washington, D.C., reels 4899–4903.

Bartlett, Ellen Strong. "Paul Bartlett: An American Sculptor." *New England Magazine* 33 (December 1905), pp. 369–82.

Chapman, Katharine Elise. "A Sculptor Who Is Also a Craftsman." *The Craftsman* 16 (July 1909), pp. 437–43.

"Paul Wayland Bartlett." Pan American Union *Bulletin* 45 (September 1917), pp. 351–63.

Wheeler, Charles V. "Bartlett (1865–1925)." *American Magazine of Art* 16 (November 1925), pp. 573–85.

Paul Wayland Bartlett, 1865–1925: Sculptures. Exh. cat., Musée de l'Orangerie. Paris: Gauthier-Villars, 1929.

Catalogue of Memorial Exhibition of the Works of Paul Wayland Bartlett. Introduction by Royal Cortissoz. New York: American Academy of Arts and Letters, 1931.

"Paul Wayland Bartlett." *American Society Legion of Honor Magazine* 14 (Summer 1943), pp. 109–15.

Adil, Carol P., and Henry A. DePhillips, Jr. *Paul Wayland Bartlett and the Art of Patination.* Wethersfield, Conn.: Paul Wayland Bartlett Society, 1991.

Somma, Thomas P. "The Myth of Bohemia and the Savage Other: Paul Wayland Bartlett's *Bear Tamer* and *Indian Ghost Dancer*." *American Art* 6 (Summer 1992), pp. 15–35.

Somma, Thomas P. *The Apotheosis of Democracy, 1908–1916: The Pediment for the House Wing of the United States Capitol.* Newark: University of Delaware Press, 1995.

199. *Bohemian Bear Tamer,* 1885–87

Bronze, 1888
69⅜ x 33 x 45½ in. (176.2 x 83.8 x 115.6 cm)
Signed and dated (top of base, right): *Paul.W.Bartlett. / 87*
Foundry mark (left side of base): GRUET FONDEUR. / PARIS.
Gift of an Association of Gentlemen, 1891 (91.14)

BARTLETT COMPLETED the *Bohemian Bear Tamer,*[1] his first large group, when he was twenty-two and established in a small studio on the Passage des Favorites in Paris. The work already reflects the full influence of his Beaux Arts training, particularly in the lively and accomplished modeling of the lifesize figure, nude save for a loincloth and a band tied around the richly modeled hair. Bartlett had developed his facility in animal sculpture through classes given by Emmanuel Frémiet.[2] Here, however, instead of copying that teacher's dramatic compositions, which often depict man brutally subdued by savage beasts,[3] Bartlett chose to model man controlling animals yet unaware of their potential brute power. A Gypsy (sometimes erroneously identified as a Native American), holding a whip behind his back, commands the attention of one of two bear cubs with an animated snap of his fingers, while the other cub sits scratching its ear with its hind paw. Bartlett may have been inspired by Gypsy animal trainers and "the itinerant little shows that hover around Paris in the summer time."[4] The sculptor was further motivated by Frémiet's interest in evolutionary principles and the relationship between the human and animal life. However, as scholar Thomas Somma has noted, Bartlett "introduced a new factor into Frémiet's equation—the human intellect—and asserted man's reasonable and essentially benevolent control over nature."[5] Thus the underlying theme of the group is the portrayal of man as the superior, thinking species.

The plaster model of *Bohemian Bear Tamer* won an honorable mention at the Paris Salon of 1887.[6] The statue was cast in bronze by the lost-wax process at the Gruet foundry in 1888[7] and was exhibited the same year at the Paris Salon.[8] The following year, it dominated the Paris Exposition Universelle,[9] where it won a Grand Prix for sculpture and was hailed as one of the most important works of American sculpture to be seen at the fair.[10] Because Bartlett had served on the international jury for the fair, he could not accept the award. The plaster was displayed again in 1893 at the World's Columbian Exposition in Chicago,[11] establishing the sculptor's artistic reputation in his own country.

Following Bartlett's initial success with *Bohemian Bear Tamer,* in November 1887 he signed a contract with the Paris foundry of Siot-Decauville et Perzinka, giving them the exclusive right to reproduce the model in two smaller sizes—27 inches and 17 inches[12]—for a ten-year period.[13] The scratching bear was also reduced and cast as a separate work, but the foundry that produced it and the date it was cast are unknown;[14] however, the sculpture is recorded as having been sold at one time through Tiffany and Company, New York.[15]

As a result of having seen *Bohemian Bear Tamer* at the Paris Exposition Universelle of 1889, nine prominent Americans wrote to Henry G. Marquand, president of the Metropolitan Museum's Board of Trustees, in March 1891. Led by Rush Christopher Hawkins, commissioner of fine arts for the American section at the 1889 Exposition Universelle, they informed Marquand that they had "purchased of Paul Wayland Bartlett, for presentation to the Metropolitan Museum of Art, his bronze group entitled the 'Bohemian.'" The donors described the piece and then commented: "The whole work is most admirable, and in its directness of conception and simplicity of treatment stands for very much that is best in classic art. And we believe, its production reflects great credit upon the young sculptor who conceived and executed it."[16]

DJH

EXHIBITIONS

National Academy of Design, New York, "Our Heritage: A Selection from the Permanent Collection of the National Academy," January 8–February 7, 1942, no. 321, as "Bohemian Bear Trainer."
Old Westbury Gardens, Westbury, N.Y., "150 Years of American Sculpture," June 14–August 28, 1960, no. 3.
MMA, "Three Centuries of American Painting," April 9–October 17, 1965.
MMA, "19th-Century America," April 16–September 7, 1970, no. 185.
Whitney Museum of American Art, New York, "200 Years of American Sculpture," March 16–September 26, 1976, no. 15.

1. The piece is also referred to as "The Bohemian," "Bohemian and Bears," "Primitive Man," and "The Bear Tamer." There is a preliminary drawing for this work in a sketchbook of Bartlett's in the Library of Congress; see Colin Eisler, *Sculptors' Drawings over Six Centuries, 1400–1950,* exh. cat., Drawing Center, New York (New York: Agrinde Publications, [1981]), no. 75.
2. For an early reference to Frémiet's influence on Bartlett, see "Exposition Universelle de 1889. La Sculpture," *Gazette des Beaux-Arts,* ser. 3, 2 (1889), p. 405, where French critic André

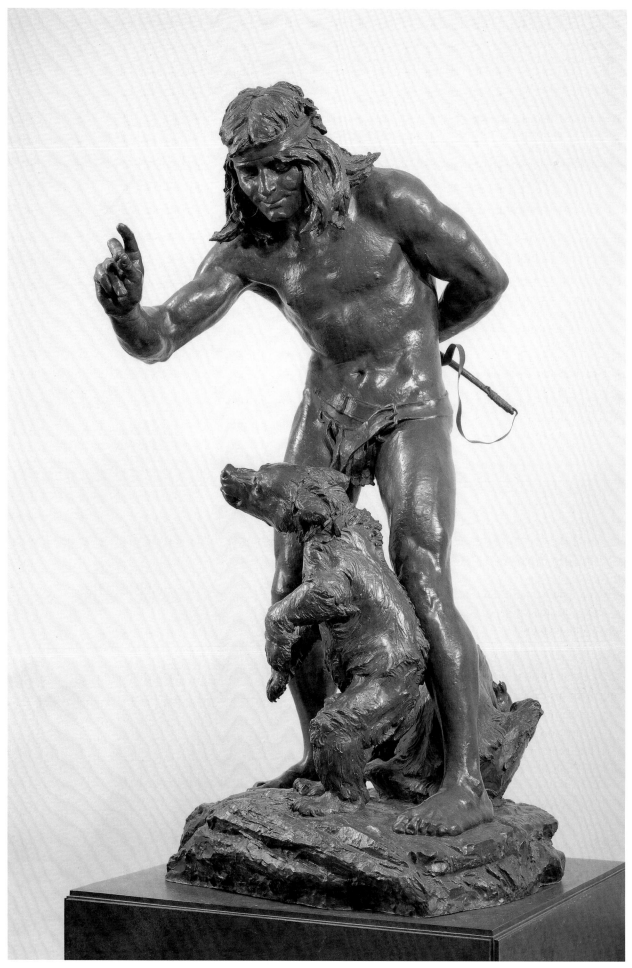

456 PAUL WAYLAND BARTLETT

Michel reviews the sculpture at the exposition, including "Bohé-mien," the bronze cast of *Bohemian Bear Tamer.* See also Wayne Craven, *Sculpture in America,* rev. ed. (Newark: University of Delaware Press, 1984), p. 429, who traces the work to Bartlett's compatriot predecessors Henry Kirke Brown (pp. 41–49) and John Quincy Adams Ward (pp. 136–54), "whose search for a truly American subject led them to represent the American Indian with an animal." Bartlett certainly would have been aware of these thematic prototypes, although his bear trainer is based on European subject matter.

3. For a discussion of this and other aspects of Frémiet's work, see Peter Fusco and H. W. Janson, eds., *The Romantics to Rodin: French Nineteenth-Century Sculpture from North American Collections,* exh. cat. (Los Angeles: Los Angeles County Museum of Art, 1980), pp. 272–80.

4. "Paul Wayland Bartlett, Sculptor," *Art Interchange* 29 (September 1892), p. 61. For further discussion of European Gypsy trainers, see Somma 1992, pp. 16–18.

5. Somma 1992, p. 22. For additional reference to man's superiority over animals as a thematic aspect of Bartlett's group, see M[ichele] B[ogart], in *The Quest for Unity: American Art between World's Fairs 1876–1893,* exh. cat. (Detroit: Detroit Institute of Arts, 1983), p. 254.

6. *Explication des ouvrages de peinture, sculpture . . . ,* Société des Artistes Français, Salon de 1887 (Paris: Paul Dupont, 1887), p. 297, no. 3620, as "Eleveur d'ours;—groupe, plâtre."

7. For a discussion of Bartlett's association with the Gruet foundry, see Michael Edward Shapiro, *Bronze Casting and American Sculpture, 1850–1900* (Newark: University of Delaware Press, 1985), pp. 122–24. See also Somma 1992, p. 15.

8. *Explication des ouvrages de peinture, sculpture . . . ,* Société des Artistes Français, Salon de 1888 (Paris: Paul Dupont, 1888), p. 303, no. 3769, as "Eleveur d'ours;—group, bronze."

9. *Exposition universelle internationale de 1889 à Paris: Catalogue générale officiel, groupe 1, oeuvres d'art* (Lille: Imprimerie L. Danel, 1889), p. 191, no. 455, as "Bohémien."

10. See Annette Blaugrund et al., *Paris 1889: American Artists at the Universal Exposition,* exh. cat. (Philadelphia: Pennsylvania Academy of the Fine Arts, 1989), figs. 21, 22, where the plaque in front of the group reads "Grand Prix." See also "Paul Wayland Bartlett, Sculptor," *Art Interchange* 29 (September 1892), p. 61.

11. *World's Columbian Exposition, 1893: Official Catalogue . . . Fine Arts* (Chicago: W. B. Conkey, 1893), p. [11], no. 10, as "Bohemian and Bears."

12. An example of the 27-inch version is at the Heckscher Museum of Art, Huntington, N.Y., while an example of the 17-inch cast is at the Smithsonian American Art Museum, Washington, D.C.

13. See Shapiro, *Bronze Casting,* pp. 123–24, where the author states that the agreement to market statuettes was the first known between an American sculptor and a French foundry.

14. An example of the scratching bear is at the Munson-Williams-Proctor Institute Museum of Art, Utica, N.Y.

15. See Sotheby Parke Bernet, New York, sale cat., September 29, 1977, no. 89, titled "Bear Cub," signed "Paul W. Bartlett," dated "1887," and inscribed "Tiffany & Co."

16. Letter of March 25, 1891, signed by Hawkins, Thomas Ritter, Charles Stewart Smith, Charles Louis Tiffany, Andrew Carnegie, Henry O. Havemeyer, Samuel P. Avery, Cornelius N. Bliss, and Cornelius Vanderbilt, MMA Archives.

200. *Standing Torso of a Woman,* ca. 1894–95

Bronze, ca. 1909
18⅛ x 7 x 5 in. (46 x 17.8 x 12.7 cm) (including stone base)
Rogers Fund, 1909 (09.88.1)

IN THE EARLY 1890S, now in a studio of his own in Paris and with his critical reputation established, Bartlett began to experiment with casting by the lost-wax process and with patination in various colors and textures. Bartlett quickly earned the respect and admiration of his fellow sculptors through his extraordinary knowledge and interest in these technical processes. In addition to figures including this bronze *Standing Torso of a Woman,* he produced numerous small objects—animals and reptiles, bowls and vases. To each new cast he applied a different color, thereby avoiding a conventional appearance in his finished works.[1] In that aspect of his creativity Bartlett was inspired by the French ceramist Jean Carriès,[2] who was known for his use of Japanese glazes.

Bartlett was commended at the Salon of 1895 for the small bronzes he exhibited in the decorative arts section.[3]

As the collection has been described:

> The subjects were ethnographic whimseys of fishes and serpents, of batrachians, crustaceans, and the like. To the artists who hung over this display, its radiant gemlike colors were even more alluring than its forms. Sculptors who had experimented arduously in alloys and *patines* were the first to acclaim Bartlett's success. . . . These "essays," as the author called them, express his delight in craftsmanship. Even during the last summer of his life, he was eagerly working with pottery and glazes.[4]

In 1904, at the Louisiana Purchase Exposition in Saint Louis,[5] Bartlett again exhibited a substantial collection of his bronzes and decorative objects and was awarded a grand prize in sculpture.

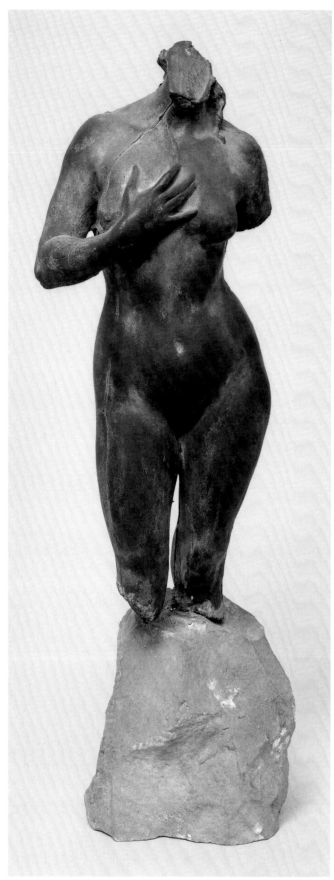

200

Standing Torso is striking in the deliberately weathered quality of the finish, which creates an antique effect. It has been suggested that the figure was a study for Bartlett's first major private commission, in 1894, from Senator William A. Clark of Montana: the doorway to his wife's tomb, in Woodlawn Cemetery, New York, which the sculptor completed in 1897.[6]

Discussions with Bartlett for the purchase of this piece and its mate, *Seated Torso of a Woman* (cat. no. 201), began in 1907, when Metropolitan trustee Daniel Chester French (pp. 326–41) wrote the sculptor: "The wish has been expressed that a collection of your small bronzes in which you have tried experiments in color in patine should be added to the collection of the Metropolitan Museum."[7] It would be two years before casts were accessioned into the Museum's collection, and yet another before the actual bronzes were received. As with *Seated Torso,* Bartlett presented the Metropolitan with a plaster cast until he could substitute a bronze for it.[8]

There is a cast of *Standing Torso* in the Musée d'Orsay, Paris.[9] The Smithsonian American Art Museum, Washington, D.C., has a version of the standing figure, but the dark, shiny patina suggests that it may have been cast after the artist's death. A number of smaller works that remained in the artist's studio at his death were probably cast posthumously. Some of the casts are stamped "SB," the initials of Bartlett's wife, Suzanne, suggesting that the casts may have been made at her behest.[10]

Standing Torso is mounted on a stone base, which has been identified as a crystalline limestone. The stone has been colored, perhaps to resemble a green sandstone.[11]

DJH

1. A notebook (ca. 1890–95) filled with formulas for patinas and techniques for lost-wax casting, together with a selected bibliography on the subject, is among Bartlett's papers in the Library of Congress. Adil and DePhillips 1991 reprints these notes.
2. The relationship of the two men is discussed in Michael Edward Shapiro, *Bronze Casting and American Sculpture, 1850–1900* (Newark: University of Delaware Press, 1985), pp. 124–25.
3. *Explication des ouvrages de peinture, sculpture . . . ,* Société des Artistes Français, Salon de 1895 (Paris: Paul Dupont, 1895), p. 319, no. 3647, as "Vitrine d'essais de fonte et de patines;—cire perdue."
4. *Dictionary of American Biography,* s.v. "Bartlett, Paul Wayland."
5. See *Official Catalogue of Exhibitors: Universal Exposition, St. Louis, U.S.A., 1904 . . . Department B, Art,* rev. ed. (Saint Louis: Official Catalogue Co., 1904), pp. 58–59, nos. 1966–2034. For illustrations of the sculptor's installation, including a cast of *Standing Torso,* see Bartlett 1905, pp. 374–75.
6. See Thomas P. Somma, "Paul Wayland Bartlett and 'The Apotheosis of Democracy,' 1908–1916: The Pediment for the House Wing of the United States Capitol," Ph.D. diss., University of Delaware, 1990, pp. 125–26. For an illustration of the relief figure on the Clark doorway, see Shapiro, *Bronze Casting,* p. 128, fig. 137.

7. French to Bartlett, March 11, 1907, Bartlett Papers, Archives of American Art, microfilm reel 4899, frame 478.
8. Bartlett to French, April 26, 1909, Daniel Chester French Family Papers, Manuscript Division, Library of Congress, Washington, D.C., microfilm reel 1, frame 673.
9. Anne Pingeot et al., *Musée d'Orsay: Catalogue sommaire illustré des sculptures* (Paris: Réunion des Musées Nationaux, 1986), p. 42, no. RF 3154.
10. I am grateful to George Gurney, Curator, Smithsonian American Art Museum, for this suggestion; letter to Donna J. Hassler, September 26, 1986, object files, MMA Department of American Paintings and Sculpture.
11. George Wheeler, Research Chemist, MMA Department of Objects Conservation, in conversation with Thayer Tolles, October 17, 1996, notes in object files, MMA Department of American Paintings and Sculpture.

201. *Seated Torso of a Woman*, ca. 1895

Bronze, ca. 1909
14 x 5 x 7 in. (35.6 x 12.7 x 17.8 cm)
Signed (right side of base): Bartlett
Rogers Fund, 1909 (09.88.2)

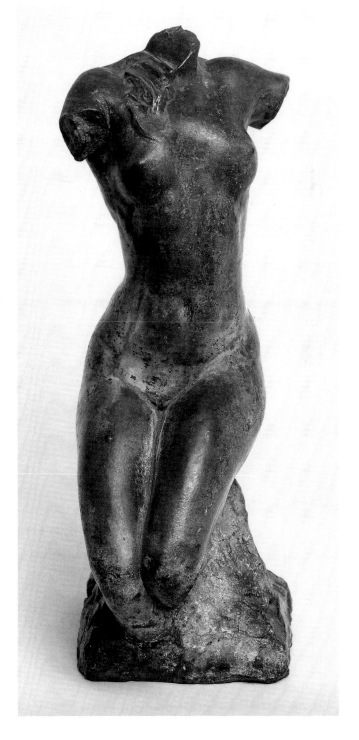

THIS *Seated Torso of a Woman,* cast by the sculptor himself by means of the lost-wax technique, is another example of Bartlett's experimentation with the color and appearance of some of his smaller works. He chemically treated this bronze figure to achieve a green effect,[1] which causes it to shimmer with iridescent blues and golds.

On the advice of Daniel Chester French, chairman of the Metropolitan Museum trustees' Committee on Sculpture, the Museum purchased the bronze and a companion piece (cat. no. 200) directly from the artist in 1909. During negotiations with the Museum, Bartlett, who was then in the United States, mentioned that he had a bronze of the seated figure available in his Paris studio.[2] However, he delayed providing a bronze cast until the following year, when he offered Museum president Robert de Forest his choice of two examples for his personal collection.[3] In the meantime, he sent the Museum a plaster cast in its stead.[4]

A cast of *Seated Torso of a Woman* is in the Musée d'Orsay, Paris.[5] Two other known casts of *Seated Torso,* at the Smithsonian American Art Museum and at the Corcoran Gallery of Art, Washington, D.C., have dark, shiny patinas completely unlike the colorful surfaces Bartlett himself produced, and they were probably cast posthumously.[6]

DJH

EXHIBITION

Sheldon Swope Art Gallery, Terre Haute, Ind., January 1948–April 1960.

1. "Mr. Bartlett has brought to the Museum two copies of the Seated Torso of a Woman in bronze. One of them has been treated to produce a green, the other a blue effect. Mr. Bartlett wished Mr. de Forest to make a choice of the copy which he

liked best, with the understanding that it would go to him, the other to the Museum"; letter from Henry W. Kent, Assistant Secretary, MMA, to Daniel Chester French, March 15, 1910, MMA Archives.

2. Bartlett to French, January 25, 1909, Daniel Chester French Family Papers, Manuscript Division, Library of Congress, Washington, D.C., microfilm reel 1, frame 658.

3. Kent to French, as in note 1.

4. Bartlett to French, April 26, 1909, French Family Papers, Library of Congress, microfilm reel 1, frame 673.

5. Anne Pingeot et al., *Musée d'Orsay: Catalogue sommaire illustré des sculptures* (Paris: Réunion des Musées Nationaux, 1986), p. 42, no. RF 3156.

6. The Metropolitan's cast is illustrated in juxtaposition with that of the Smithsonian American Art Museum in Michael Edward Shapiro, *Bronze Casting and American Sculpture, 1850–1900* (Newark: University of Delaware Press, 1985), p. 126, figs. 133, 134, pointing up the difference in their surface appearances. The Corcoran's example is titled "Female Figure." For further discussion of works presumably cast posthumously, see cat. no. 200.

202. *Romance: A Study of a Head,* ca. 1910

Plaster
17 x 17 x 9 in. (43.2 x 43.2 x 22.9 cm)
Gift of the artist, 1919 (19.35)

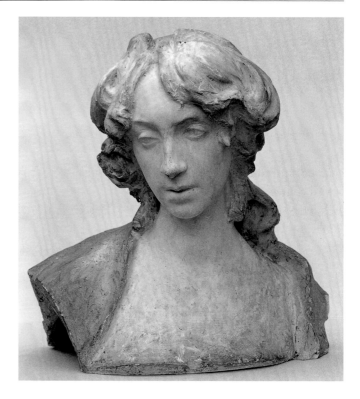

IN NOVEMBER 1908, Bartlett received a commission from the architectural firm of Carrère and Hastings to design sculpture for the Fifth Avenue facade of the New York Public Library.[1] In his Paris studio the following year, he began work on the project, which consisted of six figures, each personifying a different aspect of human knowledge. In order from the viewer's left, they represent Philosophy, Romance, Religion, Poetry, Drama, and History. These figures, each approximately 11 feet high, were translated to marble by the Piccirilli Brothers (see pp. 482–85 and 512–14) and were installed on the attic above the main entrance to the building between December 1915 and January 1916.

Romance is a preliminary study of the head for that library figure, which in its completed state depicts a young woman clad in flowing drapery and holding flowers in one hand and a book in the other. Although the plaster study has the same pensive quality found in the final marble, here the head turns to the woman's right rather than to her left, an alteration in pose that was probably the result of the sculptor's careful considerations of balance, gesture, light, and shadow in his overall scheme. The modeling in this study is understandably looser and more impressionistic than in the finished conception.

Bartlett was no stranger to the limitations that the design of architectural sculpture imposed on an artist. He had previously assisted John Quincy Adams Ward with Ward's pediment *Integrity Protecting the Works of Man* (1901–4) for the New York Stock Exchange, and he was also executing the pediment for the House of Representatives wing of the United States Capitol, which he completed in 1916 after eight years' work.[2] In his sculpture for the New York Public Library, Bartlett employed

a convincing illusionism: the figures appear almost free-standing, though they "had only a shelf one foot wide on which to stand."[3]

The plaster bust *Romance* was included in the Metropolitan Museum's "Exhibition of American Sculpture," which was organized by Daniel Chester French and accompanied by an illustrated catalogue. Neither *Romance* nor Bartlett's plaster statue *Michelangelo* (bronze in the Library of Congress) arrived in a timely fashion, for the catalogue noted that the pieces had "not [been] received at date of publication."[4] On February 3, 1919, French wrote to

Museum registrar Henry F. Davidson that *Romance* was being sent from Washington, D.C.,[5] and upon its arrival, the plaster apparently joined the exhibition.

A bronze cast (dated 1929) of the original model for the figure of *Romance* is in the collection of the Corcoran Gallery of Art, Washington, D.C.[6] DJH

1. For discussions of the project, see Michele H. Bogart, "Four Sculpture Sketches by Paul W. Bartlett for The New York Public Library," *Georgia Museum of Art Bulletin* 7, no. 2 (1982), pp. 5–24; and idem, *Public Sculpture and the Civic Ideal in New York City, 1890–1930* (Chicago: University of Chicago Press, 1989), pp. 177–84. See also William Walton, "Recent Work by Paul W. Bartlett," *Scribner's Magazine* 54 (October 1913), pp. 529–30; and Mitchell Carroll, "Paul Bartlett's Decorative Sculptures for the New York Public Library," *Art and Archaeology* 3 (January 1916), pp. 35–39.
2. For further information on these projects, see Lewis I. Sharp, *John Quincy Adams Ward: Dean of American Sculpture, with a Catalogue Raisonné* (Newark: University of Delaware Press, 1985), pp. 263–64; and Somma 1995.
3. John J. Klaber, "Paul W. Bartlett's Latest Sculpture," *Architectural Record* 39 (March 1916), p. 278.
4. *An Exhibition of American Sculpture* (New York: MMA, 1918), p. 1, nos. 7, 8.
5. French to Davidson, February 3, 1919, MMA Archives.
6. The dimensions of the figure are 65 x 38 x 8½ in.

203. *Preparedness,* 1915–16

Bronze, 1916
12½ x 4¼ x 4½ in. (31.8 x 10.8 x 11.4 cm)
Signed and dated (back edge, continuing to left side): Copy-righted. / By P.W. Bartlett. / 1916
Inscribed (banner on front): PREPAREDNESS
Foundry mark (right side of base): Cast by Griffoul·Newark·N·J·
Gift of Thomas Henry Russell and Frederic Newlin Price, 1925 (25.72)

BARTLETT WAS said to have begun this statuette of an American eagle "the day after the sinking of the Lusitania,"[1] which occurred on May 7, 1915. Thomas Somma has argued convincingly that the artist was an advocate of the preparedness movement, in which increasing numbers of Americans favored military preparation for war. Despite Bartlett's pro-French leanings, his sentiments were necessarily veiled because of his government commission for the House pediment for the United States Capitol.[2] *Preparedness* (also known as *The Eagle of Preparedness*), modeled by early 1916, is the most overt proclamation among Bartlett's works of his sympathies with the Allied cause. The stately, but loosely modeled bird is perched atop a rounded mass with a shield in front and a banner imprinted "Preparedness."

By April 1916, Bartlett had received a number of orders for bronze replicas.[3] Thus it seems clear that *Preparedness* was not made as a sketch for the World War I Victory Arch erected in 1919 in New York's Madison Square, as the acquisition papers for the piece state,[4] but that it was independently executed. Casts, including the Metropolitan Museum's, were produced at the Griffoul foundry in Newark, New Jersey; others were done in Paris.[5] Following Daniel Chester French's expression of interest in adding this example of Bartlett's work to the Metropolitan's sculpture collection, Thomas Henry Russell and Frederic Newlin Price, proprietors of the Ferargil Galleries in New York, offered *Preparedness* to the Museum.[6]

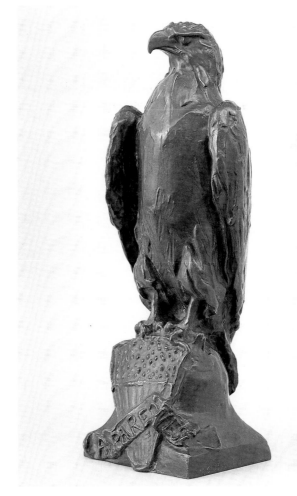

Other casts are in the collections of the Munson-Williams-Proctor Institute Museum of Art, Utica, New York; Smithsonian American Art Museum, Washington, D.C.; and Tudor Place Foundation, Washington.
DJH

EXHIBITION

Halloran General Hospital, Staten Island, N.Y., July 1947–February 1948.

1. *Catalogue of Memorial Exhibition of the Works of Paul Wayland Bartlett* (New York: American Academy of Arts and Letters, 1931), p. 28, no. 37, as "The Eagle of Preparedness."

2. Somma 1995, p. 101.
3. Bartlett to Truman Howe Bartlett, April 11, 1916, Bartlett Papers, Library of Congress, as cited in Somma 1995, pp. 131–32 n. 76.
4. According to a notation on the offer of gift form, approved and signed by Edward Robinson, Director, MMA, March 16, 1925, the "eagle was shown during the war and called Preparedness.... [It was] a sketch for proposed arch in Madison Square," MMA Archives. For a discussion of events leading to the World War I Victory Arch, see Michele H. Bogart, *Public Sculpture and the Civic Ideal in New York City, 1890–1930* (Chicago: University of Chicago Press, 1989), pp. 271–92.
5. Joel Rosenkranz, Conner-Rosenkranz, New York, to Thayer Tolles, telephone conversation, October 15, 1996.
6. Price to Joseph Breck, Assistant Director, MMA, January 24, 1925, MMA Archives.

204. *Clinton Ogilvie*, 1919

Marble, 1920
20 x 10¼ x 10 in. (50.8 x 26 x 25.4 cm)
Signed (left side): *P. W. Bartlett. / Sc.*
Gift of Mrs. Clinton Ogilvie, 1920 (20.66)

AMERICAN LANDSCAPE painter Clinton Ogilvie (1838–1900) studied with James M. Hart before working in Paris and elsewhere in Europe for extended periods from the 1860s to the early 1880s.[1] Although Ogilvie executed plein-air studies abroad, his finished paintings did not reflect the loosely composed, atmospheric style of the predominant Barbizon style but were executed with meticulous attention to detail. Typical of the canvases painted after his return to the United States about 1883 is *Near Jackson, White Mountains* (1885; MMA acc. no. 19.120). Ogilvie died in New York at the age of sixty-two.

The posthumous portrait of Ogilvie is one of a series of busts of American artists that Bartlett executed between 1919 and 1925.[2] In 1919 the sculptor produced an ambitious portrait of Ogilvie in bronze for the Hall of American Artists at New York University.[3] In that likeness the painter is depicted to the shoulders, in contemporary dress; at the base is an arrangement of palette and brushes. Bronze versions of the work, with modified terminations, are in the collections of the National Academy of Design, New York, and the Smithsonian American Art Museum, Washington, D.C. The Metropolitan's marble varies from the bronzes in its asymmetrical undraped termination with a tablet, a device consistently favored by French sculptors.

W. Francklyn Paris, who oversaw the production and gift of the bronze version for the Hall of American Artists, was also instrumental in negotiating the acquisition of

the marble for the Metropolitan. Presumably he was acting on behalf of Ogilvie's widow, the donor. Daniel Chester French, chairman of the Metropolitan Museum trustees' Committee on Sculpture, mentioned in a letter to Paris of March 19, 1920, that the marble bust was then at the studio of the Piccirilli Brothers, thus providing information about the presumed carvers of the work and its date of translation to marble.[4]
DJH

EXHIBITION

MMA, Henry R. Luce Center for the Study of American Art, "Portraits of American Artists in The Metropolitan Museum of Art," September 29, 1992–February 21, 1993.

1. See Amy Walsh, in Natalie Spassky, *American Paintings in The Metropolitan Museum of Art,* vol. 2 (New York: MMA, 1985), pp. 527–28.
2. Thomas P. Somma, "Paul Wayland Bartlett and 'The Apotheosis of Democracy,' 1908–1916: The Pediment for the House Wing of the United States Capitol," Ph.D. diss., University of Delaware, 1990, p. 155; and Somma to Thayer Tolles, telephone conversation, August 25, 1998.
3. For an illustration of the bronze portrait, which is now in the Elmer Holmes Bobst Library of New York University, see W. Francklyn Paris, *Personalities in American Art* (New York: Architectural Forum, 1930), p. 70.
4. French to Paris, March 19, 1920 (copy), Daniel Chester French Family Papers, Manuscript Division, Library of Congress, Washington, D.C., microfilm reel 5, frame 514.

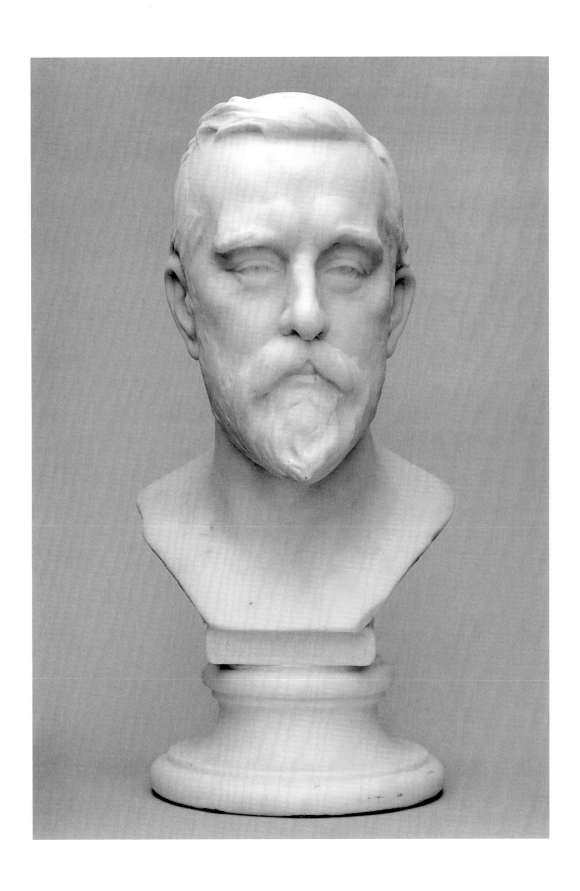

Richard Edwin Brooks (1865–1919)

Born in Braintree, Massachusetts, near the granite quarries of Quincy, Brooks began at an early age to model and to carve. His first job related to his eventual profession was at a terracotta company; he later formed his own business of designing commercial sculpture and cemetery monuments. In 1885 he studied modeling with the distinguished sculptor and critic Truman Howe Bartlett. Brooks's early three-dimensional efforts came to the attention of William E. Russell, governor of Massachusetts, who commissioned a bronze portrait bust of himself (State House, Boston) and who later encouraged Brooks to pursue his studies abroad.

In 1893 Brooks went to Paris to continue his training with Jean-Paul Aubé and Jean-Antoine Injalbert at the Académie Colarossi. Several of his works were accepted at the Paris Salons, beginning in 1894 with the bust of Governor Russell and continuing in 1896 with a bust of Oliver Wendell Holmes for the Boston Public Library. Although he pursued ideal subjects such as *Song of the Wave* (cat. no. 205) at the beginning of his career, Brooks turned increasingly to the more lucrative and steady work of portrait busts and statues, excelling in this genre. In 1897 he received from the city of Boston the important commission for a statue of Thomas Cass, a Civil War colonel (1899; Public Garden, Boston), which brought him considerable notice in the United States and a gold medal at the Paris Exposition Universelle of 1900. Still residing primarily in Paris, Brooks executed many public monuments, notably for Maryland, Massachusetts, Connecticut, and Washington, D.C. For the United States Capitol, Brooks modeled statues of Charles Carroll of Carrollton and John Hanson (both 1902) to represent the state of Maryland.

In 1904 Brooks served as chairman of the Jury of Awards for sculpture for the Louisiana Purchase Exposition in Saint Louis, a telling measure of his esteem in the field. He set up a studio in Washington in 1914, and in later years, he also maintained one in Boston. In addition to his monumental work, he modeled with equal facility on a small scale, achieving success as a medalist. Brooks produced as many as 150 portrait medallions during his career, including a series of portraits of the mayors of Boston, commissioned by Josiah Quincy, whose term in that office dated from 1895 to 1899. DJH

SELECTED BIBLIOGRAPHY

Brooks, Richard E. Newspaper clipping file, Boston Public Library.
Taft, Lorado. *The History of American Sculpture,* pp. 501–3. New York: Macmillan, 1903.
"Sentimentality in Art Deplored by R. E. Brooks." *Christian Science Monitor,* September 29, 1916, p. 6.
Obituary. *Boston Evening Transcript,* May 3, 1919.
American National Biography, s.v. "Brooks, Richard Edwin."

205. *Song of the Wave,* probably 1895

Bronze, 1904
12½ x 14⅜ x 10⅜ in. (31.8 x 36.5 x 26.4 cm)
Signed, dated, and inscribed (top of base, between figure's left hand and hip): *copyright 1904 / by Richard E. Brooks Paris / cire perdue*
Rogers Fund, 1911 (11.103.2)

THE THEME of a bather was prevalent in the late nineteenth century, since it gave an artist the opportunity to demonstrate expertise in modeling a nude figure, the most elevated in the hierarchy of subject matter and the mark of a well-trained academic sculptor. Such ideal compositions helped Brooks launch his artistic career. Of *Song of the Wave,* Lorado Taft provided further insight into Brooks's choice of subject: "Like most artists sojourning in Paris, [Brooks] made early quest for a 'Salon subject.' The 'Chant de la Vague' was the result, a graceful nude female figure presumably seated on the shore of some nameless but sounding sea."[1]

Indeed, Brooks exhibited a plaster statue of the figure, under the title "Chant de la vague," in the Paris Salon of 1895, where it was accorded an honorable mention.[2] He showed a similarly titled bronze statuette at the Salon of 1911.[3] Whether or not that bronze and the subject of this entry were the same object is not known, but no other casts of the sculpture have come to light. However, when

the statuette entered the Metropolitan Museum's collection in 1911, Brooks noted the existence of two examples.[4]

Daniel Chester French (pp. 326–41), chairman of the Metropolitan Museum trustees' Committee on Sculpture, recommended the purchase of this work, along with Brooks's *Bather* (cat. no. 206), directly from the sculptor, who sold them to the Museum at the cost of the bronze casting.[5] At the time of their acquisition by the Museum, Brooks described both bronzes as having been cast by the lost-wax process (as inscribed directly on this cast) and recently repatinated by J. Eastman Chase.[6] DJH

1. Taft 1903, p. 501.
2. *Explication des ouvrages de peinture, sculpture . . . ,* Société des Artistes Français, Salon de 1895 (Paris: Paul Dupont, 1895), p. 253, no. 2916.
3. *Explication des ouvrages de peinture, sculpture . . . ,* Société des Artistes Français, Salon de 1911 (Paris: Paul Dupont, 1911), p. 279, no. 3158.
4. Brooks to Daniel Chester French, May 21, 1911, Daniel Chester French Family Papers, Manuscript Division, Library of Congress, Washington, D.C., microfilm reel 1, frame 774.
5. Recommended purchase form, June 21, 1911, MMA Archives; and Brooks to French, as in note 4.
6. Brooks to Edward Robinson, Director, MMA, June 16, 1911, MMA Archives.

206. *The Bather,* probably 1896

Bronze, 1904
23 x 11⅜ x 10½ in. (58.4 x 28.9 x 26.7 cm)
Signed, dated, and inscribed (back of base): *copyright 1904 / by / Richard E. Brooks / Sc. et fondeur / cire-perdue. / (11)*
Rogers Fund, 1911 (11.103.1)

WHILE HE WAS in Paris, Brooks modeled and cast this statuette of a young boy atop a rock bracing himself to gauge the temperature of the water below. Though similar in theme to *Song of the Wave* (cat. no. 205), this subject has been presented in an animated moment and, in keeping with the artist's Beaux Arts training, in a composition of textural contrast among water, rock, and flesh.

At the Paris Salon of 1896, Brooks exhibited a plaster statue titled "Ah! C'est froid,"[1] probably the model for a proposed lifesize bronze. At the Salon of 1911, Brooks showed a bronze statuette, which was listed as "Baigneur."[2] It is not known whether that figure was the same as the Museum's example.

The "11" inscribed on the Museum's bronze has previously been interpreted as indicating that it was the eleventh cast.[3] However, when the Metropolitan's cast was acquired, Brooks wrote that "there are only two . . . of the 'Bather' in existence,"[4] suggesting that the "11" should be read as a Roman numeral two. A cast of *The Bather* currently at Conner-Rosenkranz, New York, shows slight modifications in the general proportions and in the tilt of the head. It was cast by C. Valsuani, a Paris foundry, and was signed by the artist but not dated. It could be the other cast that Brooks referred to in his letter, or it could have been produced after 1911.

The Bather was acquired by the Museum at the same time as Brooks's *Song of the Wave,* also on the recommendation of Daniel Chester French, and its casting and repatination are similarly described in the June 16, 1911, letter from Brooks to Museum director Edward Robinson.[5]

DJH

EXHIBITION

Parks Department, New York City, March 1949–August 1954.

1. *Explication des ouvrages de peinture, sculpture . . . ,* Société des Artistes Français, Salon de 1896 (Paris: Paul Dupont, 1896), p. 293, no. 3275.
2. *Explication des ouvrages de peinture, sculpture . . . ,* Société des Artistes Français, Salon de 1911 (Paris: Paul Dupont, 1911), p. 279, no. 3157.
3. Albert TenEyck Gardner, *American Sculpture* (New York: MMA, 1965), p. 89.
4. Brooks to Daniel Chester French, May 21, 1911, Daniel Chester French Family Papers, Manuscript Division, Library of Congress, Washington, D.C., microfilm reel 1, frame 774.
5. Recommended purchase form, dated June 21, 1911, and Brooks to Robinson, June 16, 1911, MMA Archives.

John Flanagan (1865–1952)

Flanagan, son of a marble cutter, was born in Newark, New Jersey. He served as an apprentice to his father, and from 1880 to 1882 studied modeling at evening classes at the Cooper Union in New York. After a brief stint working for the sculptor Truman Howe Bartlett in Boston, Flanagan was employed by the Perth Amboy Terra Cotta Works in New Jersey. In 1885 he became a studio assistant to Augustus Saint-Gaudens (pp. 243–325), who greatly influenced his sculptural style; he also enrolled in life classes given by George de Forest Brush at the Art Students League in New York. Flanagan went to Paris in the spring of 1890, studying with Henri Chapu at the Académie Julian and, as a matriculant at the École des Beaux-Arts beginning in July 1891, with Jean-Alexandre-Joseph Falguière. During this time Flanagan worked for Frederick William MacMonnies (pp. 428–42), another former assistant of Saint-Gaudens, on the colossal *Columbian Fountain* for the World's Columbian Exposition in Chicago.

In 1893, while still in Paris, Flanagan was commissioned to execute a statue of *Commerce* (installed 1896) and a monumental clock (installed 1902) for the Main Reading Room of the Library of Congress in Washington, D.C. In 1902, after twelve years abroad, the artist returned to New York, where he established his studio. His larger works include *Antique Education* (*Wisdom Instructing the Children of Men*) (1909), a high relief for the Free Public Library, Newark, New Jersey, and a statue of Joseph Henry for the state of New York (1927; Academy Park, Albany). He was named an academician of the National Academy of Design in 1928.

Like many Beaux Arts sculptors, Flanagan pursued the art of the medal, and he became particularly expert, indeed preeminent, in the field. His portrait medals and plaquettes, including those of such notable Americans as Theodore Roosevelt, Walt Whitman, Paul Wayland Bartlett (pp. 454–63), and J. Alden Weir, are considered to be among the finest of their kind and reveal his special talent for work in low relief. He exhibited a selection of his earliest efforts in Paris at the Salon of 1899 and at the Exposition Universelle of 1900, where he earned a silver medal. In addition to designing a number of award medals, in 1932 Flanagan modeled the George Washington bicentennial quarter-dollar, still being minted by the United States Treasury. The Metropolitan Museum has thirteen examples of Flanagan's medals and plaquettes, which span the decades of his long career.

DJH

SELECTED BIBLIOGRAPHY

Payne, Frank Owen. "John Flanagan—Sculptor and Medalist." *International Studio* 75 (April 1922), pp. 114–16.

Lockman, DeWitt McClellan. Interview with John Flanagan, August 5, 1926. Transcript, Manuscripts Department, New-York Historical Society. Microfilmed for DeWitt McClellan Lockman Papers, Archives of American Art, Smithsonian Institution, Washington, D.C., reel 503, frames 108–41.

Obituary. *New York Times,* March 29, 1952, p. 15.

Hassler, Donna J. "The Medals of John Flanagan." In Alan M. Stahl, ed., *The Medal in America,* pp. 119–33. Coinage of the Americas Conference, 1987, Proceedings no. 4. New York: American Numismatic Society, 1988.

Hassler, Donna J. "John Flanagan: An American Beaux-Arts Sculptor and Medalist." In *Public Art in New Jersey during the Period of the American Renaissance,* pp. 76–83. Wayne: Museums Council of New Jersey, 1990.

207. *Augustus Saint-Gaudens,* 1905–24

Bronze, 1924
16½ x 8 x 10 in. (41.9 x 20.3 x 25.4 cm)
Signed (back of neck): JOHN FLANAGAN · 1924.
Foundry mark (left side of neck): KUNST-FDRY. N.Y.
Francis Lathrop Fund, 1933 (33.62)

In 1905[1] FLANAGAN began his study from life of America's foremost late nineteenth-century sculptor, Augustus Saint-Gaudens, for whom he had worked on various sculptural projects during his service as studio assistant.[2] After Saint-Gaudens died in 1907, the model remained unfinished until 1920, when Flanagan resumed work on it, perhaps as a result of a commission for a bust for New York University's Hall of American Artists. He finished the head in 1924, at which time the first bronze was cast, the one now owned by the Metropolitan Museum.[3] The cast at New York University was unveiled on November 17, 1925; it differs considerably, for it terminates not at the neck but below the clothed shoulders.[4]

In 1933, when the Museum purchased the bust on the

recommendation of Joseph Breck, curator of the Department of Decorative Arts, Preston Remington, associate curator, wrote: "Its significance is clearly two-fold, for aside from its importance as an outstanding example of Flanagan's work it possesses an iconographical value which is bound to increase as the vivid personality of Saint-Gaudens recedes with the advance of time."[5] Among the three sculpted busts of Saint-Gaudens that have been executed by various artists,[6] Flanagan's remains the most striking evocation of the man.

In addition to the Metropolitan Museum's head with neckline termination, there is one at the Newark Museum, Newark, New Jersey, which was also cast by the Kunst Foundry. At the time the Metropolitan acquired this bronze in 1933, Flanagan noted that it was one of three examples (the third, cast by Valsuani in Paris, is at the American Academy of Arts and Letters, New York) and that there would be no further casts.[7] However, he later produced additional bronzes: one at the Century Association, New York, and one at the National Portrait Gallery, Washington, D.C.[8]

Flanagan included a bronze cast of the *Saint-Gaudens* head among the works he exhibited at the Paris Salon of 1931, where he was awarded a bronze medal.[9] In 1934 Flanagan also modeled a relief portrait of Saint-Gaudens at age fifty-six.[10]

The Metropolitan's bust is mounted on a black and gold Belgian marble socle, 5 inches high.

DJH

EXHIBITIONS

Federal Reserve Bank of New York, June 1982–December 1998.
Musée des Augustins, Toulouse, February 12–May 30, 1999; Musée National de la Coopération Franco-Américaine, Château de Blérancourt, June 26–October 18, 1999, "Augustus Saint-Gaudens, 1848–1907: Un maître de la sculpture américaine," no. 4.
Federal Reserve Bank of New York, March 2000–present.

1. 1905 is generally accepted as the date that Flanagan began modeling the bust, although he himself did not provide clear evidence. In a letter of October 27, 1926, in the Newark Museum files, Flanagan wrote that he began the portrait from life in 1904 in Cornish, N.H. Yet in a conversation with Metropolitan Museum curator Preston Remington, May 10, 1933, Flanagan recalled that "he started this head during the lifetime of Saint-Gaudens in 1905, modeling in plasticine, working partly in New York, partly in Cornish"; notes on object catalogue cards, MMA Department of American Paintings and Sculpture.

2. Among the projects on which Flanagan is documented as having assisted are *Abraham Lincoln* (1884–87; Lincoln Park, Chicago); *George Washington Inaugural Centennial Medal* (1889; cat. no. 128); and the Harper Publishing Company trademark (1890).

3. Flanagan conversation with Remington, May 10, 1933, notes on object catalogue cards, MMA Department of American Paintings and Sculpture.

4. The bust is now in the Ben Snow Room of the Elmer Holmes Bobst Library of New York University. For an illustration, see W. Francklyn Paris, *Personalities in American Art* (New York: Architectural Forum, 1930), p. 60.

5. Preston Remington, "Flanagan's Head of Saint-Gaudens," *MMA Bulletin* 28 (June 1933), p. 106.

6. For other portrait busts, see John H. Dryfhout, *The Work of Augustus Saint-Gaudens* (Hanover, N.H.: University Press of New England, 1982), p. 20, figs. C41 (by James Earle Fraser; pp. 596–99 below), C42 (by Henry Hering). Dryfhout's chronology (pp. 1–21) includes numerous representations of Saint-Gaudens, among them oils, etchings, sculpted bas-reliefs, and the three portrait busts.

7. Flanagan conversation with Remington, May 10, 1933, notes on object catalogue cards, MMA Department of American Paintings and Sculpture, and recommended purchase form, April 5, 1933, MMA Archives.

8. See A. Hyatt Mayor and Mark Davis, *American Art at the Century* (New York: Century Association, 1977), p. 150; and *National Portrait Gallery: Permanent Collection Illustrated Checklist* (Washington, D.C.: National Portrait Gallery in association with Smithsonian Institution Press, 1987), p. 245.

9. *Explication des ouvrages de peinture, sculpture . . . ,* Société des Artistes Français, Salon de 1931 (Paris: Georges Lang, 1931), p. 186, no. 3613, as "Tête du sculpteur Auguste Saint-Gaudens; —bronze." There is no documentation that the cast shown at the Salon was the one purchased two years later by the Metropolitan Museum.

10. For an illustration of the portrait struck as a commemorative medal, see Dryfhout, *Saint-Gaudens,* p. 21, fig. C44.

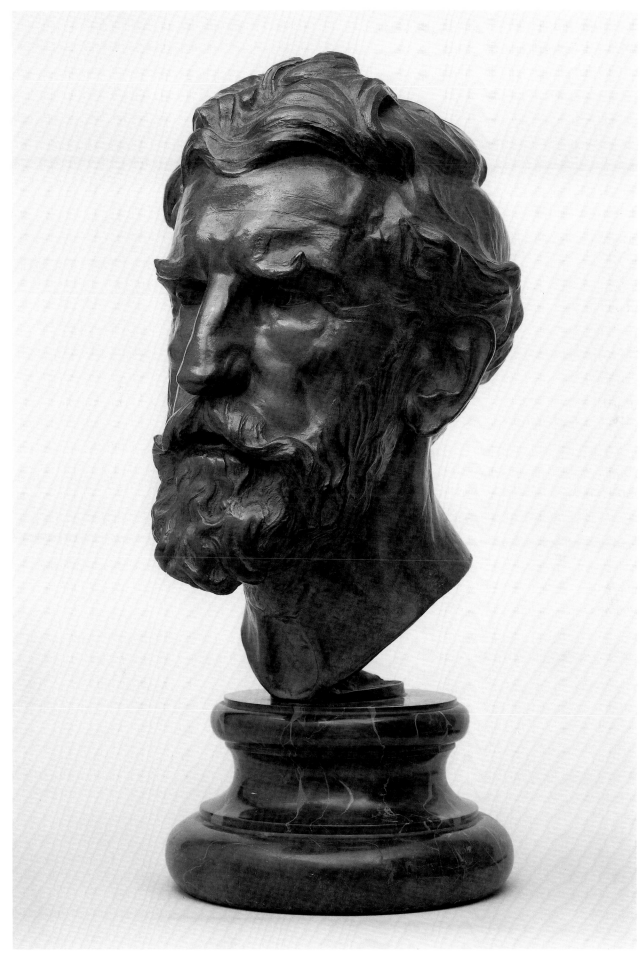

Edmund Austin Stewardson (1865–1892)

In 1882, seventeen-year-old Stewardson, a native of Philadelphia, entered the life classes at the Pennsylvania Academy of the Fine Arts under the tutelage of Thomas Eakins. Five years later he enrolled at the Académie Julian in Paris as a pupil of Henri Chapu and soon became proficient in modeling from life. That July, having placed first among seventy-two candidates for admission, he became a matriculant at the École des Beaux-Arts. He nevertheless continued to take evening classes at the Académie Julian, where Chapu asked him to assist with several projects, including his monuments of Cardinal de Bonnechose for the city of Rouen and Gustave Flaubert for Paris. Stewardson's first and only lifesize figure, *The Bather* (cat. no. 208), was awarded honorable mention at the Paris Salon of 1890.

Having established his reputation abroad, the sculptor returned to Philadelphia in 1890 and set up a studio, completing several medallions and portrait busts, such as *Alexander Harrison* (unlocated) and *Caroline Sidney Sinkler* (1891; Pennsylvania Academy of the Fine Arts). At age twenty-seven he was appointed sculpture instructor at both the University of Pennsylvania and the Pennsylvania Academy, but he died in a sailing accident off the coast of Newport, Rhode Island, before he could take up his duties. In his memory, his father, Thomas Stewardson, established at the Pennsylvania Academy the Edmund Stewardson Prize, which is still awarded annually for the best in-the-round figure done from life.

DJH

SELECTED BIBLIOGRAPHY

O. W. "Correspondence: Edmund L. [*sic*] Stewardson." *The Nation*, August 11, 1892, pp. 105–6.

Stewardson, Thomas, ed. *Edmund Stewardson*. Philadelphia: Privately printed, ca. 1895.

Seaberg, Libby W., assisted by Cherene Holland. "Artists' Biographies and Bibliographies," pp. 312–13. In Tom Armstrong et al., *200 Years of American Sculpture*. Exh. cat. New York: David R. Godine in association with Whitney Museum of American Art, 1976.

James-Gadzinski, Susan, and Mary Mullen Cunningham. *American Sculpture in the Museum of American Art of the Pennsylvania Academy of the Fine Arts*, pp. 143–46. Philadelphia: Museum of American Art of the Pennsylvania Academy of the Fine Arts, 1997.

208. *The Bather*, 1889–90

Marble, 1894
46¼ x 23 x 25 in. (117.5 x 58.4 x 63.5 cm)
Signed and dated (back of rock): Stewardson / 1890
Gift of Thomas Stewardson, 1895 (95.9)

In a letter Stewardson wrote to his father from Paris, November 10, 1889, he mentioned his realistic seated female nude: "About my figure . . . I have not tried for anything but form. . . . It is a first figure, made principally and first of all to learn what a 'life size' is, what *form* really is, a thing I have never yet learnt, doing it entirely for my own benefit in the way of study, not for the public."[1] Having studied anatomy in Philadelphia with Eakins and modeling in Paris with Chapu (to whom the French-inspired composition of *The Bather* is indebted), Stewardson now possessed the technical ability to render a three-dimensional figure from life.

At the Paris Salon of 1890, Stewardson was awarded an honorable mention for his plaster model of a young woman arranging her hair.[2] The following year he exhibited the work in Philadelphia at the annual exhibition of the Pennsylvania Academy of the Fine Arts and in New York at the Society of American Artists,[3] where the piece earned his election to that organization as its youngest member. Critics in New York, reviewing the society display, singled out *The Bather;* one called the figure "well modelled" and another "the most ambitious of the works in plaster . . . modelled with a sound knowledge of form,"[4] a comment that would have especially pleased the sculptor.

Stewardson declined a request to sell the plaster, intending to carve *The Bather* himself,[5] as his teacher Chapu had recommended. However, his sudden death in July 1892 intervened. His father, after consulting several prominent artists including Augustus Saint-Gaudens (pp. 243–325), sent the plaster model back to Paris in 1894 so *The Bather* could be carved in marble by the French sculptor Agathon Léonard. In 1895, perhaps at the suggestion of Thomas Eakins, who had advised against having a marble cut on the grounds that the refinement of the work would be ruined by another hand, the senior Stewardson had a bronze cast from the plaster.[6] He also published a series

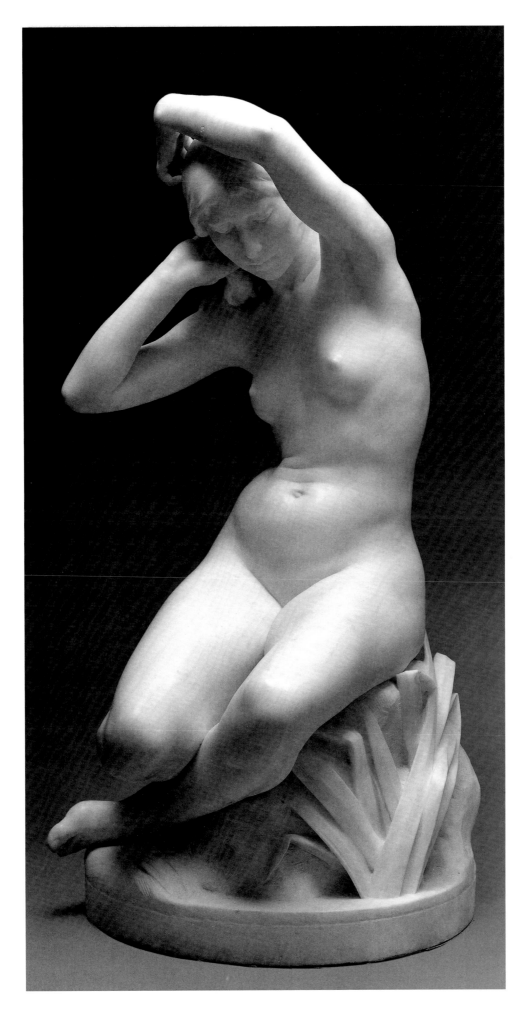

of letters and articles written in recognition of his son's achievements during his tragically short career.

In 1895 the trustees of the Metropolitan Museum accepted Thomas Stewardson's gift of the marble.[7] A 16-inch painted plaster sketch of the work (possibly the original maquette), attributed to Edmund Stewardson, is in the collection of the Pennsylvania Academy, as is the bronze version of the lifesize work.[8] DJH

1. Stewardson ca. 1895, p. 43.

2. *Explication des ouvrages de peinture, sculpture . . . ,* Société des Artistes Français, Salon de 1890 (Paris: Paul Dupont, 1890), p. 354, no. 4518, as "Baigneuse; —figure, plâtre."

3. *Pennsylvania Academy of the Fine Arts . . . Sixty-first Annual Exhibition . . . Catalogue,* 2nd ed. (Philadelphia, 1891), p. 60, no. 493, as "Baigneuse"; *Thirteenth Exhibition of the Society of American Artists* (New York, 1891), p. 40, no. 211.

4. "Splendid Art Show by the 'Society,'" *New York Herald,* April 25, 1891, p. 6; Malcolm Bell, "The Society of American Artists," *Art Amateur* 25 (June 1891), p. 6.

5. Stewardson ca. 1895, p. 44, an excerpt of a letter from Stewardson to his father, dated February 1891, which omits the name of the person making the purchase offer. However, *The Bather* was on view at the Pennsylvania Academy at that time (January 29–March 7, 1891; the Society of American Artists exhibition was April 27–May 23, 1891), and according to an entry by Mary Mullen Cunningham on the bronze cast of *The Bather,* in James-Gadzinski and Cunningham 1997, pp. 144–45, the request to purchase the plaster model was made to Stewardson by Edward Coates, president of the academy, during the academy's 1891 annual exhibition. I thank Ms. Cunningham and Susan James-Gadzinski for sharing research material gathered for the academy's sculpture catalogue; notes of a telephone call, correspondence, and draft of catalogue biography and entries, April and May 1986, object files, MMA Department of American Paintings and Sculpture.

6. Stewardson ca. 1895, p. 8.

7. Isaac H. Hall, Curator, Department of Sculpture, MMA, to Stewardson, January 22, 1895, accepting his gift of the marble, MMA Archives. It should be noted that discussion of acquisition of this work by the Metropolitan Museum began in early 1894, for John Quincy Adams Ward (pp. 136–54), a trustee, wrote to Henry G. Marquand, President, MMA, urging its acceptance; letter, January 25, 1894, MMA Archives.

8. According to James-Gadzinski and Cunningham 1997, p. 144, Thomas Stewardson had a plaster cast made of the original plaster before sending that to Paris for translation into marble and subsequently into bronze. He gave the second plaster to the Pennsylvania Academy; it and the original plaster are now unlocated.

Emil Fuchs (1866–1929)

In 1888, after studying art at the Imperial Academy of Fine Arts in his native Vienna, Fuchs went to the Royal Academy in Berlin to pursue further training in sculpture. While at the academy, in 1890 he was awarded a scholarship to study in Rome. There he began work on his first marble statue, *Mother-Love* (ca. 1890–95; Brooklyn Museum of Art), which was accorded a gold medal at the Munich International Exhibition in 1896. Fuchs remained in Italy for seven years, fulfilling a number of private portrait commissions, including a marble bust of Mrs. Carl Meyer, which won him her patronage and, through her, an introduction to John Singer Sargent.

In 1897, when Fuchs went to London to pursue his career, Sargent guided him in developing a facility for painting fashionable society portraits. Fuchs's skill as a painter and sculptor came to the attention of the British royal family: he was invited in 1900 to create the medal that marked Queen Victoria's reign in the twentieth century. When the Prince of Wales succeeded to the throne, he commissioned Fuchs to design his coronation medal and the postage stamps bearing his profile as King Edward VII.

Fuchs's paintings, medals, and sculptural works brought him international renown. In 1905 he traveled to New York to complete high-society portrait commissions, and he subsequently spent winters there. Among his medallic commissions were the Hispanic Society of America Medal of Arts and Literature (1907) and the Hudson-Fulton Celebration Medal (1909). With the outbreak of World War I, in 1915 Fuchs immigrated to New York, becoming an American citizen in 1924. Requests for his painted portraits, stylistically inspired by Sargent's broad brushwork, greatly outnumbered his sculpted likenesses, as did his medallic commissions. One of his most ambitious sculptures is the *Henry J. Heinz Memorial* (unveiled 1924; Henry J. Heinz Company Administration Building, Pittsburgh), which was accompanied by two bas-relief allegories of industry and religion (now in storage).

Adept at self-promotion, Fuchs frequently exhibited his work, including solo displays in 1916 and 1921. His most comprehensive one-artist show, consisting of 283 paintings, sculptures, drawings, etchings, and lithographs, was held at the Fine Arts Building on West 57th Street, New York, in 1925, the same year he published his autobiography.

In 1931 the Metropolitan Museum received fourteen etchings from the artist's sizeable estate; also in the Museum's collection are twenty medals by Fuchs, acquired between 1907 and 1922. The largest repository of his work is the Brooklyn Museum of Art, which received a bequest of numerous paintings and sculptures in 1932.

DJH

SELECTED BIBLIOGRAPHY

Two scrapbooks of newspaper and magazine clippings on Fuchs's work. MMA Thomas J. Watson Library.

Brinton, Selwyn. "Emil Fuchs—Some Work in Sculpture, Medals and Portraits." *International Studio* 34 (March 1908), pp. III–XVIII.

Comstock, Helen. "Sculpture by Emil Fuchs." *International Studio* 81 (April 1925), pp. 60–63.

Fuchs, Emil. *With Pencil, Brush and Chisel: The Life of an Artist.* New York: G. P. Putnam's Sons, 1925.

The Work of Emil Fuchs. Exh. cat. New York, 1925.

C[onrow], W[ilford S.]. "The Emil Fuchs Collection." *Brooklyn Museum Quarterly* 20 (January 1933), pp. 1–5.

Jones, Mark. "Emil Fuchs in England." *The Medal,* no. 6 (Spring 1985), pp. 23–29.

Miller, Scott. "The Medallic Work of Emil Fuchs." In Alan M. Stahl, ed., *The Medal in America, Volume 2,* pp. 178–233. Coinage of the Americas Conference, 1997, Proceedings no. 13. New York: American Numismatic Society, 1999.

209. *La Pensierosa,* 1912

Bronze
17¾ x 4⅞ x 4½ in. (45.1 x 12.4 x 11.4 cm)
Signed and dated (top of base, between feet): *Emil / Fuchs 1912*
Rogers Fund, 1919 (19.91)

MIDWAY IN his career, Fuchs took up the study of ideal female nudes inspired by the adolescent figure, among them *Eva* (1913; Cleveland Museum of Art) and *The Call from the Beyond* and *Dawn* (after 1912; Brooklyn Museum of Art). Particularly expressive of the sculptor's vision of youth and innocence is *La Pensierosa,*[1] the image of a self-absorbed, contemplative girl in an exaggerated contrapposto position. The figure stands on an elaborate sodalite base (2⅛ in. high), which is decorated with swags and crossed bands of silver and a silver plaque inscribed

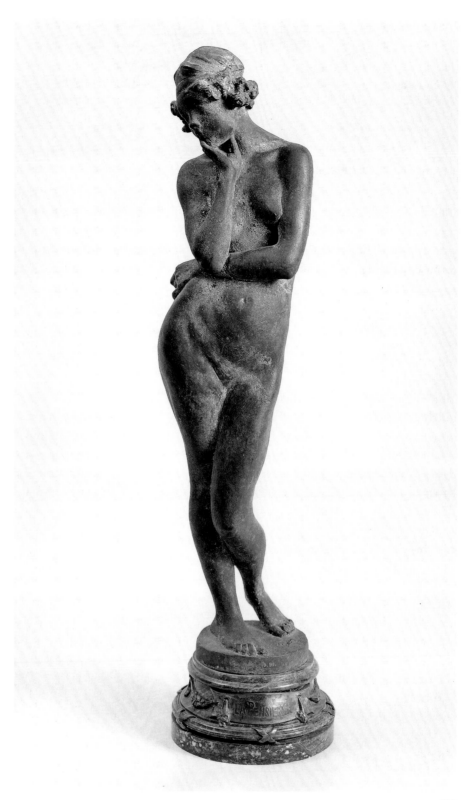

209

LA PENSIEROSA. The sculpture is imbued with an air of antiquity, the result of its greenish black matte finish, a patina popular in the early twentieth century.

The Metropolitan Museum purchased *La Pensierosa* from Fuchs on the recommendation of Daniel Chester French (pp. 326–41) and Edward D. Adams,[2] members of the trustees' Committee on Sculpture. This is the only known cast of the work. DJH

1. The Italian can be translated as "The Pensive Girl."
 Michele Cohen provided research assistance on Fuchs.
2. French to Henry W. Kent, Secretary, MMA, April 7, 1919, MMA Archives. Adams, an enthusiastic collector of American sculpture, had been chairman of the Hudson-Fulton Celebration Committee and on the board of governors for the American Numismatic Society, and had commissioned medals from Fuchs for these interests.

Hermon Atkins MacNeil (1866–1947)

MacNeil, born in Everett, Massachusetts, on the outskirts of Boston, began his formal art training in 1881 at the Massachusetts Normal Art School. After completing the program in 1885, he taught courses in art at Cornell University, resigning after the third year to pursue a career in sculpture. In 1889 MacNeil traveled to Paris and enrolled at the Académie Julian as a pupil of Henri Chapu. The following year he was admitted to the École des Beaux-Arts, studying with Jean-Alexandre-Joseph Falguière.

After his return to the United States in 1891, MacNeil assisted Philip Martiny in Chicago on architectural sculpture for the 1893 World's Columbian Exposition. Independently he created statues for the Electricity Building. MacNeil then set up a studio and for a year taught evening classes in drawing and sculpture at the Art Institute of Chicago. In 1894, he received his first important commission: four bas-reliefs illustrating the life of Père Marquette for the Marquette Building in Chicago. MacNeil's fascination with the Native American, which dates to his years in Chicago, led him in the summer of 1895 on a modeling expedition into the Far West. When he returned to Chicago, he learned that he had been awarded the first William H. Rinehart Scholarship for study in Rome. (His fellow recipient, Alexander Phimister Proctor [pp. 412–20], opted to go to Paris.) The next January, MacNeil sailed for Italy. Immediately on arrival, he began work on a statuette of a member of the Moqui tribe (cat. no. 210). Other works on Native American themes that he completed in Rome are *From Chaos Came Dawn* (1897; unlocated) and *The Sun Vow* (cat. no. 211).

After Rome, MacNeil spent a year in Paris, then returned to the United States in 1901 and settled in New York. He taught at several art schools, including the Art Students League, the Pratt Institute, and the National Academy of Design (1900–1919), to which he was elected an academician in 1906. By 1910, MacNeil had turned away from the Native American subjects for which he is best known. His lively, naturalistic style of modeling was well suited to the portrait statues and war memorials then in demand throughout the country. He executed many important commissions, including the *Soldiers and Sailors Monument* (1912; Washington Park, Albany, N.Y.) and *Ezra Cornell* (1915–17; Cornell University, Ithaca, N.Y.). For the Washington Arch in Washington Square, New York, MacNeil produced sculpture for the east pier (1914–16) depicting Washington as commander-in-chief flanked by Fame and Valor. MacNeil is represented by busts of Roger Williams (1926), Rufus Choate (1928), Francis Parkman (1929), and James Monroe (1931) at the Hall of Fame for Great Americans, Bronx Community College (formerly the University Heights campus of New York University). For the "American Art Today" exhibition of the 1939 New York World's Fair, MacNeil contributed by a plaster portrait of George Rogers Clark.

During MacNeil's long and successful career, he participated in a number of diverse projects, ranging from the design for the Liberty quarter-dollar minted from 1916 until 1932 to the model for the east pediment of the United States Supreme Court Building (1934). In 1966, MacNeil's former estate—twenty-eight acres at College Point, Queens, on the Long Island Sound, where he had established his home and studio shortly after returning from Europe—was renamed the Hermon Atkins MacNeil Park by the New York City Parks Department. DJH

SELECTED BIBLIOGRAPHY

MacNeil, Hermon Atkins, Papers. Archives of American Art, Smithsonian Institution, Washington, D.C., microfilm reels 2726–27.

Chapin, Harriet Warner. "Hermon Atkins MacNeil." *Pacific Monthly* 15 (April 1906), pp. 409–17.

Holden, Jean Stansbury. "The Sculptors MacNeil: The Varied Work of Mr. Hermon A. MacNeil and Mrs. Carol Brooks MacNeil." *World's Work* 14 (October 1907), pp. 9403–19.

Lockman, DeWitt McClellan. Interview with Hermon Atkins MacNeil, ca. 1927. Transcript, Manuscripts Department, New-York Historical Society. Microfilmed for DeWitt McClellan Lockman Papers, Archives of American Art, Smithsonian Institution, Washington, D.C., reel 503, frames 952–82.

Breithaupt, Erwin Millard, Jr. "The Life and Works of Hermon Atkins MacNeil." Master's thesis, Ohio State University, Columbus, 1947.

Block, Adolph. "1866–1947, Hermon A. MacNeil: Fifth President of the National Sculpture Society, 1910–12, 1922–24." *National Sculpture Review* 12–13 (Winter–Spring 1963–64), pp. 17, 28.

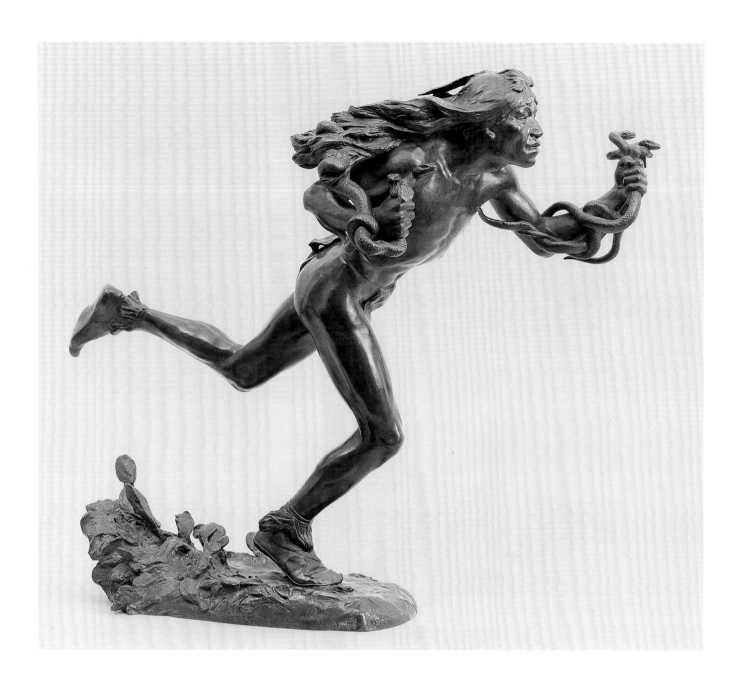

210. *The Moqui Prayer for Rain,* 1895–96

Bronze, ca. 1897
22¼ x 26 x 12 in. (56.5 x 66 x 30.5 cm)
Signed (right side of base): H·A·MACNEIL·S
Inscribed: (front of base) THE MOQVI / PRAYER·FOR·RAIN·; (left side of base) THE RETVRNING OF THE SNAKES
Foundry mark (right side of base): FOND·Nelli·ROMA·
Gift of Mr. and Mrs. Walter C. Crawford, 1978 (1978.513.6)

DURING HIS TRAVELS to the American West in summer 1895, MacNeil observed the Moqui Indians' annual nine-day prayer for rain celebrated at the top of the mesa at Oraibi, Arizona. It inspired him to make three-dimensional sketches on the spot, probably in wax or clay. For the ceremony, the Moqui used a variety of snakes they had gathered, for to them, as to many Indian tribes, snakes symbolized the lightning that brought rain to their arid climate. At the height of the dance that was the final act of the ritual, the Moqui grabbed the serpents by the handful and ran with them down the trail from the mesa, returning the snakes to the plains so that the prayer for rain could be answered.[1]

MacNeil's impression of the ceremony remained so vivid that as soon as he arrived in Italy as a Rinehart scholar he began work on this complex study of move-

ment in sculptural form—a dynamic image of a young brave at the climax of the dance, titled *The Moqui Prayer for Rain* (also known as *The Moqui Runner* and *The Returning of the Snakes*). MacNeil showed a cast of the work, along with *The Sun Vow* (cat. no. 211), at the Exposition Universelle in Paris in 1900,[2] where he was awarded a silver medal. The statuette was exhibited at the Society of American Artists in New York the following year.[3]

In Rome, when Edward E. Ayer bought the first cast of *The Moqui Prayer for Rain,* MacNeil told him that he would not make more than ten casts of the work.[4] Ayer presented his cast to the Art Institute of Chicago in 1924. Other bronzes in public collections are at the American Museum of Natural History, New York, and the Gilcrease Museum, Tulsa, Oklahoma.

MacNeil also executed a multifigure group, *Return of the Snakes* (ca. 1896; Gilcrease Museum), illustrating an earlier stage of the snake dance.[5] In addition, he designed a medal featuring the Indian runner, which was issued by the Society of Medalists in 1931.[6] Two examples are in the Metropolitan Museum's collection (acc. nos. 33.152.5, 6).

DJH

EXHIBITION

Denver Art Museum, "The Western Spirit: Exploring New Territory in American Art," February 23–April 30, 1989; loan extended, May 1989–present.

1. For MacNeil's own account of the snake dance, see Breithaupt 1947, p. 51.
2. *Exposition universelle de 1900: Catalogue officiel illustré de l'exposition décennale des beaux-arts de 1889 à 1900* (Paris: Imprimeries Lemercier; Ludovic Baschet, 1900), p. 298, no. 46, as "Danse des serpents."
3. *Twenty-third Annual Exhibition of the Society of American Artists* (New York, 1901), p. 56, no. 343, as "The Snake Runner of the Moqui—Prayer for Rain."
4. Breithaupt 1947, p. 54.
5. For an illustration of the 23-inch statuette, see Patricia Janis Broder, *Bronzes of the American West* (New York: Harry N. Abrams, 1974), p. [85], fig. 80.
6. See "Rain Makers' Medal," *American Magazine of Art* 23 (November 1931), pp. 428–29.

211. *The Sun Vow,* 1899

Bronze, 1919
72 x 32½ x 54 in. (182.9 x 82.6 x 137.2 cm)
Signed (back of base): HA MacNeil sc / R•R•S•[Roman Rinehart Scholar] ROME
Inscribed (front of base, right): THE SVN-VOW
Foundry mark (back of base): ROMAN BRONZE WORKS. N—Y—
Rogers Fund, 1919 (19.126)

MacNeil completed *The Sun Vow* by the end of 1899, his fourth year in Rome, to fulfill the final requirement of his Rinehart Scholarship.[1] His choice of subject matter, partly the result of a trip made to the American West in 1895, before he embarked on this period of study, probably owed more to what he expressed as "considerable interest in our primitive American peoples,"[2] which had occupied him from his days in Chicago.

Thoroughly disciplined by his earlier French Beaux Arts training, MacNeil approached his subject in a realistic manner. During his visits to several Native American tribes in 1895, he heard of a rite of passage that captured his imagination: before a boy on the threshold of manhood could be accepted as a warrior of his tribe, he must shoot an arrow directly into the sun. If the chieftain judging the boy's prowess was so blinded by the sun's rays that he could not follow the flight of the arrow, it was said to have gone "out of sight," and the youth had passed the test. MacNeil felt that the story, with its "patriotic ring," lent itself to a group composition.[3] In this bronze work he portrayed two Native Americans (whom he identified as Sioux)[4] straining to follow the arrow's flight.

MacNeil exhibited *The Sun Vow,* as well as *The Moqui Prayer for Rain* (cat. no. 210), at the Paris Exposition Universelle of 1900, where he was awarded a silver medal.[5] *The Sun Vow* was later shown in the United States at several important displays, such as the Pan-American Exposition in Buffalo in 1901 and the Louisiana Purchase Exposition in Saint Louis in 1904.[6]

The Sun Vow was critically acclaimed for its anatomical accuracy, technical facility, and artistic sensitivity. The first cast (1901), a lifesize bronze, now at the Art Institute of Chicago, was purchased by Howard Shaw, a Chicago architect, for the grounds of Ragdale, his country home

in Lake Forest, Illinois. A second cast (1902), once belonging to William T. Evans of Montclair, New Jersey, is now at the Montclair Art Museum. A third is at the Corcoran Gallery of Art, Washington, D.C.[7]

In 1906, the Metropolitan Museum purchased a bronze reduction of *The Sun Vow*.[8] In 1918, Museum trustee Daniel Chester French (pp. 326–41), who was organizing a long-term exhibition of American sculpture at the Metropolitan, felt strongly that the work be represented by the full-scale version: "I look on this work of MacNeil's as one of the very finest things ever done by an American sculptor and from the beginning of our plan for this exhibition, I have had it in mind as one of our trump cards."[9] A lifesize plaster of the group was thus purchased from MacNeil for the exhibition.[10] Then in 1919, the Museum purchased a full-size bronze cast, the subject of this entry, and returned the plaster to MacNeil. In 1921, the Museum sold the bronze reduction.[11] DJH

EXHIBITIONS

Corcoran Gallery of Art, Washington, D.C., October 17–November 15, 1925; Grand Central Art Galleries, New York, December 1, 1925–January 3, 1926, "Commemorative Exhibition by Members of the National Academy of Design, 1825–1925," no. 339.
Sheldon Swope Art Gallery, Terre Haute, Ind., January 1948–April 1960.
Whitney Museum of American Art, New York, "200 Years of American Sculpture," March 16–September 26, 1976, no. 153.

1. The rules of the scholarship required the recipient to complete "a life-size figure at the end of the second year, a relief containing two life-size figures before the close of the third year, and during the fourth year a life-size group of two or more figures in the round." See Lorado Taft, *The History of American Sculpture* (New York: Macmillan, 1903), pp. 438–39.

2. MacNeil to Frank Edwin Elwell (pp. 365–66), Department of Ancient and Modern Statuary, MMA, July 12, 1902, Elwell Autograph Letters for American Sculptors, MMA Thomas J. Watson Library. Accompanying MacNeil's letter was a list of his honors and prizes, which began with "Roman Rinehart Scholarship."
3. MacNeil to Winifred E. Howe, General Assistant, Educational Work, MMA, February 14, 1920, MMA Archives.
4. Ibid.
5. *Exposition universelle de 1900: Catalogue officiel illustré de l'exposition décennale des beaux-arts de 1889 à 1900* (Paris: Imprimeries Lemercier; Ludovic Baschet, 1900), p. 298, no. 45, as "Le Vœu de soleil."
6. *Pan-American Exposition: Catalogue of the Exhibition of Fine Arts* (Buffalo: David Gray, 1901), p. 69, no. 1613; and *Official Catalogue of Exhibitors: Universal Exposition, St. Louis, U.S.A., 1904 . . . Department B, Art,* rev. ed. (Saint Louis: Official Catalogue Co., 1904), p. 61, no. 2179.
7. For an illustration of Shaw's lifesize bronze in situ, see *Architectural Review* 9 (1904), p. 24. That cast, as well as the full-size casts at Montclair and the Corcoran, all lack the fig leaf that was present on the figure of the youth when the lifesize plaster entered the Metropolitan Museum's collection. Bronze reductions of the work are at the Albright-Knox Art Gallery, Buffalo, N.Y.; Baltimore Museum of Art (on extended loan from the Peabody Collection of the Maryland Commission on Artistic Property); Brookgreen Gardens, Murrells Inlet, S.C.; Buffalo Bill Historical Center, Cody, Wyo.; Chrysler Museum of Art, Norfolk, Va.; Reading Public Museum, Reading, Pa.; Gilcrease Museum, Tulsa, Okla.; Phoenix Art Museum; and Wadsworth Atheneum, Hartford.
8. See *Catalogue of Sculpture, 1741–1907* (New York: MMA, 1908), p. 29, no. 70.
9. French to Edward Robinson, Director, MMA, June 25, 1917 (copy), Daniel Chester French Family Papers, Manuscript Division, Library of Congress, Washington, D.C., microfilm reel 4, frame 177.
10. *An Exhibition of American Sculpture* (New York: MMA, 1918), p. 16, no. 52; and Minutes of the trustees' Committee on Purchases, December 16, 1918, vol. 4, p. 201, MMA Archives.
11. William J. Drake, Gorham Co., to Henry W. Kent, Secretary, MMA, February 24, 1921 (copy), MMA Archives.

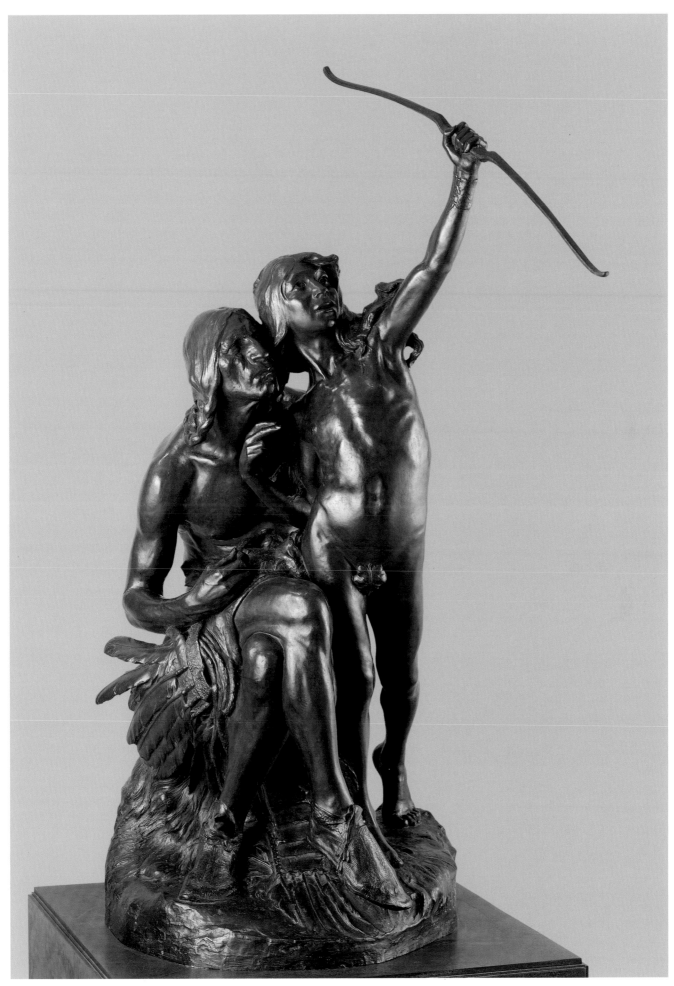

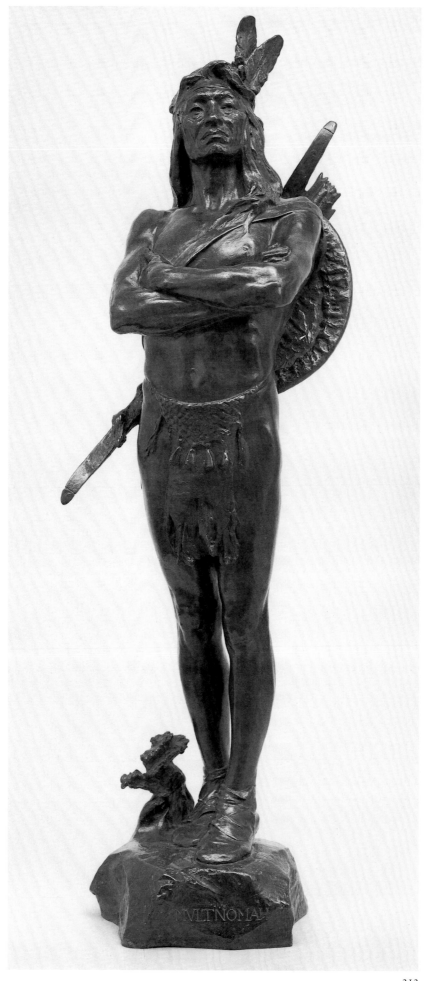

480 HERMON ATKINS MACNEIL

212. *A Chief of the Multnomah Tribe*, 1903

Bronze, probably 1907
37 x 10 x 10¼ in. (94 x 25.4 x 26 cm)
Signed and dated (back of base): H.A MacNeil / '05
Inscribed (front of base): MVLTNOMAH
Foundry mark (back of base, in cipher): R[oman] B[ronze] W[orks] / N[ew] Y[ork]
Cast number (back of base, stamped): 2
Bequest of Jacob Ruppert, 1939 (39.65.54a,b)

IN 1902, MACNEIL was commissioned by the family of David P. Thompson, a prominent local businessman and public official in Portland, Oregon, to execute in bronze a commemorative memorial as Thompson's gift to the city. The resulting work, *The Coming of the White Man,* depicts a chief of the Multnomah tribe and his medicine man standing on a large, boulderlike pedestal.[1] In planning his nostalgic image of one of the vanishing tribes of the Pacific Northwest, MacNeil took care to ensure ethnographic accuracy.[2] The monument, unveiled in 1907 in Portland's Washington Park, is situated on a hill overlooking the Columbia River gorge by which Lewis and Clark had come through the Rockies.

Because the figure of the chief was particularly admired, MacNeil modeled it on a smaller scale and issued it as a statuette. Titled *A Chief of the Multnomah Tribe,* "the subject is represented in a standing pose of great dignity with head thrown back and arms folded across his chest."[3] The model displays a feathered headdress and a bow and quiver of arrows not present in the original group. MacNeil told the Metropolitan Museum in 1939 that at least a dozen examples were cast in bronze; foundry records from the Roman Bronze Works indicate that more than twenty were produced beginning in 1903.[4] The Museum's cast, received in 1939 as part of the Jacob Ruppert bequest,[5] is stamped "2." There are two casts listed as number 2 in the foundry ledgers, one on October 16, 1903, and another, presumably this one, on October 28, 1907.[6] The casts vary in details, height, and inscribed date; some lack an inscription. Other examples are in the collections of the American Academy of Arts and Letters, New York; Museum of Fine Arts, Saint Petersburg, Florida; Lauren Rogers Museum of Art, Laurel, Mississippi; Montclair Art Museum, Montclair, New Jersey; Ohio Historical Society, Columbus; and Gilcrease Museum, Tulsa, Oklahoma. The example at the National Academy of Design, New York, may have been cast specifically to serve as MacNeil's diploma piece on his elevation from associate academician to academician in 1906.[7]

The Metropolitan's bronze is accompanied by a green marble base, 2 inches high. DJH

EXHIBITIONS

Rochester Museum of Arts and Sciences, Rochester, N.Y., February–August 1945.
The White House, Washington, D.C., March–October 1971.
Corcoran Gallery of Art, Washington, D.C., "Wilderness," October 9–November 14, 1971, no. 133.
The White House, Washington, D.C., December 1971–June 1977.

1. For an illustration of the group, see Wayne Craven, *Sculpture in America,* rev. ed. (Newark: University of Delaware Press, 1984), fig. 14.2.
2. Notes, signed F.D. (Faith Dennis, Assistant Curator, Department of Renaissance and Modern Art), of a telephone interview with MacNeil, June 8, 1939, object catalogue cards, MMA Department of American Paintings and Sculpture. Frederick W. Hodge, Bureau of American Ethnology, provided MacNeil with information on the Multnomah tribe of Oregon.
3. Preston Remington, "The Bequest of Jacob Ruppert: Sculpture," *MMA Bulletin* 34 (July 1939), p. 172.
4. Notes of a telephone interview with MacNeil, June 8, 1939, as in note 2; and Roman Bronze Works Archives, Amon Carter Museum, Fort Worth, ledger 2, pp. 110–11; ledger 4, p. 138.
5. For information on the Ruppert bequest, see Hermann Warner Williams, Jr., et al., "The Bequest of Jacob Ruppert," *MMA Bulletin* 34 (July 1939), pp. 166–74.
6. Roman Bronze Works Archives, ledger 2, p. 110. MacNeil exhibited a cast titled "Multnomah" at the National Sculpture Society in December 1903. See *National Arts Club, Fifth Exhibition of the National Sculpture Society* (New York, 1903), no. 43.
7. See D[avid] B. D[earinger], in *An American Collection: Paintings and Sculpture from the National Academy of Design,* exh. cat. (New York: National Academy of Design, 1989), p. 99.

Attilio Piccirilli (1866–1945)

Born in Massa, Italy (at the center of the Carrara marble industry), Piccirilli learned to carve marble from his father, Giuseppe. In 1880, Attilio began studying art at the Accademia di San Luca in Rome, remaining for about five years before returning to his father's employ. After a brief stint in London, Attilio came to the United States in April 1888 with his brother Furio (pp. 512–14). Two months later, their parents, brothers, and sister joined them in New York. Attilio and other family members worked for over a year at Samuel Adler's Monument and Granite Works on East 57th Street. In 1890 the family established Piccirilli Brothers Studio, located first on West 39th Street in Manhattan, then on East 142nd Street in the Bronx. In the cavernous studios, the six brothers translated into marble models created by such prominent American sculptors as John Quincy Adams Ward (pp. 136–54), Augustus Saint-Gaudens (pp. 243–325), and Daniel Chester French (pp. 326–41).

Attilio Piccirilli supervised most of the work done in the studio, and upon his father's death in 1910, he took over the firm, which operated until 1946. He was known also for sculpture of his own design, and indeed was the brother who achieved greatest recognition for his independent creations. In 1898 Piccirilli won his first competition, the *John McDonogh Memorial* (1899; Lafayette Square) for the city of New Orleans. Other important public commissions followed. In 1901 Piccirilli was selected from a field of about forty sculptors for the *Maine Memorial* (1901–13; Central Park at Columbus Circle, New York). The imposing Beaux Arts monument was designed with architect H. Van Buren Magonigle to commemorate lives lost in the Spanish-American War, especially on the battleship *Maine*. Figures carved for the memorial inspired independent pieces, notably *Fortitude,* a mother-and-child group formerly owned by William Randolph Hearst, who was the driving force behind the memorial project, and *Ideal Head* (ca. 1901; Indianapolis Museum of Art), based on the female figure History. Piccirilli's other major effort for New York City, also done in collaboration with Magonigle, is the *Firemen's Memorial* at Riverside Drive and 100th Street, which was dedicated in September 1913. The independent fragment *Study of a Head* (cat. no. 213) derived from this monument.

Piccirilli also excelled in smaller pieces in an ideal vein, which were translated into both marble and bronze and were exhibited widely over the course of his career. At the Pan-American Exposition in Buffalo in 1901, he was awarded a silver medal for his male nudes *Dancing Faun* (1895) and *Young Faun* (1898; bronze version, Governor's Mansion, Richmond, Va.). In 1909, with *A Soul,* Piccirilli began a series of ethereal female nudes (see cat. no. 214),

which express his ideal of beauty in sculptural form. *Female Nude with Broken Pitcher* (1916), a study in bronze, was reinterpreted in marble as *Spring Dream* (1918); he used this marble as his diploma piece on his election to full membership in the National Academy of Design in 1935.

Piccirilli modeled the statues *Indian Literature* and *Indian Law Giver* (both 1909), two of the thirty figures that were installed on the facade of the Brooklyn Institute of Arts and Sciences (now Brooklyn Museum of Art; all thirty and the pediment were carved by the Piccirillis). He completed two lunettes, *Sculpture* and *Orpheus* (1913–14), for the Fifth Avenue residence of Henry Clay Frick. And he designed two Pyrex glass relief panels for Rockefeller Center: *Eternal Youth* (1935; destroyed, 1968) for the Palazzo d'Italia, and *Youth Leading Industry* (1936) for the International Building.

Piccirilli's later works included marble busts of Thomas Jefferson, modeled after the portrait by Houdon, and James Monroe (both 1931), which were installed in the rotunda of the Virginia State Capitol in Richmond. In 1932 Piccirilli gave to the state of Virginia his statue of Monroe, which was erected at Monroe's home Ash Lawn, near Charlottesville. That same year he was awarded the Jefferson Presidential Medal in recognition of his contributions as an American citizen. His last significant sculpture was the *Guglielmo Marconi Memorial* (1941; Washington, D.C.).

In 1923, when the Leonardo da Vinci Art School was founded in New York, Piccirilli served as its president, an office he held for many years. The purpose of the school, to which the modest tuition was waived for those who could not pay, was to encourage United States immigrants, regardless of age, nationality, or experience, to explore and preserve their cultural heritage. DJH

SELECTED BIBLIOGRAPHY

Adams, Adeline. "A Family of Sculptors." *American Magazine of Art* 12 (July 1921), pp. 223–30.
Willson, Dixie. "Six Brothers with but a Single Goal." *American Magazine* 109 (February 1930), pp. 70, 73.
Lombardo, Josef Vincent. *Attilio Piccirilli: Life of an American Sculptor.* New York and Chicago: Pitman Publishing Corp., 1944.
Falco, Nicholas. "The Piccirilli Studio." *Bronx County Historical Society Journal* 9 (January 1972), pp. 19–22.
Bogart, Michele H. "*Maine Memorial* and *Pulitzer Fountain:* A Study in Patronage and Process." *Winterthur Portfolio* 21 (Spring 1986), pp. 41–63.
Conner, Janis, and Joel Rosenkranz. *Rediscoveries in American Sculpture: Studio Works, 1893–1939,* pp. 143–50. Austin: University of Texas Press, 1989.
Shelley, Mary, and Bill Carroll. "The Piccirilli Studio." *Bronx County Historical Society Journal* 36 (Spring 1999), pp. 1–12.

213. *Study of a Head,* 1912–13

Bronze, by 1918
12 x 6¾ x 9 in. (30.5 x 17.1 x 22.9 cm)
Rogers Fund, 1919 (19.185)

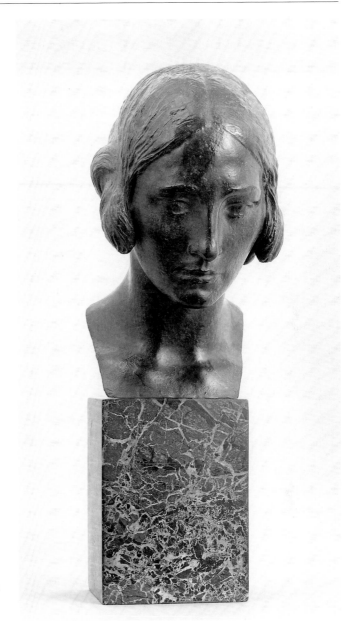

IN 1912 PICCIRILLI and the architect H. Van Buren
Magonigle were commissioned to design a memorial to
the firemen of New York City who had given their lives
in the line of duty. The monument at Riverside Drive and
100th Street was dedicated the following year. It consists
of a large sarcophagus-shaped block faced with marble,
flanked at the ends by two marble allegorical groups rep-
resenting Courage and Duty.[1] On the front of the memo-
rial, toward the Hudson River, is a bronze relief depicting
a fire engine drawn by three horses responding to an
alarm,[2] below which water issues from a grotesque head
into a marble basin the width of the monument.

A woman cradling the body of a dying fireman portrays
Courage; Duty is personified by a seated young woman
reacting stoically to the tragedy suggested by the fireman's
helmet held on her lap with her right hand and the nude
young boy sheltered with her left arm. The Metropolitan
Museum's bronze is a study of the head of Duty, "devoid
of intense feeling and obviously preoccupied in thought.
Its compassionate and quiescent expression mitigates the
feeling of pathos of the tragic face."[3]

Study of a Head was included in the Museum's exhibi-
tion of American sculpture of 1918 that was organized by
trustee Daniel Chester French[4] and opened in 1918 as an
ongoing installation. Discussions with Piccirilli about the
Museum's possibly purchasing this cast had begun by
November 1918, but several members of the trustees'
Committee on Sculpture objected to the patina. Rather
than substituting a new bronze, Piccirilli altered the finish
on the existing cast.[5] The appearance of the original
patina is not recorded; it is now a warm brown. The piece is
mounted on a green veined marble block, 7¾ inches high.

This is the only known bronze cast of *Study of a Head;*[6]
an unmarked plaster is in the collection at Chesterwood,
French's home and studio in Stockbridge, Massachusetts.[7]

DJH

EXHIBITION

Sheldon Swope Art Gallery, Terre Haute, Ind., January–July 1948.

1. For an illustration of the monument, see Lombardo 1944, p. 187,
 pl. 29; for *Duty* (detail), see p. 191, pl. 31.
2. The original relief was marble, but because of severe erosion, it
 was replaced by a bronze panel in 1953.
3. Lombardo 1944, p. 147.
4. *An Exhibition of American Sculpture* (New York: MMA, 1918), p. 18,
 no. 65. The bronze came into the Museum in February 1918,

providing a terminus for dating the cast. See Special Exhibitions
Notebooks, February 2, 1918, MMA Registrar's Office.
5. French to Piccirilli, November 29, 1918 (copy), Daniel Chester French
 Family Papers, Manuscript Division, Library of Congress, Washing-
 ton, D.C., microfilm reel 5, frame 36; and French to Edward
 Robinson, Director, MMA, December 8, 1919, MMA Archives.
6. Unsigned notes of a telephone conversation with Piccirilli,
 January 24, 1933, object catalogue cards, MMA Department of
 American Paintings and Sculpture.
7. Barbara Roberts, Chesterwood, to Donna J. Hassler, January 30,
 1992; and Hassler to Roberts, February 4, 1992 (copy), object files,
 MMA Department of American Paintings and Sculpture.

214. *Fragilina*, 1923

Marble
48½ x 15½ x 25 in. (123.2 x 39.4 x 63.5 cm)
Signed and dated (right side of base): ATTILIO PICCIRILLI /
FECIT MCMXXIII
Rogers Fund, 1926 (26.113)

THE FIRST OF a series of female nudes Piccirilli began to carve in 1909 was *A Soul*,[1] a figure kneeling by a block of chiseled stone. *Fragilina* is nearly identical in pose, but the stone was cut away to free a simplified, almost abstract form. The head, more ovoid in shape, presents less articulation in the hair and the face; the eyes appear almost veiled in stone. According to Piccirilli, "Every person has his own ideal of beauty stored away in his subconscious mind. When facial characteristics are precisely delineated, the observer is denied the opportunity of personally visualizing his ideal type. This reaction frequently takes place without full realization."[2] As the sculptor demonstrated in subsequent works, the less he represented, the more he was able to communicate through the inherent quality of the medium.

Fragilina was exhibited in New York at the National Sculpture Society in 1923 and in the National Academy of Design commemorative exhibition in 1925–26.[3] The next year, in late March, the Metropolitan Museum purchased the work through Grand Central Art Galleries, where it was on view.[4]

Another marble version, undated but presumably carved after the first was sold to the Metropolitan,[5] was at one time in the sculptor's collection.[6] Piccirilli is known to have made in 1923 two bronze casts of a smaller version, which were once in private New York City collections, one in Angelo Patri's, the other in Fiorello La Guardia's. The latter (25½ in. high) is now at the Museum of Fine Arts, Boston.[7] DJH

1. For an illustration of the work, see Lombardo 1944, pls. 36, 37.
2. Ibid., p. 348.
3. National Sculpture Society, *Exhibition of American Sculpture Catalogue* (New York, 1923), p. 341; and *Commemorative Exhibition by Members of the National Academy of Design, 1825–1925*, exh. cat., Corcoran Gallery of Art, Washington, D.C., and Grand Central Art Galleries, New York (New York, 1925), p. 6, no. 145.
4. Daniel Chester French to William Church Osborn, trustee, MMA, March 10, 1926 (copy), Daniel Chester French Family Papers, Manuscript Division, Library of Congress, Washington, D.C., microfilm reel 9, frame 155; and Erwin S. Barrie, Grand Central Art Galleries, to Henry W. Kent, Secretary, MMA, April 1, 1926, MMA Archives.
5. According to unsigned notes of a telephone conversation with Piccirilli, January 24, 1933, *Fragilina* was "the unique example"; object catalogue cards, MMA Department of American Paintings and Sculpture.
6. For an illustration, see Lombardo 1944, pl. 39. The work was subsequently acquired by Eugene Leone, owner of Mamma Leone's Ristorante, New York, which at one time was also the repository of Piccirilli's *A Soul, Flower of the Alps, Young Virgin, Spring Dream,* and *Study of a Woman*. When the restaurant relocated in October 1987, the collection was purchased by two New York art galleries.
7. Lombardo 1944, p. 392; and Rebecca Reynolds, Museum of Fine Arts, Boston, to Thayer Tolles, September 3, 1997, object files, MMA Department of American Paintings and Sculpture.

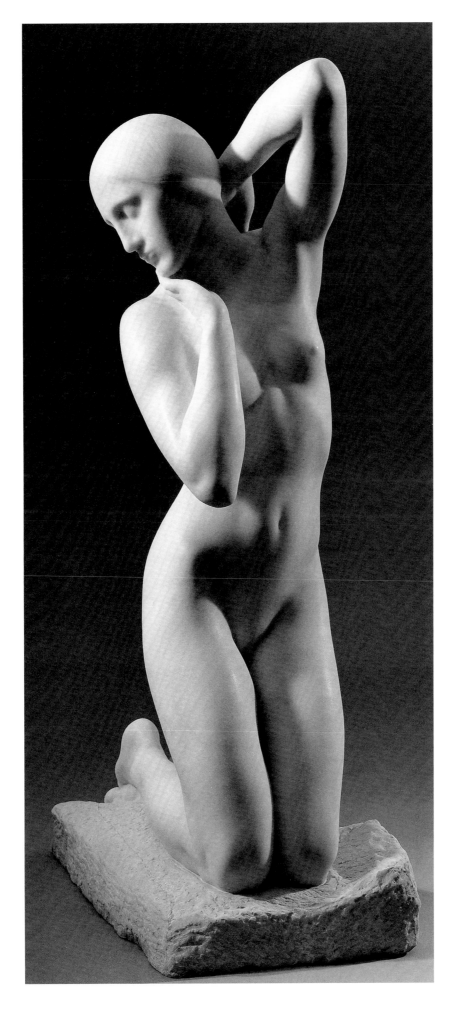

Amory Coffin Simons (1866–1959)

Born in Aiken, South Carolina, Simons received his early education in Charleston. In 1894 he left that city to spend a year in Philadelphia studying life modeling at the Pennsylvania Academy of the Fine Arts, where his instructors were Charles Grafly (pp. 403–7) and John J. Boyle. Simons then went to Paris to pursue training at the Académie Julian under the guidance of Denys Puech and later Jean-Auguste Dampt. He also worked privately with Emmanuel Frémiet and Paul Wayland Bartlett (pp. 454–63); Auguste Rodin supplied critiques on some of his models.

Throughout his career, for many years spent in Paris, Simons specialized in animal sculpture. His preferred subject was the thoroughbred horse, but he also rendered studies of dogs, cats, goats, and the occasional human portrait or nude. Though he never worked on large-scale projects, his realistic statuettes and bas-reliefs demonstrate a sure command of both subject and medium. Simons, like Bartlett, cast many of his small bronzes himself by means of the lost-wax, or cire perdue, process. He displayed his statuettes in numerous expositions at the turn of the century, earning honorable mentions at the Paris Exposition Universelle of 1900 and the Buffalo Pan-American Exposition of 1901 for *Surprise,* a horse observing a turtle at its feet. At the Louisiana Purchase Exposition of 1904 in Saint Louis, Simons was awarded a silver medal for his seven studies of horses and cats. In Paris, he was active in the expatriate art community; as a member of the American Art Association, he received a first prize for sculpture in its 1907 exhibition. In 1905, when "Buffalo Bill" Cody took his Wild West show to Paris,

Simons executed from life a bronze statuette of him on a horse (1920 cast; Buffalo Bill Historical Center, Cody, Wyo.).

After the outbreak of World War I, Simons returned to the United States and established a studio in New York, where he completed such works as *The Storm* (1921; South Carolina State Museum, Columbia) and *New York Engine Horses,* which earned the Ellin P. Speyer Memorial Prize for the best representation of an animal at the National Academy of Design's annual exhibition in 1922. In 1924 a gallery at the Baltimore Museum of Art was devoted to forty-five examples of Simons's sculpture in a display of American art; *Rearing Colt* (1917) was given to the Baltimore Museum by the artist in 1926. A testament to Simons's command of equine anatomy is his work during 1922–26 for the American Museum of Natural History, New York: three models on the development of the horse across the ages, *Neohipparion, Pliohippus,* and *Arabian Stallion, Nimr.* Simons also carried out numerous commissions for the du Pont family, to whom he was related, including sets of thoroughbred horses and dogs. In 1926 he moved to Hollywood, California, then to Santa Barbara, where he taught at the Santa Barbara School of the Arts. DJH

SELECTED BIBLIOGRAPHY

Simons, Amory Coffin, Papers. Archives of American Art, Smithsonian Institution, Washington, D.C., microfilm reel 3465.
Proske, Beatrice Gilman. *Brookgreen Gardens Sculpture,* pp. 56–58. Rev. ed. Brookgreen Gardens, S.C.: Brookgreen Gardens, 1968.

215. *Horse Scratching,* 1910

Bronze
9 x 8 x 4¾ in. (22.9 x 20.3 x 12.1 cm)
Signed: (on horse's body, in monogram) ACS; (left side of base)
A C Simons S.F Paris
Gift of the artist, 1948 (48.167.1)

Of all animal subjects, the horse was Simons's favorite. He portrayed it often, relying on intimate scale to focus on behavioral characteristics. *Horse Scratching,* modeled and cast in Paris, is an amusing study of the animal's awkward attempt to scratch its head with a forehoof. Traces of a greenish blue patina suggest that

Simons was experimenting with the color of this cast, a reflection of an interest he shared with Paul Wayland Bartlett.

Horse Scratching appeared in the National Sculpture Society exhibition of 1923 in New York and at the Baltimore Museum of Art in 1924;[1] whether it was the Mu-

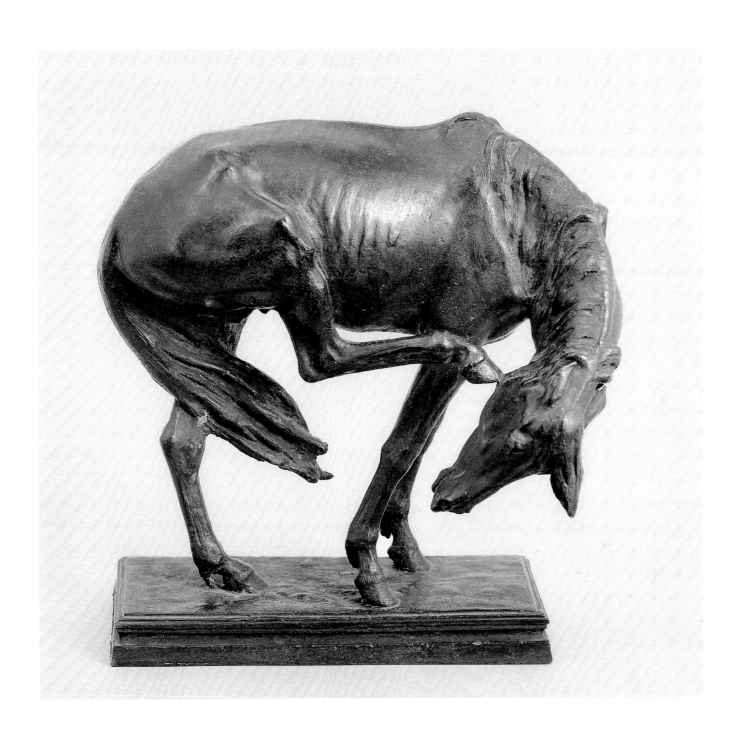

seum's example that was included at these venues is impossible to determine. Simons presented *Horse Scratching* and *Haute École* (cat. no. 216) to the Metropolitan in 1948. Another cast of *Horse Scratching* is at Brookgreen Gardens, Murrells Inlet, South Carolina, given by the sculptor in 1951.[2]

DJH

1. National Sculpture Society, *Exhibition of American Sculpture Catalogue* (New York, 1923), p. 345; and Baltimore Museum of Art, *Paintings, Drawings, Sculpture by American Artists,* exh. cat. (Baltimore, 1924), no. 121.
2. For information on and an illustration of the Brookgreen cast, see Proske 1968, pp. 57–58.

216. *Haute École*, 1910

Brass, silver
10½ x 15½ x 3½ in. (26.7 x 39.4 x 8.9 cm)
Gift of the artist, 1948 (48.167.2)

ACCORDING TO Simons, he modeled and cast *Haute École* and *Horse Scratching* (cat. no. 215) in Paris at the same time.[1] While *Horse Scratching* captures a brief moment of an animal's action, *Haute École* portrays a show horse elaborately schooled and groomed, with braided forelock and mane and a decorative tuft on the bridle, for its role as a performer. The title refers to the kind of movement the horse is demonstrating, literally high school, or advanced dressage.

A cast of *Haute École* was shown at the Baltimore Museum of Art in 1924,[2] but whether it was the one now at the Metropolitan Museum cannot be documented.

Analysis of the metal of the Metropolitan's cast indicates that this statuette is brass, a zinc-copper alloy, and the patina consists of high-purity silver.[3] Its warmth was effected by careful rubbing, underscoring Simons's interest in variations of surface color. The horse stands on a green marble base, 4 inches high, which the artist created especially for this delicate figure. DJH

EXHIBITIONS

Queens Museum, New York, "The Artist's Menagerie: Five Millennia of Animals in Art," June 29–August 25, 1974, no. 121.
MMA, Costume Institute, "Man and the Horse," December 18, 1984–September 5, 1985.
Monmouth County Historical Association, Lincroft, N.J., "The Horse: Man's Noble Companion," March 8–June 22, 1987.

1. Artist information form, December 28, 1948, MMA Archives.
2. Baltimore Museum of Art, *Paintings, Drawings, Sculpture by American Artists*, exh. cat. (Baltimore, 1924), no. 102.
3. SEM/EDS analysis report, May 28, 1997, MMA Department of Objects Conservation. I thank Mark T. Wypyski, Associate Research Scientist, for providing this information.

Karl Bitter (1867–1915)

itter enrolled at the School of Applied Arts in his native Vienna from 1881 to 1884 and continued his artistic training from 1885 to 1888 at the Imperial Academy of Fine Arts as a student of the Austrian sculptor Edmund von Hellmer. After carving stone ornament for public buildings in Vienna, he served in the Austrian army for a year before fleeing to Germany. Bitter came to New York in autumn 1889 and found employment in a firm specializing in architectural decoration.

Bitter's talent soon drew the attention of the Beaux Arts–trained architect Richard Morris Hunt (see cat. no. 217), who commissioned Bitter to work on sculptural ornament for buildings he designed. In 1891 Bitter won his first competition: to execute the Astor Memorial Gates for Trinity Church on lower Broadway. His reputation as a leading architectural sculptor was solidified with his elaborate decorative program, "The Elements, Uncontrolled and Controlled," on Hunt's Administration Building at the 1893 World's Columbian Exposition in Chicago. Other important collaborations with Hunt included inventive and lavish decorations for Ogden Goelet's Ochre Court (1888–92) in Newport, Rhode Island, and George W. Vanderbilt's Biltmore (1888–95) in Asheville, North Carolina. For Hunt's Fifth Avenue facade of the Metropolitan Museum of Art, Bitter executed four caryatids representing the arts of painting, sculpture, architecture, and music, and six roundels depicting Bramante, Dürer, Michelangelo, Raphael, Rembrandt, and Velázquez (1897–99).

Independent of Hunt, Bitter filled many orders during the 1890s, beautifying churches, homes, and public structures. For Philadelphia's Broad Street Station (1892–95; destroyed 1952), Bitter completed projecting figures, a clock, and relief panels, one the plaster *Progress of Transportation* (now in 30th Street Station). In New York colossal limestone atlantes (1896; now in Indianapolis) for the Saint Paul Building depicted three races of man, and his *Peace* (1899) is the central group of the balustrade for the Madison Square side of the courthouse of the New York State Supreme Court Appellate Division. By 1896 Bitter had built a large studio in Weehawken, New Jersey, and was employing several assistants in his flourishing practice. His seated bronze figure of archaeologist Dr. William Pepper (1895–99; University of Pennsylvania, Philadelphia) signaled a new direction in Bitter's work. Just after the turn of the century, he gave up most of his decorative sculpture to devote more time to ideal and portrait monuments, for example, the *Villard Memorial* (1902–4; Sleepy Hollow Cemetery, North Tarrytown, N.Y.) and an equestrian statue of Franz Sigel (1904–7; Riverside Drive and West 106th Street, New York). In addition to carrying out his own commissions, Bitter served as the director of sculpture for three world's fairs: Buffalo in 1901, Saint Louis in 1904, and, just before his death, San Francisco in 1915.

Although schooled in the Beaux Arts tradition, Bitter was the first American sculptor to incorporate the simplified style of archaic Greek art into contemporary design. This influence became manifest after his travel to Greece and Vienna in 1909–10, especially in his plans for the exterior embellishment of the Wisconsin State Capitol (1906–12; Madison) and the relief panels for the *Carl Schurz Monument* (1909–13; Morningside Drive and 116th Street, New York). His final work was a statue of Pomona, goddess of abundance, for the Pulitzer Fountain (1913–16; Grand Army Plaza, New York), which was completed and cast in bronze after Bitter died of injuries from being struck by an automobile in April 1915. At the time of his death, he was president of the National Sculpture Society, having also served in this office from 1906 to 1908. DJH

SELECTED BIBLIOGRAPHY

Bitter, Karl Theodore Francis, Papers. Archives of American Art, Smithsonian Institution, Washington, D.C., microfilm reels N70-8, N70-35, N70-40, and 673.

Greer, H. H. "The Work of Karl Bitter, Sculptor." *Brush and Pencil* 3 (March 1904), pp. 466–78.

Laurvik, J. Nilsen. "Karl Bitter: A Master of Decorative Sculpture." *Booklovers Magazine* 3 (May 1904), pp. 599–606. Revised and reprinted as "Karl Bitter—Decorative Sculptor." *The Sketch Book* 6 (September 1906), pp. 1–10.

Brush, Edward Hale, et al. Karl Bitter memorial section. *Art and Progress* 6 (July 1915), pp. 295–312.

Schevill, Ferdinand. *Karl Bitter: A Biography*. Chicago: University of Chicago Press for the National Sculpture Society, 1917.

Dennis, James M. *Karl Bitter: Architectural Sculptor, 1867–1915*. Madison: University of Wisconsin Press, 1967.

Rather, Susan. "Toward a New Language of Form: Karl Bitter and the Beginnings of Archaism in American Sculpture." *Winterthur Portfolio* 25 (Spring 1990), pp. 1–19.

217. *Richard Morris Hunt*, 1891

Bronze, 1892
Diam. 20 in. (50.8 cm)
Signed (lower center): *Karl Bitter—Sculptor*
Inscribed: (at right) RICH·MORRIS·HUNT·; (at left) A·D·1891·
Foundry mark (lower left): *Cast by The Henry-Bonnard Bronze C° / New York. 1892.*
Gift of Erving Wolf Foundation, 1978 (1978.206)

BITTER AND architect Richard Morris Hunt (1828–1895) collaborated on the execution of some of the most lavishly decorated American buildings of the early 1890s.[1] One of them was Marble House, William K. Vanderbilt's estate in Newport, Rhode Island. Vanderbilt, wishing to honor his architect and the great tradition in which he worked, asked Bitter to carve a high-relief portrait of Hunt, as well as one of Jules Hardouin-Mansart, the architect who completed Louis XIV's Palace of Versailles. The approximately lifesize pendant medallions are framed by gilt-plaster laurel wreaths supported by a pair of female figures.[2] Bitter subsequently included a drawing of his relief of Hunt in one of the six roundels he was designing for Hunt's facade of the Metropolitan Museum, although the portrait was eliminated from

the final scheme in 1898.[3] Earlier Bitter had incorporated a frontal portrait head of Hunt, as well as one of himself, into the Astor doors for Trinity Church, New York (1891–94).[4]

This image of Hunt was cast in bronze in 1892, presumably from the original plaster (1891; Art Institute of Chicago). The bronze cast passed from Hunt, who had been a founding trustee of the Metropolitan Museum, to his oldest son, Richard Howland Hunt, to his grandson Frank Carley Hunt, of Bridgeport, Connecticut, to his great-granddaughter Catharine Hunt Paxton, of New York, who consigned it to auction in 1978.[5] Later casts are in the collections of the American Institute of Architects and the National Portrait Gallery, both in Washington, D.C. DJH

EXHIBITIONS

MMA, "The Architecture of Richard Morris Hunt," March 20–
September 28, 1986. The work was also shown with the exhibi-
tion when it traveled to the Los Angeles County Museum of
Art, May 26–July 31, 1988.
MMA, Henry R. Luce Center for the Study of American Art, "Por-
traits of American Artists in The Metropolitan Museum of Art,"
September 29, 1992–February 21, 1993.
MMA, "The Architecture of The Metropolitan Museum of Art,
1870–1995," April 4, 1995–January 7, 1996.

1. See Lewis I. Sharp, in Susan R. Stein, ed., *The Architecture of Richard
Morris Hunt,* exh. cat. (Chicago: University of Chicago Press,
1986), pp. 139–47, 149.
2. See Stein, *Hunt,* p. 142, fig. 7.37.
3. See Morrison H. Heckscher, in Stein, *Hunt,* pp. 183–84, 187 n. 38.
4. For the Astor doors, see Stein, *Hunt,* p. 144, fig. 7.42.
5. Sotheby Parke Bernet, New York, sale cat., April 28, 1978,
no. 701. The provenance of the relief is listed incorrectly in the
catalogue. It has been clarified by Paul R. Baker, New York Uni-
versity, in a letter to Thayer Tolles, February 11, 1998, object files,
MMA Department of American Paintings and Sculpture.

218. *Claerchen,* 1893

Bronze
21¾ x 13⅛ in. (55.2 x 33.3 cm)
Signed and dated (lower right): Bitter / 93.
Inscribed (center): CLAERCHEN.
Foundry mark (lower right): Cast by The Henry-Bonnard
Bronze Cº. / New York. 1893.
Gift of Estate of Hélène Vallé, 1991 (1992.186)

BITTER COMPLETED this portrait of Clare, his six-year-
old niece, in 1893.[1] The relief is more intimate in feeling
than most of his oeuvre, and Bitter's fondness for his young
sitter is evident not only in the handling of the likeness
but in the inscription, "Claerchen," a diminutive form of
her name that recalls his Austrian heritage.

Clare, depicted in profile facing left, is set in the center
of a rectangular panel. Bitter's rendering of her handsome
features and her ruffled pinafore and blouse with full
sleeves expresses innocence and a sweet femininity. In this
sketchlike representation, Bitter eschewed minute detail,
but the handling of form is sufficiently tactile that the
bronze preserves the freshness of a preliminary clay model.

This relief, presumed to be a unique bronze, was sand
cast in 1893. It has a warm brown patina with brown-black
highlights. The portrait was made a promised gift to the
Metropolitan Museum in 1981 by Hélène Vallé, daughter
of the sitter, Clare Bitter Vallé; it entered the Museum's
collection following Hélène Vallé's death in 1991.

TT

EXHIBITION

MMA, Henry R. Luce Center for the Study of American Art,
"American Relief Sculpture," August 15–November 5, 1995.

1. The sitter is identified in the promised gift form signed by Hélène
Vallé in 1981, MMA Archives. However, Bitter's son John did not
recognize the sitter's name; telephone conversation with Thayer
Tolles, October 17, 1995, notes in object files, MMA Department
of American Paintings and Sculpture.

219. *All Angels' Church Pulpit and Choir Rail,* 1900

Limestone, oak, walnut

H. 47½ in. (120.7 cm) (horizontal portion of chair rail)

Signed (lower corner, far right end of choir rail): KARL·BITTER INV·ET·SC

Inscribed: (on masonry beneath stairway ascending to pulpit) THIS PVLPIT / WAS PRESENTED TO / ALL ANGELS' CHVRCH / ON ALL SAINTS' DAY, 1900 / BY SARAH R. CORNELL / FOR THE GREATER GLORY / OF GOD / AND IN LOVING MEMORY OF / HER HVSBAND AND TWO SONS·; (on four small horizontal tablets under pulpit, left to right) ALL·S·S / MCM // THOS·W·CORNELL // IN·MEM· / ALBERT CORNELL // FRANK·A·CORNELL

Pulpit and part of choir rail, Rogers Fund, 1978 (1978.585.1, 2)

South side of choir rail and walnut trumpeting angel surmounting oak sounding board lent by All Angels' Church (L.1983.53.1, 2)

BITTER WAS commissioned to design the pulpit and choir rail for All Angels' Church, consecrated in 1890, during its remodeling in 1897–1900. The church stood at the southeast corner of 81st Street and West End Avenue, New York, until it was demolished in 1978. The new pulpit, a gift to the church from Sarah R. Cornell in memory of her husband and sons, was a pillar pulpit on one of the nave's main columns. The decoration around the pulpit was continuous with the decoration of the choir rail, which began at the far right end, extended across the nave, breaking at the aisle, and continued up the stairway to the pulpit. Bitter looked to Northern Italian Renaissance counterparts as inspiration for the general form of his design, but in the high relief of the carving and the exuberance of the figures' movement the work relates more to later prototypes. In the tradition of Bitter's training in architectural decoration, he did his own carving instead of delegating the execution of his designs to hired craftsmen, which was the practice of most other sculptors. He considered this commission, unveiled on All Saints' Day 1900, to be among his notable works.[1]

The pulpit is installed at the Metropolitan Museum as it was in the church, supported on the column by a partial figure of Moses holding the Tablet of the Law; the corbels are decorated with heads of prophets. However, the choir rail is now lacking several panels that were originally part of it, and the break for the aisle has been eliminated. The angels that decorate the pulpit and the choir rail walk, dance, or climb on heavenly clouds and play musical instruments or carry appropriate symbolic attributes. This joyous band is divided into groups by slender blocked columns, and the processions from the left, around the pulpit, and the right, across the choir rail and up the stairs to the pulpit, meet at the center of the pulpit, above the figure of Moses, with one angel holding a long scroll and singing. Above the pulpit, the oak sounding board is surmounted by a walnut trumpeting angel, forming what has been described as "an apotheosis of what is begun below in the procession."[2] The processional theme was reiterated in the inscription below the base of the choir rail (missing, probably destroyed): "O praise the Lord, ye angels of His, ye that excel in strength; ye that fulfil

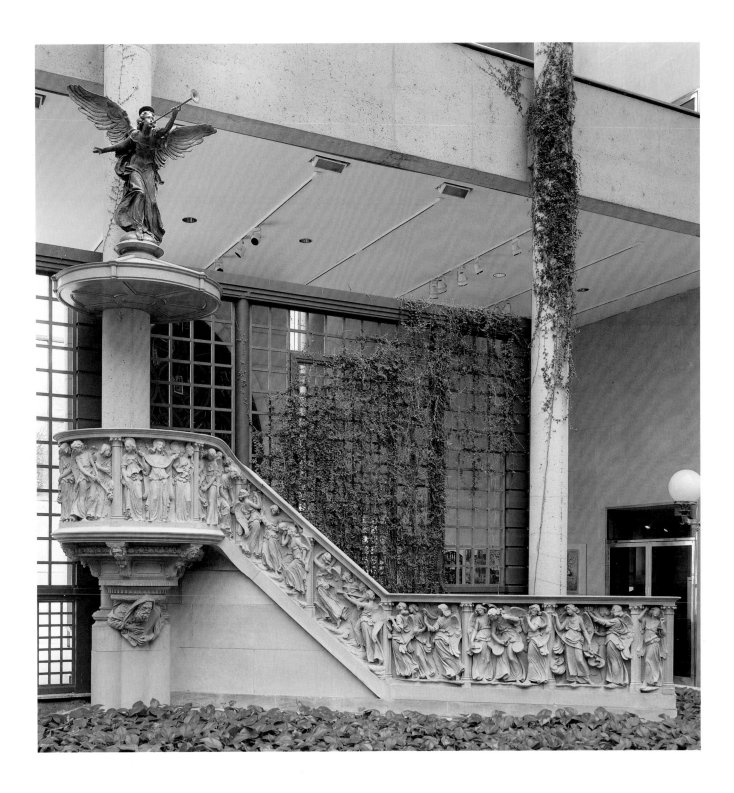

His commandment, and hearken unto the voice of His Word" (Psalm 103:20).[3]

The Metropolitan Museum acquired the pulpit and the relief panels of the stairway in 1978, the year the church was demolished.[4] With the loan of the trumpeting angel and the south side of the choir rail by All Angels' Church,[5] the pulpit and choir rail have been reunited in the Charles Engelhard Court of the American Wing. DJH

1. Bitter to Frank Edwin Elwell (pp. 365–66), Department of Ancient and Modern Statuary, MMA, July 12, 1902, Elwell Autograph Letters for American Sculptors, MMA Thomas J. Watson Library.
2. F. L., "A Contribution to Christian Art," *The Churchman* 82 (November 24, 1900), p. 638.
3. Ibid.
4. See Christie's, New York, sale cat., November 30, 1978, no. 55.
5. The congregation of All Angels' Church now worships in a sanctuary on West 80th Street.

220. *Diana,* 1910

Bronze
19¼ x 5¾ x 9 in. (48.9 x 14.6 x 22.9 cm)
Signed and dated (top of base, around edge): KARL BITTER / COPYR MCMX
Foundry mark (back of base): ROMAN BRONZE WORKS N.Y.
Rogers Fund, 1912 (12.50)

AFTER ESTABLISHING a career as an architectural and decorative sculptor, Bitter turned to monumental commissions while infrequently executing small-scale pieces. *Diana,* one of the few statuettes he is known to have modeled, is therefore unusual in his oeuvre.

Diana, goddess of the moon, the forest, and animals, was a popular subject for American Beaux Arts sculptors,[1] who, inspired by the oft-replicated prototypes of Jean-Antoine Houdon and Jean-Alexandre-Joseph Falguière, depicted the mythic huntress in a variety of poses (see also cat. nos. 93, 130, 193, 292). Bitter's first known portrayal of the goddess was completed for Idle Hour, William K. Vanderbilt's Long Island house, which was destroyed by fire in 1898. The figure was in such high relief that it extended far beyond the plane of its classical frame.[2] A *Diana* that Bitter reportedly executed for the Administration Building at the World's Columbian Exposition has not yet been further identified.[3]

The Metropolitan Museum's *Diana,* conceived in the round and identified by her attributes of the bow she holds and the crescent in her hair, demonstrates Bitter's skillful handling of the nude form, a legacy of his European academic training. This cast is said to be one of several, each inscribed with the copyright date, 1910, whose replication and sale were sponsored by the National Sculpture Society.[4] Another example is in the collection of the Museum of Fine Arts, Saint Petersburg, Florida.

Bitter exhibited *Diana* in New York at the National Academy of Design in 1910.[5] In March 1912 the Metropolitan's cast was shown at the Montross Galleries. That same month, Daniel Chester French (pp. 326–41), chairman of the Metropolitan Museum trustees' Committee on Sculpture, recommended its purchase by the Museum.[6]

DJH

EXHIBITIONS
Elvehjem Art Center, University of Wisconsin, Madison, December 1975–December 1976.
MMA, Henry R. Luce Center for the Study of American Art, "Subjects and Symbols in American Sculpture: Selections from the Permanent Collection," April 11–August 20, 2000.

1. See H. W. Janson, *19th-Century Sculpture* (New York: Harry N. Abrams, 1985), pp. 43–44; and Jeanne L. Wasserman, *Diana in Late Nineteenth-Century Sculpture: A Theme in Variations,* exh. cat. (Wellesley, Mass.: Wellesley College Museum, 1989).
2. Dennis 1967, pp. 23, 17 (ill.).
3. Trumbull White and William Igleheart, *The World's Columbian Exposition, Chicago, 1893* (Saint Louis: P. W. Ziegler, [1893]), p. 79.
4. Dennis 1967, p. 287, n. 34. But see caption for illustration on p. 243, where Dennis gave the date of the bronze then owned by Mrs. Walter Abel (Bitter's daughter) as 1909.
5. *Illustrated Catalogue, National Academy of Design Winter Exhibition 1910* (New York, 1910), p. 10, no. 16. The catalogue does not specify whether the *Diana* displayed was in plaster or bronze.
6. Recommended purchase form, March 21, 1912, MMA Archives.

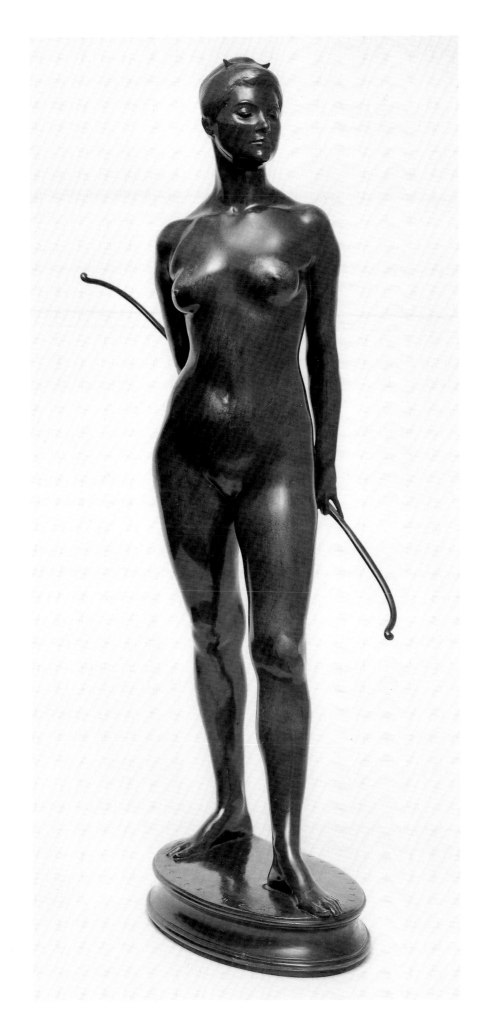

John Gutzon de la Mothe Borglum (1867–1941)

Borglum, born near Bear Lake, Idaho, a Mormon settlement, had a peripatetic childhood in the American West. About 1884 his family, including his brother Solon (pp. 508–11), moved to California, where he apprenticed himself to a lithographer in Los Angeles. Borglum trained as a painter at the San Francisco Art Association, meeting people there who greatly influenced his development. In 1890 Borglum went to Paris and enrolled at the Académie Julian for classes in sculpture given by Antonin Mercié and in painting by Jules-Joseph Lefebvre. Borglum was disenchanted with French academic training, however, and he sought out Auguste Rodin, whose vigorous modeling style had a lasting effect on his work. His first sculpture, *Fallen Warrior,* also known as *Death of the Chief* (ca. 1891; Gilcrease Museum, Tulsa, Okla.), was displayed in the exhibition of the Société Nationale des Beaux-Arts in 1891. After leaving Paris, Borglum traveled for more than a year in Spain. He returned to California in 1893, supporting himself with mural commissions and displaying *Indian Scouts* (1891; Forest Lawn Museum, Glendale, Calif.) at the World's Columbian Exposition in Chicago. In 1896 he settled in London, where he achieved considerable success painting murals and portraits and modeling busts. His statuette *Apache Pursued by U.S. Troops* (1900; R. W. Norton Art Gallery, Shreveport, La.) was well received when it was shown in France and Italy.

Borglum established a studio in New York in 1901. In 1904, having virtually abandoned painting in favor of sculpture, he was awarded a gold medal at the Louisiana Purchase Exposition for work that included *The Mares of Diomedes* (cat. no. 221) and *John Ruskin* (cat. no. 222). There followed several important public commissions: statues of the Twelve Apostles for the Cathedral of Saint John the Divine, New York (1905), a colossal marble head of Abraham Lincoln (1908; United States Capitol Rotunda), and a bronze equestrian of General Philip H. Sheridan (1908; Sheridan Circle, Washington, D.C.). Borglum taught at the Art Students League of New York during 1906–7. He was a vociferous, controversial member of the New York artistic community, often at odds with fellow sculptors. In 1912 he was involved in the formation of the Association of American Painters and Sculptors, and he was an organizer of the landmark Armory Show held the following year. In 1914 Borglum was accorded a large solo exhibition at Columbia University.

In 1910 Borglum purchased the property for his estate, Borgland, in Stamford, Connecticut. There he worked on bronze monuments for Newark, New Jersey: a seated *Lincoln* (1911) in front of the Essex County Courthouse and a massive group, *Wars of America* (1920–26; Military Park), which is composed of forty-two men and two horses and presents all the military conflicts in which the United States had been involved through World War I. His designs for the Confederate Memorial at Stone Mountain, Georgia, and his depiction of General Robert E. Lee (dedicated in 1924; subsequently replaced) were precursors to the portraits of George Washington, Thomas Jefferson, Abraham Lincoln, and Theodore Roosevelt begun in 1927 on Mount Rushmore in the Black Hills of South Dakota. The Mount Rushmore National Memorial was close to completion at the time of Borglum's death and was finished by his son, Lincoln. While Borglum is best known for this commission, which occupied the last years of his life, his oeuvre consists of almost 170 sculptures. DJH

SELECTED BIBLIOGRAPHY

Borglum, Gutzon, Collection. San Antonio Museum of Art, San Antonio, Tex. Microfilmed for Archives of American Art, Smithsonian Institution, Washington, D.C., reel 3056.

Borglum, Gutzon, Papers. Manuscript Division, Library of Congress, Washington, D.C.

Mechlin, Leila. "Gutzon Borglum, Painter and Sculptor." *International Studio* 28 (April 1906), pp. XXXV–XLIII.

Borglum, Gutzon. "Art That Is Real and American." *World's Work* 28 (June 1914), pp. 200–217.

Casey, Robert J., and Mary Borglum. *Give the Man Room: The Story of Gutzon Borglum.* Indianapolis and New York: Bobbs-Merrill, 1952.

Gutzon Borglum: The Artist and the Man. Exh. cat., University Art Galleries, University of South Dakota, Vermillion; Oscar Howe Art Center, Mitchell, S.D.; Rushmore-Borglum Story Museum, Keystone, S.D. Vermillion, S.D.: The Broadcaster, 1984.

Shaff, Howard, and Audrey Karl Shaff. *Six Wars at a Time: The Life and Times of Gutzon Borglum, Sculptor of Mount Rushmore.* Sioux Falls, S.D.: Center for Western Studies, Augustana College, 1985.

Carter, Robin Borglum. *Gutzon Borglum: His Life and Work.* Austin, Tex.: Eakin Press, 1998.

Out of Rushmore's Shadow: The Artistic Development of Gutzon Borglum (1867–1941). Exh. cat. Stamford, Conn.: Stamford Museum and Nature Center, 1999.

221. *The Mares of Diomedes*, 1902–4

Bronze, 1905
64½ x 103½ x 51 in. (163.8 x 262.9 x 129.5 cm)
Signed and dated (back of base): Gutzon·Borglum· / 1904
Inscribed (back of base): COPYRIGHT 1905
Foundry mark (back of base): GORHAM MFG. CO. FOUNDERS·
Gift of James Stillman, 1906 (06.1318)

WHILE BORGLUM'S love for western subjects is evident in much of his early work, nowhere is it manifested more dramatically than in *The Mares of Diomedes.* According to the artist, his primary motive for executing the group of seven stampeding horses was to convey "intense controlled action."[1] Borglum described his choice of the classical title in a letter to the writer Elbert Hubbard:

I discovered that name, legend, and everything pertaining to it, long after the group was entirely completed.

My first sketch of "The Mares of Diomedes" was a couple of gun limbers in stampede. The horses had charged into each other and were wrecking everything. The debris they created annoyed me, and the harness covered the horses too much, so I removed all of that. The lone rider who was in charge of one team I converted into a cowboy, but I found that he had too much clothes. I converted him into an Indian, and that did not seem satisfactory, so I finally pulled the feather and the G string off, and had a nude man riding a

savage nude horse and leading a stampede. For the sake of the public, the great lay mind, I had to find a name for it, and in my rummagings I came upon the "Seventh Labor of Hercules". My rider is Hercules. It was his job to get the Mares of Diomedes away from the King, and my group fitted it well enough, and was so named.[2]

The Mares of Diomedes was the first major work Borglum produced in the New York studio he established in 1901. The plaster model was one of the exhibited works that brought the sculptor acclaim at the Louisiana Purchase Exposition in Saint Louis in 1904.[3] The group was shown at the National Academy of Design in the winter of 1905–6,[4] at which time banker James Stillman purchased it as a gift for the Metropolitan Museum.[5] The cast, which has a green patina, is unique.

A reduction of *The Mares of Diomedes,* 21 inches high, was cast at Gorham Manufacturing Company, beginning in 1904.[6] There are examples of the reduced version in the collections of the Museum of Art, Rhode Island School of Design, Providence; the R. W. Norton Art Gallery, Shreveport, Louisiana; and the Newark Museum, Newark, New Jersey. A separate cast of the horses in the center of the composition was installed at Brookgreen Gardens, Murrells Inlet, South Carolina, in 1948.[7] DJH

EXHIBITIONS

Avery Library, Columbia University, New York, "Exhibition of Sculpture by Gutzon Borglum," opened February 28, 1914, no. 1.
Whitney Museum of American Art, New York, "200 Years of American Sculpture," March 16–September 26, 1976, no. 22.
Buffalo Bill Historical Center, Cody, Wyo., June 1984–present.

1. Quoted in J. Walker McSpadden, *Famous Sculptors of America* (New York: Dodd, Mead, 1927), p. 223.
2. Borglum to Hubbard, March 26, 1915 (copy), Borglum Papers, Library of Congress, container no. 101, "Mares of Diomedes" folder.
3. *Official Catalogue of Exhibitors: Universal Exposition, St. Louis, U.S.A., 1904 . . . Department B, Art,* rev. ed. (Saint Louis: Official Catalogue Co., 1904), p. 59, no. 2042. See also *Illustrations of Selected Works . . . Department of Art . . . Universal Exposition* (Saint Louis: Official Catalogue Co., 1904), p. 378 (ill.).
4. *National Academy of Design Eighty-first Annual Exhibition 1906, Illustrated Catalogue* (New York, 1906), p. 56, no. 341, as "Horses of Diomedes."
5. Stillman to J. P. Morgan, trustee, MMA, January 20, 1906, MMA Archives. See also Annie Nathan Meyer, "The Mares of Diomedes, by Gutzon Borglum," *MMA Bulletin* 1 (March 1906), pp. 62–63.
6. Jennifer A. Gordon, *Cast in the Shadow: Models for Public Sculpture in America,* exh. cat. (Williamstown, Mass.: Sterling and Francine Clark Art Institute, 1985), p. 23.
7. Beatrice Gilman Proske, *Brookgreen Gardens Sculpture,* rev. ed. (Brookgreen Gardens, S.C.: Brookgreen Gardens, 1968), pp. 63–64.

222. *John Ruskin,* 1903

Bronze
15 x 8¼ x 14½ in. (38.1 x 21 x 36.8 cm)
Signed and dated (top of base, back): Gutzon Borglum / 1903
Foundry mark (top of base, back): GORHAM MFG. CO FOUNDERS
Rogers Fund, 1906 (06.406)

IN 1897,[1] WHILE Borglum was living in London, he visited the English art critic John Ruskin (1819–1900) at Ruskin's home in the Lake District. Ruskin, whose seminal publications included *Modern Painters* (1843–60) and *The Stones of Venice* (1851–53), was one of the most influential minds of the Victorian age. As Borglum found him "at Windermere, he had drawn into himself. He knew his worth. He had full confidence in his own strength, but he was sad."[2]

A few years later Borglum modeled a statuette of Ruskin, endowing it with a monumental quality befitting his subject. The Rodinesque figure, book in hand, is seated in a blocklike chair, with a heavy lap robe over his legs. His thick, tightly knit eyebrows overhang his eyes, and his beard flows down his chest. The elemental quality of the work is reinforced by the boldly striated tool marks.

Borglum exhibited *Ruskin* frequently after its completion, sending it to the National Sculpture Society in 1903, and to the annuals of the Society of American Artists and the Pennsylvania Academy of the Fine Arts in 1904.[3] He displayed a cast of *Ruskin,* along with other works, in 1904 at the Louisiana Purchase Exposition, Saint Louis.[4]

In 1906, when the Metropolitan Museum was making a special effort to collect smaller bronzes by American sculptors, it purchased *John Ruskin* directly from Borglum.[5] Other Gorham casts of this work are at the Detroit Institute of Arts and the Forest Lawn Museum, Glendale, California. A plaster is in the collection of the Art Museum, Princeton University, Princeton, New Jersey. DJH

222

EXHIBITIONS

American Fine Arts Society, New York, "Exhibition of Distinguished Artists . . . Associated with [the Art Students League] during Sixty-eight Years," February 7–28, 1943, no. 29.

New York Institute for the Education of the Blind, November 1947.

Sheldon Swope Art Gallery, Terre Haute, Ind., January 1948–February 1951.

MMA, "The 75th Anniversary Exhibition of Painting and Sculpture by 75 Artists Associated with the Art Students League of New York," March 16–April 29, 1951, no. 23.

Delaware Art Center, Wilmington, "The Fiftieth Anniversary of the Exhibition of Independent Artists in 1910," January 9–February 21, 1960, no. 9.

Art Students League of New York, "American Masters from Eakins to Pollock," July 7–August 26, 1964, no. 3.

Kennedy Galleries, New York, "100th Anniversary Exhibition of Paintings and Sculpture by 100 Artists Associated with the Art Students League of New York," March 6–29, 1975.

Bell Gallery, List Art Building, Brown University, Providence, "The Classical Spirit in American Portraiture," February 6–29, 1976, no. 48.

Galerie des Beaux-Arts, Bordeaux, "Profil du Metropolitan Museum of Art de New York de Ramsès à Picasso," May 15–September 1, 1981, no. 200.

San Diego Museum of Art, October 10–December 6, 1981; Krannert Art Museum, University of Illinois, Champaign-Urbana, January 10–March 7, 1982; Fine Arts Museum of the South, Mobile, Ala., March 30–May 9, 1982; Midland Center for the Arts, Midland, Mich., June 13–August 25, 1982; Arkansas Arts Center, Little Rock, September 19–November 14, 1982, "5000 Years of Art from the Collection of The Metropolitan Museum of Art," exhibition organized by the American Federation of Arts and the MMA, no. 64.

1. *Out of Rushmore's Shadow* 1999, p. 92.
2. "The Versatile Talent of Gutzon Borglum," *Current Literature* 40 (May 1906), p. 501.

3. *National Arts Club, Fifth Exhibition of the National Sculpture Society* (New York, 1903), no. 7; *Twenty-sixth Annual Exhibition of the Society of American Artists* (New York, 1904), p. 65, no. 387; and *Pennsylvania Academy of the Fine Arts . . . Catalogue of the Seventy-third Annual Exhibition,* 2nd ed. (Philadelphia, 1904), p. 59, no. 889.

4. For a list of Borglum's exhibits, which included a collection of eleven gargoyles for Princeton University, see *Official Catalogue of Exhibitors: Universal Exposition, St. Louis, U.S.A., 1904 . . . Department B, Art,* rev. ed. (Saint Louis: Official Catalogue Co., 1904), p. 59, nos. 2042–59.

5. Object catalogue cards, MMA Department of American Paintings and Sculpture. See also D[aniel] C[hester] F[rench], "Modern American Bronzes," *MMA Bulletin* 1 (September 1906), pp. 129–30.

223. *Study of the Head of George Washington for Mount Rushmore,* ca. 1925–30

Wax
6 x 4 x 3 in. (15.2 x 10.2 x 7.6 cm)
Signed (back, in ink, partially illegible): Gutzon Borglum /
Rushmore [?]
Gift of Mrs. Henry L. Moses, 1958 (58.165)

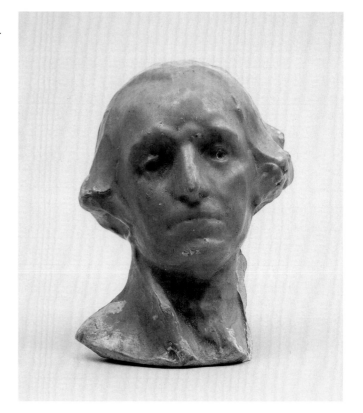

BORGLUM'S COLOSSAL head of George Washington was the first of the four presidential portraits carved out of the cliffs of Mount Rushmore in the Black Hills of South Dakota.[1] The head, "silent as the Sphinx,"[2] was unveiled on July 4, 1930. In the address Borglum gave at the ceremony, he said, "Upon Mount Rushmore we are trying to give to the portrait of Washington all the vigor and power that direct modeling makes possible and produce a head in sculpture as vital as one can hold, produced at arm's length. . . . [The] forehead of Washington [is] twenty feet from wig to nose, as animate and carefully constructed as the Houdon mask which I have followed, together with the portraits of Peale and Stewart [*sic*]."[3]

This little wax portrait head of Washington is presumably one of Borglum's earliest attempts to formulate his ideas on the memorial's principal head. Borglum subsequently produced a limited edition of heads cast in glass by the Corning Glass Company, Corning, New York, which were based on early small-scale models and in detail and scale are almost identical to the Museum's wax.[4] An example (ca. 1930) is in the collection of the South Dakota Art Museum, Brookings.

The edges of the Metropolitan's model are blunted, and the surface of the wax has yellowed over time.

DJH

1. For a history of the memorial, see Rex Alan Smith, *The Carving of Mount Rushmore* (New York: Abbeville Press, 1985).

2. Gutzon Borglum, "Carving the Real Washington," *New York Herald Tribune,* June 30, 1929, sec. 7, p. 15.

3. Gilbert C. Fite, *Mount Rushmore* (Norman: University of Oklahoma Press, 1952), p. 107. Borglum's article "Carving the Real Washington" (note 2) was illustrated with an engraving of the well-known portrait of Washington by Rembrandt Peale and with the "Athenaeum" portrait by Gilbert Stuart.

4. Information sent by Francine Marcel, South Dakota Art Museum, to Thayer Tolles, January 6, 1998, object files, MMA Department of American Paintings and Sculpture.

Charles Oscar Haag (1867–1933)

Karl Oskar Haag (who later anglicized his name) began modeling in clay at an early age while working as a potter's apprentice in his native city of Norrköping, Sweden. At age seventeen he enrolled in what is today the School of Industrial Arts in Göteborg, where he studied with C. Junghänel, a Swedish sculptor. After spending six months in Stockholm, where he witnessed labor unrest and experienced great poverty, Haag lived and worked in Germany, Switzerland, and France. In the mid-1890s he established a studio in Paris and designed decorative objects, such as jewelry, silverware, and clock cases, including pieces for the firm of René Lalique. During that period Haag studied with Jean-Antoine Injalbert. He was also influenced by the work of Auguste Rodin and the Belgian sculptor Constantin Meunier that he saw in Paris.

In autumn 1903 Haag came to the United States to complete several portrait commissions he had received in France from American visitors. Deciding to stay on, he established studios first in New Jersey, and then in the artists' colony of Silvermine, Connecticut. Haag continued to produce clocks and other decorative work to generate income, while modeling a series of genre statuettes that reveal his sympathy for proletariat labor. His sculptural productions from the early years of the twentieth century demonstrate a concern for the worker's lot and the burden of class struggle. Many of these groups, such as *The Immigrants* (ca. 1905; American Swedish Historical Foundation and Museum, Philadelphia) or *Labor Union* (ca. 1905; Augustana College Art Gallery, Rock Island, Ill.), have a monumental quality and reflect radical beliefs that belie their small scale. They were well received at an exhibition of Haag's work at the New Gallery in New York in early 1906, and *Accord* (cat. no. 224) entered the Metropolitan Museum's collection late that year.

After 1909 Haag divided his time between Silvermine and Winnetka, Illinois. His interest in social causes led to a commission for a statue commemorating nineteenth-century reformer Henry Demarest Lloyd. The result, *Corner Stone of the Castle,* was a seated figure of a dejected worker; this bronze was erected on the Lloyd estate in Winnetka in 1914. Bolstered by further Lloyd family commissions, Haag entered a new period of creativity, turning to nature for inspiration. The ensuing group of approximately fifty carvings of different types of wood, titled *Spirits of the Forest* (1915–17; Augustana College Art Gallery), is considered by many to be his best work. Although Haag is relatively unknown today, largely because of lack of patronage and major commissions, he was one of the earliest and most opinionated members of this country's progressive art movement.

Augustana College, Rock Island, Illinois, is the repository of the largest collection of Haag's work.

DJH

SELECTED BIBLIOGRAPHY

Haag, Charles Oscar, Papers. Swenson Swedish Immigration Research Center, Augustana College, Rock Island, Ill.

Spargo, John. "Charles Haag—Sculptor of Toil—Kindred Spirit to Millet and Meunier." *The Craftsman* 10 (July 1906), pp. 433–42.

Eastman, Crystal. "Charles Haag: An Immigrant Sculptor of His Kind." *The Chautauquan* 48 (October 1907), pp. 249–62.

Colley, Edna Ida. "An Exhibition of Wood Carvings and Bronzes." *Fine Arts Journal* 34 (April 1916), pp. 181–87.

von Ende, Amelia. "Charles Haag." *American-Scandinavian Review* 6 (January-February 1918), pp. 28–35.

Lundbergh, Holger. "Charles Haag." *American-Scandinavian Review* 34 (September 1946), pp. 220–26.

O'Brien, Elvy Setterqvist. "Charles Haag: A Sculptor of Toil and Nature." In Mary Em Kirn and Sherry Case Maurer, *Härute— Out Here: Swedish Immigrant Artists in Midwest America,* pp. 47–55. Exh. cat. Rock Island, Ill.: Augustana College Art Department, 1984.

Dabakis, Melissa. *Visualizing Labor in American Sculpture: Monuments, Manliness, and the Work Ethic, 1880–1935,* pp. 161–71. Cambridge and New York: Cambridge University Press, 1999.

224. *Accord,* ca. 1905

Bronze, 1906
12¾ x 5 x 10 in. (32.4 x 12.7 x 25.4 cm)
Signed (right side of base): COPYRIGHT BY CHAS. HAAG
Foundry mark (back of base): AUBRY BROS. FOUNDER. NY. 1906
Gift of several gentlemen, 1906 (06.1227)

IN CREATING genre sculpture, Haag drew on his experiences in both the Old World and the New. The idea behind *Accord,* for example, came from his own roots, as he explained in a newspaper interview: "Here is another theme I take from my life and put in bronze. . . . It is typical of my country and the toilers where I am born.

It is a man and a woman, two peasants of Sweden, who pull together the old-fashioned plow of wood. . . . I call it 'Accord,' because so I think the sexes come nearest together in the peasant class, in their daily work at the plow, in the field."[1]

Haag modeled *Accord* about 1905, possibly earlier.[2] It was included in an exhibition of his work focusing on labor themes in January–February 1906 at the New Gallery in New York. John Spargo, an early admirer of Haag's sculpture and the author of one of the first articles about the artist,[3] was instrumental in bringing *Accord* to the Metropolitan Museum. The Museum's cast was in Spargo's possession when he wrote in September of that year to introduce Haag's work and offer this piece.[4] It is the only known example in bronze. DJH

EXHIBITION

Sheldon Swope Art Gallery, Terre Haute, Ind., January 1948–February 1956.

1. "Peasant Sculptor from Sweden Seeks Field for His Art in America," *New York Times,* July 1, 1906, magazine sec., p. 6. I thank Sherry Maurer, Augustana College Art Gallery, for bringing this article to my attention.
2. The date given for *Accord* in *Catalogue of Sculpture, 1741–1907* (New York: MMA, 1908), p. 24, is "[1904]." There is no documentation to substantiate this date rather than ca. 1905.
3. Spargo, like Haag an immigrant and a social activist, was the author of a book condemning child labor, *The Bitter Cry of Children* (1906). See O'Brien 1984, p. 50.
4. Spargo to Sir C. Purdon Clarke, Director, MMA, September 14, 1906, MMA Archives. See also Dabakis 1999, p. 165.

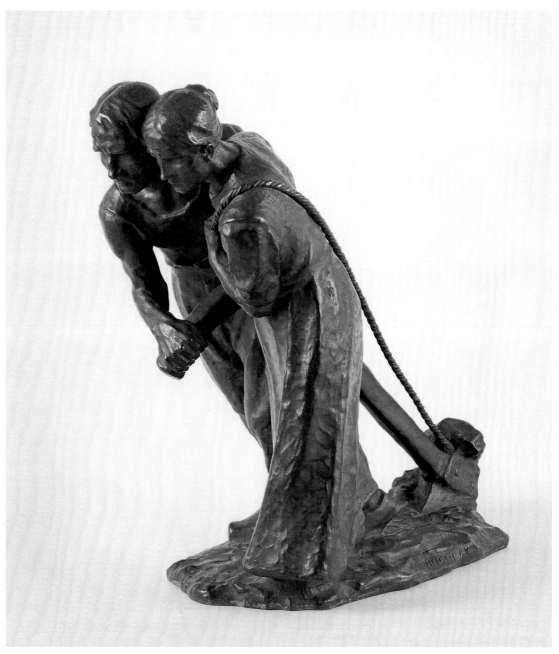

224

Robert Tait McKenzie (1867–1938)

McKenzie, who was born in Almonte, Ontario, graduated from McGill University in Montreal with a B.A. in 1889, and an M.D. in 1892. He began experimenting with three-dimensional studies of the athletic form about 1900, while medical director of physical training and demonstrator of anatomy at McGill. He modeled his first major composition, *The Sprinter* (Fitzwilliam Museum, Cambridge, England), in 1902, deriving the physical proportions of the figure by averaging the measurements of a number of champion runners. Before joining the faculty at the University of Pennsylvania, Philadelphia, he spent the summer of 1904 abroad, studying sculpture first in London and then in Paris, where he frequently socialized with a group of artists that included Paul Wayland Bartlett (pp. 454–63) and Andrew O'Connor (pp. 583–85).

From 1904 until 1929, McKenzie was professor and director of the physical education department at the University of Pennsylvania while continuing as a practicing physician, a scholar, a pioneer in sports medicine and plastic surgery, as well as an artist. His sculpted works consist of about two hundred statues and statuettes, bas-reliefs, and medals, which were drawn directly from life. Early efforts, such as *The Competitor* (cat. no. 225), were precise athletic studies inspired by the artist's fascination with the human body in motion—boxing, diving, sprinting, or juggling. McKenzie's large bas-relief of three hurdlers, *The Joy of Effort,* was created for the 1912 Olympic Games in Stockholm; it was subsequently reduced for distribution as a medal, an art form in which he excelled. McKenzie later turned to monumental portraiture, completing several statues, among them *The Youthful Franklin* (1914), *Reverend George Whitfield* (1919), and *Dr. Edgar Fahs Smith* (1926), all at the University of Pennsylvania. The artist also executed several World War I memorials, including *The Victor* (1924; Broad Street, Woodbury, N.J.), and ones in Great Britain, in Edinburgh and Cambridge.

McKenzie, who exhibited his sculpture at prominent venues throughout his career, gained recognition for his expert knowledge of the athletic condition of the human body from members of both the science and the art communities. Not only was the physician-sculptor a widely published author and speaker, but he was also the subject of numerous articles in contemporary periodicals. McKenzie's summer home and studio, which he established in Almonte in 1931, is now a museum dedicated to his life and work. The Lloyd P. Jones Gallery, Gimbel Gymnasium, at the University of Pennsylvania, houses the J. William White Collection of McKenzie's sculpture. DJH

SELECTED BIBLIOGRAPHY

McKenzie, Robert Tait, Collection. University Archives and Records Center, University of Pennsylvania, Philadelphia.

Morris, Harrison S. "R. Tait McKenzie, Sculptor and Anatomist." *International Studio* 41 (July 1910), pp. XI–XIV.

Adler, Waldo. "McKenzie, a Molder of Clay—and of Men." *Outing* 65 (February 1915), pp. 586–96.

Eberlein, Harold Donaldson. "R. Tait McKenzie,—Physician and Sculptor." *Century Magazine* 97 (December 1918), pp. 249–57.

Hussey, Christopher. *Tait McKenzie: A Sculptor of Youth.* London: Country Life, 1929.

McKenzie, R. Tait. "The Athlete in Sculpture." *Art and Archaeology* 33 (May–June 1932), pp. 115–25.

Kozar, Andrew J. *R. Tait McKenzie: The Sculptor of Athletes.* Knoxville: University of Tennessee Press, 1975. 2nd ed., *The Sport Sculpture of R. Tait McKenzie.* Champaign, Ill.: Human Kinetics Books, 1992.

McGill, Jean. *The Joy of Effort: A Biography of R. Tait McKenzie.* Bewdley, Ontario: Clay Publishing Co., 1980.

225. *The Competitor*, 1906

Bronze, ca. 1907–8
21 x 9 x 16 in. (53.3 x 22.9 x 40.6 cm)
Signed and dated (front of base): '06 / R·Tait McKenzie
Inscribed (right side of base): Copyright by / R. Tait McKenzie / 1906
Foundry mark and cast number (back of base): N° 5. / Roman Bronze Works N.Y.
Rogers Fund, 1909 (09.56.1)

McKENZIE FOUND sculpture the most suitable medium for portraying the athlete in motion. Whether he depicted a figure as a lithe runner crouched on his right leg before a race, lacing his shoe, as in this *Competitor,* or as one of a group of football players on the offensive, as in *The Onslaught* (1911; Yale University Art Gallery, New Haven), a sense of arrested or potential movement is always present in his work.[1]

Modeled in 1906, *The Competitor* is one of McKenzie's best-known, and most austere, portrayals of an athlete. It was exhibited first at the winter exhibition of the National Academy of Design in 1906–7,[2] and then during 1907 in

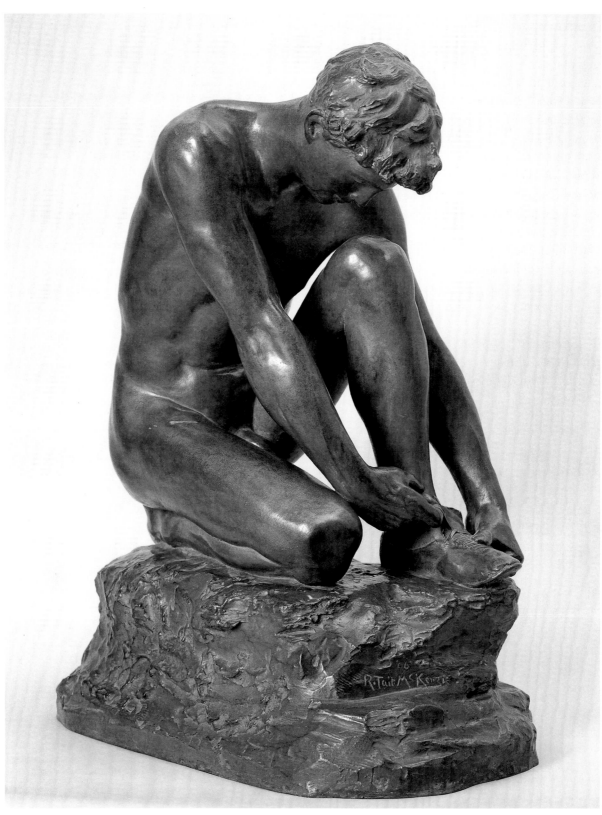

225

Philadelphia at the Pennsylvania Academy, in Paris at the Salon, and in London at the Royal Academy of Arts.[3] Daniel Chester French (pp. 326–41), chairman of the Metropolitan Museum trustees' Committee on Sculpture, initiated discussions with McKenzie in January 1908 about the possible acquisition of his work.[4] In March 1909, the Museum's Committee on Purchases acquired *The Competitor* and *Supple Juggler* (1906) for the permanent collection.[5]

At least nineteen casts of *The Competitor* were sold. One was purchased in 1923 by the Intercollegiate Conference Athletic Association (Big Ten) for use as a trophy to be awarded to "the first institution winning the outdoor track and field meet three times"; the University of Michigan won it in 1927.[6] Roman Bronze Works records indicate that McKenzie favored this foundry for the production of *The Competitor*. Between 1907 and 1918, eleven casts are recorded; presumably the Metropolitan's bronze is one of the six listed in ledger books for 1907–8.[7] Among other known casts are those at the National Gallery of Canada, Ottawa; Oregon State University, Corvallis; Reading Public Museum, Reading, Pennsylvania; University of Iowa Museum of Art, Iowa City; University of Pennsylvania, Philadelphia; and Yale University Art Gallery, New Haven.

DJH

EXHIBITIONS

Sheldon Swope Art Gallery, Terre Haute, Ind., January 1948–February 1956.

Flint Institute of Arts, Flint, Mich., "American Sculpture 1900–1965," April 1–25, 1965, no. 45, as "Track Athlete."

Memorial Art Gallery of the University of Rochester, N.Y., April 1987–July 1997.

1. For an illustration of *The Onslaught,* see Paula B. Freedman, *A Checklist of American Sculpture at Yale University* (New Haven: Yale University Art Gallery, 1992), p. 101. This particular cast is dated ca. 1920.

2. *National Academy of Design Winter Exhibition 1906* (New York, 1906), p. 58, no. 358. The medium was not specified in the catalogue. The show ran from December 22, 1906, to January 19, 1907.

3. *Pennsylvania Academy of the Fine Arts . . . Catalogue of the 102nd Annual Exhibition,* 2nd ed. (Philadelphia, 1907), p. 56, no. 611; *Explication des ouvrages de peinture, sculpture . . . ,* Société des Artistes Français, Salon de 1907 (Paris, 1907), p. 283, no. 3098 (bronze); and *The Exhibition of the Royal Academy of Arts,* MDCCCVII (London, 1907), p. 60, no. 1731, as "Statuette—bronze."

4. Kozar 1992, p. 45. Letters from French to McKenzie concerning the potential acquisition are in the McKenzie Collection, University Archives and Records Center, University of Pennsylvania.

5. Robert W. de Forest, Secretary, MMA, to McKenzie, March 19, 1909, MMA Archives.
 Supple Juggler was deaccessioned in 1956; a cast belonging to the University of Pennsylvania is illustrated in Kozar 1992, p. 45.

6. Kozar 1992, p. 46.

7. Roman Bronze Works Archives, Amon Carter Museum, Fort Worth, ledger 2, p. 144; ledger 3, p. 250; and ledger 4, p. 155.

Edmond Thomas Quinn (1867–1929)

A Philadelphia native, Quinn began training as a painter with Thomas Eakins and James P. Kelly in 1885–86 at the Pennsylvania Academy of the Fine Arts. He later took classes with Eakins at the Art Students League of Philadelphia. In 1893, after traveling in Spain, Quinn went to Paris, where he decided to specialize in sculpture and sought instruction from Jean-Antoine Injalbert.

On his return to the United States, Quinn established a studio in Philadelphia and later in New York. He modeled a kneeling *Magdalene* (unlocated) in 1900 and earned his first major commission in 1902 for a marble statue of William Howard (1905; Scottish Rite building, Williamsport, Pa.). After completing several smaller projects—mainly relief sculptures and painted portraits—Quinn was engaged to model *Persian Philosophy* (1907–9), one of thirty cornice figures on the Brooklyn Institute of Arts and Sciences (now Brooklyn Museum of Art), and a statue of Civil War general John C. Pemberton (1917; National Military Park, Vicksburg, Miss.). The *Edwin Booth Memorial,* Quinn's most recognized work (1918; Gramercy Park, New York), won a competition sponsored by the Players Club in 1914 for the best portrait of the actor as Hamlet. In 1921 Quinn designed a female figure of Victory for the First World War memorial in New Rochelle, New York.

Throughout his career Quinn executed lively portrait busts, often of well-known sitters, including a heroic-size *Edgar Allan Poe* (1909; Poe Park, Bronx, N.Y.) and *Eugene O'Neill* (ca. 1922; Newark Museum, Newark, N.J.). Quinn's monument to composer and conductor Victor Herbert—an overlifesize bust on a granite shaft—was dedicated in the Central Park Mall in 1927. For the Hall of Fame for Great Americans on the former campus of New York University (now Bronx Community College), Quinn contributed several busts, among them *James Kent* (1926) and *Oliver Wendell Holmes* (1929). At the time of his suicide in 1929, Quinn had completed a full-length model of the American statesman Henry Clay, which was enlarged for casting and erected in Caracas, Venezuela, in 1930. The Century Association, New York, organized a memorial exhibition of Quinn's work in 1933.

DJH

SELECTED BIBLIOGRAPHY

Quinn, Edmond Thomas, to Frank Edwin Elwell, Curator, Department of Ancient and Modern Statuary, MMA, October 7, 1904, Elwell Autograph Letters for American Sculptors, MMA Thomas J. Watson Library.

Sterner, Albert. "Edmond T. Quinn: Sculptor." *International Studio* 55 (1915), pp. X–XIII.

Obituary. *New York Times,* September 13, 1929, pp. 1, 16.

Sterner, Albert. "Edmond T. Quinn." *Players Bulletin,* November 1929, pp. 19–21.

Dictionary of American Biography, s.v. "Quinn, Edmond T."

226. *Nymph,* 1912

Bronze
16¼ x 6½ x 4¾ in. (41.3 x 16.5 x 12.1 cm)
Signed and dated (top of base, back): QVINN• / 1912
Inscribed (back of base): Copyright 1912 by E•T• QVINN
Foundry mark (right side of base): Cast by Griffoul Newark, N J
Amelia B. Lazarus Fund, 1913 (13.86)

In addition to modeling portrait busts and statues, Quinn also created ideal female figures, such as *Eve* (unlocated) and this charming statuette of a woodland maiden arranging a vine in her hair. In classical Greek mythology, nymphs were youthful female spirits, usually benevolent, who inhabited forests, streams, grottoes, and pools. *Nymph* was among the six works that won Quinn a silver medal at the Panama-Pacific International Exposition of 1915 in San Francisco.[1]

This bronze, or another cast of *Nymph,* was shown at the National Academy of Design in the winter exhibition of 1912–13.[2] Soon after the close of the show, Metropolitan Museum trustee Daniel Chester French (pp. 326–41) requested that Quinn submit the work for consideration, and it was approved for acquisition by the trustees' Committee on Purchases.[3] Another bronze, also dated 1912 and also cast by Griffoul, was on the New York art market in 1977.[4]

DJH

1. *Official Catalogue of the Department of Fine Arts, Panama-Pacific International Exposition* (San Francisco: Wahlgreen Co., 1915), p. 242, no. 3192. The figure was enlarged, probably in plaster, and exhibited out-of-doors (no. 4507). See also *Sculpture and Mural Paintings: Panama-Pacific International Exposition at San Francisco 1915* (San Francisco: Robert A. Reid, 1915), n.p., where the garden figure

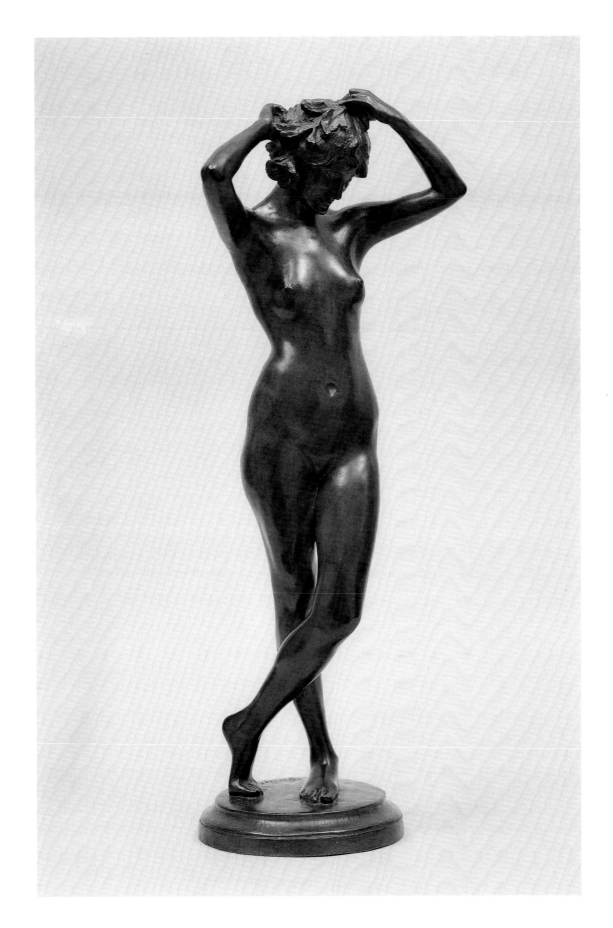

is illustrated and attributed incorrectly to "Edmond T. Irwin."

2. *Illustrated Catalogue, National Academy of Design Winter Exhibition 1912* (New York, 1912), p. 10, no. 16.
3. French to Quinn, April 15, 1913 (copy), Daniel Chester French Family Papers, Manuscript Division, Library of Congress, Wash-ington, D.C., microfilm reel 2, frame 262; and recommended purchase form, signed by Henry W. Kent, Secretary, MMA, April 21, 1913, MMA Archives.
4. Christie's, New York, sale cat., November 22–23, 1977, no. 207, as "A Bronze Figure."

Solon Hannibal Borglum (1868–1922)

Borglum was born into a Mormon family in Ogden, Utah. Working in his late teens on a ranch in Nebraska, he took up sketching his surroundings, especially the animals. With the encouragement of his older brother Gutzon (pp. 496–500), who had seen his drawings, Solon left ranching in 1893 and worked as a painter in California. In 1895 he enrolled at the Art Academy of Cincinnati, attending classes for two years. There Louis T. Rebisso, the modeling instructor, recognized his talent and arranged for him to go abroad in 1897 to continue his sculptural training.

In Paris Borglum attended classes taught by Denys Puech at the Académie Julian. He also sketched in the Jardin des Plantes and there met American animal sculptor Alexander Phimister Proctor (pp. 412–20). He later sought instruction from French animalier Emmanuel Frémiet. Borglum's work was consistently accepted at the annual Salons while he was in Paris, including in 1898 the statuette *Lassoing Wild Horses* (1898; Gilcrease Museum, Tulsa, Okla.), an image of the vanishing American frontier, and in 1899 the large plaster *Stampede of Wild Horses,* which was accorded an honorable mention.

Borglum spent the summer of 1899 in South Dakota on a Sioux reservation, where he began modeling *On the Border of the White Man's Land* (cat. no. 227). That fall, back in Paris where he came to be known as "the sculptor of the prairie," he displayed that work and two other equine compositions at the Exposition Universelle of 1900 and received a silver medal. Borglum's works from this period blend a Rodinesque aesthetic with western subject matter that sympathetically explored the relationship between man and animal, or animals battling the forces of nature, as in *The Blizzard* (ca. 1900; Newark Museum, Newark, N.J.).

Borglum returned to the United States in 1901. He displayed twelve pieces that year at the Pan-American Exposition in Buffalo, earning him a silver medal, and in 1903 he had his first solo exhibition at the Keppel Gallery in New York. He created four monumental groups of western subjects for the 1904 Louisiana Purchase Exposition in Saint Louis and also exhibited nine small bronzes; his work was awarded a gold medal. In 1906 Borglum established a residence and studio in Norwalk, Connecticut, where other artists would also settle in the artists' colony of Silvermine. His equestrian statues of Captain William O'Neill, one of Theodore Roosevelt's Rough Riders (Courthouse Plaza, Prescott, Ariz.), and General John B. Gordon (State House grounds, Atlanta, Ga.) were dedicated in 1907. For the 1915 Panama-Pacific International Exposition in San Francisco, Borglum prepared another equestrian, *The Pioneer.*

After World War I, during which Borglum set up YMCA canteens on the French front and was subsequently awarded the Croix de Guerre, he founded the School of American Sculpture in New York and increasingly focused his energies on teaching. A fountain figure, *Little Lady of the Dew,* and representations of two Native Americans, *Aspiration* and *Inspiration,* for Saint Mark's-in-the-Bouwerie in New York, were among his last works (the latter two were unveiled posthumously in 1922). Only a few months before his sudden death following an appendectomy, Borglum completed an illustrated treatise, *Sound Construction: A Comparative Analysis of Natural Forms and Their Relation to the Human Figure,* based on his teaching; the book was published the following year. In 1924 a memorial exhibition of Borglum's work was held under the auspices of the National Sculpture Society at the Union League Club of New York.

DJH

SELECTED BIBLIOGRAPHY

Borglum, Solon H., Papers. Manuscript Division, Library of Congress, Washington, D.C.

Borglum, Solon H., and Borglum Family Papers. Archives of American Art, Smithsonian Institution, Washington, D.C., microfilm reels N69–98, 1054.

Allen, Harriet Collins, Papers Relating to Solon Borglum. Archives of American Art, Smithsonian Institution, Washington, D.C., unmicrofilmed.

Goodrich, Arthur. "The Frontier in Sculpture." *World's Work* 3 (March 1902), pp. 1857–74.

Sewall, Frank. "A Sculptor of the Prairie: Solon H. Borglum." *Century Magazine* 68 (June 1904), pp. 247–51.

Eberle, Louise. "In Recognition of an American Sculptor." *Scribner's Magazine* 72 (September 1922), pp. 379–84.

Broder, Patricia Janis. *Bronzes of the American West,* pp. 70–81, 393, 406. New York: Harry N. Abrams, 1974.

Davies, A. Mervyn. *Solon H. Borglum: "A Man Who Stands Alone."* Chester, Conn.: Pequot Press, 1974.

227. *On the Border of the White Man's Land*, 1899

Bronze, 1906–7
18½ x 27½ x 10¼ in. (47 x 69.9 x 26 cm)
Signed and dated (top of base, by horse's left rear hoof):
Copyright 1906 by / Solon Borglum
Inscribed (left side of base): On The Border of
The White Mans Land
Foundry mark (right side of base): ROMAN BRONZE
WORKS N_Y_
Rogers Fund, 1907 (07.104)

BORGLUM WAS one of the first American sculptors to portray life on the western prairie based on his own experiences. In July 1899, established as an artist, he and his French bride spent three months among the Sioux on the Crow Creek reservation in South Dakota. There he heard the story of Black Eagle, a scout for General Custer in the early 1870s, who was sent to report on the unvanquished Indians west of the Missouri River. Black Eagle encountered one of them and had to kill him, taking as his prize a black eagle feather tied to the enemy's horse and so earning the name by which he became known.[1]

In an early plaster sketch, titled *The Scout*,[2] the sculptor depicted Black Eagle lying flat at the edge of a rocky cliff, shielded by his horse, watching for the foe. Borglum revised and developed this work after returning to Paris in late 1899, and it evolved into *On the Border of the White Man's Land*. The scout, now holding himself up with his left arm, hides behind his horse, parting its mane for a clear, yet camouflaged, view. The horse's tail is decorated with a black eagle feather. The finished composition, with its duality of perspective—all the details of the drama are visible on one side; on the other, only the form of the horse shows—must be viewed in the round to be fully appreciated.

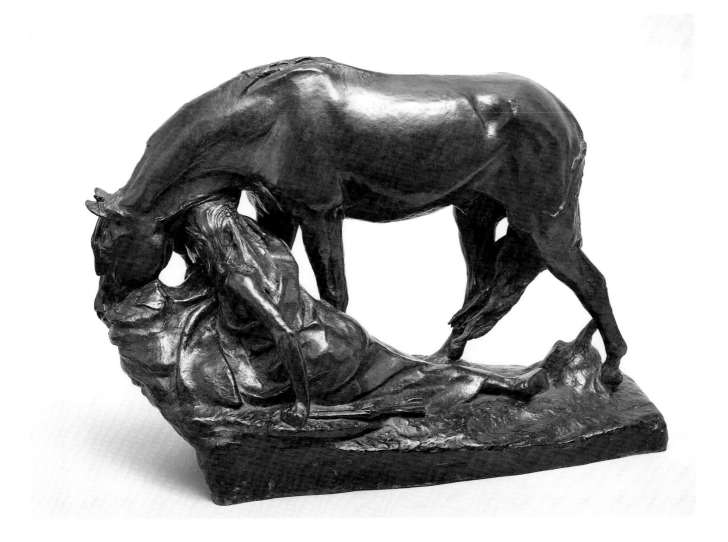

In 1900 Augustus Saint-Gaudens (pp. 243–325), Frederick William MacMonnies (pp. 428–42), and Paul Wayland Bartlett (pp. 454–63), members of the United States sculpture committee for the Exposition Universelle, visited Borglum's Paris studio seeking additional examples of his work for the American sculpture display. On seeing the plaster of *On the Border of the White Man's Land,* then in progress, they asked Borglum to include it among his submissions. Borglum felt he could not complete the work in time for the opening, but Saint-Gaudens promised him that it would be placed in the exhibition as soon as it was finished.[3] The sculpture came in over a month late, and Borglum was awarded a silver medal for the works he exhibited.[4]

On the Border of the White Man's Land was shown in the United States in a number of exhibitions, including the 1901 Pan-American Exposition, Buffalo, where Borglum won another silver medal, and the Pennsylvania Academy of the Fine Arts in 1903.[5] In 1907 the Metropolitan Museum trustees' Committee on Sculpture recommended the purchase of the bronze. This statuette, copyrighted in 1906, and a cast of *Bulls Fighting* (cat. no. 228) are listed together in the Roman Bronze Works ledgers on April 16, 1907, suggesting that the groups were cast about then.[6] Another bronze, cast by the Gorham foundry, is at Brookgreen Gardens, Murrells Inlet, South Carolina.[7] DJH

EXHIBITIONS

Sheldon Swope Art Gallery, Terre Haute, Ind., January–July 1948.
South Dakota Memorial Art Center, Brookings, "The Art of South Dakota," September 15–October 27, 1974, no. 21.
Elvehjem Art Center, University of Wisconsin, Madison, December 1975–December 1976.

1. "Remarkable Success of an Omaha Sculptor," unidentified newspaper clipping, probably from Omaha, ca. October 1899, Borglum Papers, Library of Congress.
 I am grateful to Gwynneth Kelley, of the Solon Borglum Sculpture Project, Wilton, Conn., for providing information on the sculptor and his bronzes in the Metropolitan's collection.
2. For an illustration of *The Scout,* see W. G. Bowdoin, "S. Borglum and His Work," *Art Interchange* 46 (January 1901), p. 3.
3. Davies 1974, pp. 77–78.
4. For a list of the works Borglum exhibited, see *Exposition universelle de 1900: Catalogue officiel illustré de l'exposition décennale des beaux-arts de 1889 à 1900* (Paris: Imprimeries Lemercier; Ludovic Baschet, 1900), p. 297, nos. 10, "Cheval boiteux"; 11, "Cheval et poulain au vent"; and 12, "Cheval et Indien"(*On the Border of the White Man's Land*).
5. *Pan-American Exposition: Catalogue of the Exhibition of Fine Arts* (Buffalo: David Gray, 1901), p. 153, no. 1541; and *Pennsylvania Academy of the Fine Arts . . . Catalogue of the Seventy-second Annual Exhibition,* 2nd ed. (Philadelphia, 1903), p. 83, no. 1106.
6. Roman Bronze Works Archives, Amon Carter Museum, Fort Worth, ledger 3, p. 64.
7. For an illustration and further information, see Beatrice Gilman Proske, *Brookgreen Gardens Sculpture,* rev. ed. (Brookgreen Gardens, S.C.: Brookgreen Gardens, 1968), pp. 78–79.

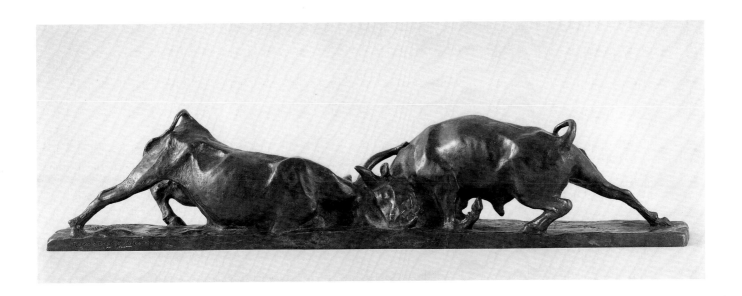

228. *Bulls Fighting*, 1899–1900

Bronze, 1906–7
4¼ x 20½ x 2⅜ in. (10.8 x 52.1 x 6 cm)
Signed: (top of base, right) Solon H Borglum; (top of base, left) Copyright 1906 by / Solon H. Borglum
Foundry mark (front of base): Roman Bronze Works N.Y.
Rogers Fund, 1907 (07.105)

BORGLUM BEGAN modeling *Bulls Fighting* on a Sioux reservation in South Dakota during summer 1899[1] and probably finished it in Paris the following year. The animals—one leaner with longer horns; the other larger and stouter—are depicted at the moment of impact, their perfectly counterbalanced forms graphically underlining the effect of their struggle.

Bulls Fighting was exhibited at the Pan-American Exposition, Buffalo, in 1901, at the National Sculpture Society exhibition in 1902, and at the Pennsylvania Academy of the Fine Arts annual in 1903.[2] The Metropolitan Museum's bronze was cast at Roman Bronze Works some six to eight years after Borglum completed his model. It has a green-brown patina, and it was acquired from Borglum at the same time as *On the Border of the White Man's Land* (cat. no. 227). Another cast of *Bulls Fighting,* with a slightly different signature and made at the American Art Foundry, is at Brookgreen Gardens, Murrells Inlet, South Carolina.[3]

DJH

EXHIBITIONS

Halloran General Hospital, Staten Island, N.Y., July 1947–February 1948.
Queens Museum, New York, "The Artist's Menagerie: Five Millennia of Animals in Art," June 29–August 25, 1974, no. 120.
Arnot Art Museum, Elmira, N.Y., "The Bronze Animalier," October 5–December 30, 1985.

1. Davies 1974, p. 76.
2. *Pan-American Exposition: Catalogue of the Exhibition of Fine Arts* (Buffalo: David Gray, 1901), p. 153, no. 1537, as "Bull Fight"; *National Arts Club . . . Fourth Exhibition of the National Sculpture Society* (New York, 1902), no. 30, as "Bull Fight"; *Pennsylvania Academy of the Fine Arts . . . Catalogue of the Seventy-second Annual Exhibition,* 2nd ed. (Philadelphia, 1903), p. 85, no. 1129, as "Bull-fight."
3. For further information, see Beatrice Gilman Proske, *Brookgreen Gardens Sculpture,* rev. ed. (Brookgreen Gardens, S.C.: Brookgreen Gardens, 1968), p. 79.

Furio Piccirilli (1868–1949)

Piccirilli, son of a marble cutter, was born in Massa, Italy, in the heart of Tuscany. He, like his older brother Attilio (pp. 482–85), studied at the Accademia di San Luca in Rome, where he remained for about five years. In April 1887 Furio went to London, finding work there carving the stone reredos for Saint Paul's Cathedral; he also prepared architectural decorations for a house in Glasgow, Scotland. The following year, Furio, Attilio, and, separately, their brother Ferruccio arrived in the United States in search of better economic opportunity and were soon joined by their parents, three brothers, and sister.

Furio and Ferruccio worked at making architectural decorations at the Perth Amboy Terra Cotta Company in New Jersey for two years. They left to join the family's newly established Piccirilli Brothers Studio, which would become renowned for carving such monumental works as Daniel Chester French's *Abraham Lincoln* (1911–22; Lincoln Memorial, Washington, D.C.) and Frederick William MacMonnies's *Civic Virtue* (1922; Borough Hall, Queens, N.Y.). Each of the six Piccirilli brothers specialized in a particular aspect of carving. Furio excelled in bas-relief work and was also responsible for selecting at American and Italian quarries the stone that the family then carved at its East 142nd Street studio in the Bronx.

Furio Piccirilli was a proficient sculptor of both human and animal forms, as titles of selected submissions to major expositions and annual exhibitions attest: *Mother and Child, Eurydice, Female Torso, Duckling Catching Flies,* and *Ostrich.* His marble relief portrait of his sister was accorded an honorable mention at the 1901 Pan-American Exposition in Buffalo, and he received silver medals at the 1904 Louisiana Purchase Exposition in Saint Louis and the 1915 Panama-Pacific International Exposition in San Francisco. Among Piccirilli's most ambitious figural groups were representations of Spring, Summer, Autumn, and Winter for the Court of the Four Seasons at the San Francisco fair.

The Piccirilli brothers worked on decorations for the facade (1914–15) of the California State Building (now San Diego Museum of Man) for the 1916 Panama California Exposition: Furio and Attilio completed portrait busts and statues of individuals significant to San Diego's early history, while Orazio and Masaniello took on ornamental work. In 1920, Furio alone executed the entire sculptural program for the Parliament Building, Winnipeg, Manitoba, the provincial capital, including a statue of Pierre Gaultier de Varennes de La Vérendrye, explorer of the Great Plains and western Canada.

After several long visits to Italy, Furio Piccirilli returned permanently in 1926 to his native country, settling in Rome. He continued to exhibit his sculptures in the United States and in 1936 was elected to full membership at the National Academy of Design, presenting a bronze penguin as his diploma piece. Piccirilli continued to work as a sculptor almost to the end of his life. DJH

SELECTED BIBLIOGRAPHY

Adams, Adeline. "A Family of Sculptors." *American Magazine of Art* 12 (July 1921), pp. 223–30.

Willson, Dixie. "Six Brothers with but a Single Goal." *American Magazine* 109 (February 1930), pp. 70, 73.

Lombardo, Josef Vincent. *Attilio Piccirilli: Life of an American Sculptor,* pp. 39–42, 279–82. New York and Chicago: Pitman Publishing Corp., 1944.

Proske, Beatrice Gilman. *Brookgreen Gardens Sculpture,* pp. 99–101. Rev. ed. Brookgreen Gardens, S.C.: Brookgreen Gardens, 1968.

Shelley, Mary, and Bill Carroll. "The Piccirilli Studio." *Bronx County Historical Society Journal* 36 (Spring 1999), pp. 1–12.

229. *Seal,* 1927

Marble
45 x 24 x 22 in. (114.3 x 61 x 55.9 cm)
Signed and dated (on rock, front): *Furio_Piccirilli / _fecit_1927*
Rogers Fund, 1929 (29.103)

Of the numbers of animals Piccirilli carved, none surpasses the sculptural quality of his *Seal.* The sea creature, characteristically portrayed balancing on top of a sloping rock, appears to have just emerged from the water, an impression vividly evoked by the glossy, highly polished finish of the black marble. Unlike the few marble sculptors of his time who carved their own works in stone directly to scale, Piccirilli modeled his subject first in clay and then enlarged it himself to its present size in the permanent medium.

Seal was exhibited in 1929 at the National Academy

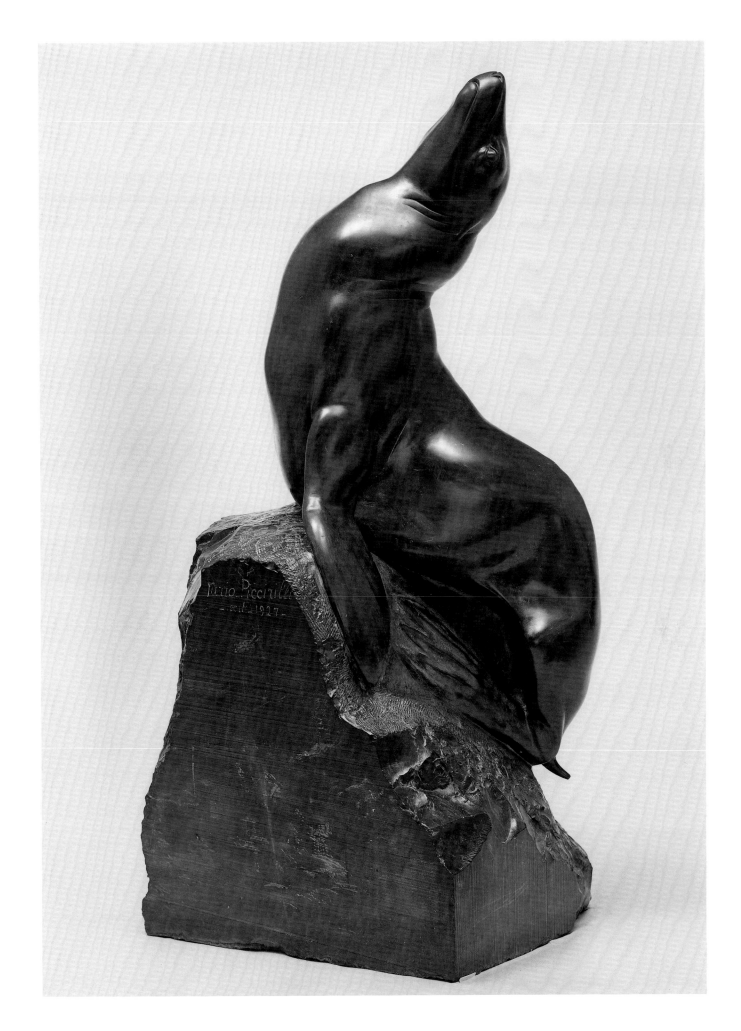

of Design annual, where it won the Ellin P. Speyer Memorial Prize "for a Painting or piece of Sculpture portraying an act of humaneness towards animals, or a Painting or piece of Sculpture of Animals."[1] Daniel Chester French (pp. 326–41), chairman of the Metropolitan Museum trustees' Committee on Sculpture, saw the work at the academy and recommended its purchase.[2] When *Seal* entered the Museum's collection, Preston Remington, Associate Curator of Decorative Arts, wrote: "It is as gratifying as it is rare to discover a work of sculpture in which subject and material are ideally suited to each other. . . . The sculptor . . . executed [*Seal*] at life size in Belgian black marble. The result is both pleasantly naturalistic and extremely effective."[3]

A version of *Seal,* also in black marble (42 in. high), was installed at Brookgreen Gardens, Murrells Inlet, South Carolina, in 1937.[4] A third marble, 37 inches high, is now at Marist College, Poughkeepsie, New York; it was formerly placed in a fountain.[5] DJH

EXHIBITION

MMA, Junior Museum, "Circus Parade," April 6, 1946–September 16, 1948.

1. *Catalogue, National Academy of Design One Hundred and Fourth Annual Exhibition* (New York, 1929), pp. 11, 20, no. 198.
2. French to Henry W. Kent, Secretary, MMA, April 9, 1929, MMA Archives.
3. P[reston] R[emington], "Accessions and Notes: A Seal by Furio Piccirilli," *MMA Bulletin* 24 (September 1929), p. 244.
4. See Proske 1968, p. 100 (ill.).
5. Douglass Kwart to Thayer Tolles, August 16, 1994; and Donise English, Marist College, to Tolles, November 28, 1994, object files, MMA Department of American Paintings and Sculpture.

Frances Grimes (1869–1963)

Born in Braceville, Ohio, Grimes spent her childhood in Decatur, Illinois, where her parents were practicing physicians. In 1892 she enrolled in a two-year art program at the Pratt Institute, Brooklyn; Herbert Adams (pp. 360–64) was her instructor. She apprenticed with Adams in his studios in New York and Cornish, New Hampshire, from 1894 to 1900, developing a special talent for carving in marble. In 1901 she was hired by Cornish resident Augustus Saint-Gaudens (pp. 243–325) and became a valued assistant. She was involved in all aspects of Saint-Gaudens's studio operation, but in particular she carved and finished marbles and modeled portrait reliefs under his direction.

In Cornish, as an active member of the region's flourishing art colony, Grimes also executed independent portraits of her talented friends and their families, among them a bas-relief of pianist and composer Arthur Whiting (1907; Music Division, New York Public Library for the Performing Arts) seated at a clavichord. After Saint-Gaudens's death in 1907, Grimes remained in his Cornish studio to complete the eight caryatids (1906–8) he had designed for the facade of the Albright (now Albright-Knox) Art Gallery, Buffalo, New York. She put the finishing touches on three of his marble bas-reliefs, which were carved by the Piccirilli Brothers Studio for the Metropolitan Museum: *The Children of Preston Hall Butler, Homer Saint-Gaudens,* and *The Children of Jacob H. Schiff* (cat. nos. 116, 119, 122).

Grimes traveled in Europe for six months before establishing her own studio in New York in 1909. She made a specialty of portrait busts and reliefs, often of children, executed in a soft, neo-Renaissance style reminiscent of the work of her mentors. Her marble bust of Bishop Henry Potter was unveiled in Grace Church, New York, in 1911. In 1915 she completed *Sleepy Hollow,* a large tinted plaster bas-relief for the overmantel in the entrance hall of Washington Irving High School, New York, presented through the Municipal Art Society.

Through the 1910s Grimes steadily built her reputation, particularly for small-scale portraits. In 1915 she won a silver medal for her work at the Panama-Pacific International Exposition in San Francisco. The National Association of Women Painters and Sculptors accorded her the McMillin

Prize in 1916 and in 1920 their National Association Medal for Sculpture. In spring 1919 Grimes and Laura Gardin Fraser held a joint exhibition of sculpture and medallions at the Arden Gallery in New York.

Grimes completed two busts for the Hall of Fame for Great Americans, New York University (now Bronx Community College): *Charlotte Cushman* (1925) and *Emma Willard* (1929), projects that complemented her interest in the woman suffrage movement. Along with steady portrait work, Grimes also designed garden sculpture, such as the playful *Boy and Duck* (1912; Toledo Museum of Art, Toledo, Ohio) and the lyrical panels *Girls Singing* (cat. no. 230). The bronze *Girl by Pool* (1913; Toledo Museum of Art) was enlarged and carved in marble (1936) for Brookgreen Gardens, Murrells Inlet, South Carolina.

In 1931 Grimes was named an associate academician and in 1945 an academician of the National Academy of Design. Though her sculptural output declined in the 1930s, she continued to produce portrait busts, reliefs, and medallions in her delicate, clear style until the late 1950s, when she retired.

Until the age of ninety Grimes lived in the Cornish area for part of each year. A memorial exhibition of her sculpture was held in July–August 1964 at the Saint-Gaudens Museum (now the Saint-Gaudens National Historic Site), Cornish, where she had long served as a trustee.

DJH

SELECTED BIBLIOGRAPHY

Grimes, Frances, "Reminiscences" (typescript), as well as clippings and correspondence by and about Grimes. Augustus Saint-Gaudens Papers, Dartmouth College Library, Hanover, N.H.

Fuller, Lucia Fairchild. "Frances Grimes: A Sculptor in Whose Works One Reads Delicacy and Intelligence." *Arts and Decoration* 14 (November 1920), pp. 34, 74.

A Circle of Friends: Art Colonies of Cornish and Dublin, esp. pp. 60–72, 88–90. Exh. cat. Durham: University Art Galleries, University of New Hampshire; Keene, N.H.: Keene State College, Thorne-Sagendorph Art Gallery, 1985.

Rubinstein, Charlotte Streifer. *American Women Sculptors: A History of Women Working in Three Dimensions,* pp. 125–26. Boston: G. K. Hall, 1990.

Colby, Virginia Reed, and James B. Atkinson. *Footprints of the Past: Images of Cornish, New Hampshire, and the Cornish Colony,* pp. 220–23. Concord: New Hampshire Historical Society, 1996.

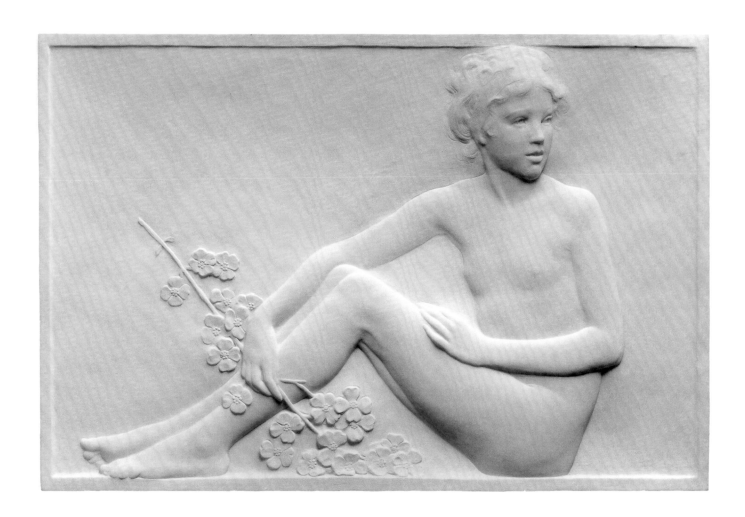

230. *Girls Singing*, 1916

Marble, 1916–17
Two panels, each 30¾ x 45 in. (78.1 x 114.3 cm)
Gift of Joseph Parsons, 1944 (44.44.1, 2)

GRIMES COMPLETED the plaster models for this pair of panels in 1916 in her New York studio. Classicizing in spirit, the two adolescent female nudes are shown seated, each looking over her shoulder nearest the viewer. One holds a dogwood branch, and the other, a sanxian, a Chinese long-neck lute.[1] When the panels are installed, according to Grimes, "the girls should be back to back so they are looking at each other."[2] The figures are framed by narrow projecting borders, but when the panels are displayed as Grimes recommended, the girls maintain a playful eye contact. *Girls Singing* was carved in marble in 1916–17 under Grimes's supervision by the firm of Amadeo Merli and Alexandro Nicolai, located in Macdougal Alley, Greenwich Village, close by her Washington Mews studio.[3]

Joseph Parsons, of New York and Lakeville, Connecticut, commissioned the panels and funded their translation into marble.[4] At the time of this commission, Parsons had been a patron of Grimes for nearly ten years; her earlier works for him included portrait medallions. Parsons planned to display the panels on either side of a fountain on the grounds of his Lakeville home.[5]

In January 1918 Metropolitan Museum trustee Daniel Chester French (pp. 326–41) wrote Grimes asking her to lend *Girls Singing* to the Museum's long-term "Exhibition of American Sculpture." She agreed, noting the request as "one of the pleasantest things that ever happened to me," and informing French that the pair was then on view at the Allies of Sculpture exhibition at the Ritz-Carlton Hotel.[6] The panels remained on loan to the Museum for twenty-six years before Parsons donated them in 1944.[7]

According to the artist, bronze reductions of *Girls Singing* were made by the Medallic Art Company.[8]

DJH

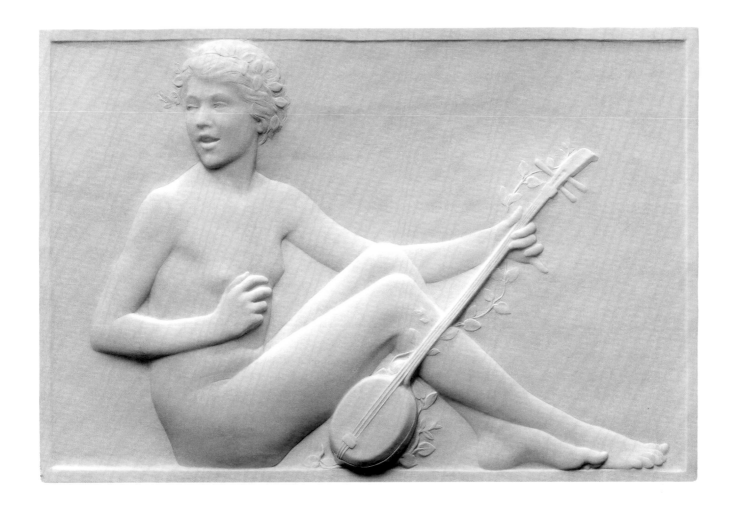

1. J. Kenneth Moore, Associate Curator, MMA Department of Musical Instruments, memo to Thayer Tolles, September 25, 1997, object files, MMA Department of American Paintings and Sculpture. Previous Museum records erroneously called the instrument Grecian in origin.

 Lisa Wizenberg assisted with research on Grimes.

2. Grimes's instructions for displaying the panels are in the copyright permission form she completed, April 26, 1944, MMA Archives. She also gave an alternate title for the pair: *Spring, North and South*.

3. According to information supplied by Grimes, the reliefs date to 1916–17 and the marble was cut by Merli and Nicolai under her supervision; copyright and information form, April 26, 1944, as in note 2. "Merli" and "Nicolai" appear in the *Trow General Directory of New York City Embracing the Boroughs of Manhattan and the Bronx, 1917* (New York: R. L. Polk and Co., 1917), p. 1382, as the marble-cutting firm of A. Merli & A. Nicolai (Amadeo Merli, Alex Nicolai), sculptors, 23 Macdougal Alley.

4. Frances Grimes, letter addressed "To the Curator of the Loan Exhibition of American Sculpture," October 3, 1929, MMA Archives.

5. Parsons to Mr. Boyles, October 17, [n.d.], MMA Archives.

6. French to Grimes, January 7, 1918, Saint-Gaudens Papers, Dartmouth College Library; and Grimes to French, January 8, 1918, Daniel Chester French Family Papers, Manuscript Division, Library of Congress, Washington, D.C., microfilm reel 4, frame 376.

7. *An Exhibition of American Sculpture* (New York: MMA, 1918), p. 10, nos. 34, 35. According to Parsons, "it seemed to me more important to leave them [at the Museum] where more people would see them"; Parsons to Mr. Boyles, as in note 5.

8. Copyright permission form completed by Grimes, April 26, 1944, as in note 2.

Charles Albert Lopez (1869–1906)

Born in Matamoros, Mexico, of Cuban ancestry, Lopez was brought as a child to the United States, reportedly to New Orleans. In the mid-1880s, he was working in New York with John M. Moffit, a British-born sculptor who specialized in tombstones, memorials, and religious figures. Presumably after Moffit's return to England, Lopez entered the studio of John Quincy Adams Ward (pp. 136–54) as a pupil and assistant. He was also enrolled in antique classes at the National Academy of Design between 1890 and 1892. During this time, Lopez created several large statues for Chicago's World's Columbian Exposition held in 1893, including a representation of Agriculture, and figures of Caesar Augustus and Minerva that were erected at the entrance of the Fine Arts Building. Having earned enough money to continue his artistic training in Paris, Lopez enrolled in the atelier of Jean-Alexandre-Joseph Falguière at the École des Beaux-Arts in October 1893. Two years later, at the Paris Salon, he exhibited a plaster bust of an old woman, titled *La Vieillesse,* which was favorably reviewed and later cast in bronze (unlocated).

When Lopez returned to New York in 1895 and established his own studio, he began to receive a number of public commissions, including a group, *East Indies,* for the temporary triumphal arch to Admiral Dewey (1899) and a marble statue of Mohammed (1900) for the Appellate Division of the Supreme Court in New York. (That work met with objections from the Muslim community, whose religion forbids the making of graven images, and in 1955, when the building was restored, the statue was removed.) In 1902 Lopez's design for a monument to President William McKinley (1908; City Hall, Philadelphia), assassinated in September 1901, was chosen over thirty-seven other entries submitted, and he made trips to Paris to work on that commission.

Lopez participated in the sculptural decoration of several large American expositions. For the Pan-American Exposition of 1901 in Buffalo, he prepared colossal groups of the Arts and Sciences for the Grand Court of the Fountains. In 1904, he won a gold medal at the Louisiana Purchase Exposition in Saint Louis, to which he contributed a quadriga for the Liberal Arts Building and six smaller works, including *The Sprinter* (see cat. no. 231). That same year he was nominated to the Society of American Artists and, in 1906, was named an associate of the National Academy of Design when the two institutions merged. By this time Lopez was heralded as "one of the most skilful of the younger men" (Taft 1903, p. 447), but he died suddenly in May 1906 at age thirty-six, after finishing the working models for his *McKinley Memorial* (detail model, *Seated Minerva and Youth,* Newark Museum, Newark, N.J.). The monument was completed by Isidore Konti (pp. 408–11). In November 1906, the National Sculpture Society held a memorial exhibition of Lopez's work. DJH

SELECTED BIBLIOGRAPHY

Lopez, Charles A., to Frank Edwin Elwell, Department of Sculpture, MMA, July 8, 1902. Elwell Autograph Letters for American Sculptors, MMA Thomas J. Watson Library.

"Charles Albert Lopez, Sculptor." *Catholic World* 74 (January 1902), p. 492 (biographical note to Charles Albert Lopez, "Sculpture in Its Relation to Church Decoration," pp. 493–505).

Taft, Lorado. *The History of American Sculpture,* p. 447. New York: Macmillan, 1903.

Memorial Exhibition of the Works of the Late Charles Albert Lopez. Exh. cat. New York: National Sculpture Society, 1906.

de K[ay], C[harles]. "Sculptures by Lopez: His Last Work, Shown with Others by the Sculpture Society, Foreshadows His Unexpected Death." *New York Times,* November 18, 1906, sec. 4, p. 4.

231. *The Sprinter,* 1902

Bronze, 1907
17¼ x 9¾ x 24 in. (43.8 x 24.8 x 61 cm)
Signed and dated (right side of base): CHARLES ALBERT LOPEZ SC. 1902
Foundry mark (front of base): ROMAN BRONZE WORKS N.Y.
Cast number (underside of base): No 5.
Rogers Fund, 1907 (07.117)

ALTHOUGH LOPEZ is best known for his monumental work, he also excelled at small groups and portraits, which were frequently displayed at the turn of the twentieth century. *The Sprinter,* an academic study of a track runner, is the only athletic figure he executed. Lopez entered the work in several exhibitions, including that of the Society of American Artists, New York, in 1902, and at the Louisiana Purchase Exposition in Saint Louis in 1904.[1]

Lopez's figure is posed in a starting position, his muscles taut and his face a mask of absolute concentration. Charles de Kay, in his review of the memorial exhibition of Lopez's work, described the figure as "braced like a drawn bow, perfectly at rest, yet tense against the signal to launch himself over the track."[2] This piece is identical in subject to a work executed the same year by R. Tait McKenzie (pp. 503–5), *The Sprinter* (Fitzwilliam Museum, Cambridge, England),[3] which suggests that the recently developed crouching start for a running race presented sculptors with a novel pose for the male figure. The United States Navy chose a cast of Lopez's *Sprinter* to serve as a championship trophy in track athletics for the Atlantic, Pacific, and Asiatic fleets (Department of the Navy, Pentagon, Washington, D.C.).[4]

The Sprinter was approved for purchase by the Metropolitan Museum in March 1907. Lopez's widow, Mary, wrote in her note of appreciation to the Museum that "the casts now in preparation will be ready within the next two weeks."[5] The Museum's bronze (cast no. 5) and cast number 6 are recorded in the Roman Bronze Works foundry ledgers on April 17, 1907; at least seven casts were produced there.[6] DJH

EXHIBITIONS

Army Air Forces Convalescent Center and Station Hospital, Pawling, N.Y., April 1944–February 1945.
Bronx Museum of the Arts, New York, "Games!!! ¡Juegos!" February 1–March 6, 1972, no. 88.

1. *Twenty-fourth Annual Exhibition of the Society of American Artists* (New York, 1902), p. 57, no. 303; and *Official Catalogue of Exhibitors: Universal Exposition, St. Louis, U.S.A., 1904, . . . Department B, Art,* rev. ed. (Saint Louis: Official Catalogue Co., 1904), p. 60, no. 2173. Kate Walsh assisted with research on Lopez.
2. De Kay 1906.
3. For illustrations of McKenzie's *Sprinter,* see Andrew J. Kozar, *The Sport Sculpture of R. Tait McKenzie,* 2nd ed. (Champaign, Ill.: Human Kinetics Books, 1992), color pl. 7.
4. Gustav Kobbe, "Artistic Trophies for U.S. Navy," *New York Herald,* November 28, 1915, sec. 3, p. 12. Evelyn B. Longman's *Victory* (cat. no. 262) was also used as a Navy trophy.
5. Mary T. Lopez to the trustees' Committee on Purchases, MMA, March 15, 1907, MMA Archives.
6. Roman Bronze Works Archives, Amon Carter Museum, Fort Worth, ledger 3, p. 83. Cast no. 7 of *The Sprinter* is listed on May 4, 1910, with a further notation on May 18, 1915, that it was sold to Gorham.

Samuel Aloysius Murray (1869–1941)

Murray, son of an immigrant Irish stonemason, began his artistic training in 1886 with Thomas Eakins at the newly formed Art Students' League in his native Philadelphia. Under Eakins's tutelage, he first studied painting, but opted to pursue sculpture since he had a decided aptitude for modeling. In 1891 Murray became an instructor in life modeling at the Philadelphia School of Design for Women (now Moore College of Art and Design), where he remained, also as a lecturer in anatomy, until a week before his death in 1941. From 1892 to 1900, Murray shared Eakins's Chestnut Street studio, and they often painted, sculpted, and photographed the same people—family members, friends and acquaintances, including Walt Whitman, and members of the clergy. In 1894 Murray's plaster bust of Eakins's father, Benjamin (Hirshhorn Museum and Sculpture Garden, Washington, D.C.), was awarded a gold medal at the Art Club of Philadelphia's sixth annual exhibition.

In 1895 Murray received his first important commission: ten biblical prophets in terracotta for the Witherspoon Building in Philadelphia. Murray was assisted by Eakins on the colossal figures, which were installed in 1898 on the building's exterior along with statues by Alexander Stirling Calder (pp. 528–31), another former pupil of Eakins. Also in 1896, the Pennsylvania Academy of the Fine Arts, under the auspices of the Fairmount Park Art Association, sponsored a one-man exhibition of Murray's work. Although he participated in the numerous world's fairs of the turn of the century and garnered medals for his submissions, Murray's reputation as a competent realist sculptor was restricted mainly to the Philadelphia area. Among the best-known of his public monuments are a bronze statue of Commodore John Barry (1907; Independence National Historic Park, Philadelphia); architectural sculpture for the Pennsylvania State Memorial at Gettysburg National Military Park, including a colossal *Winged Victory* (1909–10); and a bronze statue of Admiral George Wallace Melville (1923; League Island Park, relocated in 1967 to the Philadelphia Navy Yard). The only New York exhibition of Murray's work was held in 1931 at the Fifty-sixth Street Galleries, along with paintings by Eakins. DJH

SELECTED BIBLIOGRAPHY

Murray Collection. Sculpture, photographs, and archival material, including six scrapbooks, five of them compiled by the artist. Hirshhorn Museum and Sculpture Garden, Smithsonian Institution, Washington, D.C.

Chamberlin-Hellman, Maria. "Samuel Murray, Thomas Eakins, and the Witherspoon Prophets." *Arts Magazine* 53 (May 1979), pp. 134–39.

Rosenzweig, Phyllis. "Problems and Resources in Thomas Eakins Research: The Hirshhorn Museum's Samuel Murray Collection." *Arts Magazine* 53 (May 1979), pp. 118–20.

Goodrich, Lloyd. *Thomas Eakins,* esp. vol. 2, pp. 99–110. Cambridge, Mass.: Harvard University Press, 1982.

Panhorst, Michael W. "Samuel A. Murray, Sculptor (1869–1941)." M.A. thesis, University of Delaware, 1982.

Panhorst, Michael W. *Samuel Murray: The Hirshhorn Museum and Sculpture Garden Collection, Smithsonian Institution.* Exh. cat. Washington, D.C.: Smithsonian Institution Press, 1982.

232. *Thomas Eakins,* 1907

Bronze, by 1923
9 x 9¼ x 8½ in. (22.9 x 23.5 x 21.6 cm)
Signed and dated (top of base, right): MURRAY / 1907
Inscribed (right side of base): SAMUEL MURRAY /
COPYRIGHT 1907
Foundry mark (left side of base): ROMAN BRONZE WORKS N.Y.
Rogers Fund, 1923 (23.155)

IN 1886, ACCOMPANYING his father at Philadelphia's Woodlands Cemetery, where the elder Murray worked as a stonemason, Samuel Murray met the prominent American painter Thomas Eakins (1844–1916),[1] who was sketching there. Eakins, on hearing the young man express interest in his sketches, encouraged him to visit the newly established Art Students' League of Philadelphia, where Eakins was lecturing on aspects of art.[2] Murray enrolled in the league that November and six years later served there as Eakins's teaching assistant. The two artists formed an enduring friendship based on their respect for each other's art, and from 1892 to 1900, Murray shared Eakins's studio

on Chestnut Street. Murray benefited from the advice his "Dear Master"[3] offered on many of his sculptural projects, even after he set up his own studio in 1900.

Murray assisted Eakins with *The Agnew Clinic* (1889; University of Pennsylvania Collection of Art, Philadelphia),[4] his portrait of the Philadelphia surgeon D. Hayes Agnew, commissioned by Dr. Agnew's students at the University of Pennsylvania School of Medicine to mark the occasion of his retirement. Apparently, Eakins had to paint part of the work sitting cross-legged on the floor because the canvas was too large to fit on an easel.[5] Murray commemorated this image in his incisive study of 1907,[6] in which he showed Eakins, compactly posed, clad in his customary loose-fitting clothes, using a brush to mix the paint on his palette. (Two paintbrushes, originally held in Eakins's left hand, are missing on the Metropolitan's statuette.)[7]

Like many American artists of the late nineteenth century, Eakins and Murray used portraiture to express friendship. In 1889, the year Eakins was at work on *The Agnew Clinic,* he painted Murray's likeness (Mitchell Museum at Cedarhurst, Mount Vernon, Ill.). Before completing his seated *Eakins* of 1907, Murray modeled two portraits of Eakins in 1894: a full-size bust and a statuette of the painter standing, with palette and brushes in hand. This latter work was intended as a companion piece to his full-length statuette of Eakins's wife, Susan Macdowell Eakins, of 1894 (all pieces, Hirshhorn Museum and Sculpture Garden, Washington, D.C.).[8]

A seated *Thomas Eakins* appeared in the National Sculpture Society's exhibition of 1923,[9] where it was seen by Metropolitan Museum trustee Daniel Chester French (pp. 326–41). French wrote Murray asking about its

availability for purchase. At the close of the exhibition, the piece was delivered directly to the Museum from the National Sculpture Society.[10]

Of the other located casts of the seated *Eakins,* six are in plaster and two are in bronze. The plasters are at the Detroit Institute of Arts; Hirshhorn Museum and Sculpture Garden (two examples); Pennsylvania Academy of the Fine Arts, Philadelphia (two examples); and in a Connecticut private collection. The bronzes are at the Hirshhorn Museum and Moore College of Art and Design, Philadelphia. DJH

EXHIBITIONS

MMA, "Three Centuries of American Painting," April 9–October 17, 1965.
Corcoran Gallery of Art, Washington, D.C., "The Sculpture of Thomas Eakins," May 3–June 10, 1969, no. 23.
MMA, "Portrait of the Artist," January 18–March 7, 1972, no. 29.
National Portrait Gallery, Washington, D.C., April 1974–July 1977.
MMA, Henry R. Luce Center for the Study of American Art, "Portraits of American Artists in The Metropolitan Museum of Art," September 29, 1992–February 21, 1993.
MMA, Henry R. Luce Center for the Study of American Art, "Thomas Eakins and The Metropolitan Museum of Art," November 29, 1994–February 26, 1995.

1. For additional information on Eakins, see Goodrich 1982; Kathleen A. Foster and Cheryl Leibold, *Writing About Eakins: The Manuscripts in Charles Bregler's Thomas Eakins Collection* (Philadelphia: University of Pennsylvania Press for the Pennsylvania Academy of the Fine Arts, 1989); and William Innes Homer, *Thomas Eakins: His Life and Art* (New York: Abbeville Press, 1992). For Eakins's limited work in sculpture, see Moussa M. Domit, *The Sculpture of Thomas Eakins,* exh. cat. (Washington, D.C.: Corcoran Gallery of Art, 1969).

2. In February 1886, Eakins resigned as director of the Pennsylvania Academy of the Fine Arts schools in the face of severe complaints about his teaching practices. Many of his students left with him and organized the Philadelphia Art Students' League, where, for approximately six years, Eakins lectured on anatomy and perspective and critiqued student work. For an extended consideration, see Maria Chamberlin-Hellman, *Thomas Eakins as a Teacher,* Ph.D. diss., Columbia University, 1981 (Ann Arbor, Mich.: University Microfilms, 1981).

3. Murray often used this form of address in writing to and about Eakins, and he inscribed it on the base of a statuette of Eakins standing; see Panhorst exh. cat. 1982, p. 6.

4. For an illustration of *The Agnew Clinic,* see Goodrich 1982, vol. 2, p. 40, fig. 159.

5. For this account, see Lloyd Goodrich, *Thomas Eakins: His Life and Work* (New York: Whitney Museum of American Art, 1933), p. 125.

6. In modeling the portrait, Murray also may have referred to a photograph of Eakins in a similar seated position. For an illustration, see Gordon Hendricks, *The Photographs of Thomas Eakins* (New York: Grossman Publishers, 1972), p. 182. A print is in the MMA's collection (acc. no. 61.690.8).

7. Record photography, taken near the time of the piece's acquisition, displays the two paintbrushes; object files, MMA Department of American Paintings and Sculpture.

8. For illustrations of these three works, see Panhorst exh. cat. 1982, nos. 4–6.

9. National Sculpture Society, *Exhibition of American Sculpture Catalogue* (New York, 1923), p. 340.

10. French to Murray, May 31, 1923, Murray Collection; and Agnes Baldwin Brett, National Sculpture Society, to Edward Robinson, Director, MMA, July 24, 1923, MMA Archives, which confirms Murray's instructions to deliver the portrait to the Museum.

George Dupont Pratt (1869–1935)

Pratt, a son of Charles M. Pratt, financier, philanthropist, and founder of the Pratt Institute, was born in Brooklyn, New York. Upon his graduation from Amherst College in 1893, he joined the Long Island Railroad as a shop laborer. Within two years he had advanced to the position of superintendent of the railroad's ferries, which he held from 1895 to 1900. He then went on to serve as treasurer and vice president of the financial firm of Charles Pratt and Company, which managed his father's estate. A noted philanthropist himself, Pratt played a prominent role in the formation in 1910 of the Boy Scouts of America.

Pratt was a great sportsman and lover of the outdoors. In 1915 he was appointed conservation commissioner of the State of New York, a position he held until 1921. Although little is known about his avocation as an amateur sculptor, he may have been inspired in it by his friend and frequent hunting companion Alexander Phimister Proctor (pp. 412–20). Pratt was elected a lay member of the National Sculpture Society in 1914 and in 1930 founded the Society of Medalists.

His devoted patronage of the arts benefited a number of museums, including the American Museum of Natural History, the Mead Art Museum at Amherst College, and the Metropolitan Museum, where Pratt was a trustee from 1922 until his death. In recognition of his many gifts to the Museum, which particularly enhanced the collections of Asian and Egyptian art, textiles, and arms and armor, Pratt was elected a Benefactor in 1925.

DJH

SELECTED BIBLIOGRAPHY

Obituary. *New York Herald Tribune,* January 21, 1935, p. 10.
"George Dupont Pratt." *Museum News* 12 (February 1, 1935), p. 2.
"George Dupont Pratt in Memoriam." *MMA Bulletin* 30 (February 1935), p. 26.
American National Biography, s.v. "Pratt, George Dupont."

233. *Mountain Goat,* 1914

Bronze
7¾ x 7 x 3¾ in. (19.7 x 17.8 x 9.5 cm)
Signed and dated (front of base): © G.D.Pratt / 1914
Foundry mark (front of base): MEDALLIC ART CO., N.Y.
Stamped (right side of base): OLGJ
Gift of George D. Pratt, 1932 (32.137)

AN AVID SPORTSMAN, Pratt went on the first of many hunting trips with his friend the American sculptor Alexander Phimister Proctor in September 1910.[1] He was especially fond of Proctor's animal sculptures and frequently purchased bronze casts not just for himself but as gifts for others:[2] in April 1912 he presented six Proctor sculptures to the Brooklyn Institute of Arts and Sciences (now the Brooklyn Museum of Art). It was probably because of this close association with Proctor that Pratt himself began to model works in clay.

Pratt might have created *Mountain Goat* after a hunting trip like one that he made in October 1908 in the Canadian Rockies, specifically in pursuit of mountain goats and sheep.[3] He poised this rugged goat atop a boulderlike base. The composition, while undoubtedly rendered with enthusiasm and care, betrays his lack of academic training and therefore does not possess the anatomical realism he so admired in Proctor's work.

Pratt exhibited *Mountain Goat* at Grand Central Art Galleries in New York before presenting it to the Metropolitan in 1932.[4] When he sent the piece to the Museum for consideration, he described it as "done by a friend of mine," but soon after he confessed to being "the guilty party who did this sculpture work."[5]

Pratt had other casts of *Mountain Goat* made, for a bronze was on the art market in 1968.[6]

DJH

1. The two men met at Edmonton, Alberta, "for an antelope hunt on the prairies." See Alexander Phimister Proctor, *Sculptor in Buckskin: An Autobiography,* edited and with a foreword by Hester Elizabeth Proctor, introduction by Vivian A. Paladin (Norman: University of Oklahoma Press, 1971), p. 153.

June Herold provided research assistance on Pratt.

2. Proctor 1971, p. 153.

3. See George D. Pratt, "In the Canadian Rockies with a Camera," *Country Life in America* 16 (June 1909), p. 184. The article (pp. 183–88) was illustrated with photographs by Pratt, including one of mountain goats (p. 183), which "required patient stalking."

4. Photograph permission form completed by Pratt, November 29, 1932, MMA Archives.

5. Pratt to Herbert E. Winlock, Director, MMA, October 21, 1932, MMA Archives; and Pratt to Joseph Breck, Assistant Director, MMA, October 25, 1932, MMA Archives. Pratt may have hesitated to reveal his identity because at the time he was serving as treasurer of the Museum.

6. Advertisement for Julian Gallery, London, *Connoisseur* 167 (February 1968), p. 45.

Janet Scudder (1869–1940)

Born in Terre Haute, Indiana, Janet (baptized Netta) Scudder had her first drawing classes at the Rose Polytechnic Institute. She left home in 1887 and enrolled at the Art Academy of Cincinnati, eventually studying with the Italian-born sculptor Louis T. Rebisso, who encouraged her efforts in sculpture. In late 1890 she relocated to Chicago, hoping to earn a living by producing architectural ornament, but she was banned from the carvers' union because she was female. Undaunted, Scudder sought employment and further schooling with Lorado Taft, a French-trained sculptor who taught at the Art Institute of Chicago. He hired her as a studio assistant to point up models by other sculptors for the 1893 World's Columbian Exposition; independently she produced a figure of Justice for the Illinois State Building and the *Nymph of Wabash* for Indiana's display. Of the fair's many sculptures, Scudder was most impressed by Frederick William MacMonnies's (pp. 428–42) lavish *Columbian Fountain,* and she traveled to Paris with Taft's sister Zulime in 1894, hoping to study with MacMonnies. She spent a year in his studio, ultimately as an assistant in projects such as his *Shakespeare* (1895–96) for the Library of Congress, Washington, D.C. She also took drawing classes at the Académie Colarossi.

Scudder returned to New York in 1896 and was thwarted in her attempts to work in the studios of Augustus Saint-Gaudens (pp. 243–325) and Daniel Chester French (pp. 326–41). After completing a commissioned seal for the New York Bar Association, she focused on portrait medallions, architectural ornamentation, and funerary urns. She went back to Paris in 1898, again attending life drawing classes at the Académie Colarossi, and in 1899–1900 she traveled to Italy. For the 1900 Exposition Universelle Scudder contributed a decorative figure representing Music. At this time she discovered her métier in bronze garden fountains of lighthearted, whimsical children, such as *Frog Fountain* (cat. no. 234), *Tortoise Fountain* (1908; Brookgreen Gardens, Murrells Inlet, S.C.), and *Young Diana* (1910; Cleveland Museum of Art), which earned an honorable mention at the Salon of 1911. At least thirty fountain commissions from wealthy Americans, among them John D. Rockefeller and Henry Huntington, and the Beaux Arts architect Stanford White ensured her professional success and elevated the respectability of decorative garden sculpture. Scudder also enjoyed the distinction of being the first American woman sculptor to have her work purchased by the Musée du Luxembourg in Paris. Although she expressed contemptuous opinions about public statuary, she completed in 1908 a figure representing Japanese Art for the Brooklyn Institute of Arts and Sciences (now the Brooklyn Museum of Art). Scudder had her first solo show in 1913 at Theodore B. Starr in New York and later, in 1918, a large exhibition at Gorham Galleries. Ten of Scudder's works were exhibited in the 1915 Panama-Pacific International Exposition in San Francisco and were awarded a silver medal. In 1920 she was named an associate member of the National Academy of Design. She traveled often between New York and France, and for some years after 1913, Ville-d'Avray, near Paris, was her primary residence.

Scudder was active in World War I relief efforts, working as a Red Cross volunteer and lending her Ville-d'Avray home to the YMCA; in 1925 she was named a Chevalier of the French Legion of Honor. Scudder was also an outspoken member of the art committee of the National American Woman Suffrage Association. In addition to her sculptural interests, later in life the artist pursued painting, color theory, and briefly architecture. In 1925 Scudder published her autobiography, *Modeling My Life.* TT

SELECTED BIBLIOGRAPHY

Scudder, Janet. "The Art Student in Paris." *Metropolitan Magazine* 5 (April 1897), pp. 239–44.

Mechlin, Leila. "Janet Scudder—Sculptor." *International Studio* 39 (February 1910), pp. LXXXI–LXXXVIII.

"Janet Scudder Tells Why So Few Women Are Sculptors." *New York Times,* February 18, 1912, sec.5, p. 13.

Scudder, Janet. *Modeling My Life.* New York: Harcourt, Brace and Co., 1925.

Warlick, Mary E. "Janet Scudder: The Beaux-Arts Tradition in American Garden Sculpture." M.A. thesis, State University of New York, Binghamton, 1976.

Conner, Janis, and Joel Rosenkranz. *Rediscoveries in American Sculpture: Studio Works, 1893–1939,* pp. 151–60. Austin: University of Texas Press, 1989.

234. *Frog Fountain*, 1901

Bronze, 1906
37½ x 26 x 19 in. (95.3 x 66 x 48.3 cm)
Signed (left side of base): JANET SCUDDER.
Foundry mark (back of base): E. GRUET JNE. FONDEUR PARIS.
Rogers Fund, 1906 (06.967)

THE FIRST in a series of ornamental garden sculptures produced by Scudder, *Frog Fountain* depicts a spirited boy looking down on three open-mouthed frogs. In her autobiography, the sculptor recalled the fountain's origin: "In that moment a finished work flashed before me. I saw a little boy dancing, laughing, chuckling all to himself while a spray of water dashed over him. The idea of my Frog Fountain was born."[1] For her "water babies," Scudder acknowledged the importance of Italian Renaissance sculpture—particularly Donatello's Cantoria (1433–39; Museo dell'Opera del Duomo, Florence) and Verrocchio's *Boy and Dolphin* (ca. 1465; Palazzo Vecchio, Florence)— which she studied during a trip to Italy in the winter of 1899–1900. Curiously, Scudder never discussed the more direct influence of her mentor Frederick William MacMonnies and fountains such as his ebullient *Boy and Duck* (1895–96; cat. no. 197).

Scudder modeled *Frog Fountain* in Paris in 1901 and brought it to New York hoping to attract commissions from wealthy Americans constructing lavish homes and gardens. After considerable persistence, she prevailed on Stanford White to recommend her garden sculptures to his clients. He purchased a cast of *Frog Fountain* for his Saint James, Long Island, estate, initiating a productive working relationship between architect and sculptor that lasted until White's death in 1906.

Scudder initially chose to limit *Frog Fountain* to an edition of four but produced a fifth example at the Metropolitan Museum's request. Two of the bronzes were placed on the grounds of private residences in Stonington, Connecticut, and Bar Harbor, Maine.[2] In 1905 a marble version with cattails was commissioned by White for the former James L. Breese estate in Southampton, New York. It is now unlocated, and the original plaster was destroyed.[3] Numerous bronze reductions, intended as either parlor or fountain pieces,[4] were cast in heights of 6, 12¼, and 28½ inches.

Frog Fountain entered the Metropolitan's collection in 1906 as the largest of a group of American bronzes that were purchased and then exhibited together in September.[5] Scudder had significantly reduced the price of the cast for the Museum, and trustee Daniel Chester French wrote to acknowledge her generosity: "We appreciate that this is still an absurdly low price for it, but we hope that it may be worth something to you to have the statue in the Museum, in any event, we are gratified to you for aiding us in our endeavor to start a collection of small bronzes."[6]

Eight of Scudder's small portrait medallions were also acquired through purchase and gift of the artist.[7]

TT

EXHIBITIONS

National Museum of Women in the Arts, Washington, D.C., April 10–June 14, 1987; Minneapolis Institute of Arts, July 5–August 30, 1987; Wadsworth Atheneum, Hartford, September 19–November 15, 1987; San Diego Museum of Art, December 5, 1987–January 31, 1988; Meadows Museum, Southern Methodist University, Dallas, February 20–April 17, 1988, "American Women Artists, 1830–1930," no. 117.
Nassau County Museum of Fine Art, Roslyn Harbor, N.Y., "One Hundred Years: A Centennial Celebration of the National Association of Women Artists," October 16–December 31, 1988.
Jane Voorhees Zimmerli Art Museum, Rutgers University, New Brunswick, N.J., "The Enduring Figure 1890s–1970s: Sixteen Sculptors from the National Association of Women Artists," December 12, 1999–March 12, 2000, no. 42.

1. Scudder 1925, p. 172.
2. A bronze was auctioned at Sotheby's in 1995, but it has not been possible to trace the provenance to its early-twentieth-century origin. See Sotheby's, New York, sale cat., May 25, 1995, no. 211.
3. Unsigned notes of a telephone conversation with Scudder, February 4, 1933, object catalogue cards, MMA Department of American Paintings and Sculpture.
4. *Fauns and Fountains: American Garden Statuary, 1890–1930*, exh. cat. (Southampton, N.Y.: Parrish Art Museum, 1985), n.p.
5. Daniel Chester French to trustees' Executive Committee, May 21, 1906, MMA Archives, recommended the purchase of *Frog Fountain* and nineteen other small bronzes; and Clarence Hoblitzell, "Collection of Bronzes in the Metropolitan Museum," *The Sketch Book* 6 (December 1906), pp. 183, 186.
6. French to Scudder, June 7, 1906 (copy), Daniel Chester French Family Papers, Manuscript Division, Library of Congress, Washington, D.C., microfilm reel 1, frame 470.
7. Office of the Secretary, memo to Robert W. de Forest, Secretary, MMA, December 11, 1908, MMA Archives, notes that on December 10, 1908, Scudder brought "to the Museum the four medals purchased, together with four others which she desires to include with the original four under the amount paid to her."

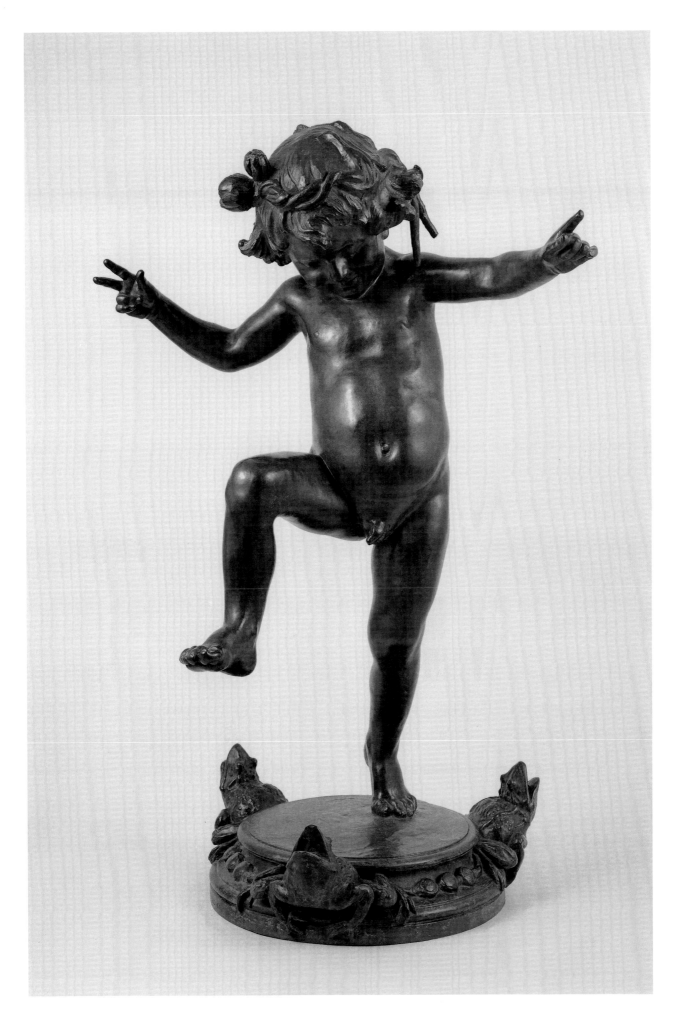

Alexander Stirling Calder (1870–1945)

Calder, a Philadelphia native, entered the Pennsylvania Academy of the Fine Arts in 1885. He attended classes in drawing, modeling, and anatomy, first under Thomas Eakins and later under Thomas Anshutz, and he served as a demonstrator of anatomy at the academy in 1889–90. During this time he was also employed by his father, Scottish immigrant Alexander Milne Calder, who was engaged on an ambitious sculptural program for Philadelphia's City Hall.

In 1890 Stirling Calder traveled to Paris with Charles Grafly (pp. 403–7) to continue his academic art training. After a period of study with Henri Chapu at the Académie Julian, he enrolled at the École des Beaux-Arts in the atelier of Jean-Alexandre-Joseph Falguière, whose influence is especially apparent in Calder's nude figure studies. He exhibited at the annual Paris Salon of the Société des Artistes Français in 1892 with a plaster bust of Cordelia (unlocated).

Returning to Philadelphia in 1892, Calder established a studio of his own. In 1893 he received a gold medal for sculpture at the Philadelphia Art Club, the first of many prestigious awards he would earn over the course of his long career. That year he won his first competition, for a full-length statue of eminent surgeon Samuel D. Gross (1897; National Library of Medicine, Washington, D.C., now located at Thomas Jefferson University, Philadelphia). Calder worked on the commission in Paris during 1895–97 and exhibited the finished bronze at the 1897 Salon. Back in Philadelphia, he executed six colossal figures of prominent Presbyterians (1898–99; now at Presbyterian Historical Society, Philadelphia) for the exterior of the Witherspoon Building, a program for which Samuel Murray (pp. 520–22) also contributed statues.

In Philadelphia, Calder exhibited his work widely and taught modeling at the Pennsylvania Museum School of Industrial Art from 1900 to 1905. During this time he completed *Man Cub* (cat. no. 235) and other studies of children and male nudes, which explored rhythmic line and movement, as well as an intricate sundial for Fairmount Park.

In 1906 Calder, who was tubercular, moved to Arizona to recover his health. When he was able to resume work, he relocated to Pasadena, California, and was joined there by his family. By 1910 he settled in New York and was involved in numerous artists' organizations, maintaining affiliations with more than a dozen over the course of his career. He was elected an academician of the National Academy of Design in 1913, and he taught there (1910–17) as well as at the Art Students League (1918–22).

Calder's appointment as acting chief of the department of sculpture for San Francisco's Panama-Pacific International Exposition in 1915, following the untimely death of Karl Bitter (pp. 489–95), resulted in some of his most important commissions. For the fair, he produced the *Fountain of Energy* and, in collaboration with Leo Lentelli and Frederick George Richard Roth (pp. 551–57), groups of nations of the East and West, which flanked the Court of the Universe. Notable among the commissions that Calder received after the fair are the *Depew Memorial Fountain* (1917; University Park, Indianapolis); *Washington as President,* modeled for the right side of the Washington Arch (1918; Washington Square, New York); and the *Swann Memorial Fountain* (1924; Logan Square, Philadelphia).

Calder remained active as an artist, working primarily in the New York area until the end of his life. In 1932 his *Leif Ericsson Memorial* was erected in Reykjavik, Iceland, and in 1936 his bust of William Penn was unveiled at New York University's Hall of Fame for Great Americans (now on the campus of Bronx Community College). Calder was known for his monumental work with decorative overtones, but unlike many of his colleagues who worked in a lingering Beaux Arts style well into the twentieth century, he adapted his naturalistic manner as his career progressed and successfully combined it with greater emphasis on stylization and simplification of line and form.

DJH

SELECTED BIBLIOGRAPHY

Paulin, L. R. E. "Alex. Stirling Calder: A Young Philadelphia Sculptor." *House and Garden* 3 (June 1903), pp. 317–25.

Hoeber, Arthur. "Calder—A 'Various' Sculptor." *World's Work* 20 (September 1910), pp. 13377–88.

Poore, Henry Rankin. "Stirling Calder, Sculptor." *International Studio* 67 (April 1919), pp. XXXVII–LI.

Bowes, Julian. "The Sculpture of Stirling Calder." *American Magazine of Art* 16 (May 1925), pp. 229–37.

Lockman, DeWitt McClellan. Interview with Alexander Stirling Calder, ca. 1927. Transcript, Manuscripts Department, New-York Historical Society. Microfilmed for DeWitt McClellan Lockman Papers, Archives of American Art, Smithsonian Institution, Washington, D.C., reel 502, frames 445–59.

Parkes, Kineton. "Stirling Calder and the American Sculptural Scene." *Apollo* 15 (March 1932), pp. 109–13.

Calder, Alexander Stirling. *Thoughts of A. Stirling Calder on Art and Life.* Edited by Nanette Calder. New York: Privately printed, 1947.

Hayes, Margaret Calder. *Three Alexander Calders: A Family Memoir.* Introduction by Malcolm Cowley. Middlebury, Vt.: Paul S. Eriksson, 1977.

235. *Man Cub*, 1901–2

Bronze, 1922
45 x 15 x 14 in. (114.3 x 38.1 x 35.6 cm)
Signed (back of orange in boy's hand): *Calder*
Foundry mark (back of base): ROMAN BRONZE WORKS N—Y—
Rogers Fund, 1922 (22.89)

CALDER MODELED this lifesize portrait of his son, Alexander (1898–1976), age four and possessed of a playful spirit so vividly captured in this "pleasantly aggressive" figure.[1] Sandy Calder posed in his father's studio, holding an orange in his right hand.[2] As one early critic noted, the boy "advances toward you, still debates, between doubt and desire, whether or not . . . to toss you the ball."[3] On a more primal level, his potential still rests between beast and man.[4] (The younger Calder would become one of the most influential American sculptors of the twentieth century,[5] best known for his invention of the mobile and the stabile, abstract sculptural forms he began in the early 1930s.)

Man Cub, modeled in 1901–2, was displayed in plaster at the annual exhibition of the Pennsylvania Academy of the Fine Arts, January–March 1902.[6] It was first put into bronze by the Bureau Brothers foundry in Philadelphia between late 1905 and early 1906 and was included at the 1906 exhibition of the Pennsylvania Academy, where it remains in the permanent collection.[7] A plaster was shown in a long-term exhibition of American sculpture opening at the Metropolitan Museum in 1918[8] and remained on loan until January 1922. At that point the Museum's Committee on Purchases requested of Calder that another bronze be cast from it for the permanent collection.[9] Calder removed the plaster, and several months later, in May, Museum trustee Daniel Chester French (pp. 326–41) saw the almost-completed bronze at the Roman Bronze Works. It entered the Museum directly.[10]

The Metropolitan's *Man Cub* has a blue-green patina of extraordinary fragility, the result of the application process to the surface of the bronze to give it a weathered appearance.[11] DJH

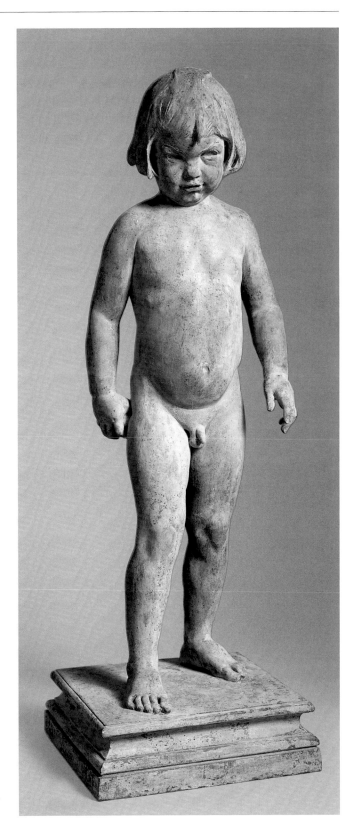

EXHIBITIONS

Old Westbury Gardens, Westbury, N.Y., "150 Years of American Sculpture," June 14–August 28, 1960, no. 7.

1964 Long Island Festival of the Long Island Arts Center, exhibition held at Swirlbul Library, Adelphi University, Garden City, N.Y., "A Century of American Art, 1864–1964," July 7–24, 1964, no. 119.

Whitney Museum of American Art, New York, "200 Years of American Sculpture," March 16–September 26, 1976, no. 31.

MMA, "As They Were: 1900–1929," April 9–September 8, 1996.

1. Leila Mechlin, "The National Sculpture Society's Exhibition at Baltimore: II. Imaginative Work," *International Studio* 35 (August 1908), p. XLVIII.

 Kazimierz Slawski assisted with research on Calder.

2. Alexander Calder, *Calder: An Autobiography with Pictures* (New York: Pantheon Books, 1966), p. 13.

3. Paulin 1903, p. 319.

4. For the *Man Cub* and the issue of potentiality, see Thomas P. Somma, "The Myth of Bohemia and the Savage Other: Paul Wayland Bartlett's *Bear Tamer* and *Indian Ghost Dancer*," *American Art* 6 (Summer 1992), p. 26.

5. For Alexander Calder's career, see Joan M. Marter, *Alexander Calder* (Cambridge and New York: Cambridge University Press, 1991); and Marla Prather et al., *Alexander Calder 1898–1976*, exh. cat. (Washington, D.C.: National Gallery of Art; New Haven: Yale University Press, 1998).

6. *Seventy-first Annual Exhibition, Pennsylvania Academy of the Fine Arts: Catalogue* (Philadelphia, 1902), p. 72, no. 1008a.

7. *Pennsylvania Academy of the Fine Arts . . . Catalogue of the 101st Annual Exhibition,* 2nd ed. (Philadelphia, 1906), p. 72, no. 903, as " 'Man-Cub.' Cast in bronze for the permanent collection of the Academy." See also Susan James-Gadzinski and Mary Mullen Cunningham, *American Sculpture in the Museum of American Art of the Pennsylvania Academy of the Fine Arts* (Philadelphia: Museum of American Art of the Pennsylvania Academy of the Fine Arts, 1997), pp. 171–72.

8. *An Exhibition of American Sculpture* (New York: MMA, 1918), no. 20, as " 'The Man Cub,' Statuette, plaster, colored; h. 45."

9. Henry W. Kent, Secretary, MMA, to Calder, January 18, 1922 (copy), and Calder to Kent, January 20, 1922, MMA Archives.

10. Calder to Edward Robinson, Director, MMA, January 21, [1922], Special Exhibition notebooks, MMA Office of the Registrar; French to Calder, May 11, 1922 (copy), Daniel Chester French Family Papers, Manuscript Division, Library of Congress, Washington, D.C., microfilm reel 6, frame 437; and Calder to Kent, May 15, 1922, MMA Archives.

11. Philip Sciavo, Roman Bronze Works, discussed the probable technique employed in achieving the patina of this sculpture and *Scratching Her Heel* (cat. no. 236) in a telephone conversation with William Hickman, MMA Department of Objects Conservation, in spring 1985, as recorded in notes, October 30, 1987, object files, MMA Department of American Paintings and Sculpture: a mixture of clay and water applied to the bronze surface and stippled with copper sulfate would simulate the blue-green color of natural copper corrosion; in some cases, the surface would then have been spray-varnished and waxed. (*Man Cub* has a matte patina, so possibly was not subjected to that step.) According to Hickman, a binder, such as a water-based glue, would have had to be added to the clay and water mixture.

236. *Scratching Her Heel,* 1921

Bronze

12 x 5 x 5 in. (30.5 x 12.7 x 12.7 cm)

Signed (front of base): *Calder*

Foundry mark (back of base): ROMAN BRONZE WORKS N_Y_

Rogers Fund, 1922 (22.154)

TRAINED IN the academic tradition, Calder excelled as a figurative sculptor and made a number of informal studies of the nude. Influenced by the realistic work of his Parisian master Falguière, Calder's smaller compositions, such as *Stretching Girl* (ca. 1920; National Academy of Design, New York), *Scratching Her Heel,* and *Model Adjusting Her Girdle* (1943; Brookgreen Gardens, Murrells Inlet, S.C.), reveal his interest in recording commonplace motions of day-to-day life in three dimensions. In *Scratching Her Heel,* for example, he presented his subject in a natural, though complicated, pose, bending and twisting to reach her left heel with her left hand. Although Calder sculpted the figure in realistic detail, he rendered the hair in a stylized fashion that reflects the more decorative aspects of his work.

Completed in 1921, the Museum's *Scratching Her Heel* is said to be the first bronze cast made.[1] Calder displayed the composition that year in several New York exhibitions, including one at the Fine Arts Building and another at Wildenstein and Company.[2] The following year, in October, Daniel Chester French recommended that the trustees' Committee on Purchases acquire it for the Museum; however, he suggested that Calder change the title of the work: "I cannot help wishing you would call it something besides 'A Girl Scratching Her Heel', which does not seem a very lady-like employment for a young woman in public."[3] Calder's response is not recorded and French's request went unheeded. The bronze has the same fragile blue-green patina that appears on *Man Cub* (cat. no. 235), which entered the collection several months earlier.[4]

Another example of *Scratching Her Heel* in bronze is in the collection of the Telfair Museum of Art, Savannah, Georgia (acquired 1921). That piece, also cast by Roman Bronze Works, has a green patina and is mounted on a two-tiered integral base nearly identical to the Metropolitan's.[5]

DJH

EXHIBITIONS

Army Air Forces Convalescent Center and Station Hospital, Pawling, N.Y., April 1944–February 1945.

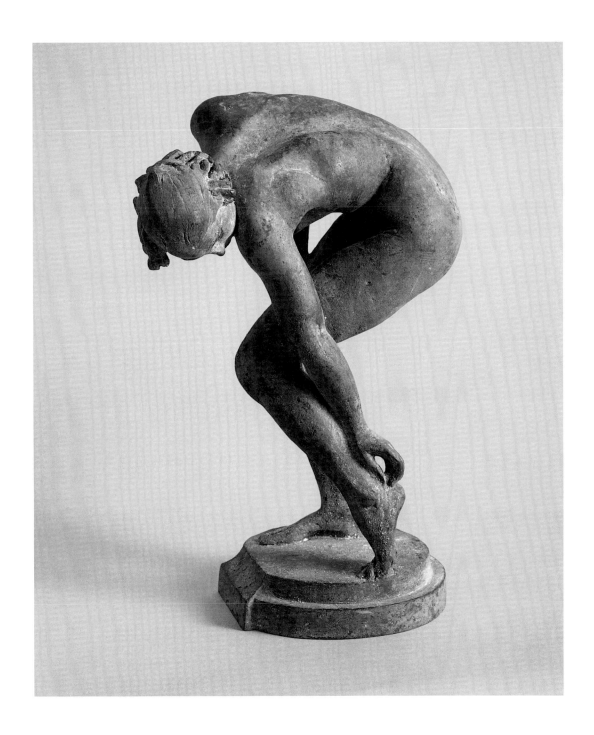

National Collection of Fine Arts, Washington, D.C., "Academy: The Academic Tradition in American Art. An Exhibition Organized on the Occasion of the One Hundred and Fiftieth Anniversary of the National Academy of Design, 1825–1975," June 6– September 1, 1975, no. 135.

1. Notes from a telephone conversation between Calder and P[reston] R[emington], Associate Curator of Decorative Arts, MMA, January 30, 1933, object catalogue cards, MMA Department of American Paintings and Sculpture. Calder did not report the number of casts made in that edition.
2. *First Retrospective Exhibition of American Art . . . Inaugurating the Junior Art Patrons of America* (New York, 1921), no. 286; and *Third Annual Exhibition, New Society of Artists* (New York, 1921), no. 87. It is not possible to determine whether it was the Metropolitan Museum's cast that was displayed at these venues before it entered the collection. However, in the case of the New Society exhibition, the cast now at the Telfair Museum of Art, Savannah, was likely the one included since it was purchased directly from Wildenstein at the time of the exhibition; see Beth Moore, Assistant Curator, Telfair Museum of Art, to Thayer Tolles, July 8, 1997, object files, MMA Department of American Paintings and Sculpture.
3. French to Calder, October 2, 1922 (copy), Daniel Chester French Family Papers, Manuscript Division, Library of Congress, Washington, D.C., microfilm reel 6, frame 668.
4. See *Man Cub* (cat. no. 235), note 11, for further information on the patination process. When the matte patina of *Scratching Her Heel* was tested, it was found to contain substantial amounts of gypsum. Gypsum suggests the presence of plaster, which may have been used as a binder and which would account for the somewhat thick, white-washed effect of the finish. Notes recorded by William Hickman, MMA Department of Objects Conservation, October 30, 1987, object files, MMA Department of American Paintings and Sculpture.
5. Moore to Tolles, as in note 2.

Frank Lynn Jenkins (1870–1927)

Frank Lynn Jenkins, or alternatively Lynn-Jenkins, was born in Torquay, England, and spent his formative years in his native country. Educated at Weston College, he began his artistic training at the Lambeth School of Art under William S. Frith and continued at the Royal Academy of Arts in London between 1893 and 1898. In the mid-1890s, in collaboration with the British painter Gerald Moira, he began work on a series of large, colored relief decorations for building interiors for which Jenkins would model the reliefs and Moira would paint their surfaces. This "painted modeling," executed with Art Nouveau overtones and literary inspirations, earned the pair numerous commissions throughout England. Jenkins was awarded a silver medal for his wall relief for the Peninsular and Oriental Pavilion for the 1900 Exposition Universelle in Paris. Perhaps his most important decorative program is an elaborate frieze completed in 1901 for the upper vestibule at Lloyd's Register of Shipping in London. For the overall design of the program, which illustrates the history of shipping, Jenkins incorporated metal, ivory, and mother-of-pearl. The sculptor, who worked comfortably in both marble and bronze, also modeled a number of portrait busts, such as one of his wife (ca. 1900; Montclair Art Museum, Montclair, N.J.). He executed several allegorical statues, including two religious groups for Saint Matthew's Church in Cockington, South Devon. Jenkins exhibited his work consistently at the Royal Academy of Arts annuals and the Liverpool Autumn Exhibition and was a founding member of the Royal Society of British Sculptors.

Probably spurred by World War I, Jenkins moved to the United States in 1917, establishing his studio in New York. His assimilation into the ranks of American sculptors was swift. In 1918 he showed a group of ideal works and portraits at the Henry Reinhardt and Sons Galleries, and in 1921 he participated in the thirty-sixth annual exhibition of the Architectural League of New York, to which he had been elected the previous year. From December 1921 to January 1922, a selection, including *La Danseuse, Daphne, Enigma, Diana,* and several portrait busts, was exhibited at the Fearon Galleries in New York. *Diana,* characteristic of his delicate figures with stylized curves, was purchased in bronze by the Metropolitan in 1922 (it was deaccessioned in 1956). In 1923 he was elected to full membership of the National Sculpture Society.

Jenkins's major commission of his ten-year American career was a bronze statue of financier Charles Custis Harrison (1925), longtime provost of the University of Pennsylvania, Philadelphia, where the sculpture is installed on the Quadrangle. At the time of Jenkins's death, he was involved in plans for a marble group to be placed in Philadelphia's Fairmount Park and in a competition for a statue, *Pioneer Woman,* to be erected in Ponca City, Oklahoma. The competition excited nationwide interest as bronze models (Woolaroc Museum, Bartlesville, Okla.) by twelve sculptors toured the country; the winner, selected by popular vote, was Bryant Baker, and Jenkins was runner-up.

DJH

SELECTED BIBLIOGRAPHY

Lanchester, H. Vaughan, and F. Lynn Jenkins. "The Application of Colour to Interior Ornament in Relief." *Journal of the Royal Institute of British Architects* 6 (April 15, 1899), pp. 329–42.

Spielmann, M. H. *British Sculpture and Sculptors of To-Day,* pp. 159, 174. London: Cassell and Co., 1901.

Spielmann, M. H. "F. Lynn Jenkins: His Decorative Sculpture, His Methods." *Magazine of Art* 26 (1902), pp. 294–301.

Obituary. *New York World,* September 2, 1927, p. 14.

Broder, Patricia J. "The Pioneer Woman, Image in Bronze." *American Art Review* 2 (September–October 1975), pp. 127–34.

237. *Madonna and Child,* by 1921

Marble, 1921–22
18 x 15 x 6½ in. (45.7 x 38.1 x 16.5 cm)
Signed and dated (left side of base): F. LYNN-JENKINS 1922
Gift of Mortimer L. Schiff, 1926 (26.44)

ALTHOUGH JENKINS executed two marble groups early in his career for Saint Matthew's Church, Cockington, South Devon,[1] *Madonna and Child* is his only other located religious subject. A marble version, almost certainly the Metropolitan Museum's, was exhibited twice in 1921, at the Architectural League of New York[2] and at the Fearon Galleries, where a critic noted that the piece "reveal[ed] the same reverent treatment that distinguishes the work of Italian masters of the Renaissance."[3] Indeed, comparison with works by Florentine quattrocento sculptors, especially the Madonna and Child reliefs of the della Robbia, is plausible in terms of overall composition and spirit of devotion between mother and child. Jenkins's figures are arranged in a pyramidal form with a demure Madonna and animated Christ. They surmount an integral plinth, carved with vertical flutes dividing molded bands.

Mortimer L. Schiff, a philanthropist and a partner in the New York investment firm of Kuhn, Loeb and Company, purchased *Madonna and Child* in 1926 directly from the artist. In his letter to Metropolitan Museum director Edward Robinson in which he offered to donate the marble, Schiff wrote that he considered it "so exceptional in its artistic value that it would seem to me to be well worthy of being placed in the Museum."[4] Schiff's beneficence signaled a second generation of family gifts of American sculpture to the Metropolitan. He and his sister were the subjects of Augustus Saint-Gaudens's relief *The Children of Jacob H. Schiff,* a marble example of which his father gave the Museum (cat. no. 122).

Madonna and Child, most likely unique, is dated 1922; the inscription was presumably added when Jenkins made additional refinements after the piece was exhibited in 1921. DJH

1. For illustrations of these works, titled *Sancta Maria, Virginum Patrona* and *St. Georgius, Puerorum Praeses,* see Spielmann 1902, p. 295.
 Kazuko Ishida assisted with research on Jenkins.
2. Architectural League of New York, *Index of Exhibits, Thirty-sixth Annual Exhibition* (New York, 1921), p. 18, no. 656, as "Madonna and Child—Marble Group." Jenkins displayed five other pieces in this show, held at the Metropolitan Museum, April 1–30, 1921.
3. "English Sculptor's Work Has Extraordinary Charm," *American Art News* 20 (December 31, 1921), p. 5.
4. Schiff to Robinson, February 8, 1926, MMA Archives.

Adolph Alexander Weinman (1870–1952)

Weinman came to New York at the age of ten from his birthplace, Karlsruhe, Germany. In his midteens he took an apprenticeship with Frederick Kaldenberg, a carver of ivory and wood; in 1888 he started evening classes in drawing and modeling at the Cooper Union, which he continued for three years. In 1890 he began a period of employment with Philip Martiny, completing architectural sculpture for the World's Columbian Exposition in Chicago in 1893. After working for Olin Levi Warner (pp. 203–38) in 1895–96, Weinman was taken on as a studio assistant by Augustus Saint-Gaudens (pp. 243–325), until Saint-Gaudens left for Europe in autumn 1897, and he also attended evening classes at the Art Students League between 1896 and 1900. He next worked as an assistant for Charles H. Niehaus (pp. 356–57) and then for Daniel Chester French (pp. 326–41).

In 1904 Weinman established his own New York studio. That year he was awarded a silver medal at the Louisiana Purchase Exposition in Saint Louis for his group *Destiny of the Red Man* (1903; reduction, 1947; R. W. Norton Art Gallery, Shreveport, La.); he designed the fair's award medals. At the Panama-Pacific International Exposition, San Francisco, in 1915, he exhibited twenty-nine works and also modeled the monumental *Rising Day* and *Descending Night* (see cat. no. 239) for the Court of the Universe. In addition, Weinman developed a particular talent for relief work, and throughout his career he designed medals and plaques, including in 1916 the new United States Mercury dime and Walking Liberty half-dollar. In 1919 he designed the J. Sanford Saltus Medal for the American Numismatic Society to recognize achievement in the art of medallic design; he won the award in 1920.

Over the first two decades of the twentieth century, Weinman executed architectural sculpture for McKim, Mead and White, for example panels representing Music and Truth (1903–6) for the library built by J. Pierpont Morgan (now Pierpont Morgan Library) and a polychrome terracotta pediment (no longer extant) for the Madison Square Presbyterian Church (1904–6). In 1909 Weinman was asked to produce seven keystones for the Fifth Avenue facade of McKim, Mead and White's north extension of the Metropolitan Museum. He also completed ornament for the firm's Pennsylvania Station, along with four monumental clock entablatures (destroyed), twenty-two granite eagles (dispersed), and bronze statues of Alexander Johnston Cassatt (1910; Rensselaer Polytechnic Institute, Troy, N.Y.) and Samuel Rea (1929–30; 2 Penn Plaza), presidents of the Pennsylvania Railroad. The sculptural program (1913–14) for New York's Municipal Building included panels representing arms of the city government, decoration for the Chambers Street triumphal archway, and the 25-foot gilt sheet-copper *Civic Fame* surmounting the central tower.

Weinman's many public commissions were unveiled steadily, for example the memorial to Major General Alexander Macomb (Detroit) in 1908, the *Union Soldiers and Sailors Monument* (Baltimore) in 1909, and a statue of Lieutenant Colonel William F. Vilas (Vicksburg, Miss.) in 1912. He also designed pediments for the state capitols of Wisconsin (1912) and Missouri (1921–27). In 1941 his nickel silver bronze statues of Alexander Hamilton and De Witt Clinton flanking the entrance of the Museum of the City of New York were dedicated. In Washington, D.C., his commissions included the exterior sculptural program for the Department of the Post Office Building (1932–34) and a pediment, the symbolic *Destiny* (1933–35), for the Pennsylvania Avenue facade of the National Archives. In these public commissions Weinman's work was more stylized and linear than his earlier, classicizing designs.

Weinman lectured on architectural sculpture at the National Academy of Design from 1910 to 1917. He was also a member of the National Commission of Fine Arts from 1928 to 1932 and president of the National Sculpture Society from 1928 to 1931.

DJH

SELECTED BIBLIOGRAPHY

Weinman, Adolph A., Papers. Archives of American Art, Smithsonian Institution, Washington, D.C., microfilm reels 283, 414, and unmicrofilmed material.

Dorr, Charles H. "A Sculptor of Monumental Architecture: Notes on the Work of Adolph Alexander Weinman." *Architectural Record* 33 (June 1913), pp. 518–32.

"Adolph Alexander Weinman." Pan American Union *Bulletin* 45 (December 1917), pp. 775–87.

"Adolph A. Weinman's Sculptures in Bronze." *Metal Arts* 2 (September 1929), pp. 423–27, 436.

Lockman, DeWitt McClellan. Interview with Adolph Alexander Weinman, April 28, 1926. Transcript, Manuscripts Department, New-York Historical Society. Microfilmed for DeWitt McClellan Lockman Papers, Archives of American Art, Smithsonian Institution, Washington, D.C., reel 504, frames 1046–61.

Weinman, Robert A. "Adolph A. Weinman, 1870–1952, Eleventh President, National Sculpture Society." *National Sculpture Review* 14 (Winter 1965–66), pp. 22, 28.

Baxter, Barbara A. "A. A. Weinman, Classic Medallist." In Alan M. Stahl, ed., *The Medal in America, Volume 2*, pp. 158–75. Coinage of the Americas Conference, 1997, Proceedings no. 13, New York: American Numismatic Society, 1999.

238. *Study for the Statue of Abraham Lincoln at Frankfort, Kentucky,* 1911

Bronze, 1912
24¾ x 11¾ x 15 in. (62.9 x 29.8 x 38.1 cm)
Signed and dated (back of base): A·A WEINMAN / FECIT © MCMXI
Inscribed (front of base): ▴STVDY▴FOR▴THE▴STATVE▴OF▴ / ▴ABRAHAM▴LINCOLN▴ / AT▴FRANKFORT▴KY▴
PRESENTED▴TO▴THE▴STATE▴OF / ▴KENTVCKY▴BY▴JAMES▴BRECKINRIDGE▴SPEED▴
Foundry mark (base): ROMAN BRONZE WORKS. N.Y.
Gift of Mrs. James Breckinridge Speed, in memory of her husband, 1913 (13.196)

WEINMAN EXECUTED two statues of Abraham Lincoln.
The first, a heroic bronze seated *Lincoln,* was unveiled in
1909 in Court House Square, Hodgenville, Kentucky.[1]
The other was installed in 1911 in the rotunda of the State
Capitol, Frankfort, Kentucky. This monument was com-
missioned by James Breckinridge Speed, a native of
Louisville and a member of a family closely allied with
Lincoln's causes. The Metropolitan Museum's bronze is a
cast of a study for the second commission and presents
Lincoln standing as he is in the finished statue, although
the figure is not articulated as fully or crisply.

Weinman made a thorough review of Lincoln's life and
of photographs and documents in the possession of the
Speed family.[2] After discarding several sketches of the pres-
ident with and without the chair,[3] Weinman represented
him as if he were rising to address an audience.

Weinman had three *Lincoln* statuettes cast at Roman
Bronze Works in 1912; the Metropolitan's cast is presumably
one of these.[4] He also modeled a large head "embod[ying]
his entire knowledge of Lincoln's features,"[5] which was
installed in Grand Rapids, Michigan, in 1913.[6] In 1914
several bronze reductions were made of the head (R. W.
Norton Art Gallery, Shreveport, La.).[7]

The Metropolitan's statuette was donated by Hattie
Bishop Speed in memory of her husband, as "acknowledge-
ment of his indebtedness for the great pleasure the museum
collections had given him."[8] Another bronze cast is at the
Speed Art Museum, Louisville, founded by Mrs. Speed.

DJH

EXHIBITIONS

Halloran General Hospital, Staten Island, July 1947–February 1948.
The White House, Washington, D.C., May 1974–June 1977.
State of New York Executive Mansion, Albany, November 1993–
present.

1. A replica was erected three weeks later at the University of Wis-
consin, Madison. For the seated *Lincoln*s, see Donald Charles
Durman, *He Belongs to the Ages: The Statues of Abraham Lincoln*
(Ann Arbor, Mich.: Edwards Brothers, 1951), pp. 106–7.
2. "Bronze Statue of Lincoln. John B. Speed Gift Will Adorn Ro-
tunda of Kentucky State Capitol," unidentified clipping, Wein-
man Papers, Archives of American Art, box 2.
3. Weinman Papers, Archives of American Art, box 7, "Photographs
of Standing Lincoln by De W. C. Ward," with eight sketches.
4. Roman Bronze Works Archives, Amon Carter Museum, Fort
Worth, ledger 4, p. 152, entry for December 21, 1912.
5. Durman, *He Belongs to the Ages,* p. 108.
6. See Fay L. Hendry, *Outdoor Sculpture in Grand Rapids* (Okemos,
Mich.: iota press, 1980), p. 66.
7. Roman Bronze Works Archives, ledger 4, p. 152, entry for Octo-
ber 30, 1914, lists four small *Lincoln* heads. A reduced bronze head
is illustrated in Sotheby's, New York, sale cat., June 6, 1997, no. 213.
8. Mrs. Speed to the trustees, MMA, May 29, 1913, MMA Archives.

239. *Descending Night,* ca. 1914

Bronze, by 1917
26 x 22¼ x 11 in. (66 x 56.5 x 27.9 cm)
Signed (top of base, back): © / A ▲A ▲WEINMAN▲FECIT
Foundry mark (back of base): ROMAN BRONZE WORKS N—Y—
Cast number (underside of base): Nº 15.
Morris K. Jesup Fund, 1994 (1994.501)

As IS OFTEN the case with turn-of-the-century small sculpture, *Descending Night* is a reduction after a full-size composition created for public purposes. Weinman modeled *Descending Night* (also known as *Setting Sun*) and a male pendant, *Rising Day,*[1] as a commission for the Panama-Pacific International Exposition of 1915 in San Francisco. The figures were placed atop massive columns rising out of two fountains in the Court of the Universe, which was designed by the architectural firm of McKim, Mead and White.[2] This open-air installation was temporary, so the figures were executed in staff, an inexpensive and impermanent mixture of plaster and fibrous materials. However, following the close of the fair, Weinman replicated both figures in bronzes of two sizes, based on his working models. Reductions of *Descending Night* exist in 55¾-inch versions and in 26-inch versions, of which the Metropolitan Museum's cast is one.[3]

Descending Night, an ideal female nude in a sinuous asymmetrical pose, personifies the waning hours of daylight. Her hands hold her hair away from her face, revealing her downcast, withdrawn countenance representing nature's mood. A guidebook to the Panama-Pacific Exposition elaborates: "The muscles are all lax—the head is drooping, the arms are closing in around the face, the wings are folding, the knees are bending—and she too will soon sink to slumber with the world in her arms."[4] To reinforce the symbolism of the work, a low-relief crescent moon and a pattern of stars surround the figure's feet on the integral base.

Foundry marks on existing bronzes as well as casting records suggest that Weinman relied almost exclusively on Roman Bronze Works to produce the reductions. He later described the 26-inch versions of *Rising Day* and *Descending Night* as his "best selling small bronzes."[5] The Metropolitan's cast is listed in the foundry ledgers on May 1, 1917, indicating a terminus ante quem of that date.[6] The patinas on casts of *Descending Night* vary from brown to rust red to the splendid green of the Museum's bronze, a reminder that color was a particularly effective means of expressing the artistic individuality of each cast.

TT

MMA, Henry R. Luce Center for the Study of American Art, "Subjects and Symbols in American Sculpture: Selections from the Permanent Collection," April 11–August 20, 2000.

1. Some contemporary publications referred to Weinman's female as *Setting Sun* rather than *Descending Night*. See, for instance, Stella G. S. Perry, *The Sculpture and Murals of the Panama-Pacific International Exposition: The Official Handbook* (San Francisco: Wahlgreen Co., 1915), pp. 21–22.
 Rising Day is a winged male figure whose upward soaring pose contrasts with the cool restraint of *Descending Night*. For an illustration of *Rising Day,* see Tom Armstrong et al., *200 Years of American Sculpture,* exh. cat. (New York: Whitney Museum of American Art, 1976), p. 115, fig. 152.
2. For a photograph of *Descending Night* in situ, see Jessie Niles Burness, *Sculpture and Mural Paintings in the Beautiful Courts, Colonnades and Avenues of the Panama-Pacific International Exposition at San Francisco 1915* (San Francisco: Robert A. Reid, 1915), n.p.
3. Casts of *Descending Night* in the 55¾-inch size are in the collections of the Corcoran Gallery of Art, Washington, D.C.; Hearst San Simeon State Historical Monument, San Simeon, Calif.; Museum of Fine Arts, Houston; Krannert Art Museum, University of Illinois, Champaign; and Smithsonian American Art Museum, Washington, D.C. Among the known 26-inch casts in public collections are those in the Cleveland Museum of Art; R. W. Norton Art Gallery, Shreveport, La.; and the White House, Washington, D.C.
4. Juliet James, *Sculpture of the Exposition Palaces and Courts: Descriptive Notes on the Art of the Statuary at the Panama-Pacific International Exposition, San Francisco* (San Francisco: H. S. Crocker Co., 1915), p. 20.
5. See William Kloss et al., *Art in the White House: A Nation's Pride* (Washington, D.C.: White House Historical Association, 1992), pp. 236, 286 n. 2, which mentions the existence of a *Descending Night* cast by Cellini Bronze Works, New York. See also Weinman to Carl B. Cobb, February 17, 1951 (copy), Weinman family collection, in which Weinman reports that he had by that date sold "fifty of each" of *Rising Day* and *Descending Night* in the smaller size and "eight of each model" in the larger size. Robert Weinman, son, and Chris Weinmann, grandson of the artist, generously shared family material.
6. Roman Bronze Works Archives, Amon Carter Museum, Fort Worth, ledger 4, p. 153. Listings for 26-inch casts of *Descending Night* appear in the foundry records from May 1916 steadily through 1919.

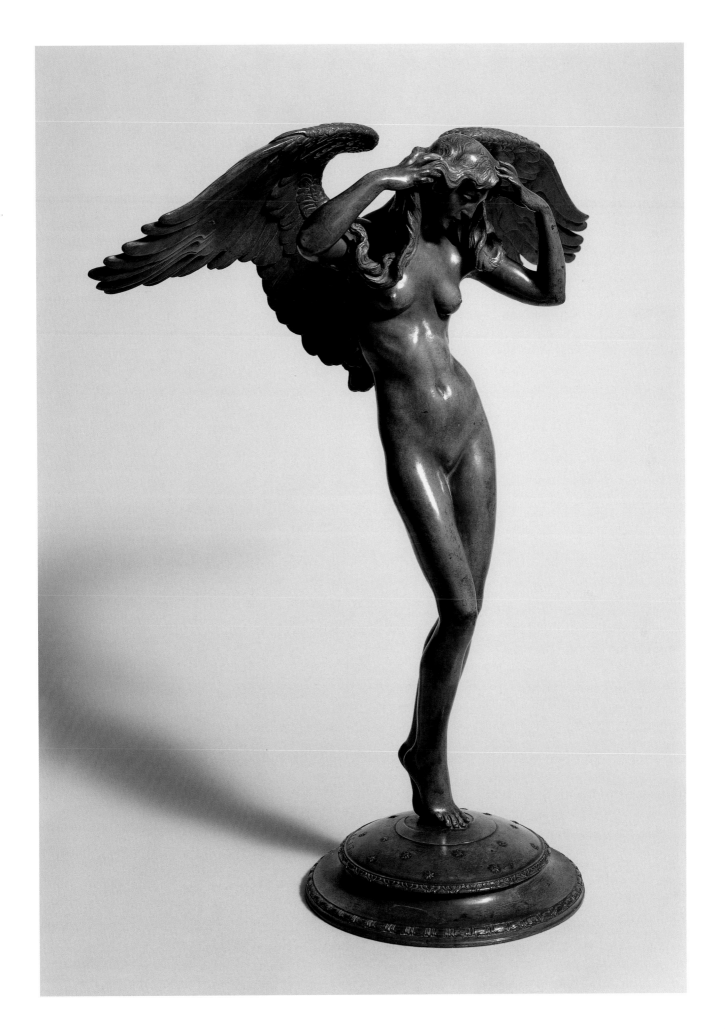

Edith Woodman Burroughs (1871–1916)

Born in Riverdale-on-Hudson, New York, Burroughs began her artistic training at the age of fifteen, enrolling in 1887 at the Art Students League. She studied drawing with Kenyon Cox and, after 1888, modeling with Augustus Saint-Gaudens (pp. 243–325). While enrolled at the league until 1892, Burroughs pursued various jobs in New York, including decorative work for Tiffany and Company and commissions for ecclesiastical sculpture. She continued her education in Paris with sculptor Jean-Antoine Injalbert and painter Luc-Olivier Merson. In Europe, in 1893 she married the aspiring American painter Bryson Burroughs, who had been a fellow student at the league (and would become assistant curator, then curator of paintings at the Metropolitan Museum). The couple traveled through England, France, and Italy, immersing themselves in cathedral towns and medieval sculpture.

Upon her return to New York in 1895, Burroughs modeled small figures and portrait busts characterized by a rich textural style. One of her first accomplished works, the detailed statuette *Circe* (1907; Newark Museum, Newark, N.J.), won the 1907 National Academy of Design's Julia A. Shaw Memorial Prize for best work of art in the exhibition by an American woman. On a second trip to Paris in 1909, Burroughs was introduced to the modern work of the French sculptor Aristide Maillol. His simplified, solid forms led her to abandon her neo-baroque style for a sparer, more refined one, as seen in adolescent figures such as *At the Threshold* (cat. no. 241). In her portraits, however, she adhered to a naturalistic approach in order to maintain "a more searched characterization and a more readily accepted likeness" (*Sculptures by Edith Woodman Burroughs* 1915, p. 6). In particular, she was commended for her busts and figures of children. She also executed medallions, notably those of writer Edgar Allan Poe (1909) and art critic Roger Fry

(1911), the former a commission for the Grolier Club of New York and the latter a friendship piece (both MMA, acc. nos. 09.116 and 16.125).

Burroughs exhibited one sculpture, a portrait of writer and diplomat John Bigelow (ca. 1910; Museum of Art, Rhode Island School of Design, Providence), in the Armory Show of 1913. That year she was elected an associate academician of the National Academy of Design. Two years later she received critical praise for the exhibition of her work at the Berlin Photographic Company in New York, where she showed thirty-nine busts and figures in a range of materials, including marble, bronze, and terracotta. Also in 1915, Burroughs won a silver medal for works exhibited at the Panama-Pacific International Exposition in San Francisco. She was commissioned for two outdoor works at the exposition, the *Fountain of Youth* for the Court of Flowers and the *Arabian Nights Fountain,* which was not installed because of lack of funds. After Burroughs's sudden death from influenza in 1916, the National Sculpture Society included examples of her sculpture and that of Helen Farnsworth Mears (pp. 541–43), also recently deceased, in an exhibition in Buffalo.

DJH

SELECTED BIBLIOGRAPHY

Sculptures by Edith Woodman Burroughs. Exh. cat., introduction by B[ryson] B[urroughs]. New York: Berlin Photographic Co., 1915.
Kobbe, Gustav. "Artists Whose Hand Was Stayed—Tragedies of the Studios Recalled by Opening of National Sculpture Society's Exhibition." *New York Herald,* June 4, 1916, magazine sec., p. 6.
Proske, Beatrice Gilman. *Brookgreen Gardens Sculpture,* pp. 261–63. Rev. ed. Brookgreen Gardens, S.C.: Brookgreen Gardens, 1968.
Hill, May Brawley. *The Woman Sculptor: Malvina Hoffman and Her Contemporaries,* pp. 10–11, 26, 32–33. Exh. cat. New York: Berry-Hill Galleries, 1984.
Rubinstein, Charlotte Streifer. *American Women Sculptors: A History of Women Working in Three Dimensions,* pp. 236–38. Boston: G. K. Hall, 1990.

240. *John La Farge,* 1908

Bronze
16¼ x 18¾ x 9 in. (41.3 x 47.6 x 22.9 cm)
Signed (right sleeve): *Edith Woodman Burroughs*
Foundry mark (right sleeve, stamped): CIRE / C. VALSUANI / PERDUE
Rogers Fund, 1910 (10.199)

BURROUGHS MODELED this bust of John La Farge (1835–1910) when the distinguished artist was about seventy-three years old, at the close of his extended career. La Farge was a major figure in late-nineteenth-century American

artistic and cultural life, known for his painting, mural decoration, writing, lecturing, and interest in Japanese art, and above all for his innovative stained-glass work.[1]

In this bust, Burroughs captured La Farge in a melan-

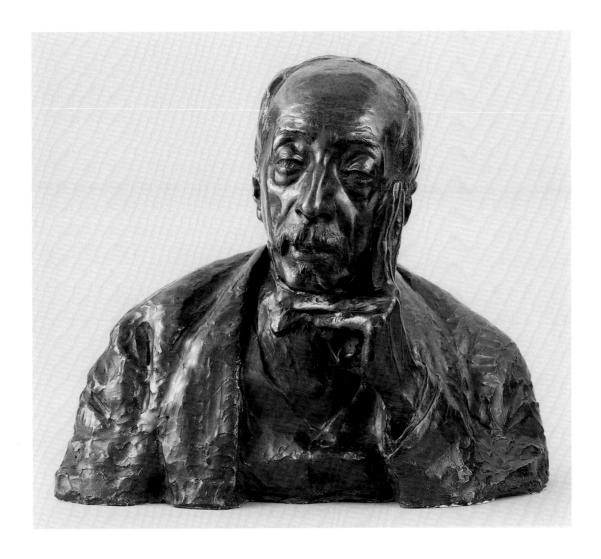

choly pose that "suggests his introspective withdrawal from fellowship."[2] The vigor of the portrait rests in Burroughs's assured surface modeling and her unapologetic rendering of her sitter's aging features. This likeness contrasts with La Farge's self-portrait of nearly fifty years earlier in the Metropolitan Museum.[3]

Burroughs's *La Farge* was first displayed at the National Academy of Design winter exhibition in 1908–9, and then at the Pennsylvania Academy of the Fine Arts annual in 1909.[4] A cast was included in Burroughs's exhibition at the Berlin Photographic Company in 1915.[5]

Burroughs lent the bronze *La Farge* to the Metropolitan Museum on November 17, 1910, just three days after La Farge's death.[6] A unique cast produced by the Parisian foundry C. Valsuani, it was purchased shortly thereafter.[7]

DJH

EXHIBITIONS

Brooklyn Museum, New York, October 13–December 30, 1979; National Collection of Fine Arts, Washington, D.C., February 22–April 20, 1980; Fine Arts Museums of San Francisco, M. H. de Young Memorial Museum, May 31–August 10, 1980; Denver Art Museum, September 24–November 30, 1980, "The American Renaissance: 1876–1917," no. 237.

Berry-Hill Galleries, New York, "The Woman Sculptor: Malvina Hoffman and Her Contemporaries," October 24–December 8, 1984, no. 2.
MMA, Henry R. Luce Center for the Study of American Art, "Portraits of American Artists in The Metropolitan Museum of Art," September 29, 1992–February 21, 1993.
MMA, Henry R. Luce Center for the Study of American Art, "John La Farge in The Metropolitan Museum of Art," October 21, 1997–January 25, 1998.

1. For a comprehensive discussion of La Farge's career, see Henry Adams et al., *John La Farge,* exh. cat. (Pittsburgh: Carnegie Museum of Art; Washington, D.C.: National Museum of American Art; New York: Abbeville, 1987).
 Kate Walsh contributed research assistance on Burroughs.
2. "At the Berlin," *New York Times,* February 7, 1915, magazine sec., p. 23.
3. For *Portrait of the Artist* by John La Farge (1859; acc. no. 34.134), see Meg Perlman, in Natalie Spassky, *American Paintings in the Metropolitan Museum of Art,* vol. 2 (New York: MMA, 1985), pp. 400–401.
4. *National Academy of Design Winter Exhibition 1908 . . . Illustrated Catalogue* (New York, 1908), p. 58, no. 379; and *Pennsylvania Academy of the Fine Arts . . . Catalogue of the 104th Annual Exhibition,* 2nd ed. (Philadelphia, 1909), p. 66, no. 867.
5. *Sculptures by Edith Woodman Burroughs* 1915, p. 10, no. 37. It is not possible to determine whether the Metropolitan's cast was the one on display.
6. Loan receipt no. 693, November 17, 1910, MMA Office of the Registrar.
7. Object catalogue cards, MMA Department of American Paintings and Sculpture.

241. *At the Threshold*, 1912

Limestone, tinted, 1919–20
62¼ x 14½ x 16 in. (158.1 x 36.8 x 40.6 cm)
Signed (right side of base): *Edith Woodman Burroughs*
Amelia B. Lazarus Fund, 1920 (20.76)

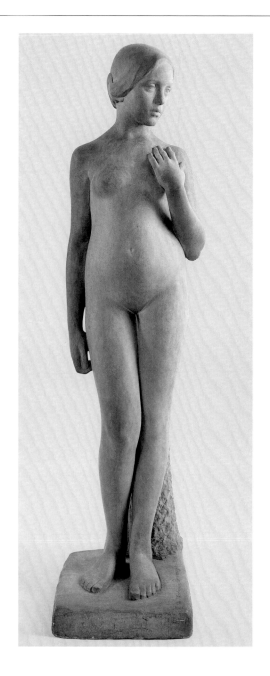

THIS LIFESIZE adolescent female depicts a "young girl of twelve or thirteen who looks out on womanhood with wondering dull eyes."[1] The work represents a stylistic departure from Burroughs's earlier, more detailed sculptures. The smooth, simplified treatment of the nude form was inspired by her trip in 1909 to Paris, where she admired the sculpture of the modernist artist Aristide Maillol.[2]

Originally executed in plaster and colored, *At the Threshold* was frequently exhibited: in the 1912–13 winter exhibition of the National Academy of Design; in 1913 at the annual display of the Pennsylvania Academy of the Fine Arts; and in 1915 in the exhibition of Burroughs's work at the Berlin Photographic Company.[3]

In 1918, two years after Burroughs's death, Metropolitan Museum trustee Daniel Chester French (pp. 326–41) selected *At the Threshold* for inclusion in a long-term exhibition of American sculpture at the Museum.[4] As he did with several other pieces borrowed for the exhibition, he encouraged its acquisition for the permanent collection. In March 1919, French notified director Edward Robinson that he and some other members of the trustees' Committee on Sculpture recommended that the work be reproduced in stone for purchase by the Museum.[5] Presumably this medium was selected in accordance with the fact that Burroughs employed stone for her late figural pieces. The sculptor's widower, Bryson Burroughs, then curator of paintings at the Museum, arranged to have *At the Threshold* translated into limestone. The carving was certainly carried out by the Piccirilli Brothers Studio, for Museum records indicate that it was Attilio Piccirilli (pp. 482–85) who removed the plaster from the building in May 1919.[6] The carvers added a structural support to the limestone statue that was not part of the original design.

DJH

EXHIBITION

Heritage Plantation of Sandwich, Mass., "Young America: Children and Art," May 12–October 27, 1985, no. 157.

1. B[ryson] B[urroughs], in *Sculptures by Edith Woodman Burroughs* 1915, p. 5.
2. For illustrations of Maillol's work, see Ursel Berger et al., *Aristide Maillol,* exh. cat. (Paris: Flammarion for the Musée des Beaux-Arts de Lausanne, 1996).
3. *Illustrated Catalogue, National Academy of Design Winter Exhibition 1912* (New York, 1912), p. 22, no. 152; *Pennsylvania Academy of the Fine Arts . . . Catalogue of the 108th Annual Exhibition,* 2nd ed. (Philadelphia, 1913), p. 76, no. 859; and *Sculptures by Edith Woodman Burroughs* 1915, p. 10, no. 25.
4. *An Exhibition of American Sculpture* (New York: MMA, 1918), p. 4, no. 18, as "On The Threshold, statue, plaster, colored."
5. French named Edward D. Adams, Herbert Adams (pp. 360–64), and George Blumenthal as approving this acquisition in his letter to Robinson, March 26, 1919, MMA Archives.
6. Attached to the form, dated January 23, 1918, noting receipt of the plaster from Bryson Burroughs for the long-term exhibition at the Metropolitan is an outgoing receipt, dated May 26, 1919, and signed Attilio Piccirilli, Special Exhibition Notebooks, MMA Office of the Registrar.

Helen Farnsworth Mears (1871–1916)

Born in Oshkosh, Wisconsin, Helen (baptized Nellie) Mears attended the Oshkosh Normal School. She studied briefly in 1892 at the Art Institute of Chicago and won a sculpture competition to represent the state of Wisconsin at the Chicago World's Columbian Exposition in 1893. Her 9-foot plaster statue, *The Genius of Wisconsin,* which was carved in marble by the Piccirilli Brothers Studio (now in the rotunda of the State Capitol, Madison), brought her a five-hundred-dollar prize from the Milwaukee Women's Club for the best work of art submitted by a Wisconsin woman. She was thus able to travel to New York in 1894 and enroll at the Art Students League in modeling classes with Augustus Saint-Gaudens (pp. 243–325). After only two weeks, Saint-Gaudens invited her to assist him in his studio.

Encouraged by Saint-Gaudens to study abroad, and with financial support from one of her Wisconsin patrons, Alice Greenwood Chapman, Mears sailed to Europe in 1896. In Paris, she studied at the Académie Vitti (an art school for women), under sculptors Alexandre Charpentier and Frederick William MacMonnies (pp. 428–42) and painters Raphael Collin and Luc-Olivier Merson, and attended the Académie Julian, working with sculptor Denys Puech. Her plaster bust *Portrait of M. D . . .* (unlocated) was exhibited at the 1897 Salon of the Société des Artistes Français. She toured Italy before returning to Paris to assist Saint-Gaudens on his equestrian *Sherman Monument* (1892–1903; Grand Army Plaza, New York) and to model bas-reliefs.

In 1899 Mears settled permanently in New York and established a studio, which she shared with her sister Mary, a professional writer. She specialized in portrait busts, reliefs, and medallions, executed in both marble and bronze, and she received commissions consistently through her career, including busts of Revolutionary War general George Rogers Clark (Milwaukee Public Museum) in 1900 and of dentist and pioneering anesthesiologist Dr. William T. G. Morton (Smithsonian Institution; copy, Hall of Fame for Great Americans, Bronx Community College) in 1908. Mears's bas-reliefs owe a considerable debt to those of Saint-Gaudens, as for example her portraits of Saint-Gaudens (1898; revised version, Paine Art Center and Arboretum, Oshkosh) and of Edward Alexander MacDowell (cat. no. 242). *Portrait of My Mother* (1907; Paine Art Center and Arboretum) received an honorable mention at the San Francisco Panama-Pacific International Exposition in 1915.

Mears also carried out public projects, receiving a commission in 1898 from the state of Illinois for a marble statue of Frances E. Willard, educator and temperance activist, for Statuary Hall of the United States Capitol (the piece was dedicated in 1905). An ambitious multipanel bas-relief, *The Fountain of Life,* was completed in plaster (destroyed) in 1904 and was exhibited at the Louisiana Purchase Exposition in Saint Louis, where Mears won a silver medal. In 1911, the sculptor's models (Paine Art Center and Arboretum) for the figure to top the dome of the Wisconsin State Capitol were rejected; this was a commission she fully expected to get, but it went instead to Daniel Chester French (pp. 326–41).

Mears continued to model portraits, but after 1911 her work took a new direction and turned to female allegorical subjects, such as *Aphrodite* (1912; Wriston Art Center Galleries, Lawrence University, Appleton, Wis.) and *Reclining Eve* (1914; Paine Art Center and Arboretum). In 1915 the *Adin Randall Memorial Fountain* (1911–15) was unveiled in Randall Park, Eau Claire, Wisconsin, the sculptor's last major project.

After Mears's sudden death in 1916, her work was presented, through the arrangements of her sister Mary, in several exhibitions, including ones at the Albright Art Gallery, Buffalo, and the Art Institute of Chicago in 1916 and the Milwaukee Art Institute in 1917, and in memorial exhibitions such as those at the Jones Art Galleries and the Peabody Museum in Baltimore in 1919 and the Brooklyn Museum in 1920. The Paine Art Center and Arboretum, Oshkosh, Wisconsin, has the largest collection of Mears's work.

DJH

SELECTED BIBLIOGRAPHY

Willcox, Louise Collier. "A Notable Woman Sculptor." *Harper's Weekly* 52 (June 20, 1908), p. 15.

Paine Art Center. *Helen Farnsworth Mears, Oshkosh, Wisconsin, 1872* [sic]–*1916: An Exhibition of Sculpture.* Oshkosh, Wis., 1970.

James, Edward T., et al., eds. *Notable American Women, 1607–1950: A Biographical Dictionary,* vol. 2, pp. 522–23. Cambridge, Mass.: Belknap Press of Harvard University Press, 1971.

Green, Susan Porter. *Helen Farnsworth Mears.* Oshkosh, Wis.: Castle-Pierce Press, 1972.

Rubinstein, Charlotte Streifer. *American Women Sculptors: A History of Women Working in Three Dimensions,* pp. 130–33. Boston: G. K. Hall, 1990.

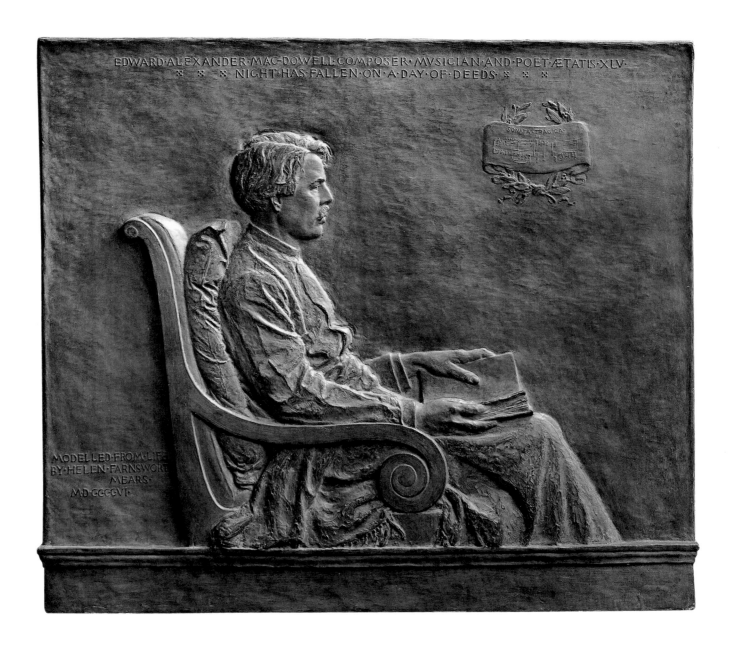

242. *Edward Alexander MacDowell*, 1906

Bronze, 1907
33½ x 40 in. (85.1 x 101.6 cm)
Signed and dated (lower left): MODELLED·FROM·LIFE / BY·HELEN·FARNSWORTH / MEARS· / M·D·C·C·C·VI·
Inscribed: (at top) EDWARD·ALEXANDER·MAC-DOW-ELL·COMPOSER· MVSICIAN · AND · POET ·
ÆTATIS · XLV· / NIGHT · HAS · FALLEN · ON ·A·DAY · OF · DEEDS·; (on scroll superimposed on
laurel wreath) SONATA · TRAGICA · / III / (with musical notation of the opening bars);
(left edge) COPYRIGHT · 1907 · BY · HELEN · FARNSWORTH · MEARS
Gift of Alice G. Chapman, 1909 (09.147)

EDWARD ALEXANDER MACDOWELL (1861–1908)
was an internationally recognized composer, pianist, and
teacher and was the first professor of music at Columbia
University (1896–1904). After his resignation from
Columbia, he continued to teach privately but suffered

increasingly from mental illness. During his last years,
MacDowell dreamed of establishing a retreat at his farm
in Peterborough, New Hampshire, where writers, artists,
musicians, and composers would find creative inspiration
in the natural surroundings. The MacDowell Colony,

founded in 1907 and still active today, was managed by his widow, Marian Nevins MacDowell, a former pupil, until 1946.[1]

It was MacDowell's deteriorating health that prompted his wife to commission his portrait. She first turned to Augustus Saint-Gaudens, who, also ill, declined but wrote that he "could think of some of my pupils that might execute it. . . ."[2] Mears had proven herself a capable sculptor of bas-reliefs, and she received the commission. She modeled the portrait during sittings at the MacDowell homes in New York and Peterborough in spring–summer 1906.[3] Mears's writer-sister Mary described MacDowell during the sittings: "The musician sat there in his invalid chair, in his clothes of soft white flannel, childlike, wondering, very beautiful, with the naïve simplicity which had ever characterized him."[4]

Mears's indebtedness to Saint-Gaudens's masterful bas-reliefs is evident. The MacDowell portrait draws its compositional inspiration from Saint-Gaudens's *Robert Louis Stevenson* (cat. nos. 124, 125) in such aspects as the profile position and the inclusion of the sitter's creative work in the inscription. MacDowell is shown seated with a cushion at his back and a throw over his legs, holding a book with sensitively modeled hands. At MacDowell's request, Mears included in the inscription a line from one of his poems, "Night has fallen on a day of deeds," as well as several bars from the third movement of his Sonata Tragica (op. 45, 1891–92) for the piano.[5]

Edward Alexander MacDowell was first shown in 1908 at the annual exhibitions of the Pennsylvania Academy of the Fine Arts and the National Academy of Design[6] and was frequently displayed thereafter both in Mears's lifetime and in memorial shows. In 1908 a bronze cast was offered to the Metropolitan Museum by Mears's patron Alice Greenwood Chapman of Milwaukee, who had purchased it from the artist. However, since the prospective donor did "not wish to have it run the risk of being turned down" by the trustees' Committee on Sculpture, Museum director Sir C. Purdon Clarke asked committee chairman Daniel

Chester French his opinion of the work before it was submitted for consideration. "I approve its acceptance, *personally*," wrote French. The work was formally accepted by the committee the following year.[7]

Other known casts are in the collections of the MacDowell Colony, Peterborough, New Hampshire; the Curtis Institute of Music, Philadelphia; and the Brooklyn Museum of Art, New York. Reductions (8 x 9½ in.) in bronze are at the MacDowell Colony and the Paine Art Center and Arboretum, Oshkosh, Wisconsin.

DJH

EXHIBITION

Currier Gallery of Art, Manchester, N.H., September 13–December 2, 1996; Wichita Art Museum, Wichita, Kans., April 20–June 15, 1997, "Community of Creativity: A Century of MacDowell Colony Artists," no. 32.

1. For summary information on MacDowell, see Stanley Sadie, ed., *The New Grove Dictionary of Music and Musicians* (London: Macmillan, 1980), vol. 11, pp. 417–22. For the MacDowell Colony, see P. Andrew Spahr et al., *Community of Creativity: A Century of MacDowell Colony Artists,* exh. cat. (Manchester, N.H.: Currier Gallery of Art, 1996).
2. Saint-Gaudens to Marian MacDowell, November 10, 1905 (copy), Augustus Saint-Gaudens Papers, Dartmouth College Library, Hanover, N.H., microfilm reel 9, frame 909. For Mrs. MacDowell's letter of request to Saint-Gaudens, November 1, [1905], see Saint-Gaudens Papers, microfilm reel 9, frame 910.
3. Green 1972, pp. 62, 66.
4. Mary Mears, "The Work and Home of Edward MacDowell, Musician," *The Craftsman* 16 (July 1909), p. 416. The Mears sisters were the first "colonists" at the MacDowell Colony; they lived and worked there for part of each year from 1908 to 1911. See *Community of Creativity*, p. 26.
5. Green 1972, p. 66.
6. *Pennsylvania Academy of the Fine Arts . . . Catalogue of the 103rd Annual Exhibition,* 3rd ed. (Philadelphia, 1908), p. 65, no. 929; and *National Academy of Design Eighty-third Annual Exhibition 1908 . . . Illustrated Catalogue* (New York, 1908), p. 57, no. 351.
7. Clarke to French, October 28, 1908, and French to Clarke, November 11, 1908 (copy), MMA Archives. The offer of gift form, signed by Acting Director Edward Robinson, shows that the work was approved November 15, 1909, MMA Archives.

Henry Merwin Shrady (1871–1922)

Shrady, a native of New York City, was educated at Columbia University, receiving an A.B. degree in 1894. He began to pursue a law degree there but left in 1895 to work as president of the Continental Match Company, owned by his brother-in-law, until 1900. While a student, and later while recuperating from a bout with typhoid fever, Shrady spent time sketching animals at the Zoological Gardens in the Bronx Park (Bronx Zoo/Wildlife Conservation Park). He drew on his knowledge of anatomy from biology studies at Columbia.

Shrady's first sculptural composition, *Artillery Going into Action* (ca. 1898; unlocated), attracted the attention of Theodore B. Starr, a New York jeweler, who encouraged Shrady to produce small bronzes. Starr bought the copyright to Shrady's earliest statuettes, including *Bull Moose* (cat. no. 243); *The Empty Saddle* (1900; National Gallery of Art, Washington, D.C.); and *Elk Buffalo (Monarch of the Plains)* (1901; Gilcrease Museum, Tulsa, Okla.), and sold casts at his Fifth Avenue gallery.

Karl Bitter (pp. 489–95), the director of sculpture for the 1901 Pan-American Exposition in Buffalo, was impressed by Shrady's animal statuettes and invited him to enlarge some models for the fairgrounds. Shrady lacked the professional training and the studio facilities necessary to conduct this work and welcomed Bitter's guidance in his studio in Weehawken, New Jersey; aside from these few weeks of instruction, Shrady was self-taught. Also in 1901, Shrady won a competition for an equestrian statue of George Washington; *George Washington at Valley Forge* (Continental Army Plaza, Brooklyn; see cat. no. 245) was dedicated in 1906.

In February 1901 the United States Congress appropriated two hundred fifty thousand dollars for an equestrian statue of Ulysses S. Grant, the sculptor to be determined through national competition. Shrady's ambitious design was unanimously selected the following year from models by twenty-three sculptors by a jury of such distinguished artists as sculptors Augustus Saint-Gaudens (pp. 243–325) and Daniel Chester French (pp. 326–41), and architects Charles F. McKim and Daniel Burnham. The *Ulysses S. Grant Memorial* (1901–24; foot of Capitol Hill, east end of Mall, Washington, D.C.) occupied Shrady for twenty years. During these years, he worked on other monument projects, including a seated statue of banker Jay Cooke (1921) for Duluth, Minnesota, and an equestrian of Major General Alpheus Starkey Williams (1921) for Belle Isle Park, Detroit. Shrady died just fifteen days before the unveiling of the *Ulysses S. Grant Memorial* on April 27, 1922, the centennial of Grant's birth; the reliefs on the pedestal of the equestrian figure were completed from his sketches and installed in 1924.

DJH

SELECTED BIBLIOGRAPHY

Shrady, Henry Merwin, Papers. Archives of American Art, Smithsonian Institution, Washington, D.C., microfilm reel 647.

Shrady, Harrie Moore, Scrapbook (1902–22), about the *Ulysses S. Grant Memorial*. Archives of American Art, Smithsonian Institution, Washington, D.C., microfilm reel 3097, frames 2–53.

Garrett, Charles Hall. "The New American Sculptor." *Munsey's Magazine* 29 (July 1903), pp. 545–52.

Church, Mrs. Benjamin S. "A Great American Sculptor: Henry Merwin Shrady." *Journal of American History* 7 (April–June 1913), pp. 1005–14.

Homage to Henry Merwin Shrady, Sculptor, 1871–1922. New York: Hall of American Artists, New York University, 1942.

Montagna, Dennis R. "Henry Merwin Shrady's Ulysses S. Grant Memorial in Washington, D.C." Ph.D. diss., University of Delaware, 1987.

American National Biography, s.v. "Shrady, Henry Merwin."

243. *Bull Moose,* 1900

Bronze
19¾ x 15⅜ x 8⅛ in. (50.2 x 39.1 x 20.6 cm)
Signed and dated (front of base): H M SHRADY / 1900
Inscribed (back of base): COPYRIGHT_ / 1900 / THEODORE– B STARR
Cast number (underside of base): 5 (encircled)
Bequest of George D. Pratt, 1935 (48.149.25)

AFTER SEEING A photographic reproduction of Shrady's first sculptural composition, *Artillery Going into Action* (ca. 1898; unlocated), Theodore B. Starr, a New York jeweler and importer of Russian bronzes, encouraged him to take up modeling small statuettes for "their mutual benefit."[1] In 1900 Shrady sold the copyright for his first compositions to Starr; the following year Starr and Shrady signed a contractual agreement that gave the sculptor a royalty on

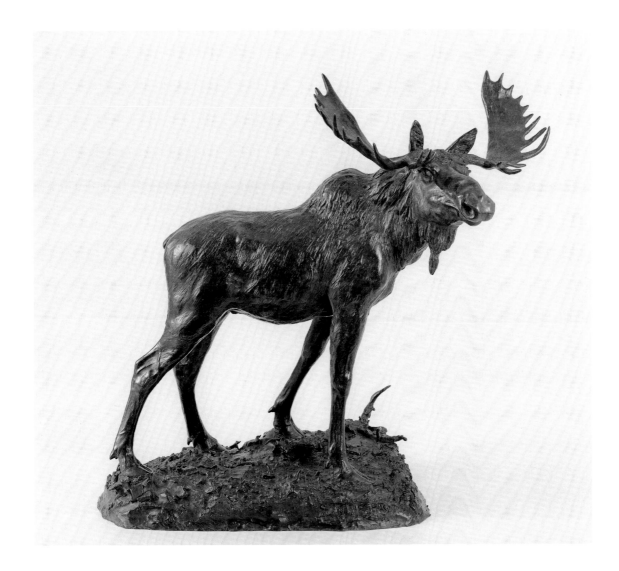

each bronze sold.[2] Shrady's realistic *Bull Moose,* modeled after a zoo animal, was one of his earliest works to be cast and was displayed by Starr in his Fifth Avenue gallery.

It was at Starr's that Karl Bitter first saw Shrady's work. Bitter, director of sculpture for the 1901 Pan-American Exposition in Buffalo, asked Shrady to enlarge his figures of a bull moose and an elk buffalo in staff, a temporary medium of plaster and straw, to decorate the bridges leading over the fair's canal.[3] Shrady completed this project in six weeks under Bitter's tutelage at his Weehawken, New Jersey, studio.[4]

Although the Metropolitan Museum's *Bull Moose,* stamped number 5, does not have a foundry mark, bronze casts in the collections of the Gilcrease Museum, Tulsa, Oklahoma, and the R. W. Norton Art Gallery, Shreveport, Louisiana, bear Roman Bronze Works inscriptions. According to Museum records, Riccardo Bertelli of the Roman Bronze Works viewed this sculpture on September 29, 1939, and said that "not more than twenty examples of it had been cast."[5]

Bull Moose was bequeathed to the Metropolitan in 1935 by George Dupont Pratt (pp. 523–24), trustee and bene-

factor of the Museum, a sculptor, and an art collector who owned a number of American animal bronzes (see cat. nos. 187, 189). It was not accessioned until 1948 because under the terms of the bequest, Pratt's widow retained life interest.[6] DJH

EXHIBITION

Elvehjem Art Center, University of Wisconsin, Madison, December 1975–December 1976.

1. Garrett 1903, p. 548, which also illustrates *Artillery Going into Action.*
2. Starr to Shrady, February 8, 1901, Shrady Papers, Archives of American Art, microfilm reel 647, frame 553.
3. The moose was enlarged to 9 feet and cast four times for placement on the canal bridges. See "American Studio Talk: Architecture of the Pan-American Exposition, Buffalo, N.Y.," *International Studio* 13 (1901), p. 302, for an illustration of the moose (without antlers in place) during the construction of the fairgrounds.
4. Garrett 1903, p. 548.
5. Notes recorded on object catalogue cards, MMA Department of American Paintings and Sculpture.
6. Extract from the minutes of the trustees' Executive Committee meeting, November 8, 1948, MMA Archives.

244. *Cavalry Charge*, 1902–16

Bronze, 1924
53½ x 102 x 44 in. (135.9 x 259.1 x 111.8 cm)
Signed (front of base): HENRY MERWIN SHRADY
Foundry mark (right side of base): CAST BY. ROMAN BRONZE WORKS·N.Y.
Gift of Mrs. Helen Fahnestock Campbell, 1925 (25.75)

CAVALRY CHARGE is a unique bronze, cast in 1924 from the quarter-size model for one of the subsidiary groups of Shrady's colossal *Ulysses S. Grant Memorial* (1901–24), erected at the east end of the Mall in Washington, D.C.[1] On winning the competition for the memorial in April 1902, Shrady and his design were challenged by more experienced sculptors, including Franklin Simmons (pp. 179–81), Charles Niehaus (pp. 356–57), and Solon Borglum (pp. 508–11), who felt that such an important commission should not go to an unknown sculptor. Niehaus, the runner-up, convinced the jury to request that he and Shrady enlarge their models of Grant on horseback to quarter-scale as a retrial, but in February 1903 Shrady's design finally prevailed.[2]

Before working on his initial sketches, Shrady made a careful study of the history of the Civil War. He borrowed Union uniforms[3] and observed reenactments of artillery and cavalry drills. He even joined the National Guard in New York for four years to experience military procedures.[4]

The monument consists of a heroic-size equestrian statue of Grant on a stone pedestal that has a bronze relief panel on each of the two long sides; these panels were enlarged and modeled by Edmund Amateis and, after Shrady's death, by Sherry Fry according to Shrady's clay sketches. On either side of the statue, which faces the U.S. Capitol, is a multifigure bronze group: to Grant's right is the *Artillery Group* (installed in 1912) and to his left, the *Cavalry Charge*.

In the *Cavalry Charge* (also called the *Cavalry Group*), which was installed on the memorial site in 1916, seven members of the regiment's color squad are dramatically

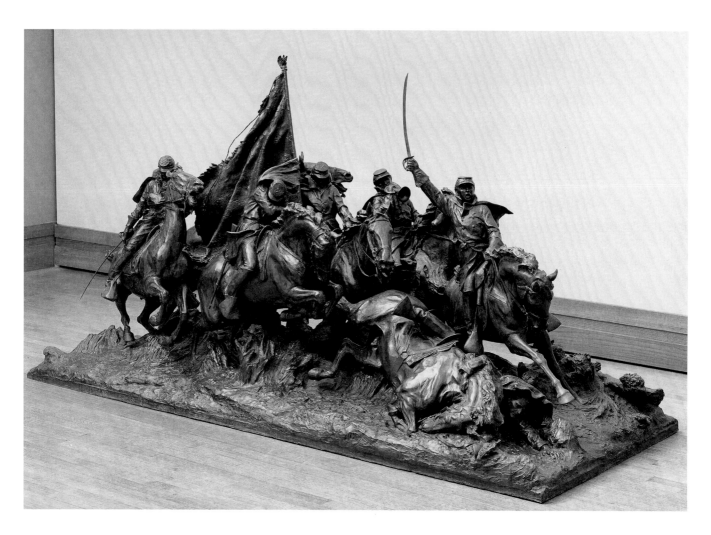

represented at the moment of their charge into battle. The leader of this complicated arrangement of soldiers on horseback has given the call to action by raising his sword high in the air, and his command is sounded by the bugler. One horse has fallen, unobserved by all except the soldier directly behind him, who ducks his head and braces for the impact as he pulls up on the reins. Friends of Shrady served as models for the cavalrymen in preparation for the lifesize cast, and the artist portrayed himself as the fallen rider.[5]

Before the cast of the quarter-size model of *Cavalry Charge* was presented as a gift to the Metropolitan Museum in 1925, it was on exhibition at the Anderson Galleries in New York.[6] DJH

EXHIBITION

Buffalo Bill Historical Center, Cody, Wyo., June 1984–present.

1. For a history and description of this monument, see Montagna 1987. See also U. S. Grant Memorial Commission, *The Grant Memorial in Washington,* Clarence O. Sherrill and James William Bryan, eds. (Washington, D.C.: Government Printing Office, 1924); William Walton, "The Field of Art: The Monument to General Grant, in Washington," *Scribner's Magazine* 49 (March 1911), pp. 381–84; and Helen Wright, "The Grant Memorial in Washington," *Art and Archaeology* 12 (April 1922), pp. 185–87.
2. Montagna 1987, pp. 19–32. Harrie Moore Shrady Scrapbook, Archives of American Art, microfilm reel 3097, frames 2–53, contains newspaper articles about the controversy surrounding the selection of Shrady's design for the Grant Memorial.
3. Lieut. Col. Q.M.C., Depot Quartermaster, U.S. Army, to Shrady, n.d., notifying him "that the Secretary of War has authorized the loan of certain Civil War uniforms in connection with the Grant Memorial," Shrady Papers, Archives of American Art, microfilm reel 647, frame 595.
4. James M. Goode, *The Outdoor Sculpture of Washington, D.C.: A Comprehensive Historical Guide* (Washington, D.C.: Smithsonian Institution Press, 1974), p. 244.
5. Ibid, p. 246.
6. [Henry W. Kent], Secretary, MMA, to members of the trustees' Committee on Sculpture, n.d. (copy), extending committee chairman Daniel Chester French's request that they "inspect" the *Cavalry Charge,* then on view at Anderson Galleries, before their meeting on February 16, [1925], MMA Archives.

245. *George Washington at Valley Forge,* 1905

Bronze, ca. 1906
25½ x 23½ x 9 in. (64.8 x 59.7 x 22.9 cm)
Signed (top of base): H. M. SHRADY
Foundry mark (left side of base): ROMAN BRONZE WORKS N–Y–
Purchase, Rogers Fund and Charles and Anita Blatt Gift, 1974 (1974.9)

IN 1899 JAMES R. HOWE campaigned for the elective office of Register of the Kings County (New York) Committee of Supervision and Construction, vowing to change the position from one that derived remuneration through fees to one with a regular salary, and to give back to the city all fees that he received in excess of a fair salary.[1] In 1901 he made that gift, $50,000 for a statue of George Washington.

A member of the selection committee for the monument saw Shrady's statuette of a riderless cavalry horse, *The Empty Saddle* (1900; National Gallery of Art, Washington, D.C.), at the New York showroom of Theodore B. Starr and invited Shrady to enter the competition. One of Shrady's two sketch models was selected as the winning submission,[2] and in December 1905 his maquette was approved by the Art Commission of the City of New York.[3] In *George Washington at Valley Forge* the somber commander-in-chief is depicted mounted on his horse, dressed in a Continental uniform, and enveloped in a heavy cloak during the bleak winter of 1777–78, when his troops were bivouacked at Valley Forge, Pennsylvania. It is the figure of the horse that gives expression to the composition, however, for with lowered head and thrown-back ears, the animal meets the severe, windy conditions.

The heroic-size sculpture on a granite base was unveiled at the Brooklyn Plaza of the Williamsburg Bridge (now Continental Army Plaza) on September 29, 1906. As Shrady was working on *George Washington at Valley Forge,* he sought critique from Augustus Saint-Gaudens, who looked at photographs of the work in progress and wrote, "I congratulate you on the lines, sentiment and character of the group, it is admirable from every point of view."[4] Shrady was commissioned to make a replica of this monument for Kansas City, Missouri, where it was dedicated in Washington Square Park in 1925.

245

The Metropolitan Museum's *George Washington at Valley Forge* is a replica of the maquette that was approved for the monument. In 1970 the artist's son, also named Henry, thought that four casts had been made of the statuette,[5] but there are more. In addition to the Metropolitan's bronze, which was purchased at Sotheby Parke-Bernet, New York, on January 25, 1974,[6] examples in public collections include those at the Bennington Museum, Bennington, Vermont; the Gilcrease Museum, Tulsa, Oklahoma; the Henry M. Flagler Museum, Palm Beach, Florida; and the Westmoreland Museum of American Art, Greensburg, Pennsylvania.

DJH

EXHIBITIONS

MMA, "New York City Public Sculpture by 19th-Century American Artists," June 18–September 29, 1974.

Brooklyn Museum, New York, October 13–December 30, 1979; National Collection of Fine Arts, Washington, D.C., February 22–April 20, 1980; Fine Arts Museums of San Francisco, M. H. de Young Memorial Museum, May 31–August 10, 1980;

Denver Art Museum, September 24–November 30, 1980, "The American Renaissance: 1876–1917," no. 268.

Federal Reserve Bank of New York, June 1982–January 1989.

Museum of the City of New York, "Celebrating George," February 22–October 22, 1989, no. 25.

Federal Reserve Bank of New York, November 1989–present.

1. "Washington's Statue Given to the City," *New York Times,* September 30, 1906, p. 9.
2. For an illustration of the original model, see Garrett 1903, p. 547.
3. Minutes of the Art Commission of the City of New York, 1905–7, December 12, 1905, submission no. 372, as cited in Lewis I. Sharp, *New York City Public Sculpture by 19th-Century American Artists,* exh. cat. (New York: MMA, 1974), p. 19. For an illustration of the monument, see p. 18.
4. Saint-Gaudens to Shrady, February 14, 1906 (copy), Shrady Papers, Archives of American Art, microfilm reel 647, frame 555.
5. Henry M. Shrady to John K. Howat, Curator, American Paintings and Sculpture, August 18, 1970, object files, MMA Department of American Paintings and Sculpture.
6. Sotheby Parke-Bernet, New York, sale cat., January 24–26, 1974, no. 385.

Alfred David Lenz (1872–1926)

Descended from German craftsmen, Lenz was born in Fond du Lac, Wisconsin, and as a young boy moved with his family to Appleton. At the age of fourteen, he became an apprentice to a local watchmaker. Lenz went to Milwaukee in 1889 and worked in a large manufacturing firm as a jeweler and engraver. Over the course of several years he attained full mastery of modeling, chasing, enameling, embossing, die sinking, and repoussé work. After a brief period of employment at the Gorham Company in New York, Lenz decided to pursue his interest in sculpture and traveled to Paris and London in 1893 for independent study. On his return, he settled briefly in Chicago, then San Francisco, and later in New York, where he was employed as a designer for several jewelry and advertising firms. Throughout his career, Lenz was an adventurer, frequently traveling to the American West and Central and South America, sometimes remaining for extended periods.

Lenz experimented extensively with casting both bronze alloys and precious metals through the lost-wax method. His innovative findings were compiled and published by the National Sculpture Society in 1933. Although he never considered himself a full-fledged sculptor, his decorative figures would earn him the laudatory epithet of a "modern Cellini." These miniature objects, including *Pavlova* (cat. no. 246), *Orchid Pearl* (ca. 1920; unlocated), and *Señorita Hootch* (1922; Newark Museum, Newark, N.J.), straddled the line between jewelry and sculpture; while they are free-flowing, they are also precise.

In 1925 the Architectural League of New York awarded Lenz the Avery Prize for his small sculpture *Star Dust* (unlocated). He died the following year in Havana, Cuba, and in 1928 the *Milwaukee Journal* held a memorial exhibition of Lenz's bronze work at its Gallery of Wisconsin Art.

DJH

SELECTED BIBLIOGRAPHY

Lenz, Alfred, Papers. Archives of American Art, Smithsonian Institution, Washington, D.C., microfilm reel D24.

"New Method Revolutionizes the Casting of Art Objects." *Sun* (New York), February 27, 1916, sec. 6, p. 2.

Price, F. Newlin. "Cellini and Alfred Lenz: A Comparison of the Work of Two Famous Craftsmen." *Arts and Decoration* 23 (June 1925), pp. 21, 64, 66.

"Journal Shows Lenz Bronzes: Memorial Exhibition Called Work of a 'Second Cellini.'" *Milwaukee Journal,* August 19, 1928, sec. 7, p. 4.

Lenz, Hugh F. *The Alfred David Lenz System of Lost Wax Casting.* New York: National Sculpture Society, 1933.

246. *Pavlova,* 1916

Bronze
8 x 2¼ x 2¼ in. (20.3 x 5.7 x 5.7 cm)
Signed (back of base): © LENZ·
Dated and inscribed (right side of base): 1916 NY
Rogers Fund, 1920 (20.17)

THIS DELICATE figure of the renowned Russian ballerina Anna Pavlova (1881–1931) was the first sculpture that Lenz completed after experimenting with lost-wax casting techniques in 1915–16. The inspiration for this composition was a solo dance or divertissement entitled *The Dragonfly,* which Pavlova choreographed to the music of violinist Fritz Kreisler's *Schön Rosmarin.*[1] She first performed *The Dragonfly* at the Century Opera House in New York on February 2, 1915, and also featured the dance the following year during her six-month engagement at the Hippodrome.[2]

Although Pavlova actually posed for this sculpture,[3] Lenz may also have been influenced by innovative publicity photographs of the dancer in her costume for *The Dragonfly* that were taken in 1916 by Hill Studios. Pavlova was photographed before a floor-to-ceiling black backdrop that enhanced the effect of suspended animation.[4] These images caused a sensation in New York, and one reviewer credited Pavlova for taking "the lead for dancing photography. . . ." The writer continued, "Her series of poses that have been switched upside down, sideways or at odd angles—to represent flying and floating in midair—

246

are astounding."[5] Lenz tried to create a similar illusion in his jewel-like statuette by using the drapery as a structural support so that the darting winged figure, with extended arms and pointed toes, soars above the base. The curvilinear design of the diminutive *Pavlova* is reminiscent of the flowing lines and organic forms found in contemporaneous Art Nouveau sculpture and jewelry.

Pavlova was first exhibited in 1919–20 at the winter exhibition of the National Academy of Design.[6] Daniel Chester French (pp. 326–41) saw the work on display and subsequently recommended it to fellow members of the Metropolitan Museum trustees' Committee on Sculpture for purchase.[7] He wrote enthusiastically of *Pavlova* to trustee William Church Osborn: "Aside from the distinct charm that the little figure has, it is probably the most remarkable piece of bronze casting that has ever been done by mortal man, and . . . it would be a very valuable addition to our collection."[8]

Pavlova was cast by the sculptor himself. The piece, with its integral base, is mounted on a green marble block, 4 inches high.

Pavlova is also the subject of three sculptures by Malvina Hoffman in the Metropolitan's collection (cat. nos. 366, 367, 370). DJH

EXHIBITIONS

Pennsylvania Academy of the Fine Arts, Philadelphia, "One Hundred and Fifteenth Annual Exhibition of the Pennsylvania Academy of the Fine Arts," February 8–March 28, 1920, no. 436, as "Pavlowa."

Vincent Astor Gallery, Library and Museum of the Performing Arts of the New York Public Library at Lincoln Center, New York, "Dance in Sculpture," February 1–April 29, 1971.

Philadelphia Art Alliance, "Dance in Sculpture," November 4–29, 1971.

1. See John and Roberta Lazzarini, *Pavlova: Repertoire of a Legend* (New York: Schirmer Books, 1980), p. 143.
 Michele Cohen provided research assistance on Lenz.
2. Lazzarini, *Pavlova*, p. 143.
3. Lenz to Henry W. Kent, Secretary, MMA, January 25, 1920, MMA Archives, in which the sculptor acknowledges Pavlova's help in executing this work.
4. For illustrations of two of the Hill Studios photographs of Pavlova in *The Dragonfly*, see Lazzarini, *Pavlova*, pp. 142–43.
5. *New York Review*, December 30, 1916, quoted in Lazzarini, *Pavlova*, p. 143.
6. *Catalogue, National Academy of Design Winter Exhibition* (New York, 1919), p. 12, no. 37, as "Pavlowa."
7. French to Edward Robinson, Director, MMA, January 9, 1919 [1920] (copy), MMA Archives.
8. French to Osborn, December 19, 1919 (copy), Daniel Chester French Family Papers, Manuscript Division, Library of Congress, Washington, D.C., microfilm reel 5, frame 443.

Frederick George Richard Roth (1872–1944)

Born in Brooklyn, Roth grew up in Bremen, Germany, where his father established a business as a cotton broker. He attended school in Bremen and worked as a photographer's assistant before enrolling in 1890 at the Imperial Academy of Fine Arts, Vienna, under Edmund von Hellmer. From 1892 to 1894, Roth received instruction in animal sculpture from Paul Meyerheim at the Royal Academy in Berlin and studied anatomy at a local veterinary school.

In 1900 Roth returned to the United States and met Karl Bitter (pp. 489–95), who employed him to model animals over a period of three years. Roth's three groups for the Pan-American Exposition of 1901 in Buffalo, notably his ambitious *Roman Chariot Race*, enhanced his artistic reputation greatly. No doubt it contributed toward the Metropolitan Museum's decision to purchase a group of his small animal bronzes in 1906, the first institution to do so.

Roth was a consistent participant in the numerous world's fairs in the early twentieth century, contributing both small groups and architectural sculpture. He earned silver medals for his work at Saint Louis in 1904 and at Buenos Aires in 1910. In 1915 Roth received a gold medal for his sculpture (including fourteen bronze statuettes) at the Panama-Pacific International Exposition in San Francisco. To crown two triumphal arches at the east and west entrances of the fair's Court of the Universe, he collaborated with Alexander Stirling Calder (pp. 528–31) and Leo Lentelli on monumental groups representing the progress of nations of the East and the West. For these, Roth contributed the animal sculpture, as well as figures for *The Alaskan*.

Roth maintained an active presence in New York artistic organizations, but he lived in Englewood, New Jersey, for much of his career. He taught at the National Academy of Design from 1910 to 1919 (he had been elected an academician in 1906) and served a term as president of the National Sculpture Society in 1919–20. An active member of the Society of Animal Painters and Sculptors, formed in 1920 to promote the art of American animaliers, Roth exhibited with this group on several occasions.

Though Roth made his name with his enchanting small bronze animals, in the first decade of the twentieth century he began producing ceramic figures, tiles, and bowls. Doulton Potteries later produced a number of his small animals in a variety of colorful glazes. Roth also created useful objects in bronze with animal motifs, such as andirons and bookends. He executed the occasional portrait or equestrian subject; his best-known effort of the latter genre was the bronze equestrian *George Washington* (1928; Morristown, N.J.).

Roth was an accomplished animalier of lifesize figures, many of which are in New York City. In 1924 the *Columbia Lion* was installed at Columbia University's Baker Field, a twenty-fifth anniversary gift of the class of 1899. Roth's most recognized work today is his bronze sculpture *Balto* (1925; East Drive at 66th Street, Central Park), a memorial to the Siberian husky that died from its heroic efforts in leading a dogsled team through perilous arctic conditions to get diphtheria antitoxin to Nome, Alaska, in January 1925.

As chief sculptor for the New York Parks Department under the Works Progress Administration between 1934 and 1936, Roth produced outdoor sculptures for Central Park, including *Dancing Goat* and *Honey Bear* (ca. 1935; Central Park Zoo); the *Sophie Irene Loeb Fountain* (1936; James Michael Levin Playground) with an Alice in Wonderland theme; and *Mother Goose* (1938; Mary Harriman Rumsey Playground) with low-relief scenes from nursery rhymes on the base. He also modeled limestone panels of various animals for the Central Park Zoo (as well as for Brooklyn's Prospect Park Zoo), which reflect his earlier designs for ceramic tiles for Grueby Pottery of Boston. These five projects, plus *Balto,* make Roth the most-represented sculptor in Central Park. DJH

SELECTED BIBLIOGRAPHY

Hoeber, Arthur. "Mr. Roth's Ceramics." *International Studio* 36 (January 1909), pp. LXXXV–LXXXVI.

Wells, Griffith T. "Frederick G. R. Roth, N.A., Interpreter of Animals: His Work in Tiles and Bronzes." *Arts and Decoration* 2 (April 1912), pp. 222–24.

"Animal and Other Sculpture of Frederick G. R. Roth." *Art World and Arts and Decoration* 9 (October 1918), pp. 346, 348.

Lockman, DeWitt McClellan. Interview with Frederick George Richard Roth, 1927. Transcript, Manuscripts Department, New-York Historical Society. Microfilmed for DeWitt McClellan Lockman Papers, Archives of American Art, Smithsonian Institution, Washington, D.C., reel 504, frames 440–58.

Osterkamp, F. E. "F. G. R. Roth, N.A., Sculptor." *The Studio* 93 (May 1927), pp. 322, 324–27, 329.

von Roth, Roger. "Frederick G. R. Roth, Seventh President, National Sculpture Society, 1919–1920." *National Sculpture Review* 13 (Fall 1964), pp. 17, 28–29.

247. *Performing Elephant,* 1902

Bronze, ca. 1906
6⅜ x 6 x 3 in. (16.2 x 15.2 x 7.6 cm)
Signed and dated (back of tub): copyrighted 1902 by / F.G.R. ROTH
Foundry mark (back of tub): ROMAN BRONZE WORKS N.Y.
Cast number (underside of tub): M.1 N11.
Rogers Fund, 1906 (06.401)

248. *Performing Elephant,* 1902

Bronze, ca. 1906
6 x 4¾ x 3 in. (15.2 x 12.1 x 7.6 cm)
Signed and dated (back of tub): copyrighted 1902 by / F.G.R. ROTH
Foundry mark (back of tub): ROMAN BRONZE WORKS N.Y.
Cast number (underside of tub): M.2 N12
Rogers Fund, 1906 (06.402)

ROTH ENJOYED modeling animals in a variety of activities, from a domestic pet tearing pages from a book (R. W. Norton Art Gallery, Shreveport, La.)[1] to trained circus beasts engaged in stunts. These two *Performing Elephants* were conceived as companions, and they reveal the sculptor's special talent for modeling small bronzes.

Roth spared no detail in his naturalistic representation of the cumbersome animals with heavy, leathery hides, as they struggle endearingly to perch on wooden tubs, their tremendous weight balanced on just two legs. Charles Caffin wrote appreciatively of the pair: "Although they are very small in size they are large in feeling. . . . The expression

247

248

of movement is admirable. . . . These little objects of art make very choice appeal to sight and touch."[2]

Roth apparently modeled several small elephants while in Europe before commencing a trio of elephants in 1902. The elephant standing on its forefeet (cat. no. 248) was reportedly made from earlier studies at the Winter Garden in Berlin while the one balancing on its hind legs (cat. no. 247) was possibly the one Roth identified as modeled after "Hattie" in the Central Park Zoo.[3] A third elephant of 1902, in a majestic trumpeting pose, is restricted by heavy chains around two legs.[4] DJH

EXHIBITIONS

Army Air Forces Convalescent Center and Station Hospital, Pawling, N.Y., April 1944–February 1945 (cat. no. 248 only).
MMA, Junior Museum, "Circus Parade," April 6, 1946–September 16, 1948.

Milwaukee Art Institute, Milwaukee, Wis., for Children's Art Program of the Junior League, October 15–December 4, 1955.
Staten Island Institute of Arts and Sciences, New York, April 1971–March 1977.
Staten Island Institute of Arts and Sciences, New York, "Sully to Sargent: 19th-Century American Paintings and Bronzes from The Metropolitan Museum of Art," March 29–May 8, 1977, nos. 13a, b; loan extended through May 1978.

1. For an illustration of *Dog Tearing Pages from a Book,* see *American Sculpture: A Tenth Anniversary Exhibition,* exh. cat. (Shreveport, La.: R. W. Norton Art Gallery, 1976), p. 26.
2. Charles H. Caffin, *American Masters of Sculpture* (New York: Doubleday, Page and Co., 1903), pp. 199–200.
3. Lockman interview, 1927, p. 19, Archives of American Art, microfilm reel 504, frame 458.
4. For an illustration of *Elephant,* see Sotheby's Arcade, New York, sale cat., October 30, 1996, no. 157.

249. *Polar Bear*, 1903

Bronze, ca. 1906
6¾ x 11½ x 4½ in. (17.1 x 29.2 x 11.4 cm)
Signed and dated (top of base): Copyright 1903 by / Fred G. R. Roth
Foundry mark (back of base): ROMAN BRONZE WORKS N.Y.
Cast number (underside of base): 3.
Rogers Fund, 1906 (06.400)

P_{OLAR} B_{EAR} is probably Roth's first study of this impressive animal, which he must have encountered on visits to city zoos here and abroad. Here Roth emphasized the characteristic silhouette of the bear, whose easy, lumbering gait is associated with the animal.

Bears, both wild and trained, were a frequent subject in Roth's oeuvre. In 1906, he was elected to the National Academy of Design on the merit of his *Polar Bears* (ca. 1905; Detroit Institute of Arts), a piece Lorado Taft called "one of the classics of American sculpture."[1] Roth was later commissioned by the Bowdoin College class of 1912 to model a colossal polar bear (1937), which was carved in granite and placed in front of Bowdoin's Sargent Gymnasium, Brunswick, Maine, in 1938. The class selected this animal because during its freshman year Admiral Robert Edwin Peary, Bowdoin class of 1877, reached the North Pole.[2]

Polar Bear and six other animal statuettes by Roth were acquired in 1906 during an ambitious campaign led by Museum trustee Daniel Chester French (pp. 326–41) to build a collection of small bronzes.[3] Roman Bronze Works foundry records for August 2, 1906, list a group of bronzes whose numbers match those on the Metropolitan pieces.[4] Whether the date refers to casting, placement of order, or receipt of payment is not known, but it suggests that the Metropolitan statuettes were cast about 1906.

Additional casts of *Polar Bear* are at the Fine Arts Museums of San Francisco and the Cranbrook Art Museum, Bloomfield Hills, Michigan. DJH

EXHIBITION

Halloran General Hospital, Staten Island, N.Y., July 1947–February 1948.

1. Lorado Taft, *The History of American Sculpture,* rev. ed. (New York: Macmillan, 1924), p. 566.
2. Roth's obituary, *New York Times,* May 24, 1944, p. 19.
3. One of these pieces, *Wolfhound,* was deaccessioned in 1993.
4. Roman Bronze Works Archives, Amon Carter Museum, Fort Worth, ledger 2, p. 72.

250. *Performing Bear,* 1903

Bronze, ca. 1906
9½ x 2¾ x 4 in. (24.1 x 7 x 10.2 cm)
Signed and dated (back of base): copyright 1903 by / F.G.R. ROTH
Foundry mark (left side of base): ROMAN BRONZE WORKS
Rogers Fund, 1906 (06.403)

PERFORMING BEAR was most likely modeled after a
tamed animal Roth saw in a circus act, either in the United
States or in Europe. Delightful in its imitation of the erect
stance of a human being, this piece is a whimsical treat-
ment of an animal that seems to be dancing. Indeed, it
addresses behavior far removed from the aggressive, often
violent conceptions of foremost French animalier Antoine-
Louis Barye. Playful compositions such as *Performing Bear*
offered a lighter alternative in which capriciousness was
emphasized over physical aggression.

Roth executed several other fanciful ursine subjects
over the course of his career. *Bear Playing* (R. W. Norton
Art Gallery, Shreveport, La.) depicts the seated animal be-
musedly reaching for its hind paw.[1] During Roth's years,
1934–36, as chief sculptor for the New York Parks Depart-
ment under the Works Progress Administration, he com-
pleted a fountain piece entitled *Honey Bear* (ca. 1935;
Central Park Zoo),[2] which relates to the earlier *Performing
Bear* in the standing pose and playful attitude.

The surface of this bronze is especially rich in its articu-
lation of the bear's heavy fur coat. DJH

EXHIBITIONS

MMA, Junior Museum, "Circus Parade," April 6, 1946–September 16,
1948.
Staten Island Institute of Arts and Sciences, New York, April 1971–
March 1977.
Staten Island Institute of Arts and Sciences, New York, "Sully to
Sargent: 19th-Century American Paintings and Bronzes from
The Metropolitan Museum of Art," March 29–May 8, 1977,
no. 13c; loan extended through May 1978.

1. *American Sculpture: A Tenth Anniversary Exhibition,* exh. cat. (Shreve-
port, La.: R. W. Norton Art Gallery, 1976), p. 26.
2. Margot Gayle and Michele Cohen, *The Art Commission and the
Municipal Art Society Guide to Manhattan's Outdoor Sculpture* (New
York: Prentice Hall Press, 1988), p. 199.

251. *Pig Tied to a Stake,* 1903

Bronze, ca. 1906
3¼ x 7 x 2¾ in. (8.3 x 17.8 x 7 cm)
Signed and dated (back of base): Fred G.R. Roth copyright 1903
Foundry mark (front of base): ROMAN BRONZE WORKS N.Y.
Cast number (underside of base): M.1 N5.
Rogers Fund, 1906 (06.404)

252. *Pig Scratching,* 1903

Bronze, ca. 1906
3½ x 5 x 2½ in. (8.9 x 12.7 x 6.4 cm)
Signed and dated (back of base): F.G.R. Roth copyright 190[3, illegible].
Foundry mark (front of base): ROMAN BRONZE WORKS N.Y.
Cast number (underside of base): M2. N5.
Rogers Fund, 1906 (06.405)

ROTH OFTEN chose to portray entertaining snippets of animal life. In *Pig Tied to a Stake,* he showed the animal struggling to pull away from the stake to which its right hind leg is bound. The companion piece, *Pig Scratching,* depicts the animal in an awkward attempt to scratch itself against a post. Roth's careful rendering of these barnyard animals might have resulted from a visit to a slaughter-house on the Lower West Side of New York.[1] DJH

EXHIBITION

Queens Museum, New York, "The Artist's Menagerie: Five Millennia of Animals in Art," June 29–August 25, 1974, nos. 117, 118.

1. Lockman interview, 1927, p. 18, Archives of American Art, microfilm reel 504, frame 457.

251

252

253. *Tricky Paterboots Clark,* 1910

Bronze
5½ x 11⅛ x 4 in. (14 x 28.3 x 10.2 cm)
Signed and dated (back of base): FGR ROTH fec / 1910
Inscribed (top of base): Tricky Paterboots Clark
Foundry mark (right side of base): ROMAN BRONZE WORKS N.Y.
Gift of Ella Mabel Clark, 1910 (10.115)

ALTHOUGH LITTLE is known about *Tricky Paterboots Clark,* it is most likely a portrait of a dog owned by Ella Mabel Clark, the donor of the work. The collared pet may be a smooth-coated fox terrier[1] because it exhibits such features of the breed as a flat skull of moderate width; a long head with tapering nose; V-shaped ears that drop forward toward the cheek; a short back; and of course the straight, flat coat.[2] The dog is depicted lying down, a ball between its forelegs, its head up and alert, and ears cocked.

Roth was adept at modeling portraits of individual animals as well as capturing the salient characteristics of a species.[3] His dog likenesses, of a variety of breeds, include a statuette of a boxer entitled *Buddy*[4] and a lifesize statue of a Siberian husky, *Balto* (1925; Central Park, New York).[5]

DJH

EXHIBITION

Halloran General Hospital, Staten Island, N.Y., July 1947–February 1948.

1. Identification kindly provided by Jeff Dorl, American Kennel Club, New York.
2. Count Henry De Bylandt, *Dogs of All Nations: Their Varieties, Characteristics, Points etc.,* vol. 2, *Non-Sporting Dogs* (London: Kegan Paul, Trench Trübner and Co., 1905), pp. 6–10.
3. Wells 1912, p. 222.
4. For an illustration of this work, see James Graham and Sons, *The Animal in Sculpture,* exh. cat. (New York, 1987), p. 68.
5. See Margot Gayle and Michele Cohen, *The Art Commission and the Municipal Art Society Guide to Manhattan's Outdoor Sculpture* (New York: Prentice Hall Press, 1988), p. 202.

Bessie Potter Vonnoh (1872–1955)

A Saint Louis native, Bessie Onahotema Potter Vonnoh produced genre statuettes depicting domestic and feminine subjects that not only captured a refined segment of turn-of-the-twentieth-century society but also contributed to the vitalization of small bronze sculpture in America. In 1886 she enrolled at the Art Institute of Chicago and studied drawing and painting on and off during the next several years. There she took modeling classes with the sculptor Lorado Taft and later assisted him with decorative sculpture for the World's Columbian Exposition of 1893, one of a group of talented women apprentices. Potter also modeled an allegorical figure, *Art,* for the Illinois State Building.

In 1894 Potter set up a studio in Chicago and began her professional career. Recognition came first with subtly tinted plaster portraits of society ladies and figures of contemporary women in Gibson-girl dress that the sculptor called "Potterines." *An American Girl* (ca. 1895; Amon Carter Museum, Fort Worth) is not an individual but a type, fulfilling Potter's objective: "What I wanted was to look for beauty in the every-day world, to catch the joy and swing of modern American life" (Vonnoh 1925, p. 9). Potter's plastic, impressionistic handling of surface in which detail is secondary to touch was a hallmark of her mature style and reflects a familiarity with current French academic practice.

In 1895 Potter traveled to Paris and visited Auguste Rodin in his studio. The following year she modeled her most successful effort, *A Young Mother* (cat. no. 254), which has defined her artistic identity to this day. Similar maternal compositions followed, as did graceful statuettes of modern-day women reading and dancing (see *Girl Dancing,* cat. no. 255). Her most impressionistic composition, *Daydreams* (1898; Corcoran Gallery of Art, Washington, D.C.), depicting two girls lounging on a sofa, parallels the contemporaneous paintings of female leisure by Edmund Tarbell and Thomas Wilmer Dewing. After 1907 Bessie Potter Vonnoh increasingly garbed her dancers in generalized classical dress, and compositions such as *The Scarf* (1908; Museum of Fine Arts, Boston) elicited comparison to ancient Tanagra figurines. The popularity of these genre pieces was fueled by their exhibition and the critical reception accorded them at venues such as the National Academy of Design, the Society of American Artists, the National Sculpture Society, and the Pennsylvania Academy of the Fine Arts. Furthermore, the large editions of casts produced beginning in the early years of the twentieth century, primarily by Roman Bronze Works, confirm that Vonnoh's artistic standing was secure.

After an eight-month trip to Europe in 1897, Vonnoh moved to New York and began work on a commission for a colossal bust of Major General S. W. Crawford for the *Smith Memorial* in Philadelphia's Fairmount Park. She also created a statue of the actress Maude Adams known as *The American Girl,* intended for the Exposition Universelle of 1900 in Paris. After bringing these projects close to completion, in 1899 she married the portrait and landscape painter Robert W. Vonnoh, whom she had met in Lorado Taft's studio. Their careers became closely linked, and they frequently exhibited together in two-artist shows, including ones in 1913 at Montross Galleries, New York, and in 1916 at the City Art Museum, Saint Louis. Bessie Potter Vonnoh also had solo exhibitions; most significant were those at the Corcoran Gallery of Art, Washington, D.C., in March 1910 and the Brooklyn Institute of Arts and Sciences (now Brooklyn Museum of Art) in March 1913. She was a member of the Lyme Art Association, in the Connecticut town where she and her husband had a summer home. Vonnoh was elected a full academician at the National Academy in 1921, that year earning its Elizabeth N. Watrous Gold Medal for *Allegresse* (Detroit Institute of Arts).

In the 1920s Vonnoh turned principally to lifesize fountain pieces, following in the footsteps of Janet Scudder (pp. 525–27). The *Theodore Roosevelt Memorial Bird Fountain* (1924–27), a birdbath with two children, animals, and birds, is in the Theodore Roosevelt Memorial Sanctuary, Oyster Bay, New York. The thematically similar *Frances Hodgson Burnett Memorial Fountain* (1926–32) was dedicated in 1937 in the Conservatory Garden of Central Park. After her husband's death in 1933 in the south of France, Vonnoh's sculptural output diminished. She remarried in 1948. Her husband, Dr. Edward L. Keyes, died after only nine months of marriage, and she survived him for six years. The Corcoran Gallery, which received a bequest from Vonnoh, has the largest public holding of her sculptures.

TT

SELECTED BIBLIOGRAPHY

Vonnoh, Bessie Potter, Papers. Archives of American Art, Smithsonian Institution, Washington, D.C., unmicrofilmed.

Monroe, Lucy. "Bessie Potter." *Brush and Pencil* 2 (April 1898), pp. 29–36.

Zimmern, Helen. "The Work of Miss Bessie Potter." *Magazine of Art* 24 (1900), pp. 522–24.

Semple, Elizabeth Anna. "The Art of Bessie Potter Vonnoh." *Pictorial Review* 12 (April 1911), pp. 12–13.

Vonnoh, Bessie Potter. "Tears and Laughter Caught in Bronze: A Great Woman Sculptor Recalls Her Trials and Triumphs." *The Delineator* 107 (October 1925), pp. 8–9, 78, 80, 82.

Conner, Janis, and Joel Rosenkranz. *Rediscoveries in American Sculpture: Studio Works, 1893–1939,* pp. 161–67. Austin: University of Texas Press, 1989.

Aronson, Julie Alane. "Bessie Potter Vonnoh (1872–1955) and Small Bronze Sculpture in America." Ph.D. diss., University of Delaware, 1995.

254. *A Young Mother,* 1896

Bronze, ca. 1906
14 x 12½ x 15½ in. (35.6 x 31.8 x 39.4 cm)
Signed, dated, and inscribed with cast number (top of base, back): *Bessie O. Potter / 1896 / Copyright / No. VI.*
Foundry mark (back of base): *Roman Bronze Works N.Y.*
Rogers Fund, 1906 (06.306)

A YOUNG MOTHER synthesizes impressionistic handling of form with realistic emotion to produce one of the most sensitive studies of the mother-and-child theme in American sculpture.[1] With the instant popular success of this piece after it was modeled in 1896, Vonnoh's name became synonymous with sculptural representations of motherhood in which psychological mood takes precedence over physical description. This intimate group depicts a new mother sitting in a rocking chair with an infant in her arms. The intense love she feels for the child is expressed though her enveloping embrace of the baby and her tender gaze downward. Only after this emotional bond is perceived does one notice other charming aspects: the open neck of the mother's gown and her foot resting on a stool each enhance the naturalism of the composition.

In their details, the faces of the mother and child are both indistinct—in the Metropolitan's cast the baby's eyes are but faint indentations on the surface. The blanket draped over the sides and back of the chair melds into the mother's skirt and further into the baby's dress. This abundance of fabric softens the composition both materially and emotionally. However, a convincing sense of bodily form is discernible beneath the undulating folds.

Vonnoh's selection of the mother-and-child theme, as a critic noted, "is the oldest of all subjects and the newest."[2] While many earlier sculptors focused on its religious or mythological associations (William Rinehart's *Latona and Her Children, Apollo and Diana* [cat. no. 44], for instance), Vonnoh found that everyday life had potential for meaningful expression. The work of the French Beaux Arts sculptor Jules Dalou provided a model for Vonnoh, particularly his widely known compositions such as *Maternal Joy* and *Seated Woman Reading* that were cast as porcelain statuettes by Sèvres.[3]

Vonnoh modeled *A Young Mother* between September and December 1896, with her friend Margaret Gerow Proctor, wife of Alexander Phimister Proctor (pp. 412–20), posing as the mother.[4] She showed the statuette first at the Pennsylvania Academy of the Fine Arts annual exhibition in 1896 and thereafter frequently during her career. It was a consistent prizewinner; she was awarded a bronze medal at the Exposition Universelle of 1900 in Paris and an honorable mention at the Pan-American Exposition of 1901 in Buffalo.[5] In 1921 Vonnoh submitted *A Young Mother* as her diploma piece after she was elected an academician of the National Academy of Design.

A Young Mother was first cast in bronze in 1899 by the Henry-Bonnard Bronze Company. The Museum's cast of *A Young Mother* and two other works by Vonnoh, *Girl Dancing* and *His First Journey* (cat. nos. 255, 256), were purchased through the Rogers Fund in 1906. Casting records from Roman Bronze Works suggest that the three pieces may have been ordered at the same time; they are listed with their cast numbers in the ledger books on June 20 and 29, 1906.[6] By July 11 they had arrived at the Museum, their accession reinforcing the institution's steadily growing collection of small bronzes.[7] The acquisition of these three pieces and *Enthroned* (cat. no. 257) within the same year attests to the high esteem in which Vonnoh and her statuettes were held, for she then was represented more extensively in the Museum's collection than any other American woman sculptor.

Vonnoh estimated that there were thirty bronze casts of *A Young Mother,*[8] among them those in the collections of the Art Institute of Chicago; the Corcoran Gallery of Art, Washington, D.C.; the Fort Worth Museum of Modern Art; the Indianapolis Museum of Art; the Montclair Art Museum, Montclair, New Jersey; the Pennsylvania Academy of the Fine Arts, Philadelphia; the San Diego Museum of Art; and the Forest Lawn Museum, Glendale, California.[9]

TT

EXHIBITIONS

Sheldon Swope Art Gallery, Terre Haute, Ind., January 1948–February 1956.
MMA, "19th-Century America," April 16–September 7, 1970, no. 199.
Whitney Museum of American Art, New York, "200 Years of American Sculpture," March 16–September 26, 1976, no. 309.
Grey Art Gallery and Study Center, New York University, "Changes in Perspective: 1880–1925," May 2–June 2, 1978.
MMA, Henry R. Luce Center for the Study of American Art, "Bronze Casting," June 11–November 3, 1991.

1. For an early account of this theme, see Frank Owen Payne, "Motherhood in American Sculpture," *Art and Archaeology* 12 (December 1921), pp. 253–63.
2. Monroe 1898, p. 34.
3. For Dalou, see Peter Fusco and H. W. Janson, eds., *The Romantics to Rodin: French Nineteenth-Century Sculpture from North American*

254

Collections, exh. cat. (Los Angeles: Los Angeles County Museum of Art, 1980), pp. 185–99. See also Aronson 1995, pp. 149–54.

4. Aronson 1995, p. 140.

5. *Exposition universelle de 1900: Catalogue officiel illustré de l'exposition décennale des beaux-arts de 1889 à 1900* (Paris: Imprimeries Lemercier; Ludovic Baschet, 1900), p. 298, no. 68, as "Une jeune Mère"; and *Pan-American Exposition: Catalogue of the Exhibition of Fine Arts* (Buffalo: David Gray, 1901), p. 72, no. 1661.

6. Roman Bronze Works Archives, Amon Carter Museum, Fort Worth, ledger 2, p. 75.

7. Patrick H. Reynolds, Registrar, MMA, list of recently accessioned bronzes at the Museum, July 11, 1906, MMA Archives.

8. Unsigned notes from conversation with Vonnoh, November 3, 1934, object catalogue cards, MMA Department of American Paintings and Sculpture.

9. Aronson 1995, p. 491.

255. *Girl Dancing*, 1897

Bronze, ca. 1906
14 x 12 x 8 in. (35.6 x 30.5 x 20.3 cm)
Signed, dated, and inscribed with cast number (top of base, back): *Bessie O Potter. / 1897 / No X. / Copyright*
Foundry mark (left side of base): *Roman Bronze Works N.Y.*
Rogers Fund, 1906 (06.305)

MODELED IN 1897, *Girl Dancing* is one of Vonnoh's earliest renditions of the solitary female in motion. It was a theme that preoccupied her for over fifteen years, culminating in *In Grecian Draperies* (1913; Corcoran Gallery of Art). In these compositions, which are often confused, Vonnoh explored the possibilities of movement and the resulting play of drapery. In *Girl Dancing,* motion in all directions is implied: as the dancer steps forward, pointing with her right foot, she sweeps her gown back with her left hand; as she pulls her skirt up with her right hand, she glances down. The fluid modeling of the figure is in keeping with Vonnoh's tendency to forego detail and seems at odds with the refinement of the subject. The skirt is particularly roughly treated, so much so that it retains the tactility of clay, rather than the light, gauzy material one expects.

Although lacking in finish, *Girl Dancing* exudes charm. "The personification of the modern skirt dance, it has its grace of line, its sinuousness of movement, its rhythm."[1] Vonnoh's graceful dancing figures were compared to Tanagra statuettes, which are similar in their movement and rendering of daily customs. Vonnoh denied studying them when she first began to produce her statuettes, but after 1907 she was increasingly drawn to Greek-inspired dress for her dancing women. Even in *Girl Dancing,* modeled a decade earlier, Vonnoh diverged from what she termed "the atrocious fashions of the day."[2] The Metropolitan's figure wears a simple, high-waisted dress with short sleeves and a ribbon, neither overtly contemporary nor classical. It seeks the middle ground that the novelist William Dean Howells felt expressed much of her sculpture: "her work, while it is as Greek as the Tanagra figurines, is as utterly and inalienably American as you are, and perfectly modern."[3]

Vonnoh's choice of subject was also timely. With the success of dancers Isadora Duncan, Loïe Fuller, and Anna Pavlova, there was a vogue for statuettes of dancers at the turn of the twentieth century. Vonnoh, Harriet Whitney Frishmuth (pp. 640–43), and others met the demand for portrayals of lithe figures in action.

Vonnoh sent *Girl Dancing* to the Paris Exposition Universelle in 1900.[4] She later recalled that there were forty-five examples;[5] other casts in public collections are at the Art Institute of Chicago; the Corcoran Gallery of Art, Washington, D.C.; and the Sheldon Memorial Art Gallery and Sculpture Garden, Lincoln, Nebraska. T T

EXHIBITIONS

Elvehjem Art Center, University of Wisconsin, Madison, December 1975–December 1976.
MMA, Costume Institute, "Dance," December 17, 1986–September 6, 1987.

1. Monroe 1898, pp. 33–34.

2. Vonnoh 1925, p. 9. For further discussion of Vonnoh's selection of costume, see Aronson 1995, pp. 170–72.

3. William Dean Howells to Larkin G. Mead, February 5, 1897, as published in Mildred Howells, ed., *Life in Letters of William Dean Howells,* vol. 2 (Garden City, N.Y.: Doubleday, Doran and Co., 1928), p. 75.

4. *Exposition universelle de 1900: Catalogue officiel illustré de l'exposition décennale des beaux-arts de 1889 à 1900* (Paris: Imprimeries Lemercier; Ludovic Baschet, 1900), p. 298, no. 69, as "Danseuse."

5. Unsigned notes from conversation with Vonnoh, November 3, 1934, object catalogue cards, MMA Department of American Paintings and Sculpture.

562 BESSIE POTTER VONNOH

256. *His First Journey*, 1901

Bronze, ca. 1906
4⅞ x 9 x 5 in. (12.4 x 22.9 x 12.7 cm)
Signed and dated (back of base): *Bessie Potter Vonnoh. 1901.*
Foundry mark (front of base): Roman Bronze Works N.Y.–
Cast number (top of base): No. X.
Rogers Fund, 1906 (06.307)

MODELED IN 1901, *His First Journey* revels in the delight and pride of the baby as he pushes himself up on his chubby arms as if to inch across a blanket. Although Vonnoh did not include an adult figure in the composition, the baby's triumph at learning to crawl is palpably shared by an onlooker, whose presence is indicated by the broad grin and upward glance on the little face.

His First Journey was part of Vonnoh's standard repertoire of exhibited statuettes. Casts were widely displayed, including at the Louisiana Purchase Exposition in 1904, the National Academy of Design in 1905, and the Panama-Pacific International Exposition in 1915.[1] According to the sculptor, the Metropolitan's cast was the tenth of thirty-nine examples,[2] but it is the only located bronze. A plaster is privately owned.[3] TT

1. See *Official Catalogue of Exhibitors: Universal Exposition, St. Louis, U.S.A., 1904 . . . Department B, Art,* rev. ed. (Saint Louis: Official Catalogue Co., 1904), p. 62, no. 2283, as "Creeping Baby"; *National Academy of Design Eightieth Annual Exhibition . . . Illustrated Catalogue* (New York, 1905), p. 58. no. 389; and *Official Catalogue of the Department of Fine Arts, Panama-Pacific International Exposition* (San Francisco: Wahlgreen Co., 1915), p. 246, no. 3063. In Saint Louis, Vonnoh was awarded a gold medal for her submissions, and in San Francisco, she received a silver medal.
2. Unsigned notes from conversation with Vonnoh, November 3, 1934, object catalogue cards, MMA Department of American Paintings and Sculpture.
3. Aronson 1995, p. 495.

257

257. *Enthroned,* 1902

Bronze, 1906
12 x 8 x 10 in. (30.5 x 20.3 x 25.4 cm)
Signed and inscribed with cast number (left side of base):
Bessie Potter Vonnoh / No. VI.
Foundry mark (top of base, back): *Roman Bronze Works N.Y.*
Gift of George A. Hearn, 1906 (06.298)

ENTHRONED's exploration of the theme of motherhood differs in spirit from related groups by Vonnoh. The mother is ensconced in a thronelike chair, centrally placed and static; an infant rests on her lap and a daughter stands on either side. She has an iconic presence, a quality reinforced by the traditional pyramidal shape of the composition and the implication of the piece's title. Although the children are posed naturally, the mother presents a Madonna-like aura, emphasizing the timelessness of the mother-and-child subject matter. Writers drew artistic comparisons to *Enthroned*: "In this charming piece she has produced in bronze the same dignity, and the same loveliness to be seen in the paintings of George DeForest Brush. 'Enthroned' has all the mystic charm of a madonna."[1] This linking of an ageless motif with modern life also finds parallels in Vonnoh's contemporaneous statuettes of dancing girls in Grecian dress.

Its interpretation notwithstanding, *Enthroned* is an engaging portrayal of the bond between mother and children. While not a portrait, the sitters have been identified as Helena Walter, a German immigrant, her daughters Helen and Josephine, and her infant son Charles.[2] The younger daughter leans backward into the shelter of her mother's lap, while the elder one looks quizzically at her infant sibling. As is common in Vonnoh's oeuvre, the subjects are united through the melting lines of flowing cloth.

When *Enthroned* was exhibited at the Society of American Artists in 1904, it earned the Julia A. Shaw Memorial Prize.[3] An award for the best work created by a woman, it accorded Vonnoh increased notice and respect, as well as membership in the society. She later recalled that twenty-one examples were produced,[4] including those in the

collections of the Corcoran Gallery of Art, Washington, D.C., and the Missouri Historical Society, Saint Louis.

The Metropolitan's example, inscribed "No. VI.," was cast in 1906. It was the gift of George A. Hearn, a retailer and Museum trustee who provided generously for the purchase of paintings by living American artists. Writing to Museum trustee Daniel Chester French (pp. 326–41) on May 23, 1906, Hearn expressed his preference for a "noir vert" patina for the cast, adding, "I am glad to see a growing disposition to encourage the talent of our own country."[5] "Enthroned Mother #6" is recorded in the Roman Bronze Works ledgers on May 3 of the same year.[6]

TT

EXHIBITION

Staten Island Institute of Arts and Sciences, New York, "Sully to Sargent: 19th-Century American Paintings and Bronzes from The Metropolitan Museum of Art," March 29–May 8, 1977, no. 18; loan extended through May 1978.

1. Frank Owen Payne, "The Work of Some American Women in Plastic Art," *Art and Archaeology* 6 (December 1917), p. 316. Vonnoh's statuettes were also compared to the paintings of Abbott H. Thayer.
2. Aronson 1995, p. 234.
3. *Twenty-sixth Annual Exhibition of the Society of American Artists* (New York, 1904), p. 66, no. 397.
4. Unsigned notes from conversation with Vonnoh, November 3, 1934, object catalogue cards, MMA Department of American Paintings and Sculpture.
5. Hearn to French, May 23, 1906, Daniel Chester French Family Papers, Manuscript Division, Library of Congress, Washington, D.C., microfilm reel 1, frame 455. Julie Aronson kindly brought this reference to my attention and read an early draft of the biography and catalogue entries.
6. Roman Bronze Works Archives, Amon Carter Museum, Fort Worth, ledger 2, p. 74.

Henri Crenier (1873–1948)

Henri Crenier trained in his native Paris at the École des Beaux-Arts with the sculptor Jean-Alexandre-Joseph Falguière, who was a close relative. In 1892 Crenier became a member of the Société des Artistes Français and regularly exhibited his portrait busts in the annual Salons, winning an honorable mention in 1897 with his *Jeune fille endormie* (unlocated).

Crenier relocated to New York in 1902 at the encouragement of a fellow Falguière pupil, Hermon Atkins MacNeil (pp. 475–81). For a time, he assisted MacNeil in his College Point, Queens, studio on the large-scale *Fountain of Liberty* intended for the 1904 Louisiana Purchase Exposition in Saint Louis. Crenier became an American citizen in 1911, having established his reputation as an architectural and monumental sculptor. His most impressive effort is the extensive program—including pediments, caryatids, and interior rotunda sculptures—executed for the new San Francisco City Hall (1913–15), erected following the city's earthquake and fire in 1906. Among Crenier's numerous other public commissions are the *James Fenimore Cooper Memorial* (Scarsdale, N.Y.) and the *Christopher Columbus Memorial* (Mamaro-

neck, N.Y.). Crenier also collaborated with such architects as Charles Wellford Leavitt and Thomas Hastings, creating fountains and garden pieces for private estates such as those for Alfred I. du Pont of Wilmington, Delaware, and Charles M. Schwab of Loretto, Pennsylvania. A frequent exhibitor of small bronze statuettes, the sculptor garnered an honorable mention when he exhibited his *Girl and Butterflies* (unlocated) at the 1915 Panama-Pacific International Exposition in San Francisco.

For over fifteen years Crenier maintained an estate in Shore Acres, Mamaroneck, and had studios there and in New York City. In the mid-1930s he became involved with government-sponsored WPA projects and moved back to New York, where he resided until his death. TT

SELECTED BIBLIOGRAPHY

Obituary. *New York Times,* October 3, 1948, p. 66.
Falk, Peter Hastings, ed. *Who Was Who in American Art, 1564–1975: 400 Years of Artists in America,* vol. 1, p. 772. Madison, Conn.: Sound View Press, 1999.

258. *Boy and Turtle,* 1912

Bronze
19¾ x 11 x 11 in. (50.2 x 27.9 x 27.9 cm)
Signed (top of base, back): *H. Crenier*
Foundry mark (left side of base): ROMAN BRONZE WORKS N–Y–
Amelia B. Lazarus Fund, 1913 (13.87)

BOY AND TURTLE succinctly demonstrates Crenier's adherence to the Beaux Arts sculptural principles inculcated early in his career. The animated pose of the nude and the expressive treatment of the green-brown bronze surface are not unlike works of his teacher Falguière, such as *Victor of the Cock Fight* (Salon of 1864; Musée d'Orsay, Paris). The boy's unbalanced stance and splayed fingers and toes reveal a momentary sense of surprise as he and his small foe confront one another. The emotional resonance of *Boy and Turtle* is further enhanced by the raised leg of the near-defenseless reptile. Crenier's younger son, Guy, recalled that when his older brother, Pierre, then twelve, posed for the piece, the sculptor placed a box under the

boy's foot to allow him to maintain the spontaneous-seeming position.[1]

Modeled and cast in 1912, the Metropolitan Museum's *Boy and Turtle* was conceived as a demonstration fountain with the hope of attracting a commission for a full-scale garden piece. Yet Crenier also saw the statuette as a finished work, since a piping system under the base enables a small jet of water to spray upward from the turtle's mouth. In spite of the sculptor's original intentions, the frolicsome *Boy and Turtle* was purchased directly from him soon after it was included in the winter exhibition of 1912–13 at the National Academy of Design.[2] Metropolitan trustee Daniel Chester French (pp. 326–41), who most

likely spotted the work at the academy, wrote to Crenier: "I should be glad to see this charming group added to the collection of small bronzes at the Museum."[3]

In a 1933 letter to the Museum, the sculptor confirmed that the Metropolitan owned the first casting of *Boy and Turtle* and that "there were a few more sold by the Firm of Theodore B. Starr."[4] The ledger books of the Roman Bronze Works foundry document that seven *Boy and Turtle* statuettes were cast between 1914 and 1918,[5] perhaps including those distributed by Starr. A 12-inch version, dated 1916 and owned by a descendant of the sculptor, is the only other statuette of this composition that has come to light. During the 1910s *Boy and Turtle* was exhibited widely.[6]

In 1923 a lifesize (5 feet high) plaster cast was shown in Mount Vernon Place in Baltimore under the auspices of the National Sculpture Society. The Municipal Art Society of Baltimore decided to have a bronze version cast and donated it to the city.[7] It was installed in the center of the square, which had been relandscaped by Thomas Hastings, of the New York architectural firm Carrère and Hastings, in 1916.[8] TT

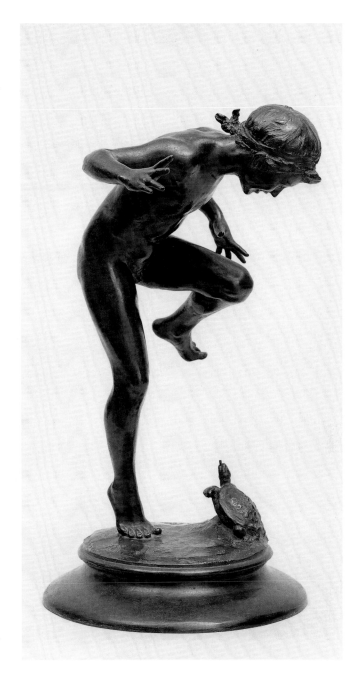

EXHIBITION

Parrish Art Museum, Southampton, N.Y., "Fauns and Fountains: American Garden Statuary, 1890–1930," April 14–June 2, 1985, no. 2.

1. Guy Crenier, telephone conversation with Ann Schoenfeld, April 2, 1984, notes in object files, MMA Department of American Paintings and Sculpture. Schoenfeld provided research assistance on Crenier.
2. *Illustrated Catalogue, National Academy of Design Winter Exhibition 1912* (New York, 1912), p. 22, no. 151.
3. French to Crenier, March 20, 1913 (copy), Daniel Chester French Family Papers, Manuscript Division, Library of Congress, Washington, D.C., microfilm reel 2, frame 142.
4. Crenier to Faith Dennis, MMA Catalogue Division, July 1, 1933, MMA Archives.
5. Roman Bronze Works Archives, Amon Carter Museum, Fort Worth, ledger 4, p. 268, and ledger 5, p. 282.
6. For instance, *Boy and Turtle* was included in a multivenue show, *Exhibition of Bronzes by American Sculptors,* under the auspices of the National Sculpture Society. During 1912–13 the exhibition traveled to Chicago, Indianapolis, Saint Louis, Buffalo, Pittsburgh, Cincinnati, Cleveland, Philadelphia, and Baltimore.
7. William Sener Rusk, *Art in Baltimore: Monuments and Memorials* (Baltimore: Norman, Remington Co., 1924), vol. 1, p. 15; and *The Rinehart School of Sculpture: 75th Anniversary Catalogue 1896–1971* (Baltimore: Maryland Institute, College of Art; Peabody Institute, 1971). The City of Baltimore accepted *Boy and Turtle* as a gift on June 4, 1924. See also Grace H. Turnbull, "Exhibition of Sculpture by American Artists, under the Auspices of the Baltimore Museum of Art and the Peabody Institute Rinehart Fund," *Art and Archaeology* 17 (February 1924), p. 1. Turnbull (pp. 646–47) suggested that the sculpture be permanently erected in Mount Vernon Place.
8. John R. Dorsey and James D. Dilts, *A Guide to Baltimore Architecture,* 2nd ed. (Centerville, Md.: Tidewater Publishers, 1981), p. 5.

Louis McClellan Potter (1873–1912)

Born in Troy, New York, Louis Potter first studied painting with the portraitist Charles Noel Flagg at the Connecticut League of Art Students in Hartford. In 1896 Potter graduated from Trinity College, Hartford, and left for Paris. There he took classes in painting, from Luc-Olivier Merson, and sculpture, from Jean-August Dampt. In 1899 Potter participated in the exhibition of the Société Nationale des Beaux-Arts, displaying a bust (unlocated) of his friend and fellow art student Bernard Boutet de Monvel.

From the outset of his career, Potter incorporated ethnographic and anthropological traits in his statuettes, reflective of his belief in universal brotherhood and supernatural influences. Stylistically, his early output is characterized by a realism recalling the work of the Belgian sculptor Constantin Meunier. He spent time in Tunis and was awarded a commission from the Bey of Tunis to produce sculpture of native Bedouins for the Paris Exposition Universelle of 1900. Potter garnered commendations for his *Young Bedouin* and *Bedouin Mother and Child* (both unlocated), and the Bey elevated him to Officier du Nichan Iftikar, or Order of Renown, in 1900. Returning to the United States, Potter settled in New York and soon earned high praise when he exhibited his *Snake Charmer* (unlocated) at the Pan-American Exposition in Buffalo in 1901. After a trip to the Far West and Alaska in 1904, Potter specialized in representations of Native Americans. His study of their customs and habitats is manifested in statuettes with titles such as *The Arrow Dance* (cat. no. 259), *The Fire Dance* (1907; Smithsonian American Art Museum, Washington, D.C.), and *Basket Weavers* (1905; Gilcrease Museum, Tulsa, Okla.).

Potter produced numerous portraits, including a memorial to Horace Wells in Hartford and busts of Mark Twain (1910; Wadsworth Atheneum, on loan to Mark Twain House, Hartford) and Charles W. Eliot (1910; Harvard University, Cambridge, Mass.). He also created utilitarian objects, such as bookends and andirons, with subjects both grotesque and decorative in nature. Potter also exhibited color etchings, many of North African subjects (Trinity College Archives), throughout his career. He studied occult science, hoping to arrive at higher spiritual awareness, although toward the end of his life he abandoned these practices, declaring them useless. Much of his later work is symbolic and allegorical in content, such as *The Earth Man* and *The Earth's Unfoldment* (Wadsworth Atheneum).

Potter's major solo exhibition was held at New York's Modern Athenian Club in April 1909. Later that spring he received the honorary degree of Master of Arts from his alma mater, Trinity College. He died unexpectedly in Seattle from a skin treatment administered by a Chinese medicine doctor. TT

SELECTED BIBLIOGRAPHY

Potter, Louis, Papers. Archives of American Art, Smithsonian Institution, Washington, D.C., unmicrofilmed.
MacDonald, Irwin M. "Louis Potter: A Sculptor Who Draws His Symbolism from an Intimate Understanding of Primitive Human Nature." *The Craftsman* 16 (June 1909), pp. 257–65.
"Louis Potter: Sculptor." *International Studio* 47 (October 1912), pp. LXV–LXVI.
American National Biography, s.v. "Potter, Louis McClellan."

259. *The Arrow Dance*, 1907

Bronze
28¾ x 15½ x 14½ in. (73 x 39.4 x 36.8 cm)
Signed and dated (top of base, left): *Loius* [sic] *Potter / 1907*
Inscribed (underside of base): 558
Foundry mark (left side of base): ROMAN BRONZE WORKS N—Y—
Gift of Mr. and Mrs. Edwin C. Stephens, in memory of Helen Tresch, 1986 (1986.343)

IN 1904 (and perhaps in subsequent years) Potter traveled to the western United States and Alaska to observe Native American lifestyles and rituals. Although the majority of the statuettes resulting from his trip document Alaska's Tlingit tribe, several of his compositions, including *The Arrow Dance,* depict Sioux customs. Potter portrayed a youth attired in a loincloth, armlets, and moccasins, with a headband around his shoulder-length hair and a single feather. The powerful figure steps energetically and points to an arrow on the ground, possibly an allusion to successful hunting. He is thoroughly absorbed in the dance, as a history of North American dance explains: "Most Indian dances are relaxed and balanced between consciousness and trance—perfectly controlled, dignified, and strangely remote even when the steps are extremely vigorous.... [T]he steps tend to favor bent knees, with the body in an erect, straight posture."[1]

Potter's statuettes depicting Native American practices were, in his day, of equal ethnographic and aesthetic interest. He rendered elemental aspects of the vanishing Indian culture untainted by encroaching modernization and without hackneyed sentimentality. *The Arrow Dance* was exhibited frequently along with other single Sioux figures, among them *The Fire Dance* (1907; Smithsonian American Art Museum, Washington, D.C.) and *The Wind* (undated; Gilcrease Museum, Tulsa, Okla.). When *The Arrow Dance* was shown at the Modern Athenian Gallery in 1909,[2] it was praised for expressing "intensity of action, of rejoicing in strength and of gay, bold battling with the elements."[3]

The Arrow Dance was copyrighted, as were many of Potter's sculptures, which indicates that it was likely produced in a multiple edition.[4] Another bronze, with a similar inscription and foundry mark, was auctioned at Sotheby's in March 1999.[5] TT

1. Jamake Highwater, *Ritual of the Wind: North American Indian Ceremonies, Music, and Dance* (New York: Alfred Van Der Marck Editions, 1984), p. 140.
2. Modern Athenian Club, *Exhibition of Sculpture by Louis Potter* (New York, 1909), no. 3.
3. MacDonald 1909, p. 263.
4. According to a document in the Louis Potter Papers, Archives of American Art, *The Arrow Dance* was copyrighted on August 13, 1907, as Class I, XXc, No. 221663.
5. Sotheby's, New York, sale cat., March 11, 1999, no. 126, as "Fallen Arrow."

Arthur Putnam (1873–1930)

Born in Waveland, Mississippi, Putnam spent most of his boyhood in Omaha, Nebraska. Not interested in formal studies and disliking school, Putnam was enrolled at Kemper Hall Military Academy in Davenport, Iowa, in 1889, but was expelled in less than a year. He worked at a photo engraver's in Omaha and an iron foundry in New Orleans and then joined his widowed mother in California, near San Diego. He found employment as a surveyor for the San Diego Flume Company and tried his hand at ranching. In August 1894 he moved to San Francisco, where he enrolled in drawing classes at the Art Students' League. There he met Julie Heyneman, his future biographer, and she arranged for him to work as an unpaid assistant in the studio of sculptor Rupert Schmid. To sustain a living Putnam also took a job in a slaughterhouse, which gained him an understanding of animal anatomy.

Putnam's particular interest in modeling Western wildlife, especially the puma and the jaguar, led him to Chicago in 1897 to apprentice in the studio of America's first animalier, Edward Kemeys (pp. 191–97). He stayed only a year before returning to California. Ultimately settling again in San Francisco, this essentially self-taught sculptor set up two studios that he shared with local artists. Through a friend, muralist Bruce Porter, Putnam met architect Willis Polk, who hired him to design ornamental work for his buildings. In 1903 Putnam received his first major commission from newspaper publisher E. W. Scripps, to model a series of five outdoor sculptures representing aspects of California history for his Miramar Ranch, north of San Diego. The three completed works from this commission, *Indian* (1904), *Padre* (1908; both Presidio Park, San Diego), and *Ploughman* (1910; Scripps Institution of Oceanography, La Jolla), show Putnam's highly expressive manner of modeling.

As a result of his success with the Scripps commission and with support from Mrs. William H. Crocker, Putnam was able to travel to Europe in late 1905. He studied bronze casting in Italy and exhibited his compositions at the annual salons in Rome in 1906 and Paris in 1907. While settled in Neuilly-sur-Seine, near Paris, Putnam suffered from pleurisy, the first of several health problems that eventually ended his artistic career.

At the end of 1906, Putnam returned to San Francisco, a city devastated that year by earthquake and fire, having to build a new home and studio. With characteristic intensity, he set to work remodeling lost compositions and creating new ones, as well as providing sculptural decorations for banks, hotels, even street-lamp bases, that were being constructed at a frenzied pace. In 1909, with his wife's brother, Fred Storey, Putnam established a foundry to cast his own bronzes, which he then exhibited at the Macbeth Gallery in New York.

In 1911, at age thirty-eight, Putnam was no longer able to sculpt, the result of an operation for a brain tumor, which left him partly paralyzed and with an altered personality. By this time he had essentially completed the modeling of the animal and figural compositions that would constitute his oeuvre. His works continued to be displayed: four pieces, *Bacchus, Deer and Puma, Puma Resting,* and *Lions,* were included in the International Exhibition of Modern Art (the Armory Show) in New York in 1913. At the Panama-Pacific International Exposition in San Francisco in 1915, he was awarded a gold medal for his fourteen submissions, which included *Snarling Jaguar* (cat. no. 260). In 1921 Putnam moved to Paris to supervise the casting of two large sets of bronzes for Alma de Bretteville (Mrs. Adolph B.) Spreckels, who donated them to the California Palace of the Legion of Honor in San Francisco (now part of the Fine Arts Museums of San Francisco) and the Fine Arts Gallery of San Diego (now the San Diego Museum of Art). Putnam remained in France, in Ville-d'Avray, until his death.

DJH

SELECTED BIBLIOGRAPHY

Porter, Bruce. "Arthur Putnam's Animal Sculpture." *Sunset* 14 (November 1904), pp. 54–58.

Berry, Rose V. S. "Arthur Putnam—California Sculptor." *American Magazine of Art* 20 (May 1929), pp. 276–82.

Heyneman, Julie Helen. *Arthur Putnam: Sculptor.* San Francisco: Johnck and Seeger, 1932. British edition, *Desert Cactus: The Portrait of a Sculptor.* London: Geoffrey Bles, 1934.

Hailey, Gene, ed. "Arthur Putnam." *California Art Research,* vol. 6, pp. 1–59. San Francisco: Works Progress Administration Project 2874, 1937.

Osborne, Carol M. "Arthur Putnam, Animal Sculptor." *American Art Review* 3 (September–October 1976), pp. 71–81.

Kamerling, Bruce. "Arthur Putnam: Sculptor of the Untamed." *Antiques and Fine Art* 7 (July–August 1990), pp. 122–29.

260. *Snarling Jaguar,* 1906

Bronze, 1909
3¼ x 12¼ x 3¾ in. (8.3 x 31.1 x 9.5 cm)
Signed and dated (top of base, by tail): PUTNAM [encircled] / 06
Inscribed (back of base, stamped): COPYRIGHT APPLIED FOR
Foundry mark (underside of base, stamped): PUTNAM & STOREY FOUNDRY. / SF CAL.
Rogers Fund, 1909 (09.81)

PUTMAN MODELED *Snarling Jaguar* in 1906, during a particularly productive period when he was living in the Paris suburb Neuilly-sur-Seine. He was well versed in the study of animal anatomy, and he preferred to work from memory so that the emotional impact of his subject matter was strengthened rather than obscured by over-attention to realistic detail. In this statuette of a recumbent jaguar, the ferocity of its snarl is suggested not only by its open jaw but also by the full attenuation of its sleek body.

In 1909, after he had returned to San Francisco and established a foundry with his brother-in-law Fred Storey, Putnam cast *Snarling Jaguar* in bronze in the lost-wax method. William Macbeth, Putnam's New York dealer, visited the Putnam-Storey foundry that year and recorded that "Mr. Putnam has happily solved the sculptor's usual difficulty in having work cast, by building a foundry of his own, so his work is strongly individual from start to finish. The wild creatures of the west, thoroughly known

by this young sculptor, have never been more faithfully or sympathetically portrayed in any medium than in these live bronzes."[1]

Daniel Chester French (pp. 326–41), chairman of the Metropolitan Museum trustees' Committee on Sculpture, first saw Putnam's work at Macbeth Gallery. He wrote Putnam that he had asked Macbeth to send three of the bronzes to the Museum for consideration and that one, *Snarling Jaguar,* was purchased. However, in the original cast of *Snarling Jaguar* that came to the Metropolitan, the jaguar figure was mounted directly on a wooden base. French disliked "the hard line between the bronze and the wood" and asked Putnam "whether [he had] ever made this piece mounted on bronze ground instead of on the board."[2] Putnam remodeled *Snarling Jaguar* with a self-base and cast it, then sent Macbeth the new cast to be exchanged with the one at the Metropolitan.[3] Putnam subsequently sent a plaster version to the Roman Bronze

Works foundry and ordered four bronzes cast.[4] None of these bronzes is located.

Snarling Jaguar was exhibited at Macbeth Gallery in late 1908 and at the Pennsylvania Academy of the Fine Arts in early 1909.[5] It was among the fourteen works by Putnam displayed at the 1915 Panama-Pacific International Exposition in San Francisco.[6] DJH

EXHIBITIONS

Halloran General Hospital, Staten Island, N.Y., July 1947–February 1948.
Detroit Institute of Arts, "Arts and Crafts in Detroit 1906–1976: The Movement, the Society, the School," November 26, 1976–January 16, 1977, not in catalogue.

1. *Art Notes,* Macbeth Gallery, New York, no. 39 (December 1909), pp. 615–16.
 Research on Arthur Putnam was conducted by Kate Walsh.
2. French to Putnam, April 21, 1909, as quoted in Heyneman 1932, p. 114.
3. Putnam to Macbeth, November 12, 1909, Macbeth Gallery Records, Archives of American Art, Smithsonian Institution, Washington, D.C., microfilm reel NMc10, frame 689.
4. Putnam to Macbeth, November 20, 1911, Macbeth Gallery Records, as in note 3, frame 705.
5. *Bronzes by a Group of American Artists,* exh. cat. (New York: Macbeth Gallery, 1908), no. 41; *Pennsylvania Academy of the Fine Arts . . . Catalogue of the 104th Annual Exhibition,* 2nd ed. (Philadelphia, 1909), p. 73, no. 948.
6. *Official Catalogue of the Department of Fine Arts, Panama-Pacific International Exposition* (San Francisco: Wahlgreen Co., 1915), p. 242, no. 3209.

Evelyn Beatrice Longman (1874–1954)

Born in Winchester, Ohio, Longman became one of America's most successful female sculptors of the early twentieth century. After briefly taking evening classes at the Art Institute of Chicago and then enrolling in 1896 as a full-time student at Olivet College in Michigan, in 1898 she returned to Chicago to train with Lorado Taft at the School of the Art Institute. She was appointed assistant instructor of modeling and graduated with highest honors in 1900.

Longman relocated to New York to assist Hermon Atkins MacNeil (pp. 475–81) and Isidore Konti (pp. 408–11) on sculptural decorations for the 1901 Pan-American Exposition in Buffalo. She then worked for Daniel Chester French (pp. 326–41) until 1905 as his only female studio assistant. Longman's earliest noteworthy accomplishment was the male figure *Victory* (1903; see cat. no. 262) that was placed on top of the Festival Hall dome at the Louisiana Purchase Exposition in Saint Louis in 1904 and earned her a silver medal. In 1906 she won a competition to complete a set of 22-by-10-foot bronze doors for the United States Naval Academy chapel in Annapolis. The doors, symbolizing War and Peace, were erected in 1909 and brought a string of commissions for other monumental allegorical sculptures, including the Horsford Memorial Bronze Doors for the Wellesley College Library (1911; Wellesley, Mass.). *Consecration (L'Amour),* a nude couple in tender embrace, was exhibited in 1915 at the Panama-Pacific International Exposition in San Francisco, where it won a silver medal. Longman enjoyed a long artistic collaboration with the architect Henry Bacon and advised him on the design of the classically inspired *Lincoln Memorial* (dedicated 1922) in Washington, D.C., for which she sculpted eagles, double wreaths, and inscriptions of speeches. By far her most widely recognized work is the 24-foot gilt *Genius of Telegraphy* (also known as *Electricity, Spirit of Communication,* or *Golden Boy*; 1914–16), a heroic winged male holding a bolt of electricity. An icon of technological progress and capitalism, it originally adorned the top of the American Telephone and Telegraph Building at 195 Broadway, New York City. Since 1992 it has been installed in front of AT&T headquarters in Basking Ridge, New Jersey.

In 1919 Longman earned the distinction of becoming the first woman sculptor to be elected an academician of the National Academy of Design. She lived in New York City until her marriage in 1920 to Nathaniel Horton Batchelder, the headmaster of Loomis Institute (now the Loomis Chaffee School) in Windsor, Connecticut. Longman relocated to the school's campus, where her career continued unabated in her studio, Chiselhurst on Farmington. She completed numerous portraits, including a mammoth bust of Thomas A. Edison taken from life in 1930 (bronze replica, Naval Research Laboratories, Washington, D.C.). Her lifesize bas-relief of Daniel Chester French (1926; National Portrait Gallery, Washington, D.C.) features a decorative frieze of his primary sculptural accomplishments. One of her more ambitious public projects for Connecticut towns is the bronze *Spanish-American War Memorial* (1927) in Hartford's Bushnell Park. Longman was accorded one-artist exhibitions at the Grand Central Art Galleries in 1928 and 1932. She and her husband settled in Osterville, Massachusetts, on Cape Cod, after his retirement in 1949. TT

SELECTED BIBLIOGRAPHY

Longman, Evelyn Beatrice, Collection. Loomis Chaffee School, Windsor, Conn.

Dickerson, James Spencer. "Evelyn B. Longman: A Western Girl Who Has Become a National Figure in Sculpture." *The World To-Day* 14 (May 1908), pp. 526–30.

Rawson, Jonathan A., Jr. "Evelyn Beatrice Longman: Feminine Sculptor." *International Studio* 45 (February 1912), pp. XCIX–CIII.

Adams, Adeline. "Evelyn Beatrice Longman." *American Magazine of Art* 19 (May 1928), pp. 237–50.

Rabetz, Marilyn and Walter, et al. *Evelyn Beatrice Longman Batchelder.* Exh. cat. Windsor, Conn.: Richmond Art Center of the Loomis Chaffee School, 1993.

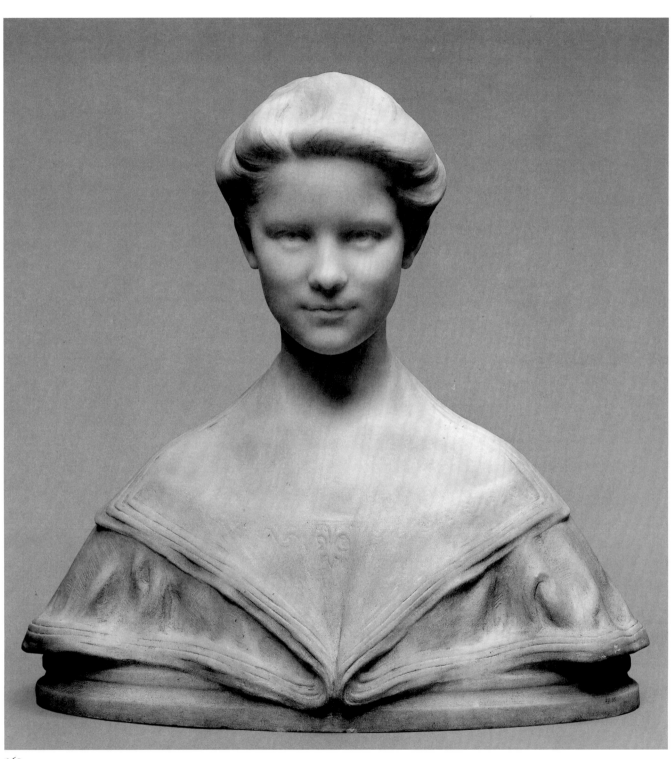

261

261. *Louise*, 1902

Marble, tinted, 1910
22 x 21 x 8 in. (55.9 x 53.3 x 20.3 cm)
Signed and dated (back of base): EVELYN BEATRICE LONGMAN 1910
Rogers Fund, 1920 (20.55)

LONGMAN FIRST modeled *Louise* in the summer of 1902, when she was working as a studio assistant to Daniel Chester French at his residence, Chesterwood, in Stockbridge, Massachusetts. The adolescent sitter, Louise Russell French (1887–1962), was French's cousin and a frequent visitor to Chesterwood from her home in Washington, D.C.[1] The initial plaster was completed in time for submission to the Society of American Artists annual in March 1903 and then to the Louisiana Purchase Exposition in 1904.[2]

Longman carved the Metropolitan Museum's *Louise,* a unique marble, in 1910. She often selected this medium for her portraits and insisted on finishing her marbles after they were roughed out by carvers. The bust-length *Louise,* mounted on a low socle, recalls prototypical Renaissance pieces by Donatello, Verrocchio, or Francesco Laurana. This association is further enhanced by the sitter's classic beauty and the decorative fleur-de-lis on her dress. A contemporaneous stylistic parallel may be drawn to the portraits of the American sculptor Herbert Adams (pp. 360–64), whom Longman met aboard ship following a European sojourn in 1906,[3] if not earlier.

Louise was exhibited in 1911 at the Roman Art Exposition, but it is not possible to determine whether a plaster or the marble was sent.[4] According to Longman, the Metropolitan's marble was included in exhibitions at the National Academy of Design in 1912 and at both the Pennsylvania Academy of the Fine Arts and the Art Institute of Chicago in 1913.[5] The bust was sold from the Chicago exhibition to a peripatetic collector who arranged to pay for it in installments. Acting as an agent for Longman, the Art Institute was instructed to hold *Louise* until it was fully paid for; because the purchaser was delinquent in his payments, the piece never left Chicago. By the time *Louise* was included in the Metropolitan's 1918 "Exhibition of American Sculpture," Longman had given up hope of being paid and had, in essence, claimed jurisdiction over the sculpture.[6] When the exhibition was extended as a permanent installation, *Louise* remained, and the Metropolitan purchased the bust directly from Longman in 1920.[7]

Two plasters, both tinted, are privately owned.

TT

EXHIBITION

Richmond Art Center of the Loomis Chaffee School, Windsor, Conn., "Evelyn Beatrice Longman Batchelder, 1874–1954," April 25–June 15, 1993.

1. Louise was the daughter of Mary Winnifred Babson and William Bates French, a cousin and brother-in-law of Daniel Chester French (who had married William French's sister, Mary). Louise Russell French married Lawrence V. Jones on August 22, 1909. Cynthia W. Smith to Donna J. Hassler, October 13, 1984, object files, MMA Department of American Paintings and Sculpture.
2. *Twenty-fifth Annual Exhibition of the Society of American Artists* (New York, 1903), p. 34, no. 99; and *Official Catalogue of Exhibitors: Universal Exposition, St. Louis, U.S.A., 1904 . . . Department B, Art,* rev. ed. (Saint Louis: Official Catalogue Co., 1904), p. 60, no. 2171.
3. Rabetz et al. 1993, p. 6.
4. See *Catalogue of the Collection of Pictures and Sculpture in the Pavilion of the United States of America at the Roman Art Exposition* (Rome, 1911), p. 54, no. 586.
5. See *Illustrated Catalogue, National Academy of Design Winter Exhibition 1912* (New York, 1912), p. 15, no. 69; *Pennsylvania Academy of the Fine Arts . . . Catalogue of the 108th Annual Exhibition,* 2nd ed. (Philadelphia, 1913), p. 66, no. 738; and *The Art Institute of Chicago: Catalogue of the Twenty-sixth Annual Exhibition of American Oil Paintings and Sculpture* (Chicago, 1913), no. 410.
6. William F. Tuttle, Secretary, Art Institute of Chicago, to Daniel Chester French, February 28, 1918, Daniel Chester French Family Papers, Manuscript Division, Library of Congress, Washington, D.C., microfilm reel 4, frame 473. This letter traces the history of *Louise*'s purchase by an unidentified collector and its subsequent loan to the Metropolitan Museum. See also *An Exhibition of American Sculpture* (New York: MMA, 1918), p. 14, no. 48.
7. Recommended purchase form, March 15, 1920, MMA Archives.

262. *Victory*, 1903

Bronze, 1908
26½ x 8¼ x 7¼ in. (67.3 x 21 x 18.4 cm)
Signed and dated (back of sphere): EVELYN B. LONGMAN / 1903
Foundry mark (left side of base): ROMAN BRONZE WORKS N–Y–
Cast number (back of sphere, stamped): № 1–
Gift of Edward D. Adams, 1912 (12.143)

THE METROPOLITAN Museum's *Victory* is a reduction of the full-size model that was displayed on the dome of the Festival Hall at the 1904 Louisiana Purchase Exposition in Saint Louis. Originally intended for the top of the less significant Varied Industries Building, Longman's statue instead became a hallmark of the exhibition and launched her career.

Eschewing established female precedents, Longman's allegorical *Victory* is a male figure. One writer observed: "it was admirably adapted by its significant virility to the spectacular position it occupied."[1] The elongated figure stands triumphantly on tiptoe, with arms raised, his left hand clasping the traditional symbols of victory: a spray of oak leaves and a laurel wreath. The athlete is clothed in a short cuirass, modeled transparently close to the body, demonstrating Longman's prowess at rendering the human form. Other classicizing details include the fillet on *Victory*'s head, leather greaves with acanthus patterning covering his shins, and a flowing mantle.

Longman produced two smaller casts of the subject (1905, Union League Club, Chicago; 1906, Art Institute of Chicago). She then further reduced the piece to the scale of the Metropolitan's cast. *Victory* was unquestionably Longman's most popular piece. The sculptor recalled that at least thirty-five replicas of this size were created,[2] of which the Metropolitan's is the first. Examples are housed in the National Academy of Design, New York; the Toledo Museum of Art; Brookgreen Gardens, Murrells Inlet, South Carolina; and the Saint Louis Art Museum.

As the catalyst and a metaphor for Longman's own sculptural accomplishments, *Victory* held special personal significance. On May 29, 1919, she presented a reduced bronze to the National Academy of Design as her diploma piece, and she gave casts to several friends.[3] Reductions were also presented as an award for the Atlantic Fleet of the United States Navy[4] and as a trophy for the track meets among the Choate, Loomis, and Taft Schools.[5]

In 2000 a sprig of oak leaves that had been missing for many years was replaced on the Metropolitan's example of *Victory*. The sprig was cast from molds taken from the bronze at the National Academy of Design. TT

EXHIBITIONS

Newark Museum, Newark, N.J., "Women Artists of America, 1707–1964," April 2–May 16, 1965.
National Museum of Women in the Arts, Washington, D.C., April 10–June 14, 1987; Minneapolis Institute of Arts, July 5–August 30, 1987; Wadsworth Atheneum, Hartford, September 19–November 15, 1987; San Diego Museum of Art, December 5, 1987–January 31, 1988; Meadows Museum, Southern Methodist University, Dallas, February 20–April 17, 1988, "American Women Artists, 1830–1930," no. 116.
MMA, Henry R. Luce Center for the Study of American Art, "Subjects and Symbols in American Sculpture: Selections from the Permanent Collection," April 11–August 20, 2000.

1. Dickerson 1908, p. 530.
2. Evelyn B. Longman Batchelder to Preston Remington, Associate Curator of Decorative Arts, MMA, April 15, 1933, MMA Archives.
3. George H. Hickok, "From the Archives: Evelyn Beatrice Longman—LC Artist in Residence," *Loomis Chaffee Alumni Magazine* (Summer 1984), pp. 10–11. The author cites the presentation of *Victory* to friends such as Rev. Frederick H. Sill, the founding headmaster of the Kent School, and the painter Charles Vezin.
4. See Gustav Kobbe, "Artistic Trophies for U.S. Navy," *New York Herald,* November 28, 1915, sec. 3, p. 12. Charles A. Lopez's *The Sprinter* (cat. no. 231) was also used as a Navy trophy.
5. Hickok, "From the Archives," pp. 10–11.

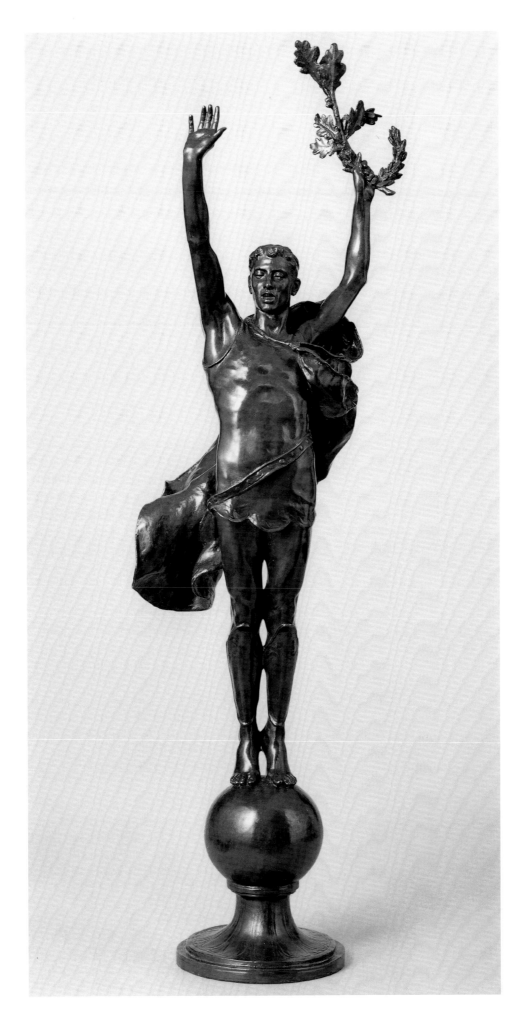

263. *Torso of a Woman,* 1911

Bronze
12 x 4 x 4½ in. (30.5 x 10.2 x 11.4 cm)
Signed and dated (right side of base): EVELYN BEATRICE LONGMAN / 1911
Foundry mark (back of base): ROMAN BRONZE WORKS. N.Y.
Rogers Fund, 1912 (12.52)

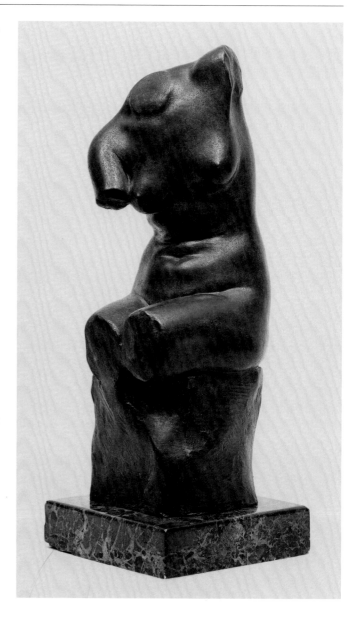

LONGMAN MODELED *Torso of a Woman* in 1911 as a com-
panion piece to *Seated Female Figure* (cat. no. 264). The
tilting truncated figure seated solidly on a rocklike form
has a distinguished artistic lineage. By deliberately choos-
ing to render an incomplete figure, Longman joined a
corps of turn-of-the-century sculptors who relied on
the part to imply the whole. Similar studies of the frag-
mented female form were made by such contemporane-
ous sculptors as Paul Wayland Bartlett in his *Seated Torso
of a Woman* (cat. no. 201). Longman's most direct inspira-
tion was undoubtedly Daniel Chester French, who in
1896 completed a plaster *Diana* (Chesterwood, Stock-
bridge, Mass.); this woman with truncated limbs sits on
a block base very similar to Longman's.

Longman displayed two sculptures, each entitled "Torso,"
in the National Academy of Design's winter exhibition of
1912, but it cannot be determined whether these are the
paired statuettes now in the Metropolitan's collection.[1] In
1933 she recalled that only one other cast of *Torso of a Woman,*
produced at the same time, existed; it was then owned by
her onetime pupil the New York City sculptor Georg
Lober.[2] However, there is another cast at Chesterwood that
was almost certainly given to French by Longman.[3]

The statuette has a dark brown patina with green high-
lights and stands on a green veined marble base 1¼ inches
in height.

TT

EXHIBITIONS

Sheldon Swope Art Gallery, Terre Haute, Ind., January–July 1948.
Berry-Hill Galleries, New York, "The Woman Sculptor: Malvina
 Hoffman and Her Contemporaries," October 24–December 8,
 1984, no. 29.

1. *Illustrated Catalogue, National Academy of Design Winter Exhibition
 1912* (New York, 1912), p. 14, nos. 54, 56. *Torsos* were also exhib-
 ited at the Panama-Pacific International Exposition (*Official Cata-
 logue of the Department of Fine Arts, Panama-Pacific International
 Exposition* [San Francisco: Wahlgreen Co., 1915], p. 239, nos. 282,
 283), and at the Albright Art Gallery (*Catalogue of a Collection of
 Small Bronzes Arranged by the National Sculpture Society* [Buffalo,
 1913], p. 7, nos. 81, 82; and *Catalogue of an Exhibition of
 Contemporary American Sculpture Held under the Auspices of the
 National Sculpture Society* [Buffalo, 1916], p. 63, nos. 456, 457).

2. Evelyn B. Longman Batchelder to Preston Remington, Associate
 Curator of Decorative Arts, MMA, April 15, 1933, MMA Archives.
 Perhaps this is the cast that was offered at Sotheby's Arcade, New
 York; see sale cat., April 5, 1995, no. 60.
3. Barbara Roberts, Chesterwood, Stockbridge, Mass., to Thayer
 Tolles, November 24, 1992, object files, MMA Department of
 American Paintings and Sculpture.

264. *Seated Female Figure*, 1911

Bronze
11½ x 3½ x 5 in. (29.2 x 8.9 x 12.7 cm)
Signed and dated (left side of base): EVELYN BEATRICE LONGMAN / 1911
Foundry mark (back of base): ROMAN BRONZE WORKS N Y
Gift of Edward D. Adams, 1927 (27.21.4)

SEATED FEMALE FIGURE represents the human
form more completely than its mate, *Torso of a Woman*
(cat. no. 263). The crossed legs, extended truncated arms,
and twist of the body add an element of dynamism to this
piece not found in its more subdued counterpart. The
Greek-inspired pose and modeling of *Seated Female Figure*
are further enhanced by the chemically applied "antique"
patina, a favored choice among sculptors of the early twen-
tieth century. Longman noted in 1933 that three casts of
Seated Female Figure were produced and were located in
the Metropolitan Museum, the City Art Museum, Saint
Louis (now Saint Louis Art Museum), and a New York
City private collection (current location unknown).[1]

The piece is mounted on a green veined marble base
1¼ inches high. T T

1. Evelyn B. Longman Batchelder to Preston Remington, Associate
 Curator of Decorative Arts, MMA, April 15, 1933, MMA Archives.

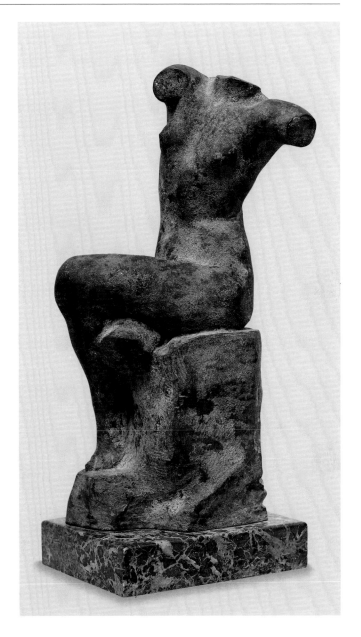

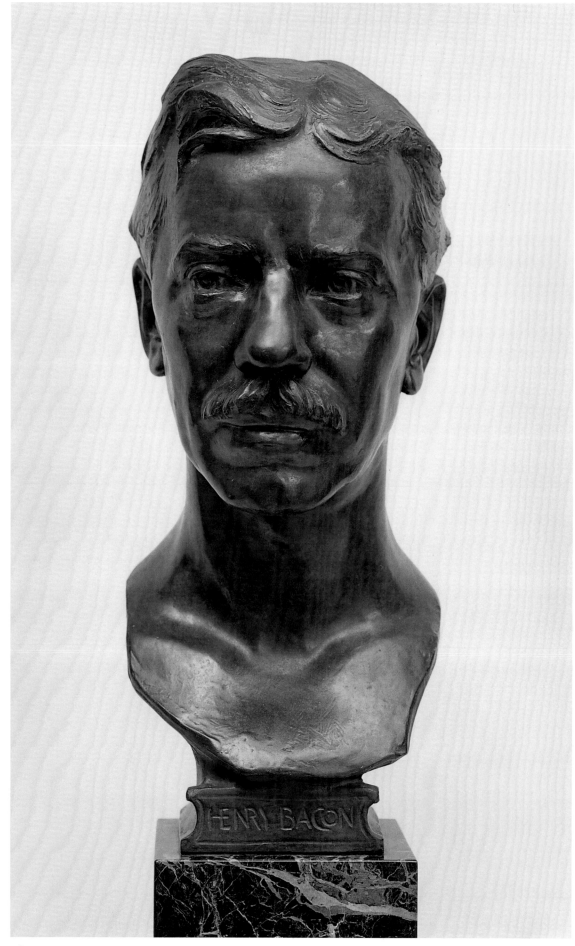

265

265. *Henry Bacon*, 1918

Bronze, 1924
17 x 7 x 5 in. (43.2 x 17.8 x 12.7 cm)
Signed and dated (right side of base): EVELYN BEATRICE LONGMAN / SCULPTOR / 1918
Inscribed (front of base): HENRY BACON
Foundry mark (back of base): ROMAN BRONZE WORKS N–Y
Gift of Mrs. Evelyn Beatrice Longman Batchelder, 1924 (24.153)

LONGMAN AND the American Beaux Arts architect Henry Bacon (1866–1924) undoubtedly met through Daniel Chester French, probably while she was an assistant in French's studio.[1] French often collaborated with Bacon on architectural programs, most significantly for the *Lincoln Memorial* (dedicated 1922). Longman designed the sculptural elements for several of Bacon's projects, including the *Illinois Centennial Monument* (1916; Logan Square, Chicago) and the *Naugatuck War Memorial* (1921; Naugatuck, Conn.). The pair earned admiration at the San Francisco 1915 Panama-Pacific International Exposition for the Fountain of Ceres, which was placed in the forecourt to the Court of Four Seasons designed by Bacon.

Longman enjoyed a close professional and personal relationship with Bacon, esteeming him a "dear friend— who taught me most of what I know, and feel, in architecture."[2] This bust is undoubtedly an expression of that sentiment. The only other known cast was presented as a gift to the Bacon family by Longman in 1918. That cast was exhibited widely: at the National Academy of Design's winter exhibition of 1918 (no. 45) and the 1919 annuals of the Pennsylvania Academy of the Fine Arts (no. 254), the Art Institute of Chicago (no. 328), and the Albright Art Gallery (no. 50). It is now in the Special Collections and Archives of Olin Library, Wesleyan University, Middletown, Connecticut.[3]

The Metropolitan's bronze is a 1924 cast. Foundry records from Roman Bronze Works from 1918 mention only one cast—certainly that given to the Bacon family.[4] Bacon died on February 16, 1924, and soon after, according to a letter of July 16, 1924, from Roman Bronze Works to the Metropolitan Museum, Longman instructed the foundry to send the Museum a cast of the bust.[5]

The bronze bust is mounted on its original black veined marble base, 6¼ inches high. TT

EXHIBITION

Berry-Hill Galleries, New York, "The Woman Sculptor: Malvina Hoffman and Her Contemporaries," October 24–December 8, 1984, no. 31.

1. Marilyn Rabetz, Loomis Chaffee School, to Thayer Tolles, November 2, 1992. According to Mrs. Rabetz, there are letters between Longman and Bacon as early as 1910, but they probably met sometime before that.
2. Note in Henry Bacon correspondence folder, Longman Collection, Loomis Chaffee School, Windsor, Conn.
3. Elizabeth A. Swaim, Special Collections Librarian and University Archivist, Olin Library, Wesleyan University, kindly located this cast.
4. Roman Bronze Works Archives, Amon Carter Museum, Fort Worth, ledger 5, p. 312, October 22, 1918. A bust of Henry Bacon is recorded with the price of $65.
5. Roman Bronze Works to MMA, July 16, 1924, MMA Archives.

266. *Mr. and Mrs. Robert W. de Forest*, 1922

Marble, 1923
Diam. 10¼ in. (26 cm)
Signed and dated (lower left, monogram): ELB
Inscribed (around edge): ROBERT WEEKS DEFOREST EMILY JOHNSTON DEFOREST // 1872 1922
Gift of Johnston de Forest, 1946 (46.118)

IN APRIL 1922 Robert and Emily de Forest sought advice from their friend Daniel Chester French on commissioning a double portrait to commemorate their fiftieth wedding anniversary.[1] Writing to Mrs. de Forest, French recommended Longman, explaining, "I wish I could do it myself, although I believe that Miss Longman would do it better."[2]

Longman's portrait of the de Forests shows the couple

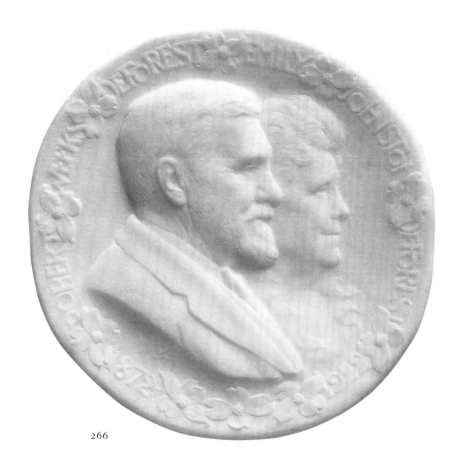

266

in profile facing right, with genial expressions and a calm presence. The dogwood blossoms around the medallion's edge symbolize durability, a fitting reference to a fifty-year marriage.

From the lifesize plaster that Longman modeled, reductions were made: family members and close friends received 5½-inch gold-plated bronze (galvano) medallions mounted on wood panels with gilt detailing. A 2-inch commemorative medal was struck in an edition of 400 by the Medallic Art Company and distributed to guests attending a golden wedding reception on November 13, 1922.[3]

The Metropolitan Museum's 10¼-inch alabaster marble, a unique work half the size of the original plaster, was executed in 1923 as a gift from Longman to the de Forests. Mrs. de Forest expressed her gratitude: "I can appreciate that this was a labor of love on your part. Nothing short of that would have produced anything so beautiful. The marble is so lovely and the work is so exquisitely done."[4]

Robert (1848–1931) and Emily (1850–1942) de Forest played vital roles in the history of the Metropolitan Museum.[5] He was president of the Board of Trustees from 1913 to 1931, first becoming a trustee in 1889. A New York lawyer, philanthropist, and civic leader, de Forest had previously been named secretary of the board in 1904 and second vice president in 1909, and was named a Benefactor of the Museum in 1920. His wife, Emily, was daughter of the first president of the Museum, the railroad magnate John Taylor Johnston. In late 1922, shortly after their anniversary celebration, the de Forests announced the gift of the American Wing to the Metropolitan Museum to house American decorative arts in sixteen period rooms and three exhibition galleries. This relief portrait of the de Forests was given to the Museum by one of their children.

TT

EXHIBITIONS

MMA, 81st Street Gallery, "Portraits of Museum Presidents," September 16–December 14, 1980.

MMA, Henry R. Luce Center for the Study of American Art, "American Relief Sculpture," August 15–November 5, 1995.

1. Robert W. de Forest to French, April 4, 1922, Daniel Chester French Family Papers, Manuscript Division, Library of Congress, Washington, D.C., microfilm reel 6, frame 381.
2. French to Mrs. de Forest, undated [spring 1922] (copy), French Family Papers, Library of Congress, microfilm reel 6, frame 406.
3. In the Metropolitan's collection are examples of the 5½-inch medallion (acc. no. 34.82.1) and the 2-inch medal (acc. no. 34.82.2), both given to the Museum by Mrs. Robert W. de Forest in 1934.
4. Mrs. de Forest to Evelyn Longman Batchelder, April 9, 1924 (de Forest 50th Anniversary folder, box 1, ser. 2, folder 12), Longman Collection, Loomis Chaffee School, Windsor, Conn.
5. See H[enry] W. Kent, "Robert W. de Forest," *MMA Bulletin* 26 (June 1931), pp. 139–40.

Andrew O'Connor, Jr. (1874–1941)

Born in Worcester, Massachusetts, Andrew O'Connor learned the rudiments of modeling and carving from his father, Andrew, a sculptor of cemetery monuments and portrait busts. In 1891–92 Andrew Jr. was a studio assistant for William Ordway Partridge (pp. 378–79) in Milton, Massachusetts, and helped Daniel Chester French (pp. 326–41) with commissions for the Chicago World's Columbian Exposition of 1893, including the colossal *Republic*. Moving to London in 1894, O'Connor modeled for, and assisted with, studies for John Singer Sargent's *Frieze of Prophets* for the Boston Public Library murals. After O'Connor returned to the United States about 1898, French helped him secure an important commission: they collaborated on the central doors of the Vanderbilt Memorial entrance (and later the tympanum and flanking frieze) of New York's Saint Bartholomew's Church, being restored by Stanford White. This commission was followed by several from Cass Gilbert for architectural sculpture. Among the works for Gilbert's buildings were an escutcheon over the main entrance of the New York Custom House (1904) and nine marble and two bronze figures for the Essex County Court House (1906) in Newark, New Jersey.

Throughout his career, O'Connor experimented widely; his early sculptures reflect the academic classicism he learned from French, while his later efforts are impressionistic, the result of his admiration for Auguste Rodin. Living in Paris from 1904 until 1914, O'Connor exhibited regularly in the annual Salons and received a second-place award in the Paris Salon of 1906 for his bronze statue of General Lawton (Garfield Park, Indianapolis). He had a one-man show at the Galerie A.-A. Hébrard in 1909. O'Connor met Gertrude Vanderbilt Whitney (pp. 592–95), who became his student, in 1900. He was one of a number of American sculptors who received her financial support, and she provided an exhibition forum for O'Connor through the gallery the Whitney Studio, New York.

At the outbreak of World War I, O'Connor set up a studio in Paxton, Massachusetts, and completed public monuments such as the statue of Abraham Lincoln (1916) for Springfield, Illinois, the *Theodore Roosevelt Memorial* (1919) at Glen View Golf Club in Chicago, and the *Lafayette Monument* (1924) for Baltimore. By 1926 O'Connor had returned to Paris and in 1928 was the first foreign sculptor to win the Grand Prix at the annual Paris Salon des Artistes Français for his limestone group *Tristram and Iseult* (Brooklyn Museum of Art). Deeply influenced by his Celtic ancestry, O'Connor spent the last decade of his life in Ireland, although he maintained a London studio. The largest single collection of his sculpture is housed in the Municipal Gallery in Dublin.

TT

SELECTED BIBLIOGRAPHY

Cortissoz, Royal. "The Work of Andrew O'Connor." *Art and Progress* 1 (October 1910), pp. 343–49.

Desmaroux, Hélène. *L'oeuvre du sculpteur O'Connor.* Paris: Librairie de France, 1927.

du Bois, Guy Pène. "Andrew O'Connor and His Sculpture." *International Studio* 86 (January 1927), pp. 55–61.

Potterton, Homan. "Celtic Sculptor in America." *Country Life* 155 (January 3–10, 1974), pp. 16–17.

Potterton, Homan. *Andrew O'Connor 1874–1941.* Exh. cat. Dublin: Trinity College, 1974.

267. *The Virgin,* 1906

Bronze, 1909
17¼ x 8 x 9 in. (43.8 x 20.3 x 22.9 cm)
Signed (right side): O'CONNOR
Rogers Fund, 1918 (18.38)

O'CONNOR MODELED *The Virgin* (also known as *Head of the Virgin*) in 1906 and cast the Metropolitan Museum's bronze in 1909. The ideal female head was a common theme in O'Connor's oeuvre during his first Parisian tenure. The sculptor's wife, Jessie, was a frequent model for these pieces and quite likely posed for this bust. The physiognomy of the expressionless Virgin, although simplified and stylized, corresponds to contemporary photographs and portrait busts of Mrs. O'Connor.[1] O'Connor's representation of the Virgin is distinguished by Mrs. O'Connor's long hair and ridged nose.

In 1910 O'Connor represented Great Britain with this cast of *The Virgin* at the International Art Exposition in Venice.[2] He exhibited it in December 1917–January 1918

in a solo show at Jacques Seligmann Company in New York, held to benefit Edith Wharton's war charities for relief efforts in France.[3] There the piece caught the attention of Daniel Chester French, chairman of the Metropolitan Museum trustees' Committee on Sculpture, and he recommended it for purchase, noting in correspondence that it was priced "with the understanding that only one copy will be sold."[4] *The Virgin* entered the Metropolitan's collection in time for inclusion in the 1918 "Exhibition of American Sculpture." A clearly pleased French reported to O'Connor, "You[r] work has received more notice than anyone else's so far."[5] T T

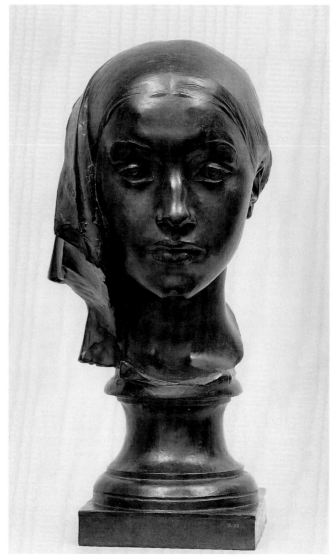

267

EXHIBITION

MMA, "An Exhibition of American Sculpture," opened March 1918, no. 59.

1. See Potterton exh. cat. 1974, pp. 28–31, for illustrations of related works.
 June R. Herold assisted with research on O'Connor.
2. *Catalogo,* Esposizione Internazionale d'Arte della Città di Venezia, 2nd ed. (Venice: Carlo Ferrari, 1910), p. 78, no. 38, as "Testa di donna."
3. *Exhibition of the Works of the Sculptor O'Connor,* Jacques Seligmann Co., New York (Paxton, Mass., 1917). *The Virgin* is illustrated on p. 87.
4. French to Edward D. Adams, trustee, MMA, January 14, 1918 (copy), Daniel Chester French Family Papers, Manuscript Division, Library of Congress, Washington, D.C., microfilm reel 4, frame 389. See also O'Connor to Preston Remington, Associate Curator of Decorative Arts, MMA, February 14, 1933, MMA Archives, stating that "there is no other bronze of this head."
5. French to O'Connor, April 1, 1918 (copy), French Family Papers, Library of Congress, microfilm reel 4, frame 532.

268. *Abraham Lincoln,* 1916

Limestone
38 x 37 x 26 in. (96.5 x 94 x 66 cm)
Gift of Mrs. Willard Straight, 1922 (22.41)

THIS IMPOSING shoulder-length depiction of Abraham Lincoln (1807–1865) was carved in 1916 as a variant after the model O'Connor made in 1915 for his *Lincoln of the Farewell Address* in Springfield, Illinois.[1] The sculptor won the competition for a full-size standing Lincoln, sponsored by the Illinois Art Commission to commemorate the upcoming centenary meeting of the first general assembly of Illinois. The bronze statue, erected in front of the state capitol, was unveiled on October 5, 1918.[2] The head of

the Springfield *Lincoln* served as the basis for the obverse of the Illinois centennial half-dollar in 1918.

Both the Springfield bronze and the Metropolitan Museum limestone portray the fifty-two-year-old Lincoln beardless, delivering his farewell address before traveling to Washington to assume the presidency. O'Connor was criticized for historical inaccuracy because the president-elect had already begun to grow a beard at the time of his inauguration. The sculptor, however, affirmed his concern

for an accurate likeness: "Simply from the mass of splendid material—masks, casts of his beautiful hands and numerous photographs—I've tried to take what I could use, to the end that I might show in sculpture, something of Lincoln's personal appearance."[3]

The tactile surface quality of the Metropolitan's limestone is accentuated by the rough carving, especially through the figure's drooping shoulders and base. Lincoln's gaunt head is deeply modeled, allowing for light and shadow to accentuate the brooding, pensive personality often associated with the president. This *Lincoln* is almost certainly the first in a series of sculptures that O'Connor based on his Springfield *Lincoln*. Another shoulder-length variant, of black granite, is in London's Royal Exchange.[4]

The Lincoln bust had been on loan to the Metropolitan for two years prior to its being donated by Mrs. Willard Straight in 1922.[5] T T

EXHIBITION

Library of Presidential Papers, New York, December 1966–August 1972.

1. O'Connor to Preston Remington, Associate Curator of Decorative Arts, February 14, 1933, MMA Archives.
2. Donald Charles Durman, *He Belongs to the Ages: The Statues of Abraham Lincoln* (Ann Arbor, Mich.: Edwards Brothers, 1951), p. 173.
3. Andrew O'Connor, preface to *Exhibition of the Works of the Sculptor O'Connor,* Jacques Seligmann Co., New York (Paxton, Mass., 1917), p. [2]. O'Connor exhibited his full-length plaster study for the Springfield *Lincoln* in this show.
4. O'Connor's interest in Lincoln continued throughout his career. In 1929–30 he produced a full-size seated and bearded *Lincoln* intended for Providence, R.I. It was cast in bronze in 1930 by the Gorham Manufacturing Company of Providence but never installed there since the state did not pay O'Connor the full balance due. Instead, it was erected in Fort Lincoln Cemetery in Washington, D.C., in 1947. See Frederic Lauriston Bullard, *Lincoln in Marble and Bronze: A Publication of the Abraham Lincoln Association, Springfield, Illinois* (New Brunswick, N.J.: Rutgers University Press, 1952), pp. 250–51.
5. "List of Accessions and Loans, April and May, 1920," *MMA Bulletin* 15 (June 1920), p. 145; and Daniel Chester French to O'Connor, January 7, 1922 (copy), Daniel Chester French Family Papers, Manuscript Division, Library of Congress, Washington, D.C., microfilm reel 6, frame 235.

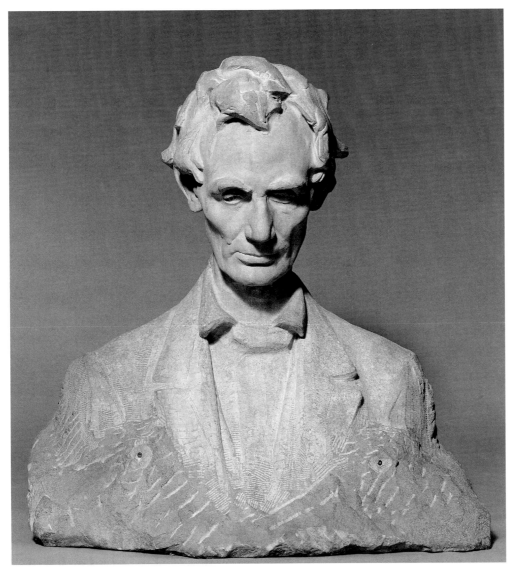

268

Charles Keck (1875–1951)

Keck was born in New York City, son of a designer of stained glass. In 1890 he entered the studio of Philip Martiny, with whom he and Adolph Alexander Weinman (pp. 534–37) worked on the production of large-scale sculpture for the World's Columbian Exposition of 1893. From 1893 to 1898, while continuing his art instruction in New York at the National Academy of Design (1893–94) and the Art Students League (1894–1901), Keck was an assistant to Martiny's former master Augustus Saint-Gaudens (pp. 243–325). Keck helped Saint-Gaudens model the drapery for *Diana* (see cat. no. 130), a 13-foot bronze installed atop New York's Madison Square Garden in 1893 (now at the Philadelphia Museum of Art). Beginning in 1898 Keck worked for two years for the sculptor John Massey Rhind.

In 1900 Keck was awarded a Rinehart Scholarship, which enabled him to live and work at the American Academy in Rome from 1901 until 1905, during which time he also visited Paris, Florence, and ancient cities in Greece and Italy. While in Rome, Keck modeled portraits of American artists Elihu Vedder (cat. no. 269) and Maurice Sterne (1904; see pp. 632–33), as well as symbolic compositions such as the medallion *Theseus Consoling Achilles for the Death of Patroclus* (1901; unlocated) and the group *The Awakening of Egypt* (1904; unlocated), these two completed to fulfill terms of the Rinehart Scholarship.

Keck returned to New York in 1905 and established a studio, at first in the former quarters of Saint-Gaudens. He submitted a 9-foot model of *Mohammed (The Genius of Islam)* to the trustees of the Brooklyn Institute of Arts and Sciences (now the Brooklyn Museum of Art), who, with the assistance of Daniel Chester French (pp. 326–41), were planning that institution's facade decoration. The figure (1909), portrayed in a turban and holding a sword and the Qur'an, was placed in the frieze to the left of the pediment over the main entrance. Keck earned other significant public commissions, including a statue of George Washington (1913; Palermo Park, Buenos Aires, Argentina), the *Lewis and Clark Monument* (1919; Charlottesville, Va.), and an equestrian group of Stonewall Jackson (unveiled 1921; Charlottesville). Among Keck's symbolic sculptural groups are *Youthful America,* a commission awarded in 1905 for the Allegheny County Soldiers' Memorial in Pittsburgh, and *Amicitia* (1921–31; Rio de Janeiro), a gift from the United States to Brazil in recognition of the centennial of its independence. In this 60-foot monument, a colossal bronze female figure holding laurel and the flags of Brazil and the United States stands on a column at the foot of which are representations of George Washington, Abraham Lincoln, José Bonifacio, and Rio Branco.

For New York, Keck completed a monumental bronze memorial statue of Father Francis P. Duffy (unveiled 1937; Times Square), a regimental chaplain decorated for service in World War I and pastor of a church in the theater district. Among other monuments for New York is the *Governor Alfred E. Smith Memorial* (1946; unveiled 1950, Governor Smith Memorial Park), a full-length portrait in bronze with relief panels on the base entitled *The Sidewalks of New York*. *Abraham Lincoln and Child* (1948; Madison Avenue near 133rd Street), an overlifesize group, was one of the sculptor's several Lincoln statues. Keck sculpted portrait busts of James Madison (1929), Elias Howe (1930), and Patrick Henry (1930) for the Hall of Fame for Great Americans, New York University (now the campus of Bronx Community College). His 330-foot-long series of frieze panels for the Bronx County Building, *The Triumph of Good Government,* was completed in 1933.

During the course of his career, Keck earned steady critical recognition for his architectural decorations, monumental sculptures, and memorials created in a realistic style. He was also recognized for his small-scale reliefs. An accomplished medalist, among his efforts are a commemorative gold dollar for the Panama-Pacific International Exposition of 1915 and half-dollars for the Vermont (1927) and Lynchburg, Virginia (1936), sesquicentennials. Keck was president of the National Sculpture Society from 1931 to 1934; a member of the Architectural League of New York, which awarded him its Medal of Honor in 1926; and an academician (1928) of the National Academy of Design, where he taught between 1930 and 1934.

JMM

SELECTED BIBLIOGRAPHY

Keck, Charles, Papers. Archives of American Art, Smithsonian Institution, Washington, D.C., microfilm reels D105, 441, 2068, and unmicrofilmed material.

Byne, Arthur G. "The Salient Characteristic of the Work of Charles Keck." *Architectural Record* 32 (August 1912), pp. 120–28.

Agopoff, Agop. "Charles Keck, 1875–1951, Twelfth President, National Sculpture Society, 1931–34." *National Sculpture Review* 15 (Spring 1966), pp. 22, 26–28.

Proske, Beatrice Gilman. *Brookgreen Gardens Sculpture,* pp. 129–31. Rev. ed. Brookgreen Gardens, S.C.: Brookgreen Gardens, 1968.

G[reenthal], K[athryn]. In Kathryn Greenthal et al., *American Figurative Sculpture in the Museum of Fine Arts, Boston,* pp. 344–48. Boston: Museum of Fine Arts, 1986.

269. *Elihu Vedder,* ca. 1904

Bronze
20¼ x 18¼ x 9¾ in. (51.4 x 46.4 x 24.8 cm)
Signed and inscribed (front of base): C K / Rome
Gift of Mrs. Charles Keck, 1952 (52.152)

KECK MET the influential American painter Elihu Vedder (1836–1923) through architect Charles Platt soon after the sculptor arrived in Italy. Keck was one of a number of young students at the American Academy in Rome who visited Vedder's studio to talk about art, admire his work, listen to stories, and receive his advice.[1] Keck esteemed Vedder highly, later referring to him as "one of the greatest of American painters" from whom he learned "more

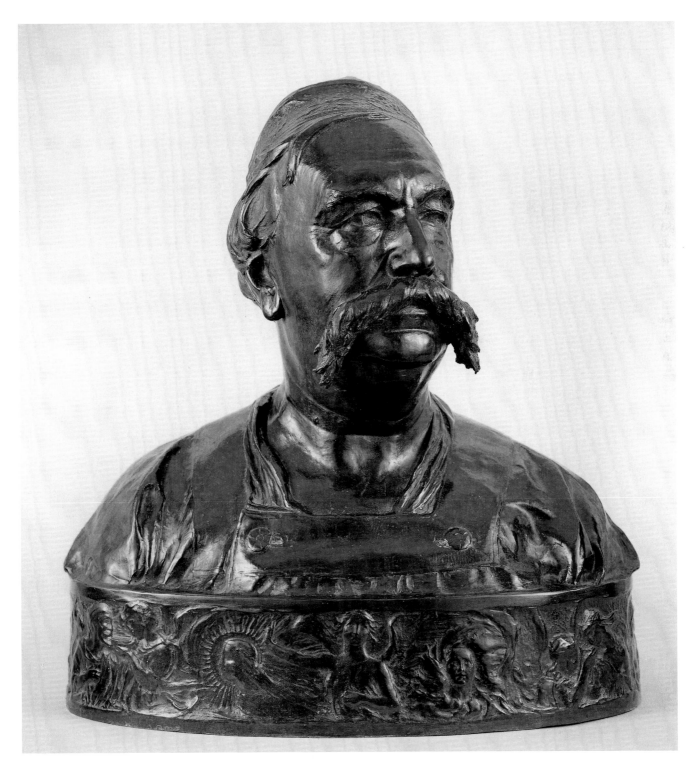

about designing than from any one else."[2] Vedder himself modeled sculptural works and decorative objects, and he collaborated with Keck on a bronze fountain piece, *The Boy* (1900–1902; Art Institute of Chicago).[3]

This likeness of Vedder is characteristic of the realistic portraits of Keck's acquaintances, which are among the sculptor's best works. Executed during the years of their friendship and Keck's studies in Rome, it depicts Vedder wearing an artist's smock and a cap that may allude to his Dutch ancestry. The truncation of the bust at the shoulders and its termination in a base decorated with figural reliefs are reminiscent of early Renaissance portrait busts, a style used by Vedder in his own work.[4] Keck was inspired in his choice of motifs for the base by Vedder's critically and commercially successful illustrations for the *Rubáiyát of Omar Khayyám,* an edition of Edward Fitzgerald's 1859 translation published by Houghton Mifflin and Company in 1884.[5] Among the images Keck selected for the bas-reliefs were Vedder's illustrations *The Soul's Answer, The Cup of Death, The Cup of Despair,* and *The Magdalen.* The stylized swirling motif visible on the base appears throughout the pages of Vedder's *Rubáiyát* as well as on its cover.[6]

Keck gave Vedder the plaster of his portrait bust, which Vedder kept until his death; it is now privately owned. A bronze cast was exhibited at the Society of American Artists annual exhibition of 1906, shortly after Keck's return from Italy.[7] A bronze was included in the Metropolitan Museum's "Exhibition of American Sculpture,"[8] a long-term installation that opened in 1918. The portrait remained on loan to the Museum until 1929, when it was returned to the artist.[9] Most likely this same bronze *Vedder* was exhibited by Keck at the National Academy of Design annual in 1947 and, his son recalled, was installed in the sculptor's studio.[10] In July 1952 Keck's widow offered this cast to the Museum as a "most characteristic" work.[11] JMM

EXHIBITIONS

MMA, "Three Centuries of American Painting," April 9–October 17, 1965.

Century Association, New York, "Centurions Associated with the Art Students League, Part One: The Past," February 7–28, 1968, no. 16.

Museum of Fine Arts, Boston, September 16–December 13, 1992; Cleveland Museum of Art, February 3–April 11, 1993; Museum of Fine Arts, Houston, May 23–August 8, 1993, "The Lure of Italy: American Artists and the Italian Experience, 1760–1914," no. 101.

MMA, Henry R. Luce Center for the Study of American Art, "American Relief Sculpture," August 15–November 5, 1995.

MMA, "As They Were: 1900–1929," April 9–September 8, 1996.

1. Regina Soria, *Elihu Vedder: American Visionary Artist in Rome (1836–1923)* (Rutherford, N.J.: Fairleigh Dickinson University Press, 1970), p. 238.

2. Unannotated typescript of speech, Keck Papers, Archives of American Art, microfilm reel 2068, frame 24.

3. For an illustration, see *Perceptions and Evocations: The Art of Elihu Vedder,* exh. cat. (Washington, D.C.: National Collection of Fine Arts, 1979), p. 233. For a list of Vedder's sculpture, see Soria, *Elihu Vedder,* pp. 385–87.

4. [Jeannine] Falino, in Theodore E. Stebbins, Jr., *The Lure of Italy: American Artists and the Italian Experience, 1760–1914,* exh. cat. (Boston: Museum of Fine Arts, 1992), p. 379, citing Vedder's *Sibilla Cumaea* (1898; American Academy of Arts and Letters, New York).

5. Ibid, p. 379.

6. For example, see Vedder's drawing for the cover of *Rubáiyát* and his illustration *The Cup of Death* in Doreen Bolger Burke, "Painters and Sculptors in a Decorative Age," in *In Pursuit of Beauty: Americans and the Aesthetic Movement,* exh. cat. (New York: MMA, 1987), p. 319, figs. 9.11, 9.12.

7. *Twenty-eighth Annual Exhibition of the Society of American Artists* (New York, 1906), p. 34, no. 107.

8. *An Exhibition of American Sculpture* (New York: MMA, 1918), p. 10, no. 41.

9. Keck acknowledged return of the work from the Museum in a typed note addressed to the MMA, April 1, 1929, Special Exhibition Notebooks, attached to receipt no. 490, January 23, 1918, MMA Office of the Registrar.

10. *National Academy, Second Half 121st Annual Exhibition* (New York: National Academy of Design, 1947), p. 20, no. 40; and Falino in *Lure of Italy,* p. 379.

11. Anne C. Keck to Robert Beverly Hale, Associate Curator of Painting and Sculpture, MMA Department of American Art, July 9, 1952, MMA Archives.

Carl Milles (1875–1955)

Milles arrived in Stockholm from his native Lagga, Sweden, in 1885 and attended school there until 1892. He was apprenticed to a cabinetmaker in Stockholm, and he took evening classes in woodworking, carving, and modeling at the Technical School. He left Sweden in 1897 for Paris, where he remained for seven years, making his living as a cabinetmaker. Milles attended lectures at the Académie Colarossi and classes at the École des Beaux-Arts from 1897 to 1900. In Paris he came to know the sculpture of Auguste Rodin, whom he probably met, and of the Belgian Constantin Meunier, and he admired the work of Jules Dalou, Jean-Alexandre-Joseph Falguière, and Aristide Maillol. In 1899 Milles exhibited at the Paris Salon for the first time, and in 1900 he won an honorable mention at the Exposition Universelle for his figures *Young Girl* and *Hagar and Ishmael*. He traveled to Holland and Belgium before settling in Munich in 1904, and the following year he married the Austrian painter Olga Granner.

After returning to Stockholm in 1906, Milles received a number of commissions for public sculpture there, including a statue of Gustavus Vasa for the Nordic Museum and *The Sun Singer*, commissioned by the Swedish Academy for a public square. Milles's individualistic style underwent a rapid transformation after 1917, when he destroyed many of the models in his studio and turned to a stylized treatment of form in which the effects of motion and gesture were paramount. In 1920 he was appointed professor of modeling at Sweden's Royal Academy of Art, and other professional recognition soon followed, including a solo exhibition at the Tate Gallery, London, in 1926–27.

Milles made his first trip to the United States in 1929. In 1931, through the auspices of Finnish architect Eliel Saarinen, he was appointed director of the sculpture department and sculptor-in-residence at the Cranbrook Academy of Art, Bloomfield Hills, Michigan, a position he held until 1950. Over the years, his students included Marshall Fredericks, Tony Rosenthal, and Duane Hanson. The Cranbrook Foundation amassed a large collection of Milles's sculpture, which is displayed on the campus in architectural and landscape settings designed by Saarinen. Among the works, some of which are bronze casts after those already installed in Sweden, are the *Jonah Fountain* (1932) and *Europa and the Bull* (ca. 1926; installed 1935).

Milles is best known for his outdoor sculptural groups, many incorporating jets of water. His mature work of the 1930s and 1940s is characterized by an exuberant sense of movement with attenuated and spirited figures. Commissions he was awarded in the United States, mostly for public

sites, include the *Triton Fountain* (1931) for the Art Institute of Chicago, *The Fountain of Faith* (1939–52) at National Memorial Park, Falls Church, Virginia, and the *William Volker Memorial Fountain* (1952–55; dedicated 1958) for Kansas City, Missouri. For the 1939 World's Fair in New York, Milles created two sculptures: *The Astronomer* (1938–39), installed near the Perisphere, and *The Pony Express* (1939) in front of the American Telephone and Telegraph Building. His finest fountain program is *The Meeting of the Waters* (1931–39; dedicated 1940, Aloe Plaza, Saint Louis), a symbolic representation of the joining of the Mississippi and Missouri Rivers.

In 1949 the Metropolitan Museum commissioned Milles to design fountain figures for a pool in the restaurant that would replace the McKim, Mead and White Pompeian court. *Aganippe: The Fountain of the Muses* was modeled in Rome, where Milles spent the winter months during 1950–55 at the invitation of the American Academy. The bronze casting of figures of the nymph Aganippe and representatives of five of the arts, as well as a centaur, a faun, a fish, three dolphins, and four fountainheads, was completed shortly before the artist's death. The fountain was installed in the Museum in 1955 and remained until 1982, when the restaurant was remodeled and the work was sold to Brookgreen Gardens, Murrells Inlet, South Carolina.

The honors accorded the sculptor's work attest to his full assimilation into the American sculptural community. In 1931 and 1932 he had solo showings in Cleveland, Detroit, New York, and Saint Louis. He was awarded gold medals by the American Institute of Architects and the Architectural League of New York in 1938, and in 1943 received an award of merit from the American Academy of Arts and Letters, to which he was elected in 1951. He was named an associate academician of the National Academy of Design in 1948. Milles became an American citizen in 1945. He died in Lidingö, Sweden, at his home and studio Millesgården, which he had donated to the people of Sweden. The estate had become a museum filled with his original sculptures, replicas of virtually every work he produced, and his extensive collection of antique sculpture and architectural elements.

J M M

SELECTED BIBLIOGRAPHY

Milles, Carl, Papers. Archives of American Art, Smithsonian Institution, Washington, D.C., microfilm reel 812.

Rogers, Meyric R. *Carl Milles: An Interpretation of His Work.* New Haven: Yale University Press, 1940.

Taylor, Francis Henry. "Aganippe: The Fountain of the Muses," *MMA Bulletin* 14 (January 1956), pp. 109–13.

Milles at Cranbrook. Bloomfield Hills, Mich.: Cranbrook Academy of Art, 1961.

Lidén, Elisabeth. *Between Water and Heaven: Carl Milles, Search for American Commissions.* Stockholm: Almqvist and Wiksell International, 1986.

Marter, Joan. "Carl Milles and His Students at Cranbrook." In *10 American Sculptors—Carl Milles' Students at Cranbrook,* pp. 7–20. Exh. cat. Lidingö, Sweden: Millesgården, 1986.

Marter, Joan, and Göran Söderlund. *Carl Milles: Sculpture and Drawings from Millesgården, Stockholm.* Exh. cat. Washington, D.C.: Trust for Museum Exhibitions, 1988.

Arvidsson, Karl Axel, ed. *Carl Milles: Episodes from My Life.* Stockholm: Millesgården and Ehrenblad Editions AB, 1991.

Carl Milles: Sculpture. Exh. cat. English ed. Washington, D.C.: International Arts and Artists; Stockholm: Millesgården, 1998.

270. *Head of Orpheus,* by 1934

Iron, ca. 1935–36
27¾ x 24¾ x 24½ in. (70.5 x 62.9 x 62.2 cm)
Signed (on neck, right rear): Carl Milles
Foundry mark (right rear): HERMAN BERGMAN fud. SWEDEN
Fletcher Fund,[1] 1940 (40.149)

THIS HEAD is a replica of that of the 26-foot central figure in Milles's *Orpheus Fountain,* which was installed in 1936 in front of the Stockholm Concert Hall.[2] Milles entered the competition for the fountain in 1926, earned the commission in 1930, and completed the models in 1934 while in residence at Cranbrook. In the finished version, Orpheus is shown playing his lyre as he towers above eight figures responding to his music.[3] According to legend, Orpheus was the son of Apollo and a Muse and the husband of Eurydice. This poet and musician from Thrace could calm or charm all inhabitants of the physical and spiritual worlds by the power of his song.

The facial type of the *Head of Orpheus,* with its broad planes, stylized hair, and angular treatment of form, is indebted both to archaic sculpture and to representations of Nordic mythological figures, frequent sources of inspiration to the artist. According to Preston Remington, Metropolitan Museum curator of Renaissance and Modern Art at the time of the acquisition, "The archaic aspect of the sculpture is emphasized by the rich, rusty brown of the iron," which was achieved by "expos[ure] to the weather."[4]

The Museum's head was purchased from Milles through the Orrefors Galleries in New York. According to the artist, three casts were made of the head, two in iron and one in bronze.[5] Milles wrote, in answer to a query about the foundry mark, "You are right in reading on the iron head Orpheus—HERMAN BERGMAN FUD. SWEDEN. They

usually mark the bronze castings in that way even the iron casts—if it is art."[6] JMM

EXHIBITIONS

MMA, "Artists for Victory: An Exhibition of Contemporary American Art," December 7, 1942–February 22, 1943.

American Academy of Arts and Letters and National Institute of Arts and Letters, New York, "Exhibition . . . of Works by Newly Elected Members, Recipients of Arts and Letters Grants and Sculpture by Carl Milles," May 13–June 23, 1943, no. 44.

American Academy of Arts and Letters and National Institute of Arts and Letters, New York, "Exhibition of Works by Newly Elected Members and by Recipients of Academy and Institute Honors," May 23–June 30, 1947, no. 71.

MMA, Henry R. Luce Center for the Study of American Art, "Subjects and Symbols in American Sculpture: Selections from the Permanent Collection," April 11–August 20, 2000.

1. Erroneously credited as purchased through the Rogers Fund in Albert TenEyck Gardner, *American Sculpture* (New York: MMA, 1965), p. 120.
2. For numerous illustrations of the fountain in Stockholm, see Rogers 1940, pls. 92–108. A sketch for the central figure of Orpheus (ca. 1926) was placed in the courtyard at Cranbrook Academy in 1930. In 1938, the eight subsidiary nudes (1934–37) were installed at Cranbrook in a separate fountain setting.
3. Preston Remington, "Orpheus by Carl Milles," *MMA Bulletin* 36 (March 1941), pp. 58–59.
4. Remington, "Orpheus by Carl Milles," p. 59.
5. Copyright and information form completed by artist following purchase, [1940], MMA Archives.
6. Milles to John B. Montignani, Assistant, MMA Catalogue Department, November 30, 1940, MMA Archives.

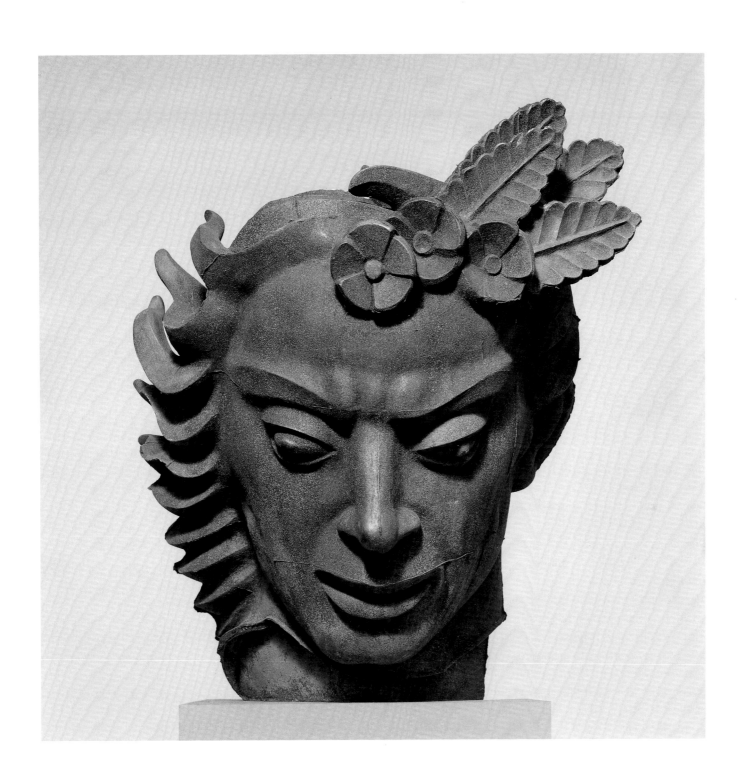

Gertrude Vanderbilt Whitney (1875–1942)

Whitney, born in New York to Alice Claypoole Gwynne and Cornelius Vanderbilt II, graduated from the Brearley School in 1894 and in 1896 married Harry Payne Whitney. Her first training in sculpture began in 1900 with Hendrik C. Andersen. In 1901 her lifesize male nude *Aspiration* was exhibited in plaster at the Pan-American Exposition in Buffalo. Whitney then studied with James Earle Fraser (pp. 596–99), first privately (ca. 1902–4) and later at the Art Students League.

Whitney set up a studio in 1907 at 19 Macdougal Alley, where Fraser and other sculptors also maintained studios. She gave substantive encouragement to American artists by providing exhibition space in her Macdougal Alley studio and the adjoining building at 8 West 8th Street. In addition, she housed young artists and provided funds for living and working expenses and for travel abroad. Among the sculptors who benefited from her patronage were John Gregory (pp. 634–36), Chester Beach (pp. 648–50), Arthur Lee (pp. 653–54), and Jo Davidson (pp. 704–18). In 1912 she set up another studio, in Westbury, Long Island, on the grounds of her family estate. Whitney's patronage of young American artists extended also to her collecting their work and her financial support of organizations that exhibited it. In 1908 she purchased four of the seven paintings sold from the exhibition "The Eight" at the Macbeth Gallery. She contributed funds to the Armory Show in 1913, and she helped found and long supported the Society of Independent Artists, which favored non-juried exhibitions.

In Paris in 1910 Whitney studied with Andrew O'Connor (pp. 583–85) and was encouraged to explore the naturalism she found in his work. She also benefited from private criticism from Auguste Rodin, whom she met in 1911; his thematic and stylistic influence is evident in her early works such as the marble *Paganism Immortel* (ca. 1907), intertwined figures atop a roughly hewn boulder, and *Despair* (1912; Whitney Museum of American Art, New York), a male figure, truncated across the chest, raising his left arm to his tilted head.

After World War I broke out in Europe, Whitney founded a hospital for war victims in Juilly, north of Paris. The months she spent at the hospital and in other volunteer service during the war would have a profound effect on her work. From the classical subjects of her early years and the sensuous surfaces indebted to Rodin, her sculpture changed to a stark naturalism in portraying subjects drawn from her wartime experiences. Between 1917 and 1919 she created small bronzes of nurses and wounded soldiers, executed in a loose, impressionistic style. She displayed these figures as "Impressions of the War" at the Whitney Studio in 1919,

having incorporated some into a pair of relief panels for the temporary Victory Arch (1919) on Fifth Avenue (she later cast at least two sets of the panels in bronze).

Whitney's best-known works are her monumental sculptures in an academic style, such as the *Titanic Memorial* (1914–29; Waterfront Park, Washington, D.C.), a heroic draped male in pink granite, 18 feet high, which centers a 30-foot exedra designed by the architect Henry Bacon. The memorial, dedicated in 1931, was originally located on Rock Creek Parkway. Overlooking the harbor of Saint Nazaire, France, the *Saint Nazaire Monument* (1924) was unveiled in 1926, its casting and installation supervised by O'Connor. It commemorated the landing site of the first American troops in France in 1917 (it was destroyed during World War II). Whitney's 114-foot granite *Christopher Columbus Monument,* also overseen by O'Connor, was dedicated in 1929 near the harbor of Palos, Spain, from which Columbus sailed in 1492. Her bronze equestrian statue of Colonel William F. Cody ("Buffalo Bill") for Cody, Wyoming, was dedicated in 1924. For New York, she produced the *Washington Heights–Inwood War Memorial* (1921; Broadway and Saint Nicholas Avenue), a group of three World War I soldiers, which was awarded a medal from the New York Society of Architects in 1922 for the best monument erected during that year, and a realistic bronze figure of Peter Stuyvesant (1936; Stuyvesant Square), director general of New Netherland from 1646 to 1664. For the New York World's Fair of 1939, Whitney contributed the streamlined *To the Morrow (Spirit of Flight),* two soaring winged figures symbolizing the progress of aviation.

Whitney formed the Whitney Studio (1914), the Friends of Young Artists (1915), and the Whitney Studio Club (1918), a meeting place and gallery for artists. In 1928, its size unwieldy and its objectives realized, the Whitney Studio Club was disbanded, and in its place the Whitney Studio Galleries (1928) and then the Whitney Museum of American Art (1930) were established. The Whitney Museum's permanent collection, which opened to the public in November 1931, was composed initially of about five hundred works of early-twentieth-century American art purchased by Whitney; in 1929 she had offered these to the Metropolitan Museum, but the Metropolitan declined to accept them.

Whitney was elected an associate member of the National Academy of Design in 1940 and also was a member of the National Association of Women Artists and the National Sculpture Society. A memorial exhibition of more than sixty examples of the sculptor's work was held at the Whitney Museum of American Art in 1943.

JMM

SELECTED BIBLIOGRAPHY

Whitney Museum of American Art, Gertrude Vanderbilt Whitney Papers. Archives of American Art, Smithsonian Institution, Washington, D.C., microfilm reels 2356–75, 2288–89, 4861, and un-microfilmed material.

Whitney, Gertrude Vanderbilt. "The End of America's Apprenticeship: American Influence on Foreign Sculpture." *Arts and Decoration* 13 (August 1920), pp. 150–51.

du Bois, Guy Pène. "Mrs. Whitney's Journey in Art." *International Studio* 76 (January 1923), pp. 351–54.

Breuning, Margaret. "Gertrude Vanderbilt Whitney's Sculpture." *Magazine of Art* 36 (February 1943), pp. 62–65.

Memorial Exhibition: Gertrude Vanderbilt Whitney. Introduction by Juliana Force. New York: Whitney Museum of American Art, 1943.

Friedman, B. H., with the research collaboration of Flora Miller Irving. *Gertrude Vanderbilt Whitney: A Biography.* Garden City, N.Y.: Doubleday, 1978.

Conner, Janis, and Joel Rosenkranz. *Rediscoveries in American Sculpture: Studio Works, 1893–1939,* pp. 169–76. Austin: University of Texas Press, 1989.

271. *Head of a Spanish Peasant,* 1911

Bronze
16¼ x 12½ x 11¼ in. (41.3 x 31.8 x 28.6 cm)
Signed and dated (back): *G. Whitney* / 1911
Foundry mark (back, in seal): CIRE / C. VALSUANI / PERDUE
Rogers Fund, 1916 (16.84)

A PORTRAIT of Adolphe Ramon, Whitney's studio assistant in Paris, this head is an example of her interest in lifesize bronze busts, and it was probably the first sculpture she completed in Paris.[1] The realistic likeness, with strong chin and downcast eyes, suggests Whitney's skill in capturing the character of her subject, as well as her mastery of sculptural modeling. Her technique of contrasting surface textures—from the smooth cheeks to the patterned scarf around his head—creates dramatic effects of light and shadow and gives the work a tactile quality.

Head of a Spanish Peasant was exhibited at the annual of the Société Nationale des Beaux-Arts in 1911 and at the National Academy of Design's winter exhibition later that year.[2] The Metropolitan Museum's bronze was purchased in 1916 through the efforts of Daniel Chester French (pp. 326–41), chairman of the trustees' Committee on Sculpture, who had seen an exhibition of Whitney's work at her West 8th Street studio.[3] In response to a query from the Metropolitan in 1933, Juliana Force, director of the Whitney Museum, wrote that "no more than six copies were made" of *Head of a Spanish Peasant.*[4] Another bronze cast of the head, also by C. Valsuani, is at the Staten Island Institute of Arts and Sciences, New York.[5] A bronze cast of a reduced version (11 in. high), dated 1913 and known as *Italian Peasant Head,* is at the Detroit Institute of Arts.[6]

The Metropolitan Museum's bronze surmounts a stepped black veined marble base, 5 inches high.

JMM

EXHIBITIONS

Whitney Museum of American Art, New York, "Memorial Exhibi-
 tion: Gertrude Vanderbilt Whitney," January 26–February 28,
 1943, no. 9.
Jane Voorhees Zimmerli Art Museum, Rutgers University, New
 Brunswick, N.J., "The Enduring Figure 1890s–1970s: Sixteen
 Sculptors from the National Association of Women Artists,"
 December 12, 1999–March 12, 2000, no. 50.

1. Conner and Rosenkranz 1989, p. 170.
2. *Catalogue des ouvrages de peinture, sculpture . . .* , Société Nationale des
 Beaux-Arts (Paris: Évreux, 1911), p. 299, no. 2063; *Illustrated Catalogue,
 National Academy of Design Winter Exhibition 1911* (New York, 1911),
 p. 11, no. 23. She continued to exhibit the head; see, for instance,
 Exhibition of Sculpture by Gertrude V. Whitney of New York (Chicago:
 Art Institute of Chicago, 1923), no. 36, as "Spanish Peasant."
3. See French to Edward D. Adams, George F. Baker, George Blu-
 menthal, and William Church Osborn (other members of the
 trustees' Committee on Sculpture), February 28, 1916; French to
 Whitney, March 10, 1916; French to Henry W. Kent, Secretary,
 MMA, May 3, 1916; and French to Whitney, May 17, 1916 (all
 copies), Daniel Chester French Family Papers, Manuscript
 Division, Library of Congress, Washington, D.C., microfilm reel 3,
 frames 373, 384, 455, and 472, respectively.
4. Force to Preston Remington, Associate Curator of Decorative
 Arts, MMA, March 15, 1933, MMA Archives.
5. See *Art Collection Handbook, 1881–1981, Staten Island Museum:
 100 Selected Works of Art from the Permanent Collection* (Staten Island,
 N.Y.: Staten Island Museum, Staten Island Institute of Arts and
 Sciences, 1981), p. 69.
6. See *Arts and Crafts in Detroit 1906–1976: The Movement, the Society,
 the School,* exh. cat. (Detroit: Detroit Institute of Arts, 1976), p. 105,
 no. 97. That work was also cast at the C. Valsuani foundry in Paris.
 It was given to the Detroit Institute in 1919.

272. *Caryatid,* 1912

Bronze, 1913
18¾ x 6½ x 5½ in. (47.6 x 16.5 x 14 cm)
Signed and dated (top of base, right rear): © *Gertrude V. Whitney* / 1913
Foundry mark (top of base, left rear, in seal, stamped): CIRE / C. VALSUANI / PERDUE
Anonymous Gift, 1922 (22.81)

THIS FIGURE was a study for one of three standing
male nudes that support the basin of an overlifesize foun-
tain. Whitney designed the fountain for the Arlington
Hotel in Washington, D.C., and it was carved in marble in
Paris but never installed; she gave the fountain to McGill
University, Montreal, in 1931.[1] The marble fountain was
exhibited at the 1913 Paris Salon, earning Whitney an
honorable mention, and that same year the study for one
of the supporting figures was cast in bronze in Paris. In
1915 Whitney exhibited the fountain at the Panama-
Pacific International Exposition in San Francisco, where
she received a bronze medal.[2]

The title of the Metropolitan's bronze, *Caryatid,* describes
the figure's function as an architectural support, but its
gender makes it more correctly an atlas. Though she posi-
tioned the subject in a classical contrapposto, both arms
upraised supporting a heavy weight, Whitney brought
her sculpture into the Rodinesque sphere by her emphasis
on the contrasts of light and shadow that serve alternately
to reveal and to mask the figure. The physical force Whit-
ney suggested through the taut musculature of the arms,
legs, and back, is also indebted to Rodin.

In 1921 the sculpture was purchased from the Galerie
Georges Petit, Paris, where Whitney's work recently had
been on exhibition.[3] The donor bought it from the exhibi-
tion expressly to give to the Metropolitan Museum; it was
then displayed in Whitney's solo show at the McLean Gal-
lery, London, before joining the Metropolitan's collection.

Like *Head of a Spanish Peasant* (cat. no. 271), "no more
than six copies were made" of the work.[4] One bronze is
at Brookgreen Gardens, Murrells Inlet, South Carolina;
another is at the Cleveland Museum of Art; and a third is
privately owned. A smaller bronze version (41⅜ in. high)
of the fountain ensemble is at the Whitney Museum of
American Art.

Caryatid stands on a green marble base, 4 inches high.

JMM

EXHIBITIONS

Salem Fine Arts Center, Winston-Salem, N.C., February 27–
 March 19, 1972; North Carolina Museum of Art, Raleigh,
 March 25–April 20, 1972, "Women: A Historical Survey of
 Works by Women Artists," no. 36.
Berry-Hill Galleries, New York, "The Woman Sculptor: Malvina
 Hoffman and Her Contemporaries," October 24–December 8,
 1984, no. 43.
MMA, "The Human Figure in Transition, 1900–1945: American
 Sculpture from the Museum's Collection," April 15, 1997–
 March 29, 1998.

1. The marble is illustrated in *Memorial Exhibition: Gertrude Vanderbilt
 Whitney* 1943, n.p. A full-size bronze version of the fountain,
 dedicated in 1924, is in Lima, Peru.

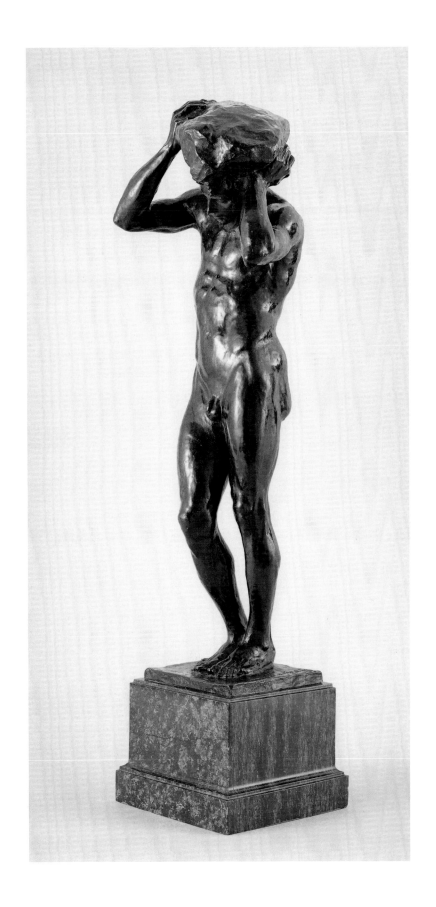

2. *Explication des ouvrages de peinture, sculpture . . . ,* Société des Artistes Français, Salon de 1913 (Paris: Paul Dupont, 1913), p. 379, no. 4144, as "Fountaine en marbre, pour le New Arlington Hotel, à Washington"; and *Official Catalogue of the Department of Fine Arts, Panama-Pacific International Exposition* (San Francisco: Wahlgreen Co., 1915), p. 248, no. 3140, as "Fountain."

3. Galeries Georges Petit, *Exposition des sculptures par Gertrude Whitney* (Paris: Imprimerie Georges Petit, 1921), p. 16, no. 7, as "Cariatide."

4. Juliana Force, Director, Whitney Museum of American Art, to Preston Remington, Associate Curator of Decorative Arts, MMA, March 15, 1933, MMA Archives.

James Earle Fraser (1876–1953)

Born in Winona, Minnesota, Fraser spent most of his childhood in the Dakota Territory, where his family settled on a ranch near Mitchell (now South Dakota). After attending school in Minneapolis, Fraser in 1891 worked as an apprentice to Richard Bock and enrolled in evening drawing classes at the Art Institute of Chicago. Fraser traveled to Paris at the age of twenty, taking with him his model for an early version of *End of the Trail*. He studied at the Académie Colarossi and with Jean-Alexandre-Joseph Falguière at the École des Beaux-Arts. Fraser was awarded the Wanamaker Prize at an exhibition of the American Art Association of Paris in 1898. His work attracted the attention of one of the jurors, Augustus Saint-Gaudens (pp. 243–325), who invited Fraser to assist him in his Paris studio on the *Sherman Monument* (1892–1903; Grand Army Plaza, New York; see cat. nos. 126, 136). In 1900 Fraser returned to the United States with Saint-Gaudens and worked as his chief assistant in his Cornish, New Hampshire, studio. Fraser moved to New York in 1902 and set up his own studio in Macdougal Alley, where a number of other sculptors were also located. For the 1904 Louisiana Purchase Exposition in Saint Louis, he was commissioned to complete a seated statue of Thomas Jefferson and an equestrian sculpture of a Cherokee chief that was installed in the fair's Court of Honor. Fraser taught at the Art Students League from 1906 to 1911.

Fraser modeled lively portrait busts and bas-reliefs of adults and children, among them E. H. Harriman, Jock Whitney, and Flora and Sonny Whitney. He completed a marble bust of Theodore Roosevelt for the Senate wing of the United States Capitol (installed 1910). Fraser was a founder of the American Association of American Painters and Sculptors, which organized the Armory Show held in 1913. To this exhibition he contributed a frame of medals, a bronze horse, and the marble group *Grief*.

Fraser drew on his early experience in frontier living as the inspiration for some of the finest sculptures of his career. In 1915 he received gold medals for his sculpture and medals at the Panama-Pacific International Exposition in San Francisco. At the entrance to the Court of Palms was his plaster *End of the Trail* (National Cowboy Hall of Fame and Western Heritage Center, Oklahoma City, Okla.), a weary brave with lowered spear astride an exhausted horse symbolizing the despair of Native Americans at the advancing white settlement. A large bronze version was not unveiled until 1929, in Shaler Park, Waupun, Wisconsin (another cast, dedicated in 1971, is in Mooney Grove Park, Visalia, Calif.). Fraser also issued reductions; a 45-inch version of 1918 is at the Detroit Institute of Arts.

In 1917 Fraser was commissioned to complete a bronze statue of Alexander Hamilton (unveiled 1923; Department of Treasury Building, Washington, D.C.). Subsequently he received many monumental commissions, including the Thomas Jefferson Memorial for Jefferson City, Missouri (1920), and a heroic seated statue of Benjamin Franklin (1938; Franklin Institute, Philadelphia). For the Hall of Fame for Great Americans at New York University (now the campus of Bronx Community College), New York, Fraser created a portrait bust of Augustus Saint-Gaudens (1926) and, working with Thomas Hudson Jones, one of Ulysses S. Grant (1923). Fraser's 65-foot statue of George Washington was placed prominently on the main axis of the New York World's Fair in 1939. His equestrian statue of Theodore Roosevelt for the New York State Memorial (unveiled 1940; American Museum of Natural History, New York) emphasizes the former president's role as an explorer and hunter. Attendant figures of a Native American and an African symbolize the two continents.

Fraser produced four pediments for the Fifteenth Street facade of the Commerce Building in Washington, D.C.: *Foreign and Domestic Commerce, Fisheries, Aeronautics,* and *Mining* (1934). He designed a 104-foot-long pediment, *The Recorder of the Archives* (1935), for the National Archives; his *Heritage* and *Guardianship* (1935) flank the steps to the building's south portico. Fraser, the most represented sculptor of outdoor monuments in Washington, also created *The Authority of Law* and *The Contemplation of Justice* (1935), located at the west entrance of the United States Supreme Court.

Fraser excelled at smaller numismatic work. In 1901 he made a special presentation medal for Saint-Gaudens in recognition of his sculpture displayed at the Pan-American Exposition in Buffalo. In 1912 he designed the Indian head and buffalo nickel for the United States Treasury, a coin minted between 1913 and 1938. In 1919 Fraser was the first recipient of the J. Sanford Saltus Medal from the American Numismatic Society for distinguished achievement in the art of the medal. Other medals by Fraser include the widely dispersed World War I Victory Medal (1919), the prestigious Navy Cross (1919), and the American Institute of Graphic Arts Medal (1920).

Fraser was elected an academician of the National Academy of Design in 1917. He served on the National Arts Commission from 1920 to 1925 and was president of the National Sculpture Society from 1924 to 1927; in 1952 he was named its honorary president. Fraser's wife, Laura Gardin Fraser, was also an accomplished medalist and sculptor.

JMM

SELECTED BIBLIOGRAPHY

Fraser, James Earle and Laura Gardin, Papers. Archives of American Art, Smithsonian Institution, Washington, D.C., microfilm reels 2548–49.

Fraser, James Earle. "Autobiography." Typescript in Augustus Saint-Gaudens Papers, Dartmouth College Library, Hanover, N.H.

Semple, Elizabeth Anna. "James Earle Fraser, Sculptor." *Century Magazine* 79 (April 1910), pp. 929–32.

"A Sculptor of People and Ideals: Illustrated with the Work of James Earle Fraser." *The Touchstone* 7 (May 1920), pp. 87–93, 161.

"James E. Fraser's Sculptures in Bronze." *Metal Arts* 2 (August 1929), pp. 365–68, 382.

Fraser, James Earle. "Noted Sculptor Tells of Pioneer Boyhood Spent in Mitchell." *Middle Border Bulletin* 3 (Winter 1944), pp. 1, 3–4.

Morris, Joseph F., ed. *James Earle Fraser*. American Sculptors Series.

Athens: University of Georgia Press in collaboration with the National Sculpture Society, 1955.

Fraser, Laura Gardin. "James Earle Fraser, 1876–1953, Ninth President, National Sculpture Society, 1924–1927." *National Sculpture Review* 14 (Summer 1965), pp. 22, 26–27.

James Earle Fraser, American Sculptor: A Retrospective Exhibition of Bronzes from Works of 1913 to 1953. Exh. cat. New York: Kennedy Galleries, 1969.

Krakel, Dean. *End of the Trail: The Odyssey of a Statue.* Norman: University of Oklahoma Press, 1973.

Freundlich, August L. "The Coins and Medals of James Earle Fraser." In Alan M. Stahl, ed., *The Medal in America,* pp. 183–99. Coinage of the Americas Conference, 1987, Proceedings no. 4. New York: American Numismatic Society, 1988.

273. *Head of a Young Artist,* by January 1920

Marble, 1933
17 x 8¼ x 14¼ in. (43.2 x 21 x 36.2 cm)
Signed: (right shoulder) J. FRASER; (right side) JAMES EARLE FRASER
Rogers Fund, 1933 (33.93)

FRASER ENJOYED considerable success as a portraitist even before he began to create his better-known public monuments. In January 1920 he had a solo exhibition of his portraits at the Arden Gallery in New York.[1] Included was his *Head of a Young Artist,* which is traditionally identified as a portrait of J. Olaf Olson, a young American painter of Norwegian descent.[2] In 1933 Fraser carved the portrait from a "block of marble removed from Milan Cathedral during restorations."[3] The meditative aspect of this finely modeled head combined with the particular translucency of the marble make it an exceptional portrait in Fraser's oeuvre.

Fraser offered the Metropolitan Museum the marble, a unique example of the subject, in lieu of a bronze statuette of *End of the Trail,* for which the Museum had paid him in June 1918 and which for some reason he had never delivered.[4] Joseph Breck, curator of Decorative Arts, endorsed acceptance of the substitution for "[the head] is, in my opinion, representative of the artist's best work."[5]

Pointing marks made in the marble during the carving process are still visible in the hair and around the rough stone near the neck. A second signature, JAMES EARLE FRASER, was added in 1951.[6] JMM

EXHIBITIONS

American Academy of Arts and Letters, and National Institute of Arts and Letters, New York, "Exhibition of Work by Newly Elected Members," May 26–June 30, 1951.

Westport Public Library, Westport, Conn., "Westport Artists of the Past: A Bicentennial Exhibition 1976," June 12–30, 1976.

1. See "A Sculptor of People and Ideals" 1920, esp. pp. 87–89. The head is illustrated on p. 89, as "An Artist."
2. The identity of the sitter is noted in an excerpt from the minutes of the trustees' Committee on Purchases, June 19, 1933. It may be that Olson is actually Olaf Olesen, who was born in Denmark in 1874, lived in New York, and exhibited at the Whitney Studio Club between 1920 and 1928; see Peter Hastings Falk, ed., *Who Was Who in American Art, 1564–1975: 400 Years of Artists in America* (Madison, Conn.: Sound View Press, 1999), vol. 3, p. 2464. Alternatively, it has been proposed that the model was Harry Dickinson Thrasher (pp. 719–20); see Virginia Reed Colby and James B. Atkinson, *Footprints of the Past: Images of Cornish, New Hampshire and the Cornish Colony* (Concord: New Hampshire Historical Society, 1996), p. 417, n. 3.
3. P[reston] R[emington], "Notes: American Sculpture: A Recent Accession," *MMA Bulletin* 28 (October 1933), p. 177.
4. Fraser to Herbert E. Winlock, Director, MMA, April 29, 1933, MMA Archives. See also recommended purchase form, May 14, 1918, MMA Archives.
5. Recommended purchase form, signed by Joseph Breck, Curator of Decorative Arts, MMA, June 7, 1933, MMA Archives, proposing substitution of *Head of a Young Artist* for *End of the Trail.*
6. Object catalogue cards, MMA Department of Modern Art.

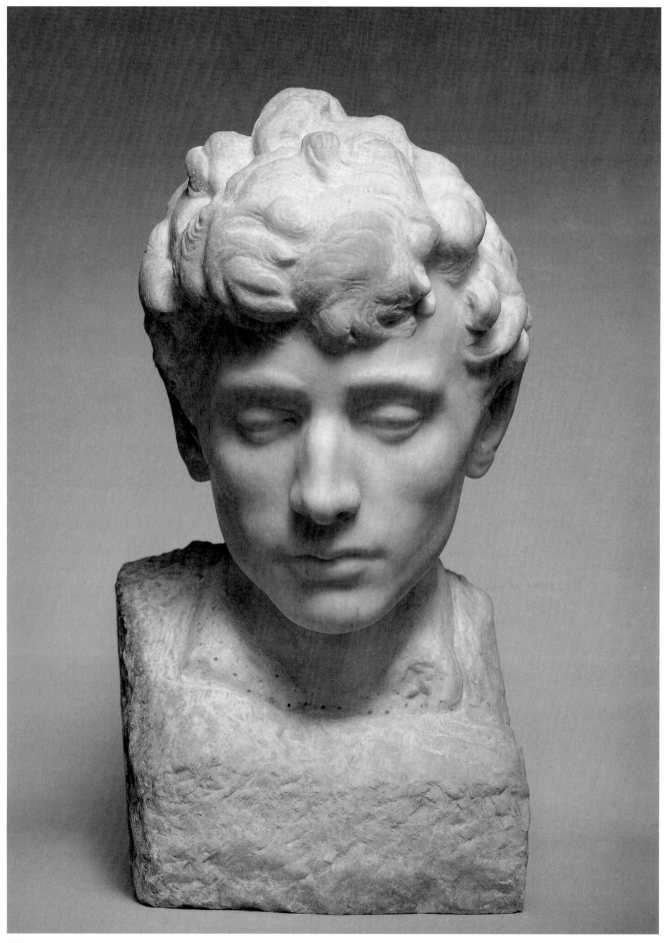

273

274. *Elihu Root*, 1926

Bronze
18½ x 14½ x 12½ in. (47 x 36.8 x 31.8 cm)
Signed and dated (edge of left shoulder): J E FRASER 1926 ©
Foundry mark (back of base): KUNST F'NDRY—N.Y.
Gift of Carnegie Corporation, 1929 (29.95)

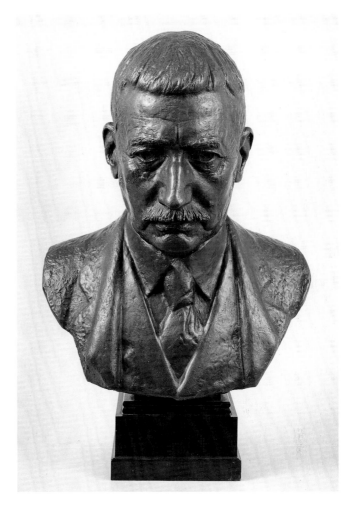

ELIHU ROOT (1845–1937), a New York lawyer, served the United States government in many capacities, including secretary of war in President William McKinley's cabinet, secretary of state in President Theodore Roosevelt's cabinet, and U.S. senator from New York.[1] He was president of the Carnegie Endowment for International Peace, chairman of the board of the Carnegie Institution of Washington, and chairman of the board of the Carnegie Corporation of New York. For the Metropolitan Museum, he served as a trustee from 1900 to 1937 and as first vice president from 1917 to 1931.

This realistic and imposing bust of Root conveys the sitter's intellectual powers and reflects Fraser's adherence to his rigorous academic training. The portrait was commissioned by the Carnegie Corporation of New York in honor of Root's eightieth birthday. In May 1929 a bronze cast was offered to the Metropolitan Museum by Frederick Paul Keppel, president of the Carnegie Corporation of New York: "James E. Fraser has recently completed what we believe is an admirable portrait bust of [Root]. . . . [T]he Corporation would take great pleasure in presenting to the Museum a replica."[2] Fraser designed for the bust "an appropriate pedestal," which was to be made in mahogany.[3] However, the Museum's decision on Fraser's proposed pedestal was put off since by Museum policy the portrait could not be displayed during the sitter's lifetime. The bronze now stands on a Belgian black marble base, 3¾ inches high.

Fraser was commissioned to make ten busts, of which there are three known versions. Eight bronze casts, including ones at the Metropolitan and the Smithsonian Museum of American Art, Washington, D.C., depict Root in a business suit. A larger marble version is at the National War College, Washington, D.C. A bronze at the New York State Bar Association, Albany, shows the subject in his judicial robes.[4] JMM

EXHIBITIONS

MMA, "The 75th Anniversary Exhibition of Painting and Sculpture by 75 Artists Associated with the Art Students League of New York," March 16–April 29, 1951, no. 35.

Century Association, New York, "Centurions Associated with the Art Students League, Part One: The Past," February 7–28, 1968, no. 9.
Westport Public Library, Westport, Conn., "Westport Artists of the Past: A Bicentennial Exhibition 1976," June 12–30, 1976.

1. See the authorized biography by Philip C. Jessup, *Elihu Root,* 2 vols. (New York: Dodd, Mead and Co., 1938).
2. Keppel to Board of Trustees, MMA, May 16, 1929, MMA Archives.
3. Fraser to Henry W. Kent, Secretary, MMA, May 1, 1929, MMA Archives.
4. Details about the busts of Root were supplied by Florence Anderson, Carnegie Corporation of New York, to Faith Dennis, Assistant, Renaissance and Modern Art, MMA, April 19, 1937, MMA Archives. See also Albert TenEyck Gardner, *American Sculpture* (New York: MMA, 1965), pp. 127–28.

Anna Vaughn Hyatt Huntington (1876–1973)

Born in Cambridge, Massachusetts, Huntington was one of the most prominent animal sculptors of the early twentieth century. She signed her work Anna V. Hyatt until her marriage in 1923 to scholar and philanthropist Archer Milton Huntington. In her choice of animal subjects she was influenced by her older sister, Harriet, who was also a sculptor. They collaborated on compositions such as *The Pride of Our Great Dane* (1895; unlocated), which they exhibited at the National Sculpture Society in 1898.

In 1898 Anna V. Hyatt briefly studied with Henry Hudson Kitson in Boston. By 1900 Hyatt was selling her work through the Boston emporium Shreve, Crump and Low, and in 1902 she showed twenty-five of her animal statuettes at the Boston Art Club. After the death of her father in 1902, Hyatt and her mother moved to New York, and she began to sketch animals regularly at the Bronx Zoo. In October 1902 Hyatt began studies at the Art Students League with George Grey Barnard (pp. 421–27) and Hermon Atkins MacNeil (pp. 475–81). She also had private instruction with Gutzon Borglum (pp. 496–500). From 1903 to 1906 Hyatt shared a studio with Abastenia St. Leger Eberle (pp. 627–29), and they collaborated on groups with animals modeled by Hyatt and figures by Eberle. Their *Men and Bull* (1904; destroyed) was awarded a bronze medal at the Louisiana Purchase Exposition in Saint Louis, and their life-size *Boy and Goat Playing* (1905; destroyed) was exhibited at the Society of American Artists in 1905. Hyatt continued to focus on small animal groups, such as the playful *Rolling Bear* (ca. 1902–6; Cleveland Museum of Art) and the somber *Winter Noon* (1903; Milwaukee Art Museum), which depicts two windblown horses huddled together.

In 1907 Hyatt traveled to France, working in Auvers-sur-Oise, north of Paris, on her animal compositions, among them *Reaching Jaguar* and *Jaguar* (cat. nos. 277, 278). She returned to the United States briefly in 1908 for the dedication of a bronze lion that she had cast in Naples for the Steele High School in Dayton, Ohio (now at Dayton Art Institute). Back in France, Hyatt settled in Paris in the former studio of sculptor Jules Dalou to begin her equestrian statue of Joan of Arc. The lifesize plaster study (destroyed) was exhibited in the Paris Salon of 1910, and Hyatt was awarded an honorable mention. In 1914 she won a competition in New York for an equestrian statue of Joan of Arc to celebrate the five-hundredth anniversary of the saint's birth. Her overlifesize *Joan of Arc* was installed at Riverside Drive and 93rd Street in 1915. Hyatt enjoyed commercial success with several different sizes of bronze reductions of the statue.

In 1914 Hyatt had a solo exhibition at the Gorham Galleries, the New York gallery of the Gorham Company foundries in Providence, Rhode Island. In 1915 she was awarded a silver medal at San Francisco's Panama-Pacific International Exposition for ten animal groups, among them *Fighting Elephants* (ca. 1911–14; Carnegie Museum of Art, Pittsburgh). Hyatt successfully modeled monumental works, in 1923 beginning an equestrian statue of the Spanish hero Rodrigo Díaz de Vivar, *El Cid Campeador,* which was installed in 1927 in the Spanish city of Seville; a full-size replica is in New York in front of the Hispanic Society of America (founded by her husband in 1904). A bout with tuberculosis from 1927 curtailed Huntington's output until about 1934. She produced some of her finest compositions during the mid-1930s, such as *Greyhounds Playing,* a bronze cast of which she donated to the Pennsylvania Academy of the Fine Arts after an aluminum version was awarded that institution's George D. Widener Memorial Medal in 1937.

In 1931, eight years after her marriage to Huntington, she and her husband established Brookgreen Gardens, a sculpture park and natural reserve in Murrells Inlet, South Carolina. Brookgreen Gardens features several hundred American sculptures of the nineteenth and early twentieth centuries, along with numerous examples of her work including *Diana of the Chase* (1922), which earned the Saltus Medal from the National Academy of Design in 1922. Huntington was named an academician there in 1922, and in 1940 she and her husband donated their Fifth Avenue mansion to the National Academy, which serves as the institution's headquarters.

In 1932 Huntington was the first woman artist to be elected to the American Academy of Arts and Letters. Four years later the American Academy honored her with a large retrospective exhibition. Between 1937 and 1939 an exhibition of Huntington's sculptures toured twenty-one institutions across the United States, and she began to donate her bronzes to American museums and schools. She worked for many years at her estate Stanerigg in Redding, Connecticut, creating two aluminum equestrian groups, *Don Quixote* (1947) and *Fighting Stallions* (1950), for Brookgreen Gardens and a bronze equestrian *José Martí* (1959, unveiled 1965; Central Park South, New York), depicting the expiring Cuban patriot on a rearing horse. In 1974, a year after Huntington's death, a substantial memorial exhibition was held at the Hispanic Society. JMM

Selected Bibliography

Huntington, Anna Hyatt, Papers. George Arents Research Library for Special Collections, Syracuse University, Syracuse, N.Y.
Huntington, Anna Hyatt, Papers. Archives of American Art, Smithsonian Institution, Washington, D.C., microfilm reels 3890–91.

Ladd, Anna Coleman. "Anna V. Hyatt—Animal Sculptor." *Art and Progress* 4 (November 1912), pp. 773–76.

Parkes, Kineton. "An American Sculptress of Animals: Anna Hyatt Huntington." *Apollo* 16 (August 1932), pp. 61–66.

Mechlin, Leila. "Anna Hyatt Huntington, Sculptor." *Carnegie Magazine* 11 (June 1937), pp. 67–71.

Anna Hyatt Huntington. American Sculptors Series 3. New York: W. W. Norton under the auspices of the National Sculpture Society, 1947.

Proske, Beatrice Gilman. *Brookgreen Gardens Sculpture,* pp. 168–80. Rev. ed. Brookgreen Gardens, S.C.: Brookgreen Gardens, 1968.

Conner, Janis, and Joel Rosenkranz. *Rediscoveries in American Sculpture: Studio Works, 1893–1939,* pp. 71–78, 187. Austin: University of Texas Press, 1989.

275. *Goats Fighting,* 1905

Bronze, before 1912
10 x 14¾ x 7½ in. (25.4 x 37.5 x 19.1 cm)
Signed (top of base, left): Anna V. Hyatt
Inscribed and dated (back of base): Copyrighted / 1905
Foundry mark (back of base, stamped): ROMAN BRONZE WORKS. N. Y.
Rogers Fund, 1912 (12.51)

FOR THIS bronze group, also known as *Goats Butting,*[1] Hyatt sculpted two goats lunging hard at each other in combat. The rocky terrain on which they are fighting emphasizes the harshness of the conflict and Hyatt's exploration of the animals' anatomy and motion. One goat lunges forward, a single hind hoof on the ground. The goats meet at their horns, and their bodies arc over the outcropping ground. Every element of the work is informed by the artist's keen powers of observation of animal subjects, both anatomical and behavioral.

Foundry records of Roman Bronze Works indicate that casts of *Goats Fighting* were produced as early as spring 1905.[2] The cast at the Metropolitan Museum was purchased from the artist through the Gorham Company in March 1912.[3] Huntington later refined the composition so that all four rear hooves touch the base and the rocky

terrain is less pronounced. An example is at the Museum of Fine Arts, Springfield, Massachusetts (cast by E. Gargani foundry), a gift of the artist in 1937. Another bronze cast was formerly at the Detroit Institute of Arts.[4]

Huntington further revised the group so that the two lunging goats each formed a 7½-inch-high bookend; they were sold in pairs by the Gorham Company.[5]

JMM

EXHIBITIONS

Queens Museum, New York, "The Artist's Menagerie: Five Millennia of Animals in Art," June 29–August 25, 1974, no. 119.

Elvehjem Art Center, University of Wisconsin, Madison, December 1975–December 1976.

Berry-Hill Galleries, New York, "The Woman Sculptor: Malvina Hoffman and Her Contemporaries," October 24–December 8, 1984, no. 24.

1. For the statuette's title as *Goats Butting,* see, for example, *Twenty-seventh Annual Exhibition of the Society of American Artists* (New York, 1905), p. 37, no. 135; and *Pennsylvania Academy of the Fine Arts . . . Catalogue of the 101st Annual Exhibition* (Philadelphia, 1906), p. 79, no. 979.

2. Roman Bronze Works invoice, April 24, 1905, Huntington Papers, Archives of American Art, microfilm reel 3890, frame 1211.

3. Recommended purchase form, March 21, 1912, accepted by trustees' Committee on Purchases, March 25, 1912, MMA Archives.

4. See T[hayer] T[olles], in *Selections from the American Collection of the Museum of Fine Arts and the George Walter Vincent Smith Art Museum* (Springfield, Mass.: Springfield Library and Museums Association, 1999), pp. 228–30.

George G. Booth, founder of the Cranbrook educational complex in Bloomfield Hills, Mich., bought a version of *Goats Fighting* and lent it to the Detroit Institute of Arts in 1919. The bronze was returned to Cranbrook in 1944, and it was sold two years later; its present location is unknown. See *Arts and Crafts in Detroit 1906–1976: The Movement, the Society, the School,* exh. cat. (Detroit: Detroit Institute of Arts, 1976), p. 97, no. 77.

5. See *Famous Small Bronzes: A Representative Exhibit Selected from the Works of Noted Contemporary Sculptors* (New York: Gorham Co., 1928), pp. 90–91. Conner and Rosenkranz 1989, p. 78, n. 9, records that 158 casts (79 pairs) of *Goat Bookends* were cast by the Gorham Company founders between 1913 and 1942.

276. *Tigers Watching,* ca. 1906

Bronze, 1906
7¼ x 13 x 6¾ in. (18.4 x 33 x 17.1 cm)
Signed (left side of base): Anna V. Hyatt.
Foundry mark (back of base): Roman Bronze Works N.Y.
Cast number (underside of base): № 5.
Rogers Fund, 1906 (06.303)

THE TWO tigers looking down over the edge of a rock were likely a result of Hyatt's studying and sketching the various animals at the Bronx Zoo. The muscular bodies of these crouching tigers are tensed and ready to pounce on their prey. Modeled in broad planes, the tigers seem fused with the rocks beneath them.

Tigers Watching was shown at the Society of American Artists in March–April 1906 along with Huntington's group *Tiger and Bird* (ca. 1906; Art Museum, Princeton University, Princeton, N.J.), which depicts a tiger springing to ensnare a heron.[1] In May of that year, Daniel Chester French (pp. 326–41), chairman of the trustees' Committee on Sculpture, recommended twenty small bronzes, among them *Tigers Watching,* for purchase by the Metropolitan. The Museum acquired its cast from the artist through the Roman Bronze Works foundry,[2] as it did Huntington's *Winter Noon* (1903), a group of two farm horses that was deaccessioned in 1997. An invoice from Roman Bronze Works billing Hyatt for the two statuettes indicates that they were delivered directly from the foundry to the Museum in June or July 1906.[3]

The R. W. Norton Art Gallery, Shreveport, Louisiana, has Roman Bronze Works cast number 3.[4]

JMM

EXHIBITIONS

Halloran General Hospital, Staten Island, N.Y., February 1947–after February 1948.

Salem Fine Arts Center, Winston-Salem, N.C., February 27–March 19, 1972; North Carolina Museum of Art, Raleigh, March 25–April 20, 1972, "Women: A Historical Survey of Works by Women Artists," no. 38.

1. *Twenty-eighth Annual Exhibition of the Society of American Artists* (New York, 1906), p. 38, no. 125, and p. 38, no. 138.

2. Recommended purchase form, accepted by trustees' Committee on Purchases, May 21, 1906, MMA Archives.

3. Roman Bronze Works invoice, June 14, 1906, Huntington Papers, Archives of American Art, microfilm reel 3890, frame 1223.

4. See *American Sculpture: A Tenth Anniversary Exhibition* (Shreveport, La.: R. W. Norton Art Gallery, 1976), p. 31, as "Jaguars on a Ledge."

277. *Reaching Jaguar*, 1906–7

Bronze, 1926
48 x 44 x 22 in. (121.9 x 111.8 x 55.9 cm)
Foundry mark (back of base, lower edge): JNO. WILLIAMS INC. N. Y. / 1926
Gift of Archer M. Huntington, 1926 (26.85.1)

THE POWERFUL effect of *Reaching Jaguar* derives from the sculpture's broadly modeled planes and the illusion that the crouching, muscular feline is just about to leap from his rocky outlook. According to Huntington in 1933, the original model for *Reaching Jaguar* dates from 1906,[1] which places the work in the period when she was frequently modeling animal subjects that she saw at the Bronx Zoo. She went to France in early 1907, settling in Auvers-sur-Oise in a studio formerly occupied by the painter Charles Daubigny, and there she refined *Reaching Jaguar* as well as a companion piece, *Jaguar* (cat. no. 278). At this time she also modeled *Jaguar Eating* (1907; Yale University Art Gallery, New Haven), a reclining feline pulling apart its prey.[2] *Reaching Jaguar* was shown in plaster at the Paris Salons of 1908 and 1910 and was among the ten sculptures exhibited by Hyatt in San Francisco's Panama-Pacific International Exposition in 1915.[3]

A tinted plaster cast of *Reaching Jaguar* was included in the long-term exhibition of American sculpture that was organized by Daniel Chester French and opened at the Metropolitan in March 1918. In 1921 tinted plaster casts of *Reaching Jaguar* and its pendant, *Jaguar*, were lent by Huntington to the Metropolitan,[4] and in 1925 her

husband offered the pair to the Museum. After they were accepted, bronzes were cast, presumably from these plasters since Huntington requested that the plasters be sent from the Metropolitan directly to John Williams foundry.[5] This *Reaching Jaguar* is the second cast; the first was originally owned by George W. French, Davenport, Iowa, and a third cast was installed in 1932 on a limestone base at Brookgreen Gardens, Murrells Inlet, South Carolina.[6] Versions in stone of the sculpture and its mate are installed as gateposts at the Bronx Zoo/Wildlife Conservation Park (1937) and at the Mariners' Museum, Newport News, Virginia.

Reductions were cast by Gorham Company founders: an example is at the Isabella Stewart Gardner Museum, Boston.[7]

JMM

EXHIBITIONS

23rd Annual Women's International Exposition of Arts and Industries, 71st Regiment Armory, New York, November 4–11, 1946.
National Arts Club, New York, "Retrospective Exhibtion of Sculpture by Anna Hyatt Huntington," May 5–June 25, 1952, no. 9 or 10.
Atlanta Art Association, March 1955–November 1963.

277

New York Cultural Center in association with Fairleigh Dickinson University, "Grand Reserves: An Exhibition of 235 Objects from the Reserves of Fifteen New York Museums and Public Collections," October 24–December 8, 1974, no. 84 (also no. 148).

Whitney Museum of American Art, New York, "200 Years of American Sculpture," March 16–September 26, 1976, no. 104.

1. R. Sands (representing Huntington) to Preston Remington, Associate Curator of Decorative Arts, MMA, April 5, 1933, MMA Archives.
2. For an illustration of *Jaguar Eating* (18¼ x 40 x 15¾ in.), see Paula B. Freedman, *A Checklist of American Sculpture at Yale University* (New Haven: Yale University Art Gallery, 1992), p. 85, no. 142.
3. *Explication des ouvrages de peinture, sculpture . . .*, Société des Artistes Français, Salon de 1908 (Paris: Paul Dupont, 1908), p. 305, no. 3259, as "Jaguar;—statue plâtre"; *Explication des ouvrages de peinture, sculpture . . .*, Société des Artistes Français, Salon de 1910 (Paris: Paul Dupont, 1910), p. 323, no. 3682, as "Jaguar;—plâtre"; and *Official Catalogue of the Department of Fine Arts, Panama-Pacific International Exposition* (San Francisco: Wahlgreen Co., 1915), p. 237, no. 3581.
4. See *An Exhibition of American Sculpture* (New York: MMA, 1918), p. 10, no. 39, as "Reaching Panther"; and "List of Accessions and Loans: May, 1921," *MMA Bulletin* 16 (June 1921), p. 139: "Plaster statues (2): Jaguar and Reaching Panther [Jaguar], by Anna Vaughn Hyatt. Lent by Miss Anna Vaughn Hyatt."
5. Extract of minutes of trustees' Executive Committee meeting, October 19, 1925; and Huntington to Edward Robinson, Director, MMA, October 23, 1925, MMA Archives. The minutes note the trustees' willingness "to accede to Mr. Huntington's wish with regard to the making of other reproductions of these figures."
6. Sands (representing Huntington) to Remington, April 5, 1933, as in note 1, MMA Archives; and Proske 1968, p. 175.
7. See Cornelius C. Vermeule, III, Walter Cahn, and Rollin van N. Hadley, *Sculpture in the Isabella Stewart Gardner Museum* (Boston: The Trustees, 1977), p. 166, no. 211.

278. *Jaguar,* 1906–7

Bronze, 1926
28½ x 42 x 25 in. (72.4 x 106.7 x 63.5 cm)
Foundry mark (right side of base): JNO. WILLIAMS INC. N.Y. / 1926
Gift of Archer M. Huntington, 1926 (26.85.2)

BOTH *JAGUAR* and its companion piece, *Reaching Jaguar* (cat. no. 277), were based on studies of Señor Lopez, a jaguar from Paraguay that was the first feline occupant of the Lion House at the Bronx Zoo, which opened to the public in 1903.[1] Huntington continued to refine these compositions in France in 1907.

Jaguar was originally exhibited at the Museum as a colored plaster, on loan from 1921 to 1925. The bronze entered the Metropolitan's collection under the same conditions as *Reaching Jaguar*.[2] According to the artist, the Museum's bronze is the second cast. The first bronze cast and its accompanying *Reaching Jaguar* were owned by George W. French, Davenport, Iowa; another *Jaguar,* on a limestone base, was placed at Brookgreen Gardens, Murrells Inlet, South Carolina, in 1932.[3] Stone versions of *Jaguar* and *Reaching Jaguar,* fashioned as gateposts, are at the Bronx Zoo/Wildlife Conservation Park and the Mariners' Museum, Newport News, Virginia. JMM

EXHIBITIONS

23rd Annual Women's International Exposition of Arts and Industries, 71st Regiment Armory, New York, November 4–11, 1946.
National Arts Club, New York, "Retrospective Exhibition of Sculpture by Anna Hyatt Huntington," May 5–June 25, 1952, no. 9 or 10.
Atlanta Art Association, March 1955–November 1963.
Nassau County Museum of Art, Roslyn Harbor, N.Y., September 1992–present.

1. Proske 1968, p. 175. See also William Bridges, *Gatherings of Animals: An Unconventional History of the New York Zoological Society* (New York: Harper and Row, 1966), pp. 133–41.
2. See "List of Accessions and Loans: May, 1921," *MMA Bulletin* 16 (June 1921), p. 139: "Plaster statues (2): Jaguar and Reaching Panther [Jaguar], by Anna Vaughn Hyatt. Lent by Miss Anna Vaughn Hyatt."
3. R. Sands (representing Huntington) to Preston Remington, Associate Curator of Decorative Arts, MMA, April 5, 1933, MMA Archives; and Proske 1968, p. 175.

278

Stuart Benson (1877–1949)

Known as a writer as well as a sculptor, Benson studied at the Detroit Art Academy under the directorship of Joseph Gies. He left his native city to move to New York, where he became art editor of *Collier's Magazine*. Between 1913 and 1917, Benson worked as art director of the A. W. Erickson Advertising Agency. He was called up for duty during World War I and was commissioned as a captain in the United States Army, serving in France from 1917 to 1919. The French government honored him by making him a Chevalier of the Legion of Honor and awarding him the Croix de Guerre and the Croix de l'Étoile Noire. Benson returned to active duty during World War II.

When Benson was demobilized from military service in 1919, he worked for the brokerage firm Morgan, Livermore and Company and in 1924 reassumed his job at *Collier's*. During his years with the magazine, he wrote plays and several short stories. By the late 1920s, Benson fulfilled a long-held aspiration: he went to France and began to concentrate on his sculpture. He divided his year, spending winters in New York and summers in La Colle-sur-Loup, in the French Maritime Alps. Two of his sculptures, cement busts, were shown at the Salon d'Automne in Paris in 1932; in 1934 he displayed two portraits with the Société des Indépendants and in 1938 a portrait at the Salon des Tuileries. His work was also shown in major American annuals: the Art Institute of Chicago (1937–41); the Pennsylvania Academy of the Fine Arts (1940); and the National Academy of Design (1944). Solo exhibitions of his works were held in New York at the Ferargil Galleries in 1935, 1937, and 1938, and at the Hudson D. Walker Gallery in 1939. That year the sculptor's bronze portrait head *Lucette* was included in "American Art Today" at the New York World's Fair. Benson made figure groups though he was best known for his portrait busts; among the few pieces currently located and in public collections are *Woman of Avignon* (1933; Allen Memorial Art Museum, Oberlin College, Oberlin, Ohio); *Head of a Girl: Pauahi Judd* (ca. 1937; Honolulu Academy of Arts); and *Provençal Woman* (ca. 1937; Art Institute of Chicago). His prominent sitters in France, England, and the United States included dancer Isadora Duncan, Christian Scientist Mary Baker Eddy, poet Robert Nichols, actress Eva Le Gallienne, and Mrs. George Blumenthal, wife of the longtime Metropolitan Museum trustee. JMM

SELECTED BIBLIOGRAPHY

[Benson, Stuart]. Biographical information, ca. 1939, typescript. MMA Archives.

Who Was Who in American Art, vol. 2 (1943–50), p. 58. Chicago: A. N. Marquis Co., 1950.

Gardner, Albert TenEyck. *American Sculpture,* p. 130. New York: MMA, 1965.

Opitz, Glenn B., ed. *Dictionary of American Sculptors,* p. 32. Poughkeepsie, N.Y.: Apollo, 1984.

279. *The Woman from Siberia*, 1938

Bronze
12½ x 7¼ x 8¾ in. (31.8 x 18.4 x 22.2 cm)
Signed (right side of neck): S.B.
Foundry mark (right side of neck, in diamond): CIRE / A VALSUANI / P[ERDUE]
Anonymous Gift, 1939 (39.36)

THIS ROUGHLY textured, simplified likeness depicts a young woman with hair pulled back and fastened at her nape. Also known as *The Woman Who Came from Siberia,* it suggests Benson's willingness to take a modernist's approach to the human figure. According to the artist, the Metropolitan Museum's example was the first cast of the sculpture, made in Paris in January 1938; a second bronze was cast by March 1939; and he intended to limit the edition to six.[1] At his one-artist exhibition at the Ferargil Galleries in November–December 1938, Benson showed *The Woman from Siberia* with ten portrait busts and small bronzes grouped as "Some Neighbors and Others."[2] He clearly had an affinity for this genre: titles such as *A Farmer's Daughter* and *The Boy Who Cuts My Grass* are evidence that "he [was] particularly happy in portraying the peasant types, who are his neighbors."[3]

The Woman from Siberia was also exhibited at M. Knoedler and Company in 1939. Through the auspices of the gallery, the Metropolitan Museum was offered its choice of either Benson's *Head of a Borderland Woman* (unlocated) or *The Woman from Siberia*; it selected the latter.[4]

The Metropolitan's bronze has a black patina and is mounted on a Belgian black marble base, 5⅜ inches high.

JMM

1. Information provided by Benson, ca. 1939, MMA Archives. Repeated in F[aith] D[ennis], "A Bronze Head by Stuart Benson," *MMA Bulletin* 34 (June 1939), p. 159.
2. *Stuart Benson: Sculpture,* exh. cat. (New York: Ferargil Galleries, 1938), no. 11, as "The Woman Who Came from Siberia."
3. Benson, biographical information, MMA Archives.
4. J. J. Cunningham, M. Knoedler and Co., to Preston Remington, Curator of Renaissance and Modern Art, MMA February 3, 1939, MMA Archives.

Herbert Haseltine (1877–1962)

Haseltine, son of American landscape painter William Stanley Haseltine and nephew of sculptor James Henry Haseltine, was born in Rome, where his parents were part of the expatriate community. From his youth Haseltine had a great interest in horses and was a skilled rider. In 1893 he went to the Westminster School in Simsbury, Connecticut. He then attended Harvard University, where he claimed to have spent much of his time drawing illustrations for the Harvard *Lampoon.*

Haseltine enrolled at the Royal Academy of Fine Arts in Munich and later studied with Alessandro Morani in Rome. He then spent two years in drawing classes at the Académie Julian in Paris. Between 1902 and 1905 he was based in Rome, hunting and playing polo. In 1905 Haseltine began instruction with Aimé Nicolas Morot, who encouraged him to pursue sculpture as a preparatory aid for his paintings. Discovering a natural proclivity for modeling, Haseltine submitted a polo group, *Riding Off* (1906; Virginia Museum of Fine Arts, Richmond), to the Salon of 1906, where it won an honorable mention. His success and social standing led to orders for sculpted thoroughbred horses from such affluent Europeans and Americans as King Edward VII and Queen Alexandra, and William K. Vanderbilt. For Harry Payne Whitney, he created *Meadowbrook Team* (1909; Whitney Museum of American Art, New York), four champion polo players and their horses. During this first phase of his career, Haseltine focused on small-scale naturalistic equine portraits and polo subjects. In 1914 he had an exhibition with the sculptor Emanuele Ordoño de Rosales at the Goupil Gallery in London.

During World War I, Haseltine served as an inspector of prisoner-of-war camps, and when the United States entered the war in 1917, he helped to organize the camouflage section of the U.S. Army in Europe. The horrors he witnessed inspired one of his most moving works, *Les Revenants* (1920; Philadelphia Museum of Art), a string of war-weary horses returning from the front. He also modeled *Le Soixante quinze* (1920; Smithsonian American Art Museum, Washington, D.C.), an arcing composition of soldiers and horses navigating challenging terrain, and *The Empty Saddle* (ca. 1921; Fine Arts Museums of San Francisco), a riderless horse memorializing members of the Cavalry Club of London who perished in the war. At the urging of Jo Davidson (pp. 704–18), after World War I Haseltine studied Egyptian sculpture in the Musée du Louvre. This experience was especially formative to the second phase of his stylistic development. His *Field Marshal V* (1921; Fogg Art Museum, Harvard University, Cambridge, Mass.), King George V's prize shire stallion, represented a shift from earlier, more realistic portrayals toward a simplified and stylized treatment of form.

Field Marshal V was the catalyst for Haseltine's series British Champion Animals, begun in 1922, which would eventually number twenty-six prizewinning horses, bulls, sheep, and pigs. Haseltine traveled to farms and attended Royal Agricultural Shows throughout the British Isles sculpting small models and later refining them in his Paris studio. The collection took several years to complete because Haseltine gave his bronzes innovative surfaces, chose his marbles to match the actual color of the animals, and experimented with different embellishments and inlays. In addition to the original one-third lifesize versions (each in an edition of three marbles and six bronzes), one-quarter size versions were also produced in an edition of twelve casts, and a one-eighth-size series of twenty animals was cast in six sets (Conner and Rosenkranz 1989, p. 48). In 1925 the original twenty British Champion Animals were exhibited at the Galerie Georges Petit in Paris and then at Knoedler's in London. Marshall Field commissioned a one-third lifesize set, which in 1934 was shown at M. Knoedler and Company in New York and presented to the Field Museum of Natural History in Chicago (the set of nineteen is now in the collection of the Virginia Museum of Fine Arts).

The final phase of Haseltine's art reflects the influence of visits he made to India in 1926 and again in 1938. A result of the first trip was a gilt-bronze equestrian statue of the sixteenth-century Maharaja Jam Shri Rawalji of Nawangagar, completed for the city of Jamnagar in 1934. Haseltine worked mainly in Paris and frequently had exhibitions of his work there and in London. Between 1940 and 1947 he was in the United States, during which time he had solo shows in several cities. The sculptor completed equestrian statues of Field Marshal Sir John Dill (1950) for Arlington National Cemetery and George Washington in gilt-bronze for the National Cathedral, Washington, D.C. (dedicated 1959). His overlifesize representation of the famous racehorse Man O'War (1940–47) is now at the Kentucky Horse Park, Lexington. Haseltine was elected an academician of the National Academy of Design in 1946. JMM

SELECTED BIBLIOGRAPHY

Haseltine, Herbert, Papers. Archives of American Art, Smithsonian Institution, Washington, D.C., microfilm reel D295.

Parkes, Kineton. "Herbert Haseltine: Animal Sculptor." *Apollo* 12 (August 1930), pp. 108–13.

Sculptures by Herbert Haseltine of Champion Domestic Animals of Great Britain. Zoology Leaflet 13. Chicago: Field Museum of Natural History, 1934.

Herbert Haseltine. Foreword by Herbert Haseltine. American Sculptors Series 7. New York: W. W. Norton under the auspices of the National Sculpture Society, 1948.

Conner, Janis, and Joel Rosenkranz. *Rediscoveries in American Sculpture: Studio Works, 1893–1939*, pp. 43–52. Austin: University of Texas Press, 1989.

Ward, Meredith E. *William Stanley Haseltine 1835–1900, Herbert Hasel-*
tine 1877–1962. Exh. cat. New York: Hirschl and Adler Galleries, 1992.

Cormack, Malcolm. *Champion Animals: Sculptures by Herbert Haseltine.* Richmond: Virginia Museum of Fine Arts, 1996.

280. *Percheron Stallion: Rhum*, 1922–24

Bronze, coral, ivory, gilt, 1925
28 x 26½ x 10⅛ in. (71.1 x 67.3 x 25.7 cm)
Signed and dated (right side of base): HASELTINE / MCMXXV
Foundry mark (back of base): ALEXIS RUDIER / Fondeur. PARIS.
Gift of Mrs. George Blumenthal, 1926 (26.160.1)

HASELTINE'S SERIES British Champion Animals included *Percheron Stallion: Rhum* and its companion group *Percheron Mare: Messaline and Foal* (cat. no. 281). Both works, which depict this celebrated French breed of heavy horses, reflect the dominant influence Egyptian art exercised on the artist's work of the 1920s. Haseltine's use of onyx for *Rhum*'s eyes (which have been replaced) and of coral for the bows that embellish its mane and tail can be related to the ancient Egyptian decorative objects he so admired. In addition, the work can be considered a "portrait," for it was modeled after a specific prizewinning horse.

The champion Rhum was foaled in 1917 and belonged to Mrs. Robert Emmet, an American by birth, of Moreton Morrell in Warwickshire, England. At shows of the Royal Agricultural Society of England between 1921 and 1923 and the Norwich Stallion Show in 1922 and 1923, Rhum received champion honors.[1] In his unpublished memoirs, Haseltine described the experience of modeling Rhum: "[Rhum] was a grand specimen of the Percherons—dappled grey, heavy of bone with powerful quarters, spirited head, a large expressive eye and delicately shaped ears.... Although of a fiery and high-spirited temperament, he was gentle and well-mannered.... I could take measurements of his legs and trace the outlines of his hoofs on a piece of cardboard with perfect confidence."[2]

According to Haseltine, he made a gilt-bronze cast of *Percheron Stallion: Rhum* for Mrs. Emmet at the same time as the bronze with green patina that is at the Metropolitan Museum.[3] Among those examples in museum collections are a 32¼-inch bronze with gilt surface at the Addison Gallery of American Art, Phillips Academy, Andover, Massachusetts; a 28-inch Bardiglio marble at the Virginia Museum of Fine Arts, Richmond; a 28-inch Burgundy limestone at the Museum of Art, Rhode Island School of Design, Providence; 12¼-inch bronzes at the Fogg Art Museum, Harvard University, Cambridge, Massachusetts, and the Honolulu Academy of Arts; and a 6¼-inch bronze at the Baltimore Museum of Art.[4]

George and Florence Blumenthal commissioned *Percheron Stallion: Rhum* and *Percheron Mare: Messaline and Foal* at the time of Haseltine's solo exhibition at the Galerie Georges Petit in Paris in 1925. Haseltine later wrote: "Before the Exhibition . . . was opened . . . Mr. and Mrs. George Blumenthal came to my studio and gave me an order for the Percherons, i.e., sire, dame and foal, for the Metropolitan Museum, New York. These I ordered to be done by Rudier cast in bronze by the sand process, with a dark green patina; Cartier in Paris executed the eyes and ornamentations, i.e., eyes in onyx and ivory, ribbons in mane and tail, in coral."[5] The Blumenthals were extremely generous benefactors of the Museum; in 1928 they gave one million dollars that was to accumulate interest until their deaths but was made an unrestricted gift by George Blumenthal before he died. He was a trustee of the Museum from 1909 until his death in 1941, serving on the Committee on Sculpture from 1909 to 1934, and as president of the Board of Trustees from 1934; he bequeathed the Museum much of his collection and his house.[6]

JMM

EXHIBITION

Graham Gallery, New York, May 1–26, 1973; National Museum of Racing, Saratoga Springs, N.Y., July 15–August 26, 1973, "Herbert Haseltine 1877–1962," no. 27.

1. *Sculptures by Herbert Haseltine of Champion Domestic Animals of Great Britain* 1934, p. 14.
2. As quoted in Cormack 1996, pp. 33–34.
3. Haseltine to Preston Remington, Associate Curator of Decorative Arts, MMA, February 1, 1933, MMA Archives.
4. See Conner and Rosenkranz 1989, p. 52, n. 13. For the Virginia marble, see Cormack 1996, pp. 32–35.
5. As quoted in Cormack 1996, p. 40.
6. Francis Henry Taylor, "The Blumenthal Collection," *MMA Bulletin* 36 (October 1941), p. 196; and Winifred E. Howe, *A History of the Metropolitan Museum of Art: Vol. II, 1905–1941* (New York: MMA, 1946), p. 102.

281. *Percheron Mare: Messaline and Foal, 1922–24*

Bronze, onyx, ivory, 1925
21¾ x 29 x 12½ in. (55.2 x 73.7 x 31.8 cm)
Signed and dated (left side of base): HASELTINE / MCMXXV
Foundry mark (back of base): ALEXIS RUDIER / Fondeur. Paris.
Gift of Mrs. George Blumenthal, 1926 (26.160.2)

THIS SCULPTURE of a mare and her foal is a companion to *Percheron Stallion: Rhum* (cat. no. 280). The rigid stance of the animals suggests that the Egyptian art Haseltine so admired, with its emphasis on frontality and contour, was the principal stylistic influence here. Spare incised lines indicate the mane and tail of the mare, as well as the soft curly hair of the foal.

Messaline belonged to Mrs. Robert Emmet of Moreton Morrell in Warwickshire, England, as did the stallion Rhum. The mare was bred in France and accumulated many first-

place prizes at British agricultural shows between 1917 and 1922, including champion at the Royal Agricultural Society of England in 1921 and 1922.[1] Haseltine later described Messaline and her foal by Rhum: "In strong contrast to the fiery and haughty Rhum, always on his toes, was the relaxed and patient-looking brood mare, whose sole preoccupation seemed to be caring for her offspring. The latter . . . was the most difficult to model; he was always hiding behind his mother, and . . . was never still for one instant. I worked very quickly, however, and managed to convey the spirit

of startled effrontery mingled with fear, as he pressed himself against the spacious flank of his protectress. I thought I could see in the tilt of his head and the rolling of his eyes, a distinct resemblance to his sire."[2]

Haseltine cast a gilt-bronze *Percheron Mare: Messaline and Foal* for Mrs. Emmet at the same time as the bronze with green patina that is at the Metropolitan Museum.[3] A 26½-inch partially gilt bronze cast of *Percheron Mare: Messaline and Foal* is at the Addison Gallery of American Art, Phillips Academy, Andover, Massachusetts. Versions 22½-inches high are at the Virginia Museum of Fine Arts, Richmond, in Bardiglio marble, and at the Museum of Art, Rhode Island School of Design, Providence, in Burgundy limestone. A 5-inch bronze is at the Baltimore Museum of Art.[4] JMM

EXHIBITIONS

Graham Gallery, New York, May 1–26, 1973; National Museum of Racing, Saratoga Springs, N.Y., July 15–August 26, 1973, "Herbert Haseltine 1877–1962," no. 26.
Queens Museum, New York, "The Artist's Menagerie: Five Millennia of Animals in Art," June 29–August 25, 1974, no. 124.
Whitney Museum of American Art, New York, "200 Years of American Sculpture," March 16–September 26, 1976, no. 92.

1. *Sculptures by Herbert Haseltine of Champion Domestic Animals of Great Britain* 1934, p. 16; and Cormack 1996, p. 37.
2. As quoted in Cormack 1996, p. 37.
3. Haseltine to Preston Remington, Associate Curator of Decorative Arts, MMA, February 1, 1933, MMA Archives.
4. See Conner and Rosenkranz 1989, p. 52, n. 13. For the Virginia marble and Haseltine's recollections of the various versions, see Cormack 1996, pp. 36–41. The Rhode Island School of Design version was formerly in the collection of the British artist Sir William Orpen, R.A.

282. *Suffolk Punch Stallion: Sudbourne Premier,* after July 1923–ca. 1924

Bronze, 1925
12 x 15¾ x 8½ in. (30.5 x 40 x 21.6 cm)
Bequest of Mary Stillman Harkness, 1950 (50.145.39)

ONE OF Haseltine's series of British Champion Animals, *Suffolk Punch Stallion: Sudbourne Premier* is massive and solid in form, with emphasis on silhouette and subtle motion. Sudbourne Premier was foaled in 1919 and from July 1923 belonged to Percy C. Vesty of Eastham Park, Wickham Market, England. The horse was first in the shows of the Royal Agricultural Society of England in 1921 and 1922 and in 1924 had an impressive seven first-place showings.[1] Haseltine was taken with Sudbourne Premier when he modeled him in England: "The moment I saw . . . the magnificent stallion of that famous breed of chestnuts, all my troubles were forgotten and my only thought was to get to work." Haseltine did the modeling outdoors as the horse was kept walking. "Sudbourne Premier was at his best: he stretched his neck and champed his bit, looking intelligently to right and left, showing a little of the whites of his eyes, which gave more life and expression to his already expressive and classical head."[2] As was Haseltine's customary method of completing the British Champion Animals, "the actual work was made in England. . . . The model was cast and finished in my studio in Paris."[3]

Replicas of *Suffolk Punch Stallion: Sudbourne Premier* are in the collections of the Fine Arts Museums of San Francisco (22-in. bronze with lapis lazuli, onyx, and ivory); the Tate Gallery, London (21¾-in. bronze with onyx and ivory); the Virginia Museum of Fine Arts, Richmond (21½-in. bronze with gold plate, lapis lazuli, onyx, and ivory); the Philadelphia Museum of Art (12-in. bronze); and the Art Museum, Princeton University, Princeton, New Jersey (11-in. bronze).[4] Haseltine also created *Head of a Suffolk Punch Stallion* (modeled ca. 1922, cast 1931; Yale University Art Gallery, New Haven), a detail of the original one-third lifesize figure.[5]

The Metropolitan Museum's *Suffolk Punch,* with its greenish gold patina, was lost-wax cast in Paris in 1925 and was purchased by Mary Stillman Harkness from M. Knoedler and Company in New York in 1934,[6] probably at the time of the artist's exhibition there of his British Champion Animals. The cast came to the Museum in Mrs. Harkness's bequest, which also included Frederick William MacMonnies's *Nathan Hale* (cat. no. 195), Jo Davidson's *Marshal Ferdinand Foch* (cat. no. 347), and Malvina Hoffman's *Bacchanale Russe* (cat. no. 366).[7] JMM

282

EXHIBITION

Graham Gallery, New York, May 1–26, 1973; National Museum of Racing, Saratoga Springs, N.Y., July 15–August 26, 1973, "Herbert Haseltine 1877–1962."

1. *Sculptures by Herbert Haseltine of Champion Domestic Animals of Great Britain* 1934, p. 12.
2. As quoted in Cormack 1996, p. 23.
3. Artist information form, March 31, 1951, MMA Archives.
4. See Conner and Rosenkranz 1989, p. 191; Cormack 1996, pp. 22–29; Donald L. Stover, *American Sculpture: The Collection of The Fine Arts Museums of San Francisco* (San Francisco: Fine Arts Museums of San Francisco, 1982), p. 55; and Richard Alley, *Catalogue of the Tate Gallery's Collection of Modern Art Other Than Works by British Artists* (London: Tate Gallery, in association with Sotheby Parke Bernet, 1981), p. 354, no. 4560. The Tate's bronze (1931–32) was a replacement for its original stone version purchased from the artist in 1925 and damaged in transit in 1930.
5. See Paula B. Freedman, *A Checklist of American Sculpture at Yale University* (New Haven: Yale University Art Gallery, 1992), p. 76. For a second example, see *American Sculpture 1845–1925* (New York: Conner-Rosenkranz, 1999), pp. 42–43, 59. For a marble version, see Ward 1992, p. 40, no. 40, ill. p. 30.
6. Artist information form, March 31, 1951, MMA Archives; and note by P[reston] R[emington], object catalogue cards, MMA Department of Modern Art.
7. For information on the Harkness gifts and bequests to the Metropolitan Museum, see *MMA Bulletin* 10 (October 1951).

Albert Laessle (1877–1954)

Laessle, son of German immigrants, studied at the Spring Garden Institute in his native Philadelphia from 1894, when he was awarded a second prize in drawing, until he graduated in 1896. He then enrolled at the Drexel Institute for evening modeling classes, supporting himself by doing odd jobs during the day. In 1898 Laessle entered the Pennsylvania Academy of the Fine Arts under the tutelage of Charles Grafly (pp. 403–7) and Thomas Anshutz, enrolling in drawing and modeling classes. He remained as a student there for six years, in 1902 earning the Edmund A. Stewardson Prize (see p. 470). Laessle began in 1901 as a studio assistant to Grafly and the two collaborated on numerous projects over the course of their careers. For Grafly's *Fountain of Man* for the 1901 Pan-American Exposition in Buffalo, Laessle designed a repeating motif of a turtle supporting a globe for the fountain's base, introducing the first of many reptile subjects in his work. Laessle won the Pennsylvania Academy's William Emlen Cresson traveling scholarship in 1904, which enabled him to study in Europe, primarily in Paris, where sculptor Michel Léonard Béguine gave him critiques of his work.

When Laessle returned to Philadelphia in 1907, he again worked in Grafly's studio and, while living in the Germantown section of Philadelphia, began to exhibit his portraits and animal subjects regularly in Philadelphia and New York. In 1913 the Pennsylvania Academy commissioned the George D. Widener Memorial Gold Medal design, with a portrait of Widener on the obverse and a male figure with a sculptor's mallet and the Great Sphinx on the reverse. Laessle received commissions for several other medals during his career, such as the Philadelphia Sesquicentennial Medal of Award (1926) and the tenth issue of the Society of Medalists, *Abundance* (1934). For the 1915 Panama-Pacific International Exposition in San Francisco, Laessle submitted twenty sculptures of animal subjects and was awarded a gold medal.

In 1921 Laessle joined the Pennsylvania Academy as an instructor and remained there for eighteen years, teaching both in Philadelphia and at the academy's summer school in Chester Springs, Pennsylvania. During that period, he maintained a studio near the Philadelphia Zoological Garden, a locale that facilitated his approach to art: attention to distinctive anatomical structure of animals rendered with a decorative and, at times, humorous flair. The sensitivity he showed toward his subjects earned him critical acclaim, and when he displayed thirty-six of his sculptures in the Philadelphia Sesqui-Centennial International Exposition in 1926, he was accorded a gold medal.

Notable among Laessle's works of the 1920s was the commission for the Victor Talking Machine Company of Camden, New Jersey. Plaster casts of *His Master's Voice,* a small terrier with cocked head listening to a Victrola, were distributed for advertising purposes. Laessle was commissioned in 1927 by the company's former president to complete five animal groups, *Pan, Billy, Dancing Goat, Turtle and Duck,* and *Frogs,* which were installed around a pool in Johnson Square, Camden (now the site of Walt Whitman Cultural Arts Center).

Although Laessle is best remembered for his small bronzes of birds, reptiles, and barnyard animals, he produced sculpture for public sites in Philadelphia. *Billy* (1914), a life-size rendition of a tethered goat, received the Fellowship Prize at the Pennsylvania Academy in 1915. In 1917 a cast was purchased for Rittenhouse Square, and the following year a second bronze was included in the Metropolitan Museum's long-term installation "An Exhibition of American Sculpture" along with Laessle's *An Outcast* (1908) and *Turkey* (1911). *Penguins* (1917) won the Widener Memorial Medal at the Pennsylvania Academy in 1918 and was purchased by the Fairmount Park Art Association for installation in the Philadelphia Zoological Garden. Laessle's bronze monument to Major General Galusha Pennypacker (1929–34), which was based on a design by Grafly, is in Logan Square and features a heroic figure atop a gun carriage flanked by striding tigers.

Many of Laessle's sculptures were given by his heirs to the National Collection of Fine Arts (now Smithsonian American Art Museum), Washington, D.C., in 1971–72.

JMM

SELECTED BIBLIOGRAPHY

Laessle, Albert, Papers. Archives of American Art, Smithsonian Institution, Washington, D.C., microfilm reel 74 and unmicrofilmed material.

Miller, D. Roy. "A Sculptor of Animal Life." *International Studio* 80 (October 1924), pp. 23–27.

Proske, Beatrice Gilman. *Brookgreen Gardens Sculpture,* pp. 180–83. Rev. ed. Brookgreen Gardens, S.C.: Brookgreen Gardens, 1968.

Peck, Robert McCracken. "Albert Laessle: American 'Animalier.'" *American Art Review* 3 (January–February 1976), pp. 68–84.

Conner, Janis, and Joel Rosenkranz. *Rediscoveries in American Sculpture: Studio Works, 1893–1939,* pp. 105–12. Austin: University of Texas Press, 1989.

James-Gadzinski, Susan, and Mary Mullen Cunningham. *American Sculpture in the Museum of American Art of the Pennsylvania Academy of the Fine Arts,* pp. 186–91. Philadelphia: Museum of American Art of the Pennsylvania Academy of the Fine Arts, 1997.

283. *Turning Turtle*, 1905

Bronze, 1917
7¾ x 10¼ x 7 in. (19.7 x 26 x 17.8 cm)
Signed and dated (top and front of base): ALBERT-LAESSLE / PARIS / 1905
Foundry mark (back of base): ROMAN BRONZE WORKS N–Y–
Rogers Fund, 1917 (17.63)

LAESSLE'S INTEREST in the turtle as a subject began during his student days at the Pennsylvania Academy of the Fine Arts, where one day a classmate brought their instructor, Charles Grafly, a large snapping turtle for dinner. Laessle borrowed the turtle for further study, and the result was a small plaster group, *Turtle and Crab* (ca. 1901; destroyed), which he showed in the 1901 Art Club of Philadelphia annual exhibition.[1] In the press, Laessle was accused of casting live animals to produce such a lifelike composition. He responded to the charge by modeling *Turtle and Lizards* (1902–3; Pennsylvania Academy of the Fine Arts) in wax and exhibiting it in the Pennsylvania Academy's annual exhibitions in 1903 and, in bronze, in 1904.

While in Paris, Laessle "had no difficulty in obtaining turtles. . . . At that time many families had turtles which were imported from Algiers and kept in the cellars to eat insects. Our *concierge* lent me his turtle, and I made a careful study. . . ."[2] Balanced by its head, one front leg, and one back leg, Laessle's turtle struggles to right itself. The sculptor exhibited a bronze cast (unlocated) in the Salon of 1907 and was informed by his French mentor Béguine that the Salon jurors refused to believe that the turtle was not cast from life but modeled "because of the peculiarity of the subject, and the accuracy of the craftsmanship."[3]

Turning Turtle was exhibited frequently after Laessle returned from Paris. It was displayed at the Pennsylvania Academy and the National Academy of Design in 1908 and was among twenty pieces that the sculptor showed in San Francisco at the Panama-Pacific International Exposition in 1915.[4] In February 1917, following a recommendation by Daniel Chester French (pp. 326–41), chairman of the Metropolitan Museum trustees' Committee on Sculpture, a bronze was purchased directly from the artist and was almost certainly cast by Roman Bronze Works

soon thereafter, for a cast is entered in the foundry ledgers under the date March 31, 1917.[5] A Gorham bronze was acquired by Brookgreen Gardens, Murrells Inlet, South Carolina, in 1934,[6] and a third located bronze, cast by Roman Bronze Works, is in the collection of the Academy of Natural Sciences of Philadelphia.

The Metropolitan Museum's bronze surmounts a breccia base, 1¼ inches high. JMM

EXHIBITION

Whitney Museum of American Art, New York, "200 Years of American Sculpture," March 16–September 26, 1976, no. 131.

1. Peck 1976, p. 70.
2. As quoted in Miller 1924, p. 25.
3. *Explication des ouvrages de peinture, sculpture . . . ,* Société des Artistes Français, Salon de 1907 (Paris, 1907), p. 276, no. 3016, as "Tortue; —bronze à cire perdue"; and Miller 1924, pp. 25–26, where it is erroneously noted that the Metropolitan's bronze cast was the one exhibited at the Salon. A photograph of that bronze, marked A. A. Hébrard, is in the Laessle Papers, Archives of American Art (Conner and Rosenkranz 1989, p. 112, n. 21).
4. *Pennsylvania Academy of the Fine Arts . . . Catalogue of the 103rd Annual Exhibition,* 3rd ed. (Philadelphia, 1908), p. 65, no. 919; *National Academy of Design Eighty-third Annual Exhibition 1908 . . . Illustrated Catalogue* (New York, 1908), p. 58, no. 360; and *Official Catalogue of the Department of Fine Arts, Panama-Pacific International Exposition* (San Francisco: Wahlgreen Co., 1915), p. 239, no. 3218.
5. Recommended purchase form signed by Henry W. Kent, Secretary, MMA, February 19, 1917, MMA Archives. The next day, February 20, 1917, French wrote to Laessle of the committee's approval; Daniel Chester French Family Papers, Manuscript Division, Library of Congress, Washington, D.C., microfilm reel 4, frame 10. See also Roman Bronze Works Archives, Amon Carter Museum, Fort Worth, ledger 4, p. 263; another cast had been entered into the ledgers on July 10, 1913.
6. Proske 1968, p. 182. Peck 1976 (p. 72) notes that in addition to the Metropolitan and Brookgreen casts, "three other casts went to private collections."

Edgar Walter (1877–1938)

Walter studied with the sculptor Douglas Tilden at the Mark Hopkins Institute of Art in San Francisco, his birthplace, and was later a pupil of the painter Fernand Cormon and the sculptor Jacques Perrin in Paris. While living in Paris, Walter exhibited regularly at the annual Salons: in 1898, 1899, 1901–3, 1905, and 1906, winning an honorable mention in 1901 for his plaster group *Lutte pour la vie*. His submissions ranged from portrait busts in bronze and marble to ideal groups to a plaster model for a mausoleum door in 1902. His composition *Primitive Man* (cat. no. 284) was shown in the Salons of 1903 and 1905. About 1910, Walter modeled the *Seligman Fountain (Bear and Faun Fountain)*, which was dedicated in 1914 in New York's Morningside Park at 116th Street. The 8-foot-high bronze group, cast by Roman Bronze Works, depicts a bear sprawling over the edge of a large, jagged rock and a faun seated beneath, trying to hide. The work was given to the city by the National Highways Protective Society in memory of Alfred L. Seligman, its former vice-president.

Walter was a longtime resident of San Francisco, one of a group of talented West Coast sculptors that included his teacher Douglas Tilden, Arthur Putnam (pp. 570–72), and Beniamino Bufano, and he completed architectural decoration for several buildings in the city. In 1915 Walter exhibited *Nymph and Bears* at the Panama-Pacific International Exposition in San Francisco and was awarded an honorable mention. There is a cast of the work, also known as *The Bear Charmer*, at the Hearst San Simeon State Historical Monument, San Simeon, California. For the main library building of Stanford University, Walter produced three sandstone figures, *Art, Philosophy,* and *Science,* which were awarded a silver medal in 1919 from the San Francisco Art Association. He created in 1923 two bronze portrait medallions, of Sigmund Steinhart and Ignatz Steinhart, for the entrance of the Steinhart Aquarium, Golden Gate Park, San Francisco. From about 1927 to 1936, he taught at the California School of Fine Arts in San Francisco. As part of the New Deal art programs, between 1934 and 1936 Walter completed a pediment, *Columbia,* in limestone for the facade of the Departmental Auditorium, Washington, D.C. After the sculptor's death, his *Penguin Girl* was included in the 1939 Golden Gate International Exposition in San Francisco.

JMM

SELECTED BIBLIOGRAPHY

Porter, Bruce, et al. *Art in California: A Survey of American Art with Special Reference to Californian Painting Sculpture and Architecture Past and Present Particularly as Those Arts Were Represented at the Panama-Pacific International Exposition,* pp. 59, 178. San Francisco: R. L. Bernier, 1916. Reprint, Irvine, Calif.: Westphal Publishing, 1988.
Taft, Lorado. *The History of American Sculpture,* pp. 536, 571, 586. Rev. ed. New York: Macmillan, 1924.
Gardner, Albert TenEyck. *American Sculpture,* pp. 128–29. New York: MMA, 1965.
100 Years of California Sculpture, p. 39. Exh. cat. Oakland, Calif.: Oakland Museum, 1982.
Gayle, Margot, and Michele Cohen. *The Art Commission and Municipal Art Society Guide to Manhattan's Outdoor Sculpture,* p. 309. New York: Prentice Hall Press, 1988.

284. *Primitive Man,* ca. 1902-3

Bronze, ca. 1905
31½ x 15 x 15 in. (80 x 38.1 x 38.1 cm)
Signed (left side of base): E. WALTER
Gift of Isaac N. Seligman, 1907 (07.112)

IN THIS depiction of a muscular youth lifting a protesting bear cub by the scruff of its neck, Walter used a variety of textures and naturalistic modeling. As Paul Wayland Bartlett did in *Bohemian Bear Tamer* (cat. no. 199), in *Primitive Man* Walter treated the theme of man's evolutionary superiority over beast. In this case, man—even in his baser state, indicated by the rudimentary loincloth and headdress—dominates. *Primitive Man* is among Walter's earliest full-figure compositions; he exhibited a plaster version at the Paris Salon of 1903 and a bronze cast at the Salon of 1905.[1] The bear was a frequent subject in the sculptor's oeuvre, from *Primitive Man* to the *Seligman Fountain* (ca. 1910–14) in New York to his *Nymph and Bears* displayed in the Panama-Pacific International Exposition in 1915.

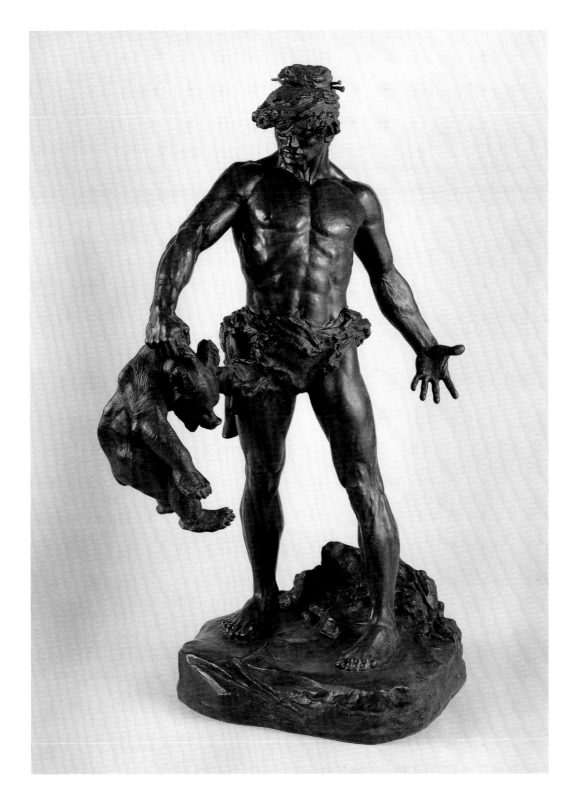

The Metropolitan Museum's cast of *Primitive Man* was the gift of banker and philanthropist Isaac N. Seligman, of J. and W. Seligman, one of New York's most influential international investment firms.[2] Seligman also gave a bronze cast of *Primitive Man* to the Toledo Museum of Art in 1912. That unmarked 15-inch reduction is presumably of the same edition as the bronze statuette *Primitive Man* that was in the lending collection of the Metropolitan Museum's extension division from 1920 until 1947.[3]

JMM

1. *Explication des ouvrages de peinture, sculpture . . .*, Société des Artistes Français, Salon de 1903 (Paris, 1903), p. 350, no. 3257, as "Homme primitif;—statue, plâtre"; and *Explication des ouvrages de peinture, sculpture . . .*, Société des Artistes Français, Salon de 1905 (Paris, 1905), p. 319, no. 3723, as "Homme primitif;—statuette, bronze."
2. See "Principal Accessions," *MMA Bulletin* 2 (April 1907), p. 87, ill.; and *Catalogue of Sculpture, 1741–1907* (New York: MMA, 1908), p. 47, no. 140. On Seligman, see "Eulogies of Life of I. N. Seligman," *New York Times,* October 3, 1917, p. 13.
3. See "List of Accessions and Loans, August–September 1920," *MMA Bulletin* 15 (November 1920), p. 258. The statuette (formerly acc. no. 20.145.2) was the gift of Howard Lehman Goodhart, in memory of Marjorie Walter Goodhart.

Mahonri Mackintosh Young (1877–1957)

Young, a grandson of the Mormon leader Brigham Young, created paintings, drawings, and prints but is primarily recognized for his realistic genre sculpture: "I cannot remember when I did not want to be a sculptor" ("An Art Born" 1918, p. 10). In his native Salt Lake City, at the age of seventeen, he became a staff artist for the *Salt Lake Tribune,* providing illustrations and engravings. Young also studied with the Paris-trained painter James Harwood. During a yearlong stay in New York in 1899, Young enrolled at the Art Students League, where he received instruction from Kenyon Cox and George Bridgman. Young was in Paris between 1901 and 1905. He took classes first at the Académie Julian, drawing with Jean-Paul Laurens and modeling briefly with Charles Raoul Verlet. He later studied at the Académie Delécluse and at the Académie Colarossi with Jean-Antoine Injalbert. While abroad, he made two trips to Italy, the first in 1902, which inspired him to commence modeling, and a second, longer one in 1905.

Soon Young was creating small sculptures of laborers he saw on the streets in Paris, among them *Tired Out* (1903; Los Angeles County Museum of Art), *Laborer* (also known as *The Shoveler*; 1903; Sheldon Memorial Art Gallery and Sculpture Garden, University of Nebraska, Lincoln), and *Stevedore* (cat. no. 285). His first statuettes were exhibited at the American Art Association of Paris in winter 1903–4; he also exhibited two pastels and a sculpture, *The Chiseler,* at the 1905 Salon d'Automne. He returned in 1905 to Salt Lake City, where he taught at the YMCA and completed portrait commissions. Finding limited opportunities to establish himself as a professional artist in Salt Lake City, Young moved in 1910 to New York, where he became associated with a group of painters that included Leon Kroll and Paul Dougherty. In 1911 Young was awarded the Helen Foster Barnett Prize at the National Academy of Design's winter exhibition for a statuette of a boatman, *Bovet Arthur—A Laborer* (1904; Newark Museum, Newark, N.J.). In 1912 he had his first one-artist exhibition of bronzes and drawings at the Berlin Photographic Company. Young received commissions in 1912, 1915, and 1917 from the American Museum of Natural History for habitat groups for dioramas. To research and execute this work (destroyed), thirty-five plaster figures in all, he traveled to the southwestern United States three times between 1912 and 1917 to make sketches of the Hopi, Apache, and Navajo peoples.

As a member of the Association of American Painters and Sculptors, Young helped to organize the Armory Show of 1913, and the inclusion of six of his sculptures did much to establish his reputation. Two were relief panels for one of his best-known works, the granite and marble *Sea Gull Monument* (1907–13; Temple Square, Salt Lake City), which celebrates the sea gulls that ate the grasshoppers destroying the crops of the earliest Mormon settlers. In 1914 the Macbeth Gallery held a group exhibition of work by Young, Abastenia St. Leger Eberle (pp. 627–29), and Chester Beach (pp. 648–50), to which Young contributed fifteen pieces, among them such labor subjects as *Scrub Woman, Shoveler,* and *Iron Worker.* In 1915 he exhibited nine works, including *Stevedore,* at the Panama-Pacific International Exposition, San Francisco, and was awarded a silver medal. He had a large solo show of sculpture, etchings, and drawings at the Sculptors' Gallery in New York in 1918.

During the 1920s Young returned to France on several occasions, at one point living there for two and a half years (1925–27) and completing statuettes of provincial subjects, including the pendants *Porteuse de Poissons* and *Porteuse de Pain* (both 1926; Museum of Art at Brigham Young University). He turned to rugged prizefighting themes, such as *Right to the Jaw* (1926; Brooklyn Museum of Art) and *The Knockdown* (1927; Smithsonian American Art Museum, Washington, D.C.); a group of these were exhibited in his solo show at the Rehn Galleries, New York, in 1928. In 1932 Young was awarded a gold medal for sculpture in the fine arts exhibition at the Olympic Games in Los Angeles for *The Knockdown.* For the New York World's Fair in 1939, Young contributed two 14-foot figures, *Agriculture* and *Industry.* In 1940 the Addison Gallery of American Art, Phillips Academy, Andover, Massachusetts, hosted a retrospective exhibition of Young's work, including watercolors, drawings, prints, and sculptures. His ambitious *This Is the Place Monument,* which includes colossal figures of Brigham Young and two counselors atop an obelisk, commemorates the Mormons' arrival in Utah. It was dedicated at Emigration Canyon, near Salt Lake City, in 1947. Young also created a seated marble likeness of Brigham Young for the United States Capitol, which was unveiled in Statuary Hall in 1950.

Between 1916 and 1943 Young taught intermittently at the Art Students League in New York. He was named an academician of the National Academy of Design in 1923 and elected a member of the American Academy of Arts and Letters in 1947. The main repository of Young's work is at Brigham Young University, Provo, Utah.

JMM

Selected Bibliography

Young, Mahonri, Collection. Harold B. Lee Library, Brigham Young University, Provo, Utah.
Lewine, J. Lester. "The Bronzes of Mahonri Young." *International Studio* 47 (October 1912), pp. LV–LIX.

"An Art Born in the West and Epitomizing the West: Illustrated from the Work of Mahonri Young." *The Touchstone* 4 (October 1918), pp. 8–18.

Young, Mahonri, and Frank Jewett Mather, Jr. *Mahonri M.Young: Retrospective Exhibition.* Exh. cat. Andover, Mass.: Addison Gallery of American Art, Phillips Academy, 1940.

Conner, Janis, and Joel Rosenkranz. *Rediscoveries in American Sculpture: Studio Works, 1893–1939,* pp. 177–86, 188. Austin: University of Texas Press, 1989.

Tarbell, Roberta K. "Mahonri Young's Sculptures of Laboring Men, Walt Whitman, and Jean-François Millet." In Geoffrey M. Sill and Roberta K. Tarbell, eds., *Walt Whitman and the Visual Arts,* pp. 142–65. New Brunswick, N.J.: Rutgers University Press, 1992.

Toone, Thomas E. *Mahonri Young: His Life and Art.* Salt Lake City: Signature Books, 1997.

Davis, Norma S. *A Song of Joys: The Biography of Mahonri Mackintosh Young—Sculptor, Painter, Etcher.* Provo, Utah: Brigham Young University Museum of Art, 1999.

285. *Stevedore,* 1904

Bronze, by 1914
16½ x 8¼ x 5¼ in. (41.9 x 21 x 13.3 cm)
Signed (top of base, between feet): M M YOUNG
Foundry mark (back of base): ROMAN BRONZE WORKS N.Y.
Rogers Fund, 1914 (14.27)

MODELED IN 1904, *Stevedore* (also known as *Charbonnier,* which implies that the load is coal) is one of Young's early studies inspired by the sketching he did on the streets of Paris. Even before arriving in Europe Young had admired Jean-François Millet's drawings and paintings of working figures: "Since those early days [Young's teens in Salt Lake City], when Millet discovered for me form, space, light and movement, I have never ceased to love and admire his work. . . . Though I studied him, I did not try to imitate him. He sent me to nature."[1] Young acknowledged another source for his sympathetic images of workers: the laborers depicted by the Belgian sculptor Constantin Meunier, whose Paris exhibitions made a great impression on Young.

In *Stevedore,* the worker's stooped posture vividly conveys the weight of the load he is bearing. He carries his load on his back and shoulders; with arms out for balance, the figure walks upward as though onto a ship or out of a hold. For Young, the laborer not only offered the opportunity to depict the human body in motion but also extolled heroic individuals who perform hard menial work with dignity. Young later stated: "I like what workers do; they are great people to me. I like their poise and balance and gestures. The worker is the essential man and I find him tremendously inspiring to art."[2] In 1917 critic Frank Owen Payne described Young and such other American sculptors as Charles Oscar Haag (pp. 501–2), Eberle, and Beach as "our champions of labor in the plastic art of today! . . . They have studied their subjects at first hand. . . . They present them to the world as they are. They reveal to us charms which we have failed of our own observation to discover."[3]

Although Roman Bronze Works foundry records do not provide conclusive evidence, this bronze statuette was probably cast after Young returned to the United States in 1905, and more likely after he moved to New York in 1910. At the Metropolitan Museum it was approved for purchase directly from the artist in early February 1914.[4] According to Young, the Museum's *Stevedore* was made in 1904 and was the first of twelve examples.[5] Other bronze casts in museum collections are at the Baltimore Museum of Art (on loan from the Peabody Collection of the Maryland Commission on Artistic Property) and the Dayton Art Institute, Dayton, Ohio. A plaster cast of *Stevedore* is at the Museum of Art at Brigham Young University.

JMM

EXHIBITIONS

Addison Gallery of American Art, Phillips Academy, Andover, Mass., "Mahonri M. Young: Retrospective Exhibition," September 21–November 12, 1940, no. 2.

Sheldon Swope Art Gallery, Terre Haute, Ind., January 1948–February 1956.

B. F. Larsen Gallery, Harris Fine Arts Center, Brigham Young University, Provo, Utah, January 13–February 3, 1969; M. Knoedler and Co., New York, March 11–April 12, 1969, "Mahonri M. Young," no. 22.

Museum of Art at Brigham Young University, Provo, Utah, "Mahonri: A Song of Joys," October 14, 1999–November 18, 2000.

1. Mahonri M. Young, "Notes at the Beginning: Being Excerpts from the Early Pages of a Projected Autobiography," in Young and Mather 1940, pp. 49–50.
2. Tarbell 1992, p. 147; and "An Art Born" 1918, p. 10.
3. Frank Owen Payne, "The Tribute of American Sculpture to Labor," *Art and Archaeology* 6 (August 1917), p. 93.
4. Recommended purchase form, authorized by the trustees' Committee on Purchases, February 9, 1914, MMA Archives.
5. Notes of a telephone conversation with the artist, May 17, 1933, recorded on object catalogue cards, MMA Department of Modern Art. See also Albert TenEyck Gardner, *American Sculpture* (New York: MMA, 1965), p. 132, "according to the sculptor, six bronze casts were made."

285

622 MAHONRI MACKINTOSH YOUNG

286. *Man with a Pick,* 1915

Bronze, 1918
28¼ x 9 x 9¼ in. (71.8 x 22.9 x 23.5 cm)
Signed (top of base, between feet): M YOUNG
Foundry mark (right side of base): ROMAN BRONZE WORKS INC. N—Y—
Gift of Mrs. E. H. Harriman, 1918 (18.107)

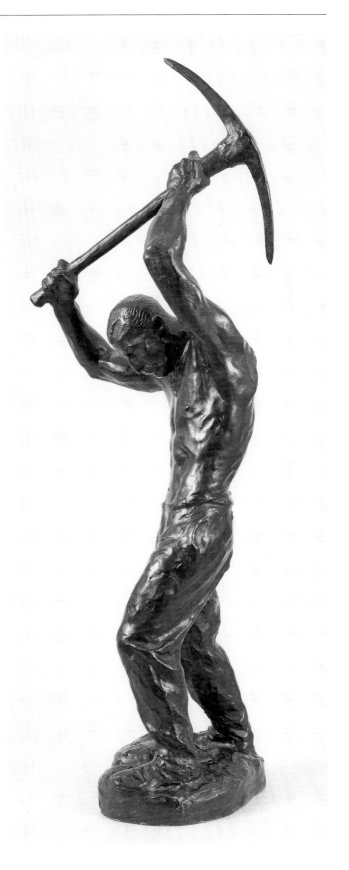

RATHER THAN introducing abstraction into his studies of common laborers, Young chose to perfect the naturalistic approach he had pursued from the beginning of his career. In *Man with a Pick,* as in the earlier companion piece, *The Heavy Sledge* (1911–12; Museum of Art at Brigham Young University),[1] the worker's struggle to combat gravity and fatigue is palpable. The compositional effect Young selected for *Man with a Pick*—suspending over the laborer's head the heavy tool he is wielding—not only opens up the figure to a more interesting play of solid and void but also heightens the viewer's sense of the man's exhausting effort. The moment depicted is the top of the swing: unclothed torso straight and taut, knees bent, feet one ahead of the other, and muscled arms and pick raised over the head. The man appears to be in the act of shifting his weight so, as Young put it, "the action was of the pick being driven downward, on a curve. . . ."[2] with maximum force. In some of Young's statuettes of laborers in which striving and endurance are most pronounced, his Mormon heritage may be particularly relevant, for such themes are central to Mormon history.[3]

The foundry mark on the Museum's *Man with a Pick,* ROMAN BRONZE WORKS INC. N—Y—, signifies that it was cast after Roman Bronze Works was incorporated in 1918.[4] It was accepted as a gift from Mrs. Edward H. Harriman, wife of the railroad developer, in October 1918; according to the artist, it was the first of two bronze casts.[5] The other bronze is at the Pennsylvania Academy of the Fine Arts, Philadelphia, while the original plaster is at the Museum of Art at Brigham Young University.[6]

JMM

EXHIBITIONS

Addison Gallery of American Art, Phillips Academy, Andover, Mass., "Mahonri M. Young: Retrospective Exhibition," September 21–November 12, 1940, no. 7.
MMA, Department of Education and Extension, "Comparisons in American Art and Literature," May 7–31, 1949.
B. F. Larsen Gallery, Harris Fine Arts Center, Brigham Young University, Provo, Utah, January 13–February 3, 1969; M. Knoedler and Co., New York, March 11–April 12, 1969, "Mahonri M. Young," no. 21.
Whitney Museum of American Art, New York, "200 Years of American Sculpture," March 16–September 26, 1976, no. 338.
Grey Art Gallery and Study Center, New York University, "Changes in Perspective: 1880–1925," May 2–June 2, 1978.

"The Figure in 20th Century American Art: Selections from The Metropolitan Museum of Art," traveling exhibition organized by the MMA and the American Federation of Arts, New York, February 1985–June 1986.

MMA, "The Human Figure in Transition, 1900–1945: American Sculpture from the Museum's Collection," April 15, 1997–March 29, 1998.

1. *The Heavy Sledge* is illustrated in Toone 1997, p. 88. Toone notes (p. 89) that *Man with a Pick* "was produced by modifying the plaster cast [for *The Heavy Sledge*]. Through a technique [Young] used several times during his career, changing and altering various parts of the original sculpture, he created a new piece, *Man with a Pick*." See also Conner and Rosenkranz 1989, p. 186, n. 12, which quotes Young's description of the process of altering *The Heavy Sledge*.
2. "The Heavy Sledge," Young Collection, as quoted in Conner and Rosenkranz 1989, p. 186, n. 12.
3. For further discussion, see Melissa Dabakis, *Visualizing Labor in American Sculpture: Monuments, Manliness, and the Work Ethic, 1880–1935* (New York: Cambridge University Press, 1999), p. 142.
4. See Michael Edward Shapiro, *Bronze Casting and American Sculpture, 1850–1900* (Newark: University of Delaware Press, 1985), p. 175. Eli Harvey's *Eagle* (cat. no. 162), cast in 1918 and presented to the Metropolitan the following year, bears a similar foundry mark.
5. Offer of gift form, accepted by trustees' Executive Committee, October 21, 1918; notes of a telephone conversation with the artist, May 17, 1933, recorded on object catalogue cards, MMA Department of Modern Art.
6. For the other bronze, see Susan James-Gadzinski and Mary Mullen Cunningham, *American Sculpture in the Museum of American Art of the Pennsylvania Academy of the Fine Arts* (Philadelphia: Museum of American Art of the Pennsylvania Academy of the Fine Arts, 1997), pp. 192–93.

Robert Ingersoll Aitken (1878–1949)

Aitken had only a year of formal art training, at the Mark Hopkins Institute of Art in his birthplace, San Francisco, where he studied with the painter Arthur F. Mathews and the sculptor Douglas Tilden. At the age of eighteen, he set up his own studio and was awarded such commissions as a monument to Admiral George Dewey's victory at Manila Bay (dedicated 1903; Union Square) and to William McKinley (dedicated 1904; Golden Gate Park), both in San Francisco. Aitken was an instructor at the Mark Hopkins Institute from 1901 to 1904. He then worked in Paris for three years, having visited there briefly in 1897.

Settling in New York in 1907, Aitken taught at the Art Students League. In 1908 he received the Helen Foster Barnett Prize at the National Academy of Design's winter exhibition for *The Flame* (1908; National Academy of Design). At San Francisco's Panama-Pacific International Exposition in 1915, sculptural groups by Aitken, including *Four Elements* for the Court of the Universe and *Fountain of the Earth* for the Court of Abundance, won a silver medal, and he also received the Architectural League of New York's Medal of Honor for sculpture that year. During 1919–22 and 1923–34 Aitken taught at the National Academy of Design, where he was elected an academician in 1914 and served as vice president from 1926 to 1933. He was president of the National Sculpture Society from 1920 to 1922 and vice president of the National Institute of Arts and Letters from 1921 to 1924.

Among Aitken's medallic commissions were the National Academy of Design's Elizabeth N. Watrous Gold Medal for sculpture (1914), which he himself was awarded in 1921 for his model of the George Rogers Clark monument for the University of Virginia, Charlottesville (dedicated 1921), and a fifty-dollar coin for the Panama-Pacific International Exposition (1915). Aitken favored a style inspired by classical and Renaissance models and overlaid with a turn-of-the-century predilection for naturalism. Notable commissions include a monument to the union leader Samuel Gompers (1933; Massachusetts Avenue and 10th Street, NW, Washington, D.C.), an ambitious multifigural tribute to organized labor ordered by the American Federation of Labor. He also completed the west pediment, *Equal Justice under Law,* of the United States Supreme Court Building (1935) and a frieze for the south facade of the Columbus Gallery of Fine Arts, Columbus, Ohio (1937; now the Columbus Museum of Art).

JMM

SELECTED BIBLIOGRAPHY

Aitken, Robert Ingersoll, Papers. Archives of American Art, Smithsonian Institution, Washington, D.C., microfilm reel 1027.

Semple, Elizabeth Anna. "Art of Robert Aitken, Sculptor." *Overland Monthly* 61 (March 1913), pp. 218–25.

Hoeber, Arthur. "Robert I. Aitken, A.N.A., an American Sculptor." *International Studio* 50 (July 1913), pp. iii–vii.

Lockman, DeWitt McClellan. Interview with Robert Ingersoll Aitken, May 31, 1927. Transcript, Manuscripts Department, New-York Historical Society. Microfilmed for DeWitt McClellan Lockman Papers, Archives of American Art, Smithsonian Institution, Washington, D.C., reel 502, frames 48–86.

Burns, Robert. "Robert Ingersoll Aitken, Biography and Works." *California Art Research,* vol. 6, pp. 60–94. Gene Hailey, ed. San Francisco: WPA Project 2874, 1936–37. Archives of American Art, Smithsonian Institution, Washington, D.C., microfilm reel NDA/Cal 1.

Proske, Beatrice Gilman. *Brookgreen Gardens Sculpture,* pp. 142–44. Rev. ed. Brookgreen Gardens, S.C.: Brookgreen Gardens, 1968.

K[ozol], P[aula] M. In Kathryn Greenthal et al., *American Figurative Sculpture in the Museum of Fine Arts, Boston,* pp. 362–65. Boston: Museum of Fine Arts, 1986.

287. *George Bellows,* 1909

Bronze, 1951
20¼ x 17½ x 11¼ in. (51.4 x 44.5 x 28.6 cm)
Signed (on back, sitter's right shoulder): R. I. AITKEN
Foundry mark (on edge of support, stamped): ROMAN BRONZE WORKS INC.
Francis Lathrop Fund, 1951 (51.154)

GEORGE WESLEY BELLOWS (1882–1925) began exhibiting his paintings in 1907, and he became an associate member of the National Academy of Design in 1909, the same year that Aitken did. Bellows was twenty-six, the youngest painter ever to be so recognized. His work was admired by collectors and curators, and beginning early in his career, his paintings were purchased by the Pennsylvania Academy of the Fine Arts and the Metropolitan Museum. He taught at the Art Students League in 1910 and 1911, when Aitken was an instructor there. This striking likeness

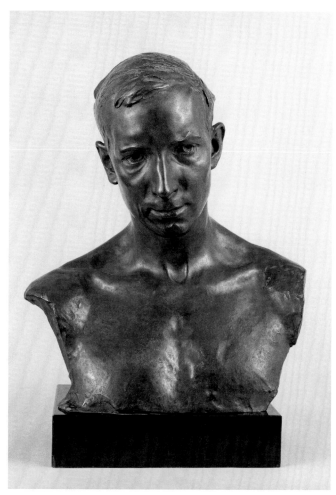

287

of Bellows was therefore created during a time of friendship and professional association between the artists. Aitken was known for lively portraits of artists and writers, and in his fluidly modeled bust of Bellows, he captured the young man who was described as "tall, shambling and a little ungainly."[1]

Aitken modeled a full-length, seated figure of Bellows in the *Frederick W. Schumacher Frieze,* a 100-foot-long relief for the facade of the Columbus Gallery of Fine Arts (completed 1937). Bellows was the youngest artist represented in this pantheon of sixty-eight great Western artists from Albrecht Dürer to Auguste Rodin.[2]

The Metropolitan Museum's *George Bellows* was cast posthumously by Roman Bronze Works directly from the original plaster model through the auspices of Aitken's widow.[3] It is mounted on a black marble base, 2¾ inches high. A lifetime bronze cast is in the collection of the Columbus Museum of Art. A plaster version of *George Bellows* was exhibited in the Armory Show of 1913.[4]

JMM

EXHIBITION

American Academy of Arts and Letters, National Institute of Arts and Letters, New York, "An Exhibition of Painting and Sculpture Commemorating the Armory Show of 1913 and the First Exhibit of the Society of Independent Artists in 1917 with Works by Members Who Exhibited There," December 2–30, 1955, no. 15.

1. Frank Crowninshield, in *George Bellows Memorial Exhibition* (New York: MMA, 1925), p. 12.
2. The frieze consists of two panels of equal length, and Bellows sits at the west end of the west panel; see *The Frederick W. Schumacher Frieze, "Masters of Art"; Robert Aitken, N.A., Sculptor* (Columbus, Ohio: Columbus Gallery of Fine Arts, 1937). The other American artists depicted on the west panel are James Abbott McNeill Whistler, John Quincy Adams Ward (pp. 136–54), John Singer Sargent (see cat. no. 113), Augustus Saint-Gaudens (pp. 243–325), and John La Farge (see cat. no. 240).
3. Note on recommended purchase form, May 22, 1951: "The purchase price of the bust will be the amount needed to reimburse Mrs. Aitken for the cost of casting the plaster into bronze"; note added October 31, 1951: "Bronze cast has been delivered to the Museum"; MMA Archives. See also Roman Bronze Works Archives, Amon Carter Museum, Fort Worth, job file 882 Mrs. Robert Aitken, which includes a handwritten note: "Color for Bellows Bust—Med Brown little green ... Mrs. Robert Aitken July 13th/1951."
4. *Catalogue of International Exhibition of Modern Art* (New York: Association of American Painters and Sculptors, 1913), p. 49, no. 686.

Mary Abastenia St. Leger Eberle (1878–1942)

Born in Webster City, Iowa, Eberle and her family moved frequently. They settled for a time in Canton, Ohio, where Eberle graduated from high school in 1895. She studied cello and briefly considered a career as a professional musician, but when, at age seventeen, she took classes in modeling at the local YMCA, she knew she wanted to become a sculptor. In 1898, after Eberle's parents moved to Puerto Rico where her father began service as an army physician, she went to New York. There she studied at the Art Students League from 1899 to 1902 and took instruction in modeling with C. Y. Harvey and George Grey Barnard (pp. 421–27) and drawing with Kenyon Cox. In the summers Eberle visited her parents in Puerto Rico and sketched the people she saw, anticipating the genre studies in her later work. She and Anna Vaughn Hyatt (pp. 600–606), with whom she shared a New York studio from 1903 to 1906, collaborated on several groups, she modeling the human figures and Hyatt the animals. Their *Men and Bull* (1904; destroyed) was commended at the Society of American Artists annual exhibition in 1904 and awarded a bronze medal at the Louisiana Purchase Exposition in Saint Louis that same year.

Eberle was elected to the National Sculpture Society in 1906 and began to exhibit her work consistently at the exhibitions of the National Academy of Design and the Pennsylvania Academy of the Fine Arts. During the summer of 1907 Eberle worked in a studio on the Lower East Side of Manhattan, and in the fall she moved to West 9th Street; in these neighborhoods she found her subjects among the poor and immigrant women and children. Examples include the ebullient *Girl Skating* (cat. no. 288), the somber *Old Woman Picking Up Coal* (1906; Hirshhorn Museum and Sculpture Garden, Washington, D.C.), and the boisterous *Girls Dancing* (1907; Corcoran Gallery of Art, Washington, D.C.). In 1907 she began her association with the Macbeth Gallery, which she maintained for many years. That year Eberle also traveled to Italy, where she had her plasters cast in a foundry in Naples, visiting again the following year. After establishing a summer residence in Woodstock, New York, in 1909, the sculptor produced *Windy Doorstep* (1910; Worcester Museum of Art, Worcester, Mass.), which was inspired by women sweeping their steps on windy mornings. For this statuette, in 1910 Eberle was awarded the Helen Foster Barnett Prize at the National Academy of Design for the best sculpture by an artist under thirty-five.

As Eberle's works received increasing critical acclaim, they were acquired by several museums and were widely illustrated in publications. She exhibited two sculptures at the 1913 Armory Show, including her *White Slave* (1913; destroyed; posthumous bronze, private collection). The sculpture, a censure of the abduction of young women for prostitution, represents a smoothly and simply formed young woman cowering in her nudity, while the roughly modeled auctioneer solicits bids for her. It caused a storm of controversy when it was published on the cover of *The Survey* magazine of May 3, 1913, a journal dedicated to labor and reform issues. Eberle also worked on behalf of woman suffrage, in 1915 organizing an exhibition of women artists at the Macbeth Gallery to raise money for the movement. That year she also exhibited twelve sculptures at the Panama-Pacific International Exposition in San Francisco, and she was awarded a bronze medal.

Eberle continued working on genre groups—almost always of female subjects—in the West Village and on the Lower East Side until 1919, when a worsening heart condition curtailed her artistic career. She was elected an associate of the National Academy of Design in 1920, and in 1921, at the Macbeth Gallery, she had her first solo exhibition, which consisted of twenty-seven earlier works. In 1922 Eberle presented twenty plasters of her works to the Kendall Young Library in Webster City, her birthplace. She continued to sculpt portraits and garden pieces on an extremely limited basis, occasionally showing her work at Grand Central Art Galleries in New York.

JMM

SELECTED BIBLIOGRAPHY

Eberle, Abastenia St. Leger. Correspondence with William Macbeth and Macbeth Gallery, in Macbeth Gallery Records. Archives of American Art, Smithsonian Institution, Washington, D.C., microfilm reels NMc6 (frames 1074–89), NMc44 (frames 219–65).

Smith, Bertha H. "Two Women Who Collaborate in Sculpture." *The Craftsman* 8 (August 1905), pp. 623–33.

Merriman, Christina. "New Bottles for New Wine: The Work of Abastenia St. Leger Eberle." *The Survey* 30 (May 3, 1913), pp. 196–99.

McIntyre, R. G. "The Broad Vision of Abastenia Eberle." *Arts and Decoration* 3 (August 1913), pp. 334–37.

The East Side in Sculpture by Abastenia St. Leger Eberle. Exh. cat. New York: Macbeth Gallery, 1921.

Chandler, Anna Curtis. "East Side Children in Sculpture: The Art of Abastenia St. Leger Eberle." *The Mentor* 14 (December 1926), pp. 28–31.

Noun, Louise R. Introduction to *Abastenia St. Leger Eberle, Sculptor (1878–1942).* Exh. cat. Des Moines, Iowa: Des Moines Art Center, 1980.

Casteras, Susan P. "Abastenia St. Leger Eberle's *White Slave.*" *Woman's Art Journal* 7 (Spring–Summer 1986), pp. 32–36.

Conner, Janis, and Joel Rosenkranz. *Rediscoveries in American Sculpture: Studio Works, 1893–1939,* pp. 27–34. Austin: University of Texas Press, 1989.

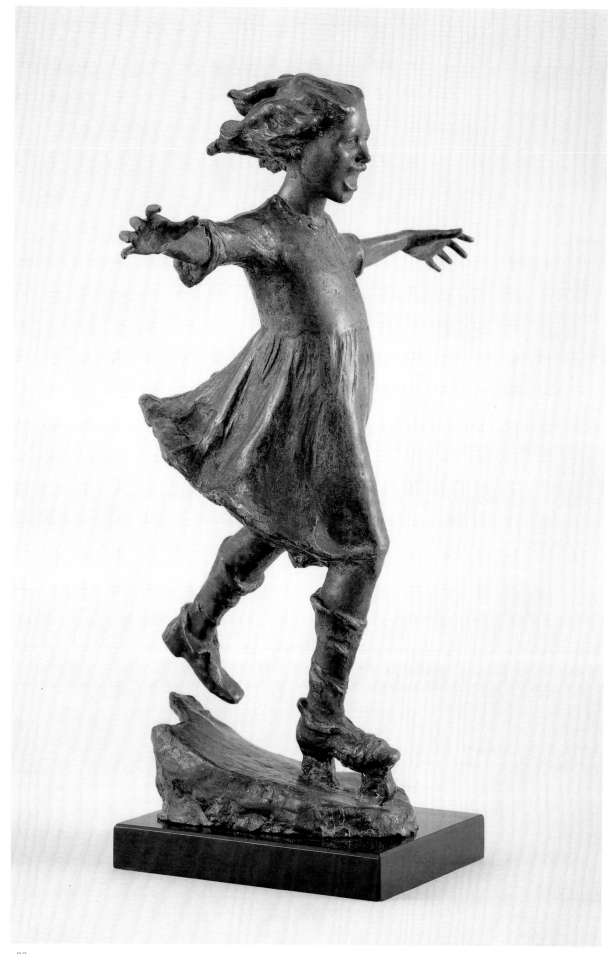

288

628 MARY ABASTENIA ST. LEGER EBERLE

288. *Girl Skating*, 1906

Bronze
13 x 11¼ x 6¼ in. (33 x 28.6 x 15.9 cm)
Signed and dated (back of base) A. SLEberle 06
Rogers Fund, 1909 (09.57)

GIRL SKATING (also known as *Roller Skating* or *Girl with Roller Skate*) is significant as Eberle's first study of an underprivileged child playing on the streets of New York, a theme that was to interest her for nearly two decades. The bronze figure is a spirited image of an excited child who utters a cry as she races ahead on only one skate, her outstretched arms balancing her against the wind that sweeps back her hair and presses her simple ragged dress against her body. Though the freedom of style and impressionistic surfaces enhance the effect of a simple and fleeting pleasure, Eberle gave poignant expression to the plight of the poor. As she explained: "The children of the East Side play without restraint; their griefs and their joys are expressed with absolute abandon. . . . [T]heir natural emotions are not retrained by the pretty curtseys taught by governesses. . . . They laugh loudly. They shout. They race on roller skates and dance unrestrainedly. I can get at the human quality in these children. They are real—real as they can be. They express life."[1]

Eberle's representations of the city's poor (frequently children) generally measure a foot in height. They depict her subjects as simple, self-sufficient, and proud. *Girl Skating,* in its candid and sympathetic approach to the urban child, relates its maker to painters of the Ashcan School and placed her among the progressive sculptors, such as Ethel Myers and Mahonri Young (pp. 620–24), who were challenging the dominant influence of classical themes practiced by academic artists. An artist with a social conscience, Eberle claimed that the creative person had a responsibility to others and served as "the specialized eye of society."[2]

Eberle exhibited *Girl Skating* at the National Academy of Design in 1907 and 1908–9 and at the Pennsylvania Academy of the Fine Arts in 1907 and 1908.[3] The Metropolitan's example, with its olive-green patina, was purchased in 1909 directly from the artist. According to

Eberle, six or eight bronzes were cast of *Girl Skating*.[4] Other casts are in the collections of the Des Moines Art Center; the Museum of Art, Rhode Island School of Design, Providence; and the Whitney Museum of American Art, New York, the latter having been purchased from Eberle by Gertrude Vanderbilt Whitney (pp. 592–95).[5]

The Metropolitan's bronze is mounted on an ebonized wood base, ¾ inch high. JMM

EXHIBITIONS

Bronx Museum of the Arts, New York, "Games!!! ¡Juegos!" February 1–March 6, 1972, no. 123.
MMA, "The Human Figure in Transition, 1900–1945: American Sculpture from the Museum's Collection," April 15, 1997–March 29, 1998.
Jane Voorhees Zimmerli Art Museum, Rutgers University, New Brunswick, N.J., "The Enduring Figure 1890s–1970s: Sixteen Sculptors from the National Association of Women Artists," December 12, 1999–March 12, 2000, no. 12.

1. "Which Is True Art?" *Washington Post,* February 6, 1916, p. 4. For further discussion of class issues in *Girl Skating,* see Melissa Dabakis, *Visualizing Labor in American Sculpture: Monuments, Manliness, and the Work Ethic, 1880–1935* (New York: Cambridge University Press, 1999), pp. 153–54.
2. Merriman 1913, p. 196.
3. *National Academy of Design Eighty-second Annual Exhibition 1907 . . . Illustrated Catalogue* (New York, 1907), p. 63, no. 393; *National Academy of Design Winter Exhibition 1908 . . . Illustrated Catalogue* (New York, 1908), p. 59, no. 411; *Pennsylvania Academy of the Fine Arts . . . Catalogue of the 102nd Annual Exhibition,* 2nd ed. (Philadelphia, 1907), p. 49, no. 514; and *Pennsylvania Academy of the Fine Arts . . . Catalogue of the 103rd Annual Exhibition,* 3rd ed. (Philadelphia, 1908), p. 57, no. 822.
4. Notes of a telephone conversation with the artist, May 16, 1933, object catalogue cards, MMA Department of Modern Art.
5. For the Whitney cast, see Patricia Hills and Roberta K. Tarbell, *The Figurative Tradition and the Whitney Museum of American Art: Paintings and Sculpture from the Permanent Collection,* exh. cat. (New York: Whitney Museum of American Art, 1980), p. 95.

Rudulph Evans (1878–1960)

Evans, who was born in Washington, D.C., worked in the studio of local sculptor U. S. J. Dunbar for eighteen months beginning in January 1894; the following year he enrolled in antique and life drawing classes at the Corcoran School of Art with Eliphalet F. Andrews. In December 1897 Evans went to Paris, training first with Denys Puech at the Académie Julian and in an anatomy class at a local medical school, and later in the atelier of Jean-Alexandre-Joseph Falguière at the École des Beaux-Arts, to which he was admitted in 1898. During his Parisian tenure, Evans modeled mostly portraits, exhibiting a bas-relief of M. Fere and a bust of Alastair d'Oyley in the Salon of 1898. He also visited the studios of Augustus Saint-Gaudens (pp. 243–325), Frederick William MacMonnies (pp. 428–42), and, in October 1898, Auguste Rodin. Rodin's expressive modeling techniques influenced Evans over the next few years, although he maintained a greater allegiance to the traditional academic style of his instructors.

In 1900 Evans returned to the United States, teaching sculpture classes briefly at the Corcoran School of Art the following year, and then settled in New York. In 1902 he completed his academic training at the Art Students League under the tutelage of H. Siddons Mowbray. In 1903 Evans earned his first major public commission, a bronze monument to Julius Sterling Morton, which was awarded a medal of honor in the Salon of 1905 and was unveiled in Nebraska City, Nebraska, the same year. Evans spent considerable periods of time in Europe, having returned to Paris in 1903 to work on the *Morton Monument*. In addition to several long stays in Paris, Evans traveled to Greece and Italy in 1910–11 and again to Italy in 1921–22. During these years, the sculptor modeled numerous society portraits and received prestigious private commissions, including those for the Frank A. Vanderlip family, with whom he lived in Scarborough, New York, between 1908 and 1910. In 1912 John D. Rockefeller ordered the fountain *Maiden with Swans* (1912–13) for his estate Kykuit at Pocantico Hills, New York.

Evans was awarded a bronze medal at the Paris Salon of 1914 for *The Golden Hour* (1912–14), a lifesize gilt bronze of a nude girl on the brink of womanhood rendered in a classic, serene manner. The sculptor earned international exposure when the French government purchased a second bronze cast for the Musée du Luxembourg, Paris (it is presumed to have been lost or destroyed during World War II). Evans's patron Frank Vanderlip gave the Metropolitan Museum a marble replica, which was carved in Paris between 1914 and 1915 and finished by the sculptor in New York in 1918 (it was deaccessioned in 1997). Other studies and derivations of *The Golden Hour* include a head (Baltimore Museum of Art), as well as just the torso and upper legs (Smithsonian American Art Museum, Washington, D.C.).

Evans continued to exhibit his work frequently after establishing a studio in New York in 1916. In 1919–20, at the winter exhibition of the National Academy of Design, he was awarded the Elizabeth N. Watrous Gold Medal for his garden group *Boy and Panther* (1917–19; Brookgreen Gardens, Murrells Inlet, S.C.). Evans was primarily a sculptor of monuments and memorials, but he also created portraits busts in a direct style, such as the four bronze heads (1929–37) for the Hall of Fame for Great Americans at Bronx Community College (then the University Heights campus of New York University).

Evans made a specialty of historical portraits; among his most successful is that of Robert E. Lee (1930–31) for the Virginia State Capitol, Richmond, dedicated in 1932. The sculptor's lifesize bronze statues of Nebraska statesmen William Jennings Bryan and J. Sterling Morton were unveiled in the United States Capitol in 1937. In 1938 Evans submitted a design for a statue of Thomas Jefferson to the Jefferson Memorial Commission. He won the commission in 1941 over more than one hundred other artists who made proposals. In 1943 Evans's 19-foot plaster figure was dedicated in John Russell Pope's Jefferson Memorial. After World War II, with metal again available for casting, a bronze replaced the plaster, and in 1947 Evans's best-known work was installed on a 6-foot-high marble pedestal. That same year he relocated his studio to Washington, D.C.

In 1926 Evans was elected to membership in the National Institute of Arts and Letters and three years later was named an academician of the National Academy of Design. In 1934 the French government made him a Chevalier of the Legion of Honor; he was also named a Cavaliere of the Order of the Crown of Italy in 1923. JMM

SELECTED BIBLIOGRAPHY

Candee, Helen Churchill. "The Sculpture of Rudulph Evans." *International Studio* 55 (May 1915), pp. LXXXIV–LXXXVI.
Obituary. *New York Times,* January 18, 1960, p. 27.
Proske, Beatrice Gilman. *Brookgreen Gardens Sculpture,* pp. 137–39. Rev. ed. Brookgreen Gardens, S.C.: Brookgreen Gardens, 1968.
Yonkers, Tescia Ann. "Rudulph Evans: An American Sculptor (1878–1960)." Ph.D. diss., George Washington University, 1984.

289. *Maude Adams*, 1906

Bronze, after 1906
12¾ x 8½ x 10 in. (32.4 x 21.6 x 25.4 cm)
Signed and inscribed (right side of base): FOR·DR·EDLICH·JR / R·EVANS·Sc
Gift of Theodore J. Edlich Jr., 1987 (1987.463.4)

MAUDE ADAMS (1872–1953) first appeared on the stage as an infant and then, after 1897, had starring roles in many plays written by her friend J. M. Barrie. She was especially renowned for her portrayal of Peter Pan, beginning in 1905, a part Barrie created especially for her.[1] Adams was at the height of her career as an actress when she first sat for Evans in 1902; the resulting bust, titled *Betsy* (unlocated), was a gift from Evans to Adams. A second portrait, of which the Metropolitan's is an example, was modeled in 1906, the result of Evans's visit to the actress's home in the Catskills the previous year. It was exhibited in March 1908 at O'Brien's Galleries in Chicago with other works by Evans and in May 1915 at the second annual exhibition of the Allied Artists of America in New York.[2]

This masklike portrait is one of the sculptor's most unusual, for the majority of his likenesses were executed in a traditional style that reflected his rigorous academic training. The expressionistic bust is terminated at the neck in the manner of some by Rodin, its vitality and motion particularly conveyed by the swept-back hair. Although the facial features are idealized and well formed, Rodin-esque elements prevail, among them the asymmetry of the composition, the concave back, and the sketchy treatment of the hair.

Adams, after resolving a misunderstanding with Evans about whether the second portrait was a commission, purchased examples in plaster and bronze. She hoped that the latter would be placed on view at the Empire Theatre, but the head was not accepted.[3] It was copyrighted by Evans in February 1909, at which time he described it as "a bronze portrait head appearing as a fragment in sculpture. A sort of mask without showing the back of the head."[4] Eleven replicas—in plaster, bronze, and marble—have been documented.[5] A plaster head was donated in 1963 to the American Academy of Arts and Letters by Theodore J. Edlich, Jr., Evans's longtime physician, who had received it as a gift from the sculptor.[6] In 1987 Edlich presented the Metropolitan with a bronze, slightly smaller in dimensions, bearing the same inscription as the plaster. Evans submitted a 10-inch bronze cast by Gorham to the National Academy of Design as his diploma work. A 6-inch bronze cast, by Roman Bronze Works, is at the National Portrait Gallery, Washington, D.C.[7] JMM

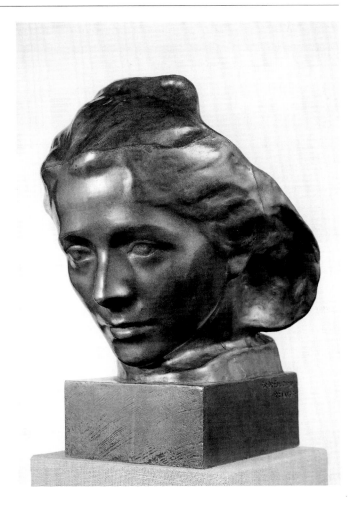

1. On Adams, see *American National Biography,* s.v. "Adams, Maude"; and Phyllis Robbins, *Maude Adams: An Intimate Portrait* (New York: G. P. Putnam's Sons, 1956), a biography corrected and authorized by the actress.
2. Yonkers 1984, p. 360; and *Allied Artists of America: Second Annual Exhibition 1915* (New York, 1915), n.p., no. 8.
3. See Lillian B. Miller and Nancy A. Johnson, *Portraits from the American Academy and Institute of Arts and Letters,* exh. cat. (Washington, D.C.: National Portrait Gallery, 1987), p. 36.
4. Quoted in Yonkers 1984, pp. 362–63.
5. Yonkers 1984, p. 360.
6. Miller and Johnson, *Portraits from the American Academy,* p. 38.
7. *National Portrait Gallery: Permanent Collection Illustrated Checklist* (Washington, D.C.: National Portrait Gallery in association with Smithsonian Institution Press, 1987), p. 15.

Maurice Sterne (1878–1957)

Known principally as a modernist painter and draftsman, Sterne spent his youth first in Liepāja on the Baltic Sea and, following the death of his father, in Moscow, where he attended a technical school. Sterne arrived in New York City in 1889, working in a factory on the Lower East Side and serving an apprenticeship to a map engraver. After studying mechanical drawing in evening classes at Cooper Union in 1892, he enrolled at the National Academy of Design in a weekly anatomy class with Thomas Eakins, who taught there until spring 1895. From 1894 until 1899 Sterne took antique and life drawing as well as painting classes at the National Academy while working to support himself. The first exhibition of his paintings was held in New York in 1902 at the Old Country Sketch Club.

In 1904 Sterne was awarded the first Mooney Traveling Scholarship from the National Academy for study and travel abroad. Living primarily in Paris, he benefited greatly from his friendship with renowned American collectors Gertrude and Leo Stein, who introduced him to current trends and influential personalities in art including artists Pablo Picasso and Henri Matisse and dealer Ambroise Vollard. Sterne was particularly captivated by the paintings of Paul Cézanne, the sculpture of Auguste Rodin, and non-Western art from African, Asian, and Indian cultures.

In 1908, when Sterne made his first sculpture, he found that three-dimensional work allowed him to solve problems of form and composition he encountered in painting. He traveled to Greece that year, studying antiquities in Athens and Delphi, while living for eight months in a monastery on Mount Hymettus. In 1910 Sterne established a studio in the artistic community of Anticoli Corrado, east of Rome, and resided there during the summers of 1910 and 1911, during which time he modeled wax sculptures. He traveled widely: to Egypt, India, Burma, Java, and to Bali, where he stayed for two years (1912–14), producing many sketches and drawings of the Balinese people. In 1912 Sterne exhibited his drawings, etchings, and paintings at the Berlin Photographic Company, New York, where he would in 1915 again have a one-artist show, this one of his work done in Bali.

Sterne returned to New York in early 1915 and became an intimate in the salon of art patron Mabel Dodge, who gathered people with modern ideas such as abstract artists Marsden Hartley and John Marin, and radical journalists Lincoln Steffens and John Reed. Sterne and Dodge were married in 1917 but were soon estranged after she joined him in Taos, New Mexico, where he had gone to paint.

Sterne returned to Italy in 1918 and thereafter spent part of each year in Anticoli Corrado. He continued to pursue sculpture, producing both busts and more ambitious nude females such as *The Awakening* (1921–26; Museum of Fine Arts, Boston) and *Seated Female* (Museum of Art, Rhode Island School of Design, Providence). In 1927 Sterne was awarded a major commission for the *Rogers-Kennedy Memorial,* which was dedicated two years later in Elm Park, Worcester, Massachusetts. This bronze monument to early settlers consists of figures of a couple plowing and sixteen limestone reliefs depicting their daily responsibilities.

Sterne became president of the Society of American Painters, Sculptors, and Gravers in 1929. In 1932 he opened a school in New York on East 57th Street, at which he taught his methods of drawing, painting, and color theory. The following year he was the first living American artist to be honored with a solo exhibition at the Museum of Modern Art in New York. He spent several years in San Francisco working on his series of murals "The Search for the Truth" (1935) for the Department of Justice building in Washington, D.C., and teaching at the California School of Fine Arts; he had two solo shows, in 1935 and 1937, at the San Francisco Museum of Art. For the Ellen Phillips Samuel Memorial on the Central Terrace, Fairmount Park, Philadelphia, Sterne contributed a bronze group of two male figures, *Welcoming to Freedom* (1939).

Sterne's artistic output decreased in the 1940s due to ill health. After 1944 he spent summers in Provincetown, Massachusetts, where he completed landscapes and marine paintings. In 1945 he was appointed to the National Fine Arts Commission, serving for seven years. JMM

SELECTED BIBLIOGRAPHY

Whitney Museum of American Art, New York, artists' files and records. Microfilmed by the Archives of American Art, Smithsonian Institution, Washington, D.C., reel N689, frames 513–697.

Birnbaum, Martin. "Maurice Sterne." *International Studio* 46 (March 1912), pp. III–IX, XIII.

Maurice Sterne: Retrospective Exhibition 1902–1932, Paintings, Sculpture, Drawings. Exh. cat., essay by Horace M. Kallen and note by Maurice Sterne. New York: Museum of Modern Art, 1933.

"An Hour in the Studio of Maurice Sterne: An Interview." *American Artist* 5 (December 1941), pp. 5–9, 39.

Mayerson, Charlotte Leon, ed. *Shadow and Light: The Life, Friends and Opinions of Maurice Sterne.* New York: Harcourt, Brace and World, 1965.

Ackerman, Martin S., and Diane L. Ackerman, eds. *Maurice Sterne Drawings.* New York: Arco Publishing, 1974.

P[aula] M. K[ozol], in Kathryn Greenthal et al., *American Figurative Sculpture in the Museum of Fine Arts, Boston,* pp. 371–76. Boston: Museum of Fine Arts, 1986.

290. *The Bomb-Thrower,* 1910; revised 1914

Bronze
12¼ x 7½ x 9⅛ in. (31.1 x 19.1 x 23.2 cm)
Rogers Fund, 1922 (22.97)

THIS POWERFUL image of an Italian anarchist, with its simplified and boldly expressive form, is a prime example of the modernist idiom in American sculpture. In Sterne's first version of the work, titled *Pasquale,* the subject has a mustache and the hair of his eyebrows and head is articulated in stylized curls.[1] According to the artist, *Pasquale* was cast in bronze in Rome in 1910, shortly before he departed for India and Bali; it was included in his New York exhibition in 1912 at the Berlin Photographic Company, where it was acquired by American artist and critic Hamilton Easter Field, who already owned a painting and a drawing of biblical subjects by Sterne.[2]

Sterne later recalled: "Upon my return from Asia in 1914, I found my original beeswax model. As I was not satisfied with the modelling I decided to work over it. I worked about 2 months and had the second cast made which is now in the Metropolitan Museum. Of course the general conception is the same, but the modelling is *entirely* different. . . . As the process of casting employed is the lost wax process and I usually work over the wax model (sometimes for weeks) before it goes to the foundry, every cast is different."[3] In the reworking, he removed the mustache, eliminated details in the hair, and simplified the surface. The result is a helmetlike head with angular face, tense brow, and cold emotion. Possibly this was in response to a published opinion: "The *Pasquale* . . . is extremely fine. . . . It has more naiveté than the work of Maillol, if not his perfect science, and the criticism that the treatment of the hair is a trifle archaic is answered on seeing the model."[4] The present head seems much closer to the archaic sculptures that Sterne admired and sketched during his sojourn in Greece than it does to the Parisian modernism to which it is often compared.

According to the sculptor, two other bronze casts similar to the one in the Metropolitan Museum were made.[5] These were acquired by the Worcester Art Museum, Worcester, Massachusetts, in 1928, and the Whitney Museum of American Art, New York, in 1954. The Metropolitan Museum's bust was purchased from Sterne through the Bourgeois Galleries, New York, in May 1922.

The Museum's *Bomb-Thrower* surmounts a painted wood base, 4⅞ inches high. J M M

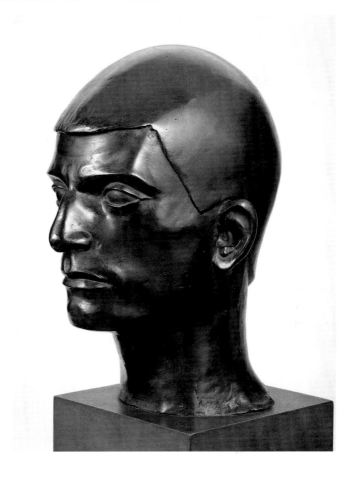

EXHIBITIONS

Museum of Modern Art, New York, "American Painting and Sculpture, 1862–1932," October 31, 1932–January 31, 1933, no. 145.
Museum of Modern Art, New York, "Maurice Sterne, Retrospective Exhibition 1902–1932, Paintings, Sculpture, Drawings," February 15–March 25, 1933, no. 163.
MMA, "A Special Exhibition of Heads in Sculpture from the Museum Collection," January 16–March 3, 1940.
"The Figure in 20th Century American Art: Selections from The Metropolitan Museum of Art," traveling exhibition organized by the MMA and the American Federation of Arts, New York, February 1985–June 1986.

1. For an illustration of *Pasquale,* see Birnbaum 1912, p. xiii.
2. Sterne to Faith Dennis, Assistant, MMA Catalogue Division, February 26, 1934, MMA Archives; and *Catalogue of an Exhibition of the Drawings, Paintings and Etchings of Maurice Sterne,* introduction by Hamilton Easter Field (New York: Berlin Photographic Co., 1912), p. 6, no. 58.
3. Sterne to Dennis, February 26, 1934, MMA Archives.
4. Birnbaum 1912, p. vi.
5. Sterne to Dennis, February 26, 1934, MMA Archives.

John Gregory (1879–1958)

Gregory came to the United States in 1893 from his native London. Settling first in Washington, D.C., he worked as a junior clerk in the United States Senate from 1893 to 1896. He was subsequently employed from 1897 to 1899 by the Columbia Recording Corporation in Bridgeport, Connecticut. Between 1899 and 1902 Gregory was apprenticed to the Scottish-born sculptor John Massey Rhind and after 1902 worked as an assistant to Hermon Atkins MacNeil (pp. 475–81). In evening classes at the Art Students League, he studied antique drawing with George Bridgman and modeling first with C. Y. Harvey and later with George Grey Barnard (pp. 421–27). Gregory continued art instruction in Europe: at the Lambeth Art School in London in 1903, then for two years in the atelier of Antonin Mercié at the École des Beaux-Arts in Paris. He returned to New York in 1906 and worked as an assistant in the studios of MacNeil, Herbert Adams (pp. 360–64), and Gutzon Borglum (pp. 496–500). Gregory became a United States citizen in 1912.

Gregory spent the years 1912–15 in Rome, having won a fellowship to work at the American Academy. There, and in widespread travels throughout Italy and Greece, his exposure to Greek and Roman sculpture led to his own style of modern classicism that made use of stylized form, rhythmic movement, and silhouetted line. Returning to New York in 1915, Gregory made a name for himself designing garden sculpture for private estates, such as *Orpheus and Dancing Panther* (1916) for Charles M. Schwab in Loretto, Pennsylvania, and *Wood Nymph* and *Bacchante* (1918–20) for Harry Payne and Gertrude Vanderbilt Whitney in Westbury, New York. After Gregory's *Philomela* (cat. no. 291) for the Whitneys was honored by the Architectural League of New York in 1921, he received many commissions, both for garden pieces and for architectural sculpture.

Gregory completed a large bronze floor plate, *The Voyage,* commissioned in 1921, for the rotunda of New York's Cunard Building. He designed the *William Corcoran Eustis Memorial,* a high-relief panel drawn from Sir Thomas Mallory's *Morte d'Arthur,* at the Corcoran Gallery of Art, Washington, D.C., in 1924, and he created a one-third-size plaster model for polychrome sculpture (1926) on the theme "The East—The Pursuit of Wisdom" for the east pediment of the Philadelphia Museum of Art. The final project was not realized for lack of funds, but the museum still has the model. For the Henry E. Huntington Mausoleum in San Marino, California, Gregory produced decorative figural panels (1927–29) based on the Four Seasons and the Four Ages of Man. He is perhaps best known for nine marble reliefs depicting scenes from Shakespeare's plays, which he completed between 1929 and 1931 for the main facade of the Folger Shakespeare Library in Washington. Two marble pier reliefs of seated female figures for an entrance to the Federal Reserve Board Building (Washington) were installed in 1937, as was an equestrian statue of General Anthony Wayne (East Terrace, Philadelphia Museum of Art). For the New York World's Fair of 1939 Gregory contributed *The Victories of Peace* and served on the selection committee for the exhibition "American Art Today," which included his bronze *Orpheus.* Among Gregory's later commissions were a granite relief panel *Urban Life* (1941) for the Municipal Center Building, Washington, and *Memory,* a 7-foot marble figure, installed in 1951 at the chapel in the Suresnes (France) American Cemetery.

Gregory also devoted many years to teaching. His appointments included those as an associate in modeling at Columbia University from 1916 to 1925 and as director of sculpture at the Beaux-Arts Institute of Design from 1921 to 1923. He was president of the National Sculpture Society from 1934 to 1939 and honorary president from 1953 to 1958, receiving the organization's Medal of Honor in 1956. After his death, the society established the John Gregory Award to recognize work in the classic tradition (aside from portrait heads) of American sculptors under the age of forty-five. Gregory was also an academician of the National Academy of Design (1934), and a member of both the National Institute of Arts and Letters (1930) and the Art Commission of the City of New York. JMM

SELECTED BIBLIOGRAPHY

Gregory, John, Papers. Archives of American Art, Smithsonian Institution, Washington, D.C., unmicrofilmed.
"John Gregory, Sculptor." *Arts and Decoration* 12 (November 15, 1919), p. 8.
Solon, Leon V. "The Garden Sculpture of John Gregory." *Architectural Record* 55 (April 1924), pp. 401–4.
"John Gregory's Sculptures in Bronze." *Metal Arts* 2 (July 1929), pp. 315–19, 322.
Parkes, Kineton. "A Classical Sculptor in America: John Gregory." *Apollo* 17 (February 1933), pp. 28–31.
Belskie, Abram, "Tribute to John Gregory"; and "The Work of John Gregory." *National Sculpture Review* 7 (Summer 1958), pp. 5, 6–7.
Proske, Beatrice Gilman. *Brookgreen Gardens Sculpture,* pp. 302–5. Rev. ed. Brookgreen Gardens, S.C.: Brookgreen Gardens, 1968.
Bronson, Steven Eric. "John Gregory: The Philadelphia Museum of Art Pediment." M.A. thesis, University of Delaware, 1977.
American National Biography, s.v. "Gregory, John."

291

291. *Philomela*, 1919–21

Bronze, 1922
12⅛ x 9⅛ x 4⅛ in. (30.8 x 23.2 x 10.5 cm)
Signed and dated (top of base, rear left): *John Gregory © / 1922*
Foundry mark (right side of base): ROMAN BRONZE WORKS N–Y–
Inscribed (top of base, front right): PHILOMELA
Cast number (top of base, rear right): № 11.
Rogers Fund, 1923 (23.106.2)

ACCORDING TO myth, Philomela was violated by her
brother-in-law, Tereus. In the ensuing horrific episodes of
violence, Philomela, her sister Procne, and Tereus were
transformed by the gods into birds. In this traditionally
conceived image, based on the classical Greek prototype of
a crouching Venus, Gregory showed the partially draped
nude figure sprouting wings and added surface interest by
including rhythmic decorative effects and archaistic styli-
zation. Because the original design for the work (1919)
was a lifesize bronze commissioned by Gertrude Vanderbilt
Whitney (pp. 592–95) for her estate in Westbury, New
York, the symmetry and frontality of the sculpture can be
explained by its intended installation against an ivy-cov-
ered wall in the Bird Garden.[1]

A full-size plaster won the Architectural League of New
York's Medal of Honor in sculpture in 1921,[2] and the work
was widely exhibited in the early 1920s: for example, in
1921 and 1922 at the annual exhibitions of the Art Insti-
tute of Chicago, in 1923 at the National Sculpture Society,
and in 1924 at the annual exhibition of the Pennsylvania
Academy of the Fine Arts.[3] The Metropolitan Museum's
cast of *Philomela,* a reduction of 1922, was purchased from
the Grand Central Art Galleries on the recommendation of
Daniel Chester French (pp. 326–41), chairman of the Mu-
seum trustees' Committee on Sculpture.[4] Other bronze
reductions in public collections are in the Corcoran Gal-
lery of Art, Washington, D.C.; the Smithsonian American
Art Museum, Washington, D.C.; and the Yale University
Art Gallery, New Haven. A marble reduction of the same
size is at the New Britain Museum of American Art, New
Britain, Connecticut. A plaster cast (1920), 37¼ inches high,
is also in the Smithsonian American Art Museum, the gift
of the sculptor's widow in 1966. Gregory gave the National
Academy of Design an excerpted full-size marble head of
Philomela as his diploma presentation in 1934.[5]

The bronze figure with self-base is mounted on a
stepped Belgian black marble base, 2 inches high.

JMM

EXHIBITIONS

Sheldon Swope Art Gallery, Terre Haute, Ind., January 1948–
 September 1953.
MMA, Henry R. Luce Center for the Study of American Art,
 "Bronze Casting," June 11–November 3, 1991.
MMA, Henry R. Luce Center for the Study of American Art,
 "Subjects and Symbols in American Sculpture: Selections from
 the Permanent Collection," April 11–August 20, 2000.

1. For an illustration, see *Fauns and Fountains: American Garden Statu-
 ary, 1890–1930,* exh. cat. (Southampton, N.Y.: Parrish Art Museum,
 1985), fig. 16.
2. *Year Book of the Architectural League of New York and Catalogue of the
 Thirty-sixth Annual Exhibition* (New York, 1921), n.p., ill.
3. See *Catalogue of the Thirty-fourth Annual Exhibition of American
 Paintings and Sculpture* (Chicago: Art Institute of Chicago, 1921),
 no. 240; *Catalogue of the Thirty-fifth Annual Exhibition of American
 Paintings and Sculpture* (Chicago: Art Institute of Chicago, 1922),
 no. 268; National Sculpture Society, *Exhibition of American Sculpture
 Catalogue* (New York, 1923), p. 332; *Pennsylvania Academy of the
 Fine Arts . . . Catalogue of the 119th Annual Exhibition,* 2nd ed.
 (Philadelphia, 1924), p. 74, no. 543.
4. French to Henry W. Kent, Secretary, MMA, April 13, 1923,
 MMA Archives. Edward McCartan's *Diana* (cat. no. 292) and
 Harriet Frishmuth's *Slavonic Dancer* (cat. no. 293) were also in
 the "Initial Exhibition of the Works of Artist Members" of the
 Painters and Sculptors Gallery Association, on view at the Grand
 Central Art Galleries, and were purchased by the Metropolitan at
 the same time.
5. For the full-size plaster, see *Descriptive Catalogue of Painting and
 Sculpture in the National Museum of American Art, Washington, D.C.*
 (Boston: G. K. Hall, 1983), p. 83. For the marble head, see *An
 American Collection: Paintings and Sculpture from the National Acad-
 emy of Design,* exh. cat. (New York: National Academy of Design,
 1989), p. 146, ill. p. 147. See also *American Sculpture 1845–1925*
 (New York: Conner-Rosenkranz, 1999), pp. 38–39, 58.

Edward Francis McCartan (1879–1947)

McCartan, born in Albany, New York, attended Albany High School for two years before studying with Herbert Adams (pp. 360–64) for six months at Brooklyn's Pratt Institute. Between 1900 and 1903 he took classes at the Art Students League with George Grey Barnard (pp. 421–27), Hermon Atkins MacNeil (pp. 475–81), George de Forest Brush, and Kenyon Cox. McCartan worked as a studio assistant to, among others, Adams, MacNeil, Isidore Konti (pp. 408–11), and Karl Bitter (pp. 489–95), whom he assisted by enlarging models for the sculptural program of the 1901 Pan-American Exposition in Buffalo. McCartan received a commission for a statue of Benito Juárez for Monterrey, Mexico (1906), and the funds he earned enabled him to go to Paris. There he studied with Jean-Antoine Injalbert at the École des Beaux-Arts from 1907 to 1910. McCartan's Paris experience was vital to the evolution of his mature style; he regarded highly the eighteenth-century French sculpture that he saw on visits to the Louvre and Versailles, and he openly emulated such artists as Jean-Antoine Houdon and Claude-Michel Clodion. He also admired Auguste Rodin, though Rodin's influence shows little in McCartan's work except for a marble group of a woman and child, *The Kiss* (begun 1908; completed 1924).

In 1910 McCartan returned to New York and again assisted Adams and others before opening his own studio in 1913. In 1912 his *Fountain* (1912), a naiad and turtle, was awarded the Helen Foster Barnett Prize at the National Academy of Design. In 1916 his dancing nymph with a baby, *Spirit of the Woods* (ca. 1914), earned the George D. Widener Memorial Medal at the Pennsylvania Academy of the Fine Arts. McCartan's fountain *Pan* (ca. 1913), ordered for a Westchester County residence, was exhibited at the Panama-Pacific International Exposition, San Francisco, in 1915. Three years later *Pan* was selected by Daniel Chester French (pp. 326–41) for the Metropolitan Museum's long-term installation of American sculpture, and it was also issued in 15- and 30-inch reductions.

McCartan's superb command of classical rhythm, his refined line, and his use of ornamental details were ideally suited to the contemporary vogue for garden sculpture, and he made a specialty of this genre, focusing on mythological and woodland themes. He produced full-size versions in either marble or bronze as well as editions of bronze reductions. Among McCartan's finest efforts are *Girl Drinking from a Shell* (ca. 1915; Reading Public Museum, Reading, Pa.); *Dionysus (Boy and Panther Cub)* (1923; remodeled 1936; Brookgreen Gardens, Murrells Inlet, S.C.); and *Diana* (cat. no. 292), a favored mythological theme to which he returned several times.

Commissions for public sculpture followed. In 1922 McCartan's memorial for poet and journalist Eugene Field was dedicated in Chicago's Lincoln Park Zoo; it features bronze figures of a fairy (Field's "Rock-a-By Lady from Hush-a-By Street") and two sleeping children on a granite pedestal carved with relief images representing some of Field's poems. For the Hall of Fame for Great Americans at New York University (now on the campus of Bronx Community College), McCartan created a portrait bust of Washington Irving in 1927. He also was known for his decoration of public buildings, among which are his reclining stone figures— *Transportation* and *Industry*—supporting a clock on the north side of the New York Central Building (now the Helmsley Building) in Manhattan. He modeled six panels with figures and decorations symbolizing telecommunications for the New Jersey Bell Telephone Building in Newark (ca. 1928). Between 1934 and 1936 McCartan completed a pediment for the Interstate Commerce Commission building (Constitution Avenue between 12th and 14th Streets, Washington, D.C.).

In 1914 McCartan began as an instructor at the School of Beaux-Arts Architects in New York (later the Beaux-Arts Institute of Design), where he encouraged the study of architectural ornament. He continued teaching, including at the Art Students League (1926–29), and between 1943 and 1947 he was director of the Rinehart School of Sculpture in Baltimore. McCartan was named an academician of the National Academy of Design in 1925, later serving as its vice president from 1940 to 1942, and was elected to the American Academy of Arts and Letters in 1944.

JMM

SELECTED BIBLIOGRAPHY

McCartan, Edward, Papers. American Academy of Arts and Letters, New York.

Patterson, Augusta Owen. "Edward McCartan, Sculptor." *International Studio* 83 (January 1926), pp. 27–31.

Lockman, DeWitt McClellan. Interview with Edward McCartan, July 19, 1927. Transcript, Manuscripts Department, New-York Historical Society. Microfilmed for DeWitt McClellan Lockman Papers, Archives of American Art, Smithsonian Institution, Washington, D.C., reel 503, frames 826–68.

Cortissoz, Royal. "The Field of Art: The Sculpture of Edward McCartan." *Scribner's Magazine* 83 (February 1928), pp. 236–44.

Faulkner, Barry. "Edward McCartan 1878 [*sic*]–1947." In *Commemorative Tributes of the American Academy of Arts and Letters 1942–1951,* pp. 70–73. New York, 1951.

Proske, Beatrice Gilman. *Brookgreen Gardens Sculpture,* pp. 221–23. Rev. ed. Brookgreen Gardens, S.C.: Brookgreen Gardens, 1968.

Conner, Janis, and Joel Rosenkranz. *Rediscoveries in American Sculpture: Studio Works, 1893–1939,* pp. 113–22. Austin: University of Texas Press, 1989.

292. *Diana*, 1923

Bronze, gilt
23½ x 15¼ x 12¾ in. (59.7 x 38.7 x 32.4 cm)
Signed and dated (top of base): E. Mᶜ CARTAN 19 © 23
Foundry mark (side of base, below dog's hind paws): ROMAN BRONZE WORKS N_Y_
Cast number (under base): № 1
Rogers Fund, 1923 (23.106.1)

LIKE MANY other Beaux Arts trained sculptors before him (see cat. nos. 93, 130–31, 193, and 220), McCartan interpreted the theme of Diana, Roman goddess of the hunt and of the moon. His *Diana,* an elegant, supple figure restraining a leaping greyhound, captures the spirit of the ideal nude in French sculpture of the eighteenth and nineteenth centuries, notably in the graceful poses, linear contour, and accurate anatomical details. McCartan used ornamental gilding as accent on the crescent moon headpiece and fillet, on the bow in her left hand, and even on the dog's leash and collar. The soft modeling of the lithe young woman and the controlled energy with which the striding Diana reins in her sleek dog arguably make this sculpture McCartan's most successful and appealing composition.

A cast of *Diana* was included in the prominent exhibition of American sculpture organized by the National Sculpture Society in 1923, and two years later was awarded the medal of honor from the Concord Art Association, Concord, Massachusetts.[1] In 1923 the Metropolitan Museum purchased its bronze through Grand Central Art Galleries; according to the sculptor this was the first of three casts originally made.[2] In 1926 McCartan informed the Metropolitan that he was dissatisfied with the cast in its collection and that he had given the foundry, Roman Bronze Works, another plaster model, which produced a more satisfactory result. He requested that he be permitted to replace the Museum's cast with one from the second edition, but there is no evidence in Museum records that this occurred.[3]

McCartan produced numerous casts of this *Diana,* and indeed the casting history is complex. McCartan said in 1927 that he limited the edition to fifteen.[4] Other located casts are at Brookgreen Gardens, Murrells Inlet, South Carolina; Canajoharie Library and Art Gallery, Canajoharie, New York; Elvehjem Museum of Art, Madison, Wisconsin; and Indianapolis Museum of Art, Indianapolis, Indiana. In 1928 McCartan enlarged *Diana* to a 7-foot bronze version for a Greenwich, Connecticut, garden; the cast, by Roman Bronze Works, was sold at Sotheby's, New York, in May 2000.[5]

McCartan also treated the Diana theme on three other occasions. In 1924 he modeled a statuette of a standing

nude with a long bow in her left hand and, with her right, stroking the head of a fawn beside her (Brookgreen Gardens). By 1932 McCartan sculpted the lifesize marble *Garden Figure,* Diana with her dog seated at her feet amid reeds, for the poolside of a Ridgefield, Connecticut, estate, and in 1939 he modeled the small *Diana with Fawn* (New-York Historical Society).[6] JMM

EXHIBITIONS

American Academy of Arts and Letters and the National Institute of Arts and Letters, New York, "Exhibition of Sculpture by Paul Manship, Works by Newly Elected Members and Recipients of 'Arts and Letters Grants,'" May 19–June 29, 1945, no. 17.
Sculpture Center, New York, "Sculpture—The Tumultuous Quarter-Century," March 15–April 18, 1953, no. 58.
Corning Museum of Glass, Corning, N.Y., "The Deer Slayers," September 9–November 18, 1956.
MMA, Henry R. Luce Center for the Study of American Art, "Bronze Casting," June 11–November 3, 1991.
MMA, "The Human Figure in Transition, 1900–1945: American Sculpture from the Museum's Collection," April 15, 1997–March 29, 1998.
MMA, Henry R. Luce Center for the Study of American Art, "Subjects and Symbols in American Sculpture: Selections from the Permanent Collection," April 11–August 20, 2000.

1. National Sculpture Society, *Exhibition of American Sculpture Catalogue* (New York, 1923), p. 339, ill. p. 165; and Concord Art Center, *Annual Exhibition of Paintings and Sculpture* (Concord, Mass., 1925), p. 6, no. 43.
2. Recommended purchase form, April 16, 1923, MMA Archives; and McCartan to Edward Robinson, Director, MMA, March 8, 1926, MMA Archives.
3. McCartan to Robinson, March 8, 1926, and Robinson to McCartan, March 9, 1926 (copy), MMA Archives. Robinson's response to McCartan requested that the figure from the second edition be delivered to the Museum for comparison; no such delivery appears in the records, nor is there evidence that the matter was pursued.
4. Lockman interview, July 19, 1927, p. 37, Archives of American Art, microfilm reel 503, frame 864; and Conner and Rosenkranz 1989, p. 122, n. 17. There is a privately owned cast marked no. 14; Cameron Shay, James Graham and Sons, telephone conversation with Thayer Tolles, May 3, 2000.
5. Sotheby's, New York, sale cat., May 24, 2000, no. 111.
6. Proske 1968, p. 223; and Conner and Rosenkranz 1989, pp. 117–18, 120. The Brookgreen standing Diana with fawn is illustrated in *Brookgreen Gardens: Sculpture by Edward McCartan* (Brookgreen Gardens, S.C., 1937), n.p.; *Garden Figure* is reproduced as *Diana* in "Garden Sculpture," *Art Digest* 6 (April 15, 1932), p. 13.

Harriet Whitney Frishmuth (1880–1980)

At a young age, Frishmuth and her mother and sisters moved to Europe from her native Philadelphia. She was educated in Paris and Dresden and spent summers in Switzerland. In Paris in 1899 Frishmuth enrolled for three months in the Académie Rodin, in a modeling class for women that Auguste Rodin visited for critiques. Six months later she entered the Académie Colarossi to train with Jean-Antoine Injalbert and Henri-Desiré Gauquié. After exhibiting at the Salon of 1903, she went to Berlin for two years to study with Cuno von Uechtritz-Steinkirch and assisted him on several monumental commissions.

Frishmuth returned to New York and studied at the Art Students League with Hermon Atkins MacNeil (pp. 475–81) and Gutzon Borglum (pp. 496–500). She then became an assistant to Karl Bitter (pp. 489–95) and studied anatomy at the College of Physicians and Surgeons of Columbia University. About 1908 she set up her own studio in her uncle's Park Avenue home. Frishmuth's sculpture at this time consisted primarily of portraits, including her first commission, a portrait relief of Dr. Abraham Jacobi for the New York County Medical Society. Her small functional objects, such as bookends and paperweights, were cast by the Gorham Company and were commercially successful. In 1912 her works were shown at Gorham Galleries in a group exhibition of women sculptors. In 1913 Frishmuth purchased a converted stable in Sniffen Court, a mews in New York's Murray Hill district, for a home and studio where she worked until 1937. She received an honorable mention for *Saki: A Sun Dial* and *Young Girl with Fish: A Fountain* (both 1913) at the San Francisco Panama-Pacific International Exposition in 1915.

Frishmuth's lyrical sculptures, often incorporating water motifs, were known for their sensuous figures and lively poses. Many were inspired by the Yugoslavian-born dancer Desha Delteil, whom she met in 1916, and others in the Fokine Ballet troupe. Frishmuth would ask them to dance to musical accompaniment until they achieved a pose that she wanted to sketch. *Extase* (1920; Wadsworth Atheneum, Hartford, Conn.), among the first of the sculptures she modeled after Delteil, features a nude female on tiptoe and with upraised arms, a pose that would be frequently repeated in her work. *The Vine* (see cat. no. 294) was one of her first sculptures to gain popular attention as a small bronze. By the 1920s Frishmuth had produced other successful bronzes of exuberant nudes; *Joy of the Waters,* a spry female reacting to the splash of cold water on her feet, was modeled lifesize in 1917 (Dayton Art Institute, Dayton, Ohio) and revised in 1920 in a 45-inch size; an example of

the latter served as her diploma piece when she was elected to full membership in the National Academy of Design in 1929. Frishmuth was awarded the Elizabeth N. Watrous Gold Medal at the National Academy's winter exhibition of 1922 for *Fantaisie* (1922; Fine Arts Museums of San Francisco), which depicts the dancers Delteil and Léon Barté intertwined in the guise of nymph and satyr. Her works were further popularized by their availability through the Gorham Galleries and the inclusion of nine sculptures in Gorham's *Famous Small Bronzes* (1928), an illustrated catalogue of sculptures available by mail order or from Gorham's New York gallery. In 1928 Frishmuth was accorded her first solo show, at Grand Central Art Galleries in New York.

Frishmuth also received public commissions, including the fountain *Scherzo* (1921) for Foshay Tower, the first tall building in Minneapolis, Minnesota. She created portrait busts, such as her marble head of Woodrow Wilson (1924), located in the Virginia State Capitol, Richmond. Later in her career the tone of her work became quieter in such sculptures as *Daydreams* (1936; Forest Lawn Museum, Glendale, Calif.) and *Reflections* (1930), which she exhibited at the New York World's Fair in 1939.

In her later years Frishmuth ceased producing new images, but she still cast, exhibited, and promoted her sculpture, and she was noted for her meticulous attention to the casting process. Although she used other foundries, the Gorham Company, Providence, Rhode Island, remained Frishmuth's principal foundry until she closed the editions of her sculptures in the late 1960s. In 1937 she had moved from New York to the Philadelphia area, and after 1967 she lived in Connecticut. JMM

SELECTED BIBLIOGRAPHY

Frishmuth, Harriet Whitney, Papers. George Arents Research Library for Special Collections, Syracuse University, Syracuse, N.Y.

Smith, Marion Couthouy. "The Art of Harriet Frishmuth." *American Magazine of Art* 16 (September 1925), pp. 474–79.

[Talcott, Ruth, ed.]. "Harriet Whitney Frishmuth, American Sculptor." *The Courier* (Syracuse University Library Associates) 9 (October 1971), pp. 21–35. Reprinted, with modifications, in Ruth Talcott, ed., "Harriet Whitney Frishmuth, 1880–1980." *National Sculpture Review* 29 (Summer 1980), pp. 22–25.

Aronson, Charles N. *Sculptured Hyacinths.* New York: Vantage Press, 1973.

Proske, Beatrice Gilman. "Harriet Whitney Frishmuth, Lyric Sculptor." *Aristos: The Journal of Esthetics* 2 (June 1984), pp. 1, 4–5.

Conner, Janis, and Joel Rosenkranz. *Rediscoveries in American Sculpture: Studio Works, 1893–1939,* pp. 35–42. Austin: University of Texas Press, 1989.

293. *Slavonic Dancer*, 1921

Bronze
13¼ x 6½ x 3½ in. (33.7 x 16.5 x 8.9 cm)
Signed and dated (top of base, below heel): HARRIET W. FRISHMUTH © 1921
Foundry mark (back of base): ROMAN BRONZE WORKS N–Y–
Rogers Fund, 1923 (23.106.3)

FOR *SLAVONIC DANCER* Frishmuth used as her model Leon Barté, a member of the Fokine Ballet who had danced with Anna Pavlova and Desha Delteil. Frishmuth modeled the work after completing *The Dancers* (1921), a sculptural group that also featured Barté, as well as Delteil. According to Ruth Talcott, Frishmuth's companion-secretary, the pose was suggested by Barté himself and was taken from choreography he was studying.[1] The figure displays fluid surfaces and an active silhouette, with contrasts of curving and angular forms. *Slavonic Dancer* recalls Rodin's advice to Frishmuth when she was a pupil: "First, always look at the silhouette of a subject and be guided by it; second, remember that movement is the transition from one attitude to another."[2]

Slavonic Dancer was exhibited at, among other venues, the National Academy of Design and the Art Institute of Chicago in 1922 and the Pennsylvania Academy of the Fine Arts in 1923.[3] According to Frishmuth, there were eight or ten bronze casts made.[4] The ones in public collections include those at the Corcoran Gallery of Art, Washington, D.C.; Hermitage Foundation Museum, Norfolk, Virginia; and Wadsworth Atheneum, Hartford, Connecticut. The Metropolitan's cast, purchased from Grand Central Art Galleries, was recommended for purchase by Daniel Chester French (pp. 326–41), chairman of the Museum trustees' Committee on Sculpture, after he saw it on view at an exhibition of members of the Painters and Sculptors Gallery Association.[5]

The bronze is mounted on a Belgian black marble base, ⅞ inch high. JMM

EXHIBITIONS

Vincent Astor Gallery, Library and Museum of the Performing Arts of the New York Public Library at Lincoln Center, New York, "Dance in Sculpture," February 1–April 29, 1971.
Philadelphia Art Alliance, "Dance in Sculpture," November 4–29, 1971.
Berry-Hill Galleries, New York, "The Woman Sculptor: Malvina Hoffman and Her Contemporaries," October 24–December 8, 1984, no. 13.
MMA, "The Human Figure in Transition, 1900–1945: American Sculpture from the Museum's Collection," April 15, 1997–March 29, 1998.

1. For Talcott's recollections, see Aronson 1973, pp. 123–24. This amends Albert TenEyck Gardner, *American Sculpture* (New York: MMA, 1965), p. 140, which states that the figure was posed for by "presumably the dancer Merio of the dance team of Merio and Desha."
2. Talcott 1971, p. 22.
3. *Catalogue, National Academy of Design, 97th Annual Exhibition* (New York, 1922), p. 16, no. 184; *Catalogue of the Thirty-fifth Annual Exhibition of Paintings and Sculpture* (Chicago: Art Institute of Chicago, 1922), no. 265; and *Pennsylvania Academy of the Fine Arts . . . Catalogue of the 118th Annual Exhibition,* 2nd ed. (Philadelphia, 1923), p. 65, no. 479.
4. Notes of a telephone conversation with Frishmuth, February 1933, object catalogue cards, MMA Department of Modern Art.
5. French to Henry W. Kent, Secretary, MMA, April 13, 1923; recommended purchase form, authorized by the trustees' Committee on Purchases, April 16, 1923, MMA Archives. See also *Grand Central Art Galleries, Initial Exhibition of the Works of Artist Members* (New York, 1923), no. 169, as "Slavonic Dance."

294. *The Vine,* 1921; revised 1923

Bronze
83½ x 49⅝ x 28½ in. (212.1 x 126.1 x 72.4 cm)
Signed and dated (front of base, left side): HARRIET. W. FRISHMUTH 1923 / ©
Foundry mark (left side of base): GORHAM CO. / FOUNDERS.
Rogers Fund, 1927 (27.66)

THE VINE depicts an exultant female nude, posed on tiptoe, whose upraised arms suspend the grapevine that gives the sculpture its title. The fluid modeling of the surfaces allows the body to be shown in an elegant unbroken arc. Bunches of grapes lie at the figure's feet. Frishmuth later recalled that "*The Vine* was first conceived as a study for my sculpture class at Sniffen Court in New York. The model at the time—it was not Desha, it was René [*sic*] Wilde—took a number of poses and when the class and I saw a pose we liked especially well, we had the model hold the pose for the ladies to sketch and then to work in the plastilene on the armatures we had constructed. As the work progressed, I decided to put the model up on her toes, changing the pose for the piece I would do. And I had her bend back a little and I had her hold a rope to simulate a vine."[1] Renée Wilde, a member of the Fokine Ballet, recalled of the experience: "One morning, a friend, dancing in the same ballet called me and said she was ill. She asked me to do her a favor and go to the studio of Harriet Frishmuth, where she was scheduled to pose for a class of students. As I had never posed before, I did not know that the pose had to be held for 25 minutes. I took the pose, later to be known as the Vine simply because it was a position I often took in my dancing. As I held it, I kept bending further and further back."[2]

This first version of *The Vine,* a 12½-inch figure standing on a mound of earth, was so popular that 350 casts were made before Frishmuth discontinued reproduction.[3] In 1923 she enlarged the sculpture to overlifesize for the National Sculpture Society's exhibition at the Hispanic Society of America; later that year, at the National Academy of Design's winter annual, *The Vine* was awarded the Julia A. Shaw Memorial Prize.[4] This time, Frishmuth's model was Desha Delteil, and according to the sculptor, the work was cast in an edition of five.[5] By late 1926 Daniel Chester French was making plans to put *The Vine* before the Metropolitan Museum trustees' Committee on Purchases, but the process was delayed since the bronze was on display in the Philadelphia Sesqui-Centennial International Exposition and was therefore not available for inspection by the trustees.[6] French wrote to Frishmuth, "If the Committee thinks as favorably as I do of this beautiful statue, it will go through unanimously and instantly."

To Edward D. Adams, a fellow member of the Committee on Sculpture, French wrote, "I consider it one of the best pieces of sculpture done in recent years in America."[7] In February 1927 the Museum acquired its cast from the artist through the Grand Central Art Galleries. Frishmuth wrote soon thereafter to Museum secretary Henry W. Kent of her "keen appreciation of the great honor conferred on one of my works."[8] A version was installed in the gardens of a private home in Riverside, Connecticut.[9] Other known casts of the 7-foot version are at the Cincinnati Art Museum; Frank H. McClung Museum, University of Tennessee, Knoxville; and University of California at Los Angeles.

JMM

EXHIBITION

World's Fair, New York, April 8, 1964–October 28, 1965.

1. Aronson 1973, p. 45. This amends the information in Albert TenEyck Gardner, *American Sculpture* (New York: MMA, 1965), p. 140, that the sculpture represents "a nude bacchante" and was "reported to have been inspired by [Delteil's] dance 'Modernistic Tango.'"
2. Wilde to Mr. Howell [John K. Howat, Curator, MMA Department of American Paintings and Sculpture], March 2, 1981, MMA Archives.
3. Talcott 1971, p. 26.
4. National Sculpture Society, *Exhibition of American Sculpture Catalogue* (New York, 1923), p. 331, ill. p. 75; and *National Academy of Design . . . Winter Exhibition* (New York, 1923), p. 17, no. 292.
5. Talcott 1971, p. 26; and notes of a telephone conversation with Frishmuth, January 6, 1933, in which she provided the information that the Museum owned the fourth example of an edition of five, the original plaster then having been destroyed, recorded on object catalogue cards, MMA Department of Modern Art.
6. See *Paintings, Sculpture and Prints in the Department of Fine Arts, Sesqui-Centennial International Exposition* (Philadelphia, 1926), p. 84; and French to Frishmuth, February 1, 1927 (copy), Daniel Chester French Family Papers, Manuscript Division, Library of Congress, Washington, D.C., microfilm reel 9, frame 563.
7. French to Frishmuth, February 1, 1927, and French to Adams, February 16, 1927 (copies), French Family Papers, Library of Congress, microfilm reel 9, frames 563, 584.
8. Recommended purchase form, February 18, 1927; purchase authorized February 21, 1927; and Frishmuth to Kent, March 3, 1927, MMA Archives.
9. For the version in Riverside, Conn., then owned by Mrs. Valeria Langeloth, see Smith 1925, p. 474, and "Gardens on the Estate of Mrs. J. Langeloth at Riverside, Conn.," *Country Life* 54 (October 1928), p. 66.

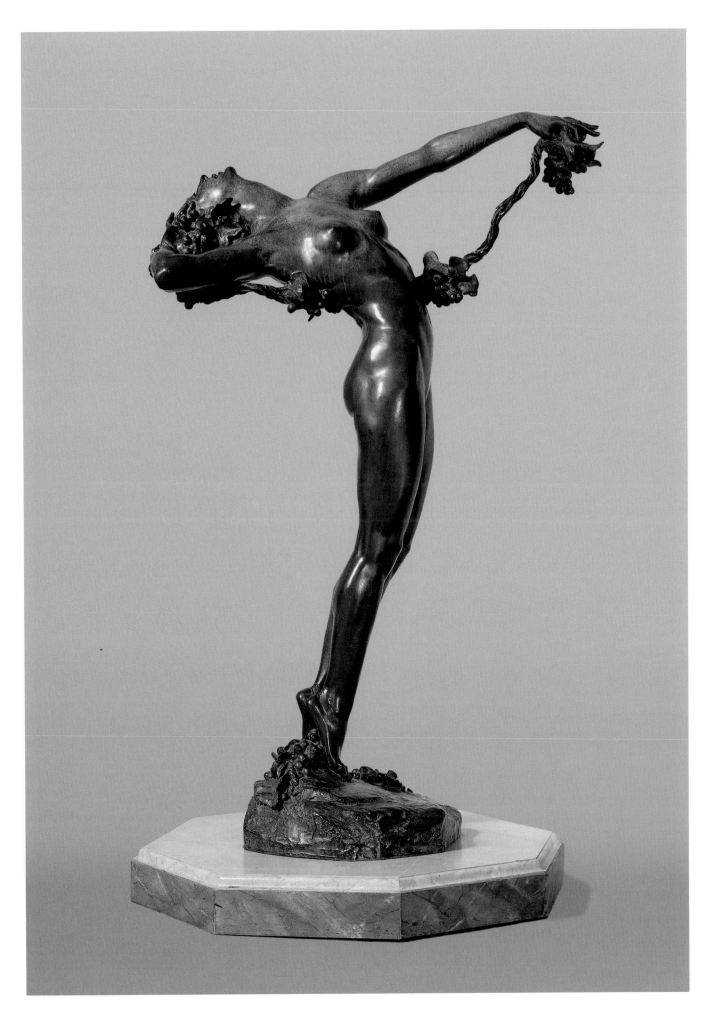

Margaret O'Laughlin Hoard (1880–1944)

Hoard painted as a child in Washington, Iowa, until an injury to her hand made it impossible to continue. As a young woman, she came to New York to study art at the Teachers College, Columbia University (1907–8). She later attended modeling classes taught by James Earle Fraser (pp. 596–99) and Robert Ingersoll Aitken (pp. 625–26) at the Art Students League, where she was awarded the Saint-Gaudens Prize. Hoard exhibited *Study of an Old Lady* in the Armory Show of 1913, and in 1915 she received an honorable mention for the two works, *Eve* (cat. no. 295) and *The Old Woman* (unlocated), shown in San Francisco at the Panama-Pacific International Exposition.

Hoard's sculptural oeuvre is small and now unlocated; her major period of activity was during the 1910s. Her ideal works have impressionistic surfaces and often appear unfinished in the manner of Rodin or her close friend George Grey Barnard (pp. 421–27), but her realistically rendered portraits suggest the influence of her teacher Aitken. Hoard was a member of the National Association of Women Artists and the Union International des Beaux-Arts et des Lettres. During the 1910s she consistently exhibited her sculptures at the National Academy of Design, the Pennsylvania Academy of the Fine Arts, and the Art Institute of Chicago.

A woman of remarkably diverse interests, Hoard played active political and philanthropic roles in her Mount Vernon, New York, community and was involved in relief efforts during World War I. She served on the New York City Board of Education as superintendent of its Public Lecture Bureau for four years in the late 1920s. Hoard also designed wallpaper and was an authority on the history of glassmaking.

JMM

SELECTED BIBLIOGRAPHY

Coughlan, Florence. "Metropolitan Museum Displays Work of Mrs. Prescott Hoard." *Mount Vernon (N.Y.) Argus,* July 30, 1936.
Obituary. *New York Times,* October 31, 1944, p. 19.
Gardner, Albert TenEyck. *American Sculpture,* pp. 137–38. New York: MMA, 1965.
Petteys, Chris. *Dictionary of Women Artists: An International Dictionary of Women Artists Born before 1900,* p. 340. Boston: G. K. Hall, 1985.

295. *Eve,* 1914

Marble
14 x 23½ x 15½ in. (35.6 x 59.7 x 39.4 cm)
Signed and dated (top of base): Margaret Hoard / 1914
Gift of Theodore Stanfield, 1919 (19.34)

THIS REMORSEFUL Eve is crouched in an attitude of despair over an overturned vessel, possibly symbolizing the lamp of life, and suggesting her fall from God's favor. Her long hair completely covers her face, alluding to her shame. The figure is smoothly modeled in marked contrast to the rough base that retains marks of the chisel.

The Museum's marble, a unique work that was carved over a nine-month period,[1] was displayed in the winter 1914 exhibition of the National Academy of Design, in the Panama-Pacific International Exposition in San Francisco in 1915, and in the Art Institute of Chicago annual in 1916.[2] *Eve* was included in the 1918 "Exhibition of American Sculpture," organized by Daniel Chester French (pp. 326–41) at the Metropolitan Museum. It was lent to the exhibition

by New Yorker Theodore Stanfield, who retired as general manager and treasurer of the American Metal Company in 1917. He gave *Eve* to the Museum in early 1919.[3]

JMM

EXHIBITION

MMA, Henry R. Luce Center for the Study of American Art, "Subjects and Symbols in American Sculpture: Selections from the Permanent Collection," April 11–August 20, 2000.

1. Hoard also said that she modeled the work the same year it was carved; notes of a telephone conversation, February 3, 1933, recorded on object catalogue cards, MMA Department of Modern Art.

2. See *Illustrated Catalogue, National Academy of Design Winter Exhibition 1914* (New York, 1914), p. 17, no. 95; *Official Catalogue of the Department of Fine Arts, Panama-Pacific International Exposition* (San Francisco: Wahlgreen Co., 1915), p. 237, no. 3137; and *Catalogue of the Twenty-ninth Annual Exhibition of American Oil Paintings and Sculpture* (Chicago: Art Institute of Chicago, 1916), p. 66, no. 607.

3. See *An Exhibition of American Sculpture* (New York: MMA, 1918), p. 10, no. 36; French to Stanfield (also spelled Sternfeld and Sternfield), April 5, 1918, and January 27, January 29, and February 19, 1919 (all copies), Daniel Chester French Family Papers, Manuscript Division, Library of Congress, Washington, D.C., microfilm reel 4, frame 538; reel 5, frames 117, 121, 146; and Theodore Stanfield obituary, *New York Times,* July 6, 1938, p. 23.

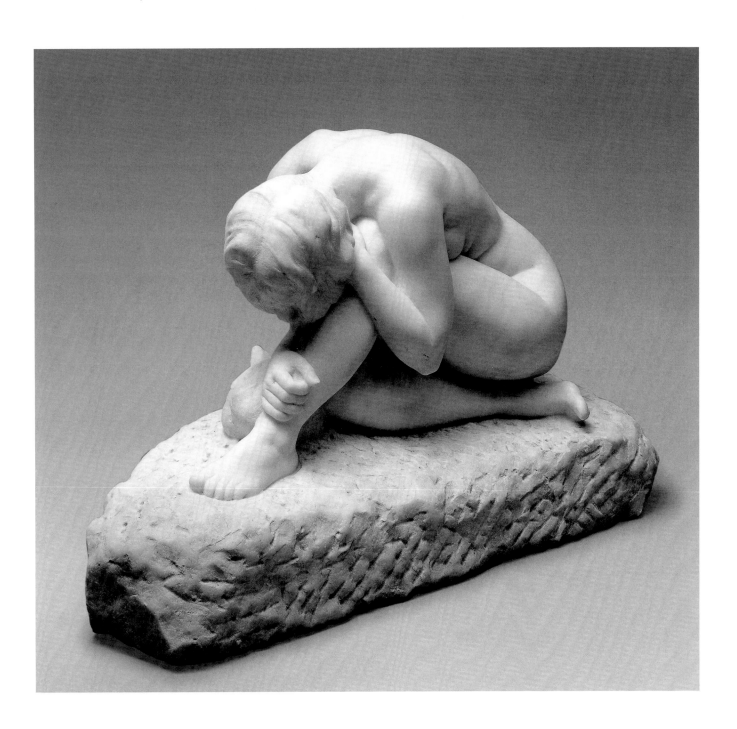

Grace Hill Turnbull (1880–1976)

After studying at the Maryland Institute of Art in her native city of Baltimore, Turnbull trained in painting first with Joseph De Camp at the Art Students League in New York and briefly in 1909 with Thomas Anshutz at the Pennsylvania Academy of the Fine Arts in Philadelphia. Turnbull subsequently studied in Paris, showing her work in the annual exhibitions of the Société Nationale des Beaux-Arts and at the International Art Union, where she was awarded the Whitelaw Reid Prize for Painting in 1914. During World War I she worked as a Red Cross volunteer in France.

Turnbull's paintings—oils and pastels—ranged in subject from landscapes to still lifes to portraits. She exhibited some sculpture in her frequent participation in the annual exhibitions of the Art Institute of Chicago (plaster *Portrait Bust,* 1912) and the Pennsylvania Academy (*The Mother,* 1913), but in the late 1920s she began to devote herself primarily to sculpture, although continuing to paint. She was essentially self-taught as a sculptor, although she had studied modeling briefly with Moses Ezekiel in Rome and with Ephraim Keyser at the Maryland Institute. Through the 1940s she focused mainly on the direct carving of animal sculptures in wood and stone, such as *Rabbit* (1939; Worcester Art Museum, Worcester, Mass.); *The Bath* (1944; Baltimore Museum of Art), a cat licking its paw; *Sleeping Calf* (1944; Corcoran Gallery of Art, Washington, D.C.); and *Gracious Countenance* (1945; Community College of Baltimore), a hippopotamus head. In her later works she combined abstract and figurative motifs. Several of her sculptures are on public view in Baltimore: *The Naiad,* a bronze nude cast in 1933, was installed in the East Garden of Mount Vernon Place in 1962, near the Washington Monument; the marble memorial to poet Lizette Woodworth Reese (1939), which depicts a shepherd surrounded by a flock of sheep, was presented by Turnbull to Eastern High School and is now at Lake Clifton Senior High School; and the green marble *King Penguin* (1956), presented to the city by Penguin Books, is now at the Baltimore Police Station on Light Street.

Turnbull exhibited her paintings and sculpture widely, including at the Maryland Institute, the National Association of Women Artists, and the National Sculpture Society. For the 1939 World's Fair exhibit, "American Art Today," she contributed a seated figure in stone. During her career Turnbull was accorded a number of solo exhibitions that included both paintings and sculpture, among which were those at the Baltimore Museum of Art (1930; 1946; 1974); Delphic Studios, New York (1931; 1936); the Corcoran Gallery of Art (1949); and Baltimore Junior College Art Gallery (1966). Turnbull received the Anna Hyatt Huntington Prize for Sculpture from the National Association of Women Artists in 1932 for *Torso* and in 1944 for *Lemur Inset for Garden Wall.* Other awards include a Fifth Purchase Prize in the "Artists for Victory" exhibition at the Metropolitan Museum in 1942 for *Python of India* (cat. no. 296). Known as a writer as well as a painter and sculptor, Turnbull published such compilations as *Tongues of Fire* (1929), extracts from religious scriptures; *The Essence of Plotinus* (1934), a translation of writings of that third-century Neoplatonic philosopher; and *Fruit of the Vine* (1950), a gathering of historical writings describing the dangers of alcohol.

Turnbull bequeathed many of her paintings and sculptures to the Maryland Historical Society, Baltimore. Her studio-home, for which she carved furniture, exterior ornament, and totemic columns depicting religious scenes (1941), is now administered by the Maryland Historical Society.

JMM

SELECTED BIBLIOGRAPHY

Turnbull, Grace. Interview with Virginia Pitcher, 1971. Oral History Collection, Maryland Historical Society, Baltimore.

Turnbull, Grace H. *Chips from My Chisel: An Autobiography.* Rindge, N.H.: Richard R. Smith, 1953.

Adler, Betty. "Artist and Scholar." *Gardens, Houses and People* 35 (November 1959), pp. 22–23.

"Grace Turnbull." *Baltimore Museum of Art Record* 5 (September 1974), n.p.

Rubinstein, Charlotte Streifer. *American Women Sculptors: A History of Women Working in Three Dimensions,* pp. 292–93. Boston: G. K. Hall, 1990.

296. *Python of India*, 1941

Marble, glass
8 x 23 x 20¾ in. (20.3 x 58.4 x 52.7 cm)
Signed and dated (lower edge): G H TURNBULL / 1941
Rogers Fund, 1942 (42.179)

I N H E R autobiography, *Chips from My Chisel,* Turnbull wrote of her fascination with the python and the resulting sculpture: "I don't know just how I happened to fall in love with the coils of a python, that great boa-constrictor native in India, that attains a length of thirty feet or so . . . I made several trips to the Washington zoo where [there] were several handsome specimens." After a guard prodded one with a stick, "It posed perfectly for the next fifteen minutes, permitting me to sketch the needed details and, when I got back to my studio, to finish the sculpture."[1] Turnbull made a 3-inch clay model of the python before direct-carving the full-size work in Westfield green marble and inserting amber glass eyes "as accent and touch of color for the head." She destroyed the clay once she had completed carving the stone, which is unique.[2] The planar surface of the tightly coiled python consists of both pitted and smooth areas, while the veining of the marble is employed to great compositional effect.

Python of India was displayed at the Baltimore Museum of Art in 1942; later that year it was included in the "Artists for Victory" exhibition at the Metropolitan Museum of Art, from which it entered the Museum's collection,

one of thirteen contemporary American sculptures purchased (see also cat. nos. 360, 361).[3] At the time of the exhibition Turnbull informed the Museum that she preferred *Python of India* to be installed on a base about 3 feet high rather than at floor level, "the intention being to emphasize the flat though watchful head peering out *over* the great coils."[4] J M M

EXHIBITION

Baltimore Museum of Art, "Paintings and Sculpture by Grace Turnbull," September 17–November 17, 1974.

1. Turnbull 1953, p. 250.
2. Artist's information form, completed by Turnbull, June 2, 1943, MMA Archives; and Turnbull 1953, p. 251.
3. *Tenth Annual Exhibition of Maryland Artists* (Baltimore: Baltimore Museum of Art, 1942), no. 135; *Artists for Victory: An Exhibition of Contemporary American Art* (New York: MMA, 1942), p. 32; and recommended purchase form, noting that on December 21, 1942, the trustees' Committee on Purchases authorized the purchase of thirteen sculptures from the "Artists for Victory" exhibition, MMA Archives.
4. Turnbull to Francis Henry Taylor, Director, MMA, December 24, [1942], MMA Archives. She repeated her request for a taller base on the artist's information form, June 2, 1943, MMA Archives.

Chester Beach (1881–1956)

Beach studied architectural modeling at the Lick Polytechnic School and modeling at the California School of Mechanical Arts (1899) in his native San Francisco. He later took drawing classes at the Mark Hopkins Institute of Art (1900–1902), while also working as a silver designer for Shreve and Company. From 1903 to 1906 he was in Paris, attending the Académie Julian, where he studied with Charles Raoul Verlet and François Laurent Rolard and was awarded a gold medal in 1905. He exhibited plasters at the annual Salons of the Société des Artistes Français in 1905 and 1907, showing, respectively, a portrait bust and a statue, *Young Nymph.*

On Beach's return to the United States in 1907, he opened a studio in New York's Macdougal Alley. He became known for his realistic small bronze figures of laborers, such as *The Stoker* (1907; Brooklyn Museum of Art), which call to mind similar compositions by Abastenia St. Leger Eberle (pp. 627–29) and Mahonri Young (pp. 620–24). In 1909 Beach showed *Young Nymph* at the winter annual of the National Academy of Design, winning the Helen Foster Barnett Prize. Beginning in 1911 the sculptor spent time in Rome, where he carved *Dawn* (1912; Cleveland Museum of Art), a male nude on horseback nearly engulfed by a cloud-like mass that is evolving into suggestions of sensuous female figures. His compositions became increasingly complex, and his small figure groups in marble, reminiscent of the impressionistic effects of Auguste Rodin, gained him much recognition for their symbolist content and fluid undulating surfaces. In 1913 his *Unfolding of Life,* a male figure removing a billowing cloak from a female nude, was in the annual at the National Academy of Design, and *Unveiling of Dawn* (cat. no. 297) was exhibited at the 1913 Armory Show in New York, along with three additional submissions. Between 1912 and 1917, Beach had six solo exhibitions, including ones in New York at the Macbeth Gallery (1912 and 1914) and the Pratt Institute (1913). In 1915 the sculptor showed *Beyond* (1911–12; Fine Arts Museums of San Francisco), an adolescent female nude, and three large groups *Primitive, Medieval, and Modern Progress* for the Court of Abundance at the Panama-Pacific International Exposition, San Francisco, earning a silver medal. In 1926, at the annual exhibition of the National Academy of Design, Beach won the Elizabeth N. Watrous Gold Medal for sculpture for *Rising Sea Mists.*

In addition to his allegorical works, Beach had steady commissions for portraits and monuments as well as for fountain and garden groups. Bronze busts of Peter Cooper (1924), Asa Gray (1925), Eli Whitney (1926), Samuel F. B. Morse (1928), and Walt Whitman (1931) are at the Hall of Fame for Great Americans on the University Heights campus of New York University (now Bronx Community College). For the Barnard College Gymnasium in New York, he modeled the statue *Torch Race, Barnard Greek Games* (1927), a running, tunic-clad female. His marble *Fountain of the Waters* (1928) is on the terrace of the Fine Arts Garden of the Cleveland Museum of Art, and for the 1939 World's Fair in New York, Beach created the fountain *Riders of the Elements.*

Beach was also an accomplished medalist and produced designs for United States coinage, modeling the Monroe Doctrine Centennial (1923), Lexington-Concord Sesquicentennial (1925), Hawaiian (1928), and Hudson Sesquicentennial (1935) commemorative half-dollars. His "War and Peace" medal (1937) for the sixteenth issue of the Society of Medalists earned him the Lindsey Memorial Prize of the National Sculpture Society in 1938, and he was awarded the prestigious J. Sanford Saltus Medal from the American Numismatic Society in 1946. He was elected to the National Sculpture Society in 1908, serving as its president from 1927 to 1928. Beach was also elected to the National Institute of Arts and Letters in 1918 and became an academician of the National Academy of Design in 1924.

JMM

SELECTED BIBLIOGRAPHY

Beach, Chester, Papers. Archives of American Art, Smithsonian Institution, Washington, D.C., microfilm reels N68-11, N727–N729.

du Bois, Guy Pène. "The Art of Chester Beach." In *Marbles and Bronzes by Chester Beach.* Exh. cat. New York: Macbeth Gallery, 1912.

Rehn, Frank K. M., Jr. "Chester Beach: A Sculptor Who Works in Stone." *Metropolitan Magazine* 39 (December 1913), pp. 34–35.

"Subtle Studies of Human Emotions Shown in the Sculpture of Chester Beach." *The Craftsman* 30 (July 1916), pp. 350–55.

Porter, Beata Beach. "Chester Beach." *National Sculpture Review* 14 (Fall 1965), pp. 20, 24–25.

Proske, Beatrice Gilman. *Brookgreen Gardens Sculpture,* pp. 200–203. Rev. ed. Brookgreen Gardens, S.C.: Brookgreen Gardens, 1968.

Fort, Ilene Susan, et al. *The Figure in American Sculpture: A Question of Modernity,* p. 178. Exh. cat. Los Angeles: Los Angeles County Museum of Art, 1995.

297. *Unveiling of Dawn*, 1913

Marble
26 x 10 x 9 in. (66 x 25.4 x 22.9 cm)
Signed (left side of base): C BEACH
Gift of Mr. and Mrs. George W. Davison, 1943 (43.20)

THIS SCULPTURE strongly suggests the symbolist-inspired marbles of Auguste Rodin. Like the French master's two-figure composition *Le Poète et la sirène* (1909; Musée National Auguste Rodin, Paris) or his many allegorical studies, the two figures of *Unveiling of Dawn* remain integral to the marble block from which they were carved. In Beach's oeuvre, *Unveiling of Dawn* falls among the small marble sculptures in which he gave natural forces an anthropomorphic guise; this series was begun in Paris with *The River's Return to the Sea* (1906; private collection) and would be continued later in such works as *Surf* (1921–22; Newark Museum, Newark, N.J.).

Unveiling of Dawn, an in-the-round composition, depicts a nude male figure lifting a cloudlike mass to reveal a nubile young woman with upraised arms. When the marble was exhibited at the Gorham Company galleries in 1913, it was described as "impressionistic in treatment" and interpreted as showing "the soul of man and woman struggling upward with the earth mists to the liberty and light of a fuller day. . . . [T]he modelling is purposely undefined . . . the whole effect being one of suggestion demanding imagination on the spectator's part to evolve it."[1] Beach intended that the sculpture be lit with a spotlight on the back to create a dramatic effect: "Marble is cut very thin back of head of figure[.] If lit from behind forms a transparent light around the head."[2]

Beach exhibited *Unveiling of Dawn* widely: at the Armory Show in New York in 1913; the National Academy winter exhibition in 1914–15; the Pennsylvania Academy of the Fine Arts in 1915; the Art Institute of Chicago in 1915–16; and the Cincinnati Art Museum in 1916.[3] The work was given to the Metropolitan Museum in 1943 by Mr. and Mrs. George W. Davison, whose patronage of Beach included a portrait bust of Mr. Davison, at the time president of the board of the Central Hanover Bank and Trust Company.[4]

JMM

EXHIBITIONS

Sheldon Swope Art Gallery, Terre Haute, Ind., January–July 1948.
Munson-Williams-Proctor Institute, Utica, N.Y., February 17–March 31, 1963; Armory of the Sixty-ninth Regiment, New York, April 6–28, 1963, "1913 Armory Show: Fiftieth Anniversary Exhibition," no. 654.
Detroit Institute of Arts, "Arts and Crafts in Detroit 1906–1976: The Movement, the Society, the School," November 26, 1976–January 16, 1977, no. 66.
Nassau County Museum of Fine Art, Roslyn Harbor, N.Y., "The Shock of Modernism in America: The Eight and Artists of the Armory Show," April 29–June 29, 1984.
MMA, "The Human Figure in Transition, 1900–1945: American Sculpture from the Museum's Collection," April 15, 1997–March 29, 1998.
MMA, Henry R. Luce Center for the Study of American Art, "Subjects and Symbols in American Sculpture: Selections from the Permanent Collection," April 11–August 20, 2000.

1. "Beach Seen in Imaginative Sculpture," *New York American,* May 26, 1913, p. 6.
2. Information provided by Beach on an undated artist's information form (sent to him January 25, 1943), which he completed after *Unveiling of Dawn* was acquired by the Metropolitan, MMA Archives. Beach also identified the marble as from Carrara and the work as a unique carving.
3. *Catalogue of International Exhibition of Modern Art* (New York: Association of American Painters and Sculptors, 1913), p. 47, no. 654; *Illustrated Catalogue, National Academy of Design Winter Exhibition 1914* (New York, 1914), p. 10, no. 6; *Pennsylvania Academy of the Fine Arts . . . Catalogue of the 110th Annual Exhibition,* 2nd ed. (Philadelphia, 1915), p. 64, no. 612; *Catalogue of the Twenty-eighth Annual Exhibition of American Oil Paintings and Sculpture* (Chicago: Art Institute of Chicago, 1915), no. 375; and Cincinnati Art Museum, *Twenty-third Annual Exhibition of American Art* (Cincinnati, 1916), p. 19, no. 174. There were twenty-four pieces by Beach shown in Cincinnati.
4. For the gift, see George W. Davison to Francis H. Taylor, Director, MMA, January 8, 1943, MMA Archives; for the portrait of Davison, see undated artist's information form (as in note 2), MMA Archives.

650 CHESTER BEACH

Alexander Finta (1881–1959)

Finta, born in Túrkeve, Hungary, was schooled in Nagyvárad and Kassa, in the latter city earning a diploma in mechanical engineering at the state technical school. He traveled extensively and then studied art in Budapest, in Florence with Adolf Hildebrand, and in Paris with Auguste Rodin. After serving Hungary in World War I, Finta created war memorials in stone for numerous cities, among them a 30-foot marble in Nitra, now in Slovakia, that depicts Christ lifting the body of a fallen soldier. By the time he emigrated to Brazil in 1919 to escape political turbulence, Finta had a national reputation as a sculptor in Hungary and left behind a sizable oeuvre of portraits, memorials, and other, small works. In Rio de Janeiro he produced numerous monuments, including a 12-foot granite statue, *Strength,* for the park of the Fluminenci Club and *Christ* for the cathedral of Rio de Janeiro. In nearby Petrópolis he executed a stucco triptych for the Sacre Coeur church and twelve caryatids for that city's cathedral; the success of these ecclesiastical works generated commissions for portraits.

To escape an outbreak of yellow fever, Finta settled in the United States in 1923, becoming a citizen in 1930. In New York he studied at Columbia University and in 1932 founded the First Presbyterian Art School, serving as its director and completing for the church bronze memorials to Dr. George Alexander and Dr. William C. Carl. Finta contributed portraits and ideal sculptures to major annuals, including those of the National Academy of Design (1927–30) and the Pennsylvania Academy of the Fine Arts (1929–31). In 1930 he displayed seven works—among them *American Flower* and *Morning*—in a vast exhibition of contemporary American sculpture at the Brooklyn Museum; he also was represented by a selection of medals in ivory and bronze. At this time Finta garnered several commissions for relief memorials, such as those to Walt Whitman, Washington Irving, and Robert Fulton. During the 1930s the sculptor participated in the Federal Arts Project of the Works Progress Administration.

Finta relocated to Los Angeles about 1939 and in the mid-1940s was employed with his wife by Twentieth Century-Fox to make decorations for the film *The Hunchback of Notre Dame.* He was a member of the Painters and Sculptors Club of Southern California, serving for a time as its vice president and consistently displaying sculptures with the group through 1950. Throughout his career Finta's Hungarian heritage earned him numerous commissions, including a statue for Saint Stephen of Hungary Church in New York of its patron saint; a bust of the Hungarian poet Sándor Petőfi for the Cleveland Public Library; and a commemorative medal for the Hungarian Reformed Federation of America. His bronze bas-relief portrait of nineteenth-century Hungarian patriot Louis Kossuth was dedicated in 1949 and installed at Wood Street at Third Avenue in Pittsburgh, Pennsylvania. A bronze bust of Kossuth, from 1954, is in Exposition Park in Los Angeles.

In addition to his work as a sculptor, Finta was a book illustrator, poet, and author of articles, short stories, novels, and books, including *Herdboy of Hungary: The True Story of Mocskos* (in collaboration with Jeanette Eaton; 1933). The Finta Múzeum in the sculptor's native Túrkeve has a selection of his work. JMM

SELECTED BIBLIOGRAPHY

McGlauflin, Alice Coe, ed. *Who's Who in American Art,* vol. 1, 1936–37, p. 146. Washington, D.C.: American Federation of Arts, 1935.

Lengyel, Alfonz. *The Life and Art of Alexander Finta, Hungarian-American Sculptor.* Washington, D.C.: Hungarian Reformed Federation of America, 1964.

Falk, Peter Hastings, ed. *Who Was Who in American Art, 1564–1975: 400 Years of Artists in America,* vol. 1, p. 1123. Madison, Conn.: Sound View Press, 1999.

298. *Patrick Cardinal Hayes*, 1927

Marble
27½ x 23½ x 14½ in. (69.9 x 59.7 x 36.8 cm)
Signed and dated (front, right side): FINTA / 1927
Gift of Victor J. Dowling and Alexander Konta, 1927 (27.153)

PATRICK JOSEPH HAYES (1867–1938) was born in New York to Irish immigrants. He was educated at Manhattan College (A.B., 1888) and Saint Joseph's Provincial Seminary, Troy, New York. After ordination to the priesthood in 1892, he studied at the Catholic University, Washington, D.C., for two years. Appointed archbishop of New York in 1919 and a cardinal in 1924, he was an effective and influential administrator of a large episcopate. During World War I, he served as a military ordinary overseeing

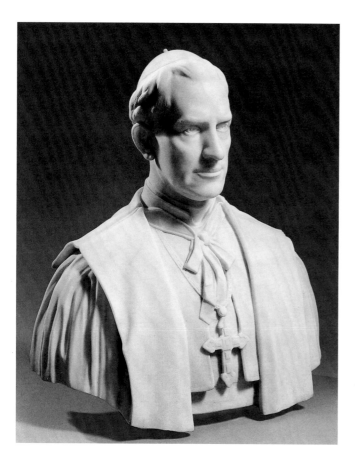

Catholics in the American armed forces, and in 1920 he organized the Catholic Charities of the Archdiocese of New York, one of the country's principal agencies of Catholic social services.[1]

This chest-length marble bust, a unique example, was displayed in the annual exhibition of the National Academy of Design in 1927.[2] At the time of the show, New York Supreme Court Judge Victor J. Dowling wrote to Metropolitan Museum president Robert W. de Forest that he and Alexander Konta, a broker, had commissioned the portrait of "the first native born New Yorker to become a Cardinal in the Roman Catholic Church and the first, as well, to become Archbishop of this See," and they offered it to the Museum.[3]

Although Daniel Chester French (pp. 326–41), chairman of the trustees' Committee on Sculpture, felt that the portrait was artistically "ordinary," it entered the Metropolitan's collection.[4] Because of the Museum's policy of not exhibiting portraits of living subjects, the bust of Cardinal Hayes was placed on view in the Room of Recent Accessions in November 1927 and then removed from the galleries until the cardinal's death in 1938.[5]

JMM

1. *American National Biography,* s.v. "Hayes, Patrick Joseph."
2. Notes of a telephone conversation between Finta and Preston Remington, Curator of Renaissance and Modern Art, MMA, September 13, 1938, object catalogue cards, MMA Department of Modern Art; and *Catalogue, National Academy of Design, One Hundred and Second Annual Exhibition* (New York, 1927), p. 28, no. 550, as "Portrait of His Eminence Cardinal Hayes."
3. Dowling to de Forest, March 22, 1927, MMA Archives.
4. French to de Forest, April 5, 1927 (copy), Daniel Chester French Family Papers, Manuscript Division, Library of Congress, Washington, D.C., microfilm reel 9, frame 642.
5. P[reston] R[emington], "Notes: Two Portrait Busts," *MMA Bulletin* 22 (November 1927), pp. 281–82.

Arthur Lee (1881–1961)

Lee and his family came to the United States in 1888 from Trondheim, Norway, and settled in Saint Paul, Minnesota. In 1902 he enrolled at the Art Students League in New York, where he studied with Kenyon Cox. During a European sojourn, beginning in 1905, Lee visited England, Italy, and France; he attended the École des Beaux-Arts in Paris for three years. His mastery of the classicizing nude partial figure, for which he came to be widely respected, was influenced by his examination of works from antiquity at the British Museum in London (including the Elgin marbles), the Louvre in Paris, and in Italy. Lee was able to extend his stay in Paris due to the patronage of Gertrude Vanderbilt Whitney (pp. 592–95), who provided him with a monthly stipend beginning in 1907. There he met artists such as Constantin Brancusi, Pablo Picasso, and Max Weber (pp. 655–56) and was impressed by the modernist aesthetics discussed in the salon of Gertrude Stein.

Lee returned to New York in 1910. He exhibited drawings and four figurative sculptures at the Armory Show in 1913, including, in bronze, *Ethiopian* (1912; Whitney Museum of American Art, New York), *Heracles,* and *Aphrodite* (1912), and in plaster, *Virgin.* Lee is now considered one of the most conservative American sculptors to have participated in that landmark show of European and American modernism. He returned to Paris for three years in 1914, and while abroad he modeled the graceful female torso *Volupté* (cat. no. 299). Two of his sculptures were included in the 1915 Panama-Pacific International Exposition in San Francisco, where he received an honorable mention. Lee had a solo exhibition at Wildenstein in New York in April 1921. He consistently displayed his work during the 1920s and 1930s at such traditional venues as the National Academy of Design, to which he was named an associate academician in 1929, and the Pennsylvania Academy of the Fine Arts, where he won the George D. Widener Memorial Medal in 1924 for *Volupté.* Lee taught sculpture at the Art Students League in 1930–32 and 1938–43, in addition to founding his own drawing school in 1938. He exhibited his bronze *Great Fortune* in "American Art Today" at the 1939 World's Fair in New York, but his sculptural output diminished in the 1940s and 1950s, and he instead pursued his interest in drawing. JMM

SELECTED BIBLIOGRAPHY

Slusser, Jean Paul. "A Note on Arthur Lee." *International Studio* 79 (June 1924), pp. 171–76.

Wescott, Glenway. "Picasso, Matisse, Brancusi, and Arthur Lee: An American Novelist Passes an Afternoon in a Sculptor's Studio in New York." *Vanity Fair* 24 (June 1925), pp. 56, 86.

"Arthur Lee, an American Sculptor in the Classical Tradition." *Vanity Fair* 25 (September 1925), p. 58.

Fort, Ilene Susan, et al. *The Figure in American Sculpture: A Question of Modernity,* p. 210. Exh. cat. Los Angeles: Los Angeles County Museum of Art, 1995.

299. *Volupté,* 1915

Marble
38½ x 14 x 11 in. (97.8 x 35.6 x 27.9 cm)
Inscribed, signed, and dated (right side of base): TO R L C / ARTHUR LEE / PARIS 1915
Inscribed (front and right side of base): VOLVPTÉ
Anonymous Gift, 1924 (24.239)

THIS SENSUOUS female torso suggests Lee's indebtedness to fragments of classical statuary that he saw during his travels in Europe. The nude, particularly idealized representations of the female form, was a frequent subject in Lee's early career and remained his strongest interest. Art historian William H. Gerdts observed of *Volupté* and of other works by Lee that his "belief in ideal beauty is manifest, but it is successfully wedded to a sense of actual humanity and of idiosyncratic form. Lee often deliberately 'fragmented' his work, not only to reinforce a classical sense of timeless loveliness but also for the sake of balancing and enhancing the remaining parts of the body."[1] This torso is one of his finest examples and features graceful contours and a delicate, refined surface. Lee described its

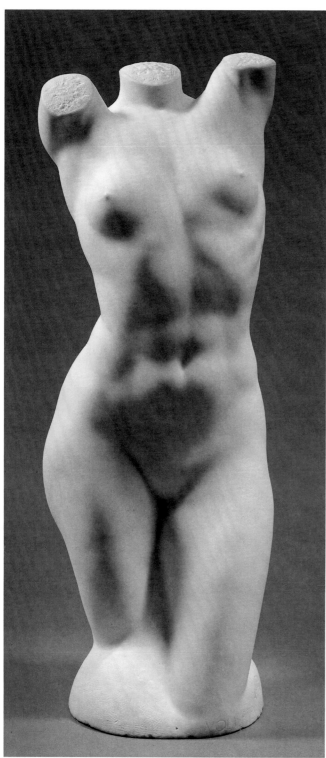

299

finish as a "golden stain" achieved by treatment of the marble with "the boiled juice of Java tobacco leaves and then crude linseed oil over that."[2]

Lee exhibited versions of *Volupté* frequently in the early 1920s, including in his solo show at Wildenstein in 1921, the National Sculpture Society in 1923, and the Pennsylvania Academy of the Fine Arts in 1924, when it was awarded the George D. Widener Memorial Medal for the best sculpture by an American citizen.[3] The marble, which Lee also referred to as *Volupté, torse parisienne,* was given to the Metropolitan Museum by two anonymous donors in December of that year.[4] Other marble versions are at the Yale University Art Gallery, New Haven (ca. 1915), and the Museum of Modern Art, New York. A bronze of the same size is at the Brooklyn Museum of Art. Lee also produced reductions in marble and in plaster.

The inscription on the Metropolitan's marble refers to Rawlins Lowndes Cottenet, whom Lee met while a student at the Art Students League and who assisted him during his first Parisian tenure.[5] JMM

EXHIBITIONS

Art Institute of Chicago, "Half a Century of American Art," November 16, 1939–January 7, 1940, no. 208.
Old Westbury Gardens, Westbury, N.Y., "150 Years of American Sculpture," June 14–August 28, 1960, no. 47.
Los Angeles County Museum of Art, February 26–April 30, 1995; Montgomery Museum of Fine Arts, June 22–September 10, 1995; Wichita Art Museum, October 22, 1995–January 7, 1996; National Academy of Design, New York, February 15–May 5, 1996, "The Figure in American Sculpture: A Question of Modernity."

1. William H. Gerdts, *The Great American Nude: A History in Art* (New York: Praeger, 1974), p. 182.
2. Lee to Joseph Breck, Assistant Director, MMA, December 16, 1924, MMA Archives. See also Wescott 1925, p. 56, where Lee mentions that "he tried to get the tone of church candle wax."
3. "Arthur Lee's Sculpture," *New York Times,* April 24, 1921, sec. 3, p. 14; National Sculpture Society, *Exhibition of American Sculpture Catalogue* (New York, 1923), p. 337, as "Torso Parisienne," p. 141; and *Pennsylvania Academy of the Fine Arts . . . Catalogue of the 119th Annual Exhibition,* 2nd ed. (Philadelphia, 1924), p. 81, no. 611, as "Voluptuousness."
4. Offer of gift form, December 15, 1924; photograph permission form completed by Lee, [1925], MMA Archives.
5. Roger Mason, interview with the artist, *Brooklyn Eagle,* January 18, 1935, p. 11; also B. H. Friedman, with the research collaboration of Flora Miller Irving, *Gertrude Vanderbilt Whitney: A Biography* (Garden City, N.Y.: Doubleday, 1978), esp. p. 244. On Cottenet, who became a landscape designer and an official at the Metropolitan Opera, see *National Cyclopaedia of American Biography,* vol. 34 (New York: James T. White and Co., 1954), pp. 583–84.

Max Weber (1881–1961)

One of the most avant-garde American artists of the early twentieth century, Weber was born to Orthodox Jewish parents in Belostock, Russia (now Białystok, Poland). In 1891 Weber immigrated to the United States with his family. They settled in Brooklyn, where he attended Pratt Institute from 1898 to 1900. Among Weber's most influential instructors was Arthur Wesley Dow. Theories of composition explained by Dow were to be important to the development of Weber's personal style.

In 1905 Weber went to Paris, where he studied at the Académies Julian, de la Grande Chaumière, and Colarossi, but more significantly he learned firsthand about French modernism and became friends with artists such as Henri Rousseau and Robert Delaunay. In 1907 Weber exhibited at the Salon d'Automne and the following year established with Henri Matisse a progressive art class, with Matisse as the instructor. Visits to see African and Oceanic works, particularly tribal sculpture, at the Musée d'Ethnographie du Trocadéro (now Musée de l'Homme) and other collections were Weber's essential supplements to his art classes with Matisse. Before returning to the United States, Weber traveled through Spain, Italy, and Holland.

After Weber returned to New York in early 1909, his paintings and drawings began to register his assimilation of the French modernists, particularly their interest in using primitivism. Pablo Picasso and Georges Braque's proto-Cubist nudes in landscape settings had a particular impact on Weber's art beginning in 1909. For Alfred Stieglitz's vanguard journal *Camera Work,* Weber contributed several articles, including in 1910 one of the first written discussions of the fourth dimension and its relationship to art: "The Fourth Dimension from a Plastic Point of View." Stieglitz also organized a solo exhibition of Weber's work in 1911 at his gallery "291."

Weber continued to produce paintings and drawings related to Cubism and primitivism. He also created sculptures between 1910 and 1915, a period of great stylistic experimentation for him. Although the importance of his growing collection of African and Precolumbian sculpture must be acknowledged as an inspiration for his own three-dimensional art, these visual sources were combined in his work with the dynamism of Futurist and Cubist pieces that he knew. Weber's nonobjective sculptures, particularly his *Spiral Rhythm* (1915; this cast, 1958–59, Hirshhorn Museum and Sculpture Garden, Washington, D.C.) and *Air-Light-Shadow* (1915; Museum of Modern Art, New York), are considered major American modernist innovations.

In Weber's writings on art, especially his *Essays on Art,* published in 1916, he expressed admiration for *Concerning the Spiritual in Art* by the Russian abstract painter Wassily Kandinsky. Like other American artists, such as Georgia O'Keeffe, Weber was attracted to Kandinsky's ideas about content and emotional valences that were possible by using color and form without recognizable subject matter. Between 1914 and 1918, Weber explored the rhythms and intensity of the modern city in such paintings as *Chinese Restaurant* (1915; Whitney Museum of American Art, New York) and *Rush Hour, New York* (1915; National Gallery of Art, Washington, D.C.). He published two volumes of poetry, *Cubist Poetry* in 1914 and *Primitives: Poems and Woodcuts* in 1926, and contributed to various leftist publications, including *Revolt* and *The Masses.*

After World War I Weber's art changed dramatically to narrative themes related to his Jewish heritage. In subsequent decades, his painting became introspective, exploring genre subjects in a more realistic style. With a renewed interest in the human figure in the 1940s and 1950s, Weber made a few additional sculptures. During this time many of his early plasters were enlarged; they were subsequently cast in bronze and exhibited at the Newark Museum in New Jersey in 1959 (he had also had a solo show there in 1913). Among Weber's many lifetime solo exhibitions were those held in Paris at the Galerie Bernheim-Jeune in 1924, at the Baltimore Museum of Art in 1942, and in New York at the Museum of Modern Art in 1930, the Whitney Museum of American Art in 1949, and the Jewish Museum in 1956.

JMM

SELECTED BIBLIOGRAPHY

Weber, Max, Papers. Originals belonging to Weber's family. Microfilmed by the Archives of American Art, Smithsonian Institution, Washington, D.C., reels NY 59-6–NY 59-8, NY 69-82–NY 69-88, NY 69-112.

Weber, Max, Papers, 1904–48. Compiled by the Whitney Museum of American Art, New York. Microfilmed for the Archives of American Art, Smithsonian Institution, Washington, D.C., reels NY 59-8–NY 59-10.

Weber, Max. *Essays on Art.* New York: W. E. Rudge, 1916. Reprint, New York and Santa Fe: Gerald Peters Gallery, 2000.

Barr, Alfred H. *Max Weber Retrospective Exhibition, 1907–1930.* New York: Museum of Modern Art, 1930.

Goodrich, Lloyd. *Max Weber: Retrospective Exhibition.* New York: Whitney Museum of American Art, 1949.

Werner, Alfred. *Max Weber.* New York: Harry N. Abrams, 1975.

Rubenstein, Daryl R. *Max Weber: A Catalogue Raisonné of His Graphic Work.* Chicago: University of Chicago Press, 1980.

North, Percy. *Max Weber: American Modern.* Exh. cat. New York: Jewish Museum, 1982.

North, Percy. *Max Weber: The Cubist Decade, 1910–1920.* Exh. cat. Atlanta, Ga.: High Museum of Art, 1991.

Weber, Max. Exh. cat. Essay by Percy North. Santa Fe and New York: Gerald Peters Gallery, 2000.

300. *Figure in Rotation,* 1917; enlarged 1947–48

Bronze, painted, ca. 1947–48
24½ x 7 x 7½ in. (62.2 x 17.8 x 19.1 cm)
Signed and numbered (back of base, bottom edge):
/3 *Max Weber*
Gift of Carl D. Lobell, 1994 (1994.341.5)

WEBER MODELED *Figure in Rotation* in 1917, after he had produced other three-dimensional works in plaster, such as *Spiral Rhythm, Air-Light-Shadow,* and *Bird,* all in 1915. This bronze of a nude woman is similar in its stocky and distorted proportions to some of the female figures in his paintings after 1910.

The head of *Figure in Rotation* is turned beyond the normal axial position in relation to the shoulders. Weber combined profile and frontal views of the same nude, similar to the way Pablo Picasso presented some of his figures. The enlarged eyes and elongated nose are analogous to Picasso's stylized heads of 1907–8.

Although these sculptures by Weber were originally created in plaster, after 1940 they were cast in bronze, usually on a larger scale. *Figure in Rotation,* enlarged from an earlier 8-inch tinted and polychromed plaster (1917; Weber Estate), was cast about 1947 or 1948 in an edition of three. Overall the sculpture has a warm, golden brown patina, and there are touches of blue paint around the eyes and black paint in the hair. Other bronzes with the same measurements include one at the Whitney Museum of American Art, acquired in 1980 (also with color applied to the eyes and a brown patina overall), and one privately owned.[1] A posthumous bronze of the same size, cast in 1980, is in full polychrome.[2]

The enlarged polychromed plaster of about 1947–48 is in the Weber Estate.

JMM

EXHIBITION

MMA, "The Human Figure in Transition, 1900–1945: American Sculpture from the Museum's Collection," April 15, 1997–March 29, 1998.
MMA, "Max Weber from the Collection," March 9–June 13, 1999.

1. For the version at the Whitney Museum, see *Painting and Sculpture Acquisitions 1973–1986* (New York: Whitney Museum of American Art, 1986), p. 161; and for the example in the collection of Mr. and Mrs. George C. Berman, New Rochelle, N.Y., see Werner 1975, fig. 58.
2. *Max Weber, Cubist Vision: Early and Late,* exh. cat. (New York: Forum Gallery, 1986), p. 11.

Josef Mario Korbel (1882–1954)

Mario Korbel came to the United States from Osik, Bohemia (now the Czech Republic), at the age of eighteen to pursue his interest in sculpture. He had previous training in decorative sculpture, but his strict Moravian upbringing had prohibited study of the nude. After a short stay in New York in 1900, he moved to Chicago, where for several years he worked at Kunst and Pfaffke, a firm that produced ornamental interior moldings. In 1905 Korbel returned to Europe, at first studying sculpture in Berlin. He continued his training at the Royal Academy of Fine Arts in Munich from 1906 to 1909 and at the Académie Julian in Paris in 1909. Back in Chicago he secured commissions for portraits and garden groups for numerous midwestern clients. For Racine, Wisconsin, he produced a monument to Karel Jonas in 1912. Korbel exhibited many of these works at the annual exhibitions of the Art Institute of Chicago, where in the 1910 Chicago artists exhibition he won the Mrs. John C. Shaffer Prize for a group of six portrait heads.

In 1913 Korbel relocated to New York City. His work was first seen in New York in 1913 in a joint show with the Chicago painter Walter Dean Goldbeck at the Henry Reinhardt Galleries; they had a second exhibition together in 1915. Korbel's inaugural solo show was at the Gorham Galleries in 1917, with fifty-seven works in marble, bronze, and plaster, including portraits, figurative statuettes, and garden groups. His primary form of expression was the nude, and the model for many of his female subjects was Hilda Beyer, a dancer with Ruth St. Denis's company, whom Korbel first saw performing in Chicago in 1912 and married in 1917. Korbel often combined classical serenity and surface refinement with impressionistic effects and graceful contours. His attention to surface texture and variations in patination was particularly striking in his statuettes of female nudes, such as *Vanity and Modesty* (ca. 1916; Cleveland Museum of Art) and *Nocturne* (1920; Cranbrook Art Museum, Bloomfield Hills, Mich.).

In 1918 Korbel spent ten months in Havana, seeking support for Bohemia in its struggle for independence. While there, he made a portrait of the president of Cuba, Mario G. Menocal, and the monumental *Alma Mater,* a seated draped female figure, for the University of Havana. During the 1920s Korbel's most significant patron was George G. Booth, owner of the *Detroit News* and founder of the Cranbrook educational complex in Bloomfield Hills, Michigan. For Booth's gardens and the grounds of Cranbrook Korbel produced the ideal female figures *Dawn* (1924), *Music* (1925), and *Atalanta* (1927). In 1924 Korbel began spending summers in Paris, completing a marble bust of Saint Thérèse, which was given to the Vatican the following year by his Long Island patrons Mr. and Mrs. Nicholas F. Brady (he also completed several other versions of this portrait). In 1925 Korbel returned to Cuba, modeling a second portrait of Menocal, as well as a fountain for his garden. In 1927 a sketch for Korbel's group *The Kiss,* a pair of embracing male and female nudes, was displayed in Paris and resulted in the artist's election to the Legion of Honor. Korbel completed a full-size marble group for the Noroton, Connecticut, estate of his patron William Ziegler, and in 1944, when he was named a full member of the National Academy of Design, gave that institution a 12-inch bronze reduction.

In 1929, the New York gallery of Jacques Seligmann and Company mounted a comprehensive exhibition of Korbel's work, including many portrait commissions. Korbel continued to exhibit frequently until his 1933 show at Wildenstein. However, the Great Depression and changing tastes in art brought about a decline in the demand for his sculpture, and after the mid-1930s his work consisted mainly of occasional portrait commissions. JMM

SELECTED BIBLIOGRAPHY

Genthe, Arnold. "The Work of Mario Korbel and Walter D. Goldbeck." *International Studio* 57 (November 1915), pp. XIX–XXIII.

Patterson, Augusta Owen. "Mario Korbel and His Sculpture." *International Studio* 84 (July 1926), pp. 51–55.

Proske, Beatrice Gilman. *Brookgreen Gardens Sculpture,* pp. 231–34. Rev. ed. Brookgreen Gardens, S.C.: Brookgreen Gardens, 1968.

Conner, Janis, and Joel Rosenkranz. *Rediscoveries in American Sculpture: Studio Works, 1893–1939,* pp. 95–104. Austin: University of Texas Press, 1989.

301. *Andante (Dancing Girls)*, 1917

Bronze, 1926
43 x 53 x 10 in. (109.2 x 134.6 x 25.4 cm)
Signed and dated (top of base, center): MARIO KORBEL / 19 © 26
Foundry mark (top of base, right side): ROMAN BRONZE WORKS N–Y–
Cast number (top of base, center): № 2
Rogers Fund, and by exchange, 1928 (28.119)

ONE OF Korbel's best-known sculptures, this composition has been called both *Andante* and *Dancing Girls*.[1] In 1917 Korbel reworked an allegorical group, *Architecture and Sculpture* (ca. 1916), which depicts two dancing nudes holding products of their arts—one, a model of a building, and the other, a statuette.[2] For *Andante,* Korbel removed the attributes and added stylized draperies to unify and balance the composition of two dancers on tiptoe facing one another and touching with the fingers of their right hands. *Andante* is one of a series of dancing figures by Korbel, its title referring to the moderate pace of the figures' rhythmic movement. Whereas the drapery falling in deep and precise folds from the nudes' bent left arms gives the composition a formality that suggests the artist's indebtedness to early classical Greek sculpture, the smooth surfaces and idealized bodies of the two young women parallel the simplified nudes of Aristide Maillol.

Andante was included in Korbel's one-artist exhibition at the Gorham Galleries in 1917, lent by Mrs. H. T. Johnson. He recalled in 1933 that he had cast *Andante* in an edition of seven 29½-inch bronzes in 1917,[3] one of which was purchased by the Metropolitan Museum the following year while Korbel was working in Cuba. In 1926 he enlarged *Andante* to 43 inches and made at least two casts, which he considered more successful than the 29½-inch composition. At his suggestion, Korbel exchanged the smaller bronze in the Museum's collection with the second cast of the larger version.[4] The Museum presumably returned the earlier bronze to the artist. A bronze cast of 29½ inches is in the Cleveland Museum of Art, and a reduction of 12¼ inches, dated 1926, is in the Cranbrook Art Museum, Bloomfield Hills, Michigan.[5]

JMM

EXHIBITIONS

Sheldon Swope Art Gallery, Terre Haute, Ind., January 1948–April 1960.
Detroit Institute of Arts, "Arts and Crafts in Detroit 1906–1976: The Movement, the Society, the School," November 26, 1976–January 16, 1977, no. 85.

1. Korbel listed both titles on the photograph reproduction permission form he completed, [1918], MMA Archives. The group inspired a poem by Katharine Stanley-Brown, published in *Art in America* 11 (August 1923), p. 228. See Katherine Solender, *The American Way in Sculpture 1890–1930*, exh. cat. (Cleveland: Cleveland Museum of Art, in cooperation with Indiana University Press, 1986), p. 36.
2. Conner and Rosenkranz 1989, p. 96. *Architecture and Sculpture* was illustrated in *Lotus Magazine* 8 (December 1916), p. 105. In 1916 this group was included in an exhibition of American sculpture at the Gorham Galleries, as well as in the Art Institute of Chicago annual (no. 702) as "Dancer group, Architecture and Sculpture."
3. Notes of a telephone conversation with Korbel, January 30, 1933, object catalogue cards, MMA Department of Modern Art. The foundry records of Roman Bronze Works list two groups of "2 females dancing," on April 3 and May 1. See Roman Bronze Works Archives, Amon Carter Museum, Fort Worth, ledger 5, p. 305.
4. According to a note on the recommended purchase form of May 14, 1918, "At the meeting of the Comm. on Purchases held May 21, 1928, it was voted to accept the offer of the sculptor to exchange this group for a copy of the same in larger size and different patina. No advance in price," MMA Archives. Korbel mentioned in the January 20, 1933, telephone interview (as in note 3) that the first cast of the larger size was owned by Mrs. Florence Hewitt.
5. See Solender, *The American Way in Sculpture 1890–1930*, pp. 36–37, and Conner and Rosenkranz 1989, p. 104, n. 8.

Gaston Lachaise (1882–1935)

Born in Paris, Lachaise first learned to carve in the shop of his father, Jean Lachaise, a master cabinetmaker and wood-carver. When he was thirteen, Gaston Lachaise enrolled at the École Bernard Palissy, then one of France's foremost applied-arts schools, to train in drawing, modeling, and carving with Jean-Paul Aubé and Alphonse Emmanuel de Moncel. His instruction at the École des Beaux-Arts began in 1898, and he studied drawing with Gabriel Jules Thomas. In Parisian galleries and museums, Lachaise also discovered "primitive," Asian, and preclassical art. The young artist submitted works to the annual Salons of the Société des Artistes Français between 1899 and 1904. By 1903 Lachaise met Isabel Dutaud Nagle, a married Canadian-American woman, ten years his senior. After compulsory military service he worked as a craftsman for the jeweler and glassmaker René Lalique in 1904 and 1905 in order to save money to follow Nagle to Boston.

Lachaise immigrated to Boston in 1906, never to return to France. He became an assistant to the sculptor Henry Hudson Kitson and carved details for Kitson's Civil War memorials. In Boston Lachaise embarked on his lifelong exploration of the female figure, his inspiration always Isabel Dutaud Nagle—clothed, nude, standing, sitting, reclining, floating; full figures, heads, torsos, fragments; in clay, plaster, bronze, marble, and cement. Kitson relocated his studio to New York City in 1909, and in 1912 Lachaise moved there too. From 1913 to 1921 Lachaise worked as an assistant to Paul Manship (pp. 745–69; see cat. no. 380), while also creating his own sculpture in his Greenwich Village studio. He exhibited a small plaster, *Nude with Coat* (1912; bronze at Lachaise Foundation, Boston), in the Armory Show of 1913 but received no attention from critics.

Lachaise became an American citizen in 1916, and the following year he married Isabel Dutaud Nagle. He held his first solo exhibition of sculpture and drawings in New York at the Stephan Bourgeois Galleries in 1918. Among the works shown was a plaster version of the sculpture that would become his most famous: *Standing Woman (Elevation;* see cat. no. 307). In his interpretation of the female form, eroticism remained essential to Lachaise's sculptural vision; his figures featured exaggerated body parts, unorthodox poses, and foreshortened limbs.

From 1920 to 1922 Lachaise served on the board of directors of the Society of Independent Artists. He had other solo exhibitions in subsequent years, including another at the Bourgeois Galleries (1920); the Kraushaar Galleries (1922, 1924); Alfred Stieglitz's Intimate Gallery (1927), and the Brummer Gallery (1928).

During the 1920s Lachaise's work was frequently discussed and illustrated in *The Dial,* an influential publication devoted to literature and the arts. Scofield Thayer, the magazine's editor from 1920 to 1926, included works by Lachaise in his exceptional collection of early modern art; on his death in 1982 he bequeathed the collection to the Metropolitan Museum (see, in particular, cat. nos. 307, 313). *Dial* staff and contributors commissioned several portraits from Lachaise. Known for his ability to combine physical attributes with a psychological interpretation of his subject, Lachaise modeled likenesses including those of Marianne Moore (cat. no. 315), Alfred Stieglitz (1925–27; Lachaise Foundation), Georgia O'Keeffe (cat. no. 320), John Marin (1928–30; Phillips Collection, Washington, D.C.), and Carl Van Vechten (1931; Art Institute of Chicago).

Lachaise received commissions for architectural decoration in New York, including in 1921 a frieze for the American Telephone and Telegraph Building; in 1931 four limestone reliefs for the RCA (now General Electric) Building, Rockefeller Center; and in 1934 two limestone panels for the International Building, also in Rockefeller Center. For the Century of Progress Exposition, Chicago World's Fair, in 1932, Lachaise produced a plaster relief, and in 1935 he was commissioned to create *Welcoming the Peoples* for Fairmount Park, Philadelphia. In 1935, only months before his death, a major retrospective of Lachaise's sculpture opened at the Museum of Modern Art; he was the second living artist so accorded (Maurice Sterne [pp. 632–33] was the first). In subsequent years solo exhibitions of his works were organized, including those at the Whitney Museum of American Art (1937) and the Brooklyn Museum (1938). The Lachaise Foundation was founded in 1963 by John B. Pierce, Jr., great-nephew of Isabel Lachaise.

JMM

SELECTED BIBLIOGRAPHY

Lachaise, Gaston, and Isabel Nagle Papers. Originals at the Lachaise Foundation, Boston. Microfilmed by the Archives of American Art, Smithsonian Institution, Washington, D.C., reels 325–27, 1034.

Lachaise, Gaston, Archive. Beinecke Rare Book and Manuscript Library, Yale University, New Haven, Conn.

Gallatin, A. E., ed. *Gaston Lachaise: Sixteen Reproductions in Collotype of the Sculptor's Work.* New York: E. P. Dutton, 1924.

Lachaise, Gaston. "A Comment on My Sculpture." *Creative Art* 3 (August 1928), pp. XXIII–XXVI.

Gaston Lachaise: Retrospective Exhibition. Exh. cat. Essay by Lincoln Kirstein. New York: Museum of Modern Art, 1935.

Kramer, Hilton, with appreciations by Hart Crane et al. *The Sculpture of Gaston Lachaise.* New York: Eakins Press, 1967.

Goodall, Donald Bannard. "Gaston Lachaise, Sculptor." Ph.D. diss., Harvard University, 1969.

Nordland, Gerald. *Gaston Lachaise: The Man and His Work.* New York: George Braziller, 1974.

Carr, Carolyn Kinder, and Margaret C. S. Christman. *Gaston Lachaise: Portrait Sculpture.* Exh. cat. Washington, D.C.: National Portrait Gallery in association with Smithsonian Institution Press, 1985.
Gaston Lachaise: Sculpture. Exh. cat. Essay by Barbara Rose. New York:

Salander-O'Reilly Galleries; Houston: Meredith Long and Co., 1991.
Gaston Lachaise (1882–1935): Sculpture and Drawings. Exh. cat. Essay by Hilton Kramer. New York: Salander-O'Reilly Galleries, 1998.

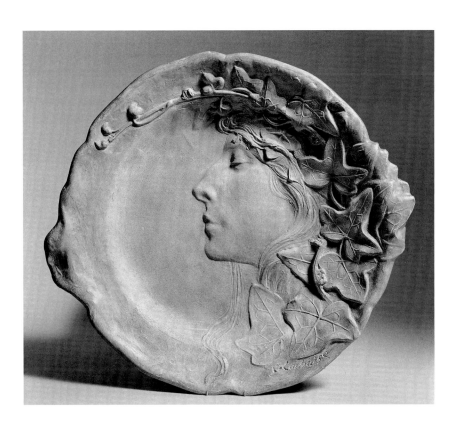

302. *Plate with Profile Head,* ca. 1904–5

Plaster, painted
12½ x 13½ x 1⅝ in. (31.8 x 34.3 x 4.1 cm)
Signed (lower right): *G. Lachaise*
Bequest of Allys Lachaise, 1967 (68.91.4)

THE PROFILE on this plaster plate is that of Isabel Dutaud Nagle (1872–1957), whom Lachaise met in Paris by about 1903 and married in New York in 1917 and who was the inspiration for much of his oeuvre. His captivation by her is already evident in this portrait of a woman, transformed into a dreamy art nouveau heroine by her lowered eyelids and long, wavy hair. Ivy tendrils and leaves connect the image to the surface of the plate. Photographs of Nagle from the period indicate that Lachaise captured a striking likeness of his subject, albeit as a symbolist icon.[1]

Lachaise presented a bronze cast of the plate to his father's physician in gratitude for the care given his father before his death in 1901.[2] The plaster was part of a bequest to the Metropolitan Museum from Allys Lachaise, sister of the artist.[3] According to her, the plate was created at the time Lachaise was working for René Lalique, which would date the work to about 1904–5.[4]　　　　　JMM

EXHIBITIONS

National Portrait Gallery, Washington, D.C., "Gaston Lachaise: Portrait Sculpture," November 22, 1985–February 16, 1986.
MMA, Henry R. Luce Center for the Study of American Art, "American Relief Sculpture," August 15–November 5, 1995.

1. For contemporary photographs of Nagle, see Carr and Christman 1985, pp. 7, 36.
2. Ibid., p. 36. A handwritten label attached to the underside of the plaster reads "Plate made in bronze in Paris for a gift to Dr. Aysaguer."
3. Henry Geldzahler, Curator, Department of Contemporary Arts, memorandum to Dudley T. Easby, Jr., Secretary, MMA, June 10, 1968, MMA Archives. Allys Lachaise's bequest to the Museum included, in addition to the plate, four plaster statuettes (cat. nos. 303–6) and three pencil drawings (acc. nos. 68.91.1–3); see "Ninety-eighth Annual Report," *MMA Bulletin* 27 (October 1968), p. 82.
4. Marie P. Charles, Curator, Lachaise Foundation, to Sabine Rewald, Assistant Curator, Department of Twentieth Century Art, October 16, 1985, object files, MMA Department of Modern Art.

303. *Standing Woman,* ca. 1906–12

Plaster, ink
9⅝ x 3½ x 4¾ in. (24.4 x 8.9 x 12.1 cm)
Bequest of Allys Lachaise, 1967 (68.91.6)

A PAPER LABEL on the base of this plaster sketch reads
"Study / Boston Studio," which suggests that the work
dates from the period Lachaise was living and working in
Boston, 1906–12. The form of *Standing Woman* can be
considered an early study for the voluptuous standing
nudes that appear in his oeuvre in the following decades.
Whereas the sexuality of those later standing female
figures is boldly asserted by their enlarged, bared breasts
and defiant stances, in this early work the female figure
modestly lowers her head and covers her breasts.

The hair and drapery of this plaster are touched with
black ink. At some past time the head was reattached to
the torso with glue. JMM

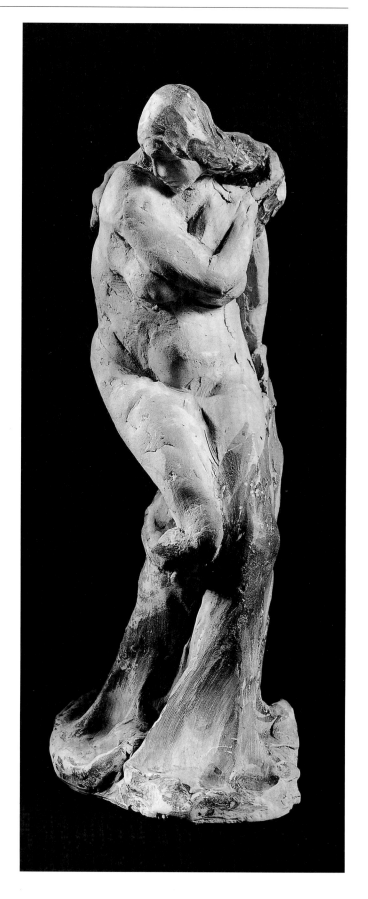

304. *Reclining Woman*, ca. 1910

Plaster
2⅝ x 4¼ x 2½ in. (6.7 x 10.8 x 6.4 cm)
Bequest of Allys Lachaise, 1967 (68.91.7)

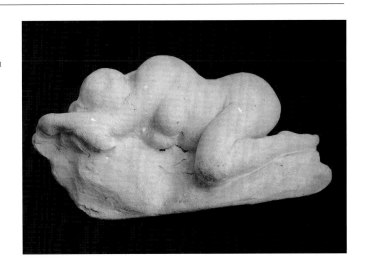

THIS SMALL plaster sketch is an early interpretation of the reclining female figure, a subject that would reappear in Lachaise's work regularly over the following two decades.[1] The figure lies on her right side, with her legs pulled up to her torso and her left arm and hair covering her face. The emphasis on full and rounded volume in *Reclining Woman* anticipates the sensuous reclining nudes of subsequent years, particularly *The Mountain* (cat. nos. 308, 316).

JMM

1. Nordland 1974, p. 108, pl. 47, published this small plaster as dating before 1910.

305. *Snake Dance, Ruth St. Denis*, 1910

Plaster
6¼ x 6 x 3 in. (15.9 x 15.2 x 7.6 cm)
Signed (top of base, right): G. Lachaise
Bequest of Allys Lachaise, 1967 (68.91.5)

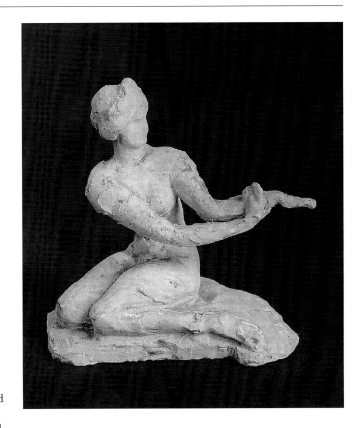

LACHAISE ENJOYED attending theatrical performances, the dance, and the circus, and after he saw Ruth St. Denis (1879–1968) dance in Boston, he persuaded her to pose for him. St. Denis later recorded: "While I was here [in Boston] I met the sculptor Gaston Lechaise [*sic*]. In these days he was a fascinating French boy, newly arrived in America, and he made some delightful studies of me in the *Cobra* and the *Incense* [Museum of Modern Art, New York], little figurines that were full of character."[1] The presence of the snake in this summary sketch in plaster, which Lachaise is said to have made from memory,[2] must mean that the work represents the dance entitled *Cobra*. Although the figure is roughly modeled, a sense of lightness and movement comes through. St. Denis is seated, wearing a dress and turban-style head covering; the snake is on her right arm.

A handwritten label on the underside of the Museum's plaster reads "Ruth St. Denis / Snake Dance in Boston."

JMM

1. *Ruth St. Denis, An Unfinished Life: An Autobiography* (New York and London: Harper and Brothers, 1939), p. 136.
2. Marie P. Charles, Curator, Lachaise Foundation, to Sabine Rewald, Assistant Curator, Department of Twentieth Century Art, October 16, 1985, object files, MMA Department of Modern Art.

306. *Lachaise's Mother Resting (Marie Lachaise in Armchair)*, ca. 1912

Plaster
8⅛ x 4¾ x 7½ in. (20.6 x 12.1 x 19.1 cm)
Signed (back of chair): *G. Lachaise*
Bequest of Allys Lachaise, 1967 (68.91.8)

MARIE BARRE LACHAISE (1856–1940) and her daughter Allys visited Lachaise first in Boston, after he settled there, and several times more before they took up permanent residence in the United States at the outbreak of World War I. According to Allys Lachaise, this plaster was modeled about 1910, but the handwritten label on the underside of the piece, "Lachaise's mother resting—New York," suggests that the plaster may date about 1912, after the artist had relocated to that city.[1] A plaster bust, *Head of a Woman,* which represents Marie Lachaise (ca. 1912; Lachaise Foundation), bears a close facial resemblance to *Lachaise's Mother Resting.*[2]

The work depicts Mme Lachaise in a long skirt seated in a high-backed chair, head leaning against its back and forearms resting on its arms. The modeling is loose, especially in the representation of the chair and the clothing, while the facial features are more carefully finished. Lachaise scholar Gerald Nordland noted that this statuette reflects the artist's training in the French academic tradition of posing subjects with furniture,[3] seen in such work as that of the popular French sculptor Jules Dalou, for example his *Nude Woman Reading in a Chair* (1878; Musée d'Orsay, Paris).[4] Lachaise's mother is seated rather than reclining, and the work is closer to genre sculpture than to Lachaise's later sensuous renderings of the reclining female figure.

Allys Lachaise lent *Lachaise's Mother Resting* to the solo exhibition of Lachaise's work at Knoedler Galleries in 1947.[5] J M M

EXHIBITION

National Portrait Gallery, Washington, D.C., "Gaston Lachaise: Portrait Sculpture," November 22, 1985–February 16, 1986.

1. Marie P. Charles, Curator, Lachaise Foundation, to Sabine Rewald, Assistant Curator, Department of Twentieth Century Art,

October 16, 1985, object files, MMA Department of Modern Art. See also Carr and Christman 1985, p. 38.
2. Carr and Christman 1985, p. 38.
3. Nordland 1974, pp. 107–8.
4. See Anne Pingeot et al., *Musée d'Orsay: Catalogue sommaire illustré des sculptures* (Paris: Réunion des Musées Nationaux, 1986), pp. 106–7.
5. *Gaston Lachaise (1882–1935): Exhibition* (New York: M. Knoedler and Co., 1947), p. 15, no. 2, as "Madame Jean Lachaise."

307. *Standing Woman*, 1912–27

Bronze, 1927
73⅞ x 32 x 17¾ in. (187.6 x 81.3 x 45.1 cm)
Signed and dated (top of base, right): G. LACHAISE / © / 1927
Bequest of Scofield Thayer, 1982 (1984.433.34)

AFTER ARRIVING in New York City in 1912, Lachaise began *Standing Woman,* which numbers among his many interpretations of his beloved Isabel Dutaud Nagle, to whom he referred as Woman. Generally accepted as one of his most important standing figures, it is an ambitious work, an overlifesize representation of the diminutive Nagle, generously proportioned to show the sculptor's passionate involvement with his subject. The majestic figure is elegantly posed—balanced on tiptoe, eyes closed, hands delicately extended in expressive gestures. The monumental scale of the undulating figure indicates that Lachaise intended to present more than a likeness of one woman; that his true subject is the Earth Mother, the regenerative force of nature.

Lachaise conceived this work in 1912, continuing to revise its composition over the next few years. It was cast in plaster for his first solo exhibition of sculpture and drawings at New York's Bourgeois Galleries in January–February 1918. At this time Stephan Bourgeois gave *Standing Woman* its oft-used alternate title, *Elevation.*[1] The critic Henry McBride, a champion of Lachaise's art, later wrote of first seeing *Standing Woman* at the gallery: "[T]he Lachaise Woman was so different that at first she seemed a priestess from another planet. . . . In a minute or two the strangeness disappeared, the authoritative satisfaction of the sculptor in his work made itself felt and a mere critic could see a beauty that though new was dateless and therefore as contemporary as it was 'early.' I left the gallery firmly convinced I had seen a masterpiece."[2]

The Metropolitan Museum's *Standing Woman* was cast in bronze for Scofield Thayer in 1927. Discussions about the casting began in 1923, when Thayer, then editor of *The Dial* magazine, was collecting modern art and was actively promoting Lachaise's reputation among an avant-garde coterie of artists and writers. Thayer and James Sibley Watson had purchased *The Dial* in 1919 and revamped it as a journal of arts and letters. Between 1920 and 1929, when it ceased to exist, *The Dial* frequently published articles about and illustrations of Lachaise's work, and several writers affiliated with the magazine sat for portraits by the sculptor (see cat. nos. 313–15). In a letter of November 1923, Lachaise agreed to Thayer's proposed terms for casting *Standing Woman:* "A plaster figure life size called once 'Elevation' and since called 'Woman' . . . is at your disposition . . . to keep as such (in plaster)

or for the purpose of having same cast in bronze 'one copie only' at your own expense. . . . I will work your bronze copie any time after [it] is cast without any further expense to you."[3] In October 1924 Lachaise wrote to Thayer from Bath, Maine: "I am going to New York this week and will know exactly about the bronze casting of the figure <u>woman</u>."[4] The sculpture was not cast in bronze, however, until 1927, shortly before it was included in a solo exhibition at the Brummer Gallery, New York, in February–March 1928. As part of his collection, the Metropolitan's *Standing Woman* was for many years on deposit at the Worcester Art Museum, Worcester, Massachusetts.[5] Thayer's bequest to the Metropolitan Museum of 343 works from his collection included six sculptures and twenty-nine drawings by Lachaise.

According to Lachaise Foundation records, there are twelve casts of this sculpture.[6] The Museum's cast is one of the four lifetime examples; others are at the Saint Louis Art Museum, the Albright-Knox Art Gallery, Buffalo, New York, and the Art Institute of Chicago.[7] Four posthumous unnumbered casts, probably authorized by Mme Isabel Lachaise, are in the collections of the Baltimore Museum of Art, the Philadelphia Museum of Art, the Virginia Museum of Fine Arts, Richmond, and the Whitney Museum of American Art, New York; the last was acquired in 1936, the year after the Whitney mounted a large exhibition of Lachaise's work and the sculptor died. Four additional posthumous casts were authorized by the Lachaise Foundation, the first example of which is in the John and Mable Ringling Museum of Art, Sarasota, Florida. JMM

EXHIBITIONS

MMA, "Selection One," February 1–April 28, 1985, no. 45.
Australian National Gallery, Canberra, March 1–April 27, 1986; Queensland Art Gallery, Brisbane, May 7–July 1, 1986, "20th Century Masters from The Metropolitan Museum of Art," no. 70.
MMA, Iris and B. Gerald Cantor Roof Garden, May 1–October 31, 1993; May 1–October 20, 1994.

1. L[isa] M. M[essinger], *"Standing Woman,"* in *Notable Acquisitions, 1984–85* (New York: MMA, 1985), p. 51.
2. *Lachaise,* exh. cat., introduction by Henry McBride (New York: Brummer Gallery, 1928), no. 27. Also published in McBride, "Modern Art," *The Dial* 84 (May 1928), p. 442.
 It is interesting to note that upon seeing *Standing Woman* in the

666 GASTON LACHAISE

1918 exhibition, Daniel Chester French (pp. 326–41), chairman of the Metropolitan Museum's trustees Committee on Sculpture from 1903 to 1931, is said to have been "shaking with rage, he was so shocked by the Lachaise sculpture"; Stephan Bourgeois, in an interview with Gerald Nordland, spring 1953, quoted in *Gaston Lachaise (1882–1935): Sculpture and Drawings,* exh. cat., essay by Gerald Nordland (Los Angeles: Los Angeles County Museum of Art, 1963), n.p. The Metropolitan did not acquire sculpture by Lachaise until Georgia O'Keeffe, as executrix of the Stieglitz estate, selected the Museum as the recipient of the Alfred Stieglitz Collection in 1949 (see cat. nos. 316, 320, 321).

3. Lachaise to Thayer, November 24, 1923, Dial/Scofield Thayer Papers, Yale Collection of American Literature, Beinecke Rare Book and Manuscript Library, Yale University, New Haven.
4. Lachaise to Thayer, October 26, 1924, Dial/Scofield Thayer Papers, as in note 2.
5. For exhibitions while the work was at the Worcester Art Museum,

see *Sculpture since Rodin* (New Haven: Yale University Art Gallery, 1949), no. 13; *The Dial and the Dial Collection* (Worcester, Mass.: Worcester Art Museum, 1959), pp. 69–70, no. 35; *The Dial Revisited* (Worcester, Mass.: Worcester Art Museum, 1971), checklist; and *"The Dial": Arts and Letters in the 1920s* (Worcester, Mass.: Worcester Art Museum, 1981), p. 157, no. 66.
6. Marie P. Charles, Lachaise Foundation, to Lisa M. Messinger, Curatorial Assistant, Department of Twentieth Century Art, May 1, 1985, object files, MMA Department of Modern Art.
7. For other lifetime casts, see Steven A. Nash, *Albright-Knox Art Gallery: Painting and Sculpture from Antiquity to 1942* (New York: Rizzoli International, 1979), pp. 522–23; Michael Edward Shapiro, "Twentieth-Century American Sculpture," *Saint Louis Art Museum Bulletin* 18 (Winter 1986), p. 8; and *Art Institute of Chicago: Twentieth-Century Painting and Sculpture,* selected by James N. Wood and Teri J. Edelstein (Chicago: Art Institute of Chicago, 1996), p. 32.

308. *The Mountain,* 1913

Sandstone, 1919
7½ x 17 x 5½ in. (19.1 x 43.2 x 14 cm)
Signed (right side of base): G. LACHAISE
Bequest of Scofield Thayer, 1982 (1984.433.29)

LACHAISE BEGAN a series of sculptures known as "The Mountain" in 1913, producing six different versions over the next two decades. The series includes the original clay and plaster (1913); this sandstone; a fieldstone version (1921); a plaster cast from the fieldstone (1924), several casts in bronze from that plaster (see cat. no. 316), and a final 9-foot cement casting (1934).[1] Gerald Nordland has written that the subject "embodies a concept of the reclining woman as an invulnerable absolute, rising from the plain of human experience as a great truth of life. From tiny feet through slender calves to expanding thighs and enormous torso the mountain rises to its idealized head."[2]

In January–February 1920 this sandstone version, carved in 1919, was shown in New York at the Stephan Bourgeois Galleries.[3] At the time of the exhibition, e. e. cummings wrote:

> In The Mountain . . . Lachaise has completely enjoyed an opportunity to work directly in the stone Himself as he calls it. . . . To speak accurately, now for the first time The Mountain actualizes the original conception of its creator; who . . . thinks in stone . . . and to whom the distinction between say bronze and alabaster is a distinction not between materials but, on the contrary, between ideas. In The Mountain as it IS Lachaise becomes supremely himself, the master of every aspect

of a surface, every flexion of a mass, every trillionth of a phenomenon.[4]

The Metropolitan's *Mountain* was in Scofield Thayer's collection at the time it was shown at the Bourgeois Galleries. Thayer wrote to Lachaise from Martha's Vineyard in July 1919 of his satisfaction that *The Mountain* "consents to be metamorphosed into stone," noting "La Montagne is one of the few things which I hope will eventually reconcile me to returning to New York."[5] Lachaise sketched a rendering of the sculpture in his journal, with the notation "La Montagne / Sold in Stone to Sc. Thayer."[6] *The Mountain* was part of the Dial Collection (see cat. nos. 307, 313) and was reproduced in *The Dial* in March 1921 in a photograph by Charles Sheeler.[7] It was on deposit at the Worcester Art Museum with Thayer's collection from 1936 until it was bequeathed to the Metropolitan Museum upon Thayer's death in 1982.[8]

According to Marie Charles of the Lachaise Foundation, this black sandstone version is similar to a bronze (dated 1930) owned by Arizona State University Art Museum, Tempe, the only bronze cast from a damaged plaster of about 1913.[9]

The Mountain is installed on a Belgian black marble base, ¾ inch high.

JMM

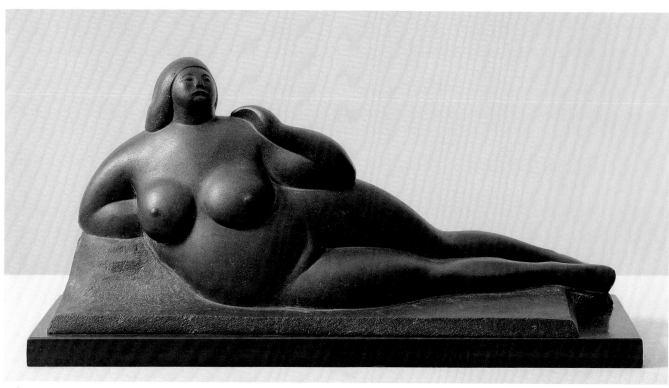

308

EXHIBITIONS

MMA, "Selection Three: 20th Century Art," October 22, 1985–
January 26, 1986.
Los Angeles County Museum of Art, February 26–April 30, 1995;
Montgomery Museum of Fine Arts, Montgomery, Ala., June 22–
September 10, 1995; Wichita Art Museum, Wichita, Kans., Octo-
ber 22, 1995–January 7, 1996; National Academy of Design, New
York, February 15–May 6, 1996, "The Figure in American Sculp-
ture: A Question of Modernity."

1. See Nordland 1974, pp. 113–18.
2. Ibid., p. 113.
3. *Exhibition of Sculptures and Drawings by Gaston Lachaise* (New York:
Bourgeois Galleries, 1920), no. 9.
4. e. e. cummings, "Gaston Lachaise," *The Dial* 68 (February 1920),
p. 204.
5. Thayer to Lachaise, July 10, 1919, Lachaise Archive, Beinecke Rare
Book and Manuscript Library, quoted in Carr and Christman
1985, p. 78.
6. For an illustration, see Phyllis Samitz Cohen, "The Gaston
Lachaise Collection," *Yale University Library Gazette* 58 (October
1983), p. 71.

7. See *The Dial* 70 (March 1921), facing p. 247. It was also illustrated
in Thayer's portfolio project of selections from the Dial Collection,
*Living Art: Twenty Facsimile Reproductions after Paintings, Drawings
and Engravings and Ten Photographs after Sculpture by Contemporary
Artists* (New York: Dial Publishing Co., 1923). *The Mountain* is
illustrated in plates 9 and 10, but plate 9, which shows the front
of the piece, appears to be a bronze version. Among the other
sculptors included in *Living Art* were Alexander Archipenko,
Constantin Brancusi, Wilhelm Lehmbruck, and Aristide Maillol.
8. While at Worcester, *The Mountain* was included in the follow-
ing exhibitions: "*The Dial* and the Dial Collection," April 30–
September 8, 1959, no. 36 ill., n.p.; "Selections from the Dial
Collection," November 13–30, 1965; "Between Sculpture and
Painting," February 23–April 9, 1978; and " 'The Dial': Arts and
Letters in the 1920s," March 7–May 10, 1981, no. 62.
9. Marie P. Charles, Lachaise Foundation, to Gail Stavitsky, Research
Assistant, Department of Twentieth Century Art, April 16, 1986,
object files, MMA Department of Modern Art. For the bronze
cast of *The Mountain* at the Arizona State University Art Museum,
Tempe, see *Gaston Lachaise (1882–1935): Sculpture and Drawings,*
exh. cat., essay by Gerald Nordland (Los Angeles: Los Angeles
County Museum of Art, 1964), no. 82.

309. *Standing Woman,* 1917

Bronze
13¾ x 3¼ x 5 in. (34.9 x 8.3 x 12.7 cm)
Signed and dated (left side of base): G. LACHAISE / 1917
Gift of Mrs. Darwin S. Morse, 1963 (63.200.12)

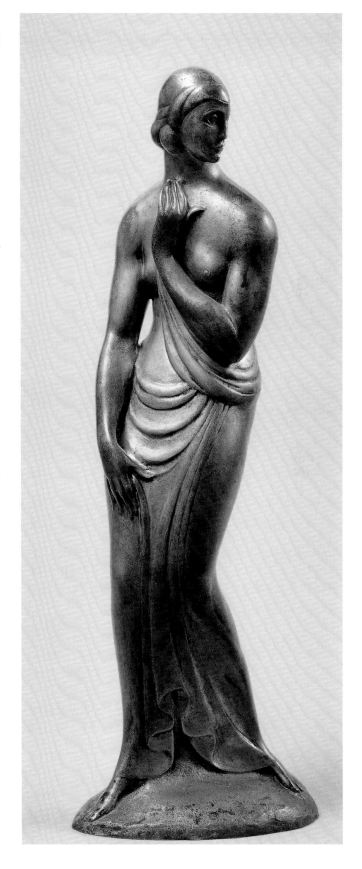

A FEMALE figure stands in a contrapposto position, with a mantle loosely covering her lower torso, while her breasts and shoulders are bared. In her left hand she holds a corner of the drape, which falls in stylized folds. The classical elegance of this statuette harkens back to the more modest nudes created by Lachaise (for example, cat. no. 303). Here the figure's small breasts and modest dignity are in striking contrast to the swollen breasts, provocative poses, and unbridled sexuality of the sculptor's other standing figures of the late teens. The patination of the work is a green gold and forecasts Lachaise's interest in stunning patinas in similar tones in his later years.

This bronze statuette was lent to the Metropolitan Museum in 1963 by Mrs. Darwin S. Morse. Mrs. Morse was the sister of Emily Winthrop Miles, an artist who owned *Standing Woman* before her death in 1962.[1] Later that year Mrs. Morse made the bronze a permanent gift along with thirty-five works from Mrs. Miles's collection, including a drawing by Alexander Stirling Calder (pp. 528–31) and examples of British and American ceramics and glass.[2]

JMM

EXHIBITION

Herbert F. Johnson Museum of Art, Cornell University, Ithaca, N.Y., November 5–December 22, 1974; Frederick S. Wight Art Gallery, University of California, Los Angeles, January 26–March 9, 1975; Museum of Contemporary Art, Chicago, May 1–June 15, 1975; Walker Art Center, Minneapolis, July 12–August 31, 1975, "Gaston Lachaise, 1882–1935."

1. Emily Winthrop Miles is represented in the Museum's collection by one sculpture and three drawings (acc. nos. 65.33.1–4), also donated by Mrs. Morse; see "Ninety-fifth Annual Report," *MMA Bulletin* 24 (October 1965), p. 43.
2. "Ninety-fourth Annual Report," *MMA Bulletin* 23 (October 1964), pp. 52–54; Mrs. Morse to Dudley T. Easby, Jr., Secretary, MMA, January 30, 1964, MMA Archives.

Mrs. Miles also donated a collection of Josiah Wedgwood and James Tassie portrait medallions to the Brooklyn Museum; see Jean Gorely and Marvin D. Schwartz, *The Emily Winthrop Miles Collection: The Work of Wedgwood and Tassie* (Brooklyn: Brooklyn Museum, 1965).

310. *Head of a Woman,* 1918

Bronze, painted, 1923 or after
10½ x 7½ x 9¼ in. (26.7 x 19.1 x 23.5 cm)
Foundry mark (right edge of neck): ROMAN BRONZE WORKS N.Y.
Gift of Carl D. Lobell, 1998 (1998.280.2)

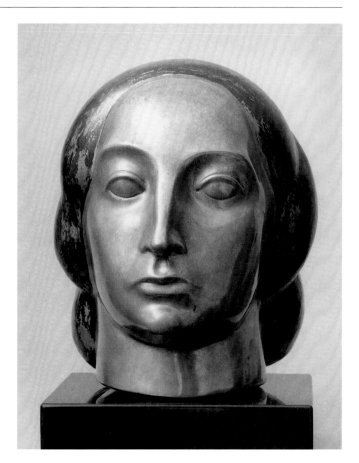

HEAD OF A WOMAN is an idealized study of the sculptor's wife, Isabel Dutaud Lachaise, who was a lifelong source for his female images. The archaic stylizations of the facial features suggest a classicizing approach to his subject, but the head conveys the strong character of his model. The head, rigidly frontal and regally serene, is among a number of idealized heads of Mme Lachaise created from about 1918 through the mid-1920s.[1]

Head of a Woman exists in several versions, including a polychrome marble (Museum of Fine Arts, Boston), which was carved in 1918. Lachaise made a plaster cast (Lachaise Foundation) from the marble head, and from the plaster, three bronzes were cast, two authorized by Lachaise and one by his wife following his death.[2] A highly polished example, cast by Roman Bronze Works, is in the collection of the Wichita Art Museum.[3] An edition of six bronzes was authorized by the Lachaise Foundation in 1957 and cast by the Modern Art Foundry in 1963. In 1923 Lachaise produced a plaster with a longer neck based on the Boston marble and also cast a bronze (both Lachaise Foundation).[4]

The date of casting of the Metropolitan Museum's short-neck bronze, which bears the foundry mark of the Roman Bronze Works, is not documented. Two bronze examples, including the Wichita cast, were shown at the Kraushaar Galleries in 1941.[5]

Head of a Woman, with black paint applied to the hair, is on a Belgian black marble base, 2 inches high. JMM

1. Carr and Christman 1985, p. 11; for other examples, see pp. 46–52.
2. P[aula] M. K[ozol], in Kathryn Greenthal et al., *American Figurative Sculpture in the Museum of Fine Arts, Boston* (Boston: Museum of Fine Arts, 1986), p. 385.
3. Carr and Christman 1985, pp. 44–45; and *Catalogue of the Roland P. Murdock Collection* (Wichita, Kans.: Wichita Art Museum, 1972), p. 133. The Wichita bust is dated 1923 in both catalogues.
4. Kozol, in *American Figurative Sculpture,* p. 385. For an illustration of a longer-neck version, see, for example, *Gaston Lachaise* 1998, no. 20.
5. Kozol, in *American Figurative Sculpture,* p. 385.

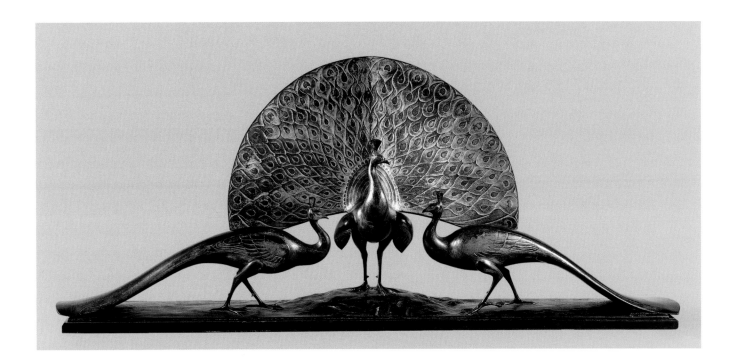

311. *The Peacocks*, 1922

Bronze, gilt
23¼ x 56½ x 10⅛ in. (59.1 x 143.5 x 25.7 cm)
Signed and dated (top of base, right): G LACHAISE / © 1922
Foundry mark (back of base): ROMAN BRONZE WORKS N–Y–
Gift of H. N. Slater, 1950 (50.173)

LACHAISE'S CREATION of decorative works, which began in 1904–5, when he worked for René Lalique, continued during his association with Paul Manship in the 1910s. Then, in the 1920s, he created his own ornamental bird and animal groups. In *The Peacocks* Lachaise arranged the three elegant birds in a frontal planar composition, the center one with tail fanned, the flanking ones in profile facing center. Although these peacocks are among the few works by Lachaise that suggest an indebtedness to Manship, their fine craftsmanship—particularly evident in the carefully incised feathers—manifests the skill that Lachaise had developed in his earlier production of decorative sculpture.

Because the overt sexuality of his female nudes was offensive to many prospective buyers, animal subjects brought Lachaise his first popular success and, along with his portraits and architectural commissions, provided him with steady income. Nevertheless, he did not wish any of those ornamental pieces to be included in the 1935 retrospective of his work held at the Museum of Modern Art because he did not consider them to be a significant contribution to modern sculpture.[1]

According to files of the Kraushaar Galleries, fourteen replicas of *The Peacocks* were made of a proposed edition of twenty.[2] Other bronzes in museum collections are at the Detroit Institute of Arts; the Newark Museum, Newark, New Jersey; the Phillips Collection, Washington, D.C.; and the Pennsylvania Academy of the Fine Arts, Philadelphia.

The Metropolitan's gilt-bronze example was donated in 1950 by textile manufacturer H. Nelson Slater through the auspices of Ferargil Galleries.[3] The accompanying stone base is 1 inch high. JMM

EXHIBITIONS

Heckscher Museum, Huntington, N.Y., "Art Deco and Its Origins," September 22–November 3, 1974, no. 120.

Rutgers University Art Gallery, New Brunswick, N.J., September 16–November 4, 1979; William Hayes Ackland Art Center, University of North Carolina, Chapel Hill, December 4, 1979–January 20, 1980; Joslyn Art Museum, Omaha, Nebr., February 16–March 30, 1980; Oakland Museum, Oakland, Calif., April 15–May 25, 1980, "Vanguard American Sculpture, 1913–1939," no. 63.

MMA, Henry R. Luce Center for the Study of American Art, "Bronze Casting," June 11–November 3, 1991.

1. *Gaston Lachaise* 1935, pp. 15–16, cited in Nordland 1974, p. 53.
2. Marie P. Charles, Curator, Lachaise Foundation, to Sabine Rewald, Assistant Curator, Department of Twentieth Century Art, October 16, 1985, object files, MMA Department of Modern Art.
3. Frederic Newlin Price, Ferargil Galleries, to Francis Henry Taylor, Director, MMA, August 10, 1950, MMA Archives. On Slater, see his obituary, *New York Times,* May 2, 1968, p. 47.

312. *Antoinette Kraushaar*, 1923

Marble
12¼ x 8⅝ x 10 in. (31.1 x 21.9 x 25.4 cm)
Signed and dated (base of neck): G. LACHAISE 1923
Gift of Carole M. Pesner, 1995 (1995.514)

ALTHOUGH LACHAISE is best known for his interpretations of the female nude, he was also a successful portraitist, notable for capturing both the physical features and the character of his sitters. *Antoinette Kraushaar* is among more than seventy-five portraits he completed during the 1920s; it represents the daughter of his art dealer at that time, John Kraushaar. Antoinette M. Kraushaar (1902–1992) began working as a stenographer in her father's art gallery when she was in her late teens. By the mid-1930s, when her father became ill, she assumed operation of the gallery, and she became the director at his death in 1946.

Commissioned by John Kraushaar, *Antoinette Kraushaar* is a perceptive likeness of a young woman. The smooth surfaces and generalized volumes of the wavy hair, simply parted at the side, complement the serenity and elegance of the head. More than three decades after posing for the portrait, Miss Kraushaar recalled that although she sat while Lachaise modeled the head in clay, her sittings continued as he carved the marble.[1] Unlike many of his contemporaries, Lachaise carved his own marbles and achieved distinction for his skill.

According to Carole Pesner, president of the Kraushaar Galleries, the portrait is an excellent likeness of Antoinette Kraushaar.[2] Two years after Lachaise completed this marble head, he created a mask of Antoinette Kraushaar's features based on the original plaster model. The bronze mask, which Lachaise gave to her father as a surprise, was in the collection of Miss Kraushaar at the time of her death.[3] It is now in a New York private collection.[4]

Before entering the Metropolitan Museum's collection, *Antoinette Kraushaar* was shown in several exhibitions devoted to Lachaise's work, including those at Knoedler Galleries in 1947; Los Angeles County Museum of Art and Whitney Museum of American Art in 1963–64; Portland Museum of Art, Portland, Maine, in 1984; and National Portrait Gallery, Washington, D.C., in 1985–86.[5] The portrait is accompanied by a green marble base, 2¾ inches high.

JMM

EXHIBITION

MMA, "As They Were: 1900–1929," April 9–September 8, 1996.

1. Goodall 1969, p. 457, cited in Carr and Christman 1985, p. 12.
2. Carole Pesner in conversation with Joan M. Marter, May 8, 1998. Miss Kraushaar was also the subject of a portrait by George Luks, which depicted her at age fifteen in a white graduation dress (1917; Brooklyn Museum of Art).
3. Carr and Christman 1985, pp. 62, 63 (ill.).
4. Pesner to Marter, telephone conversation, September 14, 2000.
5. For accompanying catalogues, see *Gaston Lachaise (1882–1935): Exhibition* (New York: M. Knoedler and Co., 1947), p. 18, no. 40; *Gaston Lachaise (1882–1935): Sculpture and Drawings* (Los Angeles: Los Angeles County Museum of Art, 1963), n.p., no. 40; *Gaston Lachaise: Sculpture and Drawings* (Portland, Maine: Portland Museum of Art, 1984), p. 35, no. 27; and Carr and Christman 1985, pp. 60–61.

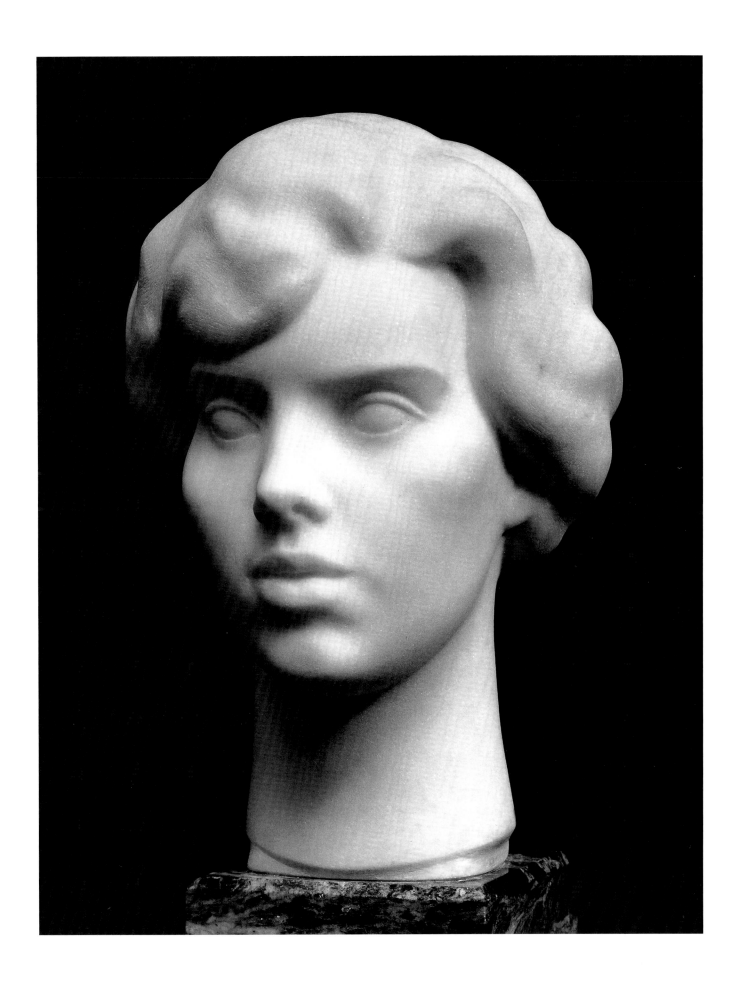

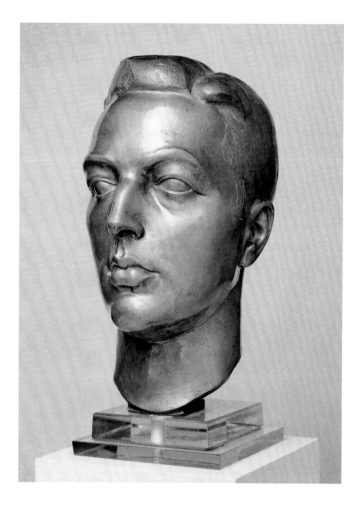

313. *Scofield Thayer,* 1923

Bronze, 1924
12⅝ x 6¼ x 9⅜ in. (32.1 x 15.9 x 23.8 cm)
Signed (right side of base): G. LACHAISE
Foundry mark (back of base): ROMAN BRONZE WORKS N–Y–
Bequest of Scofield Thayer, 1982 (1984.433.30)

IN 1919 SCOFIELD THAYER (1889–1982) and James Sibley Watson purchased *The Dial,* a journal of politics and reform founded in 1840, which under their aegis came to be noted for its focus on avant-garde art and literature. While Watson served as publisher, Thayer was editor from 1920 to 1926 and adviser from 1927 until it ceased publication in 1929. The monthly magazine featured eight full and partial articles on Lachaise, notably those by e. e. cummings (February 1920), Thomas Craven (June 1923), and Henry McBride (March 1928). It also illustrated twenty-three of Lachaise's sculptures between 1920 and 1929, including the bas-relief *Dusk* on the frontispiece of Thayer and Watson's first issue (January 1920), thereby bringing the artist's name to the attention of an audience involved in the arts.[1] In addition, Thayer purchased Lachaise's sculpture for the Dial Collection of European and American art, which served as a resource for the magazine's illustrations; 343 works of art from this collection were bequeathed to the Metropolitan Museum upon Thayer's death in 1982, including six sculptures and twenty-nine drawings by Lachaise.

During the 1920s Lachaise devoted much of his energy to creating portrait busts, many of artists and writers associated with *The Dial,* for example Marianne Moore (cat. no. 315), e. e. cummings (1924), James Sibley Watson (1927), and Henry McBride (1928). These portrait commissions were a much-needed source of income for Lachaise. When in October 1923 he lacked funds, he proposed that Thayer commission his likeness—"a portrait in bronze polished with a base in glass"—and requested a check: "this will save me out and will give me the joy of doing your portrait as one of the few portraits I desire to do."[2] Thayer immediately agreed, sending the sculptor a check for five hundred dollars and asking that the sittings take place as soon as possible.[3] The bronze was cast before August 1924, when Lachaise inquired whether Thayer would be inter-

ested in purchasing a bronze replica (cat. no. 314).[4] The first bronze, with smooth finish and shiny surface, was reproduced in the January 1926 issue of *The Dial* in a photograph by Charles Sheeler.[5] It remained in Thayer's collection until his death in 1982.[6]

The glass base, designed by Lachaise, is 1½ inches high.

JMM

EXHIBITIONS

National Portrait Gallery, Washington, D.C., "Gaston Lachaise: Portrait Sculpture," November 22, 1985–February 16, 1986.
MMA, "As They Were: 1900–1929," April 9–September 8, 1996.

1. On *The Dial* and the Dial Collection, see Nicholas Joost, *Scofield Thayer and The Dial: An Illustrated History* (Carbondale: Southern Illinois University Press, 1964); and Joost, "The Dial Collection: Tastes and Trends of the 'Twenties,'" *Apollo* 94 (December 1971), pp. 488–95. For Lachaise and *The Dial* specifically, see Phyllis Samitz Cohen, "The Gaston Lachaise Collection," *Yale University Library Gazette* 58 (October 1983), pp. 70–71; and Nordland 1974, p. 35.
2. Lachaise to Thayer, October 15, 1923, Dial/Scofield Thayer Papers, Yale Collection of American Literature, Beinecke Rare Book and Manuscript Library, Yale University, New Haven.
3. Thayer to Lachaise, October 19, 1923, Lachaise Archive, Beinecke Rare Book and Manuscript Library.
4. Lachaise to Thayer, August 23, 1924, Dial/Scofield Thayer Papers, as in note 2.
5. See *The Dial* 80 (January 1926), facing p. 48.
6. The portrait was on deposit at the Worcester Art Museum from 1959 to 1982 with the Dial Collection. See *The Dial and the Dial Collection*, exh. cat. (Worcester, Mass.: Worcester Art Museum, 1959), p. 72, no. 43; and *"The Dial": Arts and Letters in the 1920s*, exh. cat. (Worcester, Mass.: Worcester Art Museum, 1981), p. 157, no. 63.

314. *Scofield Thayer*, 1923

Bronze, 1924
12½ x 6¼ x 8⅜ in. (31.8 x 15.9 x 21.3 cm)
Signed (right side of base): G. LACHAISE
Foundry mark (back of base): ROMAN BRONZE WORKS N–Y–
Bequest of Scofield Thayer, 1982 (1984.433.31)

IN AUGUST 1924, following the completion of the original portrait bust of Thayer (cat. no. 313), Lachaise, again in urgent need of funds, asked the editor of *The Dial* if he would be interested in a replica of the work.[1] Thayer responded by agreeing to a cast of the head for his mother's collection, expressing some misgivings, however, because she felt that the lips of the portrait were so much heavier than Thayer's as to be unpleasant. Mrs. Thayer's opinion, he wrote, was supported by a consensus of his literary associates: the bust was splendid from the profile view, but the full-face view was less successful.[2] When the second cast was made, it was mounted at a slightly downward angle to minimize the prominence of the lower lip.

The second cast is of rougher quality than the first and has a dull finish.[3] It is mounted on a black marble base, 2 inches high.

JMM

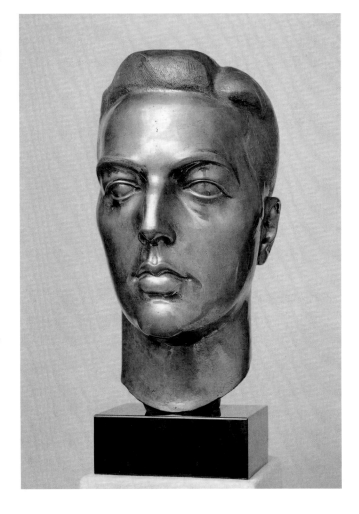

1. Lachaise to Thayer, August 23, 1924, Dial/Scofield Thayer Papers, Yale Collection of American Literature, Beinecke Rare Book and Manuscript Library, Yale University, New Haven.
2. Thayer to Lachaise, August 28, 1924, Lachaise Archive, Beinecke Rare Book and Manuscript Library.
3. Object condition report, February 27, 1985, object files, MMA Department of Modern Art. Yale Kneeland, Assistant Conservator, MMA Department of Objects Conservation, suggests that the plaster for the first bust may have been unavailable and a mold of the bronze cast was used to create the second, which would account for the discrepancy in size between the two bronzes.

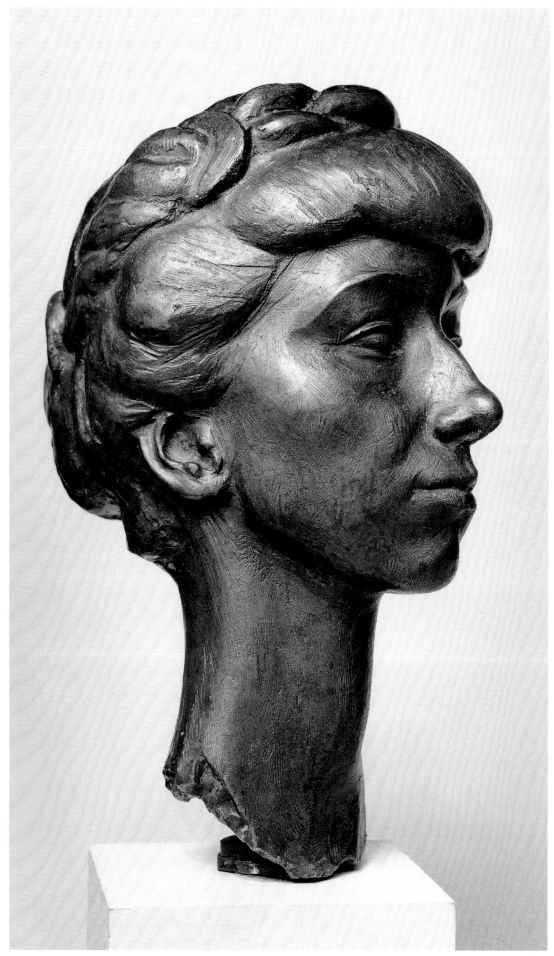

676 GASTON LACHAISE

315. *Marianne Moore, 1924*

Bronze, 1946
14½ x 8¼ x 10 in. (36.8 x 21 x 25.4 cm)
Gift of Lincoln Kirstein, 1959 (59.156)

MARIANNE MOORE (1887–1972), who is ranked among America's finest poets,[1] met Scofield Thayer (cat. no. 313, 314) in 1918. After 1920, when Thayer assumed editorship of *The Dial,* he frequently published her poems. In April 1925 Moore began working in the offices of *The Dial,* and two months later, when Thayer resigned as editor, she was named acting editor. Announcement of Thayer's resignation was not printed in *The Dial* until June 1926, at which time Moore was appointed editor. She served in that capacity until the journal ceased publication after the July 1929 issue. As a poet, she was known as a painstaking technician, moving from some use of free verse to syllabic meter and subtle rhythms. Her *Collected Poems* won a Pulitzer Prize in 1951, the National Book Award in 1952, and the Bollingen Prize in 1953.

Moore posed for this portrait by Lachaise just before receiving the Dial Award of 1924 for her extraordinary poetry. She is depicted with an alert gaze, graceful elongated neck, and trademark plaits bound around her head, apparently carefully arranged by Lachaise according to her wishes.[2] In a letter written many years later, she recalled the circumstances of the portrait bust: "In 1924 Mr. Lachaise asked me to sit for the bronze of me which the Museum has; six sittings were not enough; (the head was possibly to be completed in white marble slightly tinted,) but there was not time to complete it and it remained in plaster."[3] Moore's mother's illness prevented the poet from completing the sittings, and the portrait was never executed in tinted marble, as Lachaise had intended.

In 1946 Mme Lachaise wished to send the plaster to Moore. Lincoln Kirstein thought it should be cast in bronze and did so, including it in the exhibition of Lachaise's work at Knoedler Galleries in 1947.[4] Kirstein then presented the bronze bust to Moore, who lent it to an exhibition of the Dial Collection at the Worcester Art Museum in 1959.[5] Following the close of that show, Moore returned the portrait to Kirstein to give to the Metropolitan Museum.[6]

The Lachaise Foundation authorized an edition of ten bronze casts to be made from the 1924 plaster model, which is in its collection. Two bronzes have been cast: one is at the National Portrait Gallery, Washington, D.C., and the other is at the Lachaise Foundation.[7] JMM

EXHIBITIONS

American Academy of Arts and Letters, New York, "An Exhibition in Honor of the Seventy-fifth Birthday of Marianne Moore," November 16–December 9, 1962, no. 2.
Herbert F. Johnson Museum of Art, Cornell University, Ithaca, N.Y., November 5–December 22, 1974; Frederick S. Wight Art Gallery, University of California, Los Angeles, January 26–March 9, 1975; Museum of Contemporary Art, Chicago, May 1–June 15, 1975; Walker Art Center, Minneapolis, July 12–August 31, 1975, "Gaston Lachaise, 1882–1935."
Memorial Art Gallery, University of Rochester, N.Y., "Gaston Lachaise: Sculpture and Drawings," January 20–March 4, 1979, no. 19.
Rosenbach Museum and Library, Philadelphia, "In Her Own Image: Photographers, Painters and Sculptors View Marianne Moore," January 24–May 1, 1980.
Bellevue Art Museum, Bellevue, Wash., "Five Thousand Years of Faces," January 30–July 30, 1983.
Portland Museum of Art, Portland, Maine, "Gaston Lachaise: Sculpture and Drawings," May 16–September 16, 1984, no. 36.
National Portrait Gallery, Washington, D.C., "Gaston Lachaise: Portrait Sculpture," November 22, 1985–February 16, 1986.
MMA, "As They Were: 1900–1929," April 9–September 8, 1996.

1. On Marianne Moore, see Charles Molesworth, *Marianne Moore: A Literary Life* (New York: Atheneum, 1990; Boston: Northeastern University Press, 1991).
2. Moore, interview with Gerald Nordland, 1952, cited in Nordland 1974, p. 89; and Moore to Isabel Lachaise, July 13, 1946, Lachaise Papers, Archives of American Art, microfilm reel 326, frame 405, cited in Carr and Christman 1985, p. 84.
3. Moore to Susan Porter Smith, July 6, 1960, MMA Archives. In a 1952 interview with Nordland, as in note 2, Moore recalled that Lachaise's original intent was to have the portrait cut in marble with the hair tinted red.
4. Carr and Christman 1985, p. 84; and *Gaston Lachaise (1882–1935): Exhibition,* exh. cat., introduction by Lincoln Kirstein (New York: M. Knoedler and Co., 1947), p. 16, no. 19. Both the bronze and plaster were included in the exhibition.
5. *The Dial and the Dial Collection,* exh. cat. (Worcester, Mass.: Worcester Art Museum, 1959), p. 71, no. 41.
6. Moore to Smith, July 6, 1960, MMA Archives; and Kirstein to Robert B. Hale, Curator, MMA Department of American Paintings and Sculpture, November 10, 1959, MMA Archives.
7. Marie P. Charles, Curator, Lachaise Foundation, to Sabine Rewald, Assistant Curator, Department of Twentieth Century Art, October 16, 1985, object files, MMA Department of Modern Art. See also *National Portrait Gallery: Permanent Collection Illustrated Checklist* (Washington, D.C.: National Portrait Gallery in association with Smithsonian Institution Press, 1987), p. 206.

316. *The Mountain,* 1924

Bronze
7⅝ x 19⅜ x 9½ in. (19.4 x 49.2 x 24.1 cm)
Signed and dated (back of base, left): G. Lachaise / 1924
Foundry mark (back of base, center): ROMAN BRONZE WORKS N—Y—
Alfred Stieglitz Collection, 1949 (49.70.224)

THE SERIES known as "The Mountain" was begun in 1913 with a clay model, which was then cast in plaster for later bronze castings. Lachaise continued the series with black sandstone (cat. no. 308) and fieldstone versions, a plaster from the fieldstone, from which several casts were produced in bronze, and finally, a 9-foot cement casting (1934), which was installed on the Lenox, Massachusetts, property of the artist George L. K. Morris.[1] The Metropolitan Museum's bronze was made from the plaster cast that was taken from the fieldstone version of *The Mountain,* dated 1921. The fieldstone carving was owned by James Sibley Watson, co-owner and publisher of *The Dial* and president of the Dial Publishing Company, and now belongs to the Memorial Art Gallery, University of Rochester, New York.

In the Metropolitan's version, the head of the reclining female figure is thrown back and cradled in the enlarged left arm, creating a more unified, massive image. Lachaise apparently worked directly on the plaster (Lachaise Foundation) and then chose a shiny finish for the bronze.

Another highly polished bronze cast is in the collection of the Museum of Modern Art, New York. Subsequently, the Lachaise Foundation authorized an edition of eleven posthumous casts from the original plaster.[2]

The Mountain was included in Lachaise's solo exhibition at the Intimate Gallery in 1927. Correspondence of 1928–29 between Lachaise and Alfred Stieglitz indicates that Stieglitz retained the bronze as a result of involved financial arrangements between the two men.[3] The Stieglitz Collection, which included two other sculptures by Lachaise (cat. nos. 320, 321), was given to the Metropolitan Museum in 1949 by Georgia O'Keeffe.[4] The bronze cast is mounted on a glass plinth, ⅞ inch high, designed by the artist. JMM

EXHIBITIONS

Museum of Modern Art, New York, 1951–54.
Los Angeles County Museum of Art, "Gaston Lachaise (1882–1935): Sculpture and Drawings," December 3, 1963–January 19, 1964, no. 45.

Herbert F. Johnson Museum of Art, Cornell University, Ithaca, N.Y., November 5–December 22, 1974; Frederick S. Wight Art Gallery, University of California, Los Angeles, January 26–March 9, 1975; Museum of Contemporary Art, Chicago, May 1–June 15, 1975; Walker Art Center, Minneapolis, July 12–August 31, 1975, "Gaston Lachaise, 1882–1935."

Memorial Art Gallery, University of Rochester, N.Y., "Gaston Lachaise: Sculpture and Drawings," January 20–March 4, 1979, no. 20.

MMA, "The Human Figure in Transition, 1900–1945: American Sculpture from the Museum's Collection," April 15, 1997–March 29, 1998.

1. Nordland 1974, p. 113.
2. Nordland 1974, p. 41. For the Intimate Gallery show, see p. 36.
3. Notes of a telephone conversation between Gail Stavitsky, Research Assistant, Department of Twentieth Century Art, and Marie P. Charles, Lachaise Foundation, April 15, 1986, object files, MMA Department of Modern Art.
4. *The Mountain* was exhibited at the Philadelphia Museum of Art in 1944 in "History of an American, Alfred Stieglitz: '291' and After: Selections from the Alfred Stieglitz Collection" (no. 194). For the Museum's acceptance of the Alfred Stieglitz Collection, which includes modern works by Arthur Dove, Marsden Hartley, and John Marin, see "Eightieth Annual Report," *MMA Bulletin,* n.s. 9 (Summer 1950), p. 13.

317. *Maquette for Dolphin Fountain,* ca. 1924

Wood, painted, gilt
4½ x 14 x 5¾ in. (11.4 x 35.6 x 14.6 cm)
Inscribed (top left, near tail, in red paint): 5
Gift of Carl D. Lobell, 1997 (1997.261)

IN THE EARLY 1920s Lachaise created sculptures of wildlife, singly and in groups. As he commented in 1928: "On certain occasions I have made use of animals, sea-gulls, sea-lions, dolphins, peacocks, penguins, to translate spiritual forces."[1] Among the most lively of these compositions is his 17-inch bronze *Dolphin Fountain* (1924; Whitney Museum of American Art, New York), featuring fifteen leaping sea mammals, which was acquired during Lachaise's lifetime by Gertrude Vanderbilt Whitney (pp. 592–95).[2] The Metropolitan Museum's dolphin is a model for one of the central dolphins in the fountain.

The graceful, arching bodies of the undulating dolphins result in an animated composition closely related to Lachaise's *Two Floating Nude Acrobats* (1922) and *Flock of Seagulls* (1924), both of which feature forms suspended in space.[3]

Maquette for Dolphin Fountain is accompanied by a stepped travertine base, 3½ inches high. JMM

1. Lachaise 1928, p. 23.
2. For the Whitney fountain, see Patterson Sims, *Gaston Lachaise: A Concentration of Works from the Permanent Collection of the Whitney Museum of American Art,* exh. cat. (New York: Whitney Museum of American Art, 1980), p. 16.
3. Illustrated, ibid., pp. 16–17.

318. *Female Torso,* ca. 1924

Bronze, nickel-plated
10¼ x 6¾ x 3½ in. (26 x 17.1 x 8.9 cm)
Signed (back): G. LACHAISE
Bequest of Scofield Thayer, 1982 (1984.433.33)

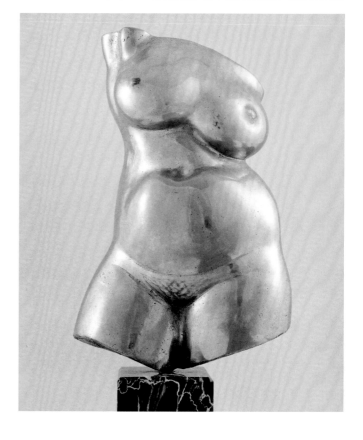

THIS FRAGMENT of the female form, from below the shoulders to the upper thighs, is also referred to as the "Classic Torso" and is generally considered to be the earliest of Lachaise's fragmented torso series.[1] Although the sculpture is a bronze shell, it achieves a strong plastic effect, and movement is implied by the contrapposto posture.

The artist created a series of six or more of these torsos from 1924 to 1928, and others from 1930 to 1933. The fragmented study originated in an alabaster torso of 1924, formerly owned by Alfred Stieglitz.[2] The surface appearance of these torsos varies widely; this *Female Torso* has a nickel-plated finish. Gerald Nordland has noted that "one torso would receive a dark finish, another would be given a burnished bronze mirror finish, still another a mottled gold and bronze matte treatment, and variations, all worked out and completed by the artist."[3]

The original plaster is owned by the Lachaise Foundation, which produced an edition of eight posthumous bronze casts.[4]

Female Torso was on deposit at the Worcester Art Museum as part of the Dial Collection of modern art from 1936 until Thayer's death in 1982.[5] It has a black veined marble base, 4 inches high. JMM

EXHIBITIONS

MMA, "Selection Three: 20th Century Art," October 22, 1985–January 26, 1986.
MMA, "The Human Figure in Transition, 1900–1945: American Sculpture from the Museum's Collection," April 15, 1997–February 29, 1998.
MMA, "Evocative Fragments," February 14–June 14, 1998.

1. For a discussion of the "Classic Torso" type, see Nordland 1974, pp. 140–44.

2. Goodall 1969, p. 581.
3. Nordland to Joan M. Marter, October 6, 1999, object files, MMA Department of Modern Art.
4. Marie P. Charles, Curator, Lachaise Foundation, to Sabine Rewald, Assistant Curator, Department of Twentieth Century Art, October 16, 1985, object files, MMA Department of Modern Art.
5. While at the Worcester Art Museum, *Female Torso* was included in two exhibitions of the Dial Collection: "*The Dial* and the Dial Collection," April 30–September 8, 1959, no. 38; and "'The Dial': Arts and Letters in the 1920s," March 7–May 10, 1981, no. 67.

319. *Nude Woman with Upraised Arms,* ca. 1926

Bronze
19 x 11½ x 6 in. (48.3 x 29.2 x 15.2 cm)
Bequest of Scofield Thayer, 1982 (1984.433.32)

THE ANATOMICAL distortions of this female figure may be related to those of Lachaise's *Woman in Balance* (1927; Fogg Art Museum, Harvard University, Cambridge, Mass.).[1] Both feature tightened midriffs, which decidedly separate the upper and lower portions of the figures. Amply proportioned breasts and hips protrude, while the arms reach upward. The subject of *Nude Woman with Upraised Arms* wears high-heeled shoes and has smooth, unarticulated

features and an almost cylindrical midsection. She is balanced on a slender pole, which serves as her seating support but also has a levitating effect.

An undated drawing titled *Seated Nude with Upraised Arms* in the Metropolitan Museum's collection (acc. no. 1984.433.236) is probably a study for this sculpture. Both the drawing and the sculpture, alternately titled *Seated Woman with Upraised Arms,* were part of Scofield Thayer's bequest of his collection to the Metropolitan Museum on his death in 1982.[2]

The black marble base is 1 inch high. JMM

EXHIBITIONS

MMA, "Selection Three: 20th Century Art," October 22, 1985–January 26, 1986.
MMA, "As They Were: 1900–1929," April 9–September 8, 1996.

1. Gerald Nordland to Joan M. Marter, October 11, 1999, object files, MMA Department of Modern Art. For an illustration of *Woman in Balance,* see Nordland 1974, p. 80.
2. While the Dial Collection was on deposit at the Worcester Art Museum, Worcester, Mass., *Nude Woman with Upraised Arms* was included in the following exhibitions at the museum: "*The Dial* and the Dial Collection," April 30–September 8, 1959, no. 37, ill., n.p.; "Selections from the Dial Collection," November 13–30, 1965; "The Dial Revisited," June 29–August 22, 1971; and " 'The Dial': Arts and Letters in the 1920s," March 7–May 10, 1981, no. 65.

320. *Georgia O'Keeffe,* 1927

Alabaster
23 x 8¼ x 12¼ in. (58.4 x 21 x 31.1 cm) (including 5¾-in. socle)
Signed and dated (back, below neck): G LACHAISE / © 1927
Alfred Stieglitz Collection, 1949 (49.92.4)

LACHAISE'S AUSTERE study of Georgia O'Keeffe (1887–1986), while a striking likeness, suggests the subject's aloof demeanor and emphasizes her growing confidence, the result of an increasingly successful artistic career. O'Keeffe was one of the most acclaimed artists in the history of American modernism. Her first solo exhibition was held at the "291" Gallery in 1917, organized by Stieglitz, whom she married in 1924. Her best-known paintings, watercolors, and drawings depict landscapes of the American Southwest, natural forms and flowers, and abstractions. After Stieglitz's death in 1946, she moved to New Mexico permanently and remained there until her death at age ninety-eight.

O'Keeffe gave Lachaise two or three sittings several years before he carved this likeness in 1927.[1] Stieglitz, who also sat for Lachaise, wrote, "We often talk of the real pleasure it was for us to 'pose' for you Lachaise—to watch you work with such passion—really a great treat."[2] Lachaise treated O'Keeffe objectively but coldly in this portrait bust because he apparently felt little sympathy for what he considered to be her unconventional persona. He did not ordinarily agree to do a portrait unless he admired the sitter, but he felt indebted to Stieglitz and therefore consented.[3] The head was included in an exhibition of Lachaise's sculpture held in 1927 at Stieglitz's Intimate Gallery, the same year that O'Keeffe enjoyed critical acclaim and profitable sales from an exhibition there.

Georgia O'Keeffe is part of the Alfred Stieglitz Collection given to the Metropolitan Museum through O'Keeffe, as executrix of his estate, in 1949, three years after Stieglitz's death.[4] Stieglitz had also purchased *The Mountain* (cat. no. 316) and *Standing Nude* (cat. no. 321) from Lachaise. JMM

EXHIBITIONS

Los Angeles County Museum of Art, December 3, 1963–January 19, 1964; Whitney Museum of American Art, New York, February 18–April 5, 1964, "Gaston Lachaise (1882–1935): Sculpture and Drawings," no. 60.
MMA, "Three Centuries of American Painting," April 9–October 17, 1965.
Herbert F. Johnson Museum of Art, Cornell University, Ithaca, N.Y., November 5–December 22, 1974; Frederick S. Wight Art Gallery, University of California, Los Angeles, January 26–March 9, 1975; Museum of Contemporary Art, Chicago, May 1–June 15, 1975; Walker Art Center, Minneapolis, July 12–August 31, 1975, "Gaston Lachaise, 1882–1935."
Whitney Museum of American Art, New York, "200 Years of American Sculpture," March 16–September 26, 1976, no. 129.
Palm Springs Desert Museum, Palm Springs, Calif., "Gaston Lachaise: 100th Anniversary Exhibition, Sculpture and Drawings," November 19–December 19, 1982, no. 37.
National Portrait Gallery, Washington, D.C., "Gaston Lachaise: Portrait Sculpture," November 22, 1985–February 16, 1986.

1. Carr and Christman 1985, p. 102.
2. Stieglitz to Lachaise, June 20, 1925, Lachaise Papers, Archives of American Art, microfilm reel 1034, frame 3, quoted in Carr and Christman 1985, p. 102.
3. Nordland 1974, p. 95.
4. On Stieglitz's collecting works by Lachaise, see also cat. no. 316. *Georgia O'Keeffe* was exhibited in "History of an American, Alfred Stieglitz: '291' and After: Selections from the Stieglitz Collection," at the Philadelphia Museum of Art in 1944 (no. 196).

321. *Standing Nude,* 1927

Bronze, nickel-plated
12⅛ x 5¼ x 3½ in. (30.8 x 13.3 x 8.9 cm)
Signed (back): © / G. LACHAISE
Alfred Stieglitz Collection, 1949 (49.70.223)

THE STANDING nude is a subject that Lachaise revisited many times during his career, and this bronze represents the culmination of a series of statuettes on this theme. His inspiration was always his wife, Isabel Dutaud Lachaise, here portrayed as a buxom woman of proud bearing. Her swelling breasts and limbs contrast with the heavy, textured folds of drapery circling her upper arms and right leg. Lachaise nickel-plated the skin, with the exception of the hair, eyes, lips, nipples, and pubic area, which have the same patination as the drapery.[1] *Standing Nude* and many other works by Lachaise are both portraits of his beloved and cultlike images of a goddess of fecundity. The statuette relates particularly to two works dating from the previous decade: *La Force Eternelle (Woman with Beads)* (1917; Smith College Museum of Art, Northampton, Mass.) and *Standing Woman with Arms behind Her Back* (ca. 1918; San Diego Museum of Art).[2] All feature a contrapposto stance with weight borne on the figures' right legs and a similar treatment of drapery.

This bronze is part of the Alfred Stieglitz Collection, given to the Metropolitan Museum in 1949 through Georgia O'Keeffe as executrix of his estate.[3] It is on a black onyx base, ¾ inch high. Another bronze cast of *Standing Nude* with a dark patina is owned by the Memorial Art Gallery, University of Rochester, New York.[4]

JMM

EXHIBITIONS

Los Angeles County Museum of Art, December 3, 1963–January 19, 1964; Whitney Museum of American Art, New York, February 18–April 5, 1964, "Gaston Lachaise (1882–1935): Sculpture and Drawings," no. 66.
MMA, "Masterpieces of 50 Centuries," November 14, 1970–February 14, 1971.
Palm Springs Desert Museum, Palm Springs, Calif., "Gaston Lachaise: 100th Anniversary Exhibition, Sculpture and Drawings," November 19–December 19, 1982, no. 34.

1. For color illustrations, see Sam Hunter and David Finn, *Lachaise* (New York: Cross River Press, 1993), pp. 122–23.
2. Nordland 1974, p. 82, ill. pp. 64, 70.
3. For other works by Lachaise that came with the Stieglitz Collection, see cat. nos. 316, 320. *Standing Nude* was exhibited at the Philadelphia Museum of Art in 1944 in "History of an American, Alfred Stieglitz: '291' and After: Selections from the Stieglitz Collection" (no. 195).
4. See *Gaston Lachaise: Sculpture and Drawings,* exh. cat., introduction by Gerald Nordland (Rochester, N.Y.: Memorial Art Gallery, University of Rochester, 1979), no. 26.

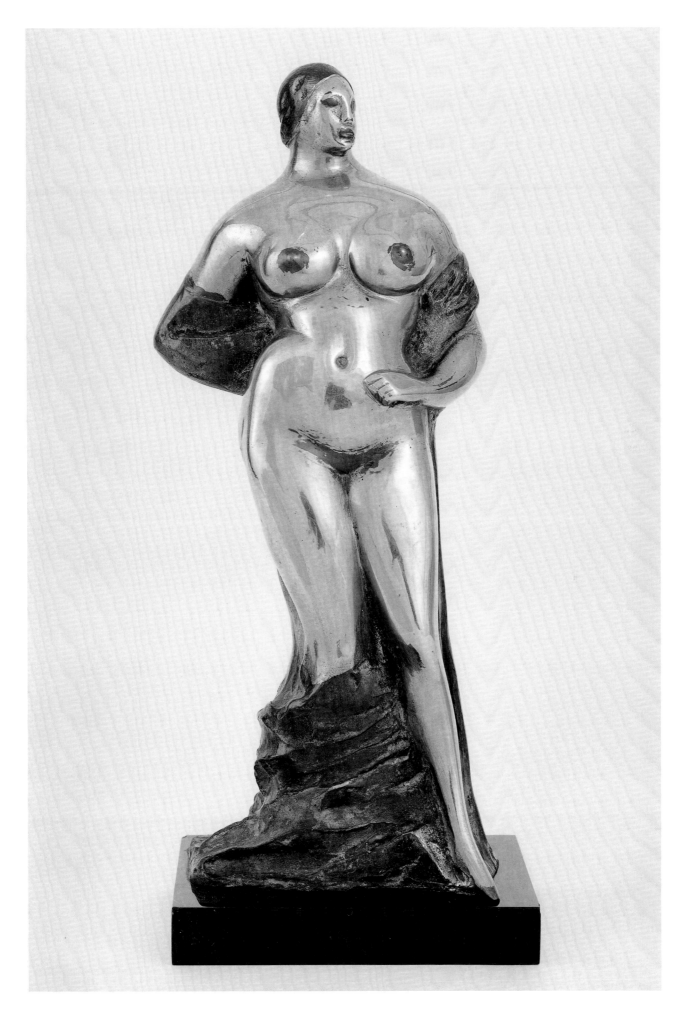

322. *Torso*, 1928

Bronze, after 1928
9¼ x 7¼ x 5 in. (23.5 x 18.4 x 12.7 cm)
Signed (lower edge of figure's right leg): G LACHAISE
Gift of Carl D. Lobell, 1998 (1998.280.1)

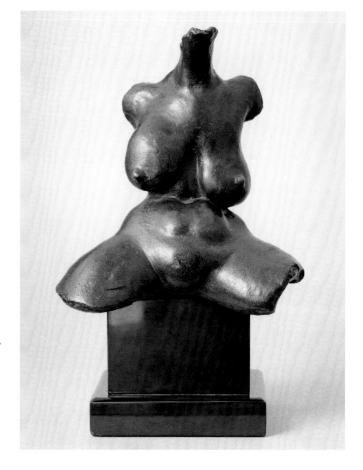

AMONG THE earliest of Lachaise's sculptural fragments, this bronze depicts a dramatically distorted nude torso of a seated female figure with ample breasts and hips. The physical proportions of the model are those of the sculptor's wife, Isabel Dutaud Lachaise, as represented in other sculptures by the artist. Muscular upper thighs, spread widely, emerge from the torso, creating an energetic and provocative pose. The composition, although fully modeled in the front, is a shell in the back.

The date of casting and the provenance of the Metropolitan Museum's bronze are not known. The original plaster, from which authorized posthumous casts have been made since the early 1960s, is in the collection of the Lachaise Foundation.[1]

Torso has a stepped black marble base, 4¼ inches high.

JMM

1. Marie P. Charles, Director, Lachaise Foundation, to Joan M. Marter, January 4, 2000, object files, MMA Department of Modern Art.

323. *Torso*, 1930

Bronze, 1931 or after
11 x 6⅞ x 3 in. (27.9 x 17.5 x 7.6 cm)
Gift of Carl D. Lobell, 1995 (1995.226.1)

IN THE EARLY 1930s Lachaise produced sculpture indicating his preoccupation with body fragments of exaggerated and distorted proportions. *Torso,* a hollow shell, is among these works and depicts enlarged buttocks, a muscular back, and upraised shoulders accentuated by a slender, pinched waist. The support for *Torso* is shaped like a tail or cloven hoof. Although this sculpture adheres to Lachaise's known involvement with the sensuous rendition of the female figure, the small fragment seems more abstract.

According to Gerald Nordland, *Torso* is a literal, though diminutive, rendering of the buttocks and the lower back

of *Standing Woman* (1930–33; Museum of Modern Art, New York) and is more fully realized than the back of *Kneeling Woman* (1932–34; Lachaise Foundation), thus relating it to other studies of the sculptor's wife, Isabel Dutaud Lachaise.[1] A bronze cast of similar dimensions has been in the collection of the Whitney Museum of American Art since 1958.[2] Another polished-bronze cast, measuring slightly larger, is owned by the Lachaise Foundation.[3]

The Metropolitan Museum's *Torso* is accompanied by a black marble base, 1 inch high.

JMM

EXHIBITION

MMA, "The Human Figure in Transition, 1900–1945: American
 Sculpture from the Museum's Collection," April 15, 1997–
 March 29, 1998.

1. Nordland 1974, p. 144–45. Both are illustrated, including back
 views, in Sam Hunter and David Finn, *Lachaise* (New York: Cross
 River Press, 1993), pp. 160–65.
2. See Patterson Sims, *Gaston Lachaise: A Concentration of Works from
 the Permanent Collection of the Whitney Museum of American Art,* exh.
 cat. (New York: Whitney Museum of American Art, 1980), p. 28.
3. See *Gaston Lachaise* 1998, no. 35.

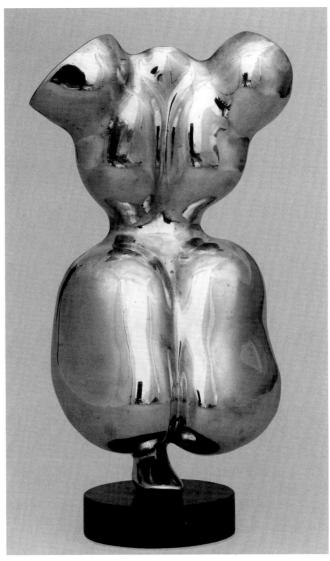

323

324. *Knees,* 1933

Bronze, 1946
13 x 12½ x 11 in. (33 x 31.8 x 27.9 cm)
Bequest of Miss Adelaide Milton de Groot (1876–1967), 1967 (67.187.171)

THROUGH THE use of an unusual composition—a pair of
legs, bent at the knee, from midcalf to midthigh—Lachaise
created yet another fragment of his personal Venus, his wife,
Isabel Dutaud Lachaise. The knees, suggesting an ample
figure in a seated position, have a provocative, sensuous
reality as light playing on the striated surfaces enhances
the skillfully modeled volumes. This work and Lachaise's
other figurative fragments have been described by Gerald
Nordland as "hav[ing] the power to startle with their ob-
sessive and emotional investigations of female anatomy."[1]

A white marble carving of *Knees,* created for Edward
M. M. Warburg in 1933, is now at the Museum of Modern
Art, New York. The Metropolitan Museum's bronze was cast
in 1946 from a plaster model now owned by the Lachaise

Foundation.[2] Nordland has suggested that this posthumous
bronze cast was authorized by Mme Lachaise for a Lachaise
exhibition organized by Lincoln Kirstein at Knoedler
Galleries in January–February 1947.[3]

Knees was on loan to the Metropolitan Museum from
1947 until it was bequeathed to the Museum by Adelaide
Milton de Groot.[4] Miss de Groot's outstanding collection
of American art included sixty paintings by such artists
as Thomas Eakins, Winslow Homer, William Merritt
Chase, and Arthur B. Davies, and two sculptures, Lachaise's
Knees and John Flannagan's stone *Wildcat* (ca. 1926–30;
acc. no. 67.187.162).

Knees is accompanied by a marble base, 3¼ inches high.

JMM

EXHIBITION

"The Figure in 20th Century American Art: Selections from The Metropolitan Museum of Art," traveling exhibition organized by the MMA and the American Federation of Arts, New York, February 1985–June 1986.

1. Nordland 1974, p. 151.
2. Marie P. Charles, Curator, Lachaise Foundation, to Sabine Rewald,

Assistant Curator, Department of Twentieth Century Art, October 16, 1985, object files, MMA Department of Modern Art.
3. Nordland to Joan M. Marter, October 6, 1999, object files, MMA Department of Modern Art; and *Gaston Lachaise (1882–1935): Exhibition,* introduction by Lincoln Kirstein (New York: M. Knoedler and Co., 1947), p. 18, no. 36 (both the bronze and plaster were included).
4. "Ninety-eighth Annual Report," *MMA Bulletin* 27 (October 1968), pp. 52, 70, 71, 82. On Miss de Groot, see her obituary, *New York Times,* June 24, 1967, p. 29.

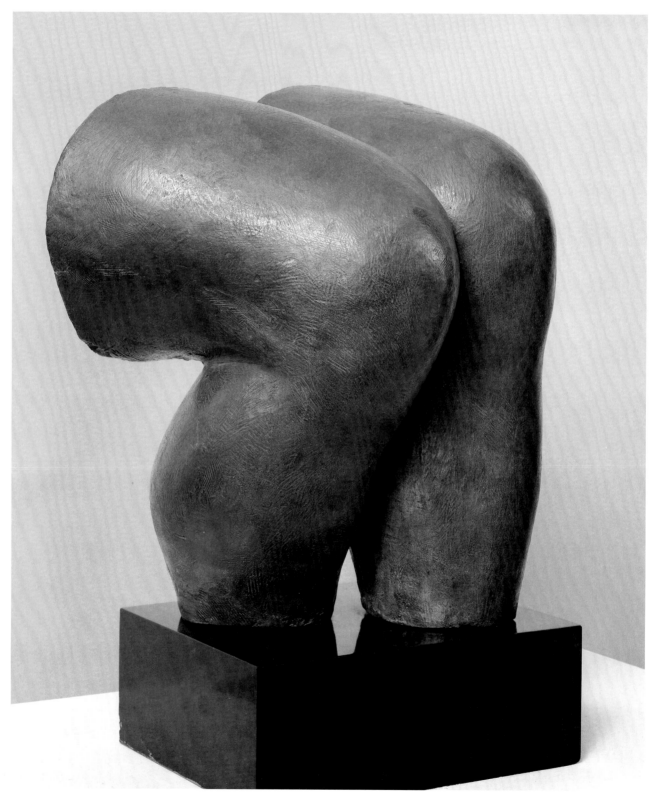

324

Elie Nadelman (1882–1946)

Nadelman, born to a cultured family in Warsaw, Poland, had some formal art training at the Warsaw Art Academy about 1899. After voluntary service in the imperial Russian army (1900–1901), he returned to the Warsaw Art Academy for a year. On a six-month trip to Munich in 1903–4, he was attracted to eighteenth- and nineteenth-century dolls at the Bayerisches Nationalmuseum, as well as classical Greek sculpture at the National Museum of Antique Sculpture (Staatliches Antikensammlungen und Glyptotek). He also became familiar with the Jugendstil movement in that city. In 1904 Nadelman moved to Paris, where he participated briefly in drawing classes at the Académie Colarossi. In Paris Nadelman continued his study of antiquities, and he was also favorably impressed by the sculpture of Michelangelo and Auguste Rodin and the paintings of Georges Seurat. He made the acquaintance of such modern artists as Pablo Picasso, Constantin Brancusi, and Amedeo Modigliani, and Leo and Gertrude Stein became his patrons. Nadelman was progressive in his experimentation with the abstraction of form while maintaining the figure as the basis of his art. His sculptures and drawings (titled *Rapports des formes* and *Recherches des volumes*) of the period reflect a mannered simplification of anatomical features and the development of his trademark curving and countercurving treatment of form.

Nadelman exhibited at the Salon d'Automne from 1905 to 1907 and at the Salon des Indépendants in 1907. His first solo exhibition, held at the Galerie Druet in Paris in April–May 1909, met with great success. Two years later, after being shown in Barcelona, his work also appeared at Paterson's Gallery in London, where the entire exhibition was purchased by Helena Rubinstein, the cosmetics manufacturer and art patron, who commissioned him to create figures and reliefs for her London house. In February 1913 twelve of Nadelman's drawings and a proto-Cubist plaster head of a male (ca. 1908; destroyed) were exhibited in New York at the Armory Show. The following year his *Vers l'unité plastique,* a compilation of facsimiles of fifty drawings, was published in Paris (reissued in New York in 1921 as *Vers la beauté plastique*).

With Helena Rubinstein's assistance, Nadelman, by now an eminent modernist, immigrated to the United States in 1914 following the outbreak of World War I. (He became an American citizen in 1927.) His first New York exhibition was held at Alfred Stieglitz's Photo-Secession Gallery ("291") in December 1915–January 1916. Another successful exhibition was held in 1917 at Scott and Fowles Gallery, and Nadelman was quickly assimilated into New York's avant-garde art world as his reputation as a modern sculptor con-

tinued to grow and his work steadily entered private and public American collections. He was a member of the artists' Penguin Club, and a friend of Gertrude Vanderbilt Whitney (pp. 592–95), critics Henry McBride and Martin Birnbaum, and artist Florine Stettheimer and her circle.

Nadelman's sculpture is a successful blend of classicism and mannerism tempered by the naïveté of folk art. The artist experimented in a variety of media, including bronze, wood, marble, plaster, papier-mâché, and his own "galvano-plastique" (plaster encased in a thin electroplating of metal to resemble bronze). He developed a highly personal style characterized by elegant, curvilinear volume and was known for his so-called significant form (a term later popularized by Clive Bell), which he defined in an essay for Stieglitz's *Camera Work* (October 1910): "The subject of any work of art is for me nothing but a pretext for creating significant form, relations of forms which create a new life that has nothing to do with life in nature, a life from which art is born, and from which spring style and unity." Nadelman is perhaps best known for his rhythmic and often witty figures of entertainers and socialites completed in polychrome wood, such as *Woman at the Piano* (1917; Museum of Modern Art, New York) or *Tango* (ca. 1919; Whitney Museum of American Art, New York).

In 1919 Nadelman married Viola Flannery, a wealthy widow, and they purchased an estate, Alderbrook, in Riverdale, the Bronx, New York, as well as maintained a Manhattan residence. During the 1920s the Nadelmans collected American and European folk art and handicrafts, amassing a collection of some seventy thousand objects. Between 1924 and 1926 they constructed a museum on their Riverdale property to house their collection, which opened as the Museum of Folk and Peasant Arts (later the Museum of Folk Arts). The depression brought the Nadelmans severe financial reverses, and their collection was sold in 1937. After 1930, when Nadelman had his final one-artist exhibition at the Galerie Bernheim-Jeune in Paris, he all but withdrew from the art scene. Nevertheless, between 1929 and 1933 he received architectural commissions for New York City: a limestone overdoor (1930–32) for the Fuller Building at 57th Street and Madison Avenue, a bronze *Aquarius* (1933) for the Bank of the Manhattan Company (later Chase Manhattan Bank) at 40 Wall Street, and a bronze eagle (1933) for the First National Bank, Broadway at Wall Street. He modeled two pairs of female figures in papier-mâché, *Two Circus Women* (ca. 1930) and *Two Female Nudes* (ca. 1931), which in 1965 were enlarged in marble for the New York State Theater at Lincoln Center. From the late 1930s until his death in 1946 he created more than four hundred small doll-like

figures in plastiline (see cat. nos. 334–45) and cast many of them in plaster. During World War II, despite a heart condition, Nadelman served as an air warden in Riverdale, and for two years he volunteered teaching ceramics and modeling to wounded soldiers at the Bronx Veterans' Hospital.

JMM

SELECTED BIBLIOGRAPHY

Nadelman, Elie, Papers. Archives of American Art, Smithsonian Institution, Washington, D.C., microfilm reel 2103.

Salmon, André. "Éli Nadelman." *L'art décoratif* 16 (March 1914), pp. 107–14.

Kirstein, Lincoln. *The Sculpture of Elie Nadelman*. Exh. cat. New York: Museum of Modern Art, 1948.

Spear, Athena T. "Elie Nadelman's Early Heads (1905–1911)." *Allen Memorial Art Museum Bulletin* 28 (Spring 1971), pp. 201–22.

Spear, Athena T. "The Multiple Styles of Elie Nadelman: Drawings and Figure Sculptures ca. 1905–12." *Allen Memorial Art Museum Bulletin* 31 (1973–74), pp. 34–58.

Kirstein, Lincoln. *Elie Nadelman*. New York: Eakins Press, 1973.

Baur, John I. H. *The Sculpture and Drawings of Elie Nadelman (1882–1946)*. Exh. cat. Chronology by Hayden Herrera. New York: Whitney Museum of American Art, 1975.

Kertess, Klaus. "Child's Play: The Late Work of Elie Nadelman." *Artforum* 23 (March 1985), pp. 64–67.

Goodman, Jonathan. "The Idealism of Elie Nadelman." *Arts Magazine* 63 (February 1989), pp. 54–59.

Nadelman, Cynthia. "The Shocking Blue Hair of Elie Nadelman." *American Heritage* 40 (March 1989), pp. 80–91.

Oaklander, Christine I. "Pioneers in Folk Art Collecting: Elie & Viola Nadelman." *Folk Art* 17 (Fall 1992), pp. 48–55.

Kramer, Hilton. *Elie Nadelman*. Exh. cat. Foreword by Cynthia Nadelman. New York: Salander-O'Reilly Galleries, 1996.

Junceau, Brandt, Klaus Kertess, Arlene Shechet, and Kiki Smith. *Elie Nadelman (1882–1946): The Late Work*. Exh. cat. New York: Salander-O'Reilly Galleries, 1999.

325. *Female Head,* ca. 1908

Marble

17½ x 8¾ x 12 in. (44.5 x 22.2 x 30.5 cm), including artificial stone base, H. 4¾ in.

Signed (edge of neck, right side): ELI NADELMAN

Gift of Mala Rubinstein Silson, 1992 (1992.211)

THIS MARBLE is one of the earliest in a group of female heads that Nadelman created in Paris beginning about 1905; the majority of them, highly polished and classicizing, were made between 1908 and 1911. Aloof, expressionless, the head is tilted, eyes closed, and lips together. A stylized coiffeur features "bands of hair divided into oblong units radiating around the forehead" and three successive bands leading at the back to a downward-twisting chignon; this motif was favored by the artist in several heads from this period.[1] The head represents an ideal, pure beauty that is remote from life itself. Nadelman's biographer and friend Lincoln Kirstein characterized the artist's early heads as "whole, perfect, precious; their final completeness was indeed a cosmetic improvement on museum pieces pitted and fragmented with time."[2] In *Female Head* the abstract harmony of forms and subtlety of detail show an indebtedness to classical Greek art but are also an homage to the classicism of the modern period. Nadelman's archaisms represented a personal vision, but he also offered them as a counteroffensive to recent developments in modern sculpture, such as Italian Futurism, which had condemned neoclassicism and called for the destruction of the art of the past.

Female Head has been dated variously: by Athena T. Spear, about 1908, and by Kirstein, 1909–10.[3] Spear established that at least thirteen carved heads by Nadelman were

included in his first exhibition at the Galerie Druet in Paris in 1909.[4] If the Metropolitan's head was not in that exhibition, it was completed in time for Nadelman's solo show at Paterson's Gallery in London in April 1911. *Female Head* was reproduced in *Black and White,* a London newspaper, on April 1, 1911, with the title *La Mystérieuse.*[5] The entire exhibition was purchased by Helena Rubinstein. Her daughter Mala Rubinstein Silson is the donor of *Female Head.*

Another version of *Female Head,* dated about 1908–9, is in the Nadelman Estate.[6] JMM

EXHIBITION

MMA, "Some Women," December 6, 1996–April 13, 1997.

1. Spear 1971, p. 212.
2. Kirstein 1973, p. 179.
3. Spear 1971, p. 213, fig. 11, which illustrates the version in the Nadelman Estate; and Lincoln Kirstein, *Elie Nadelman Drawings* (New York: H. Bittner and Co., 1949), p. 38, fig. i, ill. p. 15.
4. Spear 1971, p. 201, n. 2.
5. Ibid., p. 214, n. 19. *La Mystérieuse* was a title favored by Nadelman and used for several of his heads at different times; see Kirstein 1973, no. 26, pp. 290–91.
6. See *Elie Nadelman (1882–1946)* (New York: Salander-O'Reilly Galleries, 1997), no. 12.

326. *Standing Female,* ca. 1908

Bronze, gilt
28¼ x 9 x 13½ in. (71.8 x 22.9 x 34.3 cm)
Foundry mark (back of base): Colonelle Fondeur Paris
Gift of Mr. and Mrs. Martin Horwitz, 1975 (1975.426)

NADELMAN'S EARLY standing figures, produced contemporaneously with his classically inspired heads of 1905–11, fall into two categories: segmented (or proto-Cubist), and tubular.[1] *Standing Female,* with its tiny head, elongated limbs, and smooth, unified surface, exemplifies the tubular style found in a small group of nudes completed at this time. The simplified facial features, stylized cap of hair, and fluid volumes of the body combine to form this sexually ambiguous striding figure.

Standing Female has also been identified as *Neutral Figure* and *Standing Female Figure.*[2] According to Lincoln Kirstein, who for a time owned this bronze, it was one of the standing nudes included in Nadelman's first solo exhibition at the Galerie Druet in Paris in 1909.[3] At the time *Standing Female* was offered to the Metropolitan Museum as a gift, it was included in the 1975–76 retrospective exhibition of Nadelman's work at the Whitney Museum of American Art, New York, and the Hirshhorn Museum and Sculpture Garden, Washington, D.C.[4] JMM

EXHIBITIONS

Storm King Art Center, Mountainville, N.Y., "20th Century Sculpture: Selections from The Metropolitan Museum of Art," May 18–October 31, 1984.
MMA, "The Human Figure in Transition, 1900–1945: American Sculpture from the Museum's Collection," April 15, 1997–March 29, 1998.

1. Spear 1973–74, p. 42. For examples of other tubular nudes, of which Spear notes there are at least four, see figs. 9, "Pea-Headed Nude," 1907–8, Dr. Jerome Forman, Chicago; and 11, "Semi-Seated Tubular Nude," 1909–10, Baltimore Museum of Art. Spear documents examples in marble, bronze, wood, and plaster.
2. Ibid., pp. 42–43, as "Neutral Figure," 1908; and Kirstein 1973, p. 295, no. 78, as "Standing Female Nude," ca. 1907.
3. Kirstein 1973, p. 295, no. 78.
4. Baur 1975, p. 27, no. 9, which notes the owner as Robert Schoelkopf Gallery, New York; and donor Martin Horwitz to Henry Geldzahler, Curator, Department of Twentieth Century Art, December 10, 1975, MMA Archives.

692 ELIE NADELMAN

327. *Horse and Figure,* ca. 1912

Bronze
7¾ x 10¾ in. (19.7 x 27.3 cm)
Signed (upper left): *EN*
Bequest of Scofield Thayer, 1982 (1984.433.37)

THE DECORATIVE curvilinear effects seen in *Horse and Figure* and *Woman on a Horse* (cat. no. 328) derive from a series of spirited drawings of equestrian subjects. A related ink drawing of a reclining horse also can be dated about 1912 (private collection).[1] These two elegant bronzes belong to a group of plaques of horses that Nadelman created about 1912, when he was making these drawings and a series of terracotta high reliefs depicting the Four Seasons for the billiard room of Helena Rubinstein's London home.[2] Sources of inspiration for these drawn and sculpted images may have been the bullfights in Barcelona and the prehistoric cave paintings around Les Eyzies-de-Tayac, in the Dordogne department of France, which Nadelman saw the previous year.[3] A cast of *Horse and Figure* was included in Nadelman's solo exhibition at Stieglitz's "291" Gallery in 1915–16.[4]

Horse and Figure, Woman on a Horse, and *Horse* (cat. no. 329) were simultaneously purchased by Scofield Thayer in 1923 from the Galerie Flechtheim in Berlin.[5] Thayer was editor and co-owner of *The Dial,* by then an avant-garde magazine of arts and letters, from 1920 to 1926, and adviser from 1927 until it ceased publication in 1929. During the early 1920s Thayer accumulated an exceptional collection of more than five hundred early European and American modern paintings, works on paper, and sculptures to be used as a source of illustrations for *The Dial.* Selections from the Dial Collection were published in a portfolio of reproductions, *Living Art,* in 1923.[6] The portfolio was printed in Berlin, about the same time Thayer, then living in Vienna, purchased the two reliefs and *Horse.* The following year the Dial Collection was exhibited at the Montross Gallery, New York; Worcester Art Museum, Massachusetts; and Hillyer Art Gallery, Smith College, Northampton, Massachusetts. Most of the collection returned in the 1930s to the Worcester Art Museum in the city of Thayer's birth, where it remained on long-term loan.[7] Upon Thayer's death in 1982, his collection, then consisting of 343 works, was bequeathed to the Metropolitan Museum (see also cat. nos. 307, 308, 313, 314, 318, 319, 328, 329). JMM

EXHIBITIONS

MMA, "Selection Three: 20th Century Art," October 22, 1985–January 26, 1986.
MMA, Henry R. Luce Center for the Study of American Art, "American Relief Sculpture," August 15–November 5, 1995.

1. Baur 1975, no. 124, p. 110. In addition, a linoleum cut *Horse* (ca. 1907–9; MMA acc. nos. 50.624.1, 51.603.35) is compositionally similar but lacks the standing figure. It was shown at the Galerie Druet, Paris, in 1909 and at "291," New York, in 1915–16; see Kirstein 1973, p. 319.
2. Kirstein 1973, p. 193.
3. Ibid., p. 198.
4. *Horse and Figure* was illustrated in an installation view in "Exhibition 'Arrangements' at '291,'" *Camera Work* 48 (October 1916), p. 68; and reproduced in "Current News of Art and Exhibitions," *New York Sun,* December 15, 1915, 3rd sec., p. 7.
5. *The Dial and the Dial Collection,* exh. cat. (Worcester, Mass.: Worcester Art Museum, 1959), p. 82, no. 68.
6. *Living Art: Twenty Facsimile Reproductions after Paintings, Drawings and Engravings and Ten Photographs after Sculpture by Contemporary Artists* (New York: Dial Publishing Co., 1923).
 On *The Dial* and the Dial Collection, see Nicholas Joost, *Scofield Thayer and The Dial: An Illustrated History* (Carbondale: Southern Illinois University Press, 1964); and Joost, "The Dial Collection: Tastes and Trends of the 'Twenties,'" *Apollo* 94 (December 1971), pp. 488–95.
7. The loan of the collection inspired exhibitions at the Worcester Art Museum: "*The Dial* and the Dial Collection," April 30–September 8, 1959 (included cat. nos. 327–29); "Selections from the Dial Collection," November 13–30, 1965 (included cat. nos. 327, 329); "The Dial Revisited," June 29–August 22, 1971; and " 'The Dial': Arts and Letters in the 1920s," March 7–May 10, 1981 (included cat. nos. 327–29).

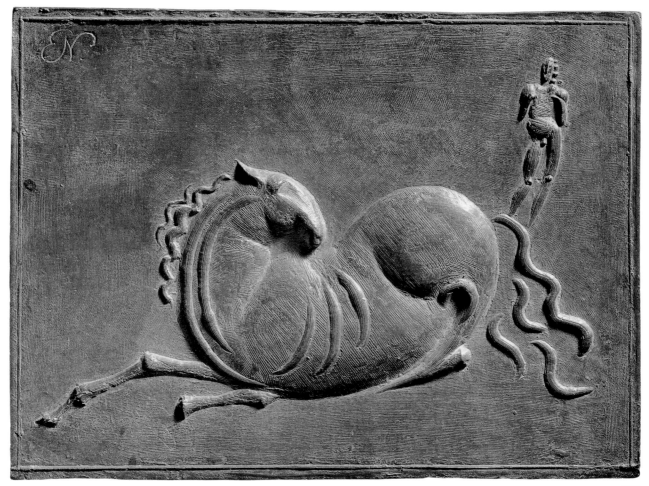

327

328

328. *Woman on a Horse,* ca. 1912

Bronze
7 x 7½ in. (17.8 x 19.1 cm)
Bequest of Scofield Thayer, 1982 (1984.433.38)

BECAUSE THE creation of a relief allowed for a combination of drawing and modeling skills, Nadelman was able to infuse his plaques with the same energetic, rhythmic quality that informs his drawings, while also evoking sculptural volume. This panel and *Horse and Figure* (cat. no. 327) are executed in a style relating to his contemporaneous tubular figures (see cat. no. 326). Related drawings suggest the lyricism with which Nadelman conceived his images of horses with female riders. According to Lincoln Kirstein, Nadelman "translated" these drawings using "thin rolls of clay with which he indicated a two-dimensional draftsmanship finally projected into voluminous rondures."[1]

Woman on a Horse was acquired for the Dial Collection by Scofield Thayer in 1923 from the Galerie Flechtheim in Berlin (see cat. no. 327).[2] From 1936 until Thayer's death in 1982 it was on deposit at the Worcester Art Museum and was included in museum exhibitions of the Dial Collection in 1959 and 1981.[3]

JMM

EXHIBITIONS

MMA, "Selection Three: 20th Century Art," October 22, 1985–
 January 26, 1986.
MMA, Henry R. Luce Center for the Study of American Art,
 "American Relief Sculpture," August 15–November 5, 1995.

1. Kirstein 1973, p. 189.
2. *The Dial and the Dial Collection,* exh. cat. (Worcester, Mass.:
 Worcester Art Museum, 1959), p. 82, no. 69.
3. See cat. no. 327, note 7.

329. *Horse,* ca. 1914

Bronze
13½ x 13¾ x 3⅝ in. (34.3 x 34.9 x 9.2 cm)
Signed (back of base): *Eli Nadelman*
Foundry mark (side of base, near horse's hind legs): ALEXIS RUDIER. / Fondeur PARIS.
Bequest of Scofield Thayer, 1982 (1984.433.39)

HORSE IS AN exercise in the expressive use of line, with all anatomic details suppressed or adjusted to form a composition of graceful, sweeping curves. Two experiences, Nadelman's attending bullfights in Barcelona in 1911 and seeing the prehistoric cave paintings of animals in the Dordogne, led to his very personal stylized designs for bulls, cows, horses, and hounds. This *Horse,* with its weight on its spindly rear legs, is one of a number of equestrian sculptures Nadelman created after his Barcelona sojourn.

After viewing *Horse* in a non-juried exhibition in Berlin in January 1923, Scofield Thayer purchased it from the Galerie Flechtheim (see cat. no. 327).[1] Writing to Albert Flechtheim, Thayer, who then held an equivocal opinion of the sculptor, called *Horse* "characteristic and amusing, if like all Nadelmann's [*sic*] work, not so very subtle."[2]

A related pen-and-ink wash drawing (ca. 1913–14; Baltimore Museum of Art) features the same lilting pose and emphasis on curvilinear volume.[3] Another statuette of a horse, also dated to about 1914, is more static in composition and erect in posture (Hirshhorn Museum and Sculpture Garden, Washington, D.C.).[4]

The Metropolitan Museum's *Horse* was on deposit at the Worcester Art Museum from 1936 until Thayer's death in 1982 as part of the Dial Collection, where it was exhibited with the collection in 1959, 1965, and 1981.[5] The bronze is mounted on a red marble base, 2¾ inches high.

JMM

EXHIBITION

MMA, "Selection Three: 20th Century Art," October 22, 1985–
 January 26, 1986.

1. *The Dial and the Dial Collection,* exh. cat. (Worcester, Mass.:
 Worcester Art Museum, 1959), p. 82, no. 70; and Kirstein 1973,
 pp. 304–5, no. 180, and p. 335, no. 141.
2. Thayer to Flechtheim, February 16, 1923 (copy), Dial/Scofield

329

Thayer Papers, Yale Collection of American Literature, Beinecke Rare Book and Manuscript Library, Yale University, New Haven. A letter from Thayer to Flechtheim, March 26, 1923 (copy), notes that he is sending payment for the three Nadelman sculptures and a drawing and requests that all be shipped to Hermann P. Riccius, Worcester, Massachusetts.

Horse was illustrated in The Dial in October 1928 (vol. 85,

facing p. 271), during Marianne Moore's tenure as editor and Thayer's as adviser.

3. Baur 1975, p. 112, no. 126. A similar pen-and-ink drawing is in Kirstein 1973, p. 317, no. 144, pl. 52.
4. Kirstein 1973, p. 305, no. 181, pl. 55. This is a reduction after a plaster horse that was owned by Helena Rubinstein before 1914.
5. See cat. no. 327, note 7.

330. Marie P. Scott, 1916[1]

Marble
28¼ x 14¼ x 11 in. (71.8 x 36.2 x 27.9 cm)
Signed (back, lower edge of dress): ELIE NADELMAN
Gift of Mrs. Stevenson Scott, 1946 (46.51)

IN STYLE, Marie P. Scott, also known as Portrait of a Little Girl, is reminiscent of Nadelman's earlier tubular figures. The manner in which the subject's arms curve out from her body suggests a denial of their underlying anatomical structure, and the features of her face seem generalized rather than an exact likeness.

Marie Scott was the daughter of Stevenson Scott, the senior partner of Scott and Fowles Gallery, Nadelman's New York dealer from 1915 to 1925. About 1915–16 the artist made a number of drawings of the little girl before he carved the half-length marble figure.[2] In addition, Nadelman completed marble busts of the sitter's father (ca. 1916; Joslyn Art Museum, Omaha, Nebr.) and mother, also named Marie (1919; Los Angeles County Museum of Art).

The first work by Nadelman to enter the Metropolitan Museum's collection, Marie P. Scott is accompanied by a marble base, 2 inches high. JMM

EXHIBITIONS

Whitney Museum of American Art, New York, "The Metropolitan Museum and Whitney Museum Acquisitions from 1943 to 1946," September 17–October 3, 1946.
MMA, "Three Centuries of American Painting," April 9–October 17, 1965.
Whitney Museum of American Art, New York, September 23–November 30, 1975; Hirshhorn Museum and Sculpture Garden, Washington, D.C., December 18, 1975–February 15, 1976, "The Sculpture and Drawings of Elie Nadelman, 1882–1946," no. 54.
MMA, "As They Were: 1900–1929," April 9–September 8, 1996.

1. Although Nadelman dated the portrait 1920, on an artist information form, February 28, 1946, MMA Archives, scholars have assigned the piece to 1916, when he completed drawings of his subject; see Kirstein 1973, p. 303, no. 166; and Baur 1975, pp. 63–64, no. 54.
2. Kirstein 1973, pp. 149, 303, pl. 84, drawing dated 1915.

331. *Julia Gardiner Gayley,* ca. 1918

Marble
23 x 19½ x 13 in. (58.4 x 49.5 x 33 cm)
Signed (back of sitter's left shoulder): ELIE NADELMAN
Gift of Mrs. Francis G. Coleman and Mrs. Charles H. Erhart Jr.,
1980 (1980.368)

AFTER A highly successful exhibition of his work at
the Scott and Fowles Gallery, New York, in 1917,
Nadelman received many portrait commissions, com-
pleting some two dozen busts of men, women, and chil-
dren between 1915 and 1935.[1] The fashionable members of
New York society regarded him as the latest exponent
of Parisian modernism. This portrait of Julia Gardiner
Gayley is an excellent example of the elegant style the
sculptor perfected to represent his sitters; she wears a
double strand of beads and an off-the-shoulder bodice.
The style he favored suggests links to the classical tradi-
tion of portraiture combined with the tasteful natural-
ism his clients preferred. Nadelman's ability to imbue

the figure with a rarefied grace led Lincoln Kirstein
to designate his portraits "souvenirs of . . . American
affluence."[2]

Julia Gardiner Gayley (ca. 1867–1937) was the mother
of the donors and the great-aunt of Ashton Hawkins,
Executive Vice President and Counsel to the Trustees of
the Metropolitan Museum. She was married from 1884 to
1910 to James Gayley, an executive with Carnegie Steel
and after 1901 U.S. Steel. In 1920 she married Gano
Dunn, an electrical engineer.[3] According to family recol-
lections, she is said to have been a brilliant woman and an
accomplished hostess who maintained an important New
York salon until her death.[4]

Julia Gardiner Gayley was on loan to the Metropolitan Museum between 1975 and 1980 before it was presented as a gift.[5] It surmounts a green marble base, 4 inches high.

JMM

1. Kirstein 1973, p. 304.
2. Ibid., p. 204.

3. Obituary, *New York Times,* May 13, 1937, p. 25; *American National Biography,* s.v. "Gayley, James," and "Dunn, Gano Sillich."
4. Ashton Hawkins, Secretary and Counsel, to Thomas B. Hess, Consultative Chairman, Department of Twentieth Century Art, June 21, 1978, object files, MMA Department of Modern Art.
5. Henry Geldzahler, Curator, MMA Department of Twentieth Century Art, to Mrs. Charles H. Erhart, Jr., December 8, 1975, object files, MMA Department of Modern Art.

332. *Robert Sterling Clark,* 1933

Plaster
16¼ x 8 x 10 in. (41.3 x 20.3 x 25.4 cm)
Gift of Lincoln Kirstein, 1970 (1970.127.1)

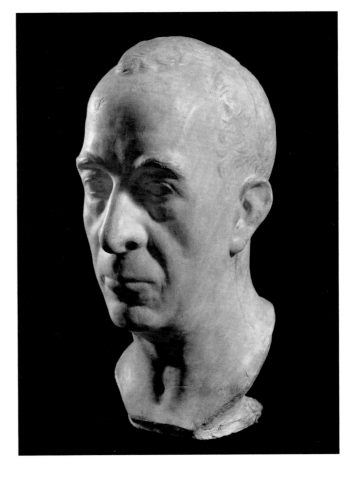

ROBERT STERLING CLARK (1877–1956), an heir to the Singer Sewing Machine Company fortune, settled in Paris in 1911. Over the next several decades he and his wife, Francine, whom he married in 1919, assembled an extraordinary collection of paintings, with a particular preference for nineteenth-century French art. At Clark's insistence the rich scope and extent of the collection remained largely concealed until 1955, when the Sterling and Francine Clark Art Institute opened to the public in Williamstown, Massachusetts.[1]

In a diary entry for February 18, 1929, Clark mentioned that he admired Nadelman's portrait head of Mrs. Stevenson Scott (1919; Los Angeles County Museum of Art).[2] Although he rarely patronized contemporary artists, by 1933 Clark commissioned portraits of himself and his wife. The Metropolitan's plaster head is a version of the marble and bronze replicas now in the collection of the Clark Art Institute (the marble of Mrs. Clark is also there).[3] Nadelman's portrait of the intensely private Clark is unusual for the incisiveness of the likeness, which tempers the cool formality and simplicity of his idealized busts. Of the portraits of himself and his wife, Clark wrote to Nadelman in 1933, "They are great; the best I have seen."[4]

JMM

EXHIBITIONS

Oklahoma Museum of Art, Oklahoma City, "Masters of the Portrait," March 4–April 29, 1979, no. 39, as "Head."
MMA, Junior Museum, "Portraits: A Selection from the Department of Twentieth Century Art," November 25, 1980–February 16, 1981.

1. On Clark and the founding of the museum, see Steven Kern et al., *The Clark: Selections from the Sterling and Francine Clark Art Institute* (New York: Hudson Hills Press, 1996).
2. Margaret C. Conrads, *American Paintings and Sculpture at the Sterling and Francine Clark Art Institute* (New York: Hudson Hills Press, 1990), p. 130. The author notes that the diaries, which are housed in the Clark Art Institute archives, provide little information about the circumstances of the commission.
3. For illustrations of the Clarks' busts in marble and bronze, see ibid., pp. 129, 131. The marble and bronze replicas of Clark were completed concurrently in spring 1933 (p. 130).
4. Clark to Nadelman, May 19, 1933 (copy), Clark Art Institute archives, quoted in Conrads, *American Paintings and Sculpture at the Sterling and Francine Clark Art Institute,* p. 128.

333. *Standing Nude,* ca. 1935–46

Plaster, shellacked
26 x 9 x 6 in. (66 x 22.9 x 15.2 cm)
Gift of Lincoln Kirstein, 1970 (1970.127.2)

334. *Mother and Child,* ca. 1935–46

Terracotta
Incised (on back): 3
Label (back, pasted and lacquered): *EN*; label (back, pasted and lacquered): Inwood Pottery
7½ x 3½ x 3½ in. (19.1 x 8.9 x 8.9 cm)
Gift of Lincoln Kirstein, 1970 (1970.127.3)

335. *Figure (Standing Female Figure),* ca. 1935–46

Plaster
8¼ x 3 x 2 in. (21 x 7.6 x 5.1 cm)
Gift of Lincoln Kirstein, 1970 (1970.127.4)

336. *Standing Figure,* ca. 1935–46

Plaster
9 x 3½ x 1¾ in. (22.9 x 8.9 x 4.5 cm)
Gift of Lincoln Kirstein, 1970 (1970.127.5)

337. *Standing Figure,* ca. 1935–46

Plaster
9 x 3¾ x 2½ in. (22.9 x 9.5 x 6.4 cm)
Gift of Lincoln Kirstein, 1970 (1970.127.6)

338. *Figure,* ca. 1935–46

Plaster
9½ x 3½ x 3 in. (24.1 x 8.9 x 7.6 cm)
Gift of Lincoln Kirstein, 1970 (1970.127.7)

339. *Figure,* ca. 1935–46

Plaster
10½ x 4 x 3¼ in. (26.7 x 10.2 x 8.3 cm)
Gift of Lincoln Kirstein, 1970 (1970.127.8)

340. *Figure,* ca. 1935–46

Plaster
8 x 3½ x 2¼ in. (20.3 x 8.9 x 5.7 cm)
Gift of Lincoln Kirstein, 1970 (1970.127.9)

341. *Figure,* ca. 1935–46

Plaster
9⅛ x 3¾ x 2½ in. (23.2 x 9.5 x 6.4 cm)
Gift of Lincoln Kirstein, 1970 (1970.127.10)

342. *Figure,* ca. 1935–46

Plaster
8¾ x 3¾ x 2½ in. (22.2 x 9.5 x 6.4 cm)
Gift of Lincoln Kirstein, 1970 (1970.127.11)

343. *Figure,* ca. 1935–46

Plaster
9 x 4 x 2¾ in. (22.9 x 10.2 x 7 cm.)
Gift of Lincoln Kirstein, 1970 (1970.127.12)

344. *Figure,* ca. 1935–46

Plaster
13½ x 3½ x 3½ in. (34.3 x 8.9 x 8.9 cm)
Gift of Lincoln Kirstein, 1970 (1970.127.13)

345. *Standing Figure,* ca. 1935–46

Plaster
12½ x 5¼ x 3¼ in. (31.8 x 13.3 x 8.3 cm)
Gift of Lincoln Kirstein, 1970 (1970.127.14)

THESE THIRTEEN doll-like sculptures represent the final chapter of Nadelman's investigations into the human form, which began with early classical heads, then moved to mannered, tubular figures, and to these unarticulated, featureless figurines, of which few are capable of standing. Nearly all focus on the solitary female form, but occasionally (as in the case of cat. no. 334), Nadelman modeled mother-and-child groups. The Metropolitan's figures display a range of treatment: some are dressed, some nude, some static, some in motion, some tubular, and some bulbous. Completed from the mid-1930s to the mid-1940s, they reveal the continuing effect of the artist's student

visits in 1903–4 to the Bayerisches Nationalmuseum in Munich, where he saw the collection of eighteenth- and nineteenth-century dolls. Nadelman was also interested in French nineteenth-century dolls. The European and American folk art that he and his wife began to acquire in the 1920s may have contributed to the inspiration for these lively, expressive figurines. The works relate ultimately to Nadelman's attraction to Greek Tanagra sculpture of the third century B.C. Klaus Kertess noted that "the visible seams of the mold's closure and the features seemingly blurred in the flow of material into the mold blend Antique grace with the honest directness of many

of the turn-of-the-century cast-iron toys and banks in Nadelman's own collection."[1]

Because of the financial reverses he suffered in the depression, Nadelman was no longer able to afford to work in marble or bronze or to employ assistants, so he began to create small figures in plastiline, a clay mixed with oil or wax so it does not harden. From 1935, when he and his wife decided to sell their folk art collection and Nadelman gave up his kiln and studio, until his death eleven years later, he modeled more than four hundred entirely by hand. Many were then cast in plaster or terracotta and were intended as finished works. If he made more than one figure from a mold, he changed its appearance: on some, he penciled, carved, or filed details or features; on others, he used varnish to vary surface appearance. Nadelman planned to replicate the figurines in inexpensive editions, but that project was never realized. JMM

EXHIBITIONS

New York Cultural Center in association with Fairleigh Dickinson University, "Grand Reserves: A Collection of 235 Objects from the Reserves of Fifteen New York Museums and Public Collections," October 24–December 8, 1974 (cat. nos. 335–43, 345).
MMA, "The Human Figure in Transition, 1900–1945: American Sculpture from the Museum's Collection," April 15, 1997–March 29, 1998 (cat. no. 333).

1. Kertess 1985, p. 65. For additional consideration of Nadelman's late work, see Junceau et al. 1999.

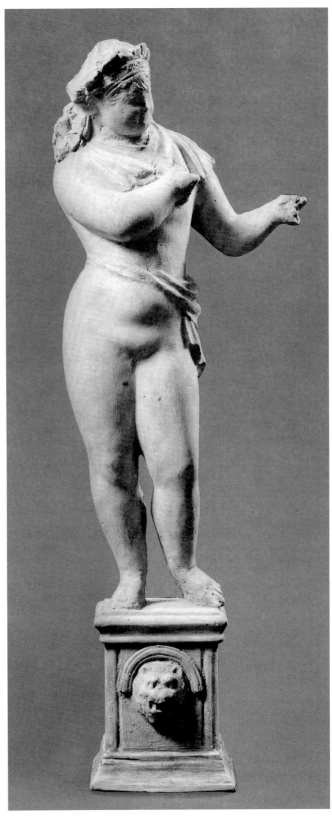

333

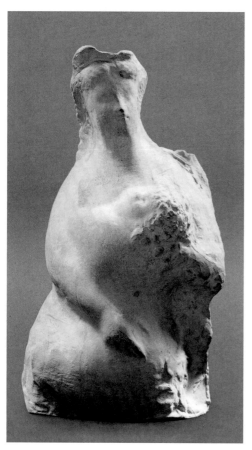

334

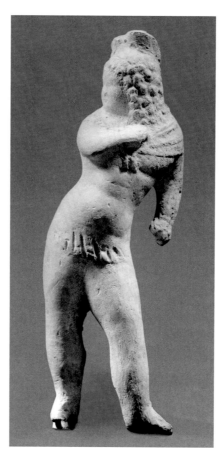

335

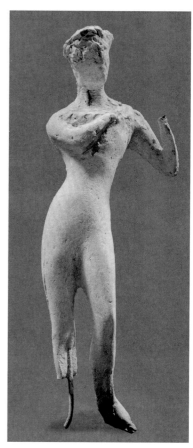

336

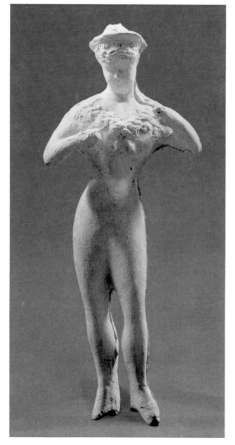

337

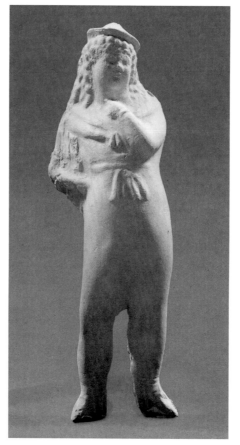

338

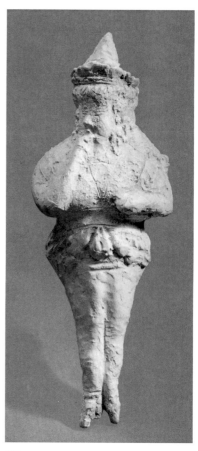

339

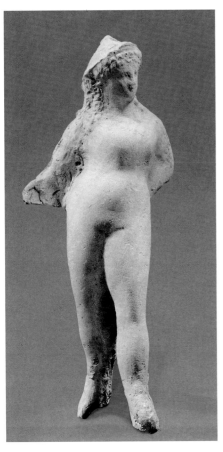

340

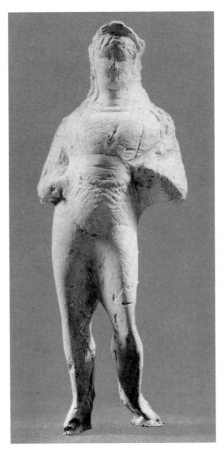

341

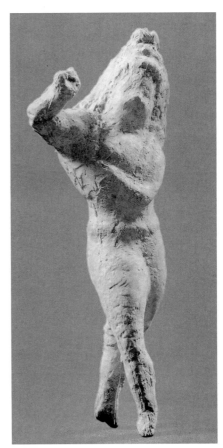

342

343

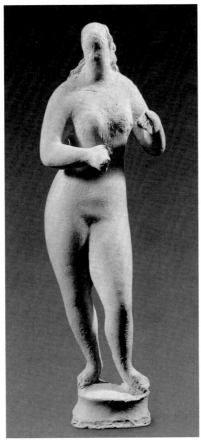

344

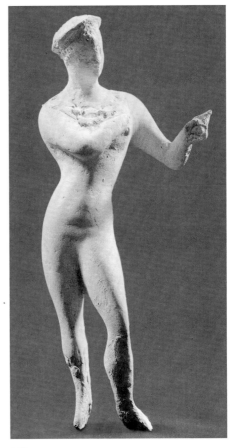

345

Jo Davidson (1883–1952)

Davidson, born in New York City to Russian Jewish immigrants, enrolled in drawing classes at the Educational Alliance and studied on a scholarship for a year at the Art Students League with George de Forest Brush, George Bridgman, and Bryson Burroughs. About 1902 Davidson moved to New Haven, Connecticut, and while preparing to enter medical school, attended Yale University's art school.

Discovering a great interest in working in clay, Davidson abandoned his plans to study medicine and returned to the Art Students League, enrolling in modeling classes. About 1903 he worked as a studio assistant for Hermon Atkins MacNeil (pp. 475–81). Davidson earned a little money making portrait drawings and finally received his first commission, for a figure of David, in 1905. The following year he established his first New York studio and exhibited *Tigers Eating* in the winter exhibition of the National Academy of Design. Realizing that an artist needed to study in Paris, Davidson enrolled at the École des Beaux-Arts in 1907 but remained in the atelier of Jean-Antoine Injalbert for only three weeks. During a three-year stay in Paris, which was marked by financial struggles, he met the sculptor Gertrude Vanderbilt Whitney (pp. 592–95; cat. no. 346), who became his friend and patron. He also got to know other progressive American artists, including Max Weber (pp. 655–56), Alfred Maurer, Edward Steichen, and John Marin, whose portrait bust he completed in 1908 (National Portrait Gallery, Washington, D.C.). To express their discontent with the Society of American Artists in Paris, Davidson and his friends in 1908 formed the New Society of American Artists. Davidson's involvement with this group suggests his commitment to modernism despite the more traditional representational appearance of his portrait heads. In 1909 the exhibition "Modern Illustrators and Statuettes by Jo Davidson" was held at the Baillie Gallery in London.

On his return to New York in 1910, Davidson held his first solo exhibition of drawings and terracotta and bronze sculptures at the New York Cooperative Society, selling several examples. In subsequent years he showed his sculpture at the Glaenzer Galleries in New York and the Reinhardt Galleries in Chicago and New York. At the Armory Show of 1913 Davidson was represented by seven sculptures and ten drawings. By that year he had completed more than thirty naturalistic portrait heads, and this sculptural genre became his personal "obsession" and his lifelong specialty. From the sales and commissions generated from his one-artist shows, Davidson maintained studios in both New York and Paris for a time beginning in 1911. He also worked in London, tapping the rich market for portraits there and attracting commissions from prominent individuals.

A war correspondent for two newspapers during World War I, Davidson made sketches of soldiers and refugees on the Belgian front and allowed his home in Céret, France, to be used as a military hospital. Returning to New York in 1916, he established a studio in the popular artists' locale of Macdougal Alley, held a large exhibition of his sculpture and war drawings at the Reinhardt Galleries, and modeled a portrait bust of President Woodrow Wilson (Princeton University, Princeton, N.J.). In 1918, through a series of portrait busts of the Allied leaders, the first of whom was Marshal Ferdinand Foch (cat. no. 347), Davidson began a "plastic history" of the luminaries of the period, frequently seeking out his sitters rather than waiting for commissions. Among the fourteen military leaders and statesmen he modeled over the next two years as part of his Peace Conference series were General John J. Pershing (1919; National Portrait Gallery) and Georges Clemenceau (1920; Fine Arts Museums of San Francisco). Davidson's iconic seated image of the writer Gertrude Stein (cat. no. 348) is the most renowned of the likenesses of famous literary and political figures he created.

Over the next three decades Davidson was popular and productive, traveling worldwide and living peripatetically in the United States and in France, where he bought a manor house, Bécheron, near Tours. He became celebrated for his portraits of such diverse personalities as John D. Rockefeller (1924), Charlie Chaplin (1925; both at the National Portrait Gallery), and Albert Einstein (1934; Whitney Museum of American Art, New York). Before 1940 Davidson created over a hundred portrait busts in marble, bronze, and terracotta, as well as a considerable number of full-length figure studies; these received less critical attention. In 1929–30, for the book publisher Doubleday, Doran and Company, Davidson modeled ten portraits of distinguished authors writing in English. Among these were James Joyce (cat. no. 350), H. G. Wells (cat. no. 351), and D. H. Lawrence (cat. no. 352); the heads were shown as a group in autumn 1931 at Knoedler in London. In 1939 Davidson's full-length bronze portrait of the cowboy humorist Will Rogers was unveiled in the United States Capitol, and the following year an 8-foot likeness of Walt Whitman was dedicated in Bear Mountain State Park, near West Point, New York. Toward the end of his life, Davidson continued his pattern of travel, going to Spain in 1938 to model portraits of Loyalists in the Spanish civil war and to South America in 1941 to model portraits of ten presidents.

The American Academy of Arts and Letters organized a retrospective exhibition of some two hundred works by Davidson, held between November 1947 and February 1948. The sculptor modeled a portrait of General Dwight D. Eisenhower at the Pentagon in 1948 and in 1951 began a series of portraits of Israeli leaders, including President Chaim Weizmann and Prime Minister David Ben-Gurion. Davidson was named a Chevalier of the French Legion of Honor in 1925 for his Paris Peace Conference series, and in 1944 he was elected to the National Institute of Arts and Letters and an associate academician of the National Academy of Design. JMM

SELECTED BIBLIOGRAPHY

Davidson, Jo, Papers. Manuscript Division, Library of Congress, Washington, D.C.

Griffin, Henry F. "Jo Davidson, Sculptor." *World's Work* 22 (August 1911), pp. 14746–55.

Davidson, Jo. "Tendencies in Sculpture: Asides on Certain of the Modern Sculptor's Professional Problems." *Vanity Fair* 7 (October 16, 1916), p. 73.

Siegrist, Mary. "Jo Davidson—Philosopher in Stone." *Arts and Decoration* 18 (November 1922), pp. 18–19, 86.

Catalogue of the First Retrospective Exhibition of Sculpture by Jo Davidson. New York: American Academy of Arts and Letters/National Institute of Arts and Letters, 1947.

Davidson, Jo. *Between Sittings: An Informal Autobiography.* New York: Dial Press, 1951.

Kuhn, Lois Harris. *The World of Jo Davidson.* New York: Farrar, Straus and Cudahy, 1958.

Jo Davidson Portrait Sculpture. Washington, D.C.: National Portrait Gallery, 1978.

Conner, Janis, and Joel Rosenkranz. *Rediscoveries in American Sculpture: Studio Works, 1893–1939,* pp. 11–18. Austin: University of Texas Press, 1989.

346. *Gertrude Vanderbilt Whitney,* 1916

Bronze, 1982
23 x 14½ x 7½ in. (58.4 x 36.8 x 19.1 cm)
Signed and dated (back of sitter's left shoulder):
JO DAVIDSON / NY 1916
Gift of Dr. Maury P. Leibovitz, 1982 (1982.511.5)

GERTRUDE VANDERBILT WHITNEY (1875–1942; pp. 592–95), a sculptor and a patron of the arts, met Davidson in Paris in 1908. Later that year she lent his *Study of a Head* to the winter exhibition of the National Academy of Design (this was possibly the bust of a young girl that Davidson recalls in his *Autobiography* as the first work he sold in Paris).[1] Whitney's patronage continued in New York with her purchase of a bronze torso and three drawings from Davidson's exhibition at the Glaenzer Galleries in 1911.[2] After Davidson returned to New York in 1916, Whitney arranged for him to rent a studio in Macdougal Alley near her own. Years later, Davidson wrote: "[S]he found many imaginative ways of bringing artists together. I recall one particular affair. Mrs. Whitney and Mrs. [Juliana] Force invited some painters and sculptors to the studio on Eighth Street. Each was to do his bit, a painting or sculpture to be completed that day. I did a bust of [the painter] Paul Dougherty. We finished up in the evening after the work was done with a party. . . . The following day the works were shown to the public under the title, 'The Works of Indigenous Sculptors and Painters.'"[3]

Davidson's portrait of Whitney is an elegant image of an attractive, bare-shouldered woman. He rendered her stylish coiffure with care but focused his greatest attention on her facial features.

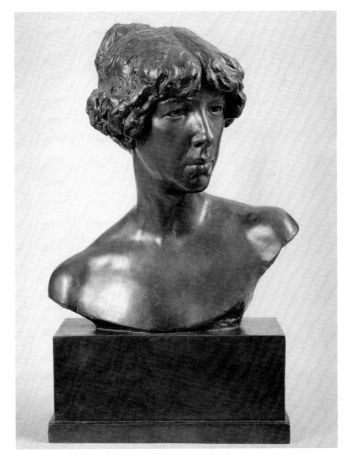

The Metropolitan Museum's bronze bust has an integral tiered base. The gift of Maury P. Leibovitz, it is a posthumous cast made at the Johnson Atelier, Mercerville, New Jersey, in December 1982. Dr. Leibovitz, a psychologist and president of Knoedler-Modarco, purchased from the Davidson estate some two hundred plasters, terracottas, marbles, and bronzes, many of which were given to American museums, including the Los Angeles County Museum of Art and the National Portrait Gallery, Washington, D.C.[4] Some models were cast posthumously from Davidson's original plasters, among them four in the Metropolitan Museum's collection.[5] Leibovitz gave the Metropolitan nine bronze and terracotta portraits in 1982.

Other examples of the *Whitney* portrait are at the National Portrait Gallery (bronze) and the Whitney Museum of American Art, New York (marble). In 1917 Davidson modeled a statuette of Whitney in contemporary dress and in 1942 completed a terracotta portrait bust (both Whitney Museum of American Art).[6]

JMM

EXHIBITION

MMA, "As They Were: 1900–1929," April 9–September 8, 1996.

1. *National Academy of Design Winter Exhibition 1908. . . Illustrated Catalogue* (New York, 1908), p. 58, no. 428; and Davidson 1951, pp. 49–50.
2. Conner and Rosenkranz 1989, p. 18, n. 5.
3. Davidson 1951, p. 125. For an account of this gathering, see "Mrs. H. P. Whitney 'Interns' Sculptors: Much Work Done," *New York Herald Tribune*, March 10, 1918, p. 14.
4. On Leibovitz, see his obituary, *New York Times*, June 5, 1992, p. B7. For the Los Angeles casts, see Ilene Susan Fort and Michael Quick, *American Art: A Catalogue of the Los Angeles County Museum of Art Collection* (Los Angeles: Los Angeles County Museum of Art, 1991), pp. 413–24; for the National Portrait Gallery casts, see *Jo Davidson Portrait Sculpture* 1978, n.p.
5. Leibovitz to Joan M. Marter, May 17, 1990, copy in object files, MMA Department of Modern Art.
6. For the National Portrait Gallery cast, see *Jo Davidson Portrait Sculpture* 1978, n.p.; and *National Portrait Gallery: Permanent Collection Illustrated Checklist* (Washington, D.C.: National Portrait Gallery in association with Smithsonian Institution Press, 1987), p. 303. For the statuette of Whitney, see Patricia Hills and Roberta K. Tarbell, *The Figurative Tradition and the Whitney Museum of American Art: Paintings and Sculpture from the Permanent Collection*, exh. cat. (New York: Whitney Museum of American Art, 1980), p. 94, fig. 13.

347. *Marshal Ferdinand Foch*, 1918

Bronze
9¾ x 8¼ x 6 in. (24.8 x 21 x 15.2 cm)
Signed (across back of sitter's right shoulder): © JO DAVIDSON
Inscribed and dated: (on chest, by sitter) *F foch*; (across back of sitter's right shoulder): MODELE AU G.Q.G. / A SENLIS NOVEMBRE 1918
Foundry mark (back, below collar, in seal): Cire / C. Valsuani / Perdue
Bequest of Mary Stillman Harkness, 1950 (50.145.41)

IN HIS AUTOBIOGRAPHY Davidson discussed his idea of a "plastic history" of World War I through busts of important figures, both civil and military, among the Allies. He recalled modeling the likeness of the French military leader Ferdinand Foch (1851–1929) in November 1918. Earlier that year, in March, Foch had been appointed to the supreme command of all Allied armies, and in August he became marshal of France. For the November sitting Davidson drove from Paris to Senlis, Foch's headquarters. "When I finished the bust I signed it at the back. The Marshal watched me doing it and said: 'I'm going to sign it too.' This was the first time that any one of my sitters had signed his bust, and it created a precedent. His signing the bust put the stamp of his approval on it, and his entourage reacted accordingly."[1] Considering that Davidson was able to spend only a few hours with Marshal Foch, this is a remarkable portrait—one that not just captures a good likeness of the sitter but also explores his character. The serious demeanor and deep lines of the face suggest the great responsibilities of his command.

Many of the portraits from the Paris Peace Conference series were reduced and cast at C. Valsuani in Paris in editions of sixteen.[2] Other *Foch* bronzes are at the Evanston Historical Society, Evanston, Illinois; the Harvard University Art Museums, Cambridge, Massachusetts; the Joe and Emily Lowe Art Gallery, Syracuse University, Syracuse, New York; and the West Point Museum, United States Military Academy, West Point, New York.

In 1950 Mary Stillman Harkness bequeathed this sculpture, as well as bronzes by Frederick William MacMonnies (cat. no. 195), Herbert Haseltine (cat. no. 282), and Malvina Hoffman (cat. no. 366), to the Metropolitan Museum.[3]

JMM

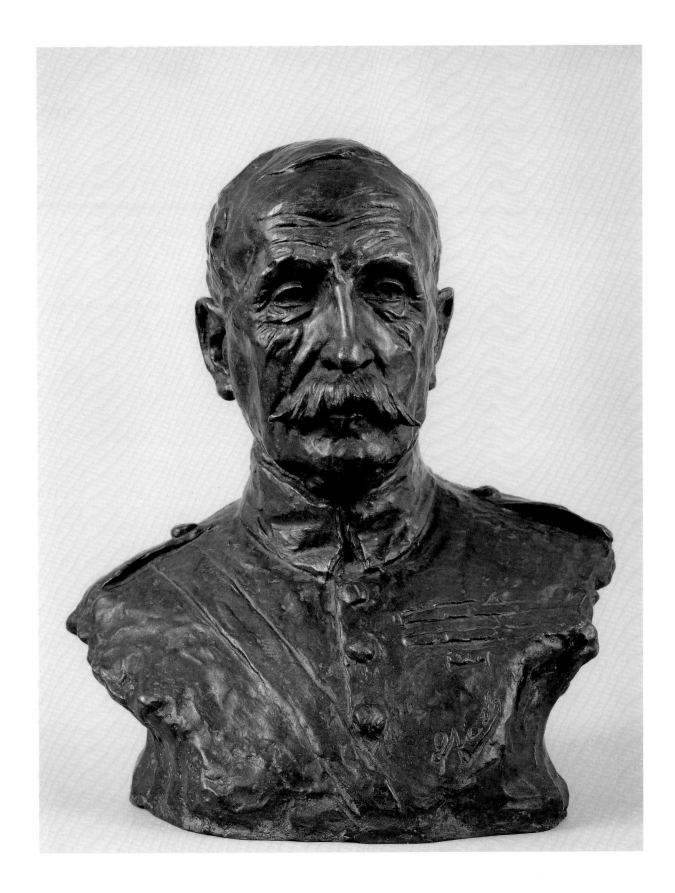

EXHIBITIONS

Art Students League of New York, "American Masters from Eakins to Pollock," July 7–August 26, 1964, no. 4.
Century Association, New York, "Centurions Associated with the Art Students League, Part One: The Past," February 7–28, 1968, no. 5.

1. Davidson 1951, p. 140.
2. Conner and Rosenkranz 1989, p. 15.
3. See the list of the Mary Stillman Harkness bequest prepared by Associate Curator Robert B. Hale, September 1950, MMA Archives; see also "List of Gifts and Bequests of Mr. and Mrs. Harkness," *MMA Bulletin* 10 (October 1951), p. 86. Davidson modeled busts of Mary Stillman and Edward S. Harkness in 1934; see Davidson 1951, pp. 279–80, 284.

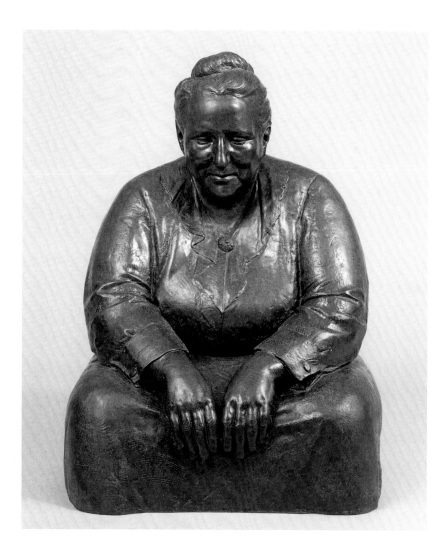

348. *Gertrude Stein,* ca. 1920–22

Bronze, 1982
33 x 22 x 24 in. (83.8 x 55.9 x 61 cm)
Signed and dated (sitter's right leg, lower edge): JO DAVIDSON / PARIS 192[obscured]
Inscribed (sitter's right leg, lower edge, by sitter): *Gertrude Stein*
Gift of Dr. Maury P. Leibovitz, 1982 (1982.511.6)

GERTRUDE STEIN (1874–1946), expatriate American author and collector, was a celebrity in the Paris literary, musical, and art worlds. Her home was frequented by such artists as Picasso, Matisse, Braque, and Gris, from whom she acquired a number of modern paintings, which formed the nucleus of her impressive collection. She was among the most controversial of American writers because of her often peculiar literary style: she avoided conventional punctuation, chose words for sound rather than meaning, and repeated words, phrases, and sentences to create a desired effect. She is probably best remembered for *Four Saints in Three Acts,* which was set to music by Virgil Thomson; the opera premiered in Hartford, Connecticut, February 8, 1934. Her memoirs were published as the *Autobiography of Alice B. Toklas* in 1933.

In 1907, while Davidson was living in Paris, he attended some of Stein's soirees; later he and his wife became friends of hers. Like Picasso's painted portrait of Stein (1907; MMA acc. no. 47.106), Davidson's likeness of the woman, monumental in concept though underlifesize, emphasizes her massive body and her brooding but dignified character. Davidson later recalled posing his subject: "To do a head of Gertrude was not enough—there was so much more to her than that. So I did a seated figure of her—a sort of modern Buddha. . . . There was an eternal quality about her—she somehow symbolized wisdom."[1] In return, Stein did a prose portrait of Davidson, which was published in the February 1923 issue of *Vanity Fair* along with an illustration of her sitting for the portrait by Davidson.[2]

According to the donor, Maury P. Leibovitz, the bronze he presented to the Metropolitan Museum was cast at the Johnson Atelier in November 1982.[3] A terracotta version

of 1922–23 is in the collection of the National Portrait Gallery, Washington, D. C., also the gift of Leibovitz, and a bronze, cast in 1954 from the original plaster, is in the collection of the Whitney Museum of American Art, New York.[4]

Bronze reductions, 8¼ inches high, are at the Carnegie Museum of Art, Pittsburgh, and the Beinecke Rare Book and Manuscript Library, Yale University, New Haven. The National Portrait Gallery also has a terracotta head, a detail from the full figure, 11 inches high.[5]

<div align="right">JMM</div>

EXHIBITIONS

Storm King Art Center, Mountainville, N.Y., "Twentieth-Century Sculpture: Selections from The Metropolitan Museum of Art," May 18–October 31, 1984.
MMA, Iris and B. Gerald Cantor Roof Garden, July 31–October 28, 1990.
MMA, "As They Were: 1900–1929," April 9–September 8, 1996.

1. Davidson 1951, pp. 174–75.

2. See Gertrude Stein, "A Portrait of Jo Davidson: An American Revolutionary of Prose Sets Down Her Impressions of an American Sculptor," *Vanity Fair* 19 (February 1923), pp. 48, 90. Of Stein's prose portrait, Davidson wrote: "When she read it aloud, I thought it was wonderful. . . . But when I tried to read it out loud to some friends, or for that matter to myself, it didn't make very much sense" (Davidson 1951, p. 175).
3. Leibovitz to Joan M. Marter, May 17, 1990, copy in object files, MMA Department of Modern Art.
4. For the National Portrait Gallery cast, see *Jo Davidson Portrait Sculpture* 1978, n.p., and *National Portrait Gallery: Permanent Collection Illustrated Checklist* (Washington, D.C.: National Portrait Gallery in association with Smithsonian Institution Press, 1987), p. 262. Though Davidson dated his portrait of Gertrude Stein as 1923 in his autobiography (1951, p. 174), the Whitney Museum dates its cast 1920. The sculpture was modeled before 1923, since a version was illustrated in Guy Pène du Bois, "Art by the Way," *International Studio* 76 (November 1922), pp. 179–81.
5. See Diana J. Strazdes et al., *American Paintings and Sculpture to 1945 in the Carnegie Museum of Art* (New York: Hudson Hills Press, 1992), pp. 158–59; and Paula B. Freedman, *A Checklist of American Sculpture at Yale University* (New Haven: Yale University Art Gallery, 1992), p. 52. For the head, see *Jo Davidson Portrait Sculpture* 1978, n.p. See also Conner and Rosenkranz 1989, p. 18, n. 12.

349. *Portrait of Lady Facing Left,* 1922

Marble
19 x 13½ in. (48.3 x 34.3 cm)
Signed and dated (lower left): J⁰ DAVIDSⁿSᶜ / PARIS 1922
Gift of Richard L. Feigen, 1981 (1981.494)

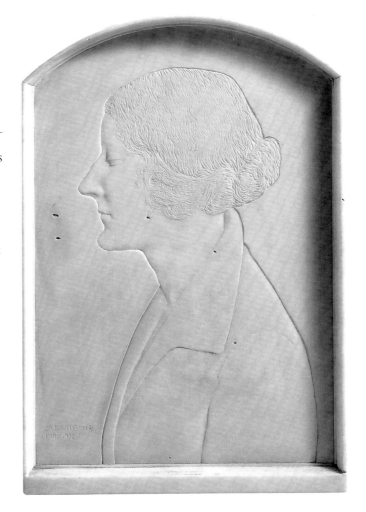

THE LOW-RELIEF marble carving is unusual in Davidson's oeuvre, for he worked almost exclusively in the round. The concept of the portrait is simple and the statement quiet. In creating it, Davidson presented the details of the face and head with extremely subtle modeling and used finely etched lines to depict the hair, reserving the deepest carved line for the subject's outline.

The solemnity of the work and the suggestion of a strong portrait likeness make Davidson's uncharacteristic failure to identify his sitter even more puzzling. In 1922, the date on the portrait, he and his wife and two sons were living in Paris. One of the sons, Jacques Davidson, identified the sitter as Mrs. Murray Thompson from an inscription on a photograph of the relief dated 1925.[1]

The small holes visible on the relief's surface are the result of inclusion losses.

<div align="right">JMM</div>

1. Janis Conner to Joan M. Marter, July 16, 1990, copy in object files, MMA Department of Modern Art: "While going through old photographs, Jacques Davidson discovered an image of the incised relief portrait in the MMA's collection."

350. *James Joyce,* 1929

Terracotta, painted, 1930 or after
17½ x 7½ x 6⅛ in. (44.5 x 19.1 x 15.6 cm)
Signed and dated (back): JO DAVIDSON / 1930
Inscribed (front of base, by sitter): *James Joyce*
Gift of Dr. Maury P. Leibovitz, 1982 (1982.511.7)

JAMES JOYCE (1882–1941) recorded the genteel poverty of his childhood in *A Portrait of the Artist as a Young Man* (1916) and went on to translate other aspects of his life, the history of Ireland, and portraits of his native Dublin into novels, short stories, poetry, and plays. *Ulysses* (1922), the detailed account of a single day in the protagonist's Dublin life, brought Joyce international acclaim. Considered the ultimate in naturalism by some critics and obscene by the authorities in most English-speaking countries, it also brought him notoriety. For the next seventeen years he occupied himself in the writing of *Finnegans Wake* (1939).

Davidson was introduced to Joyce in Paris in 1919 by Sylvia Beach, American proprietor of the Paris bookshop Shakespeare and Company and publisher of *Ulysses.* Davidson and Joyce became friends, often dining together and entertaining themselves by singing operatic arias and duets. Davidson had long wanted to model Joyce's portrait, and in 1929 George H. Doran, of the publishing house Double-day, Doran, commissioned the sculptor to do a series of busts that he envisioned would include twelve of the company's distinguished writers. Doran eventually reduced the number to ten, among them this portrait.[1] Despite their congeniality, Davidson recognized in Joyce a certain diffidence and reserve, which he emphasized in this portrait of the Irish novelist. Though less engaging than some of Davidson's other likenesses, it is a true depiction of Joyce as the artist saw him: "He was frail, detached and the essence of sensitivity. . . . In modeling his bust, my great problem was his eyes. Behind those heavy lenses they seemed to be enlarged and to occupy a lot of space, but did not focus. His high bulbous forehead gave him the look of a bird."[2]

The Metropolitan's portrait was tinted with a medium brown pigment and is mounted on an ebonized wood base, 3⅞ inches high. Davidson also made a polychrome terracotta head of Joyce without a goatee (1930; private collection). The terracotta at the Metropolitan was one of nine portrait busts given to the Museum in 1982 by Maury P. Leibovitz (see cat. no. 346). A bronze *James Joyce* is at the Harry Ransom Humanities Research Center, University of Texas at Austin. JMM

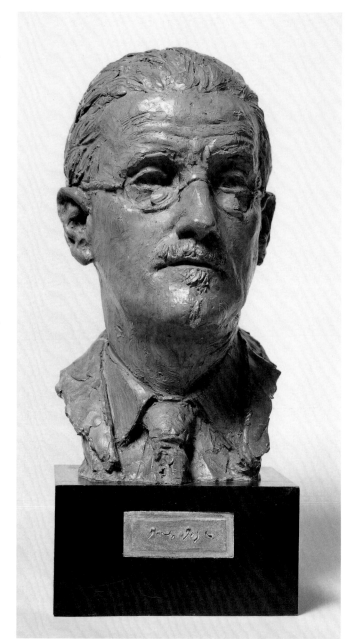

1. Davidson 1951, pp. 241–43, 260.
2. Ibid., p. 242.

351. *H. G. Wells,* 1930

Terracotta
13½ x 8 x 9 in. (34.3 x 20.3 x 22.9 cm)
Signed and dated (back): JO DAVIDSON / GRASSE 1930
Gift of Dr. Maury P. Leibovitz, 1982 (1982.511.9)

HERBERT GEORGE WELLS (1866–1946) was a British novelist and historian. Although perhaps best known for his *Outline of History* (1920), Wells also wrote such pseudoscientific novels as *The Time Machine* (1895), *The Invisible Man* (1897), and *The War of the Worlds* (1898). In picaresque novels and formal essays Wells repeated his apocalyptic themes for almost fifty years.

In recalling his visit with Wells, who was living in Grasse, France, at the time, Davidson wrote, "When H.G. discovered that he did not have to 'hold out his face' or remain immobile, but could keep on talking and could watch me work, he began to enjoy himself and gave me as many sittings as I wanted."[1] By tilting his subject's head off axis and depicting the face in a mood of relaxation, the sculptor suggested the jovial nature of the writer and the friendly exchange between the two men.

In 1982 Maury P. Leibovitz gave this terracotta to the Metropolitan Museum along with eight other portraits by Davidson (see cat. no. 346).

The accompanying wood base is 4⅞ inches high.

JMM

1. Davidson 1951, p. 250.

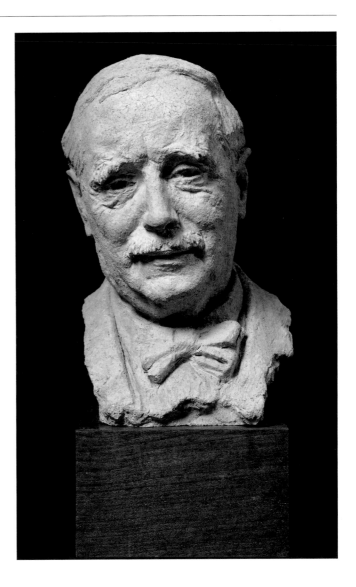

352. *D. H. Lawrence,* 1930

Terracotta, painted
16¾ x 10¼ x 7¾ in. (42.5 x 26 x 19.7 cm)
Signed and dated (back): JO DAVIDSON / VENICE 1930
Inscribed (across chest, by sitter): *D. H. Lawrence*
Gift of Dr. Maury P. Leibovitz, 1982 (1982.511.8)

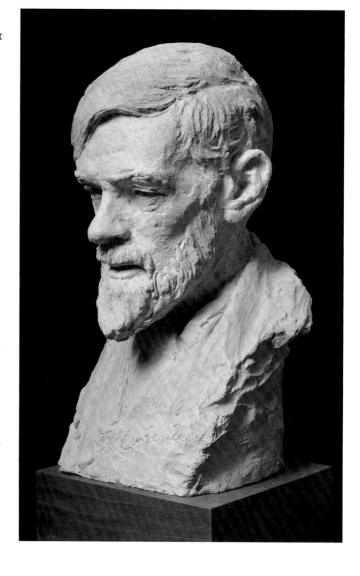

THE ENGLISH writer David Herbert Lawrence (1885–1930) produced short stories, poetry, and drama but was best known for such novels as *Sons and Lovers* (1913), *Women in Love* (1920), and *Lady Chatterly's Lover* (1928; unexpurgated, 1959). In his work Lawrence lamented the devastation caused by industrialism and commended the healing powers of nature. After leaving England in 1919, he traveled to Italy, Germany, Ceylon, Australia, New Zealand, and, ultimately, North America.

According to Davidson, this terracotta portrait of Lawrence, then very ill, was brought about through arrangements made by H. G. Wells, a friend of Lawrence's, who had recently sat for the sculptor for the Doubleday, Doran series (cat. no. 351). Wells urged his compatriot to allow Davidson to do his portrait as well, so the artist went to Venice, where Lawrence was staying. After learning of Davidson's recent experiments with polychrome sculpture, Lawrence "asked me to do him in color, and not to forget the blue of his dressing gown, of which he was very fond."[1] Davidson recorded the blue garment and sandy hair and beard of his sitter, giving this head the powerful immediacy that a terracotta portrait can convey. Soon after sitting for Davidson, Lawrence died.

This portrait was one of nine by Davidson presented by Maury P. Leibovitz to the Metropolitan Museum in 1982 (see cat. no. 346).

The accompanying wood base is 3¼ inches high.

JMM

1. Davidson 1951, p. 252.

353. *André Gide,* 1931

Bronze
14¾ x 6½ x 9 in. (37.5 x 16.5 x 22.9 cm)
Signed and dated (back of neck): © JO DAVIDSON / 1931
Foundry mark (back of neck, in seal, stamped): CIRE / C. VALSUANI / PERDUE
Gift of Dr. Maury P. Leibovitz, 1982 (1982.511.3)

ANDRÉ GIDE (1869–1951), the French novelist, drama-
tist, and travel writer, was reared by a Calvinist mother
whose influence on her son was overbearing. Gide was
introduced to the sensual delights of the primitive life
on a trip to North Africa. The contrast of sexual pleasure
with Calvinist principles of individual conscience is a re-
current theme in his best literary works, including *The
Immoralist* (1902; trans. 1930); *The Counterfeiters* (1926; trans.
1927); and *So Be It; or, The Chips Are Down* (1952; trans.
1959). Gide was awarded the Nobel Prize for Literature
in 1947.

This formal likeness of the writer suggests the severity
of classical portraiture and does not convey any sense of a
close personal association between artist and sitter. The
highly textured bronze, apparently a lifetime cast made by
Valsuani Foundry in Paris, was among nine portrait busts
presented to the Metropolitan Museum by Maury P.
Leibovitz in 1982 (see cat. no. 346).

Davidson also completed a marble replica of the *Gide*
with a bronze signature plaque inset on the base.[1]

The bust is mounted on a Belgian black marble base,
5½ inches high. JMM

1. For an illustration, see Conner and Rosenkranz 1989, p. 17.

354. *André Derain*, 1935

Bronze
22½ x 11 x 11 in. (57.2 x 27.9 x 27.9 cm)
Signed and dated (back of collar): JO DAVIDSON 1935
Inscribed (bronze plaque, front of base, by sitter): *a Derain*
Foundry mark (back of jacket, stamped): CIRE /
C. VALSUANI / PERDUE
Gift of Dr. Maury P. Leibovitz, 1982 (1982.511.2)

ANDRÉ DERAIN (1880–1954) was a painter associated
with the French avant-garde in the early twentieth century.
Known for his vibrant palette and bold style, he exhibited
with the Fauves in the Salon d'Automne in 1905. By 1908
he had become interested in the work of Cézanne and
experimented with cubist compositions. His style then
acknowledged the influence of Henri Rousseau and the
French primitives. After World War I Derain returned to
realistic depictions of the human figure.

In this naturalistic and heavily textured work, Davidson
contrasted the softer modeling of Derain's cheeks with the
overall roughness of his face, neck, and shirt collar, thereby
emphasizing the subject's heavy-set features.

Apparently a lifetime cast, *Derain* was one of nine busts
presented to the Metropolitan by Maury P. Leibovitz in
1982 (see cat. no. 346).

The Belgian black marble base is 5⅞ inches high.

JMM

355. *Jules Semon Bache*, 1936

Terracotta, painted
10¼ x 7 x 8¼ in. (26 x 17.8 x 21 cm)
Signed and dated (back of neck): JO DAVIDSON 1936
The Jules Bache Collection, 1949 (49.7.120)

THIS IS AN incisive likeness of New York financier
and philanthropist Jules Semon Bache (1861–1944), who
guided his firm, J. S. Bache and Company, to become
one of the foremost of American monetary houses. An
avid collector of European old master paintings and
decorative arts, Bache amassed one of the country's cele-
brated private holdings.[1] During the summer of 1943
he lent his collection for exhibition at the Metropolitan
Museum[2] and bequeathed it to the Metropolitan at his
death in 1944. It was transferred to Museum ownership
five years later.[3]

Davidson's interest in coloring terracotta sculpture grew

during the early 1930s, and he experimented with various
techniques, as he put it, "to accentuate the life quality of
the portrait bust. I soon developed a palette of reds, blues
and browns of different shades."[4] To achieve the realistic
flesh tint of the *Bache,* Davidson presumably used a process
of firing a mixture of clays in a kiln in his Paris studio, the
technique he employed with many other contemporane-
ous portraits. This bust was included in Davidson's retro-
spective exhibition organized by the American Academy
of Arts and Letters in 1947–48.[5]

The portrait is mounted on a stepped burled-veneer
wood base, 6½ inches high.

JMM

355

EXHIBITION

Oklahoma Museum of Art, Oklahoma City, "Masters of the Portrait," March 4–April 29, 1979, no. 41.

1. See Jules S. Bache, *A Catalogue of Paintings in the Bache Collection* (1929; 4th ed., New York, 1944).

2. Harry B. Wehle, "The Bache Collection on Loan," *MMA Bulletin,* n.s. 1 (June 1943), pp. 285–90.
3. "Eightieth Annual Report . . . 1949," *MMA Bulletin,* n.s. 9 (Summer 1950), pp. 10, 13, 26, 30.
4. Davidson 1951, p. 273.
5. *Catalogue of the First Retrospective Exhibition of Sculpture by Jo Davidson* 1947, no. 153. The bust was on deposit to the Metropolitan from the Jules Bache Foundation.

356. *Sinclair Lewis,* 1937

Terracotta, painted
14 x 7 x 8¼ in. (35.6 x 17.8 x 21 cm)
Signed and dated (back of collar): JO DAVIDSON N.Y. 1937
Gift of Albert Gallatin, 1963 (63.128)

THE NOVELIST Sinclair Lewis (1885–1951) was known primarily for his satires on American life. In *Main Street* (1920) he articulated the dissatisfaction many intellectuals felt toward patriotism, materialism, and conformity. While the novel was still enjoying critical attention, Lewis published *Babbitt* (1922), an effective attack on commercialism and convention. *Elmer Gantry* (1927) was the first major American novel to attack the hypocritical aspects of evangelism in the United States. Lewis received the Nobel Prize for Literature in 1930, the first American writer to be so honored. After that, however, his work moved from the center of the literary pantheon to its periphery. *It Can't Happen Here* (1935), a novel about a hypothetical fascist coup d'état in the United States, received some acclaim, but Lewis's work was never again as successful as his publications of the 1920s.

Davidson recalled in his autobiography that "I had been wanting to do [Lewis's portrait] for a long time. But old friends shy away with, 'What do you want to do me for?' As usual they end up by posing."[1] In this portrait, on which Davidson lightly colored the eyes blue and the shirt collar white, he presents Lewis in all his intensity. The terracotta was given to the Metropolitan Museum by Albert Gallatin, renowned as a collector of ancient art, particularly that of Egypt.[2] A bronze cast of the bust is in the collection of the National Portrait Gallery, Washington, D.C.[3]

The Metropolitan's bust is mounted on a gray marble base, 5¾ inches high. JMM

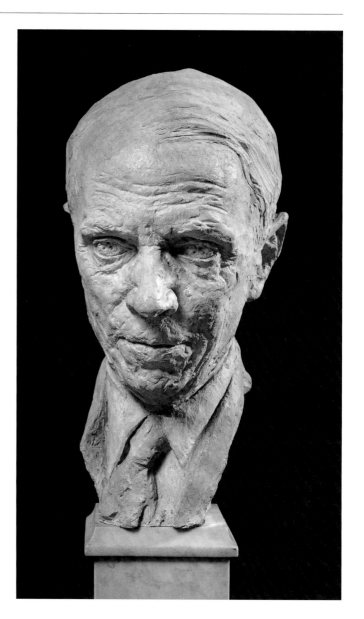

1. Davidson 1951, p. 302.
2. Albert TenEyck Gardner, Associate Curator of American Paintings and Sculpture, MMA, received the offer of the gift of this bust from Gallatin in a telephone conversation. On the Gallatin collection of Egyptian antiquities, purchased for the Metropolitan Museum, see Henry G. Fischer, "The Gallatin Egyptian Collection," *MMA Bulletin* 25 (March 1967), pp. 253–63; and "Ninety-seventh Annual Report . . . 1966–1967," *MMA Bulletin* 26 (October 1967), pp. 62–63.
3. See *Jo Davidson Portrait Sculpture* 1978, n.p.; and *National Portrait Gallery: Permanent Collection Illustrated Checklist* (Washington, D.C.: National Portrait Gallery in association with Smithsonian Institution Press, 1987), p. 176.

357. *Carl Sandburg,* 1939

Bronze, 1982
18¼ x 7¾ x 9½ in. (46.4 x 19.7 x 24.1 cm)
Inscribed (on front of base, by sitter): *Carl Sandburg*
Foundry mark (back of base): ROMAN BRONZE WORKS NY
Gift of Dr. Maury P. Leibovitz, 1982 (1982.511.4)

CARL SANDBURG (1878–1967), a distinguished poet and biographer of Abraham Lincoln, was one of the most frequently photographed men of his time. Sandburg's portrait is among the many images of important literary figures Davidson created, and it was modeled at the time the author was completing his four-volume *Abraham Lincoln: The War Years* (1939), for which he earned a Pulitzer Prize in history. Despite Davidson's great sensitivity to the subject's furrowed brow, weathered features, and trademark locks of hair on the forehead, the sculptor managed to emphasize Sandburg's inner vitality.

The Museum's bust was cast at the Johnson Atelier in December 1982,[1] probably from a bronze that had been cast at Roman Bronze Works, Davidson's New York founder.

JMM

1. Maury P. Leibovitz to Joan M. Marter, May 17, 1990, copy in object files, MMA Department of Modern Art.

358. *Self-Portrait,* 1946

Bronze, 1982
20 x 16½ x 11 in. (50.8 x 41.9 x 27.9 cm)
Signed and dated (back of sitter's right shoulder): JO DAVIDSON / SEPT 1946
Gift of Dr. Maury P. Leibovitz, 1982 (1982.511.1)

IN THIS PORTRAIT of himself at age sixty-three, David-son conveyed the pensive demeanor of his late years. With its impressionistic treatment of clothing and features, the bust is like a sketch. The artist retained his well-known thick beard but imbued the portrait with an air of pro-found melancholy rather than the vivacious attitude often noted in him by his sitters.

The naturalism that Davidson practiced from his youth well into the twentieth century seems particularly apt for suggesting the depth of his feelings in this work: the con-templative—even mournful—attitude that pervades it can be related to his physical condition and state of mind. Davidson had been deeply affected by the deaths in 1945 of his friend the war correspondent Ernie Pyle, who was killed in action, and of President Franklin D. Roosevelt, the subject of one of Davidson's portraits. At the same time the sculptor found his working schedule curtailed

by illness: he had planned to make portraits of the chief delegates to the first United Nations Assembly, in 1946, but suffered a heart attack and was in the hospital when the conference opened in San Francisco.[1] That September, when he was creating this self-portrait, he was well aware of the "full grief of war."[2] It was therefore in the spirit of mourning the genocide of the recent world conflict and his own failing strength as an artist that this bust was created.

According to donor Maury P. Leibovitz, this bronze was cast at the Johnson Atelier in December 1982.[3]

JMM

1. Davidson 1951, p. 345.
2. Ibid., p. 352.
3. Leibovitz to Joan M. Marter, May 17, 1990, copy in object files, MMA Department of Modern Art.

Harry Dickinson Thrasher (1883–1918)

Born in Plainfield, New Hampshire, Thrasher began his study of art in the nearby Cornish studio of Augustus Saint-Gaudens (pp. 243–325) in 1902. Thrasher was considered one of Saint-Gaudens's most talented assistants and remained in his employ until 1907. That year he went to New York, where he worked for Adolph Alexander Weinman (pp. 534–37) and attended classes at the Art Students League with James Earle Fraser (pp. 596–99), earning the Saint-Gaudens Figure Prize (1908) for the best figure in the sculpture classes. In 1911 Thrasher was awarded a three-year scholarship by the American Academy in Rome to visit European galleries and to occupy a studio in Rome. After he returned to the United States, he worked for Fraser and settled in Baltic, Connecticut. Thrasher's oeuvre consists of both portraits and more imaginative ideal compositions, among them *Boy Pretending He Is a Faun,* exhibited at the Architectural League of New York in 1915, and *America Embattled.* With Kenyon Cox, he designed the Prentiss Family Memorial erected in 1917 in Lakeview Cemetery, Cleveland, Ohio. In 1916 Thrasher displayed *Portrait of Boy* and *Young Duck* (cat. no. 359) in the winter exhibition of the National Academy of Design, and in 1917 he became a member of the National Sculpture Society. Examples of Thrasher's work, along with those of Frances Grimes (pp. 515–17) and Fraser, were shown at the Madison Art Gallery, in April–May 1918.

During World War I Thrasher served in the Camouflage Corps of Army Engineers and was killed in France in August 1918. Lorado Taft (1924, p. 541) later characterized Thrasher as "an artist of undoubted ability whose gifts held great promise for the future." In 1922–23 the American Academy in Rome erected a memorial in its inner courtyard to its two fellows who had died in action (Thrasher and the architect Walter Ward) with a fresco by Barry Faulkner and a marble bench with relief designs by Paul Manship (pp. 745–69), both of whom had Cornish connections.

JMM

SELECTED BIBLIOGRAPHY

Obituary. *New York American,* September 21, 1918, p. 4.
Obituary. Levy, Florence N., ed. *American Art Annual,* vol. 15, p. 284. Washington, D.C.: American Federation of Arts, 1918.
Taft, Lorado. *The History of American Sculpture,* p. 541. Rev. ed. New York: Macmillan, 1924.
Dryfhout, John H. *The Work of Augustus Saint-Gaudens,* p. 316. Hanover, N.H.: University Press of New England, 1982.
Colby, Virginia Reed, and James B. Atkinson. *Footprints of the Past: Images of Cornish, New Hampshire and the Cornish Colony,* pp. 413–17. Concord: New Hampshire Historical Society, 1996.

359. *Young Duck,* ca. 1914–16

Bronze, 1918
11 x 5½ x 8⅞ in. (27.9 x 14 x 22.5 cm)
Foundry mark (back of base): ROMAN BRONZE WORKS N–Y–
Rogers Fund, 1918 (18.120)

THRASHER PROBABLY created this naturalistic representation of a duck after his return to the United States from Rome in 1914, exhibiting it at the winter annual of the National Academy of Design in 1916.[1] The Museum's bronze was cast by Roman Bronze Works in early 1918, for a "Duck" is listed in the foundry ledgers in March 1918, the only example of Thrasher's work there recorded.[2] The timing of the casting corresponds to the March opening of the Metropolitan Museum's "Exhibition of American Sculpture," and according to lists drawn up in preparation for the show by trustee Daniel Chester French (pp. 326–41), he considered placing *Young Duck* in the opening of the long-term installation.[3] Although the work was not included, the bronze statuette was acquired by the Museum later that year through the Gorham Company in New York, just months after Thrasher's untimely death in August 1918.[4]

Another bronze *Young Duck,* cast by the American Art Foundry, is privately owned. A plaster cast was in the collection of the Whitney Museum of American Art, New York.[5]

JMM

EXHIBITIONS

Halloran General Hospital, Staten Island, N.Y., July 1947–February 1948.
Hood Museum of Art, Dartmouth College, Hanover, N.H., June 28–August 18, 1985; and University Art Galleries, University of New

359

Hampshire, Durham, September 9–October 30, 1985, "A Circle of Friends: Art Colonies of Cornish and Dublin."

1. *National Academy of Design Winter Exhibition 1916* (New York, 1916), p. 12, no. 34.
2. See Roman Bronze Works Archives, Amon Carter Museum, Fort Worth, ledger 5, p. 366.
3. See "Metropolitan Museum Exhibition, November 25, 1917," p. 2, no. 71, "Duck / Thrasher" (copy), Daniel Chester French Family Papers, Manuscript Division, Library of Congress, Washington, D.C., microfilm reel 28, frame 362.
4. Henry W. Kent, Secretary, MMA, to Gorham Company, November 20, 1918 (copy), MMA Archives.
5. The plaster cast once at the Whitney Museum was deaccessioned in December 1953 to a private collector; Kathleen Donovan, Assistant, Collections Department, Whitney Museum of American Art, to Alexis L. Boylan, research assistant, MMA Department of American Paintings and Sculpture, telephone conversation, March 18, 1999.

Carl Walters (1883–1955)

Walters was born and raised in Fort Madison, Iowa. During 1905–7 he was enrolled in classes in drawing and painting at the Minneapolis School of Fine Arts. In 1908 he moved to New York, studying with Robert Henri first at the New York School of Art and then at Henri's own school, begun in 1909. During the 1910s Walters pursued his painting career in Portland, Oregon, frequently exhibiting his Ashcan-inspired landscapes of the Pacific Northwest.

In 1919 Walters moved back to New York and turned to creating wax candles and ceramic objects—candlesticks, plates, bowls, and eventually sculpture. On visits to the Metropolitan Museum he was greatly taken with ancient Egyptian faience, notably the Dynasty 12 hippopotamus (acc. no. 17.9.1), and he resolved to approximate the colored glazes. In 1921 Walters established a ceramic studio in Cornish, New Hampshire, and the following year he moved to Woodstock, New York, joining the Maverick art colony. In Woodstock he built an outdoor kiln and produced objects in his "Walters Blue," the glaze he perfected after several years of effort. He quickly became a master of modern ceramics, specializing in capricious and fancifully decorated animals, such as *Walrus* (1933; Smithsonian American Art Museum, Washington, D.C.), *Baby Hippo* (1936; Museum of Modern Art, New York), and *Whale* (1938; Whitney Museum of American Art, New York). He made figural studies in a humorous vein, among them *Ella* (1927; Museum of Modern Art, New York), a seated circus fat lady perched incongruously on a slender metal stool. His "figures-in-cabinets," small scenes in stagelike boxes, frequently also treated the circus theme.

Walters's works were included in many international exhibitions of ceramic art, as well as in annual exhibitions of paintings and sculpture at American institutions. He had his first one-artist show at New York's Dudensing Gallery in 1927, and the following year he participated in the American Federation of Arts' touring "International Exhibition of Ceramic Art," which opened at the Metropolitan Museum, from which *Duck* (MMA acc. no. 29.130.5) was purchased. After 1930 Walters was represented by the Downtown Gallery, where he had frequent solo exhibitions. For "American Art Today," at the New York World's Fair of 1939, the artist contributed an inlaid ceramic duck.

Walters was a founding member of the Woodstock Artists Association and often exhibited with the group. In 1935 and 1936 he was awarded a John Simon Guggenheim Memorial Foundation Fellowship to do research on the adaptation of glass for sculpture and architectural decoration; for the new Whitney Museum of American Art on West 8th Street, he created a series of sixty glass relief panels of animals and circus scenes for the entrance door (1930–31). In his later years he was also an inventor, registering his cigarette machines with the Chartered Institute of American Inventors in 1942. Walters resided in West Palm Beach, Florida, as well as Woodstock, in the 1950s, and taught ceramics at the Norton Gallery and School of Art. JMM

SELECTED BIBLIOGRAPHY

Walters, Carl, Papers. Archives of American Art, Smithsonian Institution, Washington, D.C., microfilm reels D198, 2007, 2030.
Brace, Ernest. "Carl Walters." *Creative Art* 10 (June 1932), pp. 431–36.
Walters, Carl. "Ceramic Sculpture." In Brenda Putnam, *The Sculptor's Way: A Guide to Modelling and Sculpture,* pp. 283–96. New York: Farrar and Rinehart, 1939.
Homer, William. "Decorative Arts: Carl Walters, Ceramic Sculptor." *Art in America* 44 (Fall 1956), pp. 42–47, 64–65.
Carl Walters, 1883–1955: Memorial Exhibition. New York: Woodstock Artists Association, 1956.
Anderson, Ross, and Barbara Perry. *The Diversions of Keramos: American Clay Sculpture, 1925–1950,* pp. 86–95. Exh. cat. Syracuse, N.Y.: Everson Museum of Art, 1983.

360. *Cat in Tall Grass,* 1939

Clay, glazed
15½ x 13¼ x 4¼ in. (39.4 x 33.7 x 10.8 cm)
Signed and dated (underside of base): © / *Walters* / 1939 [artist's mark]
Rogers Fund, 1942 (42.183)

ON THE BODY of this whimsical representation of a feline, Walters painted a decorative striped pattern in black and ivory. Like the ancient Egyptian, Chinese, and Persian ceramists whose work the artist admired, he used a lively, stylized surface design rather than a naturalistic portrayal to render the animal's fur. Although *Cat in Tall Grass* was inspired by his own cat Old Lady, Walters did not rely on live models to create his sculptures: "I start with a clear

360

mental conception and begin at once to realize it in clay. I am not interested in literal representations."[1]

Cat in Tall Grass was displayed at the annual exhibitions of the Whitney Museum of American Art in 1940 and the Art Institute of Chicago in 1940–41.[2] At the "Artists for Victory" exhibition held at the Metropolitan Museum in 1942, Walters was awarded a sixth prize for the purchase of this sculpture by the Museum.[3] JMM

EXHIBITIONS

Cooper Union Museum for the Arts of Decoration, New York, "Nine Lives," February 23–April 2, 1949, no. 217.
Museum of Art of Ogunquit, Maine, "Ceramic Sculpture by Carl Walters (1883–1955)," in "Fourth Annual Exhibition," July 1–September 10, 1956, no. 8.
Queens Museum, New York, "American Sculpture Folk and Modern," March 12–May 8, 1977, no. 86.

1. Quoted in Homer 1956, p. 47.
2. *1940 Annual Exhibition of Contemporary American Art* (New York: Whitney Museum of American Art, 1940), no. 158; *Art Institute of Chicago: Catalogue of the Fifty-first Annual Exhibition of American Paintings and Sculpture* (Chicago, 1940), no. 322, as "Cat in Green Grass."
3. *Artists for Victory: An Exhibition of Contemporary American Art. A Picture Book of the Prize Winners* (New York: MMA, 1942), n.p., ill.; recommended purchase form, February 16, 1942, with the note of December 21, 1942, listing the thirteen sculptures from the "Artists for Victory" exhibition that were authorized for purchase, MMA Archives. For the "Artists for Victory" exhibition purchase prizes, see cat. no. 361.

José de Creeft (1884–1982)

De Creeft, born in Guadalajara, Spain, grew up in Barcelona, where in 1897 he was apprenticed to a carver of religious images. After two years' service with Masriera y Campins, a bronze foundry, he moved to Madrid in 1900. There he studied drawing with Rafael Hidalgo y Gutierrez de Caviedas and became an apprentice to Augustín Querol, official sculptor to the Spanish government. De Creeft's first exhibition, of clay and plaster portraits of children, was held in 1903 at the Circulo de Bellas Artes, Madrid.

In 1905 de Creeft moved to Paris and, at the suggestion of Auguste Rodin, enrolled at the Académie Julian, where he studied until 1907; in 1906 he was awarded the academy's first prize in the Concours de Sculpture for a clay torso. In 1909 de Creeft exhibited for the first time at the Salon of the Société des Artistes Français, showing a bronze head of a man and a plaster bust of a child. About 1915, after four years' work as a stonecutter at the Maison Greber, a shop that made reproductions in stone from plaster models, de Creeft destroyed his previous clay and plaster sculptures. He abandoned modeling in clay in favor of direct carving in wood and stone, one of the first twentieth-century artists to explore this ancient technique, and he presented the results of his new approach—a red granite head—at the Salon of the Société Nationale des Beaux-Arts in 1916. During the 1920s he showed his sculpture frequently in exhibitions in Paris. Among his works from this period was *Picador* (1925; Fundació Joan Miró, Barcelona), an assemblage of found materials, including metal tubing and canvas hose, which was shown in the exhibition of the Société des Artistes Indépendants in 1926. Despite experiments with such diverse materials as hammered lead and ceramic, de Creeft maintained his affinity for direct carving, especially female figures. In 1927 he received a large commission for two hundred stone carvings for the gardens of a fourteenth-century fortress on the island of Mallorca, a project he completed before leaving Spain in 1929.

De Creeft settled permanently in New York City in 1929. That year he had his first solo shows in the United States, at the Seattle Art Institute and at the Ferargil Galleries in New York. Through his teaching at the New School for Social Research (1932–48, 1957–60) and at the Art Students League (1944–48, 1957–79) he exercised an influence on the second generation of American direct carvers. During his long artistic career de Creeft also created oil paintings and works on paper.

De Creeft's first important commission in the United States, awarded in 1951 and completed in 1956, was the 8-foot granite *Poet* for the Ellen Phillips Samuel Memorial in Fairmount Park, Philadelphia. In 1959 his cast-bronze *Alice in Wonderland* was installed in New York in Central Park, and in 1961 he completed *Nurses,* a mural in mosaic, for the Bronx Municipal Hospital. In 1960 an exhibition of de Creeft's work was organized by the American Federation of Arts and shown at the Whitney Museum of American Art and thirteen other American museums. De Creeft joined Kennedy Galleries in 1970 and continued to exhibit there until his death. JMM

SELECTED BIBLIOGRAPHY

de Creeft, José, Papers. Archives of American Art, Smithsonian Institution, Washington, D.C., microfilm reels D150 and 375–78, and unmicrofilmed material.
Campos, Jules. *José de Creeft.* New York: Erich S. Herrmann, 1945.
Devree, Charlotte. *José de Creeft.* Exh. cat. New York: American Federation of Arts, 1960.
Campos, Jules. *The Sculpture of José de Creeft.* New York: Kennedy Graphics and DaCapo Press, 1972.
Breeskin, Adelyn D., and Virginia M. Mecklenburg. *José de Creeft: Sculpture and Drawings.* Exh. cat. Washington, D.C.: Smithsonian Institution Press for the National Museum of American Art, 1983.
José de Creeft (1884–1982): Works from the Collection of Nina de Creeft Ward and William de Creeft. Exh. cat. Cedar Falls: Gallery of Art, University of Northern Iowa, 1983.
José de Creeft: Sculpture and Drawing, 1917–1940. Exh. cat. New York: Childs Gallery, 1989.

361. *Maternity*, 1923

Granite
26¾ x 17½ x 16¾ in. (67.9 x 44.5 x 42.5 cm)
Signed (right side, incised within oval): J DE CREEFT
Rogers Fund, 1942 (42.171)

IN *MATERNITY* de Creeft linked two partial figures into a continuous shape, the physical union suggesting the emotional intimacy between mother and child. In truncating the two figures into one essential form, he heightened the expressive effect of the work. His portrayal of the mother gazing on the infant cradled in her hand and pro-

tectively enveloped in her swirling hair is a secular evocation of Renaissance studies of the Virgin and Child.

Maternity was carved directly in gray granite from the Vosges, France, and completed in Paris in 1923.[1] De Creeft showed it frequently: at the Brooklyn Museum in 1930, the Society of Independent Artists in 1936, the Passedoit

Gallery in New York in 1939, the Whitney Museum of American Art in 1940, and the Metropolitan Museum's "Artists for Victory" exhibition, which opened on December 7, 1942.[2] The Museum appropriated funds to purchase contemporary paintings, sculpture, and prints directly from the exhibition, so de Creeft's first prize for sculpture meant transferal of the work of art to the Museum's collection. Thirteen American sculptures, including *Maternity*, Grace Hill Turnbull's *Python of India* (cat. no. 296), and Carl Walters's *Cat in Tall Grass* (cat. no. 360), were thus acquired.[3] A review of art events of 1942 cited the show as the year's "most significant modern exhibition" and *Maternity* as "the most important modern sculpture."[4]

JMM

EXHIBITIONS

MMA, "The 75th Anniversary Exhibition of Painting and Sculpture by 75 Artists Associated with the Art Students League of New York," March 16–April 29, 1951, no. 50.

New School Art Center, New York, "José de Creeft: A Retrospective Exhibition," October 16–November 9, 1974, no. 3.
Nassau County Museum of Art, Roslyn Harbor, N.Y., September 1992–present.

1. Information provided by the artist, June 2, 1943, MMA Archives. De Creeft also noted that he exhibited *Maternity* "at the Salon d'Automne, Paris, and in Barcelona, after 1923. At Passedoit in 1935." These showings cannot be confirmed.
2. See *Brooklyn Museum Catalogue of an Exhibition of Recent Work by Distinguished Sculptors* (New York, 1930), no. 71; *The Society of Independent Artists, 20th Annual Anniversary Exhibition 1936* (New York, 1936), p. 7, no. 206, "La Maternite, granites"; *1940 Annual Exhibition of Contemporary American Art* (New York: Whitney Museum of American Art, 1940), no. 121; *Artists for Victory: An Exhibition of Contemporary American Art* (New York: MMA, 1942), p. 24; and Hyatt Mayor, "The Artists for Victory Exhibition," *MMA Bulletin*, n.s. 1 (December 1942), pp. 142, 143.
3. Minutes of the MMA trustees' Executive Committee meeting, June 8, 1942; and minutes of the trustees' Committee on Purchases meeting, December 21, 1942, MMA Archives.
4. "The Year in Art: A Review of 1942," *Art News* 41 (January 1–14, 1943), pp. 24–25.

362. *Emerveillement*, 1941

Serpentine rock
18⅝ x 6¾ x 6¾ in. (47.3 x 17.1 x 17.1 cm)
Signed (back): JOSE DE CREEFT
Morris K. Jesup Fund, 1941 (41.184)

ALTHOUGH HE worked in media as diverse as cast bronze, carved wood, and hammered metal, de Creeft is best known for his direct carving in stone. His most frequent subject was the female nude, realized in styles evocative of Precolumbian, African, or Asian sources. *Emerveillement* (Astonishment) is typical of those sculptural types, which manage to convey at the same time an intimate sensuality and a goddesslike remoteness. The cylindrical form, of green serpentine, suggests the original stone from which the sculpture was carved, but the swelling curves of the figure exemplify the artist's virtuosity in releasing a form from a lifeless mass. De Creeft varied the surface finish— from the highly polished contours of the face and body to the rough-hewn mass of hair and the cloth encircling the figure's waist—to exploit the intrinsic properties of his material.

The sculpture, included in de Creeft's solo exhibition of November 1941 at the Passedoit Gallery,[1] was purchased by the Metropolitan Museum from the gallery. It was one of four pieces acquired by the Museum from among sculptures exhibited in New York City during the National Art Week Exhibitions, November 17–23, 1941.[2] At that time de Creeft noted that *Emerveillement* was a unique composition.[3]

JMM

EXHIBITIONS

American Federation of Arts, New York, "José de Creeft," May 1960– May 1962, no. 9. Exhibition presented at fourteen museums in the United States.
New York World's Fair, New York City Pavilion, April–October 1964; April–October 1965.
New School Art Center, New York, "José de Creeft: A Retrospective Exhibition," October 16–November 9, 1974, no. 21.
Storm King Art Center, Mountainville, N.Y., "20th Century Sculpture: Selections from The Metropolitan Museum of Art," May 18– October 31, 1984, as "Emerveillement: Statuette."
MMA, "The Human Figure in Transition, 1900–1945: American Sculpture from the Museum's Collection," April 15, 1997– March 29, 1998.

1. *José de Creeft*, exh. cat. (New York: Passedoit Gallery, 1941), no. 1.
2. Horace H. F. Jayne, Vice Director, to G. L. Greenway, Secretary, December 10, 1941, MMA Archives.
3. Information provided by the artist, received by MMA, December 23, 1941, MMA Archives.

726 JOSÉ DE CREEFT

William Hunt Diederich (1884–1953)

Diederich, whose maternal grandfather was the Boston artist William Morris Hunt (pp. 99–101), was born in Szent-Grot, Hungary. His father, Ernst Diederich, was a cavalry officer who died in a hunting accident in 1888. The child was deeply influenced by his father's devotion to horses and dogs and at a young age was making paper silhouettes of animals. Diederich was educated in Switzerland until 1899, when his mother took him to the United States and he was enrolled at Milton Academy in Milton, Massachusetts. Between 1902 and 1904 he attended classes at the School of the Museum of Fine Arts, Boston. Diederich attended the Académie Julian in Paris in 1904–5, also studying with Emmanuel Frémier at the Jardin des Plantes. In 1905–6 Diederich traveled west to work on ranches in Wyoming, New Mexico, and Arizona. These ranching experiences were also formative in his choice of animal subjects for his sculptures and decorative objects.

Returning to the East Coast in 1906, Diederich attended classes in life drawing and modeling at the Pennsylvania Academy of the Fine Arts, in 1908 receiving the academy's Edmund Stewardson Prize (see p. 470) for his sculpture *Bronco Buster.* One of his fellow students was Paul Manship (pp. 745–69), and in summer 1908 the two artists took a walking tour of Spain. Diederich subsequently visited North Africa and capitals of Europe, including Rome in 1909, where he may have had a solo exhibition. He then settled in Paris and became friends with Gaston Lachaise (pp. 660–88), Elie Nadelman (pp. 689–703), and Alexander Archipenko. Diederich exhibited at the Salons of 1910 and 1911, and at the Salon d'Automne in 1913 he displayed *Greyhounds,* which earned critical praise.

At the outbreak of World War I Diederich returned to the United States, settling in New York. His bronze sculptures of animals, such as *Playing Dogs* (ca. 1916; Whitney Museum of American Art, New York) and *Spanish Rider* (ca. 1920; Phillips Collection, Washington, D.C.), feature smoothly polished surfaces, streamlined forms, and elegant stylized line and set a new direction away from traditional academic style. Diederich also began to work in wrought iron, another significant departure, creating utilitarian objects, such as fire screens, chandeliers, trivets, and bookends, in which the animals—usually deer, hounds, and horses with or without riders—are essentially planar in form. He showed many of his metal works and pottery in 1917 at the studio of a New York decorator, and in spring 1920 he had his first American solo exhibition of eighty-eight objects at the Kingore Galleries in New York. During the 1920s and 1930s he displayed his work widely, including in exhibitions of the National Sculpture Society in 1923, the Ferargil Galleries in 1924 and 1925, and the Architectural League of New York, where in 1927 he was awarded the Medal of Honor for design for his faience plaques. Diederich also produced ceramics, prints, and lively silhouettes on paper, examples of which are at the Metropolitan Museum. He produced public sculptures for New York: horses for the ASPCA headquarters on East 92nd Street (ca. 1925), the *Union Square War Memorial* (1934), and weathervanes (1934) for the Central Park Zoo.

In 1928 Diederich was seriously injured in a fall from a ladder at his home, Burgnthann, an eleventh-century castle near Nuremberg, Germany. From this point his artistic output began to decline. During the 1930s he traveled for long periods in Germany, Spain, and Mexico, returning to the United States in 1941. In the years before his death his reputation was tarnished because of his anti-Semitic views. He lived primarily in Tappan, New York, for the last five years of his life. JMM

SELECTED BIBLIOGRAPHY

Diederich, William Hunt, Papers. Archives of American Art, Smithsonian Institution, Washington, D.C., microfilm reels 3339, 3464–65, 3590.

[du] B[ois], G[uy] P[ène]. "Hunt Diederich: Decorator, Humorist and Stylist." *Arts and Decoration* 7 (September 1917), pp. 515–17.

Catalogue of the First American Exhibition of Sculpture by Hunt Diederich. Introduction by Christian Brinton. New York: Kingore Galleries, 1920.

Price, F. Newlin. "Diederich's Adventure in Art." *International Studio* 81 (June 1925), pp. 170–74.

Farmer, Lyn. "Interview: Diana Blake on William Hunt Diederich." *Journal of Decorative and Propaganda Arts* 9 (Summer 1988), pp. 108–21.

Conner, Janis, and Joel Rosenkranz. *Rediscoveries in American Sculpture: Studio Works, 1893–1939,* pp. 19–26. Austin: University of Texas Press, 1989.

Armstrong, Richard. *Hunt Diederich.* Exh. brochure. New York: Whitney Museum of American Art, 1991.

Irish, Carol. "William Hunt Diederich: Negotiating the Path from Sculpture to Decorative Arts, 1910–1929." M. A. thesis, Bard Graduate Center for Studies in the Decorative Arts, Design, and Culture, 1999.

363. *Hunt Scene, Three Wolves Attacking a Horse,* ca. 1920

Wrought iron
21 x 21¾ in. (53.3 x 55.2 cm)
Gift of George Biddle, 1971 (1971.110)

DIEDERICH'S UTILITARIAN objects in wrought iron satisfied his maxim that "art should be useful, should fulfill some specific end and purpose in our lives and homes."[1] *Hunt Scene, Three Wolves Attacking a Horse,* designed for placement in a window, is a circular arrangement of four frenzied animals within an octagonal outer edge. The two-dimensional plaque features the gracefully interlocked planar forms of an attenuated horse and three wolves, reflecting Diederich's fascination with silhouettes, which began in his childhood. The serration of the wolves' fur and tails and the animals' stylized and dynamic bodies seem to be an early manifestation of Art Deco, but they also derive from folk art, particularly the decorative carvings and embroideries of Diederich's native Hungary that he so admired.[2]

When Diederich gave this plaque to his friend the artist George Biddle about 1930, Biddle installed it in a circular gable window of the house he was building in Croton-on-Hudson, New York. The plaque has four nail holes, indicating that it was attached to another surface. In offering the plaque as a gift to the Metropolitan Museum, Biddle wrote, "Such work of [Diederich's] was usually done by blacksmiths or iron workers under his direct supervision."[3]

George Biddle, a muralist and portrait painter, had

known Diederich since boyhood, and the two artists were devoted friends and frequent correspondents.[4] Biddle was elected a Life Fellow of the Metropolitan Museum in May 1958 and gave the Museum a number of his own works on paper and objects from his collection.[5]

The Metropolitan has a linocut by Diederich of about 1920–25, *Horse, Hounds, and Fox* (acc. no. 1999.87), a hunt scene that is compositionally similar to *Hunt Scene, Three Wolves Attacking a Horse* in the circular arrangement of the animals. JMM

EXHIBITION

Rutgers University Art Gallery, New Brunswick, N.J., September 16–November 4, 1979; William Hayes Ackland Art Center, University of North Carolina, Chapel Hill, December 4, 1979–January 20, 1980; Joslyn Art Museum, Omaha, Nebr., February 16–March 30, 1980; Oakland Museum, Oakland, Calif., April 15–May 25, 1980, "Vanguard American Sculpture, 1913–1939," no. 33.

1. Quoted by Brinton, in *Catalogue of the First American Exhibition of Sculpture by Hunt Diederich* 1920, n.p.
2. Jeffrey Wechsler, in Joan M. Marter et al., *Vanguard American Sculpture, 1913–1939*, exh. cat. (New Brunswick, N.J.: Rutgers University Art Gallery, 1979), p. 97.
3. Biddle to Henry Geldzahler, Curator, MMA Department of Twentieth Century Art, December 28, 1970, MMA Archives.
4. See Farmer 1989, p. 108; and Biddle to Geldzahler, December 28, 1970, MMA Archives. Diederich completed a portrait of Biddle (n.d.), now in the collection of the Corcoran Gallery of Art, Washington, D.C.
5. As a Centennial Sponsor, Biddle gave the Museum one watercolor, seventeen prints, 166 lithographs (his complete lithographic oeuvre with the exception of two works), and six Brazilian figurines, MMA Archives.

364. *Fighting Goats,* ca. 1936

Bronze
39 x 17¼ x 14¾ in. (99.1 x 43.8 x 37.5 cm)
Signed (front of base): *H Diederich*
Fletcher Fund, 1955 (55.103)

OF HIS LIFELONG devotion to depicting animals at play and in combat, Diederich was quoted as saying: "Animals are a part of art themselves, they possess such glorious rhythm and spontaneity."[1] After he suffered a serious ankle injury in 1928, his commitment to sculpture waned, and he frequently reinterpreted themes that he had treated earlier in his career. Such is the case with *Fighting Goats,* the first variant of which was produced in 1917 and stands 23¼ inches high (Cleveland Museum of Art).[2] In it the forms of the two animals are more closely arranged and are composed in a less attenuated and stylized manner than they are in his other studies of fighting goats. Diederich modeled a second variant about 1927.[3] For the *Fighting Goats* of about 1936, the base consists of an exaggerated boulderlike mass, and one goat rises dramatically on its hind legs. Diederich's keen observation of animals is exemplified in this graceful, interlocking arrangement of the two goats whose bodies are lean and tensely posed.

Another example of *Fighting Goats* was purchased in 1936 and installed in 1937 at Brookgreen Gardens, Murrells Inlet, South Carolina.[4] One of three examples apparently cast in Paris, the Metropolitan's *Fighting Goats* was purchased from Frederic Newlin Price, owner of the Ferargil Galleries, New York, in May 1955.[5]

JMM

1. Price 1925, pp. 170–71.
2. For an illustration of the Cleveland group, see Katherine Solender, *The American Way in Sculpture 1890–1930,* exh. cat. (Cleveland: Cleveland Museum of Art, in cooperation with Indiana University Press, 1986), p. 43.
3. Conner and Rosenkranz 1989, p. 24.
4. Beatrice Gilman Proske, *Brookgreen Gardens Sculpture,* rev. ed. (Brookgreen Gardens, S.C.: Brookgreen Gardens, 1968), p. 274; and Robin Salmon, Vice President and Curator of Sculpture, Brookgreen Gardens, to Thayer Tolles, electronic letter, September 25, 2000.
5. Artist's information form, filled out by unidentified individual, October 27, 1955, and recommended purchase form submitted by Robert B. Hale, Associate Curator, American Paintings and Sculpture, May 31, 1955, MMA Archives.

730 WILLIAM HUNT DIEDERICH

Victor Salvatore (1884–1965)

Salvatore, born in Tivoli, Italy, came to the United States at the age of ten and settled in New York City with his family. In 1902–3 he took evening classes at New York's Art Students League, studying modeling with George Grey Barnard (pp. 421–27), antique drawing with Charles Courtney Curran, and anatomy with Kenyon Cox. Salvatore also received instruction from Charles H. Niehaus (pp. 356–57), Alexander Phimister Proctor (pp. 412–20), and Hermon Atkins MacNeil (pp. 475–81). In 1904 the young sculptor received a bronze medal at the Louisiana Purchase Exposition in Saint Louis for his portrait *Ava*. From 1906 through the early 1920s Salvatore consistently showed his sculptures at the annual exhibitions of the National Academy of Design, the Pennsylvania Academy of the Fine Arts, and the Art Institute of Chicago. Marble busts, often of children, occupied him in his early years; in 1913 two such examples, *Harriman Baby* and *Bust of a Child* (1913 or earlier; Brooklyn Museum of Art), were included in the landmark Armory Show.

In addition to many portraits Salvatore ventured into ideal subjects, exhibiting works with such titles as *The Little Dreamer, Leda and the Swan,* and *Dawn*. In 1915 he was awarded a silver medal at the Panama-Pacific International Exposition in San Francisco for five works: *Head of Old Lady, Study of a Young Girl, Study of Old Man, Seeking,* and *Youth*. He earned the Helen Foster Barnett Prize for *Big Oak* at the winter exhibition of the National Academy of Design in 1919–20.

During the 1920s and 1930s Salvatore produced portraits in both marble and bronze. His marble busts of Alexander Graham Bell (ca. 1926) and Mrs. William Eaton Brock (ca. 1925) are in the Smithsonian American Art Museum, Washington, D.C. Salvatore modeled a bust of James Fenimore Cooper (1930) for the Hall of Fame for Great Americans on the University Heights campus of New York University (now Bronx Community College). Salvatore's bronze seated statue of Cooper (1940; Cooper Park, Cooperstown, N.Y.) is probably his best-known work. He also produced lively figure studies; for example, in 1964 a cast of *Sand Lot Kid* (ca. 1943), a barefoot boy ready to swing a baseball bat, was installed at the entrance to Doubleday Field in Cooperstown.

Salvatore established a studio by 1910 in Macdougal Alley in Greenwich Village, and in 1918 he organized an outdoor art festival there to raise funds for the World War I relief effort; this event served as a precedent for the outdoor art shows in Washington Square Park, which continue today. During the 1920s and 1930s Salvatore also taught art classes at the Greenwich House Settlement. In his later years he worked in Springfield Center, Otsego County, New York, as well as in New York City. He was an academician of the National Academy of Design (1957) and a member of the Architectural League of New York. In 1966 a memorial exhibition of Salvatore's work was held at the Cooperstown Art Association, of which he had been a member, as part of its annual juried show. JMM

SELECTED BIBLIOGRAPHY

Obituary. *New York Times,* April 12, 1965, p. 35.
Opitz, Glenn B., ed. *Dictionary of American Sculptors,* p. 350. Poughkeepsie, N.Y.: Apollo, 1984.
Falk, Peter Hastings, ed. *Who Was Who in American Art, 1564–1975: 400 Years of Artists in America,* vol. 3, p. 2281. Madison, Conn.: Sound View Press, 1999.

365. *Top Knot,* ca. 1912

Marble
11¼ x 8½ x 6⅛ in. (28.6 x 21.6 x 15.6 cm)
Gift of George D. Pratt, 1924 (24.39)

THE SENSITIVE carving of a child's features attests to Salvatore's solid academic training, but the broad forehead parallels the simplified volumes favored by sculptors of the early twentieth century, such as Aristide Maillol. The charming sculpture has also been referred to as a portrait of Salvatore's patron Ruth Moore as a baby.[1] *Top Knot* was shown at the annual exhibition of the Art Institute of Chicago in 1923.[2]

According to Salvatore, this bust, carved about 1912, is unique in marble, and another example was made in bronze.[3] George D. Pratt (pp. 523–24), who presented the marble to the Metropolitan Museum in 1924, was a trustee of the Museum (1922–35) and a generous donor (see also cat. nos. 187, 189, 243, 377, 378).[4]

Although for many years the work was catalogued as *Bust of a Child,* the title *Top Knot* has been restored in the present volume.[5] The marble surmounts an oval ebonized wood base, 1¾ inches high. JMM

EXHIBITION

Cooperstown Art Association, Cooperstown, N.Y., "Victor Salvatore Memorial Show of Sculpture," July 31–August 25, 1966.

1. "There's No Shortcut to Success Says Famed Sculptor Salvatore," *Daytona Beach News Journal,* April 16, 1961.
2. *Catalogue of the Thirty-sixth Annual Exhibition of American Paintings and Sculpture* (Chicago: Art Institute of Chicago, 1923), no. 278, as "Top-knot."
3. Notes of a telephone conversation with Victor Salvatore, May 16, 1933, object catalogue cards, MMA Department of Modern Art. Salvatore mentioned that the bronze was "owned by the family"; presumably he meant the Moore family. The bronze bust's present whereabouts are unknown.
4. Salvatore's *Meditation,* donated by Pratt to the Metropolitan in 1928, was deaccessioned in 1997.
5. Albert TenEyck Gardner, *American Sculpture* (New York: MMA, 1965), p. 150, published it as "Bust of a Child: Top Knot." See also "List of Accessions and Loans," *MMA Bulletin* 19 (March 1924), p. 78, where it is recorded as "Marble bust of a Child."

Malvina Cornell Hoffman (1885–1966)

While still in her teens and a student at the Brearley School in her native New York City, Hoffman attended the Woman's School of Applied Design and the Art Students League. She also took private painting lessons with John White Alexander, who fostered her interest in sculpture. In 1906 she began sculpture classes with Herbert Adams (pp. 360–64) and George Grey Barnard (pp. 421–27) at the Veltin School and studied privately with Gutzon Borglum (pp. 496–500). Hoffman traveled to Europe in 1910, first to Italy and then to Paris, where she stayed intermittently until the outbreak of World War I. While there she met Gertrude Stein, Henri Matisse, Romaine Brooks, Frederick William MacMonnies (pp. 428–42), Mabel Dodge, and Constantin Brancusi. In her first summer in Paris, she worked as an assistant to Janet Scudder (pp. 525–27). In the months she spent in Paris during 1911–13, Hoffman benefited from critiques by Auguste Rodin, and her association with him developed into a lasting friendship. He exercised a dominant influence on her early work, such as *Column of Life* (1912/17; Los Angeles County Museum of Art), in which male and female figures are fused in an embrace, and *Spirit* (1913; Carnegie Museum of Art, Pittsburgh), which shows a female head emerging from a roughly hewn piece of marble. During the winters of 1911–13 Hoffman returned to New York to attend anatomy classes at Columbia University's College of Physicians and Surgeons, the results of which can be seen in the anatomical drawings she produced. In the spring of 1913 she held her first one-artist show in her 34th Street studio, which resulted in numerous orders and commissions from wealthy American clients.

Hoffman's first dance group, *Russian Dancers* (1911; Detroit Institute of Arts), was inspired by Anna Pavlova and Mikhail Mordkin, whom she had seen perform in London. During her years in Paris she became acquainted with Pavlova and with Vaslav Nijinsky, who were to inspire many sculptures of dancing figures. Hoffman's *Bacchanale Russe* (cat. no. 366) was exhibited in 1915 at the Panama-Pacific International Exposition, San Francisco, where she was awarded an honorable mention for her four submissions, and at the winter annual of the National Academy of Design in 1917–18, earning the Julia A. Shaw Memorial Prize. Following the end of World War I, during which time Hoffman completed many portraits, she returned to working with Pavlova, in 1921 modeling *Pavlova and Novikoff in "La Péri"* (Yale University Art Gallery, New Haven) and in 1924 completing the twenty-six-panel plaster frieze showing Pavlova dancing the *Bacchanale.* In 1924 Hoffman's polychrome portrait mask of Pavlova (see cat. no. 370) won the Elizabeth N. Watrous Gold Medal of the National Academy of Design.

During her lengthy career Hoffman maintained studios in New York City in Sniffen Court and in Paris at the Villa Asti. She produced statuettes, fountains, and sculptures as architectural decoration, but she was most renowned for her portrait studies, among them the sculptor Ivan Mestrovic (1925; Brooklyn Museum of Art), John Keats (1926; University Art Gallery, University of Pittsburgh), and Ignacy Jan Paderewski (cat. no. 369). An exhibition of one hundred examples of Hoffman's work was held at the Grand Central Art Galleries in New York in 1928 and traveled over the next two years to seven American cities, generating publicity and patronage for the artist.

Hoffman's proficient naturalism and penetrating study of character found its best expression in a commission in 1929 for the Field Museum of Natural History in Chicago: more than 100 sculptures representing the ethnic groups of the world. To gather information for the "Living Races of Man," Hoffman traveled around the world in 1931 and 1932 with her husband, Samuel Grimson, a concert violinist to whom she was married from 1924 to 1936. Approximately eighty lifesize sculptures were installed at the Field Museum's Hall of Man in 1933, when it opened, and by 1935 the full commission was on display. In her travels Hoffman was assisted by anthropologists who found appropriate ethnic types to be her models. Examples of these works were exhibited in Paris at the Musée d'Ethnographie in 1932, in 1934 at the Grand Central Art Galleries, New York, and during 1934–36 and 1936–38 in tours to numerous American cities. Hoffman published *Heads and Tales* (1936), which relates her experiences in completing this remarkable group. After her death the series of 104 sculptures was dismantled and was never fully reinstalled at the Field Museum.

Following completion of her work for the Field Museum, Hoffman continued to produce portrait commissions of prominent sitters such as Arthur Ochs (1936), Thomas J. Watson (cat. no. 373), and Wendell Willkie (1947). She was accorded a retrospective exhibition at the Virginia Museum of Fine Arts, Richmond, in 1937. For the 1939 World's Fair in New York she executed a 16-foot cylindrical fountain with relief carvings on the theme of dance around the world, and her *Elemental Man* in plaster was shown in the fair's exhibition "American Art Today." Hoffman's *American World War II Memorial,* carved with stylized relief decoration, was completed in Épinal, France, between 1948 and 1950, a shrine to the American soldiers who died. Late in her career she modeled portraits of Thomas Paine (1952) and Henry David Thoreau (1962) for the Hall of Fame for Great Americans, New York University (now on the campus of Bronx Community College).

Hoffman was intimately involved in the process of finishing and patinating her works. She mastered marble carving, plaster casting, lost-wax casting, and the building of armatures, and she wrote a book about sculptural techniques, *Sculpture Inside and Out* (1939). She became an academician of the National Academy of Design in 1931 and in 1937 was elected to membership in the National Institute of Arts and Letters. She was also named a Chevalier of the Legion of Honor in 1951 and in 1958 a Fellow of the National Sculpture Society, which awarded her its Medal of Honor in 1964. JMM

SELECTED BIBLIOGRAPHY

Hoffman, Malvina, Papers. Special Collections and Visual Resources, Getty Research Institute for the History of Art and the Humanities, Los Angeles.

Bouvé, Pauline Carrington. "The Two Foremost Women Sculptors in America: Anna Vaughn Hyatt and Malvina Hoffman." *Art and Archaeology* 26 (September 1928), pp. 74–82.

Alexandre, Arsène. *Malvina Hoffman*. Paris: J. E. Pouterman, 1930.

Hoffman, Malvina. *Heads and Tales*. New York: Charles Scribner's Sons, 1936.

Hoffman, Malvina. *Yesterday Is Tomorrow: A Personal History*. New York: Crown Publishers, 1965.

Nochlin, Linda. "Malvina Hoffman: A Life in Sculpture." *Arts Magazine* 59 (November 1984), pp. 106–10.

Conner, Janis C. *A Dancer in Relief: Works by Malvina Hoffman*. Exh. cat. Yonkers, N.Y.: Hudson River Museum, 1984.

Hill, May Brawley. *The Woman Sculptor: Malvina Hoffman and Her Contemporaries*. Exh. cat. New York: Berry-Hill Galleries, 1984.

Conner, Janis, and Joel Rosenkranz. *Rediscoveries in American Sculpture: Studio Works, 1893–1939*, pp. 53–62, 187. Austin: University of Texas Press, 1989.

Decoteau, Pamela Hibbs. "Malvina Hoffman and the 'Races of Man.'" *Woman's Art Journal* 10 (Fall 1989–Winter 1990), pp. 7–12.

366. *Bacchanale Russe*, 1912

Bronze
14 x 9 x 9 in. (35.6 x 22.9 x 22.9 cm)
Signed (back of base): MALVINA HOFFMAN ©
Foundry mark (back of base): ROMAN BRONZE WORKS N–Y–
Bequest of Mary Stillman Harkness, 1950 (50.145.40a,b)

THE DANCE was a major theme in Hoffman's oeuvre. Her inspiration stemmed principally from the work of Anna Pavlova (1881–1931), whom she first saw perform in July 1910 with Sergei Diaghilev's Ballets Russes at the Palace Theatre in London. In *Bacchanale Russe,* modeled in Paris in summer 1912, Pavlova and Mikhail Mordkin (1880–1944) are depicted beginning the *Bacchanale,* a ballet choreographed to the autumn section of *The Seasons* by Aleksandr Glazunov.[1] Hoffman distilled brilliantly a moment of action as the figures move forward together holding a billowing cloth. Energy emanates from this small bronze, in which Hoffman acknowledged Rodin's influence in her attention to movement and her portrayal of a fleeting second.

In 1917 Hoffman enlarged *Bacchanale Russe* to a heroic-size bronze, which was given in 1918 by an American collector to the French government for the Luxembourg Gardens in Paris and installed the following year. It was destroyed in the German occupation of Paris during World War II.[2] Another bronze of the same size and date was situated in the gardens of Henry G. Dalton in Bratenahl,

Ohio; it is now in the Fine Arts Garden at the Cleveland Museum of Art.[3]

Nine 14-inch bronzes, including the Metropolitan's, were cast during Hoffman's lifetime, and three were produced posthumously; another lifetime example is in the collection of the Fine Arts Museums of San Francisco.[4] In addition, two 40-inch versions were cast.[5]

The Metropolitan Museum's *Bacchanale Russe* entered the collection through the bequest of Mary Stillman Harkness, which also included bronzes by American sculptors Frederick William MacMonnies (cat. no. 195), Herbert Haseltine (cat. no. 282), and Jo Davidson (cat. no. 347).[6]

JMM

EXHIBITIONS

Vincent Astor Gallery, Library and Museum of the Performing Arts of the New York Public Library at Lincoln Center, New York, "Dance in Sculpture," February 1–April 29, 1971, as "Pavlova and Mordkin ('Bacchanale')."

Philadelphia Art Alliance, "Dance in Sculpture," November 4–29, 1971.

Salem Fine Arts Center, Winston-Salem, N.C., February 27–March 19, 1972; North Carolina Museum of Art, Raleigh,

March 25–April 20, 1972, "Women: A Historical Survey of Works by Women Artists," no. 43.

MMA, "The Human Figure in Transition, 1900–1945: American Sculpture from the Museum's Collection," April 15, 1997–March 29, 1998.

Jane Voorhees Zimmerli Art Museum, Rutgers University, New Brunswick, N.J., "The Enduring Figure 1890s–1970s: Sixteen Sculptors from the National Association of Women Artists," December 12, 1999–March 12, 2000, no. 23.

1. Conner and Rosenkranz 1989, p. 62, n. 4.
2. Artist information form, February 3, 1951, MMA Archives. See also "American Woman Sculptor Honored in France," *New York Times Magazine,* May 19, 1918, p. 12. For an illustration of the monument in situ, see Hoffman 1936, p. 39.
3. For the Cleveland cast, see Katherine Solender, *The American Way in Sculpture 1890–1930,* exh. cat. (Cleveland: Cleveland Museum of Art, in cooperation with Indiana University Press, 1986), p. 47.
4. Janis C. Conner, *Malvina Hoffman (1885–1966),* exh. cat. (New York: FAR Gallery, 1980), p. 11; and Donald L. Stover, *American Sculpture: The Collection of the Fine Arts Museums of San Francisco* (San Francisco: Fine Arts Museums of San Francisco, 1982), p. 74.
5. Conner and Rosenkranz 1989, p. 62, n. 21.
6. For the Harkness bequest, see *MMA Bulletin* 10 (October 1951). Hoffman completed a posthumous portrait of Edward S. Harkness (1946–47; Columbia Presbyterian Medical Center, New York); see Conner and Rosenkranz 1989, p. 59.

367. *Pavlova Gavotte,* 1914

Wax, 1918
14¼ x 7¼ x 7 in. (36.2 x 18.4 x 17.8 cm)
Signed (side of base at figure's left): © MALVINA HOFFMAN
Rogers Fund, 1926 (26.105)

HOFFMAN MADE studies of Anna Pavlova onstage as early as 1910 but did not meet the famous Russian ballerina until the spring of 1914 in New York, where they were introduced by Hoffman's patron Otto Kahn, chairman of the Metropolitan Opera. The two women became close friends, and Hoffman made hundreds of sketches of Pavlova dancing alone and with partners. This statuette, modeled in spring 1914,[1] depicts the ballerina in fluid motion dancing the *Gavotte.* Hoffman later recalled that Pavlova posed in her small New York studio and that "[t]he diaphanous clinging yellow satin dress, which I added as drapery after the nude figure was completed, served to accentuate the grace and rhythmic silhouette of her figure."[2]

In a letter to the Metropolitan Museum, Hoffman noted that this wax example of *Pavlova Gavotte* (alternately titled *Gavotte*) was the twelfth cast, made in 1918.[3] The statuette was exhibited at the Museum from 1918 to 1926 in the long-term installation "An Exhibition of American Sculpture."[4] At some point the sculpture was damaged, and Hoffman asked the Museum to purchase it from her, for it was "now not saleable."[5]

During Hoffman's lifetime *Pavlova Gavotte* was cast both in wax (twelve examples) and in bronze (twenty-three examples) by various American foundries.[6] Bronze casts are at the Cleveland Museum of Art; Detroit Institute of Arts; Fine Arts Museums of San Francisco; Glenbow Museum, Calgary, Alberta; and Whitney Museum of American Art, New York. JMM

EXHIBITION

MMA, Costume Institute, "Diaghilev: Costumes and Designs of the Ballets Russes," November 24, 1978–August 27, 1979.

1. Conner and Rosenkranz 1989, p. 55.
2. Hoffman 1965, p. 146.
3. Hoffman to Preston Remington, Associate Curator of Decorative Arts, MMA, March 13, 1933, MMA Archives.
4. *An Exhibition of American Sculpture* (New York: MMA, 1918), p. 10, no. 37.
5. Hoffman to Henry W. Kent, Secretary, MMA, April 14, 1926; and Kent to Hoffman (copy), April 21, 1926, acknowledging the purchase, MMA Archives. The sculpture was again damaged in 1941, when the head and right arm were broken off. The piece was repaired and the fingers on the right hand remodeled using wax from the underside of the base; notes recorded by F[aith] D[ennis], Assistant Curator, Renaissance and Modern Art, object catalogue cards, MMA Department of Modern Art.
6. Conner and Rosenkranz 1989, p. 62, n. 16. In addition, five bronzes were cast posthumously by Roman Bronze Works.

368. *A Modern Crusader,* 1918

Bronze
18¾ x 11½ x 10 in. (47.6 x 29.2 x 25.4 cm)
Signed (right side of base): MALVINA HOFFMAN
Foundry mark (back of base): ROMAN BRONZE WORKS INC. N—Y—
Gift of Mrs. E. H. Harriman, 1918 (18.122)

COLONEL MILAN PRIBIĆEVIĆ, a hero of the Serbian army in the Balkan Wars, visited the United States in the winter of 1916–17 to recruit volunteers for the cause. Hoffman met Pribićević in New York City through her sister Helen Draper, a board member of the New York chapter of the American Red Cross.[1] Hoffman too was involved in war causes, as secretary of the American Yugoslav Relief Society in World War I and with the Red Cross during both world wars. In August 1919 she traveled to Yugoslavia on behalf of the American Relief Commission to report on the distribution of American supplies to relief victims.[2]

Hoffman modeled two portraits of Pribićević; the first, smaller bust represented him in military uniform.[3] *A Modern Crusader,* which followed, shows Pribićević lifesize, also in uniform, with epaulets and an ensign on his chest and with a knitted helmet covering his head and framing his strong features. While the head covering looks like chain mail such as was worn by crusaders in the Middle Ages, it is actually a woolen type worn during World War I.

The Metropolitan's example of *A Modern Crusader* was cast by Roman Bronze Works in 1918 and, according to Hoffman, was the second cast.[4] The donor was Mrs. Edward Harriman, who also gave Mahonri Young's *Man with a Pick* (cat. no. 286) earlier that year and who, in 1924, sat for a portrait by Hoffman. Shortly after *A Modern Crusader* was acquired by the Museum, Daniel Chester French (pp. 326–41), chairman of the trustees' Committee on Sculpture, wrote to Hoffman that "it has been a great satisfaction to me to add your fine Modern Crusader to our collection of American Sculpture. . . . I have, I think, told you before how much I like this work of your hands." French went on to say that the large amount of contrast in tone between the helmet and the face did not "do justice to the model, and to the effect of the work as a whole." Hoffman agreed to having the sculpture repatinated, but correspondence suggests that instead another bronze cast was delivered to the Museum; French found it "a great improvement over the first one."[5]

Other casts of *A Modern Crusader* are at the Art Institute of Chicago and the Smithsonian American Art Museum, Washington, D.C.[6] JMM

EXHIBITION

Sheldon Swope Art Gallery, Terre Haute, Ind., January–July 1948.

1. Conner and Rosenkranz 1989, pp. 56, 62 n. 19; see also Hoffman 1936, pp. 127–28.
2. See Taylor 1979, p. 78; and obituary, *New York Times,* July 11, 1966, p. 1.
3. Conner and Rosenkranz 1989, p. 56.
4. Roman Bronze Works Archives, Amon Carter Museum, Fort Worth, ledger 5, p. 286. The first cast of *A Modern Crusader* is entered in the ledger under July 27, 1918, and the second through fourth casts are listed under November 6, 1918. See also Hoffman

to Preston Remington, Associate Curator of Decorative Arts, MMA, March 13, 1933, MMA Archives.

5. French to Hoffman, November 25, 1918, French to Edward Robinson, Director, MMA, January 29, 1919, and French to Hoffman, February 23, 1919 (all copies), Daniel Chester French Family Papers, Manuscript Division, Library of Congress, Washington, D.C., microfilm reel 5, frames 31, 121, 157.

6. See *Descriptive Catalogue of Painting and Sculpture in the National Museum of American Art, Washington, D.C.* (Boston: G. K. Hall, 1983), p. 91.

369. *Paderewski the Artist*, 1923

Bronze
16 x 13½ x 8 in. (40.6 x 34.3 x 20.3 cm)
Signed and dated (right side of neck): © / 1923 / MALVINA HOFFMAN
Foundry mark (back of support): ROMAN BRONZE WORKS N–Y–
Francis Lathrop Fund, 1940 (40.99)

FOR HOFFMAN, whose father was a professional pianist, music was an integral part of life. In 1922 she met the renowned Polish pianist and composer Ignacy Jan Paderewski (1860–1941) while visiting Switzerland.[1] Paderewski, also a statesman, was attending sessions at the League of Nations in Geneva; there Hoffman studied his features and began to prepare a portrait bust of him.[2] Later, in New York, the sculptor requested that he sit for the bust *Paderewski the Statesman* (1922; Steinway Hall, New York), then in progress. He agreed and gave her a front-row ticket to a concert of his at Carnegie Hall the evening before the modeling session. Hoffman later recalled that "[w]hile he was playing Chopin, I suddenly decided that I must do another portrait of him as the artist."[3]

She returned to her studio and quickly modeled a portrait that represented Paderewski's artistic persona. The next morning Paderewski noticed the head in her studio and declined her request that he pose so she could work on it: "Impossible. . . . This one is finished; it is the portrait of my inner self lost in my music."[4] In *Paderewski the Artist* Hoffman's spontaneity in creating the work is evident in the agitated surface and in the subject's tousled hair. As she was wont to do in her portraits of people for whom she felt a special affinity, Hoffman achieved not only a general likeness of her sitter but also an eloquent expression of his spirit. Later she completed another bust, *Paderewski the Friend,* which both artist and sitter "agreed was the most sympathetic version."[5] A more conventional portrait by Hoffman entitled *Paderewski the Man* is in the collection of the Smithsonian American Art Museum, Washington, D.C.

The Metropolitan Museum acquired *Paderewski the Artist* directly from the sculptor.[6] According to Hoffman, this bronze was the second cast; the first was acquired by the American Academy in Rome, the gift of Mrs. William Church Osborn.[7] Another bronze is at the Bates College Museum of Art, Lewiston, Maine.

Paderewski the Artist is mounted on a veined marble base, 5½ inches high. JMM

EXHIBITIONS

23rd Annual Women's International Exposition of Arts and Industries, 71st Regiment Armory, New York, November 4–11, 1946.

Hammond Museum, North Salem, N.Y., "Women in Art: Creative Talents of the Past and Present," November 9–December 22, 1974.

1. Conner and Rosenkranz 1989, p. 187, n. 27.
2. Hoffman 1936, p. 70.
3. Hoffman 1965, p. 208.
4. Ibid.
5. Ibid., p. 210; illustrated in Joshua Taylor, "Malvina Hoffman," *Art and Antiques* 2 (July–August 1979), p. 96. This bust (now lost) was cast only in plaster.

6. Recommended purchase form, signed by Preston Remington, Curator of Renaissance and Modern Art, MMA, June 3, 1940, MMA Archives: "No example of Miss Hoffman's distinguished portrait of Paderewski exists in any American collection. . . . Aside from the great interest of the subject, the head is one of Miss Hoffman's ablest achievements. It is the result of careful studies made from life."
7. Information provided by Hoffman, copyright permission form, October 3, 1940, MMA Archives. The American Academy bust is illustrated in Hoffman 1936, p. 71.

370. *Mask of Anna Pavlova,* 1924

Wax, tinted
16 x 9 x 7 in. (40.6 x 22.9 x 17.8 cm)
Signed and dated (bottom of neck): M. HOFFMAN / 1924 / ©
Gift of Mrs. L. Dean Holden, 1935 (35.107)

THIS PORTRAIT of the Russian-born ballerina Anna Pavlova, made from a life mask, creates the sense of a living, breathing woman, an impression intensified by the colored features. Since the eyes are lowered and the mouth is closed, however, there is also the suggestion of death—of the transcendence of this mortal life. One writer on Hoffman's work suggested that this image portrays Pavlova as a saint.[1] The idea is supported by Pavlova's appearance as a living icon at a lavish birthday party given for her by Hoffman. A photograph of the party shows Pavlova, like a "Byzantine Madonna," seated beneath a "huge gilded icon frame" and wearing a decorative headdress similar to the one seen in the Museum's mask.[2] Hoffman tinted the wax to give to the face a lifelike skin tone and colored the headdress and necklace the red, blue, and gold-green hues of a gold crown and gemlike stones. These were probably once bright but are now faded. The wax surmounts a blue-painted wood base, 7¾ inches high.

The Metropolitan's wax cast was on loan to the Museum from Mrs. L. Dean Holden for five years beginning in 1930 and was displayed near the head of the Grand Staircase.[3] She made the gift official in 1935. The portrait was cast in wax in an edition of twelve, and according to the artist, the Museum's wax is the ninth.[4] The nose of the Metropolitan's wax is chipped. A marble version is in the collection of the El Paso Museum of Art, and the original plaster is at the New-York Historical Society. Other wax casts are in the collections of the Carnegie Museum of Art, Pittsburgh; Corcoran Gallery of Art, Washington, D.C.; Detroit Institute of Arts; Joint Free Public Library of Morristown and Morris Township, New Jersey; and Metropolitan Opera Guild, New York. Bronze casts of a half-lifesize version are at the Fogg Art Museum, Harvard University, Cambridge, Massachusetts, and Palm Springs Desert Museum, Palm Springs, California, while a half-lifesize terracotta is at the Corcoran Gallery of Art.[5]

JMM

EXHIBITIONS

Vincent Astor Gallery, Library and Museum of the Performing Arts of the New York Public Library at Lincoln Center, New York, "Dance in Sculpture," February 1–April 29, 1971.
Whitney Museum of American Art, New York, "200 Years of American Sculpture," March 16–September 26, 1976, no. 100.
MMA, Costume Institute, "Diaghilev: Costumes and Designs of the Ballets Russes," November 24, 1978–August 27, 1979.
Hudson River Museum, Yonkers, N.Y., "A Dancer in Relief: Works by Malvina Hoffman," March 25–May 13, 1984.

1. Joshua Taylor, "Malvina Hoffman," *Art and Antiques* 2 (July–August 1979), p. 100.
2. Hoffman 1965, pp. 149–50.
3. See "List of Accessions and Loans, January 6 to February 5, 1930," *MMA Bulletin* 25 (March 1930), p. 82; and J[ohn] G. P[hillips], "A Portrait in Wax," *MMA Bulletin* 31 (January 1936), p. 15.
4. Conner 1984, n.p., entry in exhibition checklist; and Hoffman to Preston Remington, Associate Curator of Decorative Arts, MMA, March 13, 1933, MMA Archives. However, in a photography permission form, December 1, 1935, Hoffman wrote that there were six examples in wax and that she did not know which number the Metropolitan's was, MMA Archives.
5. Conner and Rosenkranz 1989, p. 187, n. 28; see also Diana J. Strazdes et al., *American Paintings and Sculpture to 1945 in the Carnegie Museum of Art* (New York: Hudson Hills Press, 1992), pp. 257–58.

371. *Ni Polog,* 1931

Bronze
5¾ x 3⅛ x 5 in. (14.6 x 7.9 x 12.7 cm)
Signed and inscribed (around right edge of neck): BALI © M. HOFFMAN
Foundry mark (back of support): C.B.W. Nº 4
Francis Lathrop Fund, 1934 (34.40.1)

HOFFMAN'S MOST important commission was a series of lifesize models of the "Living Races of Man" that she began to create in 1929 for the Field Museum of Natural History in Chicago. The series ultimately included 104 single figures, groups, and busts, all cast in bronze. When the Hall of Man opened at the Field Museum in 1933, eighty of her sculptures were exhibited (only the Native American groups had not been completed), and by 1935 the entire series was on view. Hoffman's research led her around the world, and local anthropologists helped her find "authentic" ethnic types to serve as models. Though Hoffman always considered her assignment artistic rather than anthropological, these ethnographic studies of men and women lack much of the spontaneity and character readily apparent in her portraits of personal friends.

Ni Polog represents the head of a Balinese temple dancer.[1] Hoffman also created a one-third lifesize statuette of Ni Polog in elegant costume.[2] The Museum's bronze head, cast at Cellini Bronze Works, is a reduced version (half-lifesize) of the full-size head in the Field Museum.[3] Variations in the patination of the bronze emphasize the contrast of the black hair with the warm brown flesh. During an exhibition of replicas from the "Races of Man" series at Grand Central Art Galleries in 1934, the purchase of three was recommended by Preston Remington, Curator of Renaissance and Modern Art at the Metropolitan Museum. *Ni Polog* and *Daboa* (cat. no. 372) were thus acquired.[4] *Ni Polog* was one of Hoffman's more successful replicas from the series, with sixteen examples cast; she noted in 1934 that the Museum's example was the fourth.[5]

The head is mounted on an ebonized wood base, 3 inches high. JMM

1. Hoffman 1936, pp. 258 (which includes a photograph of Ni Polog), 263.
2. Ibid., p. 258, "Golden Bronze Statuette of Balinese Dancer by M.H." The 17-inch statuette was acquired by Brookgreen Gardens in 1937; see Beatrice Gilman Proske, *Brookgreen Gardens Sculpture,* rev. ed. (Brookgreen Gardens, S.C.: Brookgreen Gardens, 1968), p. 212.
3. See Conner and Rosenkranz 1989, p. 187, nn. 30, 31.
4. Recommended purchase form, February 16, 1934, completed by Preston Remington, Curator of Renaissance and Modern Art; purchase was authorized through Henry W. Kent, Secretary, February 19, 1934, MMA Archives. For the show at Grand Central Art Galleries, see "Malvina Hoffman Uses Art to Present Characteristics of the Races," *Art Digest* 8 (February 1, 1934), p. 10.
5. Conner and Rosenkranz 1989, p. 187, n. 31; and photography permission form completed by Hoffman, February 23, 1934, MMA Archives.

372. *Daboa*, 1931

Bronze
22¾ x 8 x 11¼ in. (57.8 x 20.3 x 28.6 cm)
Signed and inscribed (right side of base): © MALVINA HOFFMAN FIELD MUSEUM CHICAGO
Foundry mark (back of base): Alexis Rudier
Francis Lathrop Fund, 1934 (34.40.2)

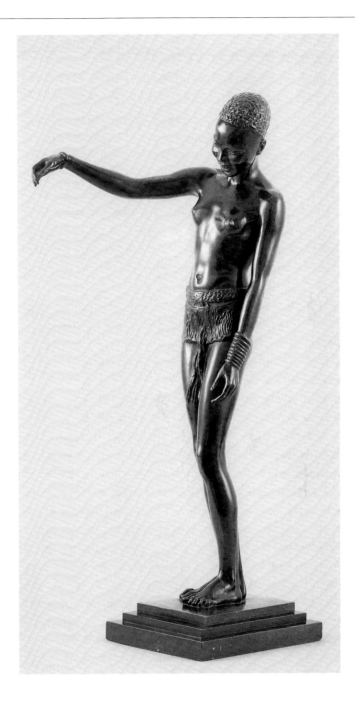

DABOA IS A lively study of a young female dancer of
the Sara tribe from the Lake Chad area in northwest cen-
tral Africa. The sculpture exemplifies Hoffman's proficiency
in representing the human body in motion, for although
the figure's feet are planted firmly on the ground, the
slender body seems to be responding to an unheard
rhythm. The Metropolitan Museum's statuette is a one-
third size reduction of the lifesize bronze statue that
Hoffman modeled for her "Living Races of Man" series
for the Field Museum of Natural History, Chicago.
Another lifesize *Daboa* is at the American Museum of
Natural History, New York.[1]

There are nineteen documented casts of the *Daboa*
statuette.[2] According to Hoffman, the Metropolitan's was
the third bronze example.[3] It was cast in Paris by Alexis
Rudier, the foundry that produced the "Races of Man"
series for the Field Museum. *Daboa* was purchased by the
Metropolitan Museum, along with *Ni Polog* (cat. no. 371),
in February 1934 during an exhibition of reductions after
the "Races of Man" at New York's Grand Central Art
Galleries.[4] Other bronze statuettes are in the collections
of the Mead Art Museum, Amherst College, Amherst,
Massachusetts, and Glenbow Museum, Calgary, Alberta.

JMM

EXHIBITIONS

Flint Institute of Arts, Flint, Mich., "American Sculpture, 1900–
1965," April 1–25, 1965, no. 31.
Sterling and Francine Clark Art Institute, Williamstown, Mass.,
"Cast in the Shadow: Models for Public Sculpture in America,"
October 12, 1985–January 5, 1986, no. 17.
MMA, "The Human Figure in Transition, 1900–1945: American
Sculpture from the Museum's Collection," April 15, 1997–
March 29, 1998.

1. Hoffman 1965, p. 153.
2. Conner and Rosenkranz 1989, p. 187, n. 31.
3. Photography permission form, completed by Hoffman, Febru-
ary 23, 1934, MMA Archives.
4. Recommended purchase form, February 16, 1934, MMA Archives,
completed by Preston Remington, Curator of Renaissance and
Modern Art: "The three sculptures which I now bring to the Com-
mittee [on Purchase]'s attention are all the result of Miss Hoffman's
remarkable work in connection with the Field Museum." The
purchase of two bronzes was authorized on February 19, 1934.
Daboa is illustrated in a full-page advertisement for the exhibition at
Grand Central Art Galleries in *Art Digest* 8 (February 1, 1934), p. [2].

373. *Thomas J. Watson,* 1946

Bronze

23¼ x 20¼ x 12½ in. (59.1 x 51.4 x 31.8 cm)

Signed and dated (right side): MALVINA HOFFMAN 1946 ©

Foundry mark (back): MODERN ART FDRY. N.Y.

Gift of Helen W. Buckner, 1973 (1973.38)

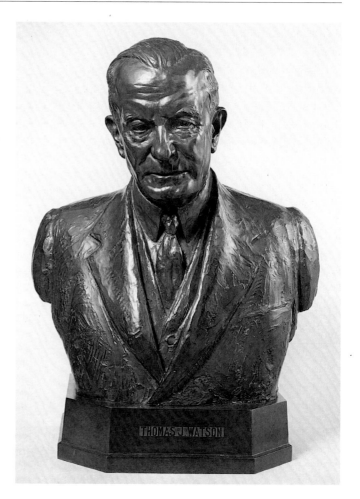

THOMAS JOHN WATSON (1874–1956) was president from 1914 and then chairman (1949–56) of Computing-Tabulating-Recording Company, which in 1924 was renamed International Business Machines Corporation (IBM). He also served as president of the International Chamber of Commerce in the 1930s and as trustee of the American Association for the United Nations and of Columbia University, causes for which he worked tirelessly. Apart from those commitments and his dedication to his company, his primary interest was art. He built an imposing art collection, devoted in large part to works by American artists, and he approved IBM sponsorship of many art exhibitions while he was president of the company.[1] He was elected a trustee of the Metropolitan Museum in 1936 and vice president in 1945. In 1946, the same year this bust was modeled, Watson served as chairman of the Museum's Seventy-fifth Anniversary Campaign. At his request in 1951 he became an honorary trustee and served until his death. In the Museum's 1954–65 building programs, a new library was part of the plan. Completed in November 1964, the library opened to the public in January 1965 as the Thomas J. Watson Library in honor of Watson's "faithful and distinguished service to the Museum."[2]

This bust of Watson in business attire is a good example of Hoffman's incisive treatment of a portrait subject, even though he was not a personal friend. In this realistic depiction the artist chose to present the solemn, conservative nature of the hardworking IBM executive. This bronze bust, which is on display in the Thomas J. Watson Library, came to the Museum as a gift from one of Watson's daughters, Helen W. Buckner.[3] Hoffman gave a plaster version to the New-York Historical Society in 1951.[4]

The portrait is mounted on its original bronze pedestal, 4 inches high, which is inscribed THOMAS J. WATSON.

JMM

1. *American National Biography,* s.v. "Watson, Thomas John."
2. Roland L. Redmond and James J. Rorimer, "Review of the Year 1958–1959," in "Eighty-ninth Annual Report," *MMA Bulletin* 18 (October 1959), p. 41; and "Metropolitan Museum to Open Its Watson Library on Tuesday," *New York Times,* January 21, 1965, p. 28.
3. Helen W. Buckner to Kay Bearman, Assistant Curator, MMA Department of Twentieth Century Art, March 6, 1973, MMA Archives.
4. *Catalogue of American Portraits in the New-York Historical Society* (New Haven: Yale University Press, 1974), vol. 2, p. 869, no. 2213.

Paul Manship (1885–1966)

Paul Howard Manship, born in Saint Paul, Minnesota, received early training in painting, drawing, and sculpture at the Mechanical Arts High School from 1900 to 1903, and he took evening classes at the Saint Paul School of Art. He worked as a commercial artist in Minneapolis and Saint Paul before moving to New York in 1905. After a brief period of study with George Bridgman and Hermon Atkins MacNeil (pp. 475–81) at the Art Students League, he worked until 1907 in the studio of Solon Hannibal Borglum (pp. 508–11), who tutored him in modeling and the dissection of animals. Manship enrolled from October 1907 to May 1908 at the Pennsylvania Academy of the Fine Arts, where he took life modeling classes under Charles Grafly (pp. 403–7), and life drawing with William Merritt Chase. In 1908, after traveling to Spain for the summer with William Hunt Diederich (pp. 727–30), Manship began working in the studio of Isidore Konti (pp. 408–11). He turned away from the expressive modeling and commonplace subjects of his earliest sculptures for classicizing themes. Konti also urged Manship to study in Rome.

In 1909, as recipient of a three-year fellowship in sculpture, Manship lived and worked at the American Academy in Rome. While there, he saw Roman and Italian Renaissance bronzes, and in 1912 he traveled around the eastern Mediterranean to study ancient Greek, Near Eastern, and Egyptian sculpture. In various cities and archaeological sites in Greece, Manship saw examples of archaic-period sculpture and painted vases, which were a major influence in the development of his signature style.

Late in 1912 Manship returned to New York with plasters created during his time in Rome. His recent sculptures were shown in early 1913 at the Architectural League of New York and were acclaimed for their meticulous craftsmanship and originality of conception. Collectors, wary of abstraction but bored with the prevailing Beaux Arts academicism, were drawn to Manship's classicizing subjects, which, although grounded in naturalism, were articulated crisply with stylized forms and rhythmic contours. At the winter exhibition of the National Academy of Design in 1913–14, *Centaur and Dryad* (see cat. no. 375) was awarded the Helen Foster Barnett Prize; *Dancer and Gazelles* (see cat. no. 382) won the same prize in 1917. In 1915 Manship's life-size *Duck Girl* (1917 cast; Rittenhouse Square, Philadelphia) was exhibited at the Pennsylvania Academy, winning the George D. Widener Memorial Gold Medal, and at the Panama-Pacific International Exposition in San Francisco he received a gold medal for his works, including *Little Brother* (see cat. no. 374), *Indian Hunter* and *Pronghorn Antelope* (see cat. nos. 377, 378), and *Centaur and Dryad*.

In 1916 Manship held his first solo exhibition in New York City at the Berlin Photographic Company. The show of 150 pieces was an enormous critical and commercial success. Manship received numerous public and private commissions, which he carried out in his expanded New York studio with assistants, who included Beniamino Bufano, Gaston Lachaise (pp. 660–88), and Reuben Nakian. During World War I Manship went to Italy as a volunteer with the Red Cross. After the war he lived in Europe between 1921 and 1926; he then returned to New York but maintained a studio in Paris until 1937. From 1922 to 1924 he was a professor at the American Academy. In 1943 Manship purchased land in Lanesville, Massachusetts, near Gloucester.

During the 1920s and 1930s Manship was highly favored for sculptural commissions. Architects were attracted to his streamlined, stylized figures, which could complement modern architecture or city plazas, as well as to his attention to every detail of the sculptural process from modeling to patination. Manship is best known for his public sculpture, notably the *Prometheus Fountain* (1934) in Rockefeller Center, New York, and the *Paul J. Rainey Memorial Gateway* (1934; see cat. no. 387) for the Bronx Zoo. For the 1939 World's Fair in New York, Manship produced the *Time and the Fates Sundial* and four related groups, *The Moods of Time*. A celestial sphere, 13 feet in diameter, was displayed in plaster at the fair; it was also installed in bronze at the League of Nations in Geneva as a memorial to Woodrow Wilson. The bold stylization and crisp linearity of Manship's oeuvre anticipated the Art Deco style in America, although he avoided any association with this style.

In the 1940s Manship's commissions began to dwindle; his style was less appealing because it appeared too traditional to those interested in abstraction. Still, he was productive, receiving commissions for such projects as the John F. Kennedy inaugural medal (1960), an armillary sphere and sundial for the New York World's Fair in 1964, and a memorial to Theodore Roosevelt in Washington, D.C. (1964; Roosevelt Island).

Among the many honors Manship received during his long career were election as an academician of the National Academy of Design in 1916 and as a member of the National Institute of Arts and Letters in 1920. He was made a Chevalier of the French Legion of Honor in 1929 and served as president of the National Sculpture Society from 1939 to 1942. He was a member of the Federal Arts Commission from 1937 to 1941, and from 1948 to 1954 was president of the American Academy of Arts and Letters, to which he had been elected in 1932. In 1958 the National

Collection of Fine Arts, Washington, D.C., held a retrospective of his work, and following his death, memorial exhibitions were held at the National Arts Club, New York, and at the National Collection of Fine Arts and the Minnesota Museum of Art, Saint Paul. His artistic estate, consisting of more than seven hundred sculptures and drawings, was deeded to the National Collection of Fine Arts (now the Smithsonian American Art Museum) and the Minnesota Museum of Art (now the Minnesota Museum of American Art). JMM

SELECTED BIBLIOGRAPHY

Manship, Paul, Papers. Originals privately owned. Microfilmed by the Archives of American Art, Smithsonian Institution, Washington, D.C., reels NY59-15–NY59-17, N714–17.

Manship Estate, Paul, Papers. Archives of American Art, Smithsonian Institution, Washington, D.C., microfilm reel 3829.

Manship, Paul. Interview, 1956, with Columbia University Oral History Research Office. Archives of American Art, Smithsonian Institution, Washington, D.C., microfilm reel 5044.

Manship, Paul. Interview, 1959, with John Morse, Archives of American Art Oral History Program. Archives of American Art, Smithsonian Institution, Washington, D.C., microfilm reel 4210.

Gallatin, A. E. *Paul Manship: A Critical Essay on His Sculpture and an Iconography.* New York: John Lane Company, 1917.

Vitry, Paul. *Paul Manship: Sculpteur Américain.* Paris: Éditions de la Gazette des Beaux-Arts, 1927.

Paul Manship. American Sculptors Series 2. New York: W. W. Norton under the auspices of the National Sculpture Society, 1947.

Murtha, Edwin. *Paul Manship.* New York: Macmillan, 1957.

Leach, Frederick D. *Paul Howard Manship, An Intimate View: Sculpture and Drawings from the Permanent Collection of the Minnesota Museum of Art.* Exh. cat. Saint Paul: Hamline University and Minnesota Museum of Art, 1972.

Paul Manship: Changing Taste in America. Exh. cat. Saint Paul: Minnesota Museum of Art, 1985.

Rather, Susan. *The Origins of Archaism and the Early Sculpture of Paul Manship.* Ph.D. diss., University of Delaware, 1986. Ann Arbor, Mich.: UMI, 1988.

Smith, Carol Hynning. *Drawings by Paul Manship: The Minnesota Museum of Art Collection.* Saint Paul: Minnesota Museum of Art, 1987.

Rand, Harry. *Paul Manship.* Exh. cat. Washington, D.C.: Smithsonian Institution Press for the National Museum of American Art, 1989.

Manship, John. *Paul Manship.* New York: Abbeville Press, 1989.

Rather, Susan. *Archaism, Modernism, and the Art of Paul Manship.* Austin: University of Texas Press, 1993.

374. *Little Brother,* 1912

Bronze, probably 1914–17
12¾ x 4¾ x 7⅛ in. (32.4 x 12.1 x 18.1 cm)
Signed and dated (top of base, right front): PAUL MANSHIP / ROME / © / 1913
Foundry mark (back of base): ROMAN BRONZE WORKS NY
Gift of J. Richardson Dilworth and Diana Dilworth Wantz, 1984 (1984.535)

MANSHIP CREATED *Little Brother* in 1912 during his three-year fellowship at the American Academy in Rome. The sculpture depicts a nude young woman seated on a low pedestal, holding an infant above her shoulder so that she can look into his face. Manship's *Playfulness* (Minneapolis Institute of Arts), a partially nude female bouncing an infant on her knees, which was made a few months earlier, served as a prototype for *Little Brother.* The female figure may also be related in facial features and body type to Manship's *Lyric Muse* (1912; Museum of Fine Arts, Boston), which depicts a kneeling nude woman holding a lyre. Although Manship completed the three plaster models in Rome, they were cast in bronze in New York, after his return to the United States. *Little Brother,* copyrighted in 1913, was among Manship's nine submissions to the National Academy of Design's 1913–14 winter annual, one of thirteen entries to the Pennsylvania Academy of the Fine Arts annual in 1914, and one of his ten sculptures at the 1915 Panama-Pacific International Exposition in San Francisco.[1]

The subject matter is one of simple domesticity with no symbolic significance. What is most important in this and the two related works is Manship's introduction of stylized drapery and figural conventions from archaic Greek sculpture, elements that became a hallmark of his style throughout his career. Manship conveys his delight in presenting crisply rendered forms, smooth surfaces, and elegant lines in this lively sculptural group.

Manship's biographer Edwin Murtha noted that *Little Brother* was cast in an edition of fifteen, but more were produced.[2] Roman Bronze Works foundry ledgers list a total of seventeen casts made between 1914 and 1917, including ten in 1914.[3]

The donors, J. Richardson Dilworth, chairman of the Museum's Board of Trustees from 1983 to 1987, and his sister, Diana Dilworth Wantz, lent this cast of *Little Brother* to the Metropolitan in 1979, giving it to the Museum in 1984. JMM

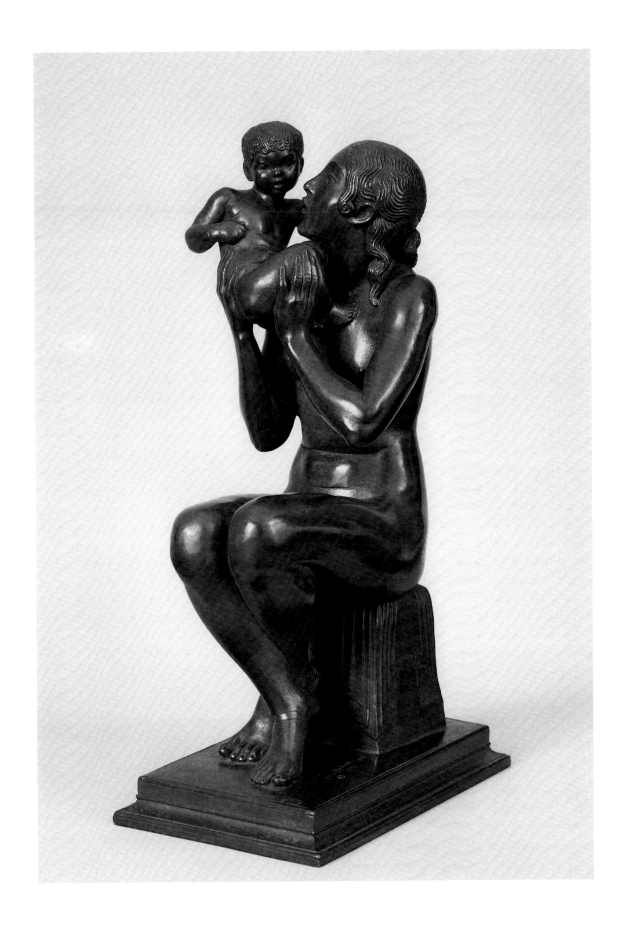

1. *Illustrated Catalogue, National Academy of Design Winter Exhibition 1913* (New York, 1913), p. 13, no. 40; *Pennsylvania Academy of the Fine Arts . . . Catalogue of the 109th Annual Exhibition,* 2nd ed. (Philadelphia, 1914), p. 53, no. 618; *Official Catalogue of the Department of Fine Arts, Panama-Pacific International Exposition* (San Francisco: Wahlgreen Co., 1915), p. 240, no. 4077.

2. Murtha 1957, p. 150, no. 18, pl. 7. Other bronzes are at the Cincinnati Art Museum; Cranbrook Art Museum, Bloomfield Hills, Mich.; Smithsonian American Art Museum, Washington, D.C.; and Stan Hywet Hall and Gardens, Akron, Ohio.

3. Roman Bronze Works Archives, Amon Carter Museum, Fort Worth, ledger 4, pp. 88–89, 124–25.

375. *Centaur and Dryad,* 1909–13

Bronze, 1913–14
27¾ x 21¼ x 11⅛ in. (70.5 x 54 x 28.3 cm)
Signed and dated (top of base, under centaur's left foreleg): PAUL • MANSHIP. / © / 1913
Amelia B. Lazarus Fund, 1914 (14.61)

CENTAUR AND DRYAD ranks as one of the major critical successes of Manship's early career. He modeled the group in Rome, commencing studies as early as 1909, and completed its elaborate pedestal in New York. The subject represented, a lecherous centaur attempting to embrace a protesting wood nymph, can be found in art of the ancient world. The rectangular pedestal of exquisite workmanship complements the theme of the group above it, the consumption of wine that releases the passions of the centaur, a mythological creature that is half-man and half-horse. There are low-relief scenes of satyrs chasing maenads, with two griffins on either narrow end. Around the bottom of the base is a decorative border of animals, birds, and dolphins.

Manship's reference to archaic rather than classical Greek models was highly innovative for an American artist of the early twentieth century. Instead of the outworn modes of academic classicism, Manship was drawn to the severity of archaic Greek art, evident in the stylized hair and curls, windswept linear treatment of drapery, smoothly articulated modeling of the bodies, and crisp silhouette of the two figures. *Centaur and Dryad* may be associated with such ancient sculptures as the metopes from the Temple of Zeus at Olympia featuring the Battle of the Lapiths and the Centaurs, for Manship was once stranded in Olympia, "so I sat in front of those wonderful sculptures from the pediment of the Temple of Zeus and drew."[1] Yet his composition has no direct prototype, and Susan Rather has argued recently that Greek vase painting and Pompeiian frescoes provide closer thematic prototypes.[2]

Centaur and Dryad, then referred to by the title *Centaur and Nymph,* was purchased directly from Manship in April 1913 and is the first replica in bronze.[3] Daniel Chester French (pp. 326–41), chairman of the Museum trustees' Committee on Sculpture, in all likelihood saw *Centaur and Dryad* when Manship displayed ten sculptures at the Architectural League of New York in early 1913;[4] the two men were also carrying on discussions that preceded the Metropolitan Museum's commissioning the *John Pierpont Morgan Memorial* (cat. no. 380) from Manship in 1915. In notifying Manship that the trustees' Committee on Sculpture had recommended the purchase of *Centaur and Dryad,* French requested, "[W]ill you proceed as soon as may be to have the group put in bronze?"[5] In early December French inquired about the status of the casting; Manship replied that he was not satisfied with the present casting of

the base and was planning to try again, this time with the Gorham foundry, which promised to provide a cast by mid-January 1914.[6] The group was not delivered to the Metropolitan Museum until April 1914, at which time Manship was compensated for the additional expense of recasting the base.[7] The bronze group and base are mounted on a black veined marble plinth, 1¾ inches high.

In December 1913 Manship submitted a cast of *Centaur and Dryad* (Detroit Institute of Arts) o the annual winter exhibition of the National Academy of Design, where it won the Helen Foster Barnett Prize for the best sculpture by an artist under the age of thirty-five.[8] That award and the acquisition of the work by the Metropolitan Museum marked the turning point in Manship's career and the beginning of a professional success that was to escalate steadily until the 1930s.

According to Edwin Murtha, five examples of *Centaur and Dryad* were cast in bronze, but more are known.[9]

JMM

EXHIBITIONS

Berlin Photographic Company, New York, "Exhibition of Sculpture by Paul Manship," February 15–March 8, 1916, no. 11.
National Arts Club, New York, "Paul Manship Memorial Exhibition," May 10–24, 1966.
Whitney Museum of American Art, New York, "200 Years of American Sculpture," March 16–September 26, 1976, no. 155.
National Pinakothek, Athens, "Under the Classical Spell: Treasures from The Metropolitan Museum of Art," September 24–December 31, 1979, no. 113.
MMA, "The Art of Paul Manship," June 11–September 1, 1991.
MMA, Henry R. Luce Center for the Study of American Art, "Subjects and Symbols in American Sculpture: Selections from the Permanent Collection," April 11–August 20, 2000.

1. Manship interview with Morse 1959, Archives of American Art, microfilm reel 4210, frame 647.
2. For an extended discussion of the composition, its sources and chronology, see Susan Rather, "The Past Made Modern: Archaism in American Sculpture," *Arts Magazine* 59 (November 1984), pp. 113–14; Rather 1993, pp. 76–85; and C[lynda] L. B[enson], *Masterworks of American Paintings and Sculpture from the Smith College Museum of Art* (New York: Hudson Hills Press in association with Smith College Museum of Art, 1999), pp. 147–49.
3. Recommended purchase form, April 21, 1913, MMA Archives; unsigned notes of a telephone conversation with Manship, January 6, 1933, recorded on object catalogue cards, MMA Department of Modern Art. In this interview the artist informed the Museum that the title of the sculpture was not *Centaur and Nymph,* but *Centaur and Dryad.*

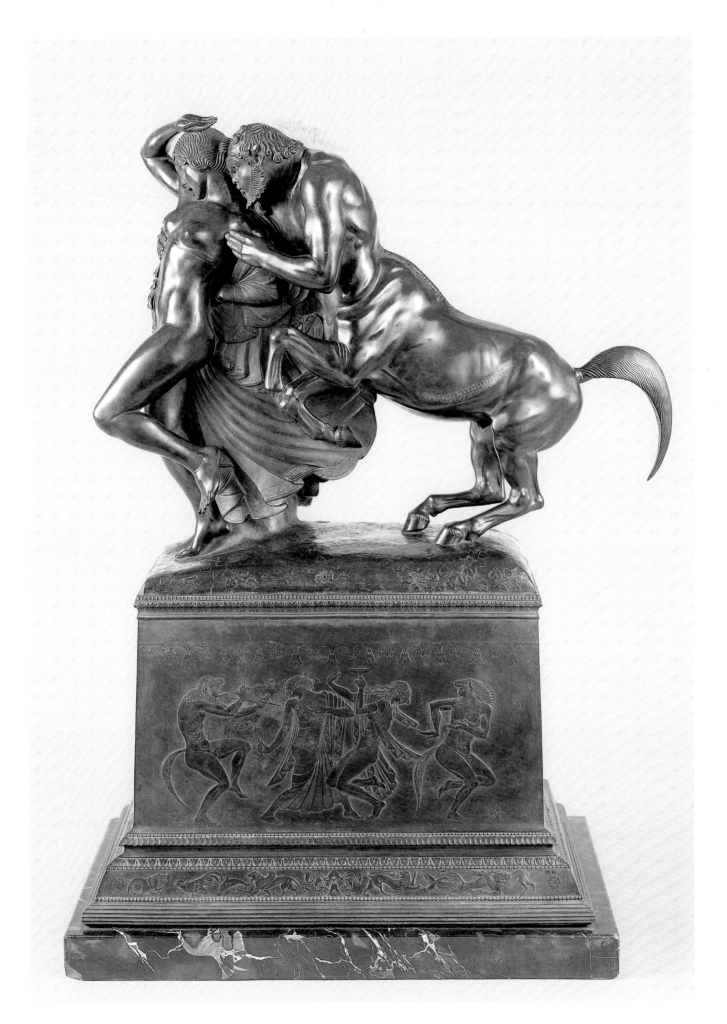

4. Rather 1993, p. 77.
5. French to Manship, April 15, 1913 (copy), Daniel Chester French Family Papers, Manuscript Division, Washington, D.C., microfilm reel 2, frame 263.
6. French to Manship, December 1, 1913 (copy), French Family Papers, Library of Congress, microfilm reel 2, frame 315; Manship to Edward Robinson, Director, MMA, December 13, 1913, MMA Archives.
7. See typewritten notation, dated April 20, 1914, on recommended purchase form, MMA Archives; Robinson to Manship, April 21, 1914, MMA Archives, which notes that after Manship brought the group to the Museum on April 20, "it was greatly admired" at a meeting of the Board of Trustees.
8. *Illustrated Catalogue, National Academy of Design Winter Exhibition 1913* (New York, 1913), p. 15, no. 72.
9. Murtha 1957, p. 150, no. 28, pl. 2. Other casts are located at the Detroit Institute of Arts; Fogg Art Museum, Harvard University, Cambridge, Mass.; Phoenix Art Museum; Saint Louis Art Museum; Smith College Museum of Art, Northampton, Mass.; and Wadsworth Atheneum, Hartford, Conn.

376. *Dryad,* 1913

Bronze, probably 1916–17
12¼ x 6¼ x 3¾ in. (31.1 x 15.9 x 9.5 cm)
Foundry mark (back): R. B. W. [Roman Bronze Works]
Gift of Estate of Mrs. Edward Robinson, 1952 (52.126.5)

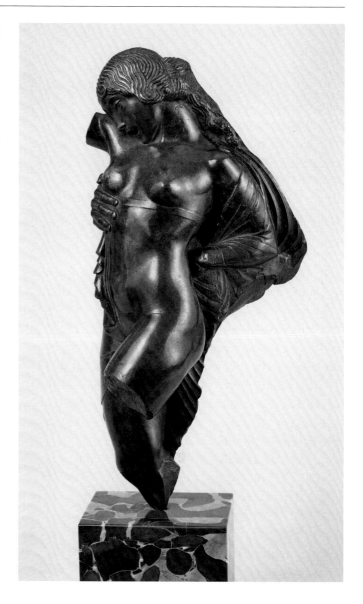

DRYAD IS A fragment of *Centaur and Dryad* (cat. no. 375) and is hollow in the back. Part of the centaur's right hand can be seen under the dryad's right breast. Her right arm is missing just below the shoulder and her legs have been truncated, the left one at midthigh and the right one below the knee.

Dryad was bequeathed to the Metropolitan by the widow of former director Edward Robinson;[1] in 1923 Manship modeled a portrait medal of the Robinsons, which he gave to the Metropolitan in 1955 (acc. nos. 55.19.1, 2). The title of *Dryad,* previously identified as *Nymph,* was corrected by curator Albert TenEyck Gardner in June 1962.[2] Another cast is at the National Academy of Design, New York, Manship's diploma presentation in May 1917 after he was elected an academician the previous year. Four works identified only as "Fragment" in the 1916–17 foundry records of Roman Bronze Works may well be casts of *Dryad.*[3]

The Metropolitan's *Dryad* is mounted on a 4-inch black veined marble base. JMM

EXHIBITIONS

National Arts Club, New York, "Paul Manship Memorial Exhibition," May 10–24, 1966.
MMA, "The Art of Paul Manship," June 11–September 1, 1991.
MMA, "The Human Figure in Transition, 1900–1945: American Sculpture from the Museum's Collection," April 15, 1997–March 29, 1998.
MMA, Henry R. Luce Center for the Study of American Art, "Subjects and Symbols in American Sculpture: Selections from the Permanent Collection," April 11–August 20, 2000.

1. "Eighty-third Annual Report . . . Additions to the Collections," *MMA Bulletin* 12 (Summer 1953), pp. 15, 16, 18, 20.
2. Notes on object catalogue cards, June 6, 1962, MMA Department of Modern Art.
3. Roman Bronze Works Archives, Amon Carter Museum, Fort Worth, ledger 4, p. 89.

377. *Indian Hunter,* 1914

Bronze, probably 1914–16
13⅝ x 13 x 8¼ in. (34.6 x 33 x 21 cm)
Signed and dated (top of base, behind figure): PAVL MANSHIP / © · / 1914·
Foundry mark (base): ROMAN BRONZE WORKS N—Y—
Bequest of George D. Pratt, 1935 (48.149.28)

378. *Pronghorn Antelope,* 1914

Bronze, probably 1914–16
12⅛ x 10¼ x 8¼ in. (30.8 x 26 x 21 cm)
Signed and dated (side of rocks): ·PAVL·MANSHIP· / ·© / 1914 ·
Foundry mark (base): ROMAN BRONZE WORKS N—Y—
Bequest of George D. Pratt, 1935 (48.149.27)

AFTER HIS return from Rome in 1912, Manship applied the format and style of preclassical works to such subjects as this Native American and the pronghorn antelope he is hunting. The pendant pieces are displayed side by side; the central space connecting the works is activated by the flight of an arrow. The Native American, kneeling on his right knee, with an animal skin draped over his left thigh, has just released the arrow from his bow. The arrow, here rendered in low relief, has pierced the right shoulder of the animal, which is falling back on its hind legs. In making the profiles of both hunter and prey the principal view, Manship treated the three-dimensional figures as sculptural reliefs. Their striking silhouettes emphasize his graphic sensibility, and his interest in archaic Greek sculpture is evoked in the decorative details on the body of the animal and the leaves and rocks on the ground beneath and in the stylized patterns of the man's plaited hair.

Manship originally designed *Indian Hunter* and *Pronghorn Antelope* to display on a mantelpiece in his New York apartment.[1] He showed a pair of the statuettes at the 1914 exhibition of the Pennsylvania Academy of the Fine Arts, the 1914–15 winter annual of the National Academy of Design, and at the Panama-Pacific International Exposition in San Francisco in 1915, among the many exhibitions in which he participated at this time and included these works.[2] The Metropolitan's *Indian Hunter* and *Pronghorn Antelope* were in the collection of George D. Pratt (pp. 523–24) and were included in his bequest to the Metropolitan Museum upon his death in 1935 but were subject to lifetime interest by his widow. In 1940 the two bronzes entered the Museum on loan, and in 1948 Mrs. Pratt released her interest in the bequest, and these two bronzes were formally accessioned (see also cat. nos. 187, 189, 243).[3]

According to Edwin Murtha, fifteen examples of the pair were cast in bronze; these were done principally at Roman Bronze Works between 1914 and 1916.[4] A sand-cast pair at the Amon Carter Museum, Fort Worth, was cast by the Gorham Manufacturing Company, Providence, Rhode Island, in 1915. Unique lifesize bronze casts of *Indian Hunter* and *Pronghorn Antelope* were made by Roman Bronze Works in 1917 for the Glen Cove, New York, garden of Herbert L. Pratt, brother of George Dupont Pratt. They are now in the collection of the Mead Art Museum, Amherst College, Amherst, Massachusetts.[5] The bronze-painted plaster models for the Amherst pair are at the Joslyn Art Museum, Omaha, Nebraska. Unique sterling silver statuettes were made by Gorham.[6] JMM

EXHIBITIONS

Corning Museum of Glass, Corning, N.Y., "The Deer Slayers," September 9–November 18, 1956.
Denver Art Museum, "The Western Spirit: Exploring New Territory," February 23–April 30, 1989; loan extended, May 1989–present.

1. Rather 1993, p. 104.
2. *Pennsylvania Academy of the Fine Arts . . . Catalogue of the 109th Annual Exhibition,* 2nd ed. (Philadelphia, 1914), p. 53, no. 620, as "Indian and Prong-Horned Antelope"; *Illustrated Catalogue, National Academy of Design Winter Exhibition 1914* (New York, 1914), p. 16, nos. 73, 84; *Official Catalogue of the Department of Fine Arts, Panama-Pacific International Exposition* (San Francisco: Wahlgreen Co., 1915), p. 240, nos. 4079, 4080.
3. See Alan Priest, "Loans from the Collection of George D. Pratt," *MMA Bulletin* 35 (December 1940), p. 238; extract from minutes of the meeting of the MMA trustees' Executive Committee, November 8, 1948, MMA Archives.
4. Murtha 1957, p. 152, nos. 51, 52; Roman Bronze Works Archives, Amon Carter Museum, Fort Worth, ledger 4, pp. 124–25.
5. Murtha 1957, p. 159, nos. 100, 101, pls. 12, 13; Roman Bronze Works Archives, entry for December 6, 1917, ledger 5, p. 168. See *Fauns and Fountains: American Garden Statuary, 1890–1930,* exh. cat. (Southampton, N.Y.: Parrish Art Museum, 1985), nos. 19, 20.
6. *From the Studio: Selections of American Sculpture, 1811–1941,* exh. cat. (New York: Hirschl and Adler Galleries, 1986), pp. 54–55.

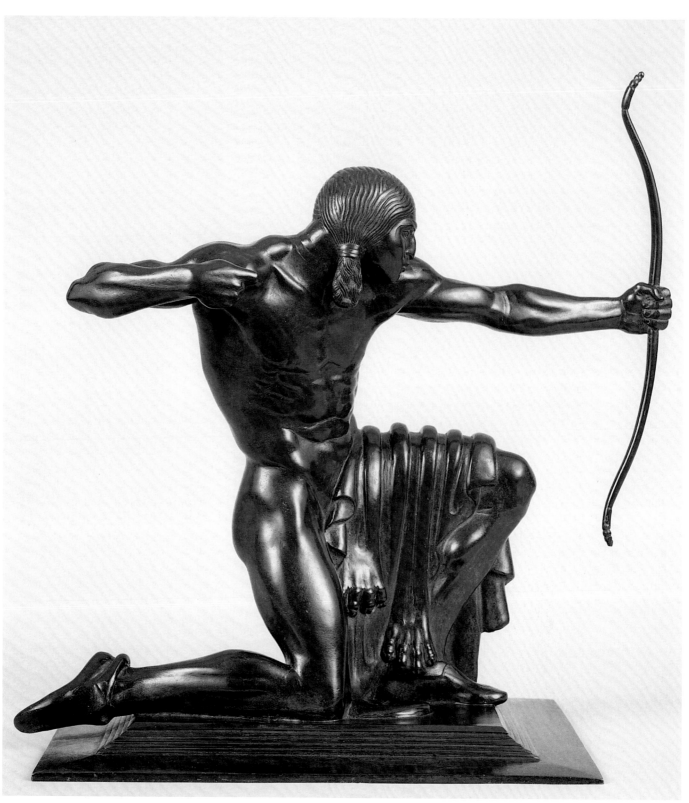

377

378

379. *Pauline Frances,* 1914

Marble, polychromed and gilt bronze frame
13½ x 10¼ x 4½ in. (34.3 x 26 x 11.4 cm); frame, 30½ x
21½ x 6¾ in. (77.5 x 54.6 x 17.1 cm)
Signed (lower left side, in shield): •OPVS•/•PAVL•/ MANSHIP•
Gift of Mrs. Edward F. Dwight, 1916 (16.42)

PAULINE FRANCES (also known as *Portrait of a Baby* and *Pauline Frances—Three Weeks Old*) is a portrait of the first of Manship's four children. As a student at the Pennsylvania Academy of the Fine Arts he had eschewed portraiture because he felt it offered a "limited opportunity for expression." The artist recalled: "Baby Pauline was . . . my first portrait. But what greater inspiration could a sculptor have than the vision of his firstborn? As I had just come back at that time from my studies in Rome I was naturally influenced by the early Renaissance sculptors."[1] He would go on to create numerous portrait sculptures and reliefs throughout his career.

The realistically depicted lifesize half-figure of the infant is wrapped in a blanket, which envelops her head and cascades down her sides. The marble is ensconced in an elaborate gilt and polychromed cast-bronze frame, which features low reliefs of musicians and real and mythical birds and animals. The motifs are arranged in an architectural format strongly reminiscent of Italian Renaissance decorative conventions. Manship was aware that "Donatello and in fact all the sculptors of the Renaissance seemed to have a wonderful feeling for the setting which they gave their sculpture."[2]

Manship's portrait of his daughter was included in exhibitions of his work shown in 1915 at the Art Institute of Chicago, Albright Art Gallery, Buffalo, Detroit Institute of Arts, and Cincinnati Art Museum, and in February 1916 in New York at the Berlin Photographic Company. A critic noted: "This little figure was a main topic of conversation in New York last spring, when it was shown [at the Berlin gallery]. . . . Every one praised its technical excellence, the skill and the beauty of the handiwork. Every one familiar with young babies marvelled at its verisimilitude. . . . He has produced a little masterpiece, valuable alike for its unusual documentary and for its purely artistic qualities, highly individual, distinguished, interesting, and also charming to the eye."[3]

Another version of *Pauline Frances,* dated 1914, shows the half-figure placed within a simple inscribed niche with a frieze of putti, garlands, and storks along the base. A polychromed plaster is at the Minnesota Museum of American Art, Saint Paul.[4] Another polychromed and gilt plaster example is privately owned.[5] The Metropolitan's version was purchased by Mrs. Edward F. Dwight for the Museum while it was on exhibition at the Berlin Photographic Company.[6]

The stepped marble base under the frame is 1¾ inches high. In 1987 the missing right corner of the lower piece was reconstructed with epoxy putty and tinted with acrylic paints.

JMM

EXHIBITIONS

MMA, "The 75th Anniversary Exhibition of Painting and Sculpture by 75 Artists Associated with the Arts Students League of New York," March 16–April 29, 1951, no. 51.

Syracuse Museum of Fine Arts, Syracuse, N.Y., "125 Years of American Art," September 16–October 11, 1953.

National Arts Club, New York, "Paul Manship Memorial Exhibition," May 10–24, 1966.

MMA, June 11–September 1, 1991; Herbert F. Johnson Museum of Art, Cornell University, Ithaca, N.Y., September 24–November 24, 1991, "The Art of Paul Manship."

Museum of Fine Arts, Boston, September 16–December 13, 1992; Cleveland Museum of Art, February 3–April 11, 1993; Museum of Fine Arts, Houston, May 23–August 8, 1993, "The Lure of Italy: American Artists and the Italian Experience, 1760–1914," no. 104.

MMA, "As They Were: 1900–1929," April 9–September 8, 1996.

1. Paul Manship, interview with Lucretia Osborn, WNYC, June 4, 1941, transcript of taped broadcast, p. 5, MMA Archives.
2. Manship, lecture to students of the Art Students League, December 4, 1915, Manship Papers, Archives of American Art, microfilm reel NY59-15, frame 599, as quoted in J[eannine] Falino, in Theodore Stebbins et al., *The Lure of Italy: American Artists and the Italian Experience, 1760–1914,* exh. cat. (Boston: Museum of Fine Arts, 1992), p. 383.
3. M[ariana] G[riswold] van Rensselaer, "The Field of Art. 'Pauline' (Mr. Manship's Portrait of His Daughter at the Age of Three Weeks)," *Scribner's Magazine* 60 (December 1916), pp. 772–73. See also *Catalogue of an Exhibition of Sculpture by Paul Manship* (New York: Berlin Photographic Co., 1916), p. 13, no. 1.
4. Murtha 1957, p. 151, no. 35, which also mentions the existence of a bronze example; *Changing Taste* 1985, p. 146, no. 105, ill.
5. This version was briefly owned by Mrs. Edward F. Dwight, donor of the Metropolitan's marble, who acquired it from Manship and gave it to Mrs. Ralph MacKay of San Francisco in 1916; see Christie's, New York, sale cat., December 1, 1989, no. 164.
6. Murtha 1957, p. 151, no. 34, pls. 8, 9, which also mentions the existence of a painted plaster of this version with the frame; Mrs. Edward F. Dwight to Edward Robinson, Director, MMA, March 9, 1916, MMA Archives.

380. *John Pierpont Morgan Memorial*, 1915–20

Limestone

108 x 64 x 6½ in. (274.3 x 162.6 x 16.5 cm)

Signed (lower left edge, obscured): [PAUL MANSHI]P / [SCUL]PTOR

Inscribed and dated: (central tablet) ERECTED ▲ BY ▲ THE ▲ MUSEUM / IN ▲ GRATEFUL ▲ REMEMBRANCE / OF ▲ THE ▲ SERVICES ▲ OF / JOHN / PIERPONT / MORGAN / FROM ▲ 1871 ▲ TO ▲ 1913 / AS ▲ TRUSTEE ▲ BENEFACTOR / AND ▲ PRESIDENT / HE ▲ WAS ▲ IN ▲ ALL ▲ RESPECTS / A ▲ GREAT ▲ CITIZEN ▲▲ HE / HELPED ▲ TO ▲ MAKE ▲ NEW ▲ YORK / THE ▲ TRUE ▲ METROPOLIS / OF ▲ AMERICA ▲▲ HIS ▲ INTEREST / IN ▲ ART ▲ WAS ▲ LIFELONG ▲▲ / HIS ▲ GENEROUS ▲ DEVOTION / TO ▲ IT ▲ COMMANDED ▲ WORLD / —WIDE ▲ APPRECIATION ▲▲ / HIS ▲ MUNIFICENT ▲ GIFTS ▲ TO / THE ▲ MUSEUM ▲ ARE ▲ AMONG / ITS ▲ CHOICEST ▲ TREASURES / VITA PLENA / LABORIS / MCMXX; (beneath respective figures on left side) COMMERCE / FINANCE / SCIENCE; (beneath respective figures on right side) ART / LITERATURE / ARCHAEOLOGY

Gift of the Trustees, 1920 (20.265)

JOHN PIERPONT MORGAN (1837–1913) was a leader of American finance and an important art collector. From 1871 until his death he served the Metropolitan Museum as a founding trustee, vice president of the board, and, from 1904, president.[1] After his death his extraordinary collection was put on exhibition at the Metropolitan Museum, and in 1916 and 1917, his son, J. P. Morgan, Jr., gave the greater portion of this loan to the Museum.[2]

In April 1913, just after Morgan's death, the Board of Trustees of the Museum formed the Morgan Memorial Committee for the purpose of planning a tribute to Morgan. The committee was headed by Edward Dean Adams, and among the other members was Daniel Chester French, chairman of the trustees' Committee on Sculpture.[3] French initially proposed a design featuring two full-size nudes flanking a tablet.[4] By October, however, "he had concluded that an architectural tablet would be preferable to a sculptural relief."[5] In spring 1915 Manship presented a sketch and a full-size photograph to the trustees, and in November 1915 he signed a contract to execute the memorial.[6]

Carved in French Champville limestone, the memorial consists of a central panel with a dedicatory inscription to Morgan. Surrounding this tablet are panels in high relief, which feature putti and a laurel wreath, winged griffins, male and female allegorical figures alluding to accomplishments in Morgan's life, and reclining figures playing lyres.[7] In the panels on the left, Mercury personifies Commerce; a rigidly frontal, draped female holding a cornucopia represents Finance; and an astronomer alludes to Science. On the right, a partially draped female personifies Art and holds aloft examples of sculpture and architecture; a bearded philosopher with an open book represents Literature; and Archaeology is represented by a half-draped female displaying artifacts from the ancient world. Bordering the panels are ornamental carvings in low relief that include additional figures related to the personifications. A scrolling pediment carved with stylized palmettes,

garlands, and flowers originally surmounted the tablet. The sides were carved with the signs of the zodiac (eight bronze details are in the collection of the Smithsonian American Art Museum, Washington, D. C., gift of the artist).

Detail of cat. no. 380

ERECTED·BY·THE·MUSEUM
IN·GRATEFUL·REMEMBRANCE
OF·THE·SERVICES·OF

JOHN
PIERPONT
MORGAN

FROM·1871·TO·1913
AS·TRUSTEE·BENEFACTOR
AND·PRESIDENT

HE·WAS·IN·ALL·RESPECTS
A·GREAT·CITIZEN··HE
HELPED·TO·MAKE·NEW·YORK
THE·TRUE·METROPOLIS
OF·AMERICA··HIS·INTEREST
IN·ART·WAS·LIFELONG·
HIS·GENEROUS·DEVOTION
TO·IT·COMMANDED·WORLD
-WIDE·APPRECIATION·
HIS·MUNIFICENT·GIFTS·TO
THE·MUSEUM·ARE·AMONG
ITS·CHOICEST·TREASURES

VITA·PLENA
LABORIS

M·C·M·X·X

While Manship seems not to have been formally commissioned to do the *Morgan Memorial* until 1915, a number of drawings at the Minnesota Museum of American Art, Saint Paul, indicate that he may have had ideas for the work as early as 1913.[8] Achieving a final design took considerable time, however, and the full-size model was not officially approved by the Morgan Memorial Committee until September 1918.[9] That fall Manship went to Italy as a volunteer in the Red Cross. Illness prevented his serving, and in February 1919 he was back in New York. He had left the work on the memorial to his principal assistant, Gaston Lachaise,[10] who seems to have completed a major portion of the carving. Manship notified the Museum in September 1920 that he was ready to deliver the memorial.[11] By late November the tablet was installed in the Great Hall and Manship was putting the last touches to the stone.[12]

In 1970, during renovations to the Museum's front plaza and Great Hall, the *Morgan Memorial* was moved from the northwest pier supporting the central dome to the south wall of the Fifth Avenue entrance vestibule, which necessitated removal of the tablet's scrollwork pediment and concealment of the sides showing signs of the zodiac.

JMM

1. On Morgan and the Metropolitan Museum, see Jean Strouse, "J. Pierpont Morgan, Financier and Collector," *MMA Bulletin* 58 (Winter 2000); on Morgan, see Strouse, *Morgan: American Financier* (New York: Random House, 1999).
2. *The Metropolitan Museum of Art: Guide to the Loan Exhibition* (New York: MMA, 1914); "The Pierpont Morgan Gift," *MMA Bulletin* 13 (January 1918), pp. 2–20.
3. Memorandum by Henry W. Kent, Assistant Secretary, MMA, April 21, 1913, MMA Archives.
4. French to Kent, July 19, 1913, MMA Archives.
5. Adams to MMA trustees, October 20, 1913, MMA Archives.
6. Manship to Adams, October 15, 1915, MMA Archives.
7. "A Tablet Erected by the Trustees of the Museum in Memory of the Late J. Pierpont Morgan," *MMA Bulletin* 15 (December 1920), pp. 266–67.
8. Smith 1987, pp. 39–43.
9. Adams to Kent, Secretary, MMA, September 20, 1918, MMA Archives.
10. Adams to Kent, September 17, 1918, MMA Archives.
11. Adams to Robert W. de Forest, President, MMA, September 28, 1920.
12. Joseph Breck, Assistant Director, MMA, to Adams, November 19, 1920; and W. M. Kendall, McKim, Mead and White, to Adams, November 22, 1920, MMA Archives.

381. *Wrestlers,* 1915

Bronze, probably 1916
9 x 16½ x 7½ in. (22.9 x 41.9 x 19.1 cm)
Signed and dated (top of base, front center): PAUL MANSHIP / © 1915
Inscribed (top of base, rear center): TO / EDWARD D. ADAMS / 6·20–1916
Foundry mark (left side of base): ROMAN BRONZE WORKS N–Y–
Gift of Edward D. Adams, 1927 (27.21.1)

MANSHIP FIRST explored this subject, two nude male figures wrapped tightly together in combat, in 1908, when he was a student and already interested in subjects from antiquity. After his fellowship at the American Academy in Rome, he returned to the theme in a startling new conception of the subject. The earlier work is a vertical composition in which the tactility of the clay shows in the bronze cast and the limbs are truncated in a manner that suggests the influence of Rodin.[1] In the 1915 work the figures come together in a lower, less compact mass with space beneath and a leg protruding from the group. Here the hair is stylized and the anatomy is prominently delineated. Manship gave special attention to the articulation of the athletes' musculature.

According to Paul Vitry and Edwin Murtha, *Wrestlers*

was cast in an edition of six, but there are more located examples.[2] Roman Bronze Works foundry ledgers list nine casts made between 1915 and 1917; the Metropolitan's example, with its dated inscription to Edward Dean Adams, was most likely cast in 1916.[3] It was given to the Museum by Adams, a longtime trustee, with nine other small bronzes previously in his country home, Rohallion, in Seabright (now Rumson), New Jersey (see cat. nos. 193, 194, 264).[4] The Metropolitan's *Wrestlers* is on a green marble base, 2 inches high.

JMM

EXHIBITIONS

National Arts Club, New York, "Paul Manship Memorial Exhibition," May 10–24, 1966.

Bronx Museum of the Arts, New York, "Games!!! ¡Juegos!" February 1–March 6, 1972, no. 87.

"The Figure in 20th Century American Art: Selections from The Metropolitan Museum of Art," traveling exhibition organized by the MMA and the American Federation of Arts, New York, February 1985–June 1986.

MMA, "The Art of Paul Manship," June 11–September 1, 1991.

MMA, "The Human Figure in Transition, 1900–1945: American Sculpture from the Museum's Collection," April 15, 1997–March 29, 1998.

1. Rand 1989, p. 12, figs. 2, 3.
2. Vitry 1927, p. 39, "Six exemplaires. Édition épuisée," pl. 14; Murtha 1957, p. 157, no. 66. In addition to the one at the Metropolitan Museum, examples are at the Corcoran Gallery of Art, Washington, D.C.; Dayton Art Institute, Dayton, Ohio; Fogg Art Museum, Harvard University, Cambridge, Mass.; Reading Public Museum, Reading, Pa.; and Smithsonian American Art Museum, Washington, D.C. A cast auctioned at Christie's, New York, May 25, 2000, no. 84, is now privately owned.
3. Roman Bronze Works Archives, Amon Carter Museum, Fort Worth, ledger 4, pp. 88–89, 125.
4. See Adams to Daniel Chester French, October 14, 1926, Daniel Chester French Family Papers, Manuscript Division, Library of Congress, Washington, D.C., microfilm reel 9, frame 459, offering bronzes; and French to Edward Robinson, Director, MMA, February 11, 1927, MMA Archives, recommending acceptance of ten sculptures.

382. *Dancer and Gazelles*, 1916

Bronze
32¼ x 35½ x 10⅛ in. (81.9 x 90.2 x 25.7 cm)
Signed and dated (top of base, rear): PAUL MANSHIP / © 1916
Foundry mark (top of base, rear): ROMAN BRONZE WORKS N.Y.
Cast number (underside of base): N° 8
Francis Lathrop Fund, 1959 (59.54)

THE SWEEPING curves and articulated silhouette of this group make it one of Manship's finest compositions. A graceful seminude dancer is poised on her toes between two gazelles that seem to move in rhythmic counterpoint to the dancer's swirling drapery. The inspiration that Manship derived from Indian art is particularly apparent in this work. Susan Rather has suggested possible pictorial sources in Rajput paintings of a young woman with a gazelle and of a prince flanked by cranes.[1] Manship likely knew this Hindu art of northwestern India from the sixteenth to nineteenth centuries. Ananda K. Coomaraswamy introduced Western audiences to such works in his 1916 publication *Rajput Painting*. Manship's sculpture also bears a close resemblance to Jacques Lipchitz's group *Femmes et Gazelles* (1911–12), but in its lithe and fluid forms it is quite different.[2]

Dancer and Gazelles was included in the exhibition of Manship's work at the Berlin Photographic Company, New York, in 1916.[3] The artist produced the sculpture in a 67-inch version, which was awarded the Helen Foster Barnett Prize at the National Academy of Design in the winter annual of 1917–18.[4] From March 1918 to October 1919, a large bronze version was on view at the Metropolitan Museum in the "Exhibition of American Sculpture."[5]

According to Edwin Murtha, twelve bronze casts of the 32¼-inch reduction were made, but the Roman Bronze Works Archives ledgers list thirteen examples cast in 1916 and 1917; the cast at the Metropolitan, number 8, appears in the ledgers under November 29, 1916.[6] The Museum's *Dancer and Gazelles*, formerly in the collection of attorney and banker Charles S. McVeigh, was purchased at auction in 1959.[7] JMM

EXHIBITIONS
The White House, Washington, D.C., June–July 1965.

National Arts Club, New York, "Paul Manship Memorial Exhibition," May 10–24, 1966.
Vincent Astor Gallery, Library and Museum of the Performing Arts of the New York Public Library at Lincoln Center, New York, "Dance in Sculpture," February 1–April 29, 1971.
Philadelphia Art Alliance, "Dance in Sculpture," November 4–29, 1971.
New York Cultural Center in association with Fairleigh Dickinson University, "Grand Reserves: A Collection of 235 Objects from the Reserves of Fifteen New York Museums and Public Collections," October 24–December 8, 1974, no. 150.
MMA, "A Bicentennial Treasury: American Masterpieces from the Metropolitan," January 29, 1976–January 2, 1977.
MMA, June 11–September 1, 1991; Herbert F. Johnson Museum of Art, Cornell University, Ithaca, N.Y., September 24–November 24, 1991, "The Art of Paul Manship"; loan extended, November 1991–present.

1. Rather 1993, pp. 117–21, fig. 63; and Susan Rather, "The Past Made Modern: Archaism in American Sculpture," *Arts Magazine* 59 (November 1984), pp. 115–16, fig. 16.
2. Rand 1989, p. 45, fig. 33.
3. *Catalogue of an Exhibition of Sculpture by Paul Manship* (New York: Berlin Photographic Co., 1916), p. 13, no. 8; Royal Cortissoz, "A Brilliant and Exotic Type in American Art," *New York Tribune*, February 20, 1916, p. 3.
4. Murtha 1957, p. 158, no. 84, pl. 17; *Illustrated Catalogue, National Academy of Design Winter Exhibition 1917* (New York, 1917), p. 10, no. 13.
5. *An Exhibition of American Sculpture* (New York: MMA, 1918), p. 16, no. 53, as "Girl with Gazelles," and incoming receipt, February 8, 1918, with notation "ret. Oct. 18, 1919," special exhibitions notebooks, MMA Office of the Registrar. Lifesize casts are at the Corcoran Gallery of Art, Washington, D.C., and the Toledo Museum of Art, Toledo, Ohio.
6. Murtha 1957, p. 158, no. 85; Roman Bronze Works Archives, Amon Carter Museum, Fort Worth, ledger 4, pp. 88–89. Located casts include those at the Art Institute of Chicago; Century Association, New York; Cleveland Museum of Art; Detroit Institute of Arts; Fine Arts Museums of San Francisco; Museum of Art, Rhode Island School of Design, Providence; National Gallery of Art, Washington, D.C.; and Smithsonian American Art Museum, Washington, D.C.
7. Parke-Bernet, New York, sale cat., April 4, 1959, no. 102; recommended purchase form, April 13, 1959, MMA Archives; and object catalogue cards, MMA Department of Modern Art.

383. *Europa and the Bull,* 1922–24

Bronze, 1924
9¼ x 11¼ x 5¾ in. (23.5 x 28.6 x 14.6 cm)
Signed and dated (back, above bull's right hind hoof): •P•MANSHIP• / © 1924
Foundry mark (back, lower edge): ROMAN BRONZE WORKS N—Y—
Bequest of Walter M. Carlebach, 1969 (69.131.13)

MANSHIP FIRST modeled this composition in a 4¾-inch sketch in 1922 and continued to a more finished work in 1924.[1] In this later version the surfaces have been smoothed and the drapery and hair rendered with specific stylized folds or incised lines. The Greek myth telling of the seduction of the Phoenician princess Europa by Zeus in the guise of a white bull has been a popular theme in art through the ages.

Manship shows Europa raising her left arm over her head to embrace the head of the bull lying behind her. The bull affectionately nuzzles and licks her arm. The simplified forms of the work include few details and a balanced interlocking of the figures; the crisply articulated silhouettes characteristic of Manship's earlier figural groups are more compacted here. The artist deliberately burnished areas of the green-brown patina to create highlights, which here emphasize his preoccupation with geometric volume over linear decoration.

Manship produced several variations on the Europa theme from the early 1920s to the mid-1930s. He enlarged *Europa and the Bull,* particularly in a 24-inch bronze.[2] He also explored this classical theme in a 1925 composition, titled *Flight of Europa,* in which Europa sits on the bull's back facing toward the tail; the bull is supported on the backs of dolphins, and a tiny winged Eros whispers in her ear.[3]

According to Edwin Murtha, twenty bronze casts of the 9¼-inch version were made.[4] The one at the Metropolitan Museum, on a green veined marble base, 1¼ inches high, was acquired in the bequest of Walter M. Carlebach.[5]

JMM

EXHIBITIONS

Queens Museum, New York, "The Artist's Menagerie: Five Millennia of Animals in Art," June 29–August 25, 1974, no. 126.
MMA, "20th Century Accessions, 1967–1974," March 7–April 23, 1974.
Heckscher Museum, Huntington, N.Y., "Art Deco and Its Origins," September 22–November 3, 1974, no. 121.
MMA, Henry R. Luce Center for the Study of American Art, "Subjects and Symbols in American Sculpture: Selections from the Permanent Collection," April 11–August 20, 2000.

1. Murtha 1957, p. 162, no. 154, p. 163, no. 169, pl. 31; Rand 1989, pp. 61–66, and figs. 53, 54, showing the 1922 bronze sketch.
2. For the 24-inch version, see Murtha 1957, p. 179, no. 354; *Changing Taste* 1985, p. 26, no. 14.
3. Murtha 1957, nos. 96, 177–80; Rand 1989, p. 68, fig. 59.
4. Murtha 1957, p. 163, no. 169. Other casts are at the Carnegie Museum of Art, Pittsburgh; Corcoran Gallery of Art, Washington, D.C.; Delaware Art Museum, Wilmington; William A. Farnsworth Art Museum, Rockland, Maine; Minnesota Museum of American Art, Saint Paul; Norton Museum of Art, West Palm Beach, Fla.; Smithsonian American Art Museum, Washington, D.C.; Walker Art Center, Minneapolis; and Yale University Art Gallery, New Haven.
5. "One-hundredth Annual Report . . . 1969–70," *MMA Bulletin* 29 (October 1970), p. 100, also pp. 79, 103.

384. *James F. Ballard,* 1925–26

Marble, 1927
21½ x 10½ x 9¼ in. (54.6 x 26.7 x 23.5 cm)
Signed (right side, under shoulder): PAUL MANSHIP
Inscribed (front of base): • JAMES • F. / • BALLARD •
Gift of Gustavus A. Pfeiffer, 1927 (27.147)

JAMES FRANKLIN BALLARD (1851–1931) established a
drug merchandising business in Saint Louis, Missouri, and
formed a collection principally of rare oriental carpets. In
1921 he lent a portion of his collection to the Metro-
politan Museum for exhibition, and in 1922 and 1923 he
made a gift to the Museum of 129 of his carpets.[1] Soon
thereafter, Gustavus A. Pfeiffer of Saint Louis, owner of
the pharmaceutical company William R. Warner (later
Warner-Lambert Company), began a correspondence with
the Museum's director, Edward Robinson, toward com-
missioning a portrait bust of Ballard that eventually would
be exhibited in the galleries with his carpets.[2] The com-
mission was given to Manship by April 1925, and the bust
was accepted for the Museum's collection in June 1927.[3]

As a student at the Pennsylvania Academy of the Fine
Arts, Manship avoided classes in portraiture for, as he later
said, "[T]here is a limited opportunity for expression in
portrait sculpture."[4] While this may explain why his por-
trait busts do not have the vitality of his sculptural groups,
he nevertheless produced a number of them, as well as por-
trait heads, reliefs, and medals.[5] In his placid likeness of
Ballard, Manship did impart a great deal of detail, for ex-
ample, the folds of the eyelids, the lines in the forehead and
chin, and the mustache. He also tinted the irises brown.

Manship carved a second marble replica for Ballard,[6]
which was given to the Saint Louis Art Museum in 1967
by one of Ballard's daughters, Nellie Ballard White, and
her two daughters. In 1929 Ballard had given that museum
seventy carpets from his collection.

JMM

EXHIBITION

Averell House, New York, "Sculpture by Paul Manship, 1933," April 11–
 May 13, 1933, no. 24.

1. On Ballard, see *National Cyclopaedia of American Biography,* vol. 25
 (New York: James T. White and Co., 1936), p. 118. For his carpet
 collection, see *Loan Exhibition of Oriental Rugs from the Collection of
 James F. Ballard of St. Louis, Mo.,* exh. cat. (New York: MMA, 1921);
 and Joseph Breck and Frances Morris, *The James F. Ballard Col-
 lection of Oriental Rugs* (New York: MMA, 1923).
2. Pfeiffer to Robinson, July 29, 1924; Robinson to Pfeiffer,
 September 15, 1924 (copy), MMA Archives. The gift was accepted
 with the provision that the bust not be exhibited in the galleries
 during the subject's lifetime in accordance with Museum policy. It
 was briefly displayed in the Room of Recent Accessions with
 Alexander Finta's portrait of another living subject, Patrick
 Cardinal Hayes (cat. no. 298); see P[reston] R[emington], "Notes:
 Two Portrait Busts," *MMA Bulletin* 22 (November 1927), pp. 281–82.
3. Pfeiffer to Robinson, April 27, 1925, MMA Archives (Pfeiffer
 wrote: "I had a very satisfactory interview with Mr. Paul Manship.
 . . . At this interview we closed arrangements for Mr. Manship to
 make a marble portrait of Mr. Ballard"); and offer of gift form, gift
 accepted by MMA trustees' Executive Committee, June 13, 1927,
 MMA Archives.
4. Murtha 1957, p. 12; Paul Manship, interview with Lucretia
 Osborn, WNYC, June 4, 1941, transcript of taped broadcast, p. 5,
 MMA Archives.
5. Murtha 1957, passim.
6. Unsigned notes of a telephone conversation with Manship, Janu-
 ary 6, 1933, recorded on object catalogue cards, MMA Depart-
 ment of Modern Art.

385. *Indian Hunter and His Dog*, 1926

Bronze
21½ x 23½ x 8⅛ in. (54.6 x 59.7 x 20.6 cm)
Signed and dated (top of base, under dog's hindquarters):
© 1926 / PAUL MANSHIP
Foundry mark (right side of base): Alexis Rudier / Fondeur Paris
Gift of Thomas Cochran, 1929 (29.162)

THE YOUNG MAN wears a loincloth and moccasins and carries a bow and two arrows. He and his large dog at his side are running swiftly and smoothly, the dog's forepaws up, offsetting the Native American's forward foot on the ground.[1] Here Manship created his own rendition of a classical hunting subject. He made this bronze as a study for a lifesize sculpture group in a fountain commissioned in 1925 by Thomas Cochran, Jr., in memory of his father. The group stands at the center of a pool of water and was installed in late 1926 in Cochran Memorial Park, Saint Paul, Minnesota.[2] The following year Manship put at the corners of the group four bronze Canadian geese, which sprayed jets of water from their beaks.[3] The vandalized work was removed to the outside of Como Park Conservatory, and in 1983 a fiberglass facsimile took its original place in Cochran Memorial Park.[4]

From the side, the running figures of boy and dog form a graceful, lively silhouette. The stylized linear patterns of the fur on the dog's chest, shoulders, head, and tail, and the boy's hair, as well as the streamlined figures of the boy and dog, illustrate Manship's interest in archaic Greek sculpture. This sculpture reminded Manship of his boyhood in the Minnesota woods, but the subject also has a direct antecedent in John Quincy Adams Ward's *Indian Hunter* (cat. no. 54).[5] The theme of the Native American hunter recurred in Manship's sculptures, such as *Indian Hunter* (cat. no. 377).[6] The elegant figural arrangement of the running hunter and leaping dog had a compositional precedent in Manship's work in his pendants *Diana* (1921) and *Actaeon* (1923).[7]

Indian Hunter and His Dog was offered to the Metropolitan Museum by Manship on behalf of Thomas Cochran, who served as a Museum trustee from 1932 to 1936.[8] The group is on a 1⅛-inch green veined marble base. According to Manship, twelve bronze casts of the work were made.[9]

JMM

EXHIBITIONS

Rochester Museum of Arts and Sciences, Rochester, N.Y., February–August 1945.
National Arts Club, New York, "Paul Manship Memorial Exhibition," May 10–24, 1966.
Sterling and Francine Clark Art Institute, Williamstown, Mass., "Cast in the Shadow: Models for Public Sculpture in America," October 12, 1985–January 5, 1986, no. 21.

1. Murtha 1957, p. 169, no. 199.
2. Ibid., p. 169, no. 198, pl. 32.
3. Ibid., p. 169, no. 206.
4. *Changing Taste* 1985, pp. 133, 135, fig. 23.
5. Ibid., p. 133; Rand 1989, p. 87.
6. For drawings of the subject, see Smith 1987, pp. 62–69.
7. *Changing Taste* 1985, pp. 72–73; Rand 1989, pp. 74–77.
8. Manship to Edward Robinson, Director, MMA, April 30, 1929, MMA Archives. See also Preston Remington, "Recent Accessions of Modern Sculpture," *MMA Bulletin* 25 (February 1930), p. 40.
9. See Manship letter, April 4, 1929, cited in *From the Studio: Selections of American Sculpture, 1811–1941,* exh. cat. (New York: Hirschl and Adler Galleries, 1986), p. 67, no. 43.

 Other casts are at the Addison Gallery of American Art, Phillips Academy, Andover, Mass.; Century Association, New York; Corcoran Gallery of Art, Washington, D.C.; Gilcrease Museum, Tulsa, Okla.; Indianapolis Museum of Art; Minnesota Museum of American Art, Saint Paul; and Smithsonian American Art Museum, Washington, D.C.

385

386. *Bellerophon and Pegasus,* 1930

Bronze, gilt, lapis lazuli
6⅜ x 4⅝ x 4¾ in. (16.2 x 11.7 x 12.1 cm), including 1¾-in.
stepped lapis lazuli base
Gift of Thelma Williams Gill, 1988 (1988.416)

FOR THIS small bronze sketch Manship relied on the ex-
ploits of a youthful hero from Greek mythology, Bellero-
phon, and the immortal flying horse, Pegasus. With the aid
of a golden bridle provided by Athena, Bellerophon was
able to master the spirited steed, which had sprung from
Medusa's severed head and was the bearer of Zeus's light-
ning bolts. In Manship's sculpture a sturdy nude male
strains to steady the winged horse with muscular flanks.

The Metropolitan Museum's bronze is accentuated with
gilding applied through the mercury gilding process.[1] The
elegant composition is set on a base of lapis lazuli fash-
ioned by Manship. A number of drawings at the Minnesota
Museum of American Art, Saint Paul, which postdate the
Metropolitan's sculpture, attest to Manship's ongoing inter-
est in this theme. One in particular (ca. 1930–36) closely
parallels the Metropolitan's small bronze and similarly
shows Bellerophon silhouetted against the rearing Pegasus.[2]
In some of the drawings, however, the tension between
the upward-thrusting horse and the backward-pulling

youth is more emphatic, as Bellerophon seems to lose
control of the beast.[3] Manship reused this allegory of the
struggle between reason and passion on the obverse of
the Carnegie Corporation Medal of 1934.[4] A bronze
Bellerophon and Pegasus (1950; Smithsonian American
Art Museum, Washington, D.C.), 7½ inches high, is a
reversed composition and more fully realized than the
Metropolitan's statuette. JMM

EXHIBITION

MMA, Henry R. Luce Center for the Study of American Art, "Sub-
 jects and Symbols in American Sculpture: Selections from the
 Permanent Collection," April 11–August 20, 2000.

1. Murtha 1957, p. 172, no. 268, pl. 70; SEM/EDS analysis report,
 July 31, 2000, MMA Department of Objects Conservation, test-
 ing conducted by Mark T. Wypyski, Associate Research Scientist.
2. Smith 1987, pp. 81–87, esp. p. 82.
3. For example, ibid., pp. 84, 85.
4. Rand 1989, pp. 136–37, fig. 139.

387. *Group of Bears,* 1932

Bronze, 1963
88 x 72 x 56 in. (223.5 x 182.9 x 142.2 cm)
Signed (top of base, in front of hind paws of standing bear):
PAUL MANSHIP / SCULPTOR
Foundry mark (left side of base): FOND. ARTISTICA / BATTAGLIA & C / MILANO
Purchase, Sheila W. and Richard J. Schwartz Fund, in honor of Lewis I. Sharp, 1989 (1989.19)

GRACE RAINEY ROGERS, who was also a benefactor of the Metropolitan Museum, commissioned Manship in 1926 to design colossal double gates for the New York Zoological Park (Bronx Zoo/Wildlife Conservation Park) to the memory of her brother, Paul J. Rainey, an explorer and game hunter. The Paul J. Rainey Memorial Gateway was installed at the zoo's main entrance in 1934.[1] The two bronze gates are flanked by stylized trees filled with lifesize animals and birds. Lunettes crowning the gates contain three bears (left) and three deer (right), all in the round. Manship, an accomplished animalier, spent two years on the design alone, modeling the animals from life and making plaster models to scale of each of the animals to be represented. With his knowledge of animal anatomy and his observation of animal behavior, he successfully captured their characteristic postures in these simplified forms.

In 1932 Manship created a full-size painted plaster version of the three bears in their same sitting, standing, and walking positions arranged all facing forward on a base of stylized rocks with ivy trailing upward.[2] This group was cast in bronze in Milan in 1963 and stood outdoors on the grounds of Manship's home in Lanesville, Massachusetts. In 1987 it was acquired by Graham Gallery, New York, from Manship's son, John, and subsequently it was purchased for the Metropolitan Museum by the donors, Richard and Sheila Schwartz.[3]

Manship modeled a 33-inch reduction of the group of bears facing forward in 1939.[4] A bronze cast is in the collection of the Smithsonian American Art Museum, Washington, D.C.[5] He incorporated this reduction in his design for the William Church Osborn Memorial Playground Gateway dedicated in 1953 in Central Park (currently in storage).[6] In yet another rearrangement of his conception of the three bears for the Rainey Gateway, in 1934 Manship used the full-size standing bear and walking bear, each on a separate base, cast in aluminum for the zoo (now Cheyenne Mountain Zoo) in Colorado Springs.[7]

A 1989 bronze, cast by Paul King Foundry, is located just south of the Metropolitan Museum in Central Park's Pat Hoffman Friedman Playground. JMM

1. Murtha 1957, p. 179, no. 344, pls. 58–60; Rand 1989, pp. 102–8.
2. Murtha 1957, p. 178, no. 328.
3. *The Animal in Sculpture: American and European, 19th and 20th Century,* exh. cat. (New York: Graham Gallery, 1987), pp. 62–63; D[onna] J. H[assler], in "Recent Acquisitions: A Selection 1988–1989," *MMA Bulletin* 47 (Fall 1989), p. 55.
4. Murtha 1957, p. 181, no. 396.
5. *Changing Taste* 1985, p. 82, no. 54; Rand 1989, p. 108.
6. Margot Gayle and Michele Cohen, *The Art Commission and the Municipal Art Society Guide to Manhattan's Outdoor Sculpture* (New York: Prentice Hall Press, 1988), p. 228. Osborn was a trustee of the Metropolitan Museum from 1904, vice president from 1932, president from 1941 to 1947, and then honorary president until his death in 1951.
7. Murtha 1957, p. 179, no. 349.

Hugo Robus (1885–1964)

Robus was born in Cleveland, Ohio. He studied painting, drawing, and design with Henry G. Keller, Carl Frederick Gottwald, and Horace E. Potter at the Cleveland School of Art (now the Cleveland Institute of Art) from 1903 to 1907, and until 1911 he spent summers designing jewelry and tableware and carving ivory in Horace Potter's studio. In the fall of 1907 Robus enrolled as a painting student at the National Academy of Design, New York, taking instruction from Emil Carlsen and Edgar M. Ward; he continued at the National Academy until 1909. In 1910 Robus first received instruction in clay modeling at the Cleveland School of Art; none of his sculptures in clay from his student years survives.

In 1912 Robus went to Paris, where he saw an exhibition of Italian Futurist paintings at the Galerie Bernheim-Jeune that year and became acquainted with modernists František Kupka, Morgan Russell, and Stanton Macdonald-Wright. In 1913 he attended the Académie de la Grande Chaumière, taking instruction from Antoine Bourdelle. Before returning to the United States in 1914 at the outbreak of World War I, Robus traveled widely, visiting Germany, Italy, Tunisia, and Algeria. He settled in New York in 1915 and until 1920 created avant-garde paintings and drawings that reveal his indebtedness to the Cubist and Futurist works he had seen in Paris. Between 1915 and 1918 Robus also taught at the Modern Art School on Washington Square, and in 1918 he purchased a summer home in New City, New York, where he and his wife were part of a small colony of artists and writers.

In 1920 Robus decided to devote himself to sculpture because he was dissatisfied with the progress of his painting. He worked slowly on a series of full-length figures and concentrated on "making form rhythmic and expressive from not just one view-point but from endless view-points" (Robus 1943, p. 95). He did not allow these works to be shown until 1933. That year his plaster *Dawn* (1931), a female figure stretching upward, was included in the first biennial exhibition of the Whitney Museum of American Art; he would exhibit at the Whitney regularly until his death. Robus is best known for his stylized, highly polished sculptures cast in bronze and silver. *Girl Washing Her Hair* (1933; see cat. no. 389), commissioned in marble by the Museum of Modern Art, New York, in 1939, was the first of Robus's sculptures to be acquired by a museum and is typical of the elegant, simplified forms he favored. Although Robus's sculpture is not easily classified in relation to twentieth-century developments, his streamlined forms seem indebted to the machinelike surfaces of Futurist sculpture by Umberto Boc-cioni and the stylized figurative studies of Alexander Archipenko and Constantin Brancusi.

From 1937 to 1939 Robus participated in the Federal Art Project of the Works Progress Administration. He was one of the founding members of the Sculptors' Guild in 1938, exhibiting there frequently and serving the group in various offices. For the 1939 World's Fair in New York, Robus served as a juror for "American Art Today," himself exhibiting *The General* (see cat. no. 388). During the 1940s and 1950s he regularly taught sculpture at Columbia University (summer and winter sessions), at the Munson-Williams-Proctor Institute (visiting artist, 1948), at Hunter College (1949–58), and at the Brooklyn Museum School (1955–57).

Robus had his first large solo exhibition of sculpture in 1949 at New York's Grand Central Art Galleries, which represented him beginning in 1946 and for the next fifteen years. He was awarded second prize for sculpture in the "Artists for Victory" exhibition at the Metropolitan Museum in 1942 (see cat. no. 390), the George D. Widener Memorial Medal at the Pennsylvania Academy of the Fine Arts in 1950 for the bronze *Dawn* (1931), and the Pennsylvania Academy's Alfred G. B. Steel Memorial Prize in 1954 for the bronze *One to Another* (1952). Between 1960 and 1962 a one-artist exhibition of Robus's work, organized by the American Federation of Arts, opened at the Whitney Museum of American Art and traveled to fifteen additional venues. The Forum Gallery, which represented Robus from 1961, held a retrospective exhibition in 1963 and a memorial exhibition in 1966. JMM

SELECTED BIBLIOGRAPHY

Robus, Hugo, Papers. Archives of American Art, Smithsonian Institution, Washington, D.C., microfilm reels N705–6 and unmicrofilmed material.

Cross, Louise. "The Sculpture of Hugo Robus." *Parnassus* 6 (April 1934), pp. 13–15.

Robus, Hugo. "The Sculptor as Self Critic." *Magazine of Art* 36 (March 1943), pp. 94–98.

Robus, Hugo. "Artists and Sculptors." *Critique* 1 (November 1946), pp. 12–15.

Rothschild, Lincoln. *Hugo Robus.* Exh. cat. New York: American Federation of Arts, 1960.

Hugo Robus (1885–1964): Memorial Exhibition. Exh. cat. New York: Forum Gallery, 1966.

Tarbell, Roberta K. *Hugo Robus (1885–1964).* Exh. cat. Washington, D.C.: Smithsonian Institution Press for the National Collection of Fine Arts, 1980.

Tarbell, Roberta K. "Hugo Robus' Pictorial Works." *Arts Magazine* 54 (March 1980), pp. 136–40.

388. *The General*, 1922

Plaster, painted
19½ x 20 x 7⅜ in. (49.5 x 50.8 x 18.7 cm)
Signed (top of base, near horse's hind leg): HUGO ROBUS
Gift of Mr. and Mrs. Robert Fishko, in memory of Bella Fishko, 1996 (1996.539)

THE GENERAL, one of the earliest of Robus's known sculptures, is a composition of horse and rider, with curving contours, rhythmic forms, and a lively silhouette. It appears to be an amalgam of Futurist and Cubist works, such as Umberto Boccioni's *Unique Forms of Continuity in Space* (1913; Museum of Modern Art, New York) and Raymond Duchamp-Villon's dynamic *Horse* (1914; private collection, New York). Robus probably saw *Unique Forms of Continuity in Space* in plaster at Boccioni's 1913 solo exhibition at Galerie La Boëtie in Paris.[1] Duchamp-Villon

exhibited his sculptures of horses in several shows in New York, including one at the Sculptor's Gallery in 1922,[2] but the simplified features and smooth surfaces of his *Seated Woman* (1914; Philadelphia Museum of Art) are closer to the forms in Robus's equestrian figure.

This painted plaster version of *The General,* which has a self-base, has traditionally been dated to 1922. Robus based this group on an earlier drawing (Hirshhorn Museum and Sculpture Garden, Washington, D.C.). He considered drawing vital to the sculptural process, for as he later

wrote: "I prefer to work unhurriedly, to draw at least the front and back elevations of a projected idea and to look over and redraw through a period of months before proceeding to construction of the sculpture. Very likely the drawing will be discarded a week or two after work in the round begins, but by then it will have served its purpose in that it has made me acquainted with the subject and aware of some of its problems."[3] *The General* was cast in bronze in New York by 1939, when a version without a self-base was exhibited at the New York World's Fair.[4] Three other bronzes are documented. One of the bronzes is at the Hirshhorn Museum, as is another plaster.[5] The plaster now at the Metropolitan Museum was included in the Robus exhibition at the National Collection of Fine Arts in 1980.[6]

Mr. and Mrs. Robert Fishko donated this sculpture to the Metropolitan Museum in memory of Mr. Fishko's mother, Bella Fishko, director of the Forum Gallery, which represented Robus from 1961. JMM

1. Tarbell 1980, p. 49; and Paul D. Schweizer, in *Avant-Garde Painting and Sculpture in America 1910–25,* exh. cat. (Wilmington: Delaware Art Museum and University of Delaware, 1975), p. 120.
2. *Duchamp-Villon,* Collections du Centre Georges Pompidou, Musée National d'Art Moderne et du Musée des Beaux-Arts de Rouen (Paris: Éditions du Centre Pompidou et Réunion des Musées Nationaux, 1998), pp. 149 (no. 47a–c), 152.
3. Robus 1943, p. 96.
4. *American Art Today: New York World's Fair* (New York: National Art Society, 1939), no. 737, ill. p. 220.
5. Tarbell 1980, pp. 163–64; and Abram Lerner, ed., *The Hirshhorn Museum and Sculpture Garden* (New York: Harry N. Abrams, 1974), pp. 223, 740.
6. *Hugo Robus (1885–1964),* brochure including checklist of the exhibition (Washington, D.C.: Smithsonian Institution, 1980), p. 8.

389. *Girl Washing Her Hair,* 1933; reduction, 1959

Bronze, 1976
8½ x 14 x 6 in. (21.6 x 35.6 x 15.2 cm)
Signed (on torso, lower inside edge): jm [encircled] HUGO ROBUS H.C.
Inscribed and dated (on torso, lower inside edge): © 1976 / FORUM / GALLERY
Gift of Mr. and Mrs. Robert Fishko, 1997 (1997.321)

THE METROPOLITAN MUSEUM's *Girl Washing Her Hair* is a posthumous cast after a 1959 half-scale reduction of a work Robus modeled in 1933. Also referred to as *Woman Washing Her Hair* and *Soap in Her Eyes,* it is one of his best-known sculptures and was created when he was just beginning to gain recognition for his three-dimensional works.

A culmination of the intense concentration that Robus had put into his sculpture over the previous decade, this depiction of a young female torso arched forward with head and hair down combines a streamlined abstraction of form with a personally idiomatic stylization. It effectively suggests the containment of a dynamic force within a smooth parabolic curve. From one side the woman's features can be seen, her grimacing expression emphasizing the tautness of her curved torso and arms stretching back over her head.

Robus's original 17-inch version of *Girl Washing Her Hair* was first shown in plaster at the Museum of Modern Art's 1939 exhibition "Art in Our Time."[1] That museum commissioned the work in marble from the artist, who selected the stone and oversaw the carving. Completed in 1940, the marble stands on a sheet of polished metal, which reflects the front of the bent-over figure.[2]

Four bronze casts were made of the full-size version during the 1950s.[3] In 1959 Robus supplied to Alva Museum Replicas a plaster reduction in half-scale, from which it produced cast-stone replicas with a bronze finish. In 1976 the Forum Gallery commissioned, with the authorization of the Robus family, an edition of bronze casts of the 8½-inch version at the Joel Meisner and Company foundry in Plainview, New York. To date, three half-scale bronze casts have been made.[4]

The Metropolitan's polished bronze, the second of the three half-scale casts, sits on a 1⅛-inch base of wood with an inset sheet of polished aluminum, which reflects the figure's torso. JMM

1. *Art in Our Time,* exh. cat. (New York: Museum of Modern Art, 1939), no. 297.
2. "New Acquisitions," *Bulletin of the Museum of Modern Art* 8 (June–July 1941), pp. 14–15; and Tarbell 1980, pp. 74, 176–77.
3. Tarbell 1980, pp. 175–77.
4. Offer of gift form, September 12, 1997, object files, MMA Department of Modern Art.

390. *Song*, 1934

Bronze, 1946–47
60 x 13½ x 14 in. (152.4 x 34.3 x 35.6 cm)
Signed (heel of figure's right foot): HUGO ROBUS
Rogers Fund, by exchange, 1947 (47.154)

SONG IS THE embodiment of a melodic line in the form of an adolescent girl, both innocent and uninhibited. Robus's young subject is presented nude, her pubescent body is lifesize, and her demeanor, with head thrown back, posture erect, and mouth open, suggests a total engagement in her musical activity. The smooth surfaces and attenuated anatomy of the nude demonstrate Robus's idiomatic combination of European modernism with his own manner of presenting the human figure. While the sinuous contours and exaggerated proportions of his subject border on abstraction, Robus enhanced the expressiveness of this nude through stylization. As in his other sculptures of the 1920s and 1930s, the masklike face of the young woman registers his interest in the masks of Japanese Nō dramas.

The sculpture, modeled in clay in 1934, was shown in plaster in a group exhibition of sculpture at the Brooklyn Museum in 1935.[1] After World War II Robus was finally able to have it cast in bronze; he was invoiced by the Modern Art Foundry, New York, in May 1946.[2] He felt that "partly because I have considered ours an age of metal and new alloys rather than stone, a very major portion of my production has been structurally sound in metal only."[3] The bronze was exhibited at the Whitney Museum of American Art annual in 1947,[4] and after that show it entered the Metropolitan Museum's collection in exchange for *Woman Combing Her Hair* (1935–36).[5] A second cast was made by Roman Bronze Works in 1956 for a private collector in Los Angeles. Bronze casts made in 1962 are at the Hirshhorn Museum and Sculpture Garden, Washington, D.C., and in a New York private collection.[6]

The Metropolitan's cast of *Song* is on an oak base, 2⅜ inches high. JMM

EXHIBITIONS

Yale University Art Gallery, New Haven, "Sculpture since Rodin," January 14–February 13, 1949, no. 29.
Dwight Art Memorial, Mount Holyoke College, South Hadley, Mass., "The Eye Listens: Music in the Visual Arts," October 23–November 15, 1950, no. 76.
East Side Settlement House, Seventh Regiment Armory, New York, January 24–29, 1955.
"Hugo Robus," traveling exhibition organized by the American Federation of Arts, 1960–62.
Forum Gallery, New York, "Hugo Robus (1885–1964): Memorial Exhibition," January 18–February 12, 1966, no. 14.
"The Figure in 20th Century American Art: Selections from The Metropolitan Museum of Art," traveling exhibition organized by the MMA and the American Federation of Arts, February 1985–June 1986.
MMA, "The Human Figure in Transition, 1900–1945: American Sculpture from the Museum's Collection," April 15, 1997–March 29, 1998.

1. Information provided by the artist, June 19, 1948, MMA Archives; and "Summer Show," *Brooklyn Museum Quarterly* 22 (July 1935), pp. 137–38.
2. Tarbell 1980, p. 178.
3. Robus 1943, p. 96. The plaster version of *Song* is illustrated in this article.
4. Information provided by the artist, June 19, 1948, MMA Archives; *1947 Annual Exhibition of Contemporary American Sculpture, Watercolors, and Drawings* (New York: Whitney Museum of American Art, 1947), no. 52.
5. In December 1942 Robus was awarded a second prize in sculpture for his *Woman Combing Her Hair* in the "Artists for Victory" exhibition at the Metropolitan Museum, and the work thus entered the Museum's collection. Letters to Robus from Juliana Force, Director, Whitney Museum, May 19, 1947, and Horace Jayne, Vice Director, MMA, August 25, 1947, MMA Archives, indicate that the Metropolitan Museum suggested this exchange through Force after the Whitney's annual closed. *Woman Combing Her Hair* was returned to Robus, who then sold it to the Munson-Williams-Proctor Institute, Utica, New York, in 1948.
6. Tarbell 1980, pp. 178–79.

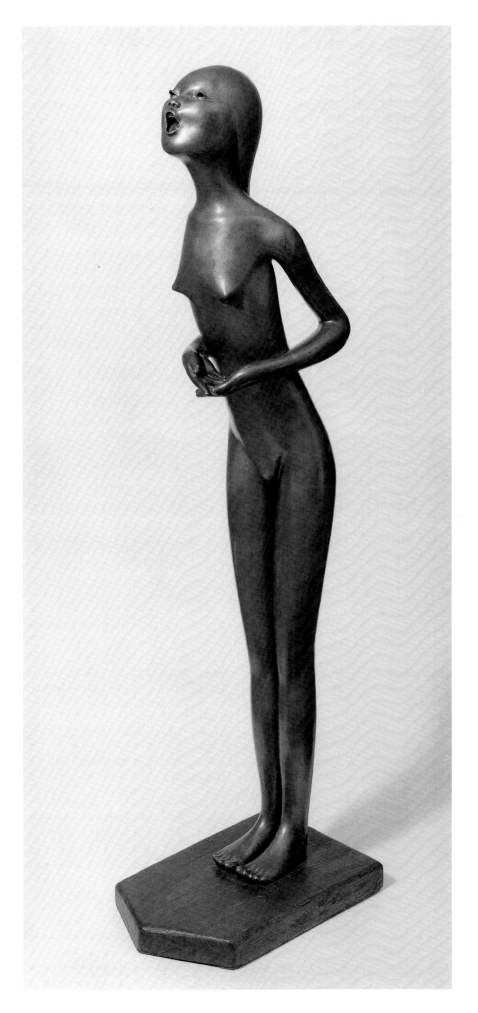

391. *Meditating Girl*, 1958

Bronze, possibly 1959
23⅞ x 20¼ x 12 in. (60.6 x 51.4 x 30.5 cm)
Signed (back, figure's right buttock): HUGO ROBUS
Foundry mark (side of figure's left foot): FOND. ART. / BATTAGLIA C. MILANO
Gift in memory of Helen and Herb Poresky by their children,
Louise A. Poresky, Phyllis Goodfriend, Daniel Poresky, and
Paul Poresky, 1990 (1990.201)

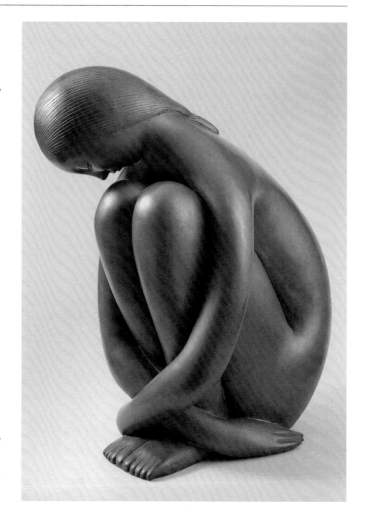

MEDITATING GIRL, a late sculpture in Robus's
oeuvre, is among a number of subjects that express his
quiet, unassuming spirit. It represents a pubescent female
sitting with knees flexed, head lowered, and eyes downcast,
recalling Aristide Maillol's contemplative nude female
entitled *La Nuit* (1907–9; Fondation Dina Vierny–Musée
Maillol, Paris). Attuned to the sculptural abstraction of
Brancusi, who attenuated or fragmented figures, Robus
explored the visual and psychic potentials of this compact
human form, with elongated arms crossed around the
ankles. The streamlined forms and polished surfaces of
Meditating Girl may be reminiscent of Constantin
Brancusi's *Sleeping Muse* (1910; MMA acc. no. 49.70.225),
but Robus's work exhibits additional influences. The face
reflects his known interest in Japanese Nō masks, and the
incised hair and interlocked body parts seem related to
Art Deco. The work is both modern in its rhythmic,
abstracted form and traditional in its use of the female
figure to convey a state of mind.

According to Roberta K. Tarbell *Meditating Girl* was
cast in 30-inch versions in plaster and bronze, and in
8-inch versions in plaster, bronze, silver, and Alvastone.[1]
However, a bronze of the 24-inch version, cast by October
1959, was included in the 1960–62 traveling exhibition of
Robus's work; it is at the Saint Louis University School of
Commerce and Finance.[2] JMM

1. Tarbell 1980, pp. 216–17.
2. Tarbell to Joan M. Marter, electronic letter, August 25, 2000;
 Rothschild 1960, p. 36, no. 15.

John Henry Bradley Storrs (1885–1956)

Storrs was born in Chicago, where his father was an architect and real estate developer. He graduated from University High School in 1905, having drawn cartoons for the school's weekly paper and served as art editor of the class yearbook. His formal training as a sculptor began later that year with a six-month apprenticeship to Arthur Bock in Hamburg, Germany. In 1907, after enrolling briefly at the Académie Franklin in Paris, Storrs traveled in Italy, Turkey, Egypt, Spain, and Greece until November. He then returned to Chicago, where he worked for his father and attended classes at the School of the Art Institute of Chicago. In late 1909 to early 1910 he studied with the sculptor Bela Pratt at the School of the Museum of Fine Arts, Boston. During the following year he trained with Charles Grafly (pp. 403–7) at the Pennsylvania Academy of the Fine Arts and was awarded the Edmund A. Stewardson Prize (see p. 470).

Storrs returned to Europe in September 1911 and spent a year at the Académie Colarossi in Paris, where he studied with Paul Wayland Bartlett (pp. 454–63) and Jean-Antoine Injalbert. He also took sketching classes with Lucien Simon at the Académie de la Grande Chaumière, and he had some instruction in sculpture from Auguste Rodin, probably in 1913–14. Storrs exhibited at some of the annual exhibitions in Paris, including the Salon d'Automne in 1913 and the Société Nationale des Beaux-Arts in 1914, submitting quiet nudes that reflected Rodin's influence. In 1914 Storrs married a French novelist and journalist, Marguerite De Ville Chabrol, and for a time lived with her family in Orléans. The couple returned to Chicago and in 1915 took a postponed wedding trip to the Canadian Rockies, Mexico, and the American Southwest, an experience that probably marked the beginning of Storrs's collecting of Native American art. At the Panama-Pacific International Exposition in San Francisco in 1915 he exhibited a marble head.

The artist went back to France in 1916; over the next several years he wrote poetry and created etchings, woodcuts, and figural sculpture that reflected the influence of Cubism in their utilization of faceted planes. He also became acquainted with the work of the Vorticists through his friendship with the English painter Jessica Dismorr, whom he met in Paris. Storrs's first solo exhibition was held at Folsom Galleries in New York in 1920 and then at the Arts Club of Chicago. Also in 1920 Storrs was commissioned by the Aero Club of France to produce for Le Mans a work commemorating Wilbur Wright's test flight; the granite monument carved with an eagle in profile, dedicated in 1922, was an example of the stylized winged-figure motif that recurred in his work of these years.

After 1921 Storrs began to produce nonobjective sculptures constructed of industrial materials. His most notable achievement was the series of sculptures in combined metals and in stone titled *Studies in Form, Forms in Space,* and *Architectural Forms,* which demonstrate his interest in contemporary American architecture, particularly the skyscraper. His architectonic approach to sculpture also reflects his familiarity with the buildings of such Chicago architects as Frank Lloyd Wright, whom he knew from his formative years. In this period Storrs became aware of Russian Constructivist sculpture through exhibitions at the Société Anonyme, established in New York by Katherine Dreier. Storrs himself had a solo exhibition presented by the Société Anonyme in 1923. Among contemporary sculptors who influenced Storrs's use of simplified geometric shapes were Aristide Maillol, recognized among modernists for his reduction of the figure to essential volumes and mass, and Jacques Lipchitz, who was working in an abstract style and with whom Storrs became friends. Storrs's work also reveals his attraction to Egyptian, Precolumbian, medieval, and Native American sculpture.

The popularity of the Art Deco style, with which Storrs's sculpture was closely related, earned the artist large-scale commissions, often connected with architectural projects. Among his best-known public sculptures is a 30-foot-high aluminum statue, *Ceres,* for the Chicago Board of Trade Building, dedicated in 1930. The vertical lines of the goddess's robe repeat those that mark the streamlined exterior of the building. For the Hall of Science at Chicago's Century of Progress Exposition in 1933, Storrs created sculptures and reliefs in plaster, including the gigantic *Knowledge Combating Ignorance.* In 1937 his United States Naval Monument, a stepped shaft of granite with marine motifs carved in relief, was unveiled in Brest, France (destroyed 1941).

By 1931 Storrs had turned increasingly to painting. He lived in Mer (Loir-et-Cher), near Orléans, in the Château de Chantecaille, which he had acquired in 1921, and made his last trip to the United States in 1939. In 1936 he was elected a Chevalier of the French Legion of Honor. Storrs was imprisoned by the Nazis during 1941–42 and again in 1944. After the war he continued to work and to show his paintings and sculptures in local museums. JMM

SELECTED BIBLIOGRAPHY

Storrs, John, Papers. Archives of American Art, Smithsonian Institution, Washington, D.C., microfilm reels 1548–58, 1774–75, 2976, and 4299–306.

Salmon, André. *John Storrs and Modern Sculpture.* Exh. cat. New York: Société Anonyme, 1923.

Bryant, Edward. "Rediscovery: John Storrs." *Art in America* 57 (May–June 1969), pp. 66–71.

Davidson, Abraham A. "John Storrs, Early Sculptor of the Machine Age." *Artforum* 13 (November 1974), pp. 41–45.

Gordon, Jennifer, et al. *John Storrs and John Flannagan: Sculpture and Works on Paper.* Exh. cat. Williamstown, Mass.: Sterling and Francine Clark Art Institute, 1980.

Frackman, Noel. *John Storrs.* Exh. cat. New York: Whitney Museum of American Art, 1986.

Dinin, Kenneth. "John Storrs: Organic Functionalism in a Modern Idiom." *Journal of Decorative and Propaganda Arts* 6 (Fall 1987), pp. 48–73.

Frackman, Noel Stern. "The Art of John Storrs." Ph.D. diss. New York University, 1987.

Frackman, Noel. "John Storrs's *Bust of Ceres:* The Goddess without a Physiognomy." *Kresge Art Museum Bulletin* 3 (1988), pp. 21–25.

John Storrs: Rhythm of Line. Exh. cat. Introduction by Meredith E. Ward. New York: Hirschl and Adler Galleries, 1993.

392. *Forms in Space No. 1,* ca. 1927

Copper, nickel silver
20¼ x 5½ x 3⅛ in. (51.4 x 14 x 7.9 cm)
Francis Lathrop Fund, 1967 (67.238)

JOHN STORRS was among the most prominent of the American sculptors who worked in a nonfigurative style during the 1920s. *Forms in Space No. 1* was constructed with machinelike precision of narrow copper bars overlaid in selected areas with nickel silver.[1] With its simple, elegant planes the work takes on the appearance of a skyscraper, seeming to surge upward while retaining the solidity of its architectural prototype. Storrs's skyscraper sculptures from his *Studies in Form, Forms in Space,* and *Architectural Forms* series of the 1920s were imagined, rather than derived, tributes to this American building type. However, in the single instance of the Metropolitan's *Forms in Space No. 1,* a specific source has been suggested: the building at 333 North Michigan Avenue, Chicago. The architects were John A. Holabird and John Wellborn Root, Jr., who would also design the Board of Trade Building for which Storrs executed his monumental aluminum *Ceres* (1930). *Forms in Space No. 1* probably dates from the same period, 1927–28, as the construction of 333 North Michigan Avenue, the first Art Deco–style skyscraper in Chicago.[2] However, according to Storrs scholar Noel Frackman, "*Forms in Space* is hardly a copy of the actual skyscraper; rather, Storrs has simplified, refined, and heightened the various elements contained within the generalized form of the building."[3]

The Museum purchased *Forms in Space No. 1* from the Downtown Gallery, New York, where it had been included in an exhibition of Storrs's work in the spring of 1965.[4]

The sculpture is mounted on a Belgian black marble block, 4¾ inches high. JMM

EXHIBITIONS

MMA, "20th Century Accessions, 1967–1974," March 7–April 23, 1974.

Museum of Contemporary Art, Chicago, November 13, 1976–January 2, 1977; University of Indiana Art Museum, Bloomington, January 18–February 20, 1977; Art Gallery of the University of Maryland, College Park, March 29–May 1, 1977, "John Storrs (1885–1956): A Retrospective Exhibition of Sculpture."

Montreal Museum of Fine Arts, "The 1920s: Age of the Metropolis," June 20–November 10, 1991, no. 638.

1. SEM/EDS report, October 16, 2000, MMA Department of Objects Conservation, testing conducted by Mark T. Wypyski, Associate Research Scientist.
2. Frackman 1986, pp. 73–74.
3. Ibid., p. 74.
4. Recommended purchase form, September 29, 1967; purchase approved, November 20, 1967, MMA Archives; *Downtown Gallery, Exhibition . . . John Storrs* (New York, 1965), no. 26.

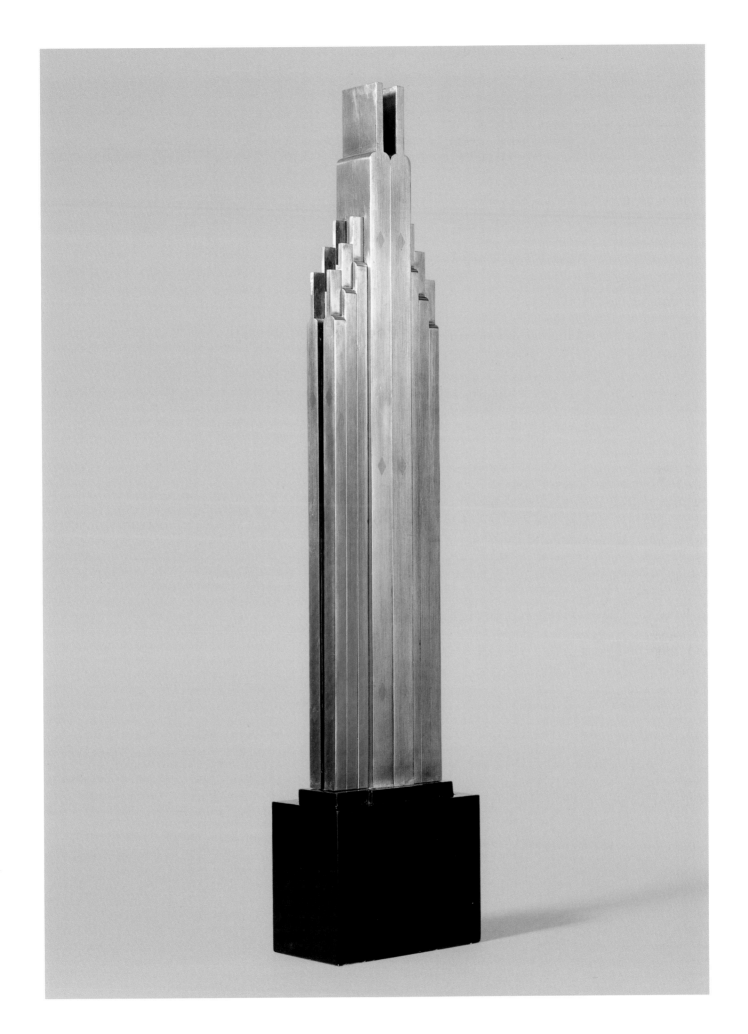

393. *Tête-à-Tête*, ca. 1939

Bronze
11 x 11½ x 2¼ in. (27.9 x 29.2 x 5.7 cm)
Signed (back, lower left corner): STORRS
Foundry mark (back, lower right corner, in seal, stamped): CIRE / VALSUANI / PERDUE
Purchase, Edward C. Moore Jr. Gift and Rogers Fund, 1970 (1970.10)

THIS COMPOSITION, consisting of a square frame enclosing a seated nude couple with interlocked right arms, whose torsos form two sides of a triangular mass, shows Storrs's return in the 1930s to the figure as an artistic motif. In its simplicity of form *Tête-à-Tête* acknowledges Storrs's long admiration of the sculpture of Aristide Maillol. In particular, Maillol's high-relief plaster composition *Desire* (ca. 1906–8; Museum of Modern Art, New York) has female and male figures similarly organized within a framing box.[1]

When *Tête-à-Tête* came to the Museum it had been published as dating to 1917,[2] but James Pilgrim, curator of the retrospective exhibition of Storrs's work at the Corcoran Gallery of Art, Washington, D.C., in May–June 1969, suggested that it be redated to about 1939 based on drawings then in the collection of Storrs's daughter, Monique Storrs Booz.[3] The work continued to be published as dating to 1917 until the 1986–87 exhibition of Storrs's work organized by the Whitney Museum of American Art.[4]

The Metropolitan's bronze was purchased from the Storrs estate through the Robert Schoelkopf Gallery, New York.[5] Other casts of *Tête-à-Tête* are at the Hirshhorn Museum and Sculpture Garden, Washington, D.C., and the Musée des Beaux-Arts, Blois (Loir-et-Cher).[6]

Tête-à-Tête is mounted on a black painted wood base, 1⅝ inches high.　　　　　　　　　　　　　JMM

EXHIBITIONS

MMA, "20th Century Accessions, 1967–1974," March 7–April 23, 1974.
Museum of Contemporary Art, Chicago, November 13, 1976–January 2, 1977; University of Indiana Art Museum, Bloomington, January 18–February 20, 1977; Art Gallery of the University of Maryland, College Park, March 29–May 1, 1977, "John Storrs (1885–1956): A Retrospective Exhibition of Sculpture."

Storm King Art Center, Mountainville, N.Y., "20th Century Sculpture: Selections from The Metropolitan Museum of Art," May 18–October 31, 1984.
"The Figure in 20th Century American Art: Selections from The Metropolitan Museum of Art," traveling exhibition organized by the MMA and the American Federation of Arts, New York, February 1985–June 1986.
Whitney Museum of American Art, New York, December 11, 1986–March 22, 1987; Amon Carter Museum, Fort Worth, May 2–July 5, 1987; J. B. Speed Art Museum, Louisville, August 28–November 1, 1987, "John Storrs."
MMA, "The Human Figure in Transition, 1900–1945: American Sculpture from the Museum's Collection," April 15, 1997–March 29, 1998.

1. Roberta K. Tarbell to Joan M. Marter, June 12, 1990, object files, MMA Department of Modern Art.
2. See, for example, *Downtown Gallery, Exhibition . . . John Storrs* (New York, 1965), no. 16.
3. According to notes on object catalogue cards, MMA Department of Modern Art: "Dealer dates [the work] 1917. Pilgrim dates it c. 1939 from drawings in the artist's daughter's collection. / [Downtown Gallery owner Edith] Halpert had two copies cast at a later date by the Modern Art Foundry."
4. For example, *Tête-à-Tête* is listed as dating to 1917 in the checklist of the exhibition "20th Century Sculpture: Selections from The Metropolitan Museum of Art" at Storm King Art Center in 1984; and in Lowery Stokes Sims, *The Figure in 20th Century American Art: Selections from The Metropolitan Museum of Art*, exh. cat. (New York: American Federation of Arts, 1984), p. 18. In Frackman 1986, p. 139, the work is listed as ca. 1939; on p. 140, one of the drawings in that exhibition is listed as "Sculpture Studies (including Tête-à-Tête), 1939 . . . [Estate of Monique Storrs Booz, lent by courtesy of Robert Schoelkopf Gallery, Ltd.]."
5. Recommended purchase form signed by Henry Geldzahler, Curator, MMA Department of Contemporary Arts, January 26, 1970, MMA Archives.
6. Valerie Fletcher, Hirshhorn Museum and Sculpture Garden, to Dana Pilson, MMA Department of American Paintings and Sculpture, telephone conversation, October 11, 2000; and *John Storrs 1885–1956*, exh. cat. (Beaugency: Musée de l'Orléanais, 1987), p. 46, no. 24, listed as "Couple, vers 1948."

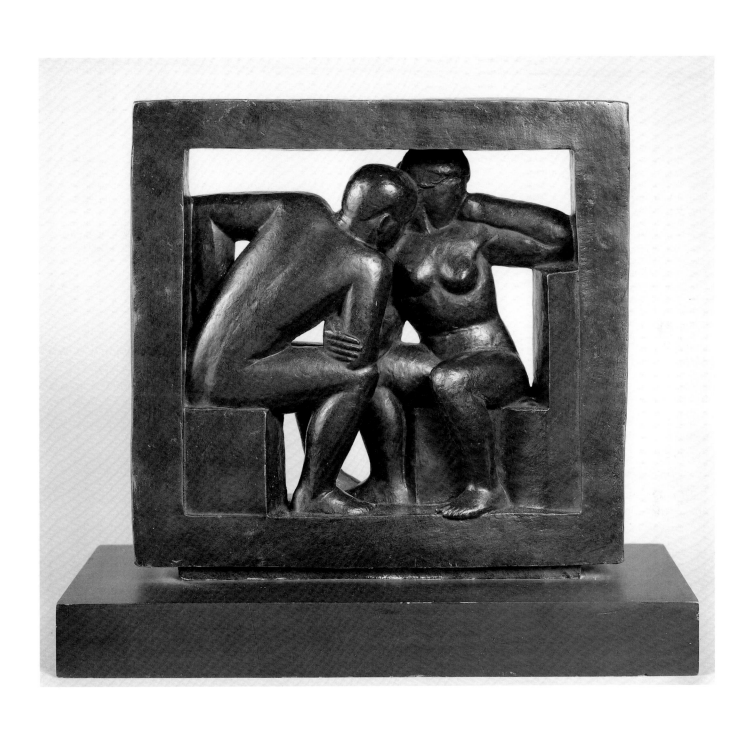

Concordance of Accession and Catalogue Numbers for Volumes 1 and 2

Accession	Cat.	Accession	Cat.	Accession	Cat.	Accession	Cat.
72.3	7	05.13.1	47	09.57	288	18.120	359
77.2a	75	05.15.1	116	09.81	260	18.122	368
80.12	39	05.15.2	119	09.88.1	200	19.34	295
83.3	159	05.15.3	122	09.88.2	201	19.35	202
84.8.2	1	06.146	21	09.147	242	19.47	145
84.9	62	06.298	257	10.115	253	19.91	209
86.4	40	06.303	276	10.199	240	19.94.1	162
88.5a	35	06.305	255	10.200	56	19.124	134
88.9	157	06.306	254	10.233	111	19.126	211
90.17	69	06.307	256	11.41	156	19.127	154
90.18.1, 2	128	06.313	95	11.68.1	43	19.185	213
91.4	42	06.314	96	11.103.1	206	20.17	246
91.13	65	06.315	97	11.103.2	205	20.55	261
91.14	199	06.316	98	12.29	117	20.66	204
92.7	82	06.317	99	12.50	220	20.76	241
94.8a	37	06.318	100	12.51	275	20.125	148
94.9.1	5	06.319	101	12.52	263	20.265	380
94.9.2	25	06.320	102	12.53	184	22.41	268
94.9.3	27	06.400	249	12.76.1	124	22.59	164
94.9.4	15	06.401	247	12.76.2	126	22.61	197
94.14	3	06.402	248	12.76.3	113	22.81	272
94.28	66	06.403	250	12.76.4	115	22.89	235
95.2.6	9	06.404	251	12.143	262	22.97	290
95.8.1	16	06.405	252	13.78	114	22.154	236
95.8.2	28	06.406	222	13.86	226	23.83	83
95.9	208	06.967	234	13.87	258	23.106.1	292
96.11	190	06.982	8	13.196	238	23.106.2	291
96.15	67	06.983	73	13.214	31	23.106.3	293
97.10	76	06.1192	151	14.27	285	23.155	232
97.11	74	06.1227	224	14.61	375	24.20	110
97.13.1	13	06.1264	158	14.77	149	24.39	365
97.13.2a–e	14	06.1318	221	14.92	48	24.153	265
97.19	196	07.42	160	14.119	150	24.239	299
98.5.1	92	07.50	153	15.48	85	25.72	203
98.5.2	86	07.77	167	15.75	143	25.75	244
98.5.3	87	07.79	166	15.105.1	132	25.89	135
98.5.4	103	07.80	165	15.105.2	133	25.234	118
98.9.2	89	07.81	79	16.27	183	26.44	237
98.9.3	90	07.90	137	16.42	379	26.85.1	277
98.9.4	91	07.101	141	16.84	271	26.85.2	278
98.9.5	93	07.104	227	17.63	283	26.105	367
98.9.6	94	07.105	228	17.90.1	136	26.113	214
99.7.1	45	07.112	284	17.90.2	57	26.120	142
99.7.2	46	07.113	72	17.90.3	58	26.160.1	280
99.8	11	07.117	231	17.90.4	60	26.160.2	281
00.9	19	07.223	22	17.104	127	27.21.1	381
02.11.1	70	07.224	20	17.174	49	27.21.4	264
04.38.1	63	08.69	161	18.38	267	27.21.8	194
04.38.2	64	08.216	139	18.80	80	27.21.9	193
05.12	44	09.56.1	225	18.107	286	27.64	104

Index of Artists and Titles for Volumes 1 and 2